THE EMILY CARR COLLECTION

BY EMILY CARR

Klee Wyck
The Book of Small
The House of All Sorts
Growing Pains
The Heart of a Peacock
Pause: *A Sketch Book*
Hundreds and Thousands: *The Journals of An Artist*

The Emily Carr Collection

FOUR COMPLETE AND UNABRIDGED

CANADIAN CLASSICS

Emily Carr

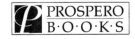

PROSPERO
B·O·O·K·S

National Library of Canada Cataloguing in Publication Data

Carr, Emily, 1871-1945
The Emily Carr collection.

ISBN 1-55267-234-4

1. Carr, Emily, 1871-1945—Written works. I. Title.

ND249.C3A2 2002 759.11 C2002-903876-6

The publisher gratefully acknowledges the support of the Canada Council for
the Arts and the Ontario Arts Council for its publishing program.

We acknowledge the financial support of the Government of Canada through the
Book Publishing Industry Development Program (BPIDP) for our publishing activities.

Prospero Books
A division of Indigo Books and Music Inc.

www.keyporter.com

Cover design: Peter Maher
Electronic formatting: Heidi Palfrey

Printed and bound in Canada

02 03 04 05 06 07 6 5 4 3 2 1

Contents

Klee Wyck

Contents

Foreword

My earliest vivid memories of Emily Carr go back to a period considerably more than a quarter of a century ago, to a time when she was living in Victoria, British Columbia, still largely unnoticed as an artist and, by most of those who did know her in that capacity, unappreciated or treated with ridicule and even hostility. In those days she was a familiar figure passing down Simcoe Street in front of our house which was little more than a stone's throw away from her home. With methodical punctuality by which you could almost have set your clock, she passed by each morning on her way to the grocer's or butcher's. She trundled in front of her an old-fashioned baby carriage in which sat her favourite pet, Woo, a small Javanese monkey dressed in a bright costume of black, red and brown which Emily had made for her. Bounding around her as she went would be six or eight of the great shaggy sheep dogs which she raised for sale. Half an hour later you could see her returning, the baby carriage piled high with parcels, Woo skipping along at the end of a leash, darting under the hedge to catch succulent earwigs which she loved to crunch or sometimes creeping right through the hedge into the garden to have her tail pulled by the children hiding there. The great sheep dogs still bounced around the quaint figure whom they recognized as their devoted mistress. I thought of her then, as did the children behind the hedge and as did most of her fellow-citizens who thought of her at all, as an eccentric, middle-aged woman who kept an apartment house on Simcoe Street near Beacon Hill Park, who surrounded herself with numbers of pets—birds, chipmunks, white rats and the favourite Woo—and raised English sheep dogs in kennels in her large garden.

Emily Carr was a great painter, certainly one of the greatest women painters of any time. It has been said that for originality, versatility, driving creative power and strong, individual achievement she has few equals among modern artists. Her talent in drawing revealed itself when she was still a small child and was encouraged by her father. Emily set herself, early, and with singleness of devotion, to master the technique of painting and, despite discouragement and many difficulties, worked with great courage and experimental enthusiasm until the time of her death.

After the turn of the century, with study in San Francisco and England behind her, she became particularly concerned with the problem of devising a style in painting which would make it possible for her to express adequately not only what she saw but also what she felt in her subject matter—the great

totem poles, tribal houses and villages of the West Coast Indians and, later, the tangled, solemn, majestic beauty of the Pacific Coast forest. Nothing ever meant so much to her as the struggle to gain that power; she was never satisfied that she had achieved her aim. In this connection, therefore, it is interesting to have the opinion of Lawren Harris, himself a great original Canadian painter and for years one of Emily Carr's closest and most valued friends. He says in an article, "The Paintings and Drawings of Emily Carr",

It (British Columbia) is another world from all the land east of the Great Divide. Emily Carr was the first artist to discover this. It involved her in a conscious struggle to achieve a technique that would match the great, new motifs of British Columbia. It was primarily this long and deepening discovery which made her work modern and vital, as it was her love of its moods, mystery and majesty that gave it the quality of indwelling spirit which the Indians knew so well. It was also her life with the Indians and their native culture which led her to share and understand their outlook on nature and life, and gave her paintings of totems, Indian villages and the forest a quality and power which no white person had achieved before.

Emily Carr is now also recognized as a remarkable writer. Her diaries, which first came to light after her death and remain still unpublished, make it clear that her desire to express herself in words began in the late 1920's. As in the case of her painting, she worked very hard to master this medium. She was fascinated by the great range of new possibilities which it opened up but mastery of it did not come easily.

Why did she turn to writing? Sometimes, undoubtedly, merely for comfort in her loneliness, sometimes quite consciously to relive experiences of the past. She once told me that when she was working on the first stages of a painting, trying to put down in pictorial form a subject for which she had made field sketches, she found it of great value to "word" her experience. In this way, she said, the circumstances and all the details of the incident or place would come back to her more vividly and she could reconstruct them more faithfully than was possible with paint and canvas alone. From this developed, I suspect, one of the controlling principles of her method and style in literary composition.

I have seen her "peeling" a sentence, as she called it,—a process which involved stripping away all ambiguous or unnecessary words, replacing a vague word by a sharper, clearer one until the sentence emerged clean and precise in its meaning and strong in its impact on the reader. As a result, there is in her writing the quality of immediacy, the ability, by means of descriptive

words chosen with the greatest accuracy, to carry the reader into the very heart of the experience she is describing, whether it be an incident from her own childhood or a sketch of an Indian and his village—and that so swiftly as to give an impression almost of magic, of incantation.

She has spoken many times in her diaries of the difficulties she had to overcome in writing. Late in October, 1936, she made a characteristic, vivid entry:

There's words enough, paint and brushes enough and thoughts enough. The whole difficulty seems to be getting the thoughts clear enough, making them stand still long enough to be fitted with words and paint. They are so elusive—like wild birds singing above your head, twittering close beside you, chortling in front of you, but gone the moment you put out a hand. If ever you do catch hold of a piece of a thought it breaks away leaving the piece in your hand just to aggravate you. If one only could encompass the whole, corral it, enclose it safe—but then maybe it would die, dwindle away because it could not go on growing. I don't think thoughts *could* stand still—the fringes of them would always be tangling into something just a little further on and that would draw it out and out. I guess that is just *why* it is so difficult to catch a complete idea—it's because everything is always on the move, always expanding.

A very closely related characteristic of her writing is its sincerity. I shall let her speak again for herself in her own forceful, inimitable style.

Be careful that you do not write or paint anything that is not your own, that you don't know in your own soul. You will have to experiment and try things out for yourself and you will not be sure of what you are doing. That's all right, you are feeling your way into the thing. But don't take what someone else has made sure of and pretend that it's you yourself that have made sure of it, till it's yours absolutely by conviction. It's stealing to take it and hypocrisy and you'll fall in a hole. . . . If you're going to lick the icing off somebody else's cake you won't be nourished and it won't do you any good,—or you might find the cake had caraway seeds and you hate them. But if you make your own cake and *know the recipe and stir the thing with your own hand* it's *your* own cake. You can ice it or not as you like. Such lots of folks are licking the icing off the other fellow's cake!

Consequently, Emily Carr's style is characterized by a great simplicity and directness—a simplicity, it's true, that is a little deceptive in view of the

sustained discipline from which it resulted—but perhaps it is just in that way that the only true simplicity is achieved. Words are used by her with great courage, sometimes taking on new and vivid meanings. They are in her writing the equivalent of the quick, sure brush strokes and dramatic, strong colours which are so characteristic of her canvases.

It has been remarked by many readers—and with justification—that Emily Carr's prose style has much in common with poetry. This is to be seen in her rigid selectivity in the use of diction described above, in her daring use of metaphorical language, in the rhythm, the cadence of her writing and in her consciousness of form. Look, for instance, at this passage from "Century Time":

In the late afternoon a great shadow mountain stepped across the lake and brooded over the cemetery. It had done this at the end of every sunny day for centuries, long, long before that piece of land was a cemetery. Dark came and held the shadow mountain there all night, but when morning broke, it was back again inside its mountain, which pushed its grand purple dome up into the sky and dared the pines swarming around its base to creep higher than half way up its bare rocky sides.

Indians do not hinder the progress of their dead by embalming or tight coffining. When the spirit has gone they give the body back to the earth. Cased only in a box it is laid in a shallow grave. The earth welcomes the body—coaxes new life and beauty from it, hurries over what men shudder at. Lovely tender herbage bursts from the graves—swiftly—exulting over corruption.

and again at this passage from "Bobtails":

The top of Beacon Hill was bare. You could see north, south, east and west. The dogs rested, tongues lolling, while I looked at the new day, at the pine trees, at the sky, at the sea where it lay flat, and at the near broom bushes drooped with early morning wetness. The song of the meadow-lark crumbled away the last remnants of night, three sad lingering notes followed by an exultant double note that gobbled up the still vibrating three.

For one moment the morning took you far out into vague chill; your body snatched you back into its cosiness, back to the waiting dogs on the hill top. They could not follow out there; their world was walled, their noses trailed the earth.

or at this from "Canoe":

The canoe passed shores crammed with trees, trees overhanging stony beaches, trees held back by rocky cliffs, pointed fir trees climbing its dark masses up the mountain sides, moonlight silvering their blackness.

Our going was imperceptible, the woman's steering paddle the only thing that moved, its silent cuts stirring phosphorus like white fire.

Time and texture faded, ceased to exist—day was gone, yet it was not night. Water was not wet or deep, just smoothness spread with light.

Such writing transcends the usual limits of prose and becomes (but without aesthetic offence) lyrical.

The quality of form, not a surprising attribute in view of her distinction as a painter, can be seen over and over again but notably in the exquisite lyric, "White Currants", in the simply shaped but touchingly effective "Sophie" and in "D'Sonoqua" which has the quality of a musical symphony with its dominant themes, its sectional development and its use of suspense and tense emotional crescendo.

As a final point in this discussion of Emily Carr's literary style it should be noted that she was not a great reader. Her style is, therefore, not the result of imitation of literary models. Undoubtedly it is better so, for the originality and simplicity which marked all her work, whether in painting, rug-making, pottery or writing, remained uninhibited by academic literary standards. Of these Miss Carr knew little or nothing. But there is some literary influence. She was a devoted reader of the poems of Walt Whitman, attracted to them by Whitman's deep feeling for nature and by his vigorous style. There is too, I think, a discernible influence at times of the Bible, notably of the Psalms, and of the English Prayerbook.

But above everything else, Emily Carr was a truly great Canadian. Her devotion to her own land marked everything she did. She approached no subject in writing or painting with any condescension or purely artistic self-consciousness. She was driven always by a passion to make her own experience in the place in which life had set her vivid and real for the onlooker or the reader and to do this with dignity and distinction. She found life in her part of Canada often hard and baffling but always rich and full. It was her single purpose to share through the medium of her art and in as memorable a fashion as possible the experiences of her life. She was never happy outside Canada. Indeed, during her sojourns in England and France she was the victim of such overwhelming homesickness that she became physically ill and was ordered by her physician to return to her Canadian home.

She was an amazing woman. May I take the liberty of quoting a note which I set down in 1941? I hold the views as firmly today as then:

I have heard her talking and watched her devour the conversation of others, of Lawren Harris, of Arthur Benjamin, of Garnett Sedgewick; I have watched her anger tower over some meanness in the work or conduct of an artist and I have seen her become incandescent with generous enthusiasm for another's fine work; I have seen her gentleness to an old woman and to an animal; I have beheld the vision of forest and sky enter and light her eyes as she sat far from them—and I am convinced that Emily Carr is a great genius and that we will do well to add her to that small list of originals who have been produced in this place and have lived and commented in one way or another on this Canada of ours.

Emily Carr was herself more modest. Asked a few years before her death to state what had been the outstanding events of her life, she wrote,

Outstanding events!—work and more work! The most outstanding seems to me the buying of an old caravan trailer which I had towed to out-of-the-way corners and where I sat self-contained with dogs, monk and work—Walt Whitman and others on the shelf—writing in the long, dark evenings after painting—loving everything terrifically. In later years my work had some praise and some successes, but the outstanding event to me was the *doing* which I am still at. Don't pickle me away as a "done".

It is impossible to think of that vivid person as a "done". No, she goes on in her work. As surely as Wordsworth marked the English Lake District with his peculiar kind of seeing and feeling, leaving us his experience patterned in poetry, so surely this extraordinary, sensitive, gifted Canadian touched a part of our landscape and life and left her imprint there so clearly that now we, who have seen her canvases or read her books must feel, as we enter the vastness of the western forest or stand before a totem pole or in the lonely ruin of an Indian village, less bewildered and alone because we recognize that another was here before us and humanized all this by setting down in paint or words her reaction to it.

IRA DILWORTH

Robin Hill,
Knowlton, P.Q.,
June, 1951

Ucluelet

The Lady Missionaries expected me. They sent an enormous Irishman in a tiny canoe to meet the steamer. We got to the Ucluelet wharf soon after dawn. Everything was big and cold and strange to me, a fifteen-year-old school girl. I was the only soul on the wharf. The Irishman did not have any trouble deciding which was I.

It was low tide, so there was a long, sickening ladder with slimy rungs to climb down to get to the canoe. The man's big laugh and the tippiness of the canoe were even more frightening than the ladder. The paddle in his great arms rushed the canoe through the waves.

We came to Toxis, which was the Indian name for the Mission House. It stood just above hightide water. The sea was in front of it and the forest behind.

The house was of wood, unpainted. There were no blinds or curtains. It looked, as we paddled up to it, as if it were stuffed with black. When the canoe stuck in the mud, the big Irishman picked me up in his arms and set me down on the doorstep.

The Missionaries were at the door. Smells of cooking fish jumped out past them. People lived on fish at Ucluelet.

Both the Missionaries were dignified, but the Greater Missionary had the most dignity. They had long noses straddled by spectacles, thin lips, mild eyes, and wore straight, dark dresses buttoned to the chin.

There was only two of everything in the kitchen, so I had to sit on a box, drink from a bowl and eat my food out of a tin pie-dish.

After breakfast came a long prayer. Outside the kitchen window, just a few feet away at the edge of the forest, stood a grand balsam pine tree. It was very tall and straight.

The Missionaries' "trespasses" jumped me back from the pine tree to the Lord's Prayer just in time to "Amen". We got up from our knees to find the house full of Indians. They had come to look at me.

I felt so young and empty standing there before the Indians and the two grave Missionaries! The Chief, old Hipi, was held to be a reader of faces. He perched himself on the top of the Missionaries' drug cupboard; his brown fists clutched the edge of it, his elbows taut and shoulders hunched. His crumpled shoes hung loose as if they dangled from strings and had no feet in them. The stare of his eyes searched me right through. Suddenly they were done; he lifted them above me to the window, uttered several terse sentences in Chinook, jumped off the cupboard and strode back to the village.

I was half afraid to ask the Missionary, "What did he say?"

"Not much. Only that you had no fear, that you were not stuck up, and that you knew how to laugh."

Toxis sat upon a long, slow lick of sand, but the beach of the Indian village was short and bit deep into the shoreline. Rocky points jutted out into the sea at either end of it.

Toxis and the village were a mile apart. The school house was half-way between the two and, like them, was pinched between sea and forest.

The school house called itself "church house" on Sundays. It had a sharp roof, two windows on each side, a door in front, and a woodshed behind.

The school equipment consisted of a map of the world, a blackboard, a stove, crude desks and benches and, on a box behind the door, the pail of drinking-water and a tin dipper.

The Lesser Missionary went to school first and lit the fire. If the tide were high she had to go over the trail at the forest's edge. It was full of holes where high seas had undermined the big tree roots. Huge upturned stumps necessitated detours through hard-leafed salal bushes and skunk cabbage bogs. The Lesser Missionary hated putting her feet on ground which she could not see, because it was so covered with growing green. She was glad when she came out of the dark forest and saw the unpainted school house. The Greater Missionary had no nerves and a long, slow stride. As she came over the trail she blew blasts on a cow's horn. She had an amazing wind, the blasts were stunning, but they failed to call the children to school, because no voice had ever suggested time or obligation to these Indian children. Then the Greater Missionary went to the village and hand-picked her scholars from the huts.

On my first morning in Ucluelet there was a full attendance at school because visitors were rare. After the Lord's Prayer the Missionaries duetted a hymn while the children stared at me.

When the Missionary put *A*, *B*, *C* on the board the children began squirming out of their desks and pattering down to the drinking bucket. The dipper registered each drink with a clank when they threw it back.

The door squeaked open and shut all the time, with a second's pause between opening and closing. Spitting on the floor was forbidden, so the children went out and spat off the porch. They had not yet mastered the use of the pocket handkerchief, so not a second elapsed between sniffs.

Education being well under way, I slipped out to see the village.

When I did not return after the second's time permitted for spitting, the children began to wriggle from the desks to the drinking bucket, then to the spitting step, looking for me. Once outside, their little bare feet never stopped till they had caught me up.

After that I was shut up tight at Toxis until school was well started; then I went to the village, careful to creep low when passing under the school windows.

On the point at either end of the bay crouched a huddle of houses—large, squat houses made of thick, hand-hewn cedar planks, pegged and slotted together. They had flat, square fronts. The side walls were made of driftwood. Bark and shakes, weighted with stones against the wind, were used for roofs. Every house stood separate from the next. Wind roared through narrow spaces between.

Houses and people were alike. Wind, rain, forest and sea had done the same things to both—both were soaked through and through with sunshine, too.

I was shy of the Indians at first. When I knocked at their doors and received no answer I entered their houses timidly, but I found a grunt of welcome was always waiting inside and that Indians did not knock before entering. Usually some old crone was squatted on the earth floor, weaving cedar fibre or tatters of old cloth into a mat, her claw-like fingers twining in and out, in and out, among the strands that were fastened to a crude frame of sticks. Papooses tumbled around her on the floor for she was papoose-minder as well as mat-maker.

Each of the large houses was the home of several families. The door and the smoke-hole were common to all, but each family had its own fire with its own things round it. That was their own home.

The interiors of the great houses were dim. Smoke teased your eyes and throat. The earth floors were not clean.

It amused the Indians to see me unfold my camp stool, and my sketch sack made them curious. When boats, trees, houses, appeared on the paper, jabbering interest closed me about. I could not understand their talk. One day, by grin and gesture, I got permission to sketch an old mat-maker. She nodded and I set to work. Suddenly a cat jumped in through the smoke-hole and leaped down from a rafter on to a pile of loose boxes. As the clatter of the topple ceased there was a bestial roar, a pile of mats and blankets burst upwards, and a man's head came out of them. He shouted and his black eyes snapped at me and the old woman's smile dried out.

"Klatawa" (Chinook for "Go") she shouted, and I went. Later, the old wife called to me across the bay, but I would not heed her call.

"Why did you not reply when old Mrs. Wynook called you?" the Missionary asked.

"She was angry and drove me away."

"She was calling, 'Klee Wyck, come back, come back.' when I heard her."

"What does 'Klee Wyck' mean?"

"I do not know."

The mission house door creaked open and something looking like a bundle of tired rags tumbled on to the floor and groaned.

"Why, Mrs. Wynook," exclaimed the Missionary, "I thought you could not walk!"

The tired old woman leaned forward and began to stroke my skirt.

"What does Klee Wyck mean, Mrs. Wynook?" asked the Missionary.

Mrs. Wynook put her thumbs into the corners of her mouth and stretched them upwards. She pointed at me; there was a long, guttural jabber in Chinook between her and the Missionary. Finally the Missionary said, "Klee Wyck is the Indians' name for you. It means 'Laughing One'."

The old woman tried to make the Missionary believe that her husband thought it was I, not the cat, who had toppled the boxes and woke him, but the Missionary, scenting a lie, asked for "straight talk". Then Mrs. Wynook told how the old Indians thought the spirit of a person got caught in a picture of him, trapped there so that, after the person died, it had to stay in the picture.

"Tell her that I will not make any more pictures of the old people," I said. It must have hurt the Indians dreadfully to have the things they had always believed trampled on and torn from their hugging. Down deep we all hug something. The great forest hugs its silence. The sea and the air hug the spilled cries of sea-birds. The forest hugs only silence; its birds and even its beasts are mute.

When night came down upon Ucluelet the Indian people folded themselves into their houses and slept.

At the Mission House candles were lit. After eating fish, and praying aloud, the Missionaries creaked up the bare stair, each carrying her own tin candlestick. I had a cot and scrambled quickly into it. Blindless and carpetless, it was a bleak bedroom even in summer.

The room was deathly still. Outside, the black forest was still, too, but with a vibrant stillness tense with life. From my bed I could look one storey higher into the balsam pine. Because of his closeness to me, the pine towered above his fellows, his top tapering to heaven.

Every day might have been a Sunday in the Indian village. At Toxis only the seventh day was the Sabbath. Then the Missionaries conducted service in the school house which had shifted its job to church as the cow's horn turned itself into a church bell for the day.

The Indian women with handkerchiefs on their heads, plaid shawls round their shoulders and full skirts billowing about their legs, waddled leisurely towards church. It was very hard for them to squeeze their bodies into the children's desks. They took two whole seats each, and even then the squeezing must have hurt.

Women sat on one side of the church. The very few men who came sat on the other. The Missionaries insisted that men come to church wearing trousers, and that their shirt tails must be tucked inside the trousers. So the Indian men stayed away.

"Our trespasses" had been dealt with and the hymn, which was generally pitched too high or too low, had at last hit square, when the door was swung violently back, slopping the drinking bucket. In the outside sunlight stood old Tanook, shirt tails flapping and legs bare. He entered, strode up the middle of the room and took the front seat.

Quick intakes of horror caught the breath of the women; the Greater Missionary held on to her note, the Lesser jumped an octave.

A woman in the back seat took off her shawl. From hand to hand it travelled under the desks to the top of the room, crossed the aisle and passed into the hand of Jimmy John, old Tanook's nephew, sitting with the men. Jimmy John squeezed from his seat and laid the shawl across his uncle's bare knees.

The Missionary's address rolled on in choppy Chinook, undertoned by a gentle voice from the back of the room which told Tanook in pure Indian words what he was to do.

With a defiant shake of his wild hair old Tanook got up; twisting the shawl about his middle he marched down the aisles, paused at the pail to take a loud drink, dashed back the dipper with a clank, and strode out.

The service was over, the people had gone, but a pink print figure sat on in the back seat. Her face was sunk down on her chest. She was waiting till all were away before she slunk home. It is considered more indecent for an Indian woman to go shawl-less than for an Indian man to go bare-legged. The woman's heroic gesture had saved her husband's dignity before the Missionaries but had shamed her before her own people.

The Greater Missionary patted the pink shoulder as she passed.

"Brave woman!" said the Greater Missionary, smiling.

One day I walked upon a strip of land that belonged to nothing.

The sea soaked it often enough to make it unpalatable to the forest. Roots of trees refused to thrive in its saltiness.

In this place belonging neither to sea nor to land I came upon an old man dressed in nothing but a brief shirt. He was sawing the limbs from a fallen tree. The swish of the sea tried to drown the purr of his saw. The purr of the saw tried to sneak back into the forest, but the forest threw it out again into the sea. Sea and forest were always at this game of toss with noises.

The fallen tree lay crosswise in this "nothing's place"; it blocked my way. I sat down beside the sawing Indian and we had dumb talk, pointing to the sun and to the sea, the eagles in the air and the crows on the beach. Nodding and laughing together I sat and he sawed. The old man sawed as if aeons of time were before him, and as if all the years behind him had been leisurely and all the years in front of him would be equally so. There was strength still in his back and limbs but his teeth were all worn to the gums. The shock of hair that fell to his shoulders was grizzled. Life had sweetened the old man. He was luscious with time like the end berries of the strawberry season.

With a final grin, I got up and patted his arm—"Goodbye!" He patted my hand. When he saw me turn to break through the forest so that I could round his great fallen tree, he ran and pulled me back, shaking his head and scolding me.

"Swaawa! Hiyu swaawa!" Swaawa were cougar: the forest was full of these great cats. The Indians forbade their children to go into the forest, not even into its edge. I was to them a child, ignorant about the wild things which they knew so well. In these things the Indian could speak with authority to white people.

Tanoo

Jimmie had a good boat. He and his wife, Louisa, agreed to take me to the old villages of Tanoo, Skedans and Chumshewa, on the southern island of the Queen Charlotte group. We were to start off at the Indian's usual "eight o'clock" and got off at the usual "near noon". The missionary had asked me to take his pretty daughter along.

We chugged and bobbed over all sorts of water and came to Tanoo in the evening. It looked very solemn as we came nearer. Quite far out from land Jimmie shut off the engine and plopped the anchor into the sea. Then he shoved the canoe overboard, and putting my sheep dog and me into it, nosed it gently through the kelp. The grating of our canoe on the pebbles warned the silence that we were come to break it.

The dog and I jumped out and Jimmie and the canoe went back for the others.

It was so still and solemn on the beach, it would have seemed irreverent to speak aloud; it was if everything were waiting and holding its breath. The dog felt it too; he stood with cocked ears, trembling. When the others came and moved about and spoke this feeling went away.

At one side of the Tanoo beach rose a big bluff, black now that the sun was behind it. It is said that the bluff is haunted. At its foot was the skeleton of a house; all that was left of it was the great beams and the corner posts and two carved poles one at each end of it. Inside, where the people used to live, was stuffed with elderberry bushes, scrub trees and fireweed. In that part of the village no other houses were left, but there were lots of totem poles sticking up. A tall slender one belonged to Louisa's grandmother. It had a story carved on it; Louisa told it to us in a loose sort of way as if she had half forgotten it. On the base of this pole was the figure of a man; he had on a tall, tall hat, which was made up of sections, and was a hat of great honour. On the top of the hat perched a raven. Little figures of men were clinging to every ring of honour all the way up the hat. The story told that the man had adopted a raven as his son. The raven turned out to be a wicked trickster and brought a flood upon his foster parents. When the waters rose the man's nephews and relations climbed up the rings of his hat of honour and were thus saved from being drowned. It was a fine pole, bleached of all colour and then bloomed over again with greeny-yellow mould.

The feelings Jimmie and Louisa had in this old village of their own people must have been quite different from ours. They must have made my curiosity seem small. Often Jimmie and Louisa went off hand in hand by themselves for a little, talking in Indian as they went.

A nose of land ran out into the sea from Tanoo and split the village into two parts; the parts diverged at a slight angle, so that the village of Tanoo had a walleyed stare out over the sea.

Beyond the little point there were three fine house fronts. A tall totem pole stood up against each house; in the centre of its front. When Jimmie cut away the growth around the foot of them, the paint on the poles was quite bright. The lowest figure of the centre pole was a great eagle; the other two were beavers with immense teeth—they held sticks in their hands. All three base figures had a hole through the pole so that people could enter and leave the house through the totem.

Our first night in solemn Tanoo was very strange indeed.

When we saw the Indians carrying the little canoe down to the water we said:

"What are you going out to the boat for?"

"We are going to sleep out there."

"You are going to leave us alone in Tanoo?"

"You can call if anything is wrong," they said.

But we knew the boat was too far out beyond the kelp beds for them to hear us.

The canoe glided out and then there was nothing but wide black space. We two girls shivered. I wanted the tent flaps open; it did not seem quite so bad to me if I could feel the trees close.

Very early in the morning I got to work. The boat lay far out with no sign of life on her. The Indians did not come ashore; it got late and we wanted breakfast—we called and called but there was no answer.

"Do you remember what they said about those Indians being asphyxiated by the fumes from their engine while they slept?"

"I was thinking of that too."

We ran out on the point as far as we could so as to get nearer to the boat and we called and called both together. There was a horrible feeling down inside us that neither of us cared to speak about. After a long while a black head popped up in the boat.

"You must not leave us again like that," we told Jimmie and Louisa.

I met them coming over the sand, Louisa hurrying ahead to get supper. Away back I saw Jimmie carrying something dreadful with long arms trailing behind in the sand, its great round body speared by the stick on Jimmie's shoulder.

"We've took the missionary's daughter hunting devilfish," chuckled Louisa, as she passed me.

We ate some of the devilfish for supper, fried in pieces like sausage. It was sweet like chicken, but very tough.

The devilfish were in the puddles around the rocks at low tide. When they saw people come, they threw their tentacles around the rocks and stuck their heads into the rocky creases; the only way to make them let go was to beat their heads in when you got the chance.

It was long past dinnertime. Louisa could not cook because there was no water in camp. That was Jimmie's job. The spring was back in the woods, nobody but Jimmie knew where, and he was far out at sea tinkering on his boat. Louisa called and called; Jimmie heard, because his head popped up, but he would not come. Every time she called the same two Indian words.

"Make it hotter, Louisa; I want to get back to work." She called the same two words again.

"Are those words swears?"

"No, if I swore I would have to use English words."

"Why?"

"There are no swears in Haida."

"What do you say if you are angry or want to insult anybody?"

"You would say, 'Your father or your mother was a slave,' but I could not say that to Jimmie."

"Well, say something hot. I want dinner!"

She called the same two words again but her voice was different this time. Jimmie came.

Pictures of all the poles were in my sketch sack. I strapped it up and said, "That's that."

Then we went away from Tanoo and left the silence to heal itself—left the totem poles staring, staring out over the sea.

Almost immediately we were in rough water. Jimmie spread a sail in the bottom of the boat, and we women all lay flat. Nobody spoke—only groans. When the boat pitched all our bodies rolled one way and then rolled back. Under the sail where I was lying something seemed very slithery.

"Jimmie, what is under me?"

"Only the devilfish we are taking home to Mother—she likes them very much."

"Ugh!" I said. Sea-sickness on top of devilfish seemed too much.

Jimmie said, "They're dead; it won't hurt them when you roll over."

Skedans

J immie, the Indian, knew the jagged reefs of Skedans Bay by heart. He knew where the bobbing kelp nobs grew and that their long, hose-like tubes were waiting to strangle his propeller. Today the face of the bay was buttered over with calm and there was a wide blue sky overhead. Everything looked safe, but Jimmie knew how treacherous the bottom of Skedans Bay was; that's why he lay across the bow of his boat, anxiously peering into the water and motioning to Louisa his wife, who was at the wheel.

The engine stopped far out. There was the plop and gurgle of the anchor striking and settling and then the sigh of the little canoe being pushed over the edge of the boat, the slap as she struck the water. Jimmie got the sheep dog and me over to the beach first, so that I could get to work right away; then he went back for Louisa and the missionary's daughter.

Skedans was more open than Tanoo. The trees stood farther back from it. Behind the bay another point bit deeply into the land, so that light came in across the water from behind the village too.

There was no soil to be seen. Above the beach it was all luxuriant growth; the earth was so full of vitality that every seed which blew across her surface

germinated and burst. The growing things jumbled themselves together into a dense thicket; so tensely earnest were things about growing in Skedans that everything linked with everything else, hurrying to grow to the limit of its own capacity; weeds and weaklings alike throve in the rich moistness.

Memories came out of this place to meet the Indians; you saw remembering in their brightening eyes and heard it in the quick hushed words they said to each other in Haida.

Skedans Beach was wide. Sea-drift was scattered over it. Behind the logs the ground sloped up a little to the old village site. It was smothered now under a green tangle, just one grey roof still squatted there among the bushes, and a battered row of totem poles circled the bay; many of them were mortuary poles, high with square fronts on top. The fronts were carved with totem designs of birds and beasts. The tops of the poles behind these carved fronts were hollowed out and the coffins stood, each in its hole on its end, the square front hiding it. Some of the old mortuary poles were broken and you saw skulls peeping out through the cracks.

To the right of Skedans were twin cones of earth and rock. They were covered to the top with trees and scrub. The land ran out beyond these mounds and met the jagged reefs of the bay.

We broke through growth above our heads to reach the house. It was of the old type, but had been repaired a little by halibut fishers who still used it occasionally. The walls were full of cracks and knotholes. There were stones, blackened by fire, lying on the earth floor. Above them was a great smoke-hole in the roof; it had a flap that could be adjusted to the wind. Sleeping benches ran along the wall and there was a rude table made of driftwood by the halibut fishers: Indians use the floor for their tables and seats.

When the fire roared, our blankets were spread on the platforms, and Louisa's stew-pot simmered. The place was grand—we had got close down to real things. In Skedans there were no shams.

When night came we cuddled into our blankets. The night was still. Just the waves splashed slow and even along the beach. If your face was towards the wall, the sea tang seeped in at the cracks and poured over it; if you turned round and faced in, there was the lovely smoky smell of our wood fire on the clay floor.

Early in the morning Jimmie stirred the embers; then he went out and brought us icy water from the spring to wash our faces in. He cut a little path like a green tunnel from the house to the beach, so that we could come and go easily. I went out to sketch the poles.

They were in a long straggling row the entire length of the bay and pointed this way and that; but no matter how drunken their tilt, the Haida poles never

lost their dignity. They looked sadder, perhaps, when they bowed forward and more stern when they tipped back. They were bleached to a pinkish silver colour and cracked by the sun, but nothing could make them mean or poor, because the Indians had put strong thought into them and had believed sincerely in what they were trying to express.

The twisted trees and high tossed driftwood hinted that Skedans could be as thoroughly fierce as she was calm. She was downright about everything.

Cumshewa

Tanoo, Skedans and Cumshewa lie fairly close to each other on the map, yet each is quite unlike the others when you come to it. All have the West Coast wetness but Cumshewa seems always to drip, always to be blurred with mist, its foliage always to hang wet-heavy. Cumshewa rain soaked my paper, Cumshewa rain trickled among my paints.

Only one house was left in the village of Cumshewa, a large, low and desolately forsaken house that had a carefully padlocked door and a gaping hole in the wall.

We spent a miserable night in this old house. All our bones were pierced with chill. The rain spat great drops through the smoke-hole into our fire. In comfortless, damp blankets we got through the night.

In the morning Jimmie made so hot a fire that the rain splatters hissed when they dropped into it. I went out to work on the leaky beach and Jimmie rigged up a sort of shelter over my work so that the trickles ran down my neck instead of down my picture, but if I had possessed the arms and legs of a centipede they would not have been enough to hold my things together to defy the elements' meanness towards my canopy, materials and temper.

Through the hole in the side of the house I could hear the fretful mewings of the cat. Indian people and the elements give and take like brothers, accommodating themselves to each others' ways without complaint. My Indians never said to me, "Hurry and get this over so that we may go home and be more comfortable." Indians are comfortable everywhere.

Not far from the house sat a great wooden raven mounted on a rather low pole; his wings were flattened to his sides. A few feet from him stuck up an empty pole. His mate had sat there but she had rotted away long ago, leaving him moss-grown, dilapidated and alone to watch dead Indian bones, for these two great birds had been set, one on either side of the doorway of a big house that had been full of dead Indians who had died during a smallpox epidemic.

Bursting growth had hidden house and bones long ago. Rain turned their dust into mud; these strong young trees were richer perhaps for that Indian dust. They grew up round the dilapidated old raven, sheltering him from the tearing winds now that he was old and rotting because the rain seeped through the moss that grew upon his back and in the hollows of his eye-sockets. The Cumshewa totem poles were dark and colourless, the wood toneless from pouring rain.

When Jimmie, Louisa, the cat and the missionary's daughter saw me squeeze back into the house through the hole and heard me say, "Done", they all jumped up. Curling the cat into her hat, Louisa set about packing; Jimmie went to prepare his boat. The cat was peeved. She preferred Louisa's hat near the fire to the outside rain.

The memory of Cumshewa is of a great lonesomeness smothered in a blur of rain. Our boat headed for the sea. As we rounded the point Cumshewa was suddenly like something that had not quite happened.

Sophie

S ophie knocked gently on my Vancouver studio door.

"Baskets. I got baskets."

They were beautiful, made by her own people, West Coast Indian baskets. She had big ones in a cloth tied at the four corners and little ones in a flour-sack.

She had a baby slung on her back in a shawl, a girl child clinging to her skirts, and a heavy-faced boy plodding behind her.

"I have no money for baskets."

"Money no matter," said Sophie. "Old clo', waum skirt—good fo' basket."

I wanted the big round one. Its price was eight dollars.

"Next month I am going to Victoria. I will bring back some clothes and get your basket."

I asked her in to rest a while and gave the youngsters bread and jam. When she tied up her baskets she left the one I coveted on the floor.

"Take it away," I said. "It will be a month before I can go to Victoria. Then I will bring clothes back with me and come to get the basket."

"You keep now. Bymby pay," said Sophie.

"Where do you live?"

"North Vancouver Mission."

"What is your name?"

"Me Sophie Frank. Everybody know me."

Sophie's house was bare but clean. It had three rooms. Later when it got cold Sophie's Frank would cut out all the partition walls. Sophie said, "Thlee loom, thlee stobe. One loom, one stobe." The floor of the house was clean scrubbed. It was chair, table and bed for the family. There was one chair; the coal-oil lamp sat on that. Sophie pushed the babies into corners, spread my old clothes on the floor to appraise them, and was satisfied. So, having tested each other's trade-straightness, we began a long, long friendship—forty years. I have seen Sophie glad, sad, sick and drunk. I have asked her why she did this or that thing—Indian ways that I did not understand—her answer was invariably "Nice ladies always do." That was Sophie's ideal—being nice.

Every year Sophie had a new baby. Almost every year she buried one. Her little graves were dotted all over the cemetery. I never knew more than three of her twenty-one children to be alive at one time. By the time she was in her early fifties every child was dead and Sophie had cried her eyes dry. Then she took to drink.

"I got a new baby. I got a new baby."

Sophie, seated on the floor of her house, saw me coming through the open door and waved the papoose cradle. Two little girls rolled round on the floor; the new baby was near her in a basket-cradle. Sophie took off the cloth tented over the basket and exhibited the baby, a lean poor thing.

Sophie herself was small and square. Her black hair sprang thick and strong on each side of the clean, straight parting and hung in twin braids across her shoulders. Her eyes were sad and heavy-lidded. Between prominent, rounded cheekbones her nose lay rather flat, broadening and snubby at the tip. Her wide upper lip pouted. It was sharp-edged, puckering over a row of poor teeth—the soothing pucker of lips trying to ease an aching tooth or to hush a crying child. She had a soft little body, a back straight as honesty itself, and the small hands and feet of an Indian.

Sophie's English was good enough, but when Frank, her husband, was there she became dumb as a plate.

"Why won't you talk before Frank, Sophie?"

"Frank he learn school English. Me, no. Frank laugh my English words."

When we were alone she chattered to me like a sparrow.

In May, when the village was white with cherry blossom and the blue water of Burrard Inlet crept almost to Sophie's door—just a streak of grey sand and a plank walk between—and when Vancouver city was more beautiful to look at

across the water than to be in,—it was then I loved to take the ferry to the North Shore and go to Sophie's.

Behind the village stood mountains topped by the grand old "Lions", twin peaks, very white and blue. The nearer mountains were every shade of young foliage, tender grey-green, getting greener and greener till, when they were close, you saw that the village grass outgreened them all. Hens strutted their broods, papooses and pups and kittens rolled everywhere—it was good indeed to spend a day on the Reserve in spring.

Sophie and I went to see her babies' graves first. Sophie took her best plaid skirt, the one that had three rows of velvet ribbon round the hem, from a nail on the wall, and bound a yellow silk handkerchief round her head. No matter what the weather, she always wore her great shawl, clamping it down with her arms, the fringe trickling over her fingers. Sophie wore her shoes when she walked with me, if she remembered.

Across the water we could see the city. The Indian Reserve was a different world—no hurry, no business.

We walked over the twisty, up-and-down road to the cemetery. Casamin, Tommy, George, Rosie, Maria, Mary, Emily, and all the rest were there under a tangle of vines. We rambled, seeking out Sophie's graves. Some had little wooden crosses, some had stones. Two babies lay outside the cemetery fence: they had not faced life long enough for baptism.

"See! Me got stone for Rosie now."

"It looks very nice. It must have cost lots of money, Sophie."

"Grave man make cheap for me. He say, 'You got lots, lots stone from me, Sophie. Maybe bymby you get some more died baby, then you want more stone. So I make cheap for you.'"

Sophie's kitchen was crammed with excited women. They had come to see Sophie's brand-new twins. Sophie was on a mattress beside the cook stove. The twin girls were in small basket papoose cradles, woven by Sophie herself. The babies were wrapped in cotton wool which made their dark faces look darker; they were laced into their baskets and stuck up at the edge of Sophie's mattress beside the kitchen stove. Their brown, wrinkled faces were like potatoes baked in their jackets, their hands no bigger than brown spiders.

They were thrilling, those very, very tiny babies. Everybody was excited over them. I sat down on the floor close to Sophie.

"Sophie, if the baby was a girl it was to have my name. There are two babies and I have only one name. What are we going to do about it?"

"The biggest and the best is yours," said Sophie.

My Em'ly lived three months. Sophie's Maria lived three weeks. I bought Em'ly's tombstone. Sophie bought Maria's.

Sophie's "mad" rampaged inside her like a lion roaring in the breast of a dove.

"Look see," she said, holding a red and yellow handkerchief, caught together at the corners and chinking with broken glass and bits of plaster of Paris. "Bad boy bloke my grave flower! Cost five dollar one, and now boy all bloke fo' me. Bad, bad boy! You come talk me fo' p'liceman?"

At the City Hall she spread the handkerchief on the table and held half a plaster of Paris lily and a dove's tail up to the eyes of the law, while I talked.

"My mad fo' boy bloke my plitty glave flower," she said, forgetting, in her fury, to be shy of the "English words".

The big man of the law was kind. He said, "It's too bad, Sophie. What do you want me to do about it?"

"You make boy buy more this plitty kind for my glave."

"The boy has no money but I can make his old grandmother pay a little every week."

Sophie looked long at the broken pieces and shook her head.

"That ole, ole woman got no money." Sophie's anger was dying, soothed by sympathy like a child, the woman in her tender towards old Granny. "My bloke no matter for ole woman," said Sophie, gathering up the pieces. "You scold boy big, Policeman? No make glanny pay."

"I sure will, Sophie."

There was a black skirt spread over the top of the packing case in the centre of Sophie's room. On it stood the small white coffin. A lighted candle was at the head, another at the foot. The little dead girl in the coffin held a doll in her arms. It had hardly been out of them since I had taken it to her a week before. The glassy eyes of the doll stared out of the coffin, up past the closed eyelids of the child.

Though Sophie had been through this nineteen times before, the twentieth time was no easier. Her two friends, Susan and Sara, were there by the coffin, crying for her.

The outer door opened and a half dozen women came in, their shawls drawn low across their foreheads, their faces grim. They stepped over to the coffin and looked in. Then they sat around it on the floor and began to cry, first with baby whimpers, softly, then louder, louder still—with violence and strong howling: torrents of tears burst from their eyes and rolled down their cheeks. Sophie and Sara and Susan did it too. It sounded horrible—like tortured dogs.

Suddenly they stopped. Sophie went to the bucket and got water in a tin basin. She took a towel in her hand and went to each of the guests in turn holding the basin while they washed their faces and dried them on the towel. Then the women all went out except Sophie, Sara and Susan. This crying had gone on at intervals for three days—ever since the child had died. Sophie was worn out. There had been, too, all the long weeks of Rosie's tubercular dying to go through.

"Sophie, couldn't you lie down and rest?"

She shook her head. "Nobody sleep in Injun house till dead people go to cemet'ry."

The beds had all been taken away.

"When is the funeral?"

"I dunno. Pliest go Vancouver. He not come two more day."

She laid her hand on the corner of the little coffin.

"See! Coffin-man think box fo' Injun baby no matter."

The seams of the cheap little coffin had burst.

As Sophie and I were coming down the village street we met an Indian woman whom I did not know. She nodded to Sophie, looked at me and half paused. Sophie's mouth was set, her bare feet pattered quick, hurrying me past the woman.

"Go church house now?" she asked me.

The Catholic church had twin towers. Wide steps led up to the front door which was always open. Inside it was bright, in a misty way, and still except for the wind and sea-echoes. The windows were gay coloured glass; when you knelt the wooden footstools and pews creaked. Hush lurked in every corner. Always a few candles burned. Everything but those flickers of flame was stone-still.

When we came out of the church we sat on the steps for a little. I said, "Who was that woman we met, Sophie?"

"Mrs. Chief Joe Capilano."

"Oh! I would like to know Mrs. Chief Joe Capilano. Why did you hurry by so quick? She wanted to stop."

"I don' want you know Mrs. Chief Joe."

"Why?"

"You fliend for me, not fliend for her."

"My heart has room for more than one friend, Sophie."

"You fliend for me, I not want Mrs. Chief Joe get you."

"You are always my first and best friend, Sophie." She hung her head, her mouth obstinate. We went to Sara's house.

Sara was Sophie's aunt, a wizened bit of a woman whose eyes, nose, mouth and wrinkles were all twisted to the perpetual expressing of pain. Once she had had a merry heart, but pain had trampled out the merriness. She lay on a bed draped with hangings of clean, white rags dangling from poles. The wall behind her bed, too, was padded heavily with newspaper to keep draughts off her "Lumatiz".

"Hello, Sara. How are you?"

"Em'ly! Sophie's Em'ly!"

The pain wrinkles scuttled off to make way for Sara's smile, but hurried back to twist for her pain.

"I dunno what for I got Lumatiz, Em'ly. I dunno. I dunno."

Everything perplexed poor Sara. Her merry heart and tortured body were always at odds. She drew a humped wrist across her nose and said, "I dunno, I dunno", after each remark.

"Goodbye, Sophie's Em'ly; come some more soon. I like that you come. I dunno why I got pain, lots pain. I dunno—I dunno."

I said to Sophie, "You see! The others know I am your big friend. They call me 'Sophie's Em'ly'."

She was happy.

Susan lived on one side of Sophie's house and Mrs. Johnson, the Indian widow of a white man, on the other. The widow's house was beyond words clean. The cook-stove was a mirror, the floor white as a sheet from scrubbing. Mrs. Johnson's hands were clever and busy. The row of hard kitchen chairs had each its own antimacassar and cushion. The crocheted bedspread and embroidered pillowslips, all the work of Mrs. Johnson's hands, were smoothed taut. Mrs. Johnson's husband had been a sea captain. She had loved him deeply and remained a widow though she had had many offers of marriage after he died. Once the Indian agent came, and said:

"Mrs. Johnson, there is a good man who has a farm and money in the bank. He is shy, so he sent me to ask if you will marry him."

"Tell that good man, 'Thank you', Mr. Agent, but tell him, too, that Mrs. Johnson only got love for her dead Johnson."

Sophie's other neighbour, Susan, produced and buried babies almost as fast as Sophie herself. The two women laughed for each other and cried for each other. With babies on their backs and baskets on their arms they crossed over on the ferry to Vancouver and sold their baskets from door to door. When they came to my studio they rested and drank tea with me. My parrot, sheep dog, the white rats and the totem pole pictures all interested them. "An' you got Injun flower, too," said Susan.

"Indian flowers?"

She pointed to ferns and wild things I had brought in from the woods.

Sophie's house was shut up. There was a chain and padlock on the gate. I went to Susan.

"Where is Sophie?"

"Sophie in sick house. Got sick eye."

I went to the hospital. The little Indian ward had four beds. I took ice cream and the nurse divided it into four portions.

A homesick little Indian girl cried in the bed in one corner, an old woman grumbled in another. In a third there was a young mother with a baby, and in the fourth bed was Sophie.

There were flowers. The room was bright. It seemed to me that the four brown faces on the four white pillows should be happier and far more comfortable here than lying on mattresses on the hard floors in the village, with all the family muddle going on about them.

"How nice it is here, Sophie."

"Not much good of hospital, Em'ly."

"Oh! What is the matter with it?"

"Bad bed."

"What is wrong with the beds?"

"Move, move, all time shake. 'Spose me move, bed move too."

She rolled herself to show how the springs worked. "Me ole-fashion, Em'ly. Me like kitchen floor fo' sick."

Susan and Sophie were in my kitchen, rocking their sorrows back and forth and alternately wagging their heads and giggling with shut eyes at some small joke.

"You go live Victoria now, Em'ly," wailed Sophie, "and we never see those babies, never!"

Neither woman had a baby on her back these days. But each had a little new grave in the cemetery. I had told them about a friend's twin babies. I went to the telephone.

"Mrs. Dingle, you said I might bring Sophie to see the twins?"

"Surely, any time," came the ready reply.

"Come, Sophie and Susan, we can go and see the babies now."

The mothers of all those little cemetery mounds stood looking and looking at the thriving white babies, kicking and sprawling on their bed. The women said, "Oh my!—Oh my!" over and over.

Susan's hand crept from beneath her shawl to touch a baby's leg. Sophie's hand shot out and slapped Susan's.

The mother of the babies said, "It's all right, Susan; you may touch my baby."

Sophie's eyes burned Susan for daring to do what she so longed to do herself. She folded her hands resolutely under her shawl and whispered to me, "Nice ladies don' touch, Em'ly."

D'Sonoqua

I was sketching in a remote Indian village when I first saw her. The village was one of those that the Indians use only for a few months in each year; the rest of the time it stands empty and desolate. I went there in one of its empty times, in a drizzling dusk.

When the Indian agent dumped me on the beach in front of the village, he said, "There is not a soul here. I will come back for you in two days." Then he went away.

I had a small griffon dog with me, and also a little Indian girl, who, when she saw the boat go away, clung to my sleeve and wailed, "I'm 'fraid."

We went up to the old deserted Mission House. At the sound of the key in the rusty lock, rats scuttled away. The stove was broken, the wood wet. I had forgotten to bring candles. We spread our blankets on the floor, and spent a poor night. Perhaps my lack of sleep played its part in the shock that I got, when I saw her for the first time.

Water was in the air, half mist, half rain. The stinging nettles, higher than my head, left their nervy smart on my ears and forehead, as I beat my way through them, trying all the while to keep my feet on the plank walk which they hid. Big yellow slugs crawled on the walk and slimed it. My feet slipped and I shot headlong to her very base, for she had no feet. The nettles that were above my head reached only to her knee.

It was not the fall alone that jerked the "Oh's" out of me, for the great wooden image towering above me was indeed terrifying.

The nettle bed ended a few yards beyond her, and then a rocky bluff jutted out, with waves battering it below. I scrambled up and went out on the bluff, so that I could see the creature above the nettles. The forest was behind her, the sea in front.

Her head and trunk were carved out of, or rather into, the bole of a great red cedar. She seemed to be part of the tree itself, as if she had grown there at its heart, and the carver had only chipped away the outer wood so that you could

see her. Her arms were spliced and socketed to the trunk, and were flung wide in a circling, compelling movement. Her breasts were two eagle-heads, fiercely carved. That much, and the column of her great neck, and her strong chin, I had seen when I slithered to the ground beneath her. Now I saw her face.

The eyes were two rounds of black, set in wider rounds of white, and placed in deep sockets under wide, black eyebrows. Their fixed stare bored into me as if the very life of the old cedar looked out, and it seemed that the voice of the tree itself might have burst from that great round cavity, with projecting lips, that was her mouth. Her ears were round, and stuck out to catch all sounds. The salt air had not dimmed the heavy red of her trunk and arms and thighs. Her hands were black, with blunt finger-tips painted a dazzling white. I stood looking at her for a long, long time.

The rain stopped, and white mist came up from the sea, gradually paling her back into the forest. It was as if she belonged there, and the mist were carrying her home. Presently the mist took the forest too, and, wrapping them both together, hid them away.

"Who is that image?" I asked the little Indian girl, when I got back to the house.

She knew which one I meant, but to gain time, she said, "What image?"

"The terrible one, out there on the bluff."

"I dunno," she lied.

I never went to that village again, but the fierce wooden image often came to me, both in my waking and in my sleeping.

Several years passed, and I was once more sketching in an Indian village. There were Indians in this village, and in a mild backward way it was "going modern". That is, the Indians had pushed the forest back a little to let the sun touch the new buildings that were replacing the old community houses. Small houses, primitive enough to a white man's thinking, pushed here and there between the old. Where some of the big community houses had been torn down, for the sake of the lumber, the great corner posts and massive roof-beams of the old structure were often left, standing naked against the sky, and the new little house was built inside, on the spot where the old one had been.

It was in one of these empty skeletons that I found her again. She had once been a supporting post for the great centre beam. Her pole-mate, representing the Raven, stood opposite her, but the beam that had rested on their heads was gone. The two poles faced in, and one judged the great size of the house by the distance between them. The corner posts were still in place, and the earth floor, once beaten to the hardness of rock by naked feet, was carpeted now with rich lush grass.

I knew her by the stuck-out ears, shouting mouth, and deep eye-sockets. These sockets had no eye-balls, but were empty holes, filled with stare. The stare, though not so fierce as that of the former image, was more intense. The whole figure expressed power, weight, domination, rather than ferocity. Her feet were planted heavily on the head of the squatting bear, carved beneath them. A man could have sat on either huge shoulder. She was unpainted, weather-worn, sun-cracked and the arms and hands seemed to hang loosely. The fingers were thrust into the carven mouths of two human heads, held crowns down. From behind, the sun made unfathomable shadows in eye, cheek and mouth. Horror tumbled out of them.

I saw Indian Tom on the beach, and went to him.

"Who is she?"

The Indian's eyes, coming slowly from across the sea, followed my pointing finger. Resentment showed in his face, greeny-brown and wrinkled like a baked apple,—resentment that white folks should pry into matters wholly Indian.

"Who is that big carved woman?" I repeated.

"D'Sonoqua." No white tongue could have fondled the name as he did.

"Who is D'Sonoqua?"

"She is the wild woman of the woods."

"What does she do?"

"She steals children."

"To eat them?"

"No, she carries them to her caves; that," pointing to a purple scar on the mountain across the bay, "is one of her caves. When she cries 'oo-oo-oo-oeo,' Indian mothers are too frightened to move. They stand like trees, and the children go with D'Sonoqua."

"Then she is bad?"

"Sometimes bad . . . sometimes good," Tom replied, glancing furtively at those stuck-out ears. Then he got up and walked away.

I went back, and sitting in front of the image, gave stare for stare. But her stare so over-powered mine, that I could scarcely wrench my eyes away from the clutch of those empty sockets. The power that I felt was not in the thing itself, but in some tremendous force behind it, that the carver had believed in.

A shadow passed across her hands and their gruesome holdings. A little bird, with its beak full of nesting material, flew into the cavity of her mouth, right in the pathway of that terrible oo-oo-oo-oeo. Then my eye caught something that I had missed—a tabby cat asleep between her feet.

This was D'Sonoqua, and she was a supernatural being, who belonged to these Indians.

"Of course," I said to myself, "I do not believe in supernatural beings. Still—who understands the mysteries behind the forest? What would one do if one did meet a supernatural being?" Half of me wished that I could meet her, and half of me hoped I would not.

Chug—chug—the little boat had come into the bay to take me to another village, more lonely and deserted than this. Who knew what I should see there? But soon supernatural beings went clean out of my mind, because I was wholly absorbed in being naturally seasick.

When you have been tossed and wracked and chilled, any wharf looks good, even a rickety one, with its crooked legs stockinged in barnacles. Our boat nosed under its clammy darkness, and I crawled up the straight slimy ladder, wondering which was worse, natural seasickness, or supernatural "creeps". The trees crowded to the very edge of the water, and the outer ones, hanging over it, shadowed the shoreline into a velvet smudge. D'Sonoqua might walk in places like this. I sat for a long time on the damp, dusky beach, waiting for the stage. One by one dots of light popped from the scattered cabins, and made the dark seem darker. Finally the stage came.

We drove through the forest over a long straight road, with black pine trees marching on both sides. When we came to the wharf the little gas mail-boat was waiting for us. Smell and blurred light oozed thickly out of the engine room, and except for one lantern on the wharf everything else was dark. Clutching my little dog, I sat on the mail sacks which had been tossed on to the deck.

The ropes were loosed, and we slid out into the oily black water. The moon that had gone with us through the forest was away now. Black pine-covered mountains jagged up on both sides of the inlet like teeth. Every gasp of the engine shook us like a great sob. There was no rail round the deck, and the edge of the boat lay level with the black slithering horror below. It was like being swallowed again and again by some terrible monster, but never going down. As we slid through the water, hour after hour, I found myself listening for the oo-oo-oo-oeo.

Midnight brought us to a knob of land, lapped by the water on three sides, with the forest threatening to gobble it up on the fourth. There was a rude landing, a rooming-house, an eating-place, and a store, all for the convenience of fishermen and loggers. I was given a room, but after I had blown out my candle, the stillness and the darkness would not let me sleep.

In the brilliant sparkle of the morning when everything that was not superlatively blue was superlatively green, I dickered with a man who was taking a party up the inlet that he should drop me off at the village I was headed for.

"But," he protested, "there is nobody there."

To myself I said, "There is D'Sonoqua."

From the shore, as we rowed to it, came a thin feminine cry—the mewing of a cat. The keel of the boat had barely grated in the pebbles, when the cat sprang aboard, passed the man shipping his oars, and crouched for a spring into my lap. Leaning forward, the man seized the creature roughly, and with a cry of "Dirty Indian vermin!" flung her out into the sea.

I jumped ashore, refusing his help, and with a curt "Call for me at sundown," strode up the beach; the cat followed me.

When we had crossed the beach and come to a steep bank, the cat ran ahead. Then I saw that she was no lean, ill-favoured Indian cat, but a sleek aristocratic Persian. My snobbish little griffon dog, who usually refused to let an Indian cat come near me, surprised me by trudging beside her in comradely fashion.

The village was typical of the villages of these Indians. It had only one street, and that had only one side, because all the houses faced the beach. The two community houses were very old, dilapidated and bleached, and the handful of other shanties seemed never to have been young; they had grown so old before they were finished, that it was then not worth while finishing them.

Rusty padlocks carefully protected the gaping walls. There was the usual broad plank in front of the houses, the general sitting and sunning place for Indians. Little streams ran under it, and weeds poked up through every crack, half hiding the companies of tins, kettles, and rags, which patiently waited for the next gale and their next move.

In front of the Chief's house was a high, carved totem pole, surmounted by a large wooden eagle. Storms had robbed him of both wings, and his head had a resentful twist, as if he blamed somebody. The heavy wooden heads of two squatting bears peered over the nettle-tops. The windows were too high for peeping in or out. "But, save D'Sonoqua, who is there to peep?" I said aloud, just to break the silence. A fierce sun burned down as if it wanted to expose every ugliness and forlornness. It drew the noxious smell out of the skunk cabbages, growing in the rich black ooze of the stream, scummed the water-barrels with green slime, and branded the desolation into my very soul.

The cat kept very close, rubbing and bumping itself and purring ecstatically; and although I had not seen them come, two more cats had joined us. When I sat down they curled into my lap, and then the strangeness of the place did not bite into me so deeply. I got up, determined to look behind the houses.

Nettles grew in the narrow spaces between the houses. I beat them down, and made my way over the bruised dark-smelling mass into a space of low jungle.

Long ago the trees had been felled and left lying. Young forest had burst through the slash, making an impregnable barrier, and sealing up the secrets which lay behind it. An eagle flew out of the forest, circled the village, and flew back again.

Once again I broke silence, calling after him, "Tell D'Sonoqua—" and turning, saw her close, towering above me in the jungle.

Like the D'Sonoqua of the other villages she was carved into the bole of a red cedar tree. Sun and storm had bleached the wood, moss here and there softened the crudeness of the modelling; sincerity underlay every stroke.

She appeared to be neither wooden nor stationary, but a singing spirit, young and fresh, passing through the jungle. No violence coarsened her; no power domineered to wither her. She was graciously feminine. Across her forehead her creator had fashioned the Sistheutl, or mythical two-headed sea-serpent. One of its heads fell to either shoulder, hiding the stuck-out ears, and framing her face from a central parting on her forehead which seemed to increase its womanliness.

She caught your breath, this D'Sonoqua, alive in the dead bole of the cedar. She summed up the depth and charm of the whole forest, driving away its menace.

I sat down to sketch. What was the noise of purring and rubbing going on about my feet? Cats. I rubbed my eyes to make sure I was seeing right, and counted a dozen of them. They jumped into my lap and sprang to my shoulders. They were real—and very feminine.

There we were—D'Sonoqua, the cats and I—the woman who only a few moments ago had forced herself to come behind the houses in trembling fear of the "wild woman of the woods"—wild in the sense that forest-creatures are wild—shy, untouchable.

The Blouse

The sound of waves came in at the open door; the smell of the sea and of the sun-warmed earth came in too. It was expected that very soon death would enter. A row of women sat outside the hut—they were waiting to mourn and howl when death came.

The huddle of bones and withered skin on the mattress inside the hut knew death was coming. Although the woman was childless and had no husband, she knew that the women of her tribe would make sorrow-noise for her when death came.

The eyes of the dying woman were glassy and half closed. I knelt beside her and put my hand over her cold bony one. My blouse touched her and she opened her eyes wide. Turning her hand, she feebly clutched the silk of my sleeve.

"Is there something you want, Mary?"

"Good," she whispered, still clutching the sleeve.

I thought that she was dead, holding my sleeve in a death grip. One of the women came in and tried to free me. Mary's eyes opened and she spoke in Indian.

"Mary wants your blouse," said the stooping woman to me.

"Wants my blouse?"

"Uh huh—wants for grave."

"To be buried in?"

"No, for grave-house."

I understood. Mary had not many things now but she had been important once. They would build a little wooden room with a show window in it over her grave. Here they would display her few poor possessions, the few hoarded trifles of her strong days. My blouse would be an addition.

The dying woman's eyes were on my face.

I scrambled out of the blouse and into my jacket. I laid the blouse across Mary. She died with her hands upon it.

The Stare

Millie's stare was the biggest thing in the hut. It dimmed for a moment as we stood in its way—but in us it had no interest. The moment we moved from its path it tightened again—this tense, living stare glowing in the sunken eyes of a sick Indian child.

All the life that remained in the emaciated, shrivelled little creature was concentrated in that stare. It burned a path for itself right across the sea to the horizon, burning with longing focused upon the return of her father's whaling-boat.

The missionary bent over the child.

"Millie!"

Millie's eyes lifted grudgingly, then hastened back to their watching.

Turning to the old crone who took the place of a mother who was dead and cared for the little girl, the missionary asked, "How is she, Granny?"

"I t'ink s'pose boat no come quick, Milly die plitty soon now."

"Is there no word of the boats?"

"No, maybe all Injun-man dead. Whale fishin' heap, heap bad for make die."

They brought the child food. She struggled to force down enough to keep the life in her till her father came. Squatted on her mat on the earth floor, her chin resting on the sharp knees encircled by her sticks of arms, she sat from dawn till dark, watching. When light was gone the stare fought its way, helped by Millie's ears, listening, listening out into black night.

It was in the early morning that the whaling-boats came home. When the mist lifted, Millie saw eight specks out on the horizon. Taut, motionless, uttering no word, she watched them grow.

"The boats are coming!" The cry rang through the village. Women left their bannock-baking, their basket-weaving and hurried to the shore. The old crone who tended Millie hobbled to the beach with the rest.

"The boats are coming!" Old men warming their stiff bodies in the sun shaded dull eyes with their hands to look far out to sea, groaning with joy that their sons were safe.

"The boats are coming!" Quick ears of children heard the cry in the school house and squeezing from their desks without leave, pattered down to the shore. The missionary followed. It was the event of the year, this return of the whaling-boats.

Millie's father was the first to land. His eyes searched among the people.

"My child?"

His feet followed the women's pointing fingers. Racing up the bank, his bulk filled the doorway of the hut. The stare enveloped him, Millie swayed towards him. Her arms fell down. The heavy plaits of her hair swung forward. Brittle with long watching, the stare had snapped.

Greenville

The cannery boss said, "Try Sam; he has a gas boat and comes from Greenville. That's Sam over there—the Indian in the striped shirt."

I came close to where Sam was forking salmon from the scow on to the cannery chutes.

"Sam, I want to go to Greenville. Could you take me there on Sunday?"

"Uh huh."

"What time Sunday?"

"Eight o'clock."

On Sunday morning I sat on the wharf from eight o'clock till noon. Sam's gas boat was down below. There was a yellow tarpaulin tented across her middle. Four bare feet stuck out at one end and two black heads at the other.

From stir to start it took the Indians four hours. Sam and his son sauntered up and down getting things as if time did not exist. Round noon the gas boat's impudent sputter ticked out across the wide face of the Naas River.

The Indian and his son were silent travellers.

I had a small griffon dog who sat at my feet quivering and alert. I felt like an open piano that any of the elements could strum on.

The great Naas swept grandly along. The nameless little river that Greenville was on emptied into the Naas. When our boat turned from the great into the little river she had no more ambition. Her engine died after a few puffs. Then we drifted a short way and nosed alongside a crude plank landing. This was Greenville.

It was between lights, neither day nor dark.

Five or six shadows came limping down the bank to the landing—Indian dogs—gaunt forsaken creatures. They knew when they heard the engine it meant man. The dogs looked queer.

"What is the matter with the dogs?"

"Porkpine," grunted the Indian.

The creatures' faces were swollen into wrong shapes. Porcupine quills festered in the swellings.

"Why don't the Indians take their dogs with them and not leave them to starve or hunt porcupine?"

"Cannery Boss say no can."

When I went towards the dogs, they backed away growling.

"Him hiyu fierce," warned the Indian.

In the dusk with the bedding and bundles on their shoulders the two Indians looked monstrous moving up the bank ahead of me.

I held my dog tight because of the fierceness of those skulking shadow-dogs following us.

Greenville was a large village, low and flat. Its stagnant swamps and ditches were glory places for the mosquitoes to breed in. Only the hum of the miserable creatures stirred the heavy murk that beaded our foreheads with sweat as we pushed our way through it.

Half-built, unpainted houses, old before ever they were finished, sat hunched irregularly along the grass-grown way. Planks on spindly trestles bridged the scummed sloughs. Emptiness glared from windows and shouted

up dead chimneys, weighted emptiness, that crushed the breath back into your lungs and chilled the heart in your sweating body.

Stumbling over stones and hummocks I hurried after the men who were anxious to place me and be gone down the Naas to the cannery again.

I asked the Indian, "Is there no one in this village?"

"One ole man, one woman, and one baby stop. Everybody go cannery."

"Where can I stay?"

"Teacher's house good for you."

"Where is the teacher?"

"Teacher gone too."

We were away from the village street now and making our way through bracken breast high. The school house was among it crouched on the edge of the woods. It was school house and living quarters combined. Trees pressed it close; undergrowth surged up over its windows.

The Indian unlocked the door, pushed us in and slammed the door too violently, as if something terrible were behind us.

"What was it you shut out, Sam?"

"Mosquito."

In here the hum of the mosquitoes had stopped, as every other thing had stopped in the murky grey of this dreadful place, clock, calendar, even the air—the match the Indian struck refused to live.

We felt our way through the long school room to a room behind that was darker still. It had a drawn blind and every crevice was sealed. The air in it felt as solid as the table and the stove. You chewed rather than breathed it. It tasted of coal-oil after we lit the lamp.

I opened a door into the shed. The pungent smell of cut stove-wood that came in was good.

The Indians were leaving me.

"Stop! The old man and the woman, where are they? Show me."

Before I went I opened all the doors. Mosquitoes were better than this strangling deadness, and I never could come back alone and open the door of the big dark room. Then I ran through the bracken and caught up with the Indians.

They led me to the farthest house in the village. It was cut off from the school house by space filled with desperate loneliness.

The old man was on the floor; he looked like a shrivelled old bird there on his mattress, caged about with mosquito netting. He had lumbago. His wife and grandchild were there too.

The womanliness of the old squaw stayed with me when I came back. All night long I was glad of that woman in Greenville.

It was dark when I got back to the school and the air was oozing sluggishly through the room.

I felt like a thief taking possession of another's things without leave. The school teacher had left everything shipshape. Everything told the type of woman she was.

Soon I made smoke roll round inside the stove and a tiny flame wavered. I turned forward the almanac sheets and set the clock ticking. When the kettle sang things had begun to live.

The night was long and black. As dawn came I watched things slowly poke out of the black. Each thing was a surprise.

The nights afterwards in this place were not bad like the first one, because I then had my bearings. All my senses had touched the objects around me. But it was lying in that smothering darkness and not knowing what was near me—what I might touch if I reached out a hand—that made the first night so horrible.

When I opened the school house door in the morning the village dogs were in the bracken watching. They went frantic over the biscuits I threw to them. A black one came crouching. She let me pull the porcupine quills out of her face. When the others saw her fear dry up, they came closer too. It was people they wanted even more than food. Wherever I went about the village they followed me.

In the swampy places and ditches of Greenville skunk cabbages grew—gold and brimming with rank smell—hypocrites of loveliness peeping from the lush green of their great leaves. The smell of them was sickening.

I looked through the blindless windows of the Indian houses. Half-eaten meals littered the tables. Because the tide had been right to go, bedding had been stripped from the springs, food left about, water left unemptied to rust the kettles. Indians slip in and out of their places like animals. Tides and seasons are the things that rule their lives: domestic arrangements are mere incidentals.

The houses looked as if they had been shaken out of a dice box on to the land and stayed just where they lit. The elements dominated them from the start. As soon as a few boards were put together the family moved in, and the house went on building around them until some new interest came along. Then the Indian dropped his tools. If you asked when he was going to finish building his house he said, "Nodder day—me too busy now," and after a long pull on his pipe he would probably lie round in the sun for days doing nothing.

I went often to the last house in the village to gossip with the woman. She was not as old as you thought at first, but very weatherbeaten. She was a friendly soul, but she spoke no English. We conversed like this,—one would point at something, the other clap her hands and laugh, or moan and shake her head as was right. Our eyebrows worked too and our shoulders and heads. A great deal of fun and information passed back and forth between us.

Ginger Pop, my griffon, was a joy to Granny. With a chuckle that wobbled the fat all over her, she would plant her finger on the snub of her own broad nose and wrinkle it back towards her forehead in imitation of the dog's snub, and laugh till the tears poured out of her eyes. All the while the black eyes of her solemn grandchild stared.

Granny also enjoyed my duck "pantalettes" that came below my skirts to the soles of my shoes, my duplicate pairs of gloves, and the cheese-cloth veil with a glass window in front. This was my mosquito armour. Hers consisted of pair upon pair of heavy wool stockings handknitted, and worn layer upon layer till they were deeper than the probes of the mosquitoes, and her legs looked like barrels.

The old man and I had a few Chinook words in common. I went sometimes to the darkened shed where he was building a boat. He kept a smudge and the air was stifling. Tears and sweat ran down our faces. He wiped his face with the bandana floating under his hat brim to protect his neck and blew at the mosquitoes and rubbed his lumbago. Suddenly his eye would catch the comic face of Ginger Pop and he too would throw down his tools and give himself up to mirth at the pup's expense. When he laughed, that was the time to ask him things.

"I am sorry that there are no totem poles in Greenville. I like totem poles," I said.

"Halo totem stick kopa Greenville."

"Old village with totem poles stop up the Naas?"

"Uh huh."

"I would like to see them."

"Uh huh."

"Will you take me in your boat?"

"Uh huh, Halo tillicum kopet."

"I want to see the poles, not people. You take me tomorrow?"

"Uh huh."

So we went to Gittex and Angedar, two old village sites on the Naas River. His old boat crept through the side-wash meanderings of the Naas. Suddenly we came out on to its turbulent waters and shot across them: and there, tipping drunkenly

over the top of dense growth, were the totem poles of Gittex. They looked like mere sticks in the vast sea of green that had swallowed the old village. Once they, too, had been forest trees, till the Indian mutilated and turned them into bare poles. Then he enriched the shorn things with carvings. He wanted some way of showing people things that were in his mind, things about the creatures and about himself and their relation to each other. He cut forms to fit the thoughts that the birds and animals and fish suggested to him, and to these he added something of himself. When they were all linked together they made very strong talk for the people. He grafted this new language on to the great cedar trunks and called them totem poles and stuck them up in the villages with great ceremony. Then the cedar and the creatures and the man all talked together through the totem poles to the people. The carver did even more—he let his imaginings rise above the objects that he saw and pictured supernatural beings too.

The creatures that had flesh and blood like themselves the Indians understood. They accepted them as their ancestors but the supernatural things they feared and tried to propitiate.

Every clan took a creature for its particular crest. Individuals had private crests too, which they earned for themselves often by privation and torture and fasting. These totem creatures were believed to help specially those who were of their crest.

When you looked at a man's pole, his crests told you who he was, whom he might marry and whom he might not marry—for people of the same crest were forbidden to marry each other.

You knew also by the totem what sort of man he was or at least what he should be because men tried to be like the creature of their crest, fierce, or brave, or wise, or strong.

Then the missionaries came and took the Indians away from their old villages and the totem poles and put them into new places where life was easier, where they bought things from a store instead of taking them from nature.

Greenville, which the Indians called "Lakalzap", was one of these new villages. They took no totem poles with them to hamper their progress in new ways; the poles were left standing in the old places. But now there was no one to listen to their talk any more. By and by they would rot and topple to the earth, unless white men came and carried them away to museums. There they would be labelled as exhibits, dumb before the crowds who gaped and laughed and said, "This is the distorted foolishness of an uncivilized people." And the poor poles could not talk back because the white man did not understand their language.

At Gittex there was a wooden bear on top of such a high pole that he was able still to look over the top of the woods. He was a joke of a bear—every bit

of him was merry. He had one paw up against his face, he bent forward and his feet clung to the pole. I tried to circle about so that I could see his face but the monstrous tangle was impossible to break through.

I did beat my way to the base of another pole only to find myself drowned under an avalanche of growth sweeping down the valley. The dog and I were alone in it—just nothings in the overwhelming immensity.

My Indian had gone out to mid-river. It seemed an awful thing to shatter that silence with a shout, but I was hungry and I dared not raise my veil till I got far out on the Naas. Mosquitoes would have filled my mouth.

After seven days the Indians came back with their boat and took me down the Naas again.

I left the old man and woman leisurely busy, the woman at her wash-tub and the man in his stifling boat-house. Each gave me a passing grin and a nod when I said goodbye; comings and goings are as ordinary to Indians as breathing.

I let the clock run down. Flapped the leaves of the calendar back, and shut the Greenville school house tight.

The dogs followed to the edge of the water, their stomachs and hearts sore at seeing us go. Perhaps in a way dogs are more domestic and more responsive than Indians.

Two Bits and a Wheel-Barrow

The smallest coin we had in Canada in early days was a dime, worth ten cents. The Indians called this coin "a Bit". Our next coin, double in buying power and in size, was a twenty-five cent piece and this the Indians called "Two Bits".

Two bits was the top price that old Jenny knew. She asked two bits for everything she had to sell, were it canoe-bailer, eagle's wing, cedar-bark basket or woven mat. She priced each at "two bits" and if I had said, "How much for your husband or your cat?" she would have answered "two bits" just the same.

Her old husband did not look worth two bits. He was blind and very moth-eaten. All day he lay upon a heap of rags in the corner of their hut. He was quite blind but he had some strength still. Jenny made him lie there except when he was led, because he fell into the fire or into the big iron cook-pot and burned himself if he went alone. There was such a litter over the floor that he could not help tripping on something if he took even a step. So Jenny Two-Bits ordered her old blind Tom to stay in his corner till she was ready. Jenny was

getting feeble. She was lame in the hip and walked with a crooked stick that she had pulled from the sea.

Tommy knew that day had come when he felt Jenny Two-Bits' stick jab him. The stick stayed in the jab until Tom took hold. Then still holding the stick Jenny steered him across to where she lay. When he came close she pulled herself up by hanging on-to his clothes. When bits of his old rags tore off in her hands she scolded Tom bitterly for having such poor, weak clothes.

Tom could tell by the cold clammy feel how very new the morning was when Jenny pushed him out of the door and told him to stand by the wall and not move while she went for the wheel-barrow. It screeched down the alley. Jenny backed Tom between the handles and he took hold of them. Then she tied a rope to each of his arms above the elbow. She used the ropes for reins and hobbled along, slapping the barrow with her stick to make Tom go and poking her stick into his back to make him stop. At that early hour the village was empty. They always tried to be the first on the beach so that they could have the pick of what the sea had thrown up.

They went slowly to the far end of the village street where the bank was low and here they left the barrow.

Jenny Two-Bits led Tom along the quiet shore. She peered this way and that to see what the waves had brought in. Sometimes the sea gave them good things, sometimes nothing at all, but there were always bits of firewood and bark to be had if they got there before anyone else.

The old woman's eyes were very sharp and the wheel-barrow hardly ever came back empty. When Jenny found anything worthwhile, first she peered, then she beat it with her stick and took Tom's hand and laid it on the wet cast-up thing. Tom would lift it and carry it to the barrow. Then they came back to their shanty and sat down in the sun outside the door to rest.

Sometimes Jenny and Tom went in a canoe to fish out in the bay. Tom held the lines, Jenny paddled.

When they caught a fish or when Jenny sold something for two bits or when they sat together baking themselves in the sunshine, they were happy enough.

Sleep

When I was a child I was staying at one of Victoria's beaches. I was down on the point watching a school of porpoises at play off Trail Island when a canoe came round the headland. She was steering straight for our beach.

The Government allowed the Indians to use the beaches when they were travelling, so they made camp and slept wherever the night happened to fall.

In the canoe were a man and woman, half a dozen children, a dog, a cat and a coop of fowls, besides all the Indians' things. She was a West Coast canoe—dug out of a great red cedar tree. She was long and slim, with a high prow shaped like a wolf's head. She was painted black with a line of blue running round the top of the inside. Her stern went straight down into the water. The Indian mother sat in the stern and steered the canoe with a paddle.

When the canoe was near the shore, the man and the woman drove their paddles strong and hard, and the canoe shot high up on to the pebbles with a growling sound. The barefoot children swarmed over her side and waded ashore.

The man and the woman got out and dragged the canoe high onto the beach. There was a baby tucked into the woman's shawl; the shawl bound the child close to her body. She waddled slowly across the beach, her bare feet settling in the sand with every step, her fleshy body squared down on to her feet. All the movements of the man and the woman were slow and steady; their springless feet padded flatly; their backs and shoulders were straight. The few words they said to each other were guttural and low-pitched.

The Indian children did not race up and down the beach, astonished at strange new things, as we always were. These children belonged to the beach, and were as much a part of it as the drift-logs and the stones.

The man gathered a handful of sticks and lit a fire. They took a big iron pot and their food out of the canoe, and set them by the fire. The woman sat among the things with her baby—she managed the shawl and the baby so that she had her arms free, and her hands moved among the kettles and food.

The man and a boy, about as big as I was, came up the path on the bank with tin pails. When they saw me, the boy hung back and stared. The man grinned and pointed to our well. He had coarse hair hanging to his shoulders; it was unbrushed and his head was bound with a red band. He had wrinkles everywhere, face, hands and clothing. His coat and pants were in tatters. He was brown and dirty all over, but his face was gentle and kind.

Soon I heard the pad-pad of their naked feet on the clay of the path. The water from the boy's pail slopped in the dust while he stared back at me.

They made tea and ate stuff out of the iron pot; it was fish, I could smell it. The man and the woman sat beside the pot, but the children took pieces and ran up and down eating them.

They had hung a tent from the limb of the old willow tree that lolled over the sand from the bank. The bundles and blankets had been tossed into the tent; the flaps were open and I could see everything lying higgledy-piggledy inside.

Each child ate what he wanted, then he went into the tent and tumbled, dead with sleep, among the bundles. The man, too, stopped eating and went into the tent and lay down. The dog and the cat were curled up among the blankets.

The woman on the beach drew the smouldering logs apart; when she poured a little water on them they hissed. Last of all she too went into the tent with her baby.

The tent full of sleep greyed itself into the shadow under the willow tree. The wolf's head of the canoe stuck up black on the beach a little longer; then it faded back and back into the night. The sea kept on going slap-slap-slap over the beach.

Sailing to Yan

A t the appointed time I sat on the beach waiting for the Indian. He did not come and there was no sign of his boat.

An Indian woman came down the bank carrying a heavy not-walking-age child. A slim girl of twelve was with her. She carried a paddle and going to a light canoe that was high on the sand, she began to drag it towards the sea.

The woman put the baby into the canoe and she and the girl grunted and shunted the canoe into the water, then they beckoned to me.

"Go now," said the woman.

"Go where?"

"Yan.—My man tell me come take you go Yan."

"But—the baby—?"

Between Yan and Masset lay ugly waters—I could not—no, I really could not—a tippy little canoe—a woman with her arms full of baby—and a girl child—!

The girl was rigging a ragged flour sack in the canoe for a sail. The pole was already placed, the rag flapped limply around it. The wind and the waves were crisp and sparkling. They were ready, waiting to bulge the sack and toss the canoe.

"How can you manage the canoe and the baby?" I asked the woman and hung back.

Pointing to the bow seat, the woman commanded, "Sit down."

I got in and sat.

The woman waded out holding the canoe and easing it about in the sand until it was afloat. Then she got in and clamped the child between her knees.

Her paddle worked without noise among the waves. The wind filled the flour sack beautifully as if it had been a silk sail.

The canoe took the water as a beaver launches himself—with a silent scoot.

The straight young girl with black hair and eyes and the lank print dress that clung to her childish shape, held the sail rope and humoured the whimsical little canoe. The sack now bulged with wind as tight as once it had bulged with flour. The woman's paddle advised the canoe just how to cut each wave.

We streaked across the water and were at Yan before I remembered to be frightened. The canoe grumbled over the pebbly beach and we got out.

We lit a fire on the beach and ate.

The brave old totems stood solemnly round the bay. Behind them were the old houses of Yan, and behind that again was the forest. All around was a blaze of rosy pink fireweed, rioting from the rich black soil and bursting into loose delicate blossoms, each head pointing straight to the sky.

Nobody lived in Yan. Yan's people had moved to the newer village of Masset, where there was a store, an Indian agent and a church.

Sometimes Indians came over to Yan to cultivate a few patches of garden. When they went away again the stare in the empty hollows of the totem eyes followed them across the sea, as the mournful eyes of chained dogs follow their retreating masters.

Just one carved face smiled in the village of Yan. It was on a low mortuary pole and was that of a man wearing a very, very high hat of honour. The grin showed his every tooth. On the pole which stood next sat a great wooden eagle. He looked down his nose with a dour expression as a big sister looks when a little sister laughs in church.

The first point at the end of Yan beach was low and covered with coarse rushes. Over it you could see other headlands—point after point . . . jutting out, on and on . . . beyond the wide sweep of Yan beach to the edge of the world.

There was lots of work for me to do in Yan. I went down the beach far away from the Indians. At first it was hot, but by and by haze came creeping over the farther points, blotting them out one after the other as if it were suddenly aware that you had been allowed to see too much. The mist came nearer and nearer till it caught Yan too in its woolly whiteness. It stole my totem poles; only the closest ones were left and they were just grey streaks in the mist. I saw myself as a wet rag sticking up in a tub of suds. When the woolly mist began to thread and fall down in rain I went to find the woman.

She had opened one of the houses and was sitting on the floor close to a low fire. The baby was asleep in her lap. Under her shawl she and the child were one big heap in the half-dark of the house. The young girl hugged her

knees and looked into the fire. I sat in to warm myself and my clothes steamed. The fire hissed and crackled at us.

I said to the woman, "How old is your baby?"

"Ten month. He not my baby. That," pointing to the girl, "not my chile too."

"Whom do they belong to?"

"Me. One woman give to me. All my chiles die—I got lots, lots dead baby. My fliend solly me 'cause I got no more chile so she give this an' this for mine."

"Gave her children away? Didn't she love them?"

"She love plenty lots. She cly, cly—no eat—no sleep—cly, cly—all time cly."

"Then why did she give her children away?"

"I big fliend for that woman—she solly me—she got lots more baby, so she give this and this for me."

She folded the sleeping child in her shawl and laid him down. Then she lifted up some loose boards lying on the earth floor and there was a pit. She knelt, dipped her hand in and pulled out an axe. Then she brought wood from the beach and chopped as many sticks as we had used for our fire. She laid them near the fire stones, and put the axe in the pit and covered it again. That done, she put the fire out carefully and padlocked the door.

The girl child guiding the little canoe with the flour-sack sail slipped us back through the quiet mist to Masset.

Cha-atl

While I was staying at the missionary's house, waiting to find some-one to take me to Cha-atl, the missionary got a farm girl, with no ankles and no sense of humour, to stay there with me. She was to keep me company, and to avoid scandal, because the missionary's wife and family were away. The girl had a good enough heart stowed away in an ox-like body. Her name was Maria.

Jimmie, a Haida Indian, had a good boat, and he agreed to take me to Cha-atl, so he and his wife Louisa, Maria and I all started off in the boat. I took my sheep dog and Louisa took her cat.

We made a short stop at a little island where there were a few totem poles and a great smell because of all the dogfish thrown up on the beach and putrefying in the sun. Then we went on till we got to the long narrow Skidegate Inlet.

The tips of the fresh young pines made circles of pale green from the wide base of each tree to the top. They looked like multitudes of little ladies in crinolines trooping down the bank.

The day was hot and still. Eagles circled in the sky and porpoises followed us up the Inlet till we came to the shallows; they leaped up and down in the water making a great commotion on both sides of our boat. Their blunt noses came right out of the water and their tails splashed furiously. It was exciting to watch them.

It took Jimmie all his time in the shallows to keep us in the channel. Louisa was at the wheel while he lay face down on the edge of the boat peering into the water and making signals to Louisa with his arms.

In the late afternoon, Jimmie shut off the engine and said, "Listen."

Then we heard a terrific pounding and roaring. It was the surf-beat on the west coast of the Queen Charlotte Islands. Every minute it got louder as we came nearer to the mouth of the Inlet. It was as if you were coming into the jaws of something too big and awful even to have a name. It never quite got us, because we turned into Cha-atl, just before we came to the corner, so we did not see the awfulness of the roaring ocean. Seamen say this is one of the worst waters in the world and one of the most wicked coasts.

Cha-atl had been abandoned a great many years. The one house standing was quite uninhabitable. Trees had pushed the roof off and burst the sides. Under the hot sun the lush growth smelt rank.

Jimmie lowered the canoe and put Billy, the dog, and me ashore. He left the gas boat anchored far out. When he had put me on the beach, he went back to get Louisa and Maria and the things. While I stood there that awful boom, boom, seemed to drown out every other thing. It made even the forest seem weak and shivery. Perhaps if you could have seen the breakers and had not had the whole weight of the noise left entirely to your ears it would not have seemed so stunning. When the others came ashore the noise seemed more bearable.

There were many fine totem poles in Cha-atl—Haida poles, tragic and fierce. The wood of them was bleached out, but looked green from the mosses which grew in the chinks, and the tufts of grass on the heads of the figures stuck up like coarse hair. The human faces carved on the totem poles were stern and grim, the animal faces fierce and strong; supernatural things were pictured on the poles too. Everything about Cha-atl was so vast and deep you shrivelled up.

When it was too dark to work I came back to the others. They were gathered round a fire on the beach. We did not talk while we ate; you had to shout to be heard above the surf. The smell of the ocean was very strong.

Jimmie had hung one end of my tent to a totem pole that leaned far over the sand. The great carved beaks of the eagle and the raven nearly touched the canvas.

"Jimmie, don't you think that pole might fall on us in the night?"

"No, it has leaned over like that for many, many years."

Louisa's white cat looked like a ghost with the firelight on her eyes. We

began to talk about ghosts and supernatural things—tomtoms that beat themselves, animals that spoke like men, bodies of great chiefs, who had lain in their coffins in the houses of their people till they stank and there were smallpox epidemics—stories that Louisa's grandmother had told her.

When we held the face of the clock to the firelight we saw that it was late. Louisa went to the tent and laughed aloud; she called out, "Come and see."

The walls of the tent and our beds and blankets were crawling with great yellow slugs. With sticks we poked them into a pan. They put in their horns and blunted their noses, puckering the thick lips which ran along their sides and curving their bodies crossly. We tossed them into the bush.

Louisa hung the lantern on to the tent pole and said—

"Jimmie and I will go now."

"Go?"

"Yes, to the gas boat."

"'Way out there and leave us all alone? Haven't you got a tent?"

Jimmie said he forgot it.

"But . . . Jimmie won't sleep in Cha-atl . . . too many ghosts . . ."

"What about us?"

"There are some bears around, but I don't think they will bother you . . . Goodnight."

Their lantern bobbed over the water, then it went out, and there was not anything out there but roar. If only one could have seen it pounding!

We lay down upon the bed of rushes that the Indians had made for us and drew the blanket across us. Maria said, "It's awful. I'm scared to death." Then she rolled over and snored tremendously. Our lantern brought in mosquitoes, so I got up and put it out. Then I went from the tent.

Where the sea had been was mud now, a wide grey stretch of it with black rocks and their blacker shadows dotted over it here and there. The moon was rising behind the forest—a bright moon. It threw the shadows of the totems across the sand; an owl cried, and then a sea-bird. To be able to hear these close sounds showed that my ears must be getting used to the breakers. By and by the roar got fainter and fainter and the silence stronger. The shadows of the totem poles across the beach seemed as real as the poles themselves.

Dawn and the sea came in together. The moon and the shadows were gone. The air was crisp and salty. I caught water where it trickled down a rock and washed myself.

The totem poles stood tranquil in the dawn. The West Coast was almost quiet; the silence had swallowed up the roar.

And morning had come to Cha-atl.

Wash Mary

Mary came to wash for Mother every Monday.

The wash-house was across the yard from the kitchen door—a long narrow room. The south side of it was of open lattice—when the steam poured through it looked as if the wash-house was on fire. There was a stove in the wash-house. A big oval copper boiler stood on the top of the stove. There was a sink and a pump, and a long bench on which the wooden tubs sat.

Mary stood on a block of wood while she washed because she was so little. Her arms went up and down, up and down over the wash board and the suds bobbed in the tub. The smell of washing came out through the lattice with the steam, and the sound of rubbing and swishing came out too.

The strong colours of Mary's print dress, brown face, and black hair were paled by the steam that rolled round her from the tubs. She had splendid braids of hair—the part went clear from her forehead to her spine. At each side of the part the hair sprang strong and thick. The plaits began behind each ear. Down at the ends they were thinner and were tied together with string. They made a loop across her back that looked like a splendid strong handle to lift little Mary up by. Her big plaid shawl hung on a nail while she washed. Mary's face was dark and wrinkled and kind.

Mother said to me, "Go across the yard and say to Mary, 'Chahko muckamuck, Mary'."

"What does it mean?"

"Come to dinner."

"Mother, is Mary an Indian?"

"Yes child; run along, Mary will be hungry."

"Chahko muckamuck—Chahko muckamuck—" I said over and over as I ran across the yard.

When I said to Mary, "Chahko muckamuck", the little woman looked up and laughed at me just as one little girl laughs at another little girl.

I used to hang round at noon on Mondays so that I could go and say, "Chahko muckamuck, Mary". I liked to see her stroke the suds from her arms back into the tub and dry her arms on her wide skirt as she crossed to the kitchen. Then too I used to watch her lug out the big basket and tip-toe on her bare feet to hang the wash on the line, her mouth full of clothes pins— the old straight kind that had no spring, but round wooden knobs on the top that made them look like a row of little dolls dancing over the empty flapping clothes.

As long as I could remember Mary had always come on Mondays and then suddenly she did not come any more.

I asked, "Where is Wash Mary?"

Mother said, "You may come with me to see her."

We took things in a basket and went to a funny little house in Fairfield Road where Mary lived. She did not stay on the Reserve where the Songhees Indians lived. Perhaps she belonged to a different tribe—I do not know—but she wanted to live as white people did. She was a Catholic.

Mary's house was poor but very clean. She was in bed; she was very, very thin and coughed all the time. The brown was all bleached out of her skin. Her fingers were like pale yellow claws now, not a bit like the brown hands that had hung the clothes on our line. Just her black hair was the same and her kind, tired eyes.

She was very glad to see Mother and me.

Mother said, "Poor Mary", and stroked her hair.

A tall man in a long black dress came into Mary's house. He wore a string of beads with a cross round his waist. He came to the bed and spoke to Mary and Mother and I came away.

After we were outside again, Mother said quietly—"Poor Mary!"

Juice

It was unbelievably hot. We three women came out of the store each eating a juicy pear. There was ten cents express on every pound of freight that came up the Cariboo road. Fruit weighs heavy. Everything came in by mule-train.

The first bite into those Bartletts was intoxicating. The juice met your teeth with a gush.

I was considering the most advantageous spot to set my bite next when I saw Doctor Cabbage's eye over the top of my pear, feasting on the fruit with unquenched longing.

I was on the store step, so I could look right into his eyes. They were dry and filmed. The skin of his hands and face was shrivelled, his clothes nothing but a bunch of tatters hanging on a dry stick. I believe the wind could have tossed him like a dead leaf, and that nothing juicy had ever happened in Doctor Cabbage's life.

"It is a good apple?"

After he had asked, his dry tongue made a slow trip across his lips and went back into his mouth hotter and dryer for thinking of the fruit.

"Would you like it?"

A gleam burst through his filmed eyes. He drew the hot air into his throat with a gasp, held his hand out for the pear and then took a deep greedy bite beside mine.

The juice trickled down his chin—his tongue jumped out and caught it; he sipped the oozing juice from the holes our bites had made. He licked the drops running down the rind, then with his eyes still on the pear, he held it out for me to take back.

"No, it's all yours."

"Me eat him every bit?"

"Yes."

His eyes squinted at the fruit as if he could not quite believe his ears and that all the pear in his hands belonged to him. Then he took bite after bite, rolling each bite slowly round his mouth, catching every drop of juice with loud suckings. He ate the core. He ate the tail, and licked his fingers over and over like a cat.

"Hyas Klosshe (very good)," he said, and trotted up the hill as though his joints had been oiled.

Some days later I had occasion to ride through the Indian village. All the cow ponies were busy—the only mount available was an old, old mare who resented each step she took, and if you stopped one instant she went fast asleep.

Indian boys were playing football in the street of their village. I drew up to ask direction. The ball bounced exactly under my horse's stomach. The animal had already gone to sleep and did not notice. Out of a cabin shot a whirl of a little man, riddled with anger. It was Doctor Cabbage.

He confiscated the ball and scolded the boys so furiously that the whole team melted away—you'd think there was not a boy left in the world.

Laying his hand on my sleeping steed, Doctor Cabbage smiled up at me.

"You brave good rider," he said, "Skookum tumtum (good heart)!"

I thanked Doctor Cabbage for the compliment and for his gallant rescue.

I woke my horse with great difficulty, and decided that honour for conspicuous bravery was sometimes very easily won.

Friends

"We have a good house now. We would like you to stay with us when you come. My third stepfather gave me the house when he was dead. He was a good man."

I wrote back, "I would like to stay with you in your house."

Louisa met me down on the mud flats. She had to walk out half a mile because the tide was low. She wore gum boots and carried another pair in her hand for me. Her two small barefoot sons took my bags on their backs. Louisa's greetings were gracious and suitable to the dignity of her third step-father's house.

It was a nice house, and had a garden and verandah. There was a large kitchen, a living-room and double parlours. The back parlour was given to me. It had a handsome brass bed with spread and pillow-slips heavily embroidered, and an eiderdown. There was also a fine dresser in the room; on it stood a candle in a beer bottle and a tin pie-plate to hold hairpins. There was lots of light and air in the room because the blind would not draw down and the window would not shut up.

A big chest in the centre of the room held the best clothes of all the family. Everyone was due to dress there for church on Sunday morning.

Between my parlour and the front parlour was an archway hung with skimpy purple curtains of plush. If any visitors came for music in the evenings and stayed too long, Louisa said, "You must go now, my friend wants to go to bed."

The outer parlour ran to music. It had a player-piano—an immense instrument with a volume that rocked the house—an organ, a flute and some harmonicas. When the cabinet for the player rolls, the bench, a big sofa, a stand-lamp with shade, and some rocking chairs got into the room, there was scarcely any space for people.

In the living-room stood a glass case and in it were Louisa's and Jimmie's wedding presents and all their anniversary presents. They had been married a long time, so the case was quite full.

The kitchen was comfortable, with a fine cook-stove, a sink, and a round table to eat off. Louisa had been cook in a cannery and cooked well. Visitors often came in to watch us eat. They just slipped in and sat in chairs against the wall and we went on eating. Mrs. Green, Louisa's mother, dropped in very often. Louisa's house was the best in the village.

At night Louisa's boys, Jim and Joe, opened a funny little door in the living-room wall and disappeared. Their footsteps sounded up and more up, a creak on each step, then there was silence. By and by Jimmie and Louisa disappeared through the little door too. Only they made louder creaks as they stepped. The house was then quite quiet—just the waves sighing on the shore.

Louisa's mother, Mrs. Green, was a remarkable woman. She clung vigorously to the old Indian ways, which sometimes embarrassed Louisa. In the middle of

talking, the old lady would spit on to the wood-pile behind the stove. When Louisa saw she was going to, she ran with a newspaper, but she seldom got there in time. She was a little ashamed, too, of her mother's smoking a pipe; but Louisa was most respectful to her mother—she never scolded her.

One day I was passing the cabin in the village where Mrs. Green lived. I saw the old lady standing barefoot in a trunk which was filled with thick brown kelp leaves dried hard. They were covered with tiny grey eggs. Louisa told me it was fish roe and was much relished by the Japanese. Mrs. Green knew where the fish put their eggs in the beds of kelp, and she went out in her canoe and got them. After she had dried them she sent them to the store in Prince Rupert and the store shipped them to Japan, giving Mrs. Green value in goods.

When Mrs. Green had tramped the kelp flat, Louisa and I sat on the trunk and she roped it and did up the clasps. Then we put the trunk on the boys' little wagon and between us trundled it to the wharf. They came home then to write a letter to the store man at Prince Rupert. Louisa got the pen and ink, and her black head and her mother's grey one bent over the kitchen table. They had the store catalogue: it was worn soft and black. Mrs. Green had been deciding all the year what to get with the money from the fish roe. Louisa's tongue kept lolling out of the corner of her mouth as she worried over the words; she found them harder to write than to say in English. It seemed as if the lolling tongue made it easier to put them on the paper.

"Can I help you?" I asked.

Louisa shoved the paper across the table to me with a glad sigh, crushing up her scrawled sheet. They referred over and over to the catalogue, telling me what to write. "One plaid shawl with fringe, a piece of pink print, a yellow silk handkerchief, groceries" were all written down, but the old woman kept turning back the catalogue and Louisa kept turning it forward again and saying firmly, "That is all you need, Mother!" Still the old woman's fingers kept stealthily slipping back the pages with longing.

I ended the letter and left room for something else on the list.

"Was there anything more that you wanted, Mrs. Green?"

"Yes, me like *that!*" she said with a defiant glance at Louisa.

It was a patent tobacco pipe with a little tin lid. Louisa looked ashamed.

"What a fine pipe, Mrs. Green, you ought to have that," I said.

"Me like little smoke," said Mrs. Green, looking slyly at Louisa.

That night, old Mother Green sat by the stove puffing happily on her old clay pipe. She leaned forward and poked my knee. "That lid good," she said. "When me small, small girl me mama tell me go fetch pipe often; I put in my mouth to keep the fire; that way me begin like smoke." She had a longish face

scribbled all over with wrinkles. When she talked English the big wrinkles round her eyes and mouth were seams deep and tight and little wrinkles, like stitches, crossed them.

The candle in my room gave just enough light to show off the darkness. Morning made clear the picture that was opposite my bed. It was of three very young infants. How they could stick up so straight with no support at that age was surprising. They had embroidered robes three times as long as themselves, and the most amazing expressions on their faces. Their six eyes were shut as tight as licked envelopes—the infants, clearly, had tremendous wills, and had determined never to open their eyes. Their little faces were like those of very old people; their fierce wrinkles seemed to catch and pinch my stare, so that I could not get it away. I stared and stared. Louisa found me staring.

I said, "Whose babies are those?"

"Mother's tripples," she replied grandly.

"You mean they were Mrs. Green's babies?"

"Yes, the only tripples ever born on Queen Charlotte Islands."

"Did they die?"

"One died and the other two never lived. We kept the dead ones till the live one died, then we pictured them all together."

Whenever I saw that remarkable old woman, with her hoe and spade, starting off in her canoe to cultivate the potatoes she grew wherever she could find a pocket of earth on the little islands round about, I thought of the "tripples". If they had lived and had inherited her strength and determination, they could have rocked the Queen Charlotte Islands.

Martha's Joey

One day our father and his three little girls were going over James Bay Bridge in Victoria. We met a jolly-faced old Indian woman with a little fair-haired white boy about as old as I was.

Father said, "Hello Joey!", and to the woman he said: "How are you getting on, Martha?"

Father had given each of us a big flat chocolate in silver paper done up like a dollar piece. We were saving them to eat when we got home.

Father said, "Who will give her chocolate to Joey?"

We were all willing. Father took mine because I was the smallest and the greediest of his little girls.

The boy took it from my hand shyly, but Martha beamed so wide all over me that I felt very generous.

After we had passed on I said, "Father, who is Joey?"

"Joey", said my father, "was left when he was a tiny baby at Indian Martha's house. One very dark stormy night a man and woman knocked at her door. They asked if she would take the child in out of the wet, while they went on an errand. They would soon be back, they said, but they never came again, though Martha went on expecting them and caring for the child. She washed the fine clothes he had been dressed in and took them to the priest; but nobody could find out anything about the couple who had forsaken the baby.

"Martha had no children and she got to love the boy very much. She dressed him in Indian clothes and took him for her own. She called him Joey."

I often thought about what Father had told us about Joey.

One day Mother said I could go with her, and we went to a little hut in a green field where somebody's cows grazed. That was where Martha lived.

We knocked at the door but there was no answer. As we stood there we could hear someone inside the house crying and crying. Mother opened the door and we went in.

Martha was sitting on the floor. Her hair was sticking out wildly, and her face was all swollen with crying. Things were thrown about the floor as if she did not care about anything any more. She could only sit swaying back and forth crying out, "Joey—my Joey—my Joey—".

Mother put some nice things on the floor beside her, but she did not look at them. She just went on crying and moaning.

Mother bent over Martha and stroked her shoulder; but it was no good saying anything, she was sobbing too hard to hear. I don't think she even knew we were there. The cat came and cried and begged for food. The house was cold.

Mother was crying a little when we came away.

"Is Joey dead, Mother?"

"No, the priests have taken him from Martha and sent him away to school."

"Why couldn't he stay with Martha and go to school like other Indian boys?"

"Joey is not an Indian; he is a white boy. Martha is not his mother."

"But Joey's mother did not want him; she gave him away to Martha and that made him her boy. He's hers. It's beastly of the priest to steal him from Martha."

Martha cried till she had no more tears and then she died.

Salt Water

A t five o'clock that July morning the sea, sky, and beach of Skidegate were rosily smoothed into one. There was neither horizon, cloud, nor sound; of that pink, spread silence even I had become part, belonging as much to sky as to earth, as much to sleeping as waking as I went stumbling over the Skidegate sands.

At the edge of the shrunken sea some Indians were waiting for me, a man and his young nephew and niece. They stood beside the little go-between canoe which was to carry us to a phantom gas boat floating far out in the Bay.

We were going to three old forsaken villages of the British Columbia Indians, going that I might sketch. We were to be away five days.

"The morning is good," I said to the Indian.

"Uh huh," he nodded.

The boy and the girl shrank back shyly, grinning, whispering guttural comments upon my Ginger Pop, the little griffon dog who trotted by my side.

In obedience to a grunt and a pointing finger, I took my place in the canoe and was rowed out to the gas boat. She tipped peevishly as I boarded, circling a great round "O" upon the glassy water; I watched the "O" flatten back into smoothness. The man went to fetch the girl and boy, the food and blankets.

I had once before visited these three villages, Skedans, Tanoo and Cumshewa. The bitter-sweet of their overwhelming loneliness created a longing to return to them. The Indian had never thwarted the growth-force springing up so terrifically in them. He had but homed himself there awhile, making use of what he needed, leaving the rest as it always was. Civilization crept nearer and the Indian went to meet it, abandoning his old haunts. Then the rush of wild growth swooped and gobbled up all that was foreign to it. Rapidly it was obliterating every trace of man. Now only a few hand-hewn cedar planks and roof beams remained, moss-grown and sagging—a few totem poles, greyed and split.

We had been scarcely an hour on the sea when the rosiness turned to lead, grey mist wrapped us about and the sea puckered into sullen, green bulges.

The Indians went into the boat's cabin. I preferred the open. Sitting upon a box, braced against the cabin wall, I felt very ill indeed. There was no deck rail, the waves grew bigger and bigger licking hungrily towards me. I put the dog in his travelling box and sent him below.

Soon we began dipping into green valleys, and tearing up erupting hills. I could scarcely retain my grip on the box. It seemed as if my veins were filled with sea water rather than blood, and that my head was full of emptiness.

After seven hours of this misery our engine shut off outside Skedans Bay.
The Indian tossed the anchor overboard. My heart seemed to go with it in its
gurgling plop to find bottom, for mist had turned to rain and Skedans skulked
dim and uninviting.

"Can the boat not go nearer?"

The Indian shook his head. "No can, water floor welly wicked, make boat
bloke." I knew that there were kelp beds and reefs which could rip the bottoms
from boats down in Skedans Bay.

"Eat now?" asked the man.

"No, I want to land."

The canoe sighed across our deck. The waves met her with an angry spank.
The Indian juggled her through the kelp. Kelpie heads bobbed around us like
drowning Aunt Sallies, flat brown streamers growing from their crowns and
floating out on the waves like long tresses. The sea battered our canoe roughly.
Again and again we experienced nightmare drownings, which worked up and
up to a point but never reached there. When we finally beached, the land was
scarcely less wet than the sea. The rain water lacked the sting of salt but it
soaked deeper.

The Indian lit a great fire for me on the beach; then he went back to his gas
boat, and a wall of mist and rain cut me off from all human beings.

Skedans on a stormy day looked menacing. To the right of the Bay imme-
diately behind the reef, rose a pair of uncouth cone-like hills, their heads
bonneted in lowering clouds. The clumsy hills were heavily treed save where
deep bare scars ran down their sides, as if some monster cruelty had ripped
them from crown to base. Behind these two hills the sea bit into the shoreline
so deeply as to leave only a narrow neck of land, and the bedlam of waves
pounding on the shores back and front of the village site pinched the silence
out of forsaken old Skedans.

Wind raced across the breast-high growth around the meagre ruins more
poignantly desolate for having once known man.

A row of crazily tipped totem poles straggled along the low bank skirting
Skedans Bay. The poles were deep planted to defy storms. In their bleached and
hollow upper ends stood coffin-boxes, boarded endwise into the pole by heavy
cedar planks boldly carved with the crest of the little huddle of bones inside the
box, bones which had once been a chief of Eagle, Bear or Whale Clan.

Out in the anchored gas boat the Indian girl became seasick, so they
brought her ashore. Leaving her by the fire I wandered to the far end of the
Bay. Ginger Pop was still on the gas boat and I missed him at my heels for the
place was very desolate, awash with rain, and the sea pounding and snatching

all it could reach, hurling great waves only to snatch them back to increase the volume of its next blow.

Suddenly above the din rose a human cry. The girl was beckoning to me wildly. "Uncle's boat," she cried. "It is driving for the reef!"

I saw the gas boat scudding towards her doom, saw the Indian in the small canoe battling to make shore with our bedding and food.

"Listen!" screamed the girl, "it is my brother."

Terrified shrieks from the gas boat pierced the tumult, "Uncle, Uncle!"

The man hurled the food and blankets ashore without beaching the canoe, then he stepped into the waves, holding the frantic thing like a dog straining on a leash. He beckoned me as near as the waves would let me go.

"Water heap wicked—maybe no come back—take care my girl," he said, and was gone.

Rushing out to the point above the reef, we watched the conflict between canoe and sea. When the man reached the gas boat, the screams of the boy stopped. With great risk they loaded the canoe till she began to take water. The boy bailed furiously. The long dogged pull of the man's oars challenged death inch by inch, wave by wave. There were spells like eternity, when the fury out there seemed empty when the girl hid her face on my shoulder and screeched. I stared and stared, watching to tell the Indians in the home village what the sea had done to their man and boy. How it had sucked them again and again into awful hollows, walled them about with waves, churned so madly that the boat did not budge in spite of those desperate pulling oars.

Then some sea demon tossed her upon a crest and another plunged her back again. The hugging sea wanted her, but inch by inch she won. Then a great breaker dashed her on the beach with the smashing hurl of a spoiled child returning some coveted toy.

The boy jumped out and made fast. The man struggled a few paces through the foam and fell face down. We dragged him in. His face was purple. "He is dying!"—No, life came back with tearing sobs.

Among our sodden stuff was a can of milk, another of beans; we heated them, they put new life into us. Night was coming. We made what preparation we could, spreading a tent-fly over a great log and drying out our blankets. There was no lack of driftwood for the fire.

The Indian's heart was sore for his boat; it looked as if nothing could save her. She was drifting more slowly now, her propeller fouled in kelp.

Mine was sore for my Ginger Pop in his box on the doomed boat. We each took our trouble to an opposite end of the bay . . . brooding.

Suddenly the mournful little group on the farther point galvanized into life. I heard a chorus of yells, saw the man strip off his oilskin pants, tie them to a pole and beat the air. I hurried across but found the Indians limp and despairing again.

"Boat see we was Indian, no stop," said the man bitterly.

Fish boats were hurrying to shelter, few came our way, sanctuary was not to be found in Skedans Bay. I could not help hoping none would see our distress signal. The thought of going out on that awful sea appalled me.

A Norwegian seine boat did see us however. She stood by and sent two small boats ashore. One went to the rescue of the drifting gas boat and the other beached for us.

"Please, please leave us here on the land," I begged. The Indians began rushing our things into the boat and the big Norwegian sailors with long beards like brigands said, "Hurry! Hurry!" I stood where land and sea wrangled ferociously over the overlap. The tea kettle was in my hand. "Wait!" I roared above the din of the waves, seeing I was about to be seized like a bale of goods and hurled into the boat. "Wait!"—plunging a hand into my pocket I took out a box of "Mothersill's Seasick Remedy", unwrapped a pill, put it on my tongue and took a gulp from the kettle's spout; then I let them put me into the maniac boat. She was wide and flat-bottomed. It was like riding through bedlam on a shovel. "Mothersill" was useless; her failure climaxed as we reached the seiner, which at that particular moment was standing on her nose. When she sat down again they tied the rescued gas boat to her tail and dragged us aboard the seiner. When they set me on the heaving deck, I flopped on top of the fish hatch and lay there sprawling like a star fish.

Rooting among my things the Indian girl got a yellow parasol and a large tin cup; but the parasol flew overboard and the cup was too late—it went clanking down the deck. Being now beyond decency I made no effort to retrieve it. The waves did better than the cup anyway, gurgling and sloshing around the hatch which was a foot higher than the deck. Spray washed over me. The taste of the sea was on my lips.

The Captain ordered "all below"; everyone rushed to obey save me. I lay among the turmoil with everything rattling and smashing around and in my head no more sense than a jelly fish.

Then the Captain strode across the deck, picked me up like a baby and dumped me into the berth in his own cabin. I am sure it must have been right on top of the boiler for I never felt so hot in my life. One by one my senses clicked off as if the cigarette ladies jazzing over every inch of the cabin walls had pressed buttons.

When I awoke it hardly seemed possible that this was the same boat or the same sea or that this was the same me lying flat and still above an engine that purred soft and contented as an old cat. Then I saw that the Indian girl was beside me.

"Where are we?"

"I dunno."

"Where are they taking us?"

"I dunno."

"What time is it?"

"I dunno."

"Is Ginger Pop safe?"

"I dunno."

I turned my attention to the Captain's cabin, lit vaguely from the deck lantern. The cigarette ladies now sat steady and demure. From the window I could see dark shore close to us. Suddenly there was no more light in the room because the Captain stood in the doorway, and said, as casually as if he picked up castaways off beaches most nights, "Wants a few minutes to midnight— then I shall put you off at the scows."

"The scows?"

"Yep, scows tied up in Cumshewa Inlet for the fish boats to dump their catches in."

"What shall I do there?"

"When the scows are full, packers come and tow them to the canneries."

"And must I sit among the fish and wait for a packer?"

"That's the idea."

"How long before one will come?"

"Ask the fish."

"I suppose the Indians will be there too?"

"No, we tow them on farther, their engine's broke."

Solitary, uncounted hours in one of those hideous square-snouted pits of fish smell! Already I could feel the cold brutes slithering around me for aeons and aeons of time before the tow ropes went taut, and we set out for the cannery. There, men with spiked poles would swarm into the scow, hook each fish under the gills. The creatures would hurtle through the air like silver streaks, landing into the cannery chutes with slithery thumps, and pass on to the ripping knives. . . . The Captain's voice roused me from loathsome thoughts.

"Here we are!"

He looked at me—scratched his head—frowned. "We're here," he repeated, "and now what the dickens—? There is a small cabin on the house scow—

that's the one anchored here permanently—but the two men who live on it will have been completely out these many hours. Doubt if sirens, blows, nor nothin' could rouse 'em. Well, see what I can do. . . ."

He disappeared as the engine bell rang. The Indian girl, without goodbye, went to join her uncle.

Captain returned jubilant.

"There is a Jap fishboat tied to the scows. Her Captain will go below with his men and let you have his berth till four A.M.; you'll have to clear out then— that's lookin' far into the future tho'. Come on."

I followed his bobbing lantern along a succession of narrow planks mounted on trestles, giddy, vague as walking a tight rope across night. We passed three cavernous squares of black. Fish smell darted at us from their depths. When the planks ended the Captain said, "Jump!" I obeyed wildly, landing on a floored pit filled with the most terrifying growls.

"Snores," said the captain. ". . . House scow."

We tumbled over strange objects, the door knob of the cabin looked like a pupil-less eye as the lantern light caught its dead stare.

We scrambled up the far side of the scow pit and so on to the Jap boat; three steps higher and we were in the wheel-house. There was a short narrow bench behind the wheel—this was to be my bed. On it was my roll of damp blankets, my sketch sack, and Ginger Pop's box with a mad-for-joy Ginger inside it, who transformed me immediately back from a bale of goods to his own special divinity.

The new day beat itself into my consciousness under the knuckles of the Japanese captain. I thanked my host for the uncomfortable night which, but for his kindness, would have been far worse, and biddably leapt from the boat to the scow. It seemed that now I had no more voice in the disposal of my own person than a salmon. I was goods—I made no arrangements, possessed neither ticket, pass, nor postage stamp—a pick-up that somebody asked someone else to dump somewhere.

At the sound of my landing in the scow bottom, the door of the cabin opened, and yellow lamplight trickled over a miscellany of objects on the deck. Two men peered from the doorway; someone had warned them I was coming. Their beds were made, the cabin was tidied, and there were hot biscuits and coffee on the table.

"Good morning, I am afraid I am a nuisance. . . . I'm sorry."

"Not at all, not at all, quite a—quite er—" he gave up before he came to what I was and said, "Breakfast's ready . . . crockery scant . . . but plenty grub, plenty grub; . . . cute nipper," pointing to Ginger Pop. "Name?"

"Ginger Pop."

"Ha! Ha!" He had a big round laugh. "Some name, some pup, eh?"

The little room was of rough lumber. It contained two of each bare necessity—crockery, chairs, beds, two men, a stove, a table.

"Us'll have first go," said the wider, the more conversational of the two. He waved me into one of the chairs and took the other.

"This here," thumbing back at the dour man by the stove, "is Jones; he's cook, I'm Smith."

I told them who I was but they already knew all about us. News travels quickly over the sea top. Once submerged and it is locked in secrecy. The hot food tasted splendid. At last we yielded the crockery to Jones.

"Now," said Smith, "you've et well; how'd you like a sleep?"

"I should like a sleep very much indeed," I replied, and without more ado, hat, gum boots and all climbed up to Smith's bed. Ginger Pop threw himself across my chest with his nose tucked under my chin. I pulled my hat far over my face. The dog instantly began to snore. Smith thought it was I. "Pore soul's dead beat," he whispered to Jones, and was answered by a "serves-'er-right" grunt.

It was nearly noon when I awoke. I could not place myself underneath the hat. The cabin was bedlam. Jones stretched upon his bed was snoring, Smith on the floor with my sketch sack for a pillow "duetted", Ginger Pop under my chin was doing it too. The walls took the snores and compounded them into a hodge-podge chorus and bounced it from wall to wall.

Slipping off the bed and stepping gingerly over Smith I went out of the cabin into the fullness of a July noon, spread munificently over the Cumshewa Inlet. The near shores were packed with trees, trees soaked in sunshine. For all their crowding, there was room between every tree, every leaf, for limitless mystery. On many of their tops sat a bald-headed eagle, fish glutted, his white cap startling against the deep green of the fir trees. No cloud, no sound, save only the deep thunderous snores coming from the cabin. The sleeping men were far, far away, no more here than the trouble of last night's storm was upon the face of the Inlet.

The door of the cabin creaked. Smith's blinky eye peeped out to see if he had dreamed us. When he saw Ginger and me he beamed, hoped we were rested, hoped we were hungry, hoped Jones' dinner would be ready soon; then the door banged, shutting himself and his hopes into the cabin. He was out again soon, carrying a small tin basin, a grey towel, and a lump of soap. Placing the things on a barrel-end, he was just about to dip when the long neck of Jones twisted around Smith's body and plunged first with loud sput-

ters. Still dripping he rushed back among the smells of his meat and dumplings. Smith refilled the basin and washed himself with amazing thoroughness considering his equipment, engaging me in conversation all the while. After he had hurled the last remaining sud into the sea he filled the basin yet again, solemnly handed me the soap and, polishing his face as if it had been a brass knob, shut Jones and himself up and left me to it.

We dined in the order we had breakfasted.

"Mr. Smith," I said, "how am I going to get out of here?"

"That is," said Smith with an airy wave of his knife, "in the hands of the fish."

"They haven't any," I replied a little sulkily. The restriction of four walls and two teacups was beginning to tell and nobody seemed to be doing anything about releasing me.

"Pardon, Miss, I were speakin' figurative. Meanin' that if them fish critters is reasonable there'll be boats; after boats there'll be packers."

"Easy yourself now," he coaxed, "'Ave another dumpling?"

Ginger and I scrambled over the various scows getting what peeps of the Inlet we could. It was very beautiful.

By and by we saw the scrawny form of Jones hugging the cabin close while he eased his way with clinging feet past the scow house to the far end. Here he leaned from the overhang and like a magician, produced a little boat from nowhere.

He saw us watching and had a happy thought. He could relieve the congestion in the scow house. He actually grinned—"Going to the spring. You and the dog care for a spell ashore?" He helped Ginger across the ledge and the awkward drop into the boat, but left me to do the best I could. I was thicker than Jones and the rim of the boat beyond the cabin was very meagre.

The narrow beach was covered with sea-drift. Silence and heat lay heavy upon it. Few breezes found their way up the Inlet. The dense shore growth was impossible to break into. Jones filled his pails at the spring and returned to the scow, leaving us stranded on the shore. When the shadows were long he returned for us. As we were eating supper, night fell.

We sat around the coal-oil lamp which stood upon the table, telling stories. At the back of each mind was a wonder as to whose lot would be cast on the floor if no packer came before night. Little fish boats began to come. We went out to watch them toss their catch hastily into the scows and rush back like retrieving pups to fetch more.

There was a great bright moon now. The fish looked alive, shooting through the air. In the scows they slithered over one another, skidding, switch-

backing across the silver mound till each found a resting-place only to be bounced out by some weightier fellow.

The busy little boats broke the calm and brought a tang of freshness from the outside to remind the Inlet that she too was part of the great salt sea.

So absorbed was I in the fish that I forgot the packer till I heard the enthusiastic ring in Jones' voice as he cried "Packer!" He ran to his cupboard and found a bone for Ginger while Smith parleyed with the packer's Japanese captain. Yes, he was going my way. He would take me.

Smith led me along the narrow walk and gave me into the Captain's care. Besides myself there was another passenger, a bad-tempered Englishman with a cold in his head. As there was nowhere else, we were obliged to sit side by side on the red plush cushion behind the Captain and his wheel. All were silent as we slipped through the flat shiny water bordered on either side by mountainous fir-treed shores. The tree tops looked like interminable picket fences silhouetted against the sky, with water shadows as sharp and precise as themselves.

My fellow passenger coughed, hawked, sneezed and sniffed. Often he leaned forward and whispered into the Captain's ear. Then the Captain would turn and say to me, "You wish to sleep now? My man will show you." I knew it was "sniffer" wanting the entire couch and I clung to the red plush like a limpet. By and by, however, we came to open water and began to toss, and then I was glad to be led away by the most curious little creature. Doubtless he had a middle because there was a shrivelled little voice pickled away somewhere in his vitals, but his sou'wester came so low and his sea-boots so high, the rest of him seemed negligible.

This kind little person navigated me successfully over the deck gear, holding a lantern and giving little inarticulate clucks continuously, but my heart struck bottom when he slid back a small hatch and sank into the pit by jerks till he was all gone but the crown of his sou'wester.

"Come you please, lady," piped the queer little voice. There was barely room for our four feet on the floor between the two pair of short narrow bunks which tapered to a point in the stern of the boat. To get into a berth you must first horizontal yourself, then tip and roll. "Sou'wester-Boots" steadied me and held aside fishermen's gear while I tipped, rolled, and scraped my nose on the underneath of the top bunk.

"I do wish you good sleep, lady."

My escort and the light were gone. The blackness was intense and heavy with the smell of fish and tar.

I was under the sea, could feel it rushing by on the other side of the thin boards, kissing, kissing the boat as it passed. Surely at any moment it would

gush into my ears. At the back of the narrow berth some live-seeming thing grizzled up my spine, the engine bell rang and it scuttled back again; then the rudder groaned, and I knew what the thing was. Soon the mechanics of the boat seemed to be part of myself. I waited for the sequence—bell, grizzle, groan—bell, grizzle, groan; they had become part of me.

Several times during the night the hatch slid back, a lantern swung into my den and shadow hands too enormous for this tiny place reached for some article.

"I am afraid I am holding up all the sleeping quarters," I said.

"Please, lady, nobody do sleep when at night we go."

I floated in and out of consciousness, and dream fish swam into my one ear and out of the other.

At three A.M. the rudder cable stopped playing scales on my vertebrae. The boat still breathed but she did not go. Sou'wester opened my lid and called, "Please, lady, the Cannery."

I rolled, righted, climbed, followed. He carried my sketch sack and Ginger's box. We took a few steps and then the pulse of the engine was no longer under our feet. We stood on some grounded thing that had such a tilt it pushed against our walking. We came to the base of an abnormally long perpendicular fish ladder, stretching up, up into shadow so overwhelmingly deep it seemed as if a pit had been inverted over our heads. It was the wharf and the Cannery.

A bulky object mounted the ladder, and was swallowed into the gloom. After a second a spot of dim light dangled high above. Breaths cold and deathly came from the inky velvet under the wharf. I could hear mud sucking sluggishly around the base of piles, the click of mussels and barnacles, the hiss and squirt of clams. From far above came a testy voice . . . "Come on, there." There were four sneezes, the lantern dipping at each sneeze.

"Quick, go!" said Sou'wester, "Man do be mad."

I could not . . . could not mount into that giddy blackness; that weazened little creature, all hat and boots, was such a tower of strength to abandon for a vague black ascent into . . . nothingness.

"Couldn't I . . . couldn't I crawl under the wharf round to the beach?" I begged.

"It is not possible, go!"

"The dog?"

"He . . . you see!" Even as he spoke, Ginger's box swung over my head.

"What's the matter down there? . . . Hurry!"

I grasped the cold slimy rung. My feet slithered and scrunched on stranded things. Next rung . . . the next and next . . . endless horrible rungs, hissing and smells belching from under the wharf. These things at least were half

tangible. Empty nothingness, behind, around; hanging in the void, clinging to slipperiness, was horrible—horrible beyond words! . . .

Only one more rung, then the great timber that skirted the wharf would have to be climbed over and with no rung above to cling to. . . .

The impact of my body, flung down upon the wharf, jerked my mind back from nowhere.

"Fool! Why did you let go?" "Sneezer" retrieved the lantern he had flung down, to grip me as I reeled . . . Six sneezes . . . dying footsteps . . . dark.

I groped for the dog's box.

Nothing amazed Ginger Pop. Not even that his mistress should be sitting T-squared against wharf and shed . . . time, three A.M. . . . place, a far north Cannery of British Columbia.

Century Time

Y ou would never guess it was a cemetery. Death had not spoiled it at all. It was full of trees and bushes except in one corner where the graves were. Even they were fast being covered with greenery.

Bushes almost hid the raw, split-log fence and the gate of cedar strips with a cross above it, which told you that the enclosed space belonged to the dead. The land about the cemetery might change owners, but the ownership of the cemetery would not change. It belonged to the dead for all time.

Persistent growth pushed up through the earth of it—on and on eternally—growth that was the richer for men's bodies helping to build it.

The Indian settlement was small. Not many new graves were required each year. The Indians only cleared a small bit of ground at a time. When that was full they cleared more. Just as soon as the grave boxes were covered with earth, vines and brambles began to creep over the mounds. Nobody cut them away. It was no time at all before life spread a green blanket over the Indian dead.

It was a quiet place this Indian cemetery, lying a little aloof from the village. A big stump field, swampy and green, separated them. Birds called across the field and flew into the quiet tangle of the cemetery bushes and nested there among foliage so newly created that it did not know anything about time. There was no road into the cemetery to be worn dusty by feet, or stirred into gritty clouds by hearse wheels. The village had no hearse. The dead were carried by friendly hands across the stump field.

The wooded part of the cemetery dropped steeply to a lake. You could not see the water of the lake because of the trees, but you could feel the space

between the cemetery and the purple-topped mountain beyond.

In the late afternoon a great shadow-mountain stepped across the lake and brooded over the cemetery. It had done this at the end of every sunny day for centuries, long, long before that piece of land was a cemetery. Dark came and held the shadow-mountain there all night, but when morning broke, it was back again inside its mountain, which pushed its grand purple dome up into the sky and dared the pines swarming around its base to creep higher than half-way up its bare rocky sides.

Indians do not hinder the progress of their dead by embalming or tight coffining. When the spirit has gone they give the body back to the earth. The earth welcomes the body—coaxes new life and beauty from it, hurries over what men shudder at. Lovely tender herbage bursts from the graves, swiftly, exulting over corruption.

Opening the gate I entered and walked among the graves. Pushing aside the wild roses, bramble blossoms and scarlet honeysuckle which hugged the crude wooden crosses, I read the lettering on them—

SACRED OF KATIE—IPOO

SAM BOYAN HE DIDE—IPOO

RIP JULIE YECTON—IPOO

JOSEPH'S ROSIE DI—IPOO

Even these scant words were an innovation—white men's ways; in the old days totem signs would have told you who lay there. The Indian tongue had no written words. In place of the crosses the things belonging to the dead would have been heaped on the grave: all his dear treasures, clothes, pots and pans, bracelets—so that everyone might see what life had given to him in things of his own.

"IPOO" was common to almost every grave. I wrote the four-lettered word on a piece of paper and took it to a woman in the village.

"What does this mean? It is on the graves."

"Mean die time."

"Die time?"

"Uh huh. Tell when he die."

"But all the graves tell the same."

"Uh huh. Four this kind," (she pointed separately to each of the four letters, IPOO) "tell now time."

"But everybody did not die at the same time. Some died long ago and some die now?"

"Uh huh. Maybe some year just one man die—one baby. Maybe influenza come—he come two time—one time long far, one time close. He make lots, lots Injun die."

"But, if it means the time people died, why do they put 'IPOO' on the old graves as well as on the new?"

Difficult English thoughts furrowed her still forehead. Hard English words came from her slow tongue in abrupt jerks. Her brown finger touched the and the I and the P. "He know," she said, "he tell it. This one and this one" (pointing to the two O's) "small—he no matter. He change every year. Just this one and this matter" (pointing again to I and P). "He tell it."

Time was marked by centuries in this cemetery. Years—little years—what are they? As insignificant as the fact that reversing the figure nine turns it into the letter P.

Kitwancool

When the Indians told me about the Kitwancool totem poles, I said: "How can I get to Kitwancool?"

"Dunno," the Indians replied.

White men told me about the Kitwancool poles too, but when I told them I wanted to go there, they advised me—"Keep out." But the thought of those old Kitwancool poles pulled at me. I was at Kitwangak, twenty or so miles from Kitwancool.

Then a halfbreed at Kitwangak said to me, "The young son of the Kitwancool Chief is going in tomorrow with a load of lumber. I asked if he would take you; he will."

"How can I get out again?"

"The boy is coming back to Kitwangak after two days."

The Chief's son Aleck was shy, but he spoke good English. He said I was to be at the Hudson's Bay store at eight the next morning.

I bought enough food and mosquito oil to last me two days; then I sat in front of the Hudson's Bay store from eight to eleven o'clock, waiting. I saw Aleck drive past to load his lumber. The wagon had four wheels and a long pole. He tied the lumber to the pole and a sack of oats to the lumber; I was to sit on the oats. Rigged up in front somehow was a place for the driver—no real seat, just a couple of coal-oil boxes bound to some boards. Three men sat on the two boxes. The road was terrible. When we bumped, the man on the down side of the boxes fell off.

A sturdy old man trudged behind the wagon. Sometimes he rode a bit on the end of the long pole, which tossed him up and down like a see-saw. The old man carried a gun and walked most of the way.

The noon sun burnt fiercely on our heads. The oat-sack gave no support to my back, and my feet dangled. I had to clutch the corner of the oat-sack with one hand to keep from falling off—with the other I held my small griffon dog. Every minute I thought we would be pitched off the pole. You could seldom see the old man because of clouds of yellow dust rolling behind the wagon. The scrub growth at the road-side smelt red hot.

The scraggy ponies dragged their feet heavily; sweat cut rivers through the dust that was caked on their sides.

One of the three men on the front seat of the wagon seemed to be a hero. The other men questioned him all the way, though generally Indians do not talk as they travel. When one of the men fell off the seat he ran round the wagon to the high side and jumped up again and all the while he did not stop asking the hero questions. There were so many holes in the road and the men fell off so often that they were always changing places, like birds on a roost in cold weather.

Suddenly we gave such an enormous bump that we all fell off together, and the horses stopped. When the wheels were not rattling any more we could hear water running. Then the old man came out of the clouds of dust behind us and said there was a stream close by.

We threw ourselves onto our stomachs, put our lips to the water and drank like horses. The Indians took the bits out of their horses' mouths and gave them food. Then the men crawled under the wagon to eat their lunch in its shade; I sat by the shadiest wheel. It was splendid to put my legs straight out and have the earth support them and the wheel support my back. The old man went to sleep.

After he woke and after the horses had pulled the wagon out of the big hole, we rumbled on again.

When the sun began to go down we were in woods, and the clouds of mosquitoes were as thick as the clouds of dust, but more painful. We let them eat us because, after bumping for seven hours, we were too tired to fight.

At last we came to a great dip where the road wound around the edge of a ravine shaped like an oblong bowl. There were trees growing in this earth bowl. It seemed to be bottomless. We were level with the tree-tops as we looked down. The road was narrow—its edges broken.

I was afraid and said, "I want to walk."

Aleck waved his hand across the ravine. "Kitwancool," he said and I saw

some grey roofs on the far side of the hollow. After we had circled the ravine and climbed the road on the other side we would be there, unless we were lying dead in that deep bowl.

I said again, "I want to walk."

"Village dogs will kill you and the little dog," said Aleck. But I did walk around the bend and up the hill, until the village was near. Then I rode into Kitwancool on the oat-sack.

The dogs rushed out in a pack. The village people came out too. They made a fuss over the hero-man, clustering about him and jabbering. They paid no more attention to me than to the oat-sack. All of them went into the nearest house taking Aleck, the hero, the old man and the other man with them, and shut the door.

I wanted to cry, sticking alone up there on top of the oats and lumber, the sagging horses in front and the yapping dogs all round, nobody to ask about anything and very tired. Aleck had told me I could sleep on the verandah of his father's house, because I only had a cot and a tent-fly with me, and bears came into the village often at night. But how did I know which was his father's house? The dogs would tear me if I got down and there was no one to ask, anyway.

Suddenly something at the other end of the village attracted the dogs. The pack tore off and the dust hid me from them.

Aleck came out of the house and said, "We are going to have dinner in this house now." Then he went in again and shut the door.

The wagon was standing in the new part of the village. Below us, on the right, I could see a row of old houses. They were dim, for the light was going, but above them, black and clear against the sky stood the old totem poles of Kitwancool. I jumped down from the wagon and came to them. That part of the village was quite dead. Between the river and the poles was a flat of green grass. Above, stood the houses, grey and broken. They were in a long, wavering row, with wide, windowless fronts. The totem poles stood before them there on the top of a little bank above the green flat. There were a few poles down on the flat too, and some graves that had fences round them and roofs over the tops.

When it was almost dark I went back to the wagon.

The house of Aleck's father was the last one at the other end of the new village. It was one great room like a hall and was built of new logs. It had seven windows and two doors; all the windows were propped open with blue castor-oil bottles.

I was surprised to find that the old man who had trudged behind our wagon was Chief Douse—Aleck's father.

Mrs. Douse was more important than Mr. Douse; she was chieftainess in her own right, and had great dignity. Neither of them spoke to me that night. Aleck showed me where to put my bed on the verandah and I hung the fly over it. I ate a dry scrap of food and turned into my blankets. I had no netting, and the mosquitoes tormented me.

My heart said into the thick dark, "Why did I come?"

And the dark answered, "You know."

In the morning the hero-man came to me and said, "My mother-in-law wishes to speak with you. She does not know English words so she will talk through my tongue."

I stood before the tall, cold woman. She folded her arms across her body and her eyes searched my face. They were as expressive as if she were saying the words herself instead of using the hero's tongue.

"My mother-in-law wishes to know why you have come to our village."

"I want to make some pictures of the totem poles."

"What do you want our totem poles for?"

"Because they are beautiful. They are getting old now, and your people make very few new ones. The young people do not value the poles as the old ones did. By and by there will be no more poles. I want to make pictures of them, so that your young people as well as the white people will see how fine your totem poles used to be."

Mrs. Douse listened when the young man told her this. Her eyes raked my face to see if I was talking "straight." Then she waved her hand towards the village.

"Go along," she said through the interpreter, "and I shall see." She was neither friendly nor angry. Perhaps I was going to be turned out of this place that had been so difficult to get into.

The air was hot and heavy. I turned towards the old village with the pup Ginger Pop at my heels. Suddenly there was a roar of yelpings, and I saw my little dog putting half a dozen big ones to rout down the village street. Their tails were flat, their tongues lolled and they yelped. The Douses all rushed out of their house to see what the noise was about, and we laughed together so hard that the strain, which before had been between us, broke.

The sun enriched the old poles grandly. They were carved elaborately and with great sincerity. Several times the figure of a woman that held a child was represented. The babies had faces like wise little old men. The mothers expressed all

womanhood—the big wooden hands holding the child were so full of tenderness they had to be distorted enormously in order to contain it all. Womanhood was strong in Kitwancool. Perhaps, after all, Mrs. Douse might let me stay.

I sat in front of a totem mother and began to draw—so full of her strange, wild beauty that I did not notice the storm that was coming, till the totem poles went black, flashed vividly white and then went black again. Bang upon bang, came the claps of thunder. The hills on one side tossed it to the hills on the other; sheets of rain washed over me. I was beside a grave down on the green flat; some of the pickets of its fence were gone, so I crawled through on to the grave with Ginger Pop in my arms to shelter under its roof. Stinging nettles grew on top of the grave with mosquitoes hiding under their leaves. While I was beating down the nettles with my easel, it struck the head of a big wooden bear squatted on the grave. He startled me. He was painted red. As I sat down upon him my foot hit something that made a hollow rattling noise. It was a shaman's rattle. This then must be a shaman's, a medicine-man's grave, and this the rattle he had used to scare away evil spirits. Shamen worked black magic. His body lay here just a few feet below me in the earth. At the thought I made a dash for the broken community house on the bank above. All the Indian horses had got there first and taken for their shelter the only corner of the house that had any roof over it.

I put my stool near the wall and sat upon it. The water ran down the wall in rivers. The dog shivered under my coat—both of us were wet to the skin. My sketch sack was so full of water that when I emptied it on to the ground it made the pool we sat in bigger.

After two hours the rain stopped suddenly. The horses held their bones stiff and quivered their skins. It made the rain fly out of their coats and splash me. One by one they trooped out through a hole in the wall. When their hooves struck the baseboard there was a sodden thud. Ginger Pop shook himself too, but I could only drip. Water poured from the eyes of the totems and from the tips of their carved noses. New little rivers trickled across the green flat. The big river was whipped to froth. A blur like boiling mist hung over it.

When I got back to the new village I found my bed and things in a corner of the Douses' great room. The hero told me, "My mother-in-law says you may live in her house. Here is a rocking-chair for you."

Mrs. Douse acknowledged my gratitude stolidly. I gave Mr. Douse a dollar and asked if I might have a big fire to dry my things and make tea. There were two stoves—the one at their end of the room was alight. Soon, mine too was roaring and it was cosy. When the Indians accepted me as one of themselves, I was very grateful.

The people who lived in that big room of the Douses were two married daughters, their husbands and children, the son Aleck and an orphan girl called Lizzie. The old couple came and went continually, but they ate and slept in a shanty at the back of the new house. This little place had been made round them. The floor was of earth and the walls were of cedar. The fire on the ground sent its smoke through a smoke-hole in the roof. Dried salmon hung on racks. The old people's mattress was on the floor. The place was full of themselves—they had breathed themselves into it as a bird, with its head under its wing, breathes itself into its own cosiness. The Douses were glad for their children to have the big fine house and be modern but this was the right sort of place for themselves.

Life in the big house was most interesting. A baby swung in its cradle from the rafters; everyone tossed the cradle as he passed and the baby cooed and gurgled. There was a crippled child of six—pinched and white under her brown skin; she sat in a chair all day. And there was Orphan Lizzie who would slip out into the wet bushes and come back with a wild strawberry or a flower in her grubby little hand, and kneeling by the sick child's chair, would open her fingers suddenly on the surprise.

There was no rush, no scolding, no roughness in this household. When anyone was sleepy he slept; when they were hungry they ate; if they were sorry they cried, and if they were glad they sang. They enjoyed Ginger Pop's fiery temper, the tilt of his nose and particularly the way he kept the house free of Indian dogs. It was Ginger who bridged the gap between their language and mine with laughter. Ginger's snore was the only sound in that great room at night. Indians sleep quietly.

Orphan Lizzie was shy as a rabbit but completely unselfconscious. It was she who set the food on the big table and cleared away the dishes. There did not seem to be any particular meal-times. Lizzie always took a long lick at the top of the jam-tin as she passed it.

The first morning I woke at the Douses', I went very early to wash myself in the creek below the house. I was kneeling on the stones brushing my teeth. It was very cold. Suddenly I looked up—Lizzie was close by me watching. When I looked up, she darted away like a fawn, leaving her water pails behind. Later, Mrs. Douse came to my corner of the house, carrying a tin basin; behind her was Lizzie with a tiny glass cream pitcher full of water, and behind Lizzie was the hero.

"My mother-in-law says the river is too cold for you to wash in. Here is water and a basin for you."

Everyone watched my washing next morning. The washing of my ears interested them most.

One day after work I found the Douse family all sitting round on the floor. In the centre of the group was Lizzie. She was beating something in a pail, beating it with her hands; her arms were blobbed with pink froth to the elbows. Everyone stuck his hand into Lizzie's pail and hooked out some of the froth in the crook of his fingers, then took long delicious licks. They invited me to lick too. It was "soperlallie", or soap berry. It grows in the woods; when you beat the berry it froths up and has a queer bitter taste. The Indians love it.

For two days from dawn till dark I worked down in the old part of the village. On the third day Aleck was to take me back to Kitwangak. But that night it started to rain. It rained for three days and three nights without stopping; the road was impossible. I had only provisioned for two days, had been here five and had given all the best bits from my box to the sick child. All the food I had left for the last three days was hard tack and raisins. I drank hot water, and rocked my hunger to the tune of the rain beating on the window. Ginger Pop munched hard tack unconcerned—amusing everybody.

The Indians would have shared the loaf and jam-tin with me, but I did not tell them that I had no food. The thought of Lizzie's tongue licking the jam-tin stopped me.

When it rained, the Indians drowsed like flies, heavy as the day itself.

On the sixth day of my stay in Kitwancool the sun shone again, but we had to wait a bit for the puddles to drain.

I straightened out my obligations and said goodbye to Mr. and Mrs. Douse. The light wagon that was taking me out seemed luxurious after the thing I had come in on. I climbed up beside Aleck. He gathered his reins and "giddapped".

Mrs. Douse, followed by her husband, came out of the house and waved a halt. She spoke to Aleck.

"My mother wants to see your pictures."

"But I showed her every one before they were packed."

At the time I had thought her stolidly indifferent.

"My mother wishes to see the pictures again."

I clambered over the back of the wagon, unpacked the wet canvases and opened the sketchbooks. She went through them all. The two best poles in the village belonged to Mrs. Douse. She argued and discussed with her husband. I told Aleck to ask if his mother would like to have me give her pictures of her poles. If so, I would send them through the Hudson's Bay store at Kitwangak.

Mrs. Douse's neck loosened. Her head nodded violently and I saw her smile for the first time.

Repacking, I climbed over the back of the seat to Aleck.

"Giddap!"

The reins flapped: we were off. The dust was laid; everything was keen and fresh; indeed the appetites of the mosquitoes were very keen.

When I got back to Kitwangak the Mounted Police came to see me.

"You have been in to Kitwancool?"

"Yes."

"How did the Indians treat you?"

"Splendidly."

"Learned their lesson, eh?" said the man. "We have had no end of trouble with those people—chased missionaries out and drove surveyors off with axes—simply won't have whites in their village. I would never have advised anyone going in—particularly a woman. No, I would certainly have said, 'Keep out'."

"Then I am glad I did not ask for your advice," I said. "Perhaps it is because I am a woman that they were so good to me."

"One of the men who went in on the wagon with you was straight from jail, a fierce, troublesome customer."

Now I knew who the hero was.

Canoe

Three red bulls—sluggish bestial creatures with white faces and morose bloodshot eyes—made me long to get away from the village. But I could not: there was no boat.

I knew the roof and the ricketiness of every Indian woodshed. This was the steepest roof of them all, and I was panting a bit. It is not easy to climb with a little dog in one hand and the hot breath of three bulls close behind you. Those three detestable white faces were clustered round my canvas below. They were giving terrible bellows and hoofing up the sand.

Far across the water there appeared a tiny speck: it grew and grew. By the time the bulls had decided to move on, it was a sizeable canoe heading for the mud-flats beyond the beach. The tide was very far out. When the canoe grounded down there on the mud, an Indian family swarmed over her side,

and began plodding heavily across the sucking ooze towards an Indian hut above the beach. I met them where the sand and the mud joined.

"Are you going back to Alliford? Will you take me?"

"Uh huh," they were; "Uh huh," they would.

"How soon?"

"Plitty-big-hully-up-quick."

I ran up the hill to the mission house. Lunch was ready but I did not wait. I packed my things in a hurry and ran down the hill to the Indian hut, and sat myself on a beach log where I could watch the Indians' movements.

The Indians gathered raspberries from a poor little patch at the back of the house. They borrowed a huge preserving kettle from the farthest house in the village. Grandpa fetched it; his locomotion was very slow. The women took pails to the village tap, lit a fire, heated water; washed clothes—hung out—gathered in; set dough, made bread, baked bread; boiled jam, bottled jam; cooked meals and ate meals. Grandpa and the baby took sleeps on the kitchen floor, while I sat and sat on my log with my little dog in my lap, waiting. When the bulls came down our way I ran, clutching the dog. When the bulls had passed, we sat down again. But even when I was running, I watched the canoe. Sometimes I went to the door and asked,

"When do we go?"

"Bymby," or "Plitty soon," they said.

I suggested going up to the mission house to get something to eat, but they shook their heads violently, made the motion of swift running in the direction of the canoe and said, "Big-hully-up-quick."

I found a ship's biscuit and a wizened apple in my sketch sack. They smelled of turpentine and revolted my appetite. At dusk I ate them greedily.

It did not get dark. The sun and the moon crossed ways before day ended. By and by the bulls nodded up the hill and sat in front of the mission gate to spend the night. In the house the Indians lit a coal-oil lamp. The tide brought the canoe in. She floated there before me.

At nine o'clock everything was ready. The Indians waded back and forth stowing the jam, the hot bread, the wash, and sundry bundles in the canoe. They beckoned to me. As I waded out, the water was icy against my naked feet. I was given the bow seat, a small round stick like a hen roost. I sat down on the floor and rested my back against the roost, holding the small dog in my lap. Behind me in the point of the canoe were two Indian dogs, which kept thrusting mangy muzzles under my arms, sniffing at my griffon dog.

Grandpa took one oar, the small boy of six the other. The mother in the stern held a sleeping child under her shawl and grasped the steering paddle. A

young girl beside her settled into a shawl-swathed lump. Children tumbled themselves among the household goods and immediately slept.

Loosed from her mooring, the big canoe glided forward. The man and the boy rowed her into the current. When she met it she swerved like a frightened horse—accepted—gave herself to its guiding, her wolf's head stuck proud and high above the water.

The child-rower tipped forward in sleep and rolled among the bundles. The old man, shipping the child's oar and his own, slumped down among the jam, loaves and washing, resting his bent old back against the thwart.

The canoe passed shores crammed with trees—trees overhanging stony beaches, trees held back by rocky cliffs, pointed fir trees climbing in dark masses up the mountain sides, moonlight silvering their blackness.

Our going was imperceptible, the woman's steering paddle the only thing that moved, its silent cuts stirring phosphorous like white fire.

Time and texture faded . . . ceased to exist . . . day was gone, yet it was not night. Water was not wet nor deep, just smoothness spread with light.

As the canoe glided on, her human cargo was as silent as the cedar-life that once had filled her. She had done with the forest now; when they shoved her into the sea they had dug out her heart. Submissively she accepted the new element, going with the tide. When tide or wind crossed her she became fractious. Some still element of the forest clung yet to the cedar's hollow rind which resented the restless push of waves.

Once only during the whole trip were words exchanged in the canoe. The old man, turning to me, said,

"Where you come from?"

"Victoria."

"Victorlia? Victorlia good place—still. Vancouver, Seattle, lots, lots trouble. Victorlia plenty still."

It was midnight when the wolf-like nose of our canoe nuzzled up to the landing at Alliford. All the village was dark. Our little group was silhouetted on the landing for one moment while silver passed from my hand to the Indian's.

"Good-night."

"Gu-ni'."

One solitary speck and a huddle of specks moved across the beach, crossed the edge of visibility and plunged into immense night.

Slowly the canoe drifted away from the moonlit landing, till, at the end of her rope, she lay an empty thing, floating among the shadows of an inverted forest.

The Book of Small

Contents

The Book of Small

A Little Town and a Little Girl

Sunday

All our Sundays were exactly alike. They began on Saturday night after Bong the Chinaboy had washed up and gone away, after our toys, dolls and books, all but *The Peep of Day* and Bunyan's *Pilgrim's Progress*, had been stored away in drawers and boxes till Monday, and every Bible and prayer-book in the house was puffing itself out, looking more important every minute.

Then the clothes-horse came galloping into the kitchen and straddled round the stove inviting our clean clothes to mount and be aired. The enormous wooden tub that looked half coffin and half baby-bath was set in the middle of the kitchen floor with a rag mat for dripping on laid close beside it. The great iron soup pot, the copper wash-boiler and several kettles covered the top of the stove, and big sister Dede filled them by working the kitchen pump-handle furiously. It was a sad old pump and always groaned several times before it poured. Dede got the brown windsor soap, heated the towels and put on a thick white apron with a bib. Mother unbuttoned us and by that time the pots and kettles were steaming.

Dede scrubbed hard. If you wriggled, the flat of the long-handled tin dipper came down spankety on your skin.

As soon as each child was bathed Dede took it pick-a-back and rushed it upstairs through the cold house. We were allowed to say our prayers kneeling in bed on Saturday night, steamy, brown-windsory prayers—then we cuddled down and tumbled very comfortably into Sunday.

At seven o'clock Father stood beside our bed and said, "Rise up! Rise up! It's Sunday, children." He need not have told us; we knew Father's Sunday smell—Wright's coal-tar soap and camphor. Father had a splendid chest of camphor-wood which had come from England round the Horn in a sailing-ship with him. His clean clothes lived in it and on Sunday he was very camphory. The chest was high and very heavy. It had brass handles and wooden knobs. The top let down as a writing desk with pigeon-holes; below there were little drawers for handkerchiefs and collars and long drawers for clothes. On top of the chest stood Father's locked desk for papers. The key of it was on his ring with lots of others. This desk had a secret drawer and a brass plate with R. H. CARR engraved on it.

On top of the top desk stood the little Dutchman, a china figure with a head that took off and a stomach full of little candies like coloured hailstones. If we had been very good all week we got hailstones Sunday morning.

Family prayers were uppish with big words on Sunday—reverend awe-ful words that only God and Father understood.

No work was done in the Carr house on Sunday. Everything had been polished frightfully on Saturday and all Sunday's food cooked too. On Sunday morning Bong milked the cow and went away from breakfast until evening milking-time. Beds were made, the dinner-table set, and then we got into our very starchiest and most uncomfortable clothes for church.

Our family had a big gap in the middle of it where William, John and Thomas had all been born and died in quick succession, which left a wide space between Dede and Tallie and the four younger children.

Lizzie, Alice and I were always dressed exactly alike. Father wanted my two big sisters to dress the same, but they rebelled, and Mother stood behind them. Father thought we looked like orphans if we were clothed differently. The Orphans sat in front of us at church. No two of them had anything alike. People gave them all the things their own children had grown out of—some of them were very strange in shape and colour.

When we were all dressed, we went to Mother's room to be looked over. Mother was very delicate and could not get up early or walk the two miles to church, and neither could Tallie or little Dick.

Father went to Dr. Reid's Presbyterian Church at the corner of Pandora and Blanshard streets. Father was not particularly Presbyterian, but he was a little deaf and he liked Dr. Reid because, if we sat at the top of the church, he could hear his sermons. There was just the Orphans in front of us, and the stove in front of them. The heat of the stove sent them all to sleep. But Dr. Reid was a kind preacher—he did not bang the Bible, nor shout to wake them up. Sometimes I went to sleep too, but I tried not to because of what happened at home after Sunday's dinner.

If the road had not been so crooked it would have been a straight line from the gate of our lily-field to the church door. We did not have to turn a single corner. Lizzie, Alice and I walked in the middle of the road and took hands. Dede was on one end of us and Father on the other. Dede carried a parasol, and Father, a fat yellow stick, not a flourish stick but one to walk with. If we met anything, we dangled in a row behind Father like the tail of a kite.

We were always very early for church and could watch the Orphans march in. The Matron arranged every bad Orphan between two good ones, and put very little ones beside big ones, then she set herself down behind them where she could watch and poke any Orphan that needed it. She was glad when the stove sent them all to sleep and did not poke unless an Orphan had adenoids and snored.

The minute the church bell stopped a little door in front of the Orphans opened, and Dr. Reid came out and somebody behind him shut the door, which was rounded at the top and had a reverend shut.

Dr. Reid had very shiny eyes and very red lips. He wore a black gown with two little white tabs like the tail of a bird sticking out from under his beard. He carried a roll in his hand like Moses, and on it were all the things that he was going to say to us. He walked slowly between the Orphans and the stove and climbed into the pulpit and prayed. The S's sizzled in his mouth as if they were frying. He was a very nice minister and the only parson that Father ever asked to dinner.

The moment Dr. Reid amened, we rushed straight out of the church off home. Father said it was very bad taste for people to stand gabbing at church doors. We came down Church Hill, past the Convent Garden, up Marvin's Hill, through the wild part of Beacon Hill Park into our own gate. The only time we stopped was to gather some catnip to take home to the cats, and the only turn we made was into our own gate.

Our Sunday dinner was cold saddle of mutton. It was roasted on Saturday in a big tin oven on legs, which was pushed up to the open grate fire in the break-fast-room. Father had this fire-place specially built just like the ones in England. The oven fitted right up to it. He thought everything English was much better than anything Canadian. The oven came round the Horn with him, and the big pewter hot-water dishes that he ate his chops and steaks off, and the heavy mahogany furniture and lots of other things that you could not buy in Canada then. The tin oven had a jack which you wound up like a clock and it turned the roast on a spit. It said 'tick, tick, tick' and turned the meat one way, and then 'tock, tock, tock' and turned it the other. The meat sizzled and sputtered. Someone was always opening the little tin door in the back to baste it, using a long iron spoon, with the dripping that was caught in a pan beneath the meat. Father said no roast under twenty pounds was worth eating because the juice had all run out of it, so it was lucky he had a big family.

Red currant jelly was served with the cold mutton, and potato salad and pickled cabbage, afterwards there was deep apple pie with lots of Devonshire cream. In the centre of the dinner-table, just below the cruet stand, stood an enormous loaf of bread. Mr. Harding, the baker, cooked one for Father every Saturday. It was four loaves baked in one so that it did not get as stale as four small loaves would have. It was made cottage-loaf-shape—two storeys high with a dimple in the top.

When dinner was finished, Father folded his napkin very straight, he even slipped his long fingers inside each fold again after it was in the ring, for Father always wanted everything straight and right. Then he looked up one side of the table and down the other. We all tried not to squirm because he always

picked the squirmiest. When he had decided who should start, he said, "Tell me what you remember of the sermon."

If Dede was asked first, she "here and there'd" all over the sermon. If it was Lizzie, she ploughed steadily through from text to amen. Alice always remembered the text. Sometimes I remembered one of Dr. Reid's jokes, that is if I was asked first—if not I usually said, "The others have told it all, Father," and was dreadfully uncomfortable when Father said, "Very well; repeat it, then."

When we had done everything we could with Dr. Reid's sermon, Father went into the sitting room to take his Sunday nap, Mother read, and Dede took hold of our religion.

She taught Sunday School in Bishop Cridge's house, to a huge family of Balls and an enormous family of Fawcetts, a smarty boy called Eddy, a few other children who came and went, and us. The Bishop's invalid sister sat in the room all the time. Her cheeks were hollow, she had sharp eyes with red rims, sat by the fire, wore a cap and coughed, not because she had to, but just to remind us that she was watching and listening.

From dinner till it was time to go to the Bishop's, we learned collects, texts and hymns. Dede was shamed because the Balls, the Fawcetts and all the others did better than I who was her own sister.

You got a little text-card when you knew your lessons. When you had six little cards you had earned a big text-card. I hardly ever got a little card and always lost it on the way home, so that I never earned a big one. I could sing much better than Addie Ball, who just talked the hymns out very loud, but Dede only told me not to shout and let Addie groan away without any tune at all.

When Dede marched us home, Father was ready, and Mother had her hat on, to start for the Sunday walk around our place. Dede stayed home to get the tea, but first she played very loud hymns on the piano. They followed us all round the fields. Tallie was not strong enough for the walking so she lay on the horsehair sofa in the drawing-room looking very pretty, resting up for her evening visitor. Lizzie squeezed out of coming whenever she could because she had rather creep into a corner and learn more texts. She had millions of texts piled up inside her head just waiting for things to happen, then she pushed the right text over onto them. If you got mad any time after noon, the sun was going to set on your wrath. You could feel the great globe getting hotter and hotter and making your mad fiercer because of the way the text stirred it up. If you did not see things just in Lizzie's way, you were dead in your sins.

So the rest of us started for the Sunday walk. We went out the side door into the garden, through ever so many gates and the cow-yard, on into a

shrubbery which ran round two sides of the cow pasture, but was railed off to keep the cows from destroying the shrubs. A twisty little path ran through the shrubbery. Father wanted his place to look exactly like England. He planted cowslips and primroses and hawthorn hedges and all the Englishy flowers. He had stiles and meadows and took away all the wild Canadian-ness and made it as meek and English as he could.

We did not take the twisty path but a straight little one of red earth, close up under the hedge. We went singly, Father first, then Mother with little Dick by the hand. Because of William, John and Thomas being dead, Mother's only boy was Dick. He had a lovely little face with blue eyes and yellow curls. He wore a little pant suit with a pleated skirt over the pants which came half-way down over his thin little legs. These suits were very fashionable for small boys—Mr. Wilson knew that they would sell, because of the jack-knife on a knotted cord brought through the buttonhole and dropping into a pocket on the chest. When boys saw these knife suits they teased and teased till they got one. Alice plodded along behind Dick, her arms hung loose and floppy. Father thought all make-believes were wicked on Sunday, even make-believe babies, so her darling dolls sat staring on the shelf in our bedroom all day. I came last and wished that our Sunday walk was not quite so much fenced. First there was the thorny hedge and then the high pickets.

Mr. Green, my friend Edna's father, took his family to the beach every Sunday. They clattered and chattered past our place having such jokes. I poked my head through the hedge to whisper,

"Hello, Edna!"

"Hello! How dull you do look walking round your own cow-field! Come to the beach with us."

"I don't think I can."

"Ask your mother."

I scraped between Alice and the hedge.

"Can I, Mother?"

"Your Father likes you to walk with him on Sunday."

I stuck my head through the thorns again, and shook it. Once I actually asked Father myself if I could go with the Greens, and he looked as hurt as if I'd hit him.

"Are my nine acres not enough, but you must want to tear over the whole earth? Is the Sabbath a right day to go pleasuring on the beach?" he said.

But one Sunday I did go with the Greens. Father had the gout and did not know. We had fun and I got "show-off" from being too happy. The boys dared

me to walk a log over the sea, and I fell in. When I came home dripping, Lizzie had a text about my sin finding me out.

But I was telling about the family taggling along the path under the hedge. Father's stick was on the constant poke, pushing a root down or a branch up, or a stone into place, for he was very particular about everything being just right.

As we neared the top corner of our big field, that one wild place where the trees and bushes were allowed to grow thick and tangled, and where there was a deep ditch with stinging-nettles about it, and a rank, muddy smell. Father began to frown and to walk faster and faster till we were crouched down in the path, running after one another like frightened quail. If there were voices on the other side of the hedge, we raced like mad.

This corner of Father's property always made him very sore. When he came from England he bought ten acres of fine land adjoining Beacon Hill Park, which was owned by the City of Victoria. It took Father a lot of money to clear his land. He left every fine tree he could, because he loved trees, but he cleared away the scrub to make meadows for the cows, and a beautiful garden. Then he built what was considered in 1863 a big fine house. It was all made of California redwood. The chimneys were of California brick and the mantel-pieces of black marble. Every material used in the building of Father's house was the very best, because he never bought anything cheap or shoddy. He had to send far away for most of it, and all the time his family was getting bigger and more expensive, too; so, when a Mrs. Lush came and asked if he would sell her the corner acre next to the Park and farthest away from our house, and as she offered a good price, he sold. But first he said, "Promise me that you will never build a Public House on the land," and Mrs. Lush said, "No, Mr. Carr, I never will." But as soon as the land was hers, Mrs. Lush broke her word, and put up one of the horridest saloons in Victoria right there. Father felt dreadful, but he could not do anything about it, except to put up a high fence and coax that part of the hawthorn hedge to grow as tall and be as prickly as it could.

Mrs. Lush's Public House was called the Park Hotel, but afterwards the name was changed to the Colonist Hotel. It was just a nice drive from Esquimalt, which was then a Naval Station, and hacks filled with tipsy sailors and noisy ladies drove past our house going to the Park Hotel in the daytime and at night. It hurt Father right up till he was seventy years old, when he died.

After we had passed the Park Hotel acre we went slow again so that Father could enjoy his land. We came to the "pickets," a sort of gate without hinges;

we lifted the pickets out of notches in the fence and made a hole through which we passed into the lily field.

Nothing, not even fairyland, could have been so lovely as our lily field. The wild lilies blossomed in April or May but they seemed to be always in the field, because, the very first time you saw them, they did something to the back of your eyes which kept themselves there, and something to your nose, so that you smelled them whenever you thought of them. The field was roofed by tall, thin pine trees. The ground underneath was clear and grassed. The lilies were thickly sprinkled everywhere. They were white, with gold in their hearts and brown eyes that stared back into the earth because their necks hooked down. But each lily had five sharp white petals rolling back and pointing to the tree-tops, like millions and millions of tiny quivering fingers. The smell was fresh and earthy. In all your thinking you could picture nothing more beautiful than our lily field.

We turned back towards our house then, and climbed a stile over a snake fence. On the other side of the fence was a mass of rock, rich and soft with moss, and all round it were mock orange and spirea and oak trees.

Father and Mother sat down upon the rock. You could see the thinking in their eyes. Father's was proud thinking as he looked across the beautiful place that he had made out of wild Canadian land—he thought how splen-didly English he had made it look. Mother's eyes followed our whispered Sunday playing.

When Father got up, Mother got up too. We walked round the lower hay field, going back into the garden by the back gate, on the opposite side of the house from which we had left. Then we admired the vegetables, fruit and flowers until the front door flew open and Dede jangled the big brass dinner bell for us to come in to tea.

When the meal was finished the most sober part of all Sunday came, and that was the Bible reading. Church and Sunday School had partly belonged to Dr. Reid and Dede. The Bible reading was all God's. We all came into the sit-ting-room with our faces very straight and our Bibles in our hands.

There was always a nice fire in the grate, because, even in summer, Victoria nights are chilly. The curtains were drawn across the windows and the table was in front of the fire. It was a round table with a red cloth, and the brass lamp sitting in the middle threw a fine light on all the Bibles when we drew our chairs in close.

Father's chair was big and stuffed, Mother's low, with a high back. They faced each other where the table began to turn away from the fire. Between

their chairs where it was too hot for anyone to sit, the cats lay sprawling on the rug before the fire. We circled between Father and Mother on the other side of the table.

Father opened the big Family Bible at the place marked by the cross-stitch text Lizzie had worked. In the middle of the Bible, between the "old" and the "new," were some blank pages, and all of us were written there. Sometimes Father let us look at ourselves and at William, John and Thomas who were each written there twice, once for being born, and once for dying. That was the only time that John, Thomas and William seemed to be real and take part in the family's doings. We did little sums with their Bible dates, but could never remember if they had lived for days or years. As they were dead before we were born, and we had never known them as Johnny- or Tommy- or Willie-babies, they felt old and grown up to us.

Tallie was more interested in the marriage page. There was only one entry on it, "Richard and Emily Carr," who were Father and Mother.

Tallie said, "Father, Mother was only eighteen when she married you, wasn't she?"

"Yes," said Father, "and had more sense than some girls I could name at twenty." He was always very frowny when the doorbell rang in the middle of Bible reading and Tallie went out and did not come back.

We read right straight through the Bible, begat chapters and all, though even Father stuck at some of the names.

On and on we read till the nine o'clock gun went off at Esquimalt. Father, Mother, and Dede set their watches by the gun and then we went on reading again until we came to the end of the chapter. The three smallest of us had to spell out most of the words and be told how to say them. We got most dreadfully sleepy. No matter how hard you pressed your finger down on the eighth verse from the last one you had read, when the child next to you was finishing and kicked your shin you jumped and the place was lost. Then you got scolded and were furious with your finger. Mother said, "Richard, the children are tired," but Father said, "Attention! Children" and went right on to the end of the chapter. He thought it was rude to God to stop in a chapter's middle nor must we shut our Bibles up with a glad bang when at last we were through.

No matter how sleepy we had been during Bible reading, when Father got out the *Sunday at Home* we were wide awake to hear the short chapter of the serial story. Father did not believe in fairy stories for children. *At the Back of the North Wind* was as fairy as anything, but, because it was in the *Sunday at Home*, Father thought it was all right.

We kissed Mother good night. While the others were kissing Father I ran behind him (I did so hate kissing beards) and, if Father was leaning back, I could just reach his bald spot and slap the kiss there.

Dede lighted the candle and we followed her, peeping into the drawing room to say good night to Tallie and her beau. We did not like him much because he kissed us and was preachy when we cheeked pretty Tallie, who did not rule over us as Dede did; but he brought candy—chocolates for Tallie and a bag of "broken mixed" for the children, big hunky pieces that sucked you right into sleep.

Dede put Dick to bed. Lizzie had a room of her own. Alice and I shared. We undid each other and brushed our hair to long sweet suckings.

"I wish he'd come in the morning before church."

"What for?"

"Sunday'd be lots nicer if you could have a chunk of candy in your cheek all day."

"Stupid! Could you go to church with candy poking out of your cheek like another nose? Could you slobber candy over your Sunday School Lesson and the Bible reading?"

Alice was two years older than I. She stopped brushing her long red hair, jumped into bed, leaned over the chair that the candle sat on.

Pouf! . . . Out went Sunday and the candle.

The Cow Yard

The cow yard was large. Not length and breadth alone determined its dimensions, it had height and depth also. Above it continually hovered the spirit of maternity. Its good earth floor, hardened by many feet, pulsed with rich growth wherever there was any protection from the perpetual movement over its surface.

Across the ample width of the Cow Yard, the old Barn and the New Barn faced each other. Both were old, but one was very old; in it lodged the lesser creatures. The Cow alone occupied the New Barn.

But it was in the Cow Yard that you felt most strongly the warm life-giving existence of the great red-and-white loose-knit Cow. When she walked, her great bag swung slowly from side to side. From one end of her large-hipped square body nodded a massive head, surmounted by long, pointed horns. From the other dangled her tail with its heavy curl and pendulum-like movement. As her cloven hoofs moved through the mud, they made a slow clinging

squelch, all in tune with the bagging, sagging, nodding, leisureliness of the Cow's whole being.

Of the three little girls who played in the Cow Yard, Bigger tired of it soonest. Right through she was a pure, clean child, and had an enormous conscience. The garden rather than the Cow Yard suited her crisp frocks and tidy ways best, and she was a little afraid of the Cow.

Middle was a born mother, and had huge doll families. She liked equally the tidy garden and the free Cow Yard.

Small was wholly a Cow Yard child.

When the Cow's nose was deep in her bran mash, and her milk purring into the pail in long, even streams, first sounding tinny in the empty pail and then making a deeper and richer sound as the pail filled, Bong, sitting on his three-legged stool, sang to the Cow—a Chinese song in a falsetto voice. The Cow took her nose out of the mash bucket, threw back her great ears, and listened. She pulled a tuft of sweet hay from her rack, and stood quite still, chewing softly, her ears right about, so that she might not miss one bit of Bong's song.

One of the seven gates of the Cow Yard opened into the Pond Place. The Pond was round and deep, and the primroses and daffodils that grew on its bank leaned so far over to peep at themselves that some of them got drowned. Lilacs and pink and white may filled the air with sweetness in Spring. Birds nested there. The Cow walked on a wide walk paved with stones when she came to the Pond to drink. Hurdles of iron ran down each side of the walk and into the water, so that she should not go too far, and get mired. The three girls who came to play used to roost on the hurdles and fish for tadpoles with an iron dipper that belonged to the hens' wheat-bin. From the brown surface of the water three upside-down little girls laughed up and mocked them, just as an upside-down Cow looked up from the water and mocked the Cow when she drank. Doubtless the tadpoles laughed, because down under the water where they darted back and forth no upside-down tadpoles mocked.

The overflow from the Pond meandered through the Cow Yard in a wide, rock-bordered ditch. There were two bridges across the ditch; one made of two planks for people to walk over, and the other made of logs, strong and wide enough for the Cow. The hens drank from the running water. Musk grew under the Cow's bridge; its yellow blossoms gleamed like cats' eyes in the cool dark.

Special things happened in the Cow Yard at each season of the year, but the most special things happened in Spring.

First came the bonfire. All winter the heap in the centre of the Cow Yard had mounted higher and higher with orchard prunings, branches that had blown down in the winter winds, old boxes and hens' nests, garbage, and now, on top of all, the spring-cleaning discards.

The three little girls sat on three upturned barrels. Even Bigger, her hands folded in a spotless lap, enjoyed this Cow Yard event. The Cow, safely off in the pasture, could not stamp and sway at her. Middle, hugging a doll, and Small, hugging a kitten, banged their heels on the sides of the hollow barrels, which made splendid noises like drums.

The man came from the barn with paper and matches, and off the bonfire blazed with a tremendous roar. It was so hot that the barrels had to be moved back. The hens ran helter-skelter. The rabbits wiggled their noses furiously as the whiffs of smoke reached their hutches. The ducks waddled off to the Pond to cool themselves. Soon there was nothing left of the bonfire but ashes and red embers. Then the barrels were rolled up close, and the three little girls roasted potatoes in the hot ashes.

Bigger told stories while the potatoes roasted. Her stories were grand and impossible, and when they soared beyond imagining, Small said, "Let's have some real ones now," and turned to Middle, "Will you marry?"

"Of course," came the prompt reply. "And I shall have a hundred children. Will you?"

Small considered. "Well, that depends. If I don't join a circus and ride a white horse through hoops of fire, I may marry a farmer, if he has plenty of creatures. That is, I wouldn't marry just a vegetable man."

"I am going to be a missionary," said Bigger, "and go out to the Heathen."

"Huh! if you're scared of our old cow, what will you be of cannibals?" said Small. "Why not marry a missionary, and send him out first, so they wouldn't be so hungry when you got there?"

"You are a foolish child," said Bigger. "The potatoes are cooked. You fish them out, Small, your hands and pinafore are dirty anyway."

The ashes of the bonfire were scarcely cold before Spring burst through the brown earth, and the ashes and everything. The Cow and the chickens kept the tender green shoots cropped down, but every night more pushed up and would not be kept under. The Cow watched the willow trees that grew beside the Pond. Just before the silky grey pussies burst their buds, she licked up as far as she could reach and ate them, blowing hard, upside-down sniffs—all puff-out and no pull-in—as though the bitter-sweet of the pussy-willows was very

agreeable to her. She stood with half-closed eyes, chewing and rolling her jaws from side to side, with delighted slobbering.

About this time, the fussy old hens got fussier. After sticking their feathers on end, and clucking and squawking and being annoyed at everybody, they suddenly sat down on their nests, and refused to get up, staring into space as though their orange eyes saw something away off. Then they were moved into a quiet shed and put into clean boxes of hollowed-out hay, filled with eggs. They sat on top of the eggs for ages and ages. If you put your hand on them, they flattened their feathers to their bodies and their bodies down on their eggs and gave beaky growls. Then, when you had almost forgotten that they ever had legs and could walk, you went to the shed and put food and water before them. Fluffy chickens peeped out of every corner of the hen's feathers, till she looked as fat as seven hens. Then she strutted out into the yard, to brag before the other creatures, with all the chicks bobbing behind her.

One old hen was delighted with her chickens and went off, clucking to keep them close, and scratching up grubs and insects for them by the way, but when they came to the ditch her little ones jumped into the water and swam off. She felt that life had cheated her, and she sat down and sulked.

"How mad she must be, after sitting so long," said Bigger.

"As long as they are alive, I don't see why she should care," said Middle. "They'll come to her to be cuddled when they are tired and cold."

"Oh, girls," cried Small, bursting with a big idea, "if the hen hatched ducks, why couldn't the Cow have a colt? It would be so splendid to have a horse!"

Bigger got up from the stone where she was sitting. "Come on," she said to Middle, "she is such a foolish child. Let's play ladies in the garden, and leave her to mudpuddle in the Cow Yard."

The ducklings crept back to the old hen when they were tired, just as Middle had said they would. The old hen squatted down delightedly, loosening up her feathers, and the little ducks snuggled among them.

"Aren't they beastly wet and cold against your skin?" shouted Small across the ditch to the hen. "Gee, don't mothers love hard!"

She cast a look around the yard. Through the fence she saw the Cow in the pasture, chewing drowsily. Spring sunshine, new grass, daisies and buttercups filled the pasture. The Cow had not a trouble in the world.

Small nodded to the Cow. "All the same, old Cow, I do wish you could do something about a colt. Oh, dear, I do want to learn to ride!"

Suddenly she sprang up, jumped the ditch, tiptoed to reach the iron hoop that kept the pasture-gate fast, and ran up to the Cow. "Be a sport, old girl,"

she whispered in the great hairy ear, and taking her by the horn she led the Cow up to the fence.

The Cow stood meek and still. Small climbed to the top rail of the fence, and jumped on the broad expanse of red back, far too wide for her short legs to grip. For one still moment, while the slow mind of the Cow surmounted her astonishment, Small sat in the wide valley between horns and hip-bones. Then it seemed as though the Cow fell apart, and as if every part of her shot in a different direction.

Small hurled through space and bumped hard. "Beast!" she gasped, when she had sorted herself from the mud and the stones. "Bong may call you the Old Lady, but I call you a mean, miserable old cow." And she shook her fist at the still-waving heels and tail at the other end of the pasture.

That night, when Small showed Middle the bruises, and explained how they had come, Middle said, "I expect you had better marry a farmer; maybe you're not exactly suited for a circus rider."

Spring had just about filled up the Cow Yard. The rabbits' secrets were all out now. They had bunged up the doors of their sleeping boxes with hay and stuff, and had pretended that there was nothing there at all. But if you went too close, they stamped their feet and wagged their ears, and made out that they were brave as lions. But now that it had got too stuffy in the boxes, the mother pulled down the barricade and all the fluffy babies scampered out, more than you could count.

One day when the Cow was standing under the loft, the loveliest baby pigeon fell plumb on her back. But there were so many young things around, all more or less foolish, that the Cow was not even surprised.

Then one morning the Father called the little girls into the Cow Yard, to see the pigmy image of the Old Cow herself, spot for spot, except that it had no wisdom. He had a foolish baby face and foolish legs; he seemed to wonder whose legs these were, and never dreamed that they were his own. But he was sure that he owned his tail, and flipped it joyously.

The Cow was terribly proud of him, and licked him and licked him till all his hair crinkled up.

Now, the Cow Yard was not Heaven, so of course bad things and sad things happened there too.

Close by the side of the ditch was a tree covered with ivy. The running water had washed some of the roots bare, and they stuck out. When the little girls sailed boats down the ditch, the roots tipped the boats and tried to drown the dolls.

It was not a very big tree, but the heavy bunch of ivy that hung about it made it look immense. The leaves of the ivy formed a dense dark surface about a foot away from the bole of the tree, for the leaves hung on long stems. The question was—what filled the mysterious space between the leaves and the tree? Away above the ivy, at the top, the bare branches of the tree waved skinny arms, as if they warned you that something terrible was there.

One day the children heard the Father say to the Mother, "The ivy has killed that tree."

It was strange that the ivy could kill anything. Small thought about it a lot, but she did not like to ask the older ones, who thought her questions silly. She would not have thrust her arm into that space for anything.

The pigeons flew over the tree, from the roof of one barn to the roof of the other, but they never lighted on it. Sometimes the noisy barn sparrows flew into the ivy; they were instantly silent, and you never saw them come out. Sometimes owls hoo-hoo-hooed in there. Once when Small was sitting on the chopping block, one flew out, perfectly silently, as though its business were very secret. Small crept home and up to bed, although it was not quite time, and drew the covers tight up over her head. To herself she called that tree "The Killing Tree".

Then one day she found a dead sparrow under the Killing Tree.

She picked it up. The bird was cold, its head flopped over her hand; the rest of it was stiff and its legs stuck up. Queer grey lids covered its eyes.

Small buried it in a little box filled with violets. A week later she dug it up, to see just what did happen to dead things. The bird's eyes were sunk away back in its head. There were some worms in the box, and it smelled horrid. Small buried the bird in the earth again quickly.

Winter came by and by and, looking out from their bedroom window, Middle said, "The Old Cow Yard tree is down." They dressed quickly and went to look.

The tree had broken the Cow's bridge and lay across the ditch, the forlorn top broken and pitiful. The heavy ivy, looking blacker than ever against the snow, still hid the mystery place.

"Mercy, it's good it did not fall on the Cow and kill her," said Small. "It's a beastly tree and I'm glad it is down!"

"Why should it fall on the Cow; and why was it a beastly tree?" asked Middle.

"Because and because," said Small, and pressed her lips together tight.

"You *are* silly," retorted Middle.

When they came back from school, the top branches were chopped up, and the ivy piled ready for burning. The little tawny roots of the ivy stuck out

all over the bole like coarse hair. The Man was sawing the tree in lengths. He rolled one towards the children. "Here's a seat for you," he said. Middle sat down. Small came close to the Man.

"Mr. Jack, when you chopped the ivy off the tree did you find anything in there?"

"Why, I found the tree."

"I mean," said Small in a tense voice, "anything between the tree and the ivy?"

"There wasn't nothing in there that I saw," replied the Man. "Did you lose a ball or something maybe?"

"When are you going to burn the ivy?"

"Just waiting till you came home from school," and he struck a match.

Dense, acrid smoke blinded the children. When they could see again, long tongues of flame were licking the leaves, which hissed back like a hundred angry cats, before they parched, crackled, and finally burst into flames.

"Isn't it a splendid bonfire?" asked Middle. "Shall we cook potatoes?"

"No," said Small.

The next spring, when everyone had forgotten that there ever had been a Cow Yard tree, the Father bought a horse. The Cow Yard was filled with excitement; children shouted, hens ran, ducks waddled off quacking, but the Cow did not even look up. She went right on eating some greens from a pile thrown over the fence from the vegetable garden.

"I suppose we shall have to call it the Horse Yard now," said Small. "He's bigger and so much grander than the Cow."

Middle gave the horse an appraising look. "Higher, but not so thick," she said.

The horse saw the pile of greens. He held his head high, and there was confidence in the ring of his iron shoes as he crossed the bridge.

The Cow munched on, flapping the flies off her sides with a lazy tail. When she got a particularly juicy green, her tail forgot to flap, and lay curled across her back.

When the horse came close, the tail jumped off the Cow's back and swished across his nose. He snorted and pulled back, but still kept his eyes on the pile of greens. He left his four feet and the tips of his ears just where they had been, but the roots of his ears, and his neck and lips stretched forward toward the greens till he looked as if he would fall for crookedness. The Cow's head moved ever so little; she gave him a look, and pointed one horn right at his eye. His body shot back to where it should be, square above his legs, and he sighed and turned away, with his ears and tail pressed down tight.

"I guess it will be all right for us to call it the Cow Yard still," said Middle.

The Bishop and the Canary

Small had earned the canary and loved him. How she did love him! When they had told her, "You may take your pick," and she leaned over the cage and saw the four fluffy yellow balls, too young to have even sung their first song, her breath and her heart acted so queerly that it seemed as if she must strangle.

She chose the one with the topknot. He was the first live creature she had ever owned.

"Mine! I shall be his God," she whispered.

How could she time her dancing feet to careful stepping? She was glad the cage protected him sufficiently so that she could hug it without hurting him.

Save for the flowers that poked their faces through the fences, and for the sunshine, the long street was empty. She wished that there was someone to show him to—someone to say, "He *is* lovely!"

A gate opened and the Bishop stepped into the street. The Bishop was very holy—everybody said so. His eyes were blue, as if by his perpetual contemplation of Heaven they had taken its colour. His gentle voice, vague and distant, came from up there too. His plump hands were transparent against the clerically black vest.

Though she played ladies with his little girls, Small stood in great awe of the Bishop. She had never voluntarily addressed him. When they were playing in his house, the children tiptoed past his study. God and the Bishop were in there making new hymns and collects.

Her lovely bird! Because there was no one else to show him to she must show him to the Bishop. Birds belonged to the sky. The Bishop would understand. She was not at all afraid now. The bird gave her courage.

She ran across the street.

"Look, Bishop! Look at my bird!"

The Bishop's thoughts were too far away, he did not heed nor even hear the cry of joy.

She stood before him with the cage held high. "Bishop! Oh please Bishop, see!"

Dimly the Bishop became aware of some object obstructing his way. He laid a dimpled hand upon the little girl's head.

"Ah, child, you are a pretty picture," he said, and moved her gently from his path.

The Bishop went his way. The child stood still.

"My beautiful bird!"

The look of hurt fury which she hurled at the Bishop's back might have singed his clerical broadcloth.

The Blessing

Father's religion was grim and stern, Mother's gentle. Father's operated through the Presbyterian, Mother's through the Anglican Church. *Our* religion was hybrid: on Sunday morning we were Presbyterian, Sunday evening we were Anglican.

Our little Presbyterian legs ached from the long walk to church on Sunday morning. Our hearts got heavy and our eyes tired before the Presbyterian prayers and the long Presbyterian sermon were over. Even so, we felt a strong "rightness" about Father's church which made it endurable. Through scorch of summer heat, through snow and rain, we all taggled along behind Father. Toothaches, headaches, stomach-aches—nothing was strong enough to dodge or elude morning religion.

Mother's religion was a Sunday evening privilege. The Anglican church was much nearer our house than the Presbyterian, just a little walk down over Marvin's Hill to our own James' Bay mud-flats. The little church sat on the dry rim just above the far side.

Evening service was a treat that depended on whether big sister wanted to be bothered with us. Being out at night was very special too—moon and stars so high, town lights and harbour lights low and twinkly when seen from the top of Marvin's Hill on our side of the mud-flats. A river of meandering sludge loitered its way through the mud—a huge silver snake that twisted among the sea-grass. On the opposite side of the little valley, on a rocky ridge, stood Christ Church Cathedral, black against the night-blue of the sky. Christ Church had chimes and played scales on them to walk her people to church. As we had no chimes, not even a bell on our church, we marched along on the spare noise of the Cathedral chimes.

The mud-flats did not always smell nice although the bushes of sweet-briar on the edge of the high-water rim did their best, and the sea crept in between the calfless wooden legs of James' Bay Bridge, washed the muddied grass and stole out again.

Our Church was mellow. It had a gentle, mild Bishop. He wore a long black gown with a long white surplice over it. His immense puffed sleeves were

caught in at the wrists by black bands and fluted out again in little white frills round his wrists. There was a dimple on each knuckle of his hands. He was a wide man and looked wider in his surplice, especially from our pew, which was close up under the pulpit. He looked very high above us and every time he caught his breath his beard hoisted and waved out.

The Bishop's voice was as gentle as if it came from the moon. Every one of his sentences was separated from the next by a wheezy little gasp. His face was round and circled by a mist of white hair. He kept the lids shut over his blue, blue eyes most of the time, as if he was afraid their blueness would fade. When you stood before him you felt it was the lids of his own eyes he saw, not you.

The Bishop's favourite word was "Ah!", not mournful or vexed "ahs", just slow contemplating "ahs". But it was the Bishop's Blessing! He blessed most splendidly! From the moment you went into church you waited for it. You could nap through most of the Presbyterian sermon, but, although the pews were most comfortable, red cushions, footstool and all, you dared not nap through the Bishop's for fear you'd miss the blessing.

Our Evangelical church was beautiful. There was lots of music. A lady in a little red velvet bonnet, with strings under the chin, played the organ.

There were four splendid chandeliers dangling high under the roof. They had round, wide reflectors made of very shiny, very crinkly tin. Every crinkle caught its own particular bit of light and tossed it round the church—and up there ever so high the gas jets hissed and flickered. Music stole whispering from the organ and crept up among the chandeliers and the polished rafters to make echoes.

Our choir was mixed and sang in every sort of clothes, not in surplices like the Cathedral choir on the hill.

The Bishop climbed into the pulpit. He laid the sheets of his sermon on the open Bible which sat on a red velvet cushion; then he shut his eyes and began to preach. Once in a while he would stop, open his eyes, put on his glasses and read back to be sure he had not skipped.

When the last page was turned the Bishop said a gentle "Amen" and then he lifted his big round sleeves with his hands dangling out of the ends. We all stood up and drooped our heads. The church was full of stillness. The Bishop curved his palms out over us—they looked pink against his white sleeves. He gave the blessing just as if he was taking it straight from God and giving it to us.

Then the Bishop came down the pulpit stairs; the organ played and the choir sang him into the vestry; the verger nipped the side lights off in such a hurry that everyone fell over a footstool.

Big doors rolled back into the wall on either side of the church door to let us out. As soon as we were all in the night the verger rolled shut the doors and blotted out the chandeliers.

We climbed Marvin's Hill, each of us carrying home a bit of the Bishop's blessing.

Singing

Small's singing was joyful noise more than music; what it lacked in elegance it made up in volume. As fire cannot help giving heat so Small's happiness could not help giving song, in spite of family complaint. They called her singing a "horrible row", and said it shamed them before the neighbours, but Small sang on. She sang in the cow-yard, mostly, not that she went there specially to sing, but she was so happy when she was there among the creatures that the singing did itself. She had but to open her mouth and the noise jumped out.

The moment Small sat down upon the cow-yard woodpile the big rooster would jump into her lap and the cow amble across the yard to plant her squareness, one leg under each corner, right in front of Small and, to shut out completely the view of the old red barn, the hen houses, and the manure-pile.

The straight outline of the cow's back in front of Small was like a range of mountains with low hills and little valleys. The tail end of the cow was as square as a box. Horns were her only curve—back, front, tail, neck and nose in profile, were all straight lines. Even the slobber dripping from her chin fell in slithery streaks.

When Small began to sing the old cow's nose-line shot from straight down to straight out, her chin rose into the air, her jaws rolled. The harder Small sang, the harder the cow chewed and the faster she twiddled her ears around as if stirring the song into the food to be rechewed in cud along with her breakfast.

Small loved her cow-yard audience—hens twisting their silly heads and clawing the earth with mincing feet, their down eye looking for grubs, their up eye peering at Small, ducks trying hard to out-quack the song, pigeons clapping their white wings, rabbits hoisting and sinking their noses—whether in appreciation or derision Small could never tell.

White fluttered through the cow-yard gate, Bigger's apron heralding an agitated Bigger, both hands wrestling with the buttons of her apron behind and her tongue ready sharpened to attack Small's singing.

"It's disgusting! Stop that vulgar row, Small! What must the neighbours think? Stop it, I say!"

Small sang harder, bellowing the words. "The cow likes it and this is her yard."

"I wish to goodness that she would roof her yard then, or that you would sing under an umbrella, Small, and so keep the sound down and not let it boil over the fences. There's the breakfast bell! Throw that fowl out of your lap and come! Song before breakfast means tears before night."

"Whose tears—mine, the cow's or the rooster's?"

"Oh, oh, oh! That cow-brute has dripped slobber down my clean apron! You're a disgusting pair," shrieked Bigger and rushed from the yard.

Breakfast over, the Elder detained Small.

"Small, this singing of yours is scandalous! Yesterday I was walking up the street with a lady. Half a block from our gate she stopped dead. 'Listen! Someone is in trouble,' she said. How do you think I felt saying, 'Oh, no, it is only my little sister singing'?"

Small reddened but said stubbornly, "The cow likes my singing."

Cows are different from humans; perhaps the hairiness of their ears strains sound.

The Bishop came to pay a sick-visit to Small's mother. He prayed and Small watched and listened. His deliberate chewing of the words, with closed eyes, reminded her of the cow chewing her cud. The Bishop was squarely built, a slow calm man. "They are very alike," thought Small.

Rising from his knees, the Bishop, aware of the little girl's stare, said, "You grow, child!"

"She does," said Small's mother. "So does her voice; her singing is rather a family problem."

"Song is good," replied Bishop. "Is it hymns you sing, child?"

"No, Mr. Bishop, I prefer cow-songs."

The Bishop's "a-a-h!" long drawn and flat lasted all the way down the stairs.

"You should not have said that," said Small's mother. "A Bishop is a Bishop."

"And a cow is a cow. Is it so wicked to sing to a cow?"

"Not wicked at all. I love your happy cow-yard songs coming into my window. We will have your voice trained some day. Then perhaps the others will not scold so much about your singing."

"But will the cow like my voice squeezed little and polite? It won't be half so much fun singing beautifully as boiling over like the jam kettle."

Small's four sisters and her brother went holidaying to a farm in Metchosin. Small was left at home with her mother. Just at first Small, to whom animal life

was so dear, felt a pang that she was not of the farm party. But the quiet of the empty house was a new experience and something happened.

Mrs. Gregory, her mother's friend of long standing, came to spend an afternoon.

Both ladies were nearing the age of fifty—straightbacked, neatly made little ladies who sat primly on the horsehair chairs in the drawing-room wearing little lace-trimmed matron's caps and stitching each on a piece of plain sewing as they chatted.

Having exchanged recipes for puddings, discussed the virtue of red flannel as against white, the problem of Chinese help and the sewing-circle where they made brown holland aprons for orphans, all topics were exhausted.

They sewed in silence, broken after a bit by Mrs. Gregory saying, "There was English mail this morning, Emily. Do you ever get homesick for the Old Country?"

Small's mother looked with empty eyes across the garden. "My home and my family are here," she replied.

The ladies began "remembering". One would say, "Do you remember?" and the other would say, "I call to mind." Soon this remembering carried them right away from that Canadian drawing-room. They were back in Devonshire lanes, girl brides rambling along with their Richard and William, pausing now and then to gather primroses and to listen to the larks and cuckoos.

Small's mother said, "Richard was always one for wanting to see new countries."

"My William's hobby," said Mrs. Gregory, "was growing things. Here or there made no difference to him as long as there was earth to dig and flowers to grow."

Small knew that Richard and William were her Father and Mr. Gregory or she would never have recognized the ladies' two jokey boys of the Devonshire lanes in the grave middle-aged men she knew as her father and Mrs. Gregory's husband.

The ladies laid their sewing upon the table and, dropping their hands into their laps, sat idle, relaxing their shoulders in the hard backs of the chairs. Small felt it extraordinary to see them doing nothing, to see Canada suddenly spill out of their eyes as if a dam had burst and let the pent-up England behind drown Canada, to see them sitting in real chairs and yet not there at all.

The house was quite still. In the yard Bong was chopping kindling and droning a little Chinese song.

Suddenly Mrs. Gregory said, "Emily, let's sing!" and began:

"I cannot sing the old songs now I sang long years ago. . . ."

Small's mother joined, no shyness, no hesitation. The two rusty little

voices lifted, found to their amazement that they *could* sing the old songs still, and their voices got stronger and stronger with each song.

Sitting on a stool between them, half hidden by the tablecloth and entirely forgotten by the ladies, Small watched and listened, saw their still fingers, unornamented except for the plain gold band on the third left of each hand, lying in sober-coloured stuff-dress laps, little white caps perched on hair yet brown, lace jabots pinned under their chins by huge brooches. Mrs. Gregory's brooch was composed of tiny flowers woven from human hair grown on the heads of various members of her family. The flowers were glassed over the top and framed in gold, and there were earrings to match dangling from her ears. The brooch Small's mother wore was made of quartz with veins of gold running through it. Richard had dug the quartz himself from the California gold mines and had had it mounted in gold for his wife with earrings of the same.

Each lady had winds and winds of thin gold watch-chain round her neck, chains which tethered gold watches hiding in stitched pockets on the fronts of their dresses. There the ladies' hearts and their watches could tick duets.

Small sat still as a mouse. The singing was as solemn to her as church. She had always supposed that Mother-ladies stopped singing when there were no more babies in their nurseries to be sung to. Here were two ladies nearly fifty years old, throwing back their heads to sing love songs, nursery songs, hymns, God Save the Queen, Rule Britannia—songs that spilled over the drawing-room as easily as Small's cow songs spilled over the yard, only Small's songs were new, fresh grass snatched as the cow snatched pasture grass. The ladies' songs were rechews—cudded fodder.

Small sneezed!

Two mouths snapped like mousetraps! Four cheeks flushed! Seizing her sewing, Mrs. Gregory said sharply, "Hunt my thimble, child!"

Small's mother said, "I clean forgot the tea," and hurried from the room.

Small never told a soul about that singing but now, when she sat on the cow-yard woodpile she raised her chin and sang clean over the cow's back, over the yard and over the garden, straight into her mother's window . . . let Bigger and the Elder scold!

The Praying Chair

The wicker chair was new and had a crisp creak. At a quarter to eight every morning Father sat in it to read family prayers. The little book the prayers came out of was sewed into a black calico pinafore

because its own cover was a vivid colour and Father did not think that was reverent.

The Elder, a sister much older than the rest of the children, knelt before a hard, straight chair: Mother and little Dick knelt together at a low soft chair. The three little girls, Bigger, Middle, and Small usually knelt in the bay window and buried their faces in its cushioned seat but Small's Father liked her to kneel beside him sometimes. If she did not get her face down quickly he beckoned and Small had to go from the window-seat to under the arm of the wicker chair. It was stuffy under there. Small liked the window-seat best, where she could peep and count how many morning-glories were out, how many new rosebuds climbing to look in through the window at her.

Father's wicker chair helped pray. It creaked and whispered more than the children would ever have dared to. When finally Father leaned across the arm to reach for the cross-work book-mark he had laid on the table during prayers, the chair squawked a perfectly grand Amen.

One morning Father had a bit of gout and Small thought that instead of Amen Father said "Ouch!" She could not be quite sure because just at the very moment that the chair amened, Tibby, the cat, gave a tremendous meow and a splendid idea popped into Small's head.

Small had wanted a dog—she did not remember how long she had wanted it—it must have been from the beginning of the world. The bigger she got the harder she wanted.

As soon as everyone had gone about their day's business Small took Tibby and went back to the praying chair.

"Look, Tibby, let's you and me and the praying chair ask God to give you a puppy for me. Hens get ducks, why couldn't you get a puppy? Father always sits in that chair to pray. It must be a good chair; it amens splendidly. I'll do the words: you and the chair can amen. I don't mind what kind of a puppy it is as long as it's alive."

She tipped the chair and poked Tibby underneath into the cage-like base. Tibby left her tail out.

"So much the better," said Small. "It'll pinch when the time for amen is ready."

Tibby's amen was so effective that Small's Mother came to see what was the trouble.

"Poor cat! Her tail is pinched. Take her out into the garden, Small."

"It's all spoilt now!"

"What is?"

"We were praying for a puppy."

"Your Father won't hear of a puppy in his garden, Small."

Small's birthday was coming.

The Elder said, "I know something that is coming for your birthday!"

"Is it—is it—"

"Wait and see."

"Does it commence with 'd'? Or, if it's just a little one, maybe with 'p'?"

"I think it does."

The day before the great day Small's singing was a greater nuisance than usual. Everyone scolded till she danced off to the woodshed to sing there, selected three boxes of varying sizes and brushed them out.

"Which size will fit him? Middle, when you got your new hair-brush what did you do with the old one?"

"Threw it out."

Small searched the rubbish pile which was waiting for the Spring bonfire and found the brush-back with its few remaining bristles.

"A lot of brushing with a few is as good as a little brushing with a lot . . ."

"Rosie," she said to the wax doll whose face had melted smooth because a mother, careless of dead dolls, had left her sitting in the sun, "Rosie, I shall give your woollie to my new pup. You are all cold anyhow. You melt if you are warmed. Pups are live and shivery . . ."

"He . . . she . . . Oh, Rosie what *shall* I do if it's a she? It took years to think up a good enough name and it's a boy's name. Oh, well, if it's a girl she'll have thousands of puppies; the Elder says they always do."

She plaited a collar of bright braid, sewing on three hooks and eyes at varying distances.

"Will he be so big—or so big—or so big? I don't care about his size or shape or colour as long as he's alive."

She put the collar into the pocket of tomorrow's clean pinafore.

"Hurry up and go, day, so that tomorrow can come!" And she went off to bed so as to hurry night.

Small's father drew back the front-door bolt; that only half unlocked the new day—the little prayer book in its drab covering did the rest. It seemed a terrible time before the chair arm squeaked Amen. The Elder rose, slow as a snail. Small wanted to shout, "Hurry, hurry! Get the pup for me!"

Everyone kissed Small for her birthday; then all went into the breakfast room. On Small's plate was a flat, flat parcel. Small's eyes filled, drowning the gladness.

"Open it!" shouted everyone.

The Elder cut the string. "I am glad to see," she remarked, noting Small's quivering blue hands, "that you did not shirk your cold bath because it was your birthday."

The present was the picture of a little girl holding a dog in her arms.

"She looks like you," said Middle.

"No, she isn't like me, she has a dog."

Small went to the fire pretending to warm her blue hands. She took something from her apron pocket, dropped it into the flames.

"I'm not hungry—can I go and feed my ducks?" In the cow-yard she could cry.

The birthday dawdled. Small went to bed early that night too.

"Small, you forgot your prayers!" cried Bigger.

"I didn't—God's deaf."

"You're dreadfully, dreadfully wicked—maybe you'll die in the night."

"Don't care."

Years passed. Small's father and mother were dead. The Elder was no more reasonable than Small's father had been about dogs. Small never asked now, but the want was still there, grown larger. Bigger, Middle and Small were grown up, but the Elder still regarded them as children, allowed them no rights. Like every girl Small built castles in the air. Her castle was an ark, her man a Noah, she tended the beasts.

Unexpected as Amen in a sermon's middle came Small's dog. She had been away for a long, long time; on her return the Elder was softened. Wanting to keep Small home, she said, "There's a dog in the yard for you."

Dabbing a kiss on the Elder's cheek Small rushed. Kneeling she took the dog's muzzle between her hands. He sniffed, licked, accepted. Maybe he too had waited for a human peculiarly his. She loosed him. He circled round and round. Was he scenting the dream-pup jealously?

He had been named already. The dream-pup would always keep the name that had been his for his own.

"He'll run away—chain him. Remember he must not come in the house, Small!"

Small roamed beach and woods, the dog with her always. Owning him was better even than she had dreamed.

Small sat on a park bench waiting for a pupil, the dog asleep at her feet. The child-pupil, planning a surprise for Small, stole up behind her and threw her arms round her neck. Small screamed. The dog sprang, caught the child's arm between his teeth, made two tiny bruises and dropped down—shamed.

"That dog is vicious," said the Elder.

"Oh, no, he thought someone was hurting me; he was dreadfully ashamed when he saw that it was a child."

"He must be kept chained."

Chickens for table use were killed close to the dog's kennel. He smelled the blood—heard their squawks. The maid took a long feather and tickled his nose with it. He sprang, caught the girl's hand instead of the feather. The Elder's mouth went hard and grim.

"I teased him beyond endurance," pleaded the maid.

That day Small was hurt in an accident. The dog was not allowed to go to her room. Broken-hearted he lay in his kennel, disgraced, forsaken. Small was sent away to an old friend to recuperate. The day before she was to return, the old lady's son came to Small blurting, "They've killed your dog."

"Cruel, unjust, beastly!" shrieked Small.

"Hush!" commanded the old lady. "The dog was vicious."

"He was not! He was not! Both times he was provoked!"

Small ran and ran across the field till she dropped face down among the standing grain. There was a dark patch on the earth where her tears fell among roots of the grain.

"Only a dog! This is wrong, Small," said the not-understanding old woman.

Small went home and for six weeks spoke no word to the Elder—very few to anybody. She loathed the Elder's hands; they made her sick. Finally the Elder lost patience. "I did not kill the vicious brute," she cried. "The police shot him."

"You made them!"

Small could look at the Elder's hands again.

Small was middle-aged; she built a house. The Elder had offered her another dog. "Never till I have a home of my own," she had said. The Elder shrugged.

Now that Small had her house, the Elder criticized it. "Too far forward," she said. "You could have a nice front garden."

"I wanted a large back yard."

"A glut of dogs, eh Small?"

"A kennel of Bobtail Sheep dogs."

The Elder poked a head, white now, into Small's puppy nursery. "What are you doing, Small?"

"Bottling puppies—too many for the mothers."

"Why not bucket them?"

"There is demand for them—sheep dogs—cattle dogs."

"How many pups just now?"

"Eve's eight, Rhoda's seven, Loo's nine."

"Twenty-four—mercy! and, besides, those absurd bearded old patriarchs—Moses, Adam and the rest."

"Open the door for Adam."

The kennel sire entered, shaggy, noble, majestic. He rested his chin a moment on Small's shoulder where she sat with pup and feeding bottle, ran his eye round the walls where his mates and their families cuddled in boxes. He embraced all in good fellowship, including the Elder, picked the sunniest spot on the nursery floor and sprawled out.

"Oh, Small, I was throwing out Father's old wicker chair. Would you like it in the kennel nursery to sit in while bottling the pups?"

"The praying chair?—Oh, yes."

So the Praying Chair came to Small's kennel. Sitting in it Small remembered Tibby, the picture pup, the want, her first dog. Adam rested his chin on the old chair's arm. Small leaned forward to rest her cheek against his woolly head. All rasp, all crispness gone, "Amen", whispered the Praying Chair.

Mrs. Crane

I heard two women talking. One said to the other, "Mrs. Crane has a large heart."

"Yes," replied her companion, "and it is in the right place too."

I thought, "That's queer—hearts are in the middle of people. How can any person know if another person's heart is big or small, or if it is in the right or the wrong place?"

Soon after I heard this conversation about Mrs. Crane's heart, our Mother was seized with a very serious illness. My sister Alice and I—she was two years older—were hushed into the garden with our dolls and there, peeping from behind the currant bushes, we saw a high yellow dogcart stop in front of our gate. Mrs. Crane descended from it and came stalking up our garden walk.

"Come to enquire, I s'pose," whispered Alice.

"My! Isn't she long and narrow?" I replied.

Silently I fell to trying to make all the different hearts I knew fit into Mrs. Crane's body—the gold locket one that made your neck shiver, beautiful valentine ones with forget-me-nots around them, sugar hearts, with mottoes, a

horrible brown thing Mother said was a pig's heart and boiled for the cat—none of these would fit into Mrs. Crane's long narrow body.

She seemed to grow taller and taller as she came nearer. When she tiptoed up the steps, to us, crouched behind the currant bushes, she seemed a giant.

My big sister opened the door to Mrs. Crane. They whispered. Then my sister came to us and said, "Children, kind Mrs. Crane is going to take you home with her until Mother is better."

Alice's big eyes darkened with trouble. Obediently she picked up her doll and turned towards the house. I set my doll down with a spank, planted my feet wide apart and said, "Don't want to go!"

My sister gave me an impatient shake. Mrs. Crane ahemmed.

We were scrubbed hard, and buttoned into our starchiest. Mrs. Crane took one of Alice's hands and one of mine into a firm black kid grip and marched us to the gate. While she opened the gate, she let go of Alice's hand but doubled her grip on mine. Her eyes were like brown chocolate drops, hot and rich in colour when she looked at Alice, but when she looked at me they went cold and stale-looking.

We were hoisted up to the back seat of the dogcart. Father's splendid carpet bag with red roses on its sides and the great brass lock, was put under our feet to keep them from dangling. The bag was full of clean frocks and handkerchiefs and hairbrushes.

Mrs. Crane climbed up in front beside Mr. Crane. His seat was half a storey higher than hers. Mr. Crane cracked his whip and the yellow wheels spun furiously. Our house got smaller and smaller, then the road twisted and it was gone altogether. The world felt enormous.

We crossed two bridges. Mud flats were under one and the gas works were under the other—they both smelt horrid. The horse's hoofs made a deafening clatter on the bridges, and then they pounded steadily on and on over the hard road. When at last we came to the Cranes' house, it seemed as if we must have gone all around the world, and then somehow got there hind-before. You passed the Cranes' back gate first, and then you came to the front gate. The front door was on the back of the house. The house faced the water, which looked like a river, but was really the sea and salt. You went down the hill to the house and up the hill to the stable; everything was backwards to what it was at home and made you feel like Mother's egg-timer turned over.

Mrs. Crane had three little girls. The two younger were the same age as Alice and I.

The three little Cranes ran out of the house when they heard us come. They kissed Mama politely and, falling on Papa, hugged him like bears.

A man came to lead the horse away. The little Cranes were all busy guessing what was in the parcels that came from under the seat of the dogcart, but the receding clop! clop! of the horse's hoofs, hammered desolation into the souls of Alice and me.

The Cranes' hall was big and warm and dark, except for the glow from a large heater, which pulled out shiny things like the noses of a lot of guns hanging in a rack on the wall and the fire irons and the stair rods. It picked out the brass lock of Father's bag and the poor glassy eyes of stuffed bear and wolves and owls and deer. Helen saw me looking at them as we went upstairs and said, "My Papa shot all those."

"What for?"

Helen stared at me. "What for? Doesn't your Papa go in for sport?"

"What is sport, Helen?"

Helen considered. "Why it's—killing things just for fun, not because you are hungry, chasing things with dogs and shooting them."

"My Father does not do that."

"My Papa is a crack shot," boasted Helen.

Alice and I had a grown-up bedroom. One window looked over the water and had a window seat. The other window looked into a little pine wood. There was a pair of beautiful blue china candlesticks on the mantel-piece.

We children had nursery tea. Mrs. Crane had Grace the biggest girl pour tea and Grace was snobbish. After tea we went into the drawing-room.

Mrs. Crane's drawing-room was a most beautiful room. There was a big three-cornered piano in it, two sofas and a lot of lazy chairs for lolling in. At home only Father and Mother sat in easy chairs: they did not think it was good for little girls to sit on any kind but straight up-and-down chairs of wood or cane. Mrs. Crane's lazy chairs were fat and soft and were dressed up in shiny stuff with rosebuds sprinkled all over it. But bowls of real roses everywhere made the cloth ones look foolish and growing ones poking their pink faces into the open windows were best of all and smelled lovely. A bright little fire burned in the grate and kept the little sea breeze from being too cold and the breeze kept the fire from being too hot. In front of the fire was a big fur rug; a brown-and-white dog was sprawled out upon it.

When we five little girls trooped into the drawing-room, I thought that the dog was the only creature in the room. Then I saw the top of Mr. Crane's head and his slippers sticking out above and below a mound of newspapers in an easy chair on one side of the fire. On the other side the fire lit up Mrs. Crane's hands folded in her lap. Her face was hidden behind a beaded drape hanging from a brass rod which shaded her eyes from the fire-light. One hand lifted

and patted a stool at her knee—this Helen went and sat on. Mrs. Crane's lap was deep and should have been splendid to sit in, but her little girls never sat there. Helen said it was because Mama's heart was weak and I said, "But Helen, I thought big things were always strong?"

Helen did not know what I meant, because of course she had not heard those ladies discussing her Mother's heart and so she did not know what I knew about it.

Mrs. Crane told "Gracie dear", to play one of her "pieces" on the piano. She always added dear to her children's names as if it was a part of them.

Mary Crane and our Alice were shy little girls. They sat on the sofa with their dolls in their laps. Their eyes stared like the dolls' eyes. Mrs. Crane would not allow dolls to be dressed or undressed in the drawing-room; she said it was not nice. I sat on the edge of a chair till it tipped, then I found myself in the very best place in all the room—right down on the fur rug beside the dog. When I put my head down on his side, he thumped his tail and a lovely live quiver ran through his whole body. I had meant to fight off sleep because of that strange bed upstairs, but the fire was warm and the dog comforting . . . I couldn't think whose far-off voice it was saying, "Come to bed, children," or whose hand it was shaking me.

The cold upstairs woke us up. Mrs. Crane looked black and tall standing by the mantel-piece lighting the blue candles. The big room ran away into dark corners. The bed was turned down and our nighties were ready, but we did not seem to know what to do next unless it was to cry. Mrs. Crane did not seem to know what to do either, so she said, "Perhaps you little girls would like to come into my little girls' room while they undress?" So we sat on their ottoman and watched. They brushed themselves a great deal—their hair and nails and teeth. They folded their clothes and said their prayers into Mrs. Crane's front, then stepped into bed very politely. Mrs. Crane told them to lie on their right sides, keep their mouths shut and breathe through their noses, then she threw the windows up wide. The wind rushed in, sputtered the candle and swept between Mrs. Crane's kisses and the children's foreheads. Then she blew the candle gently as if she was trying to teach the wind manners.

Back in our room, Mrs. Crane said something about "undoing buttons". I backed up to Alice very quickly and she told Mrs. Crane that we could undo each other.

"Very well," said Mrs. Crane, "I'll come back and put out the candle presently."

We scurried into bed, pulled the covers up over our heads and lay very still.

She came and stood beside the two white mounds for a second—then two gentle puffs, the up-screech of the window, long soft footsteps receding down the hall.

Two heads popped up from the covers.

"Weren't you scared she'd kiss us?"

"Awfully! Or that she'd want to hear our prayers?"

"The Crane girls are very religious."

"How'd you know?"

"They said two verses of 'Now I lay me'. We only know one."

Alice always slept quickly and beautifully. I tossed every way and did not sleep, till all my troubles were pickled away in tears.

At breakfast while Mrs. Crane was busy with the teacups I got the first chance of staring at her hard. The light was good and she was much lower, sitting. She talked to Mr. Crane as she poured the tea, using big polite words in a deep voice. The words rolled round her wisdom teeth before they came out. Her hair, skin and dress were brown like her eyes. Her heart could not help being in the right place, it was clasped so tight by her corset and her brown stuff dress was stretched so taut above that and buttoned from chin to waist. Her heart certainly could not be a wide one. Her hands were clean and strong, with big knuckles. The longer I looked at Mrs. Crane the less I liked her. But I did like a lot of her things—the vase in the middle of the dining-room table for instance. Helen called it Mama's "epergne". It was a two-storey thing of glass and silver and was always full of choice flowers, pure white geraniums that one longed to stroke and kiss to see if they were real, fat begonias and big heavy-headed fuchsias. Flowers loved Mrs. Crane and grew for her.

Mrs. Crane's garden was not as tidy as Father's but the flowers had a good time and were not so prim. Mrs. Crane was lenient with her flowers. She let the wild ones scramble up and down each side of the clay path that ran down the bank to the sea. They jumbled themselves up like dancers—roses and honeysuckle climbed everywhere. The front drive, which was really behind the house, was circular and enclosed a space filled with fruit trees and raspberry canes. The vegetable garden was in the front and the flowerbeds in the back, because, of course, the front of the house was at the back. There was a little croquet lawn too and the little pine wood that our bedroom looked out on.

In the middle of this wood was a large platform with lots of dog-kennels on it—to these Mr. Crane's hunting dogs were chained.

The dogs did not know anything about women or girls and Mrs. Crane did not like them. Mr. Crane would not let the children handle them; he said it

spoilt them for hunting. I wanted to go to them dreadfully but Helen said that I must not. The children were allowed to have the old one who had been in the drawing-room because he was no good for hunting.

Helen said, "Once I had a little black dog. I loved him very much, but Papa said he was a mongrel. So he got his gun and shot him. When the little dog saw the gun pointed at him he sat up and begged. The shot went through his heart, but he still sat up with the beg frozen in his paws."

"Oh Helen, how could your father? Why didn't your mother stop him?"

"It did not make any difference to Mama. It was not her dog."

In our house nobody would have thought of telling Father "not to". Nor would we have thought of meddling with Father's things. In the Cranes' home it was different. When Helen took me into a funny little room built all by itself in the garden and said, "This is Papa's Den," I was frightened and said, "Oh Helen! surely we ought not to."

There was not a single woman's thing in the Den. There were guns and fishing rods and wading boots and there was a desk with papers and lots of big books. There was a bottle of quicksilver. Helen uncorked it and poured it onto the table. It did amazing things, breaking itself to bits and then joining itself together again, but presently it rolled off the table and we could not find it. Whenever Mr. Crane came home after that, I was in terror for fear he would ask about the quicksilver and I hated him because he had shot the little begging dog.

The little Cranes never took liberties with Mama's things.

It seemed years since we left home, but neither Alice nor I had had a birthday and there had been only one Sunday at Mrs. Crane's. There was one splendid thing though and that was Cricket. He was a pinto pony belonging to the children. Every day he was saddled and we rode him in turns. The older girls rode in a long habit. Helen's legs and mine were too young to be considered improper by Mrs. Crane. So our frillies flapped joyously. Helen switched Cricket to make him go fast, but fast or slow were alike to me. It was a delight to feel his warm sides against my legs. The toss of his mane, the switch of his tail, his long sighs and short snorts, the delicious tickle of his lips when you fed him sugar—everything about him was entrancing, even the horsy smell. Just the thought of Cricket, when you were crying yourself to sleep, helped.

There was no more room for Cricket in Mrs. Crane's heart than there was for the dogs, but Mrs. Crane's heart did take in an old lady called Mrs. Miles. Mrs. Miles was almost deaf and almost blind. She wore a lace cap and a great many shawls and she knitted and blinked, knitted and blinked, all day. She

came to stay with Mrs. Crane while we were there. Mrs. Miles liked fresh rasp-berries for her breakfast and to make up for being nearly blind and nearly deaf, Mrs. Crane gave her everything she could that she was fond of. We children had to get up earlier to pick raspberries and Mrs. Crane did not even mind if our fresh frocks got wetted with dew, because she wanted to comfort Mrs. Miles for being old and deaf and blind.

One Sunday afternoon Mrs. Miles draped her fluffiest shawl over her cap and face and everything and presently big snores came straining through it. Mr. Crane's newspaper was sitting on top of his bald spot and he was snoring too—the paper flapped in and out above his mouth. Mr. Crane's "awk, awk" and Mrs. Miles' "eek, eek" wouldn't keep step and we little girls giggled.

Mrs. Crane said, "It is very rude for little girls to laugh at their elders."

Helen asked, "Even at their snores, Mama?"

"Even at their snores," said Mrs. Crane. She hushed us into the far corner of the drawing-room and read us a very dull story.

Helen on the stool at her mother's knee and the three others on the sofa were all comfortable enough to shut their eyes and forget, but how could any-one on a three-legged stool under the high top of the sofa sleep? Especially if the fringe of an antimacassar lolled over the top and tickled your neck? My fingers reached up to the little tails of wool bunched in colours and began to plait—red, yellow, black, red, yellow, black. A neat little row of pigtails hung there when the story was done and I thought it looked fine.

When we trooped down the stairs next morning, Mrs. Crane was waiting at the foot. Her teeth looked very long, the chocolate of her eyes very stale. From the upper landing we must have looked like a long caterpillar following her to the drawing-room.

Of course she knew it was me, because she had told me to sit there, but she put me through five separate agonies, her pointing finger getting longer and her voice deeper, with every "Did you do it?" When it came to me, her finger touched the antimacassar and her voice dragged me into a deep pit. When I said my, "Yes, Mrs. Crane," she said that I had desecrated the work of her dear dead mother's hands, that it was Satan that had told my idle fingers to do it, that I was a naughty mischievous child and that after breakfast I must undo all the little pigtails.

Not the boom of the breakfast gong, nor the bellow of Mr. Crane's family prayers, nor the leather cushion that always smelt so real and nice when your nose went into it, could drown those horrid sobs. They couldn't be swallowed nor would they let my breakfast pass them. So Mrs. Crane excused me and I went to the beastly antimacassar and wished her mother had taken it to

Heaven with her. Mrs. Miles came and sat near and blinked and clicked, blinked and clicked.

"Please! Please! Mrs. Crane, can't we go home?"

"And make your poor Mama worse?"

I did not even want to ride Cricket that day.

After tea we went to visit a friend of Mrs. Crane's. We went in the boat. Mr. Crane rowed. Night came. Under the bridges the black was thick and the traffic thundered over our heads. Then we got into a boom of loose logs. They bumped our boat and made it shiver and when Mr. Crane stood up and pushed them away with his oar, it tipped. Helen and I were one on each side of Mrs. Crane in the stern. When she pulled one tiller rope her elbow dug into me, when she pulled the other her other elbow dug into Helen.

The ropes rattled in and out and the tiller squeaked. I began to shake and my teeth to chatter.

"Stop it, child!" said Mrs. Crane.

But I could not stop. I stared down into the black water and shook and shook and was deadly cold.

Mrs. Crane said I must have taken a chill. I had not eaten anything all day, so she gave me a large dose of castor oil when we got home. I felt dreadfully bad, especially in bed, when Alice said, "Why can't you behave? You've annoyed Mrs. Crane all day."

"I hate her! I hate her!" I cried. "She's got a pig's heart."

Alice said, "For shame!"—hitched the bedclothes over her shoulder and immediately long breaths came from her.

Next morning was wet, but about noon there was meek sunshine and Helen and I were sent to run up and down the drive.

Everything was so opposite at Mrs. Crane's that sometimes you had to feel your head to be sure you were not standing on it. For instance you could do all sorts of things in the garden, climb trees and swing on gates. It was not even wicked to step on a flower bed. But it was naughty to play in the stable yard among the creatures, or to tumble in the hay in the loft, or to lift a chicken, or to hold a puppy. Every time we came to the stable end of the drive, I just *had* to stop and talk to Cricket through the bars and peer into his great big eyes and whisper into his ears.

In the yard behind Cricket I saw a hen.

"Oh Helen, just look at that poor hen! How bad she does feel!"

"How do you know she feels bad?"

"Well, look at her shut eyes and her head and tail and wings all flopped. She feels as I did yesterday. Maybe oil . . ."

"I'll pour if you'll hold," said Helen.

We took the hen to the nursery. She liked the holding, but was angry at the pouring. When her throat was full she flapped free. I did not know a hen could fly so high. She knocked several things over and gargled the oil in her throat, then her big muddy feet clutched the top of the bookcase and she spat the oil over Mrs. Crane's books so that she could cackle. She had seemed so meek and sick we could not believe it. I was still staring when I heard a little squashed "Mama" come from Helen, as if something had crushed it out of her.

Sometimes I have thought that Mrs. Crane had the power to grow and shrivel at will. She filled the room, her eyes burnt and her voice froze.

"Catch that fowl!"

As I mounted the chair to catch the hen, I saw what her muddy feet and the oil had done to me. Helen's hair was long and she could hide behind it, but mine was short. I stepped carefully over the hateful blue bottle oozing sluggishly over the rug.

Out on the drive I plunged my burning face down into the fowl's soft feathers.

"Oh, old hen, I wish I could shrivel and get under your wing!" I cried. I had to put her down and go back alone.

It seemed almost as if I had shrivelled, I felt so shamed and small when I saw Mrs. Crane on her knees scrubbing the rug.

I went close. "I'm sorry, Mrs. Crane."

No answer. I went closer. "I wanted to help your hen. She's better. Perhaps it was only a little cuddling she wanted."

Oh, why didn't she speak! Why didn't she scold or even smack, not just scrub, scrub, scrub!

I stood looking down at Mrs. Crane. I had never seen the top of her before. I saw the part of her hair, the round of her shoulders, her broad back, her thickness when you saw her from on top. Perhaps after all there was room for quite a wide heart.

Suddenly now while I could reach her, I wanted to put my arms round her and cry.

Mrs. Crane rose so suddenly that she almost trod on me. I stepped back. The wings of her nose trembled. Mrs. Crane was smelling.

She strode to the doll cupboard and doubled down into it. When she backed out, a starfish dangled from the tips of the fingers of each hand. Helen and I had caught some under the boathouse ten days before and dressed them

up in doll's clothes. Mrs. Crane's nose and hands were as far as they could get away from each other.

Mrs. Crane looked at me hard. "Such things never enter my Helen's head," she said. "Your mama is better; they are coming for you tonight."

In spite of the bad-smell-nose she wore, and the disgust in her fingertips, Mrs. Crane seemed to me just then a most beautiful woman.

"Oh, Mrs. Crane!"

My hands trembled up in that silly way pieces of us have of doing on their own, but the rest of me pulled them down quickly before Mrs. Crane saw.

White Currants

It happened many times, and it always happened just in that corner of the old garden.

When it was going to happen, the dance in your feet took you there without your doing anything about it. You danced through the flower garden and the vegetable garden till you came to the row of currant bushes, and then you danced down it.

First came the black currants with their strong wild smell. Then came the red currants hanging in bright tart clusters. On the very last bush in the row the currants were white. The white currants ripened first. The riper they got, the clearer they grew, till you could almost see right through them. You could see the tiny veins in their skins and the seeds and the juice. Each currant hung there like an almost-told secret.

Oh! you thought, if the currants were just a wee bit clearer, then perhaps you could see them *living*, inside.

The white currant bush was the finish of the garden, and after it was a little spare place before you came to the fence. Nobody ever came there except to dump garden rubbish.

Bursting higgledy-piggledy up through the rubbish everywhere, grew a half-wild mauvy-pink flower. The leaves and the blossoms were not much to look at, because it poured every drop of its glory into its smell. When you went there the colour and the smell took you and wrapped you up in themselves.

The smell called the bees and the butterflies from ever so far. The white butterflies liked it best; there were millions of them flickering among the pink flowers, and the hum of the bees never stopped.

The sun dazzled the butterflies' wings and called the smell out of the flowers. Everything trembled. When you went in among the mauvy-pink flowers

and the butterflies you began to tremble too; you seemed to become a part of it—and then what do you think happened? Somebody else was there too. He was on a white horse and he had brought another white horse for me.

We flew round and round in and out among the mauvy-pink blossoms, on the white horses. I never saw the boy; he was there and I knew his name, but who gave it to him or where he came from I did not know. He was different from other boys, you did not have to see him, that was why I liked him so. I never saw the horses either, but I knew that they were there and that they were white.

In and out, round and round we went. Some of the pink flowers were above our heads with bits of blue sky peeping through, and below us was a mass of pink. None of the flowers seemed quite joined to the earth—you only saw their tops, not where they went into the earth.

Everything was going so fast—the butterflies' wings, the pink flowers, the hum and the smell, that they stopped being four things and became one most lovely thing, and the little boy and the white horses and I were in the middle of it, like the seeds that you saw dimly inside the white currants. In fact, the beautiful thing *was* like the white currants, like a big splendid secret getting clearer and clearer every moment—just a second more and——.

"Come and gather the white currants," a grown-up voice called from the vegetable garden.

The most beautiful thing fell apart. The bees and the butterflies and the mauvy-pink flowers and the smell, stopped being one and sat down in their own four places. The boy and the horses were gone.

The grown-up was picking beans. I took the glass dish.

"If we left the white currants, wouldn't they ripen a little more? Wouldn't they get—clearer?"

"No, they would shrivel."

"Oh!"

Then I asked, "What is the name of that mauvy-pink flower?"

"Rocket."

"Rocket?"

"Yes—the same as fireworks."

Rockets! Beautiful things that tear up into the air and burst!

The Orange Lily

Henry Mitchell's nursery garden was set with long rows of trees, shrubs and plants. It sat on the edge of the town. In one corner of its acreage was the little grey cottage where Henry and his wife, Anne, lived. They were childless and well on in years, trying honestly to choke down homesickness and to acclimatize themselves as well as their Old Country plants to their step-land.

Small came into the nursery garden taking the gravel path at a gallop, the steps at a jump, tiptoeing to reach the doorbell—then she turned sharp against the temptation of peering through the coloured glass at the door-sides to see sombre Anne Mitchell come down the hall multicoloured—green face, red dress, blue hair. The turn brought Small face to face with the Orange Lily.

The lily grew in the angle made by the front of the house and the side of the porch. Small's knees doubled to the splintery porch floor. She leaned over to look into the lily's trumpet, stuck out a finger to feel the petals. They had not the greasy feel of the wax lilies they resembled, they had not the smooth hard shininess of china. They were cool, slippery and alive.

Lily rolled her petals grandly wide as sentinelled doors roll back for royalty. The entrance to her trumpet was guarded by a group of rust-powdered stamens—her powerful perfume pushed past these. What was in the bottom of Lily's trumpet? What was it that the stamens were so carefully guarding? Small pushed the stamens aside and looked. The trumpet was empty—the emptiness of a church after parson and people have gone, when the music is asleep in the organ and the markers dangle from the Bible on the lectern.

Anne Mitchell opened the cottage door.

"Come see my everlasting flowers, Small—my flowers that never die."

With a backward look Small said, "What a lovely lily!"

"Well enough but strong-smelling, gaudy. Come see the everlastings."

The front room of the cottage was empty; newspapers were spread over the floor and heaped with the crisping everlasting flowers, each colour in a separate pile. The sunlight in the room was dulled by drawn white blinds. The air was heavy—dead, dusty as the air of a hay loft.

The flowers crackled at Anne's touch. "Enough to wreathe the winter's dead," she said with a happy little sigh and, taking a pink bud from the pile, twined it in the lace of her black cap. It dropped against her thin old cheek that was nearly as pink, nearly as dry as the flower.

"Come, Mrs. Gray's wreath!" She took Small to the sitting-room. Half of Mrs. Gray's wreath was on the table, Anne's cat, an invalid guinea hen and

Henry huddled round the stove. The fire and the funereal everlastings crackled cheerfully.

Presently Small said, "I had better go now."

"You shall have a posy," said Anne, laying down the wreath.

"Will there be enough for Mrs. Gray and me too?" asked Small.

"We will gather flowers from the garden for you."

The Orange Lily! Oh if Mrs. Mitchell would only give me the Orange Lily! Oh, if only I could hold it in my hand and look and look!

Anne passed the lily. Beyond was the bed of pinks—white, clove, cinnamon.

"Smell like puddings, don't they?" said Small.

"My dear!"

Anne's scissors chawed the wiry stems almost as sapless as the everlastings. Life seemed to have rushed to the heads of the pinks and flopped them face down to the ground. Anne blew off the dust as she bunched the pinks. Small went back to the lily. With pocket-handkerchief she wiped the petals she had rusted by pushing aside the stamens.

"There are four more lilies to come, Mrs. Mitchell!"

Anne lifted the corner of her black silk apron.

"That lily has rusted your nose, Small."

She scrubbed.

Small went home.

"Here's pinks," she said, tossing the bunch upon the table.

In her heart she hugged an Orange Lily. It had burned itself there not with flaming petals, not through the hot, rich smell. Soundless, formless, white—it burned there.

How Lizzie Was Shamed Right Through

Now that I am eight, the same age that Lizzie was when the party happened, and am getting quite near to being grown-up, I can see how shamed poor Lizzie must have been of me then.

Now I know why the Langleys, who were so old, gave a party for us who were so little, but then I was only four so I did not wonder about it at all, nor notice that the fair, shy boy was their own little brother, hundreds and hundreds of years younger than his big brother and two big sisters. They did not poke his party in the little boy's face, did not say, "Albert, this is your party. You must be kind and polite to the boys and girls." That would have made

Albert shyer than he was already. They let him enjoy his own party just as the other children were enjoying it.

The Langleys' party was the first one we had ever been to. Mother made us look very nice. We had frilly white dresses, very starched. Lizzie who was eight, and Alice who was six, had blue sashes and hair ribbons. There was pink ribbon on me and I was only four.

Sister Dede bustled round saying, "Hurry! Hurry!" scrubbing finger nails and polishing shoes. She knotted our ribbons very tightly so that we should not lose them,—they pulled the little hairs under our curls and made us "ooch" and wriggle. Then Dede gave us little smacks and called us boobies. The starch in the trimming about our knees was very scratchy. Dede snapped the white elastics under our chins as she put on our hats and said to Mother, "I wonder how long these youngsters will stay clean." Being fixed up for the party was very painful.

There were three pairs of white cotton gloves waiting on the hall stand, like the mitts of the three little kittens. Mother sorted them and stroked them onto the fingers we held out as stiff as they'd go, and by the time that Mr. Russell's hansom cab, the only one in Victoria, jingled up to the door, we were quite ready.

Mother kissed us. Dede kissed us.

"Have you all got clean pocket handkerchiefs?"

Yes, we had.

"Don't forget to use them."

No, we wouldn't.

"Be sure to thank Miss Langley for the nice time."

"S'pose it isn't nice?"

"Say 'thank you' even more politely."

We sat in a row on the seat; Mr. Russell slammed the apron of the cab down in front of us, jumped up like a monkey to his perch at the back, and we were off—eight, six and four years old going to our first party.

It was such fun sitting there and being taken by the horse, just as if he knew all by himself where to find parties for little girls, for, after Mr. Russell had climbed up behind so that you could not see him, you forgot that there was a driver.

Lizzie looked over my hat and said to Alice, "I do hope this child will behave decently, don't you? There! See, already!" She pointed to the tips of my gloves which were all black from feeling the edge and buttons of the cab's inside.

"Stop it, bad child," she squealed so shrilly that a little door in the roof of the cab opened and Mr. Russell put his head in. When he saw it was only a "mad" squeal he took his head out again and shut up the hole.

We drove a long way before we came to the Langleys'. Their gate did not know which road it liked best, Moss or Fairfield, so it straddled the corner and gaped wide. We drove up to the door. The two Miss Langleys and Mr. Langley were there, shaking boys and girls by the hands.

The three Langleys had been grown-up a long, long time. They had big shining teeth which their lips hugged tight till smiles pushed them back and then you saw how strong and white the teeth were. They had yellow hair, blue eyes, and had to double down a long way to reach the children's hands.

Mr. Russell flung back the apron of his cab but we still kept on sitting there in a close row like the three monkeys, "See no evil, hear no evil, and speak no evil." He said, "Come now, little leddies. Me 'oss and 'ansom baint inwited." He lifted me out and Mr. Langley had to pull the others from the cab, for now that we were in the middle of the party Lizzie was as scared as any of us. She took Alice by one hand and me by the other and we shook hands with all the Langleys, for no matter how scared Lizzie was she always did, and made us do, what she knew was right.

The house was the wide, sitting sort. Vines and creepers tied it down to the ground.

The garden was big. It had tress, bushes and lawns—there were rocks covered with ivy, too.

The Langleys tried to mix the children by suggesting "hide and seek" among the bushes. Everybody hid but no one would seek. Each child wanted to hold a hand belonging to another of its own family. The boys were very, very shy and the girls' clothes so starchy they rattled if they moved.

By and by Miss Langley counted . . . "Sixteen," she said. "That is all we have invited so we had better start." Something was coming up the drive. Lizzie thought it was our cab and that Miss Langley meant that it was time to be going home, so she took us up to Miss Langley to say what Mother had told us to, but it was not Mr. Russell at all. It was Mr. Winter's big picnic carriage, all shiny and new, the one he had got specially for taking children to parties and picnics. There seemed to be no end to the amount of children he could stuff into this carriage, but there was, because, when they put me in, there was not a crack of space left except the door handle, so I sat on that. The boys were all up in the front seat, swarming over Mr. Winter like sparrows. Behind sat all the little girls—so still—so polite. Suddenly I had a thought and cried, "If this door busted open I'd fall out!"

"Millie, don't say 'busted'. It's horrible! Say 'bursted'." Lizzie's face was red with shame.

We went to Foul Bay and had games on the beach. After we had played a long time Lizzie was just as clean as when we left home, Alice was almost as

clean, and I was all mussed up, but they were not having half such a good time as I.

We went back to the Langleys' house for tea. There were all sorts of sandwiches and there was cocoa and two kinds of cake—one just plain currant, the other a most beautiful cake with pink icing and jelly.

Lizzie and Alice sat across the table from me and were being frightfully polite, taking little nibbling bites like ladies, holding their cups with one hand, and never forgetting "thank you".

My mug was big, it took both my hands. Even then it was heavy and slopped. Miss Langley said, "Oh, your pretty frock!" and tied a bib round me and pulled the little neck hairs so hard that I could not help one or two squeaks . . . they weren't big, but Lizzie scowled and whispered to Alice. I was sure she said, "Bad, dirty little thing." I was just going to make a face at her when Miss Kate Langley came with the splendid pink cake. I had a piece of the currant kind on my plate. I was so afraid Miss Kate would see it and pass me—maybe she would never come back—that I stuffed the currant cake into both cheeks and held my hand up as the girls did at lessons if they wanted something.

"Jelly cake, dear!"

I couldn't speak, but I nodded. Lizzie's forehead crinkled like cream when mother was skimming for butter. She mouthed across at me, "I'm going to tell." My mouth was too busy to do anything with, but I did the worst I could at her with my eyes and nose. She had spoilt everything. Somehow the jelly cake was not half as nice as I thought it was going to be.

The moment tea was over Miss Langley took my bib off and, holding me by the wrists with my hands in the air, said:

"Come, dear. Let me wash you before . . ."

She washed beautifully, and was a lovely lady. I told her about my cat Tibby, and after she had washed my face she kissed it.

I felt very special going back to the others with my hand in that of the biggest and best Miss Langley.

Out on the lawn they were playing "Presents for shies." Mr. Langley stuck up four wobbly poles and put a prize on top of each—bells and tops and whistles. If your shy hit a pole so that a prize fell off, it was yours to keep. I wanted a whistle most dreadfully. When my turn came my shy flew right over the other side of the garden. I had been quite sure that I could knock the whistle off the pole but my shy stick just would not do it. I had three tries and then I ran to Alice who was sitting on a bench and put my head down in her lap and howled. She lifted me by the ribbon and spread her handkerchief under my face so that I should not spoil her dress. Miss Langley heard my crying.

"There, there!" she said and gave me a little muslin bag with six candies in it—but it was not a whistle.

Lizzie told Miss Langley that she was very ashamed of me and that I always did behave dreadfully at parties. That made me stop crying and shout, "I never, never went to one before." Then I did make the very worst face I knew how at Lizzie and gave two sweets to Alice, two to Miss Langley, two to myself, and threw the empty bag at Lizzie as she went off to have her shy. I don't know how I should have felt if she had won a whistle but when she came back without any prize I picked up the bag and put the candy I was not eating in it and gave it to her.

Jingle, jingle, clop, clop—Mr. Russell's cab was coming up the drive. Again Lizzie marched us to Miss Langley.

"Thank you for a very nice party, Miss Langley," she said.

Then she poked at Alice, but Alice only went red as a geranium! She had forgotten what it was she had to say. Poor Lizzie looked down at me and saw the spot of jelly, the cocoa and the front part of me where I'd gone under the bush after my shy stick. She pushed me back and pulled her own clean skirt across me quickly.

When Lizzie wasn't looking at her Alice could remember all right. She said, "Miss Langley, I liked myself, and I'm glad I came."

Miss Langley gave her such a lovely smile that I tore my hand from Lizzie's, ran up and tiptoed, with my face as high as it would go, for Miss Langley to kiss.

We all jumped into the cab then and the apron slammed off everything but our heads and waving hands. The cab whisked round. The party was gone.

"Where're your gloves?"

"L—l—lost."

"Where's your hankie?"

"L—l—lost."

Lizzie took out her own and nearly twisted the nose off my face.

"I'm going to tell Mother about 'busted', about grabbing the jelly cake with your mouth full, about having to wear a bib and be washed. Oh! and there's the two lost things as well. I expect you'll get spanked, you disgusting child. I'm shamed right through about you, and I'm never, never, never going to take you to a party again."

One of my eyes cried for tiredness and the other because I was mad.

Alice got out her hankie, her very best one with Christmas scent on it. "Keep it," she whispered, pushing it into my hand. "Then there'll be only one lost thing instead of two."

British Columbia Nightingale

My sister Alice was two years older than I and knew a lot. Lizzie was two years older than Alice and thought she knew it all. My great big sister *did* know everything. Mother knew all about God. Father knew all about the earth. I knew more than our baby, but I was always wondering and wondering.

Some wonders started inside you just like a stomach-ache. Some started in outside things when you saw, smelled, heard or felt them. The wonder tickled your thinking—coming from nowhere it got into your head running round and round inside until you asked a grown-up about this particular wonder and then it stopped bothering you.

Lizzie, Alice and I were playing in the garden when our Chinaboy Bong came down the path—that is how I know exactly what time of evening it was that this new noise set me wondering, because Bong was very punctual. The tassel on the end of his pigtail waggled all down the path and, as he turned out of the gate, it gave a special little flip. Then you knew that it was almost bed-time. It was just as the slip-slop of Bong's Chinese shoes faded away that I first noticed that new noise.

First it was just a little bunch of grating snaps following each other very quickly, as if someone were dragging a stick across a picket fence as he ran. The rattles got quicker and quicker, more and more, till it sounded as if millions of sticks were being dragged across millions of fences.

I said, "Listen girls! What is it?"

Alice said she did not hear anything in particular.

Lizzie said, "It's just Spring noises, silly!"

First the sound would seem here, then there, then everywhere—suddenly it would stop dead and then the stillness startled you, but soon the rattles would clatter together again filling the whole world with the most tremendous racket, all except just where you stood.

I was glad when my big sister put her head out of the window and called, "Bed-time, children!" I wanted to pull the covers up over my head and shut out the noise.

We went into the sitting-room to kiss Father and Mother goodnight. The fire and the lamp were lighted. Mother was sewing—Father looked at her over the top of his newspaper and said:

"Listen to British Columbia's nightingale, Mother! Spring has come."

Mother replied, "Yes, he certainly does love Spring in the Beacon Hill skunk-cabbage swamp!"

"Come along, children!" called Big Sister.

Upstairs our bedroom was full of the noise. It came pouring in through the dormer window. When the candle was taken away it seemed louder because of the dark. I called to Big Sister as she went down the stair, "Please may we have the window shut?"

"Certainly not! Stuffy little girl! The night is not cold."

"It isn't the cold, it's the noise."

"Noise? Fiddlesticks! Go to sleep."

I nosed close to Alice, "Do you know what nightingales are Alice?"

"Some sort of creature."

"They must be simply *enormous* to make such a big noise."

Alice's "uh-huh" was sleep talk.

I lay trying to "size" the nightingale by its noise. Our piano even with sister Edith pounding her hardest could never fill the whole night like that. Our cow was bigger than the piano, but even when they shut her calf away from her and great moos made her sides go in and out, her bellows only rumbled round the yard. This nightingale's voice crackled through the woods, the sky and everywhere. The band that played in the Queen's birthday parade died when you lost sight of it. This sound of something which you could not see at all filled the world. Why, even the cannon that went off at Esquimalt for people to set their watches by every night at nine-thirty and made Victoria's windows rattle, went silent after one great bang, but this monster in Beacon Hill Park adjoining our own property kept on and on with its roar of crackles.

I knew now why we were never allowed to go into Beacon Hill swamp to gather spring flowers: it was not on account of the mud at all, but because of this nightingale monster.

"I shall never, never go into Beacon Hill Park again," I said to myself. "I won't let on I'm scared but when we go for a walk I shall say, 'Let's go to the beach, it's much nicer than the Park.'"

I thought, "Perhaps she comes to the Park like the birds to nest in the Spring. Perhaps the Park might be safe in winter when the Monster went south."

I heard Father shoot the front-door bolt and the grown-ups coming up the stair. As the candles flickered past our door I whispered, "Mother!"

She came to me.

"Why are you not asleep?"

"Mother, how big is a nightingale?"

"Nightingales are small birds, we do not have them in Victoria."

Birds!—None in Victoria!

"But Father said—"

"That was just a joke, calling our little green frogs nightingales. Go to sleep, child."

Dear little hopping frogs!—I slept.

Time

F ather was a stern straight man. Straight legs and shoulders; straight side-trim to his beard, the ends of which were straight-cut across his chest. From under heavy eyebrows his look was direct, though once in a rare while a little twinkle forced its way through. Then something was likely to happen.

Our family had to whiz around Father like a top round its peg.

It was Sunday. Father was carving the saddle of mutton. Everybody was helped. Father's plate had gone up for vegetables. Uncle and Auntie Hays were visiting us from San Francisco.

Father's twinkle ran up the table to Mother and zigzagged back, skipping Auntie, who was fixing her napkin over her large front with a diamond pin.

Father said, "What about a picnic on Saturday, Mother? We will have the omnibus and go to Mill Stream."

The two big sisters, we three little girls and the small brother were glad. Mother beamed on us all. Auntie attended to her mutton. Uncle never did have anything to say. He was like the long cushion in the church pew—made to be sat on.

All week we stared at the clock, but, for all she ticked, her hands stuck; it took ages for her to register even a minute. But Saturday did come at last and with it, sharp at ten, the yellow bus.

Uncle Hays made a nest of cushions in one corner of the bus for Auntie. Pies and cakes, white-wrapped and tucked into baskets like babies, the tea-billy wrapped in a newspaper petticoat—all were loaded in and we took our places and rattled away.

The bus had two horses and carpet seats. Its wheels were iron-bound and made a terrible racket over the stones.

Only the very middle of our town was paved and sprinkled; beyond the town was dust and bumps.

The seats of the bus were high. We three little girls discovered that we bumped less if we did not dangle, so we knelt on the seat and rested our arms on the open window ledges, till Auntie told Uncle he must shut all the

windows except one, or the dust would ruin her new dust coat. After that we dangled and bumped.

Auntie grumbled all the way about Victoria's poor little blue water-barrel cart, that could only do the middle of the town, and told us of the splendid water-wagons of San Francisco.

At last we drove through a gate and down a lane and stopped. The driver opened the door and we all spilled out onto the grass beside a beautiful stream.

Uncle built a new nest for Auntie. There were pine boughs as well as pillows to it now, and she looked like a great fat bird sitting there peeping and cooing at Uncle over the edge.

The table-cloth was spread on the grass close to Auntie's nest. As soon as lunch was over Mother said, "Now children, run along. Don't go into the thick woods, keep by the stream."

Father looked at his watch and said, "It's now one o'clock—you have till five."

Downwards the stream broadened into a meadow; upstream it bored a green tunnel through the forest, a tunnel crooked as a bed-spring. It curled round and round because there were so many boulders and trees and dams in the way. The sides of the tunnel were forest, the top overhanging trees, the floor racing water.

We could not have squeezed into the woods had we tried because they were so thick, and we could not have seen where to put our feet, nor could we have seen over the top, because the undergrowth was so high.

Every twist the stream took it sang a different tune and kept different time. It would rush around the corner of a great boulder and pour bubbling into a still pool, lie there pretending it had come to be still, but all the time it was going round and round as if it was learning to write "O's"; then it would pour itself smoothly over a wedged log and go purling over the pebbles, quiet and dreamy. Suddenly it would rush for another turn, and roar into a rocky basin trickling out of that again into a wide singing place. It had to do all these queer things and use force and roughness to get by some of the obstacles. But sometimes the stream was very gentle, and its round stones were covered with a fine brown moss. When the moss was wet it looked just like babies' hair. You could pretend the stones were babies in their bath and the stream was sponging water over their heads.

Five-finger maidenhair ferns grew all along the banks. Some of them spread their thin black arms over the edge and, dipping their fingers in the water, washed them gently to and fro. Then the wind lifted them and tossed them in the air like thousands of waving hands. All kinds of mosses grew by the

stream—tufty, flat, ferny, and curly, green, yellow and a whitish kind that was tipped with scarlet sealing wax.

Yellow eyes of musk blossoms peeped from crannies. They had a thick, soft smell. The smell of the earth was rich. The pines and the cedars smelled spicy. The wind mixed all the smells into a great, grand smell that made you love everything. There were immense sober pines whose tops you could not see, and little pines, fluffed out ready to dance. The drooping boughs of the cedars formed a thatch so thick and tight that creatures could shelter under it no matter how hard it rained. The bushes did not grow tight to the cedars because it was too dry and dark under them. Even their own lower limbs were red-brown and the earth bare underneath.

The wind sauntered up the stream bumping into everything. It was not strong enough to sweep boldly up the tunnel, but quivered along, giving bluffs and boulders playful little whacks before turning the next corner and crumbling the surface of that pool.

There was much to see as we went up the river, and we went slowly because there were so many things to get over and under. Sometimes there were little rims of muddy beach, pocked with the dent of deer hooves. Except for the stream the place was very quiet. It was like the stillness of a bird held in the hand with just its heart throbbing.

Sometimes a kingfisher screamed or a squirrel scolded and made you jump. I heard a plop down at my feet—it was a great golden-brown toad. I took him in my hands.

One sister said, "Ugh!" The other said, "Warts".

I put him in a tin and weighted it with a stone and hid it under a skunk cabbage.

We were very, very far up the stream, though it had not seemed a long way at all, when our big sister came around the bend behind us.

"Come children," she called. "It is time to go home."

We looked at each other. What did she mean? Time to go home? We had only just come.

I faced about.

"It is not," I said rudely, and received a smart box on the ear. But it was not our sister's word we doubted, it was Time.

I lagged behind to pick up the toad, wondering deeply about Time. What *was* Time anyway, that things could play such tricks with it? A stream could squeeze a whole afternoon into one minute. A clock could spread one week out into a whole year.

The baskets were packed. Uncle was building another nest for Auntie. Mother was seated in the bus looking very tired. Dick was asleep on the seat with his head in Mother's lap and his toy watch dangling out of his pocket.

I stared at the watch hard. The hands were at the same place they were when we started in the morning. Play things were always truer than real.

The bus started bumping along and the dust rolled behind. I sat opposite Auntie. I had draped a skunk cabbage leaf over the toad's tin.

"See dear, you will have to throw that leaf out of the window; the smell of it upsets Auntie." She detested me, and always tacked on that hypocritical "dear".

The leaf fluttered out of the window. I put my hand over the top of the tin.

"What have you got in the tin, dear? Let Auntie see."

I shot it under her nose, hoping it would scare her. It did. She gave a regular parrot-screech. The big sister reached across, seized the tin, looked, and flung tin, golden toad and all, out of the window.

Then suddenly those gone hours pulled out and out like taffy. It *was* late. The bus wheels started to roll quietly because we were in town now and under Mr. Redfern's big clock, which gave six slow sad strikes.

Father pulled out his big silver watch. Uncle pulled out a gold one. Auntie fussed with a fancy thing all wound up in lace and gold chains.

They all said "Correct", snapped the cases shut and put them back in their pockets.

I leaned against Father and shut my eyes.

Throb-throb-throb—was that Father's watch eating up minutes or was it hop-hop-hop, my golden toad, making his patient way down the long dusty road, back to the lovely stream where there was no time?

A Little Town
and a Little Girl

Beginnings

Victoria, on Vancouver Island, British Columbia, was the little town; I was the little girl.

It is hard to remember just when you first became aware of being alive. It is like looking through rain onto a bald, new lawn; as you watch, the brown is all pricked with pale green. You did not see the points pierce, did not hear the stab—there they are!

My father did not come straight from England to Victoria when, a lad of nineteen, he started out to see something of the world. He went to many countries, looking, thinking, choosing. At last he heard of the California gold rush and went there. He decided that California was a very fine country, but after the rush was over he went back to England, married an English girl and brought his bride out to California in a sailing ship, all round Cape Horn. Intending to settle in California, he went into business but after a while it irked Father to live under any flag other than his own. In a few years, having decided to go back "home" to live, he chartered a vessel and took to England the first shipment of California wheat. But, staunch Englishman though my Father was, the New Land had said something to him and he chafed at the limitations of the Old which, while he was away from it, had appeared perfect. His spirit grew restless and, selling all his effects, he brought his wife and two small daughters out to the new world. Round the Horn they came again, and up, up, up the west coast of America till they came to the most English-tasting bit of all Canada—Victoria on the south end of Vancouver Island, which was then a Crown Colony.

Father stood still, torn by his loyalty to the Old Land and his delight in the New. He saw that nearly all the people in Victoria were English and smiled at how they tried to be more English than the English themselves, just to prove to themselves and the world how loyal they were being to the Old Land.

Father set his family down in British Columbia. He and Mother had accepted Canada long before I, the youngest but one of their nine children, was born. By that time their homesickness was healed. Instead of being English they had broadened out into being British, just as Fort Camosun had swelled herself from being a little Hudson's Bay Fort, inside a stockade with bastions at the corners, into being the little town of Victoria, and the capital of British Columbia.

Father bought ten acres of land—part of what was known as Beckley Farm. It was over James' Bay and I have heard my mother tell how she cried at the lonesomeness of going to live in a forest. Yet Father's land was only one mile out of the town. There was but one other house near—that of Mr. James Bissett of the Hudson's Bay Company. Mr. Bissett had a wife and family. They moved East long before I was born but I was to know, when nearly grown up, what the love of those pioneer women must have been for one another, for when years later I stood at Mrs. Bissett's door in Lachine, seeing her for the first time, and said, "Mrs. Bissett, I am Emily Carr's daughter, Emily," she took me to herself in the most terrific hug.

As far back as I can remember Father's place was all made and in order. The house was large and well-built, of California redwood, the garden prim and carefully tended. Everything about it was extremely English. It was as though Father had buried a tremendous homesickness in this new soil and it had rooted and sprung up English. There were hawthorn hedges, primrose banks, and cow pastures with shrubberies.

We had an orchard and a great tin-lined apple room, wonderful strawberry beds and raspberry and currant bushes, all from imported English stock, and an Isabella grape vine which Father took great pride in. We had chickens and cows and a pig, a grand vegetable garden—almost everything we ate grew on our own place.

Just one of Father's fields was left Canadian. It was a piece of land which he bought later when Canada had made Father and Mother love her, and at the end of fifty years we still called that piece of ground "the New Field". The New Field had a snake fence around it, that is, a zigzag fence made of split cedar logs or of young sapling trees laid criss-cross, their own weight holding them in place so that they required no nails. Snake fences were extravagant in land and in wood, but wood and land were cheaper in Canada in early days than were nails and hinges. You made a gate wherever you wanted one by lowering bars to pass through and piling them up again. The only English thing in our New Field was a stile built across the snake fence.

The New Field was full of tall fir trees with a few oaks. The underbrush had been cleared away and the ground was carpeted with our wild Canadian lilies, the most delicately lovely of all flowers—white with bent necks and brown eyes looking back into the earth. Their long, slender petals, rolled back from their drooping faces, pointed straight up at the sky, like millions of quivering white fingers. The leaves of the lilies were very shiny—green, mottled with brown, and their perfume like heaven and earth mixed.

James' Bay and Dallas Road

J ames' Bay district, where Father's property lay, was to the south of the town. When people said they were going over James' Bay they meant that they were going to cross a wooden bridge that straddled on piles across the James' Bay mud flats. At high tide the sea flooded under the bridge and covered the flats. It receded again as the tide went out with a lot of kissing and squelching at the mud around the bridge supports, and left a fearful smell behind it which annoyed the nose but was said to be healthy.

James' Bay was the part of the town to be first settled after Victoria had ceased to be a fort. Many Hudson's Bay men built fine homes across the Bay— Sir James Douglas, Mr. Alexander Munroe, Mr. James Bissett, Mr. James Lawson, Senator Macdonald, Bishop Cridge and Dr. Helmcken.

The district began at the south corner of the Bridge where Belville Street crossed it. Belville skirted the mud flats until they ended at Blanshard Street. On the other side of the Bridge, Belville ran along the harbour's edge, skipping places where it could not get to the water. When it came to the mouth of the harbour it met Dallas Road and doubled back along the shore of the Straits of Juan de Fuca, making a peninsula of the James' Bay District, the limit of which was Beacon Hill Park, a beautiful piece of wild land given to the people of Victoria by Sir James Douglas.

The Hill itself was grassy, with here and there little thickets of oak scrub and clumps of broom. Beyond the Hill the land was heavily wooded. When you climbed to the top of Beacon Hill and looked around you knew that the school geography was right after all and that the world really was round. Beacon Hill seemed to be the whole top of it and from all sides the land ran away from you and the edges were lost. To the west lay the purple hills of Sooke; to the south were the Straits of Juan de Fuca, rimmed by the snowy Olympic mountains, whose peaks were always playing in and out among the clouds till you could not tell which was peak and which sky. On the east there were more sea and islands. The town was on the north, with purple Cedar Hill and green Mount Tolmie standing behind it. Our winds came from the Olympics in summer and from the icy north in the winter.

There was a good race track measuring exactly one mile, running round the base of Beacon Hill. Here they had horse-racing and foot-racing. They played cricket and football on the flat ground outside the track, and there were sham battles between sailors and soldiers all over the Hill on the Queen's Birthday. In the woody swamps of the Park millions and millions of frogs croaked all

through the Spring nights. They sounded as if all the world was made of stiff paper and was crackling up.

Dallas Road was the first pleasure drive made in Victoria. Everyone drove along it to admire the view. The road ran sometimes close to the edge of the clay cliffs and sometimes there were thickets of willow and wild rose bushes between. The trees and bushes were so waved by the beating of the wind that they grew crooked from always being pushed north when they were really trying to poke south into the sun. There were stretches of fine, soft grass on the cliffs and great patches of camass and buttercups. As the wind swept over these they looked as if they, too, were running away from the sea. How the petals of the wild roses managed to stick to their middles I can't think, but they did and the bushes were more pink than green in June. Their perfume, salted by the sea air, was the most wonderful thing that ever happened to your nose.

Beside one of the willow clumps on the Dallas Road were two white picket fences, each just as long as a man. They were the graves of two sailors who died of smallpox before Victoria had a cemetery. The fences were kept painted but the names on the head-boards were faded right out.

Farther along Dallas Road on the two highest parts of the cliffs were set two cannons, hidden from the Straits by sodded earth mounds. These were really ammunition cellars, one on either side of each cannon; they had heavy-timbered and padlocked doors which we children longed to see inside. These cannons guarded the entrance to Esquimalt Harbour, a British naval base, three miles out from Victoria.

Most of the beaches below Dallas Road were pebbly and had rough, rocky points jutting out into the sea and dividing the long beaches and the little bays one from another. All the beaches were piled with driftwood—great logs bruised and battered out of all resemblance to trees except that some of them still had tremendous, interlocked roots tough as iron, which defied all the pounding of the waves, all the battering against the rocks to break them. The waves could only wash them naked and fling them high up on the beach to show man what he had to wrestle against under the soil of the Canadian West. But the settlers were not stopped. They went straight ahead taming the land. It took more than roots to stop these men.

The waters of the Straits were icy. Occasionally we were allowed to put on white cotton nightgowns and go bathing in the sea. Your body went down, the nightgown stayed up, icy cold bit through your skin. At the first plunge you had no breath left; when it came back it was in screeches that out-screamed the seagulls.

Silence and Pioneers

The silence of our Western forests was so profound that our ears could scarcely comprehend it. If you spoke your voice came back to you as your face is thrown back to you in a mirror. It seemed as if the forests were so full of silence that there was no room for sounds. The birds who lived there were birds of prey—eagles, hawks, owls. Had a song bird loosed his throat the others would have pounced. Sober-coloured, silent little birds were the first to follow settlers into the West. Gulls there had always been; they began with the sea and had always cried over it. The vast sky spaces above, hungry for noise, steadily lapped up their cries. The forest was different—she brooded over silence and secrecy.

When we were children Father and Mother occasionally drove out beyond the town to Saanich, Metchosin or the Highland District, to visit some settler or other carving a home for his family in the midst of overwhelming growth—rebellious, untutored land that challenged his every effort. The settler was raising a family who would carry on from generation to generation. As he and his wife toiled at the breaking and the clearing they thought, "We are taming this wilderness for our children. It will be easier for them than for us. They will only have to carry on."

They felled mighty trees with vigour and used blasting powder and sweat to dislodge the monster roots. The harder they worked with the land, the more they loved these rooty little brown patches among the overwhelming green. The pioneer walked round his new field, pointing with hardened, twisted fingers to this and that which he had accomplished while the woman wrestled with the inconveniences of her crude home, planning the smart, modern house her children would have by and by, but the children would never have that intense joy of creating from nothing which their parents had enjoyed; they would never understand the secret wrapped in virgin land.

Mr. Scaife, a pioneer, had dug a deep ditch round his forest field. The field was new ploughed. He showed Father with pride how few blackened stumps there were now left in the earth of it. I let go of Father's hand to gather wild flowers among the pokes of the snake fence. I fell into the deep, dry ditch. Brambles and tall grasses closed over my head, torn roots in the earthy sides of the ditch scraped me as I went down. It was the secret sort of place where snakes like to wriggle and where black hornets build their nests—nearly dark, only a little green light filtering through the brambles over my head. I screamed in terror. Willie Scaife, a farm lad, jumped into the ditch and pulled me out. He was my first hero.

The first Victorians could tell splendid stories of when Victoria was a Hudson's Bay Post, was called Fort Camosun and had a strong blockade about it with a bastion at each corner to protect the families of the Hudson's Bay men from Indians and wild beasts.

Though my parents did not come to Victoria till after the days of the Fort and I was not born for many years after that, still there were people in Victoria only middle-aged when I was little, who had lived in the old Fort and could actually tell you about it. Nothing delighted me more than to hear these "still-fresh-yesterday" stories, that were not old "once-upon-a-timers"! You could ask questions of the very story people themselves and they did not have to crinkle their foreheads, trying to remember a long way back.

There was a childless couple with whom I was a favourite—Mrs. Lewis and her husband, the sea captain. Mrs. Lewis had been Miss Mary Langford before her marriage. Her Father was Captain Langford, a naval man. I am not certain whether the Langfords ever actually lived in the Fort or not but they came to Victoria at the very beginning of its being. Captain Langford built a log farmhouse six or seven miles out of town. The district was named for him.

Sometimes when Captain Lewis was away Mrs. Lewis invited me to stay with her for company. They lived on Belville Street, on the same side of James' Bay as we did, in a pretty cottage with flowers and canaries all over it. The windows overlooked the Harbour and Mrs. Lewis could watch the Captain's boat, the old paddle-wheel steamer, *Princess Louise*, go and come through the Harbour's mouth, and could wave to the Captain on his bridge. It was Captain Lewis who took me for my first trip by sea, and later, when the Railway was built to Nanaimo, for my first trip by rail. When you put your hand in his it was like being led about by a geography (he knew everywhere) and Mrs. Lewis was history. Seated at her feet before the fire among the dogs and cats, I listened open-mouthed to tales of early Fort days.

Mrs. Lewis was a good teller. She was pretty to watch. The little bunch of black curls pinned high at the back of her head bobbed as she talked and her eyes sparkled. She told how young Naval officers used to take the pretty Miss Langfords out riding. When they came to Goldstream and Millstream, which were bubbling rivers with steep banks, that crossed the Langford trails, the men would blindfold the girls' horses and lead them across the river, using as a bridge a couple of fallen logs. One night as they were hurrying along a narrow deer trail, trying to get home before dark, they saw a panther stretched out on the limb of a tree under which they must pass in single file. The bushes were too dense for them to turn aside, so each rider whipped his horse and made a dash along the trail under the panther.

Mrs. Lewis told, too, of the coming of their piano from England. It sailed all round Cape Horn and was the first piano to come into the Colony of British Columbia. It landed at Esquimalt Harbour and was carried on the backs of Indians in relays of twenty at a time through a rough bush trail from Esquimalt to Langford. The tired Indians put the piano down in a field outside the house to rest a minute. The Langford girls rushed out with the key, unlocked and played the piano out there in the field. The Indians were very much astonished. They looked up into the sky and into the woods to see where the noise came from.

The stories jumped sharply out of Mrs. Lewis's mouth almost catching her breath, as she recalled vividly the excitement which these strange happenings had brought to her and to her sister, just out from their sheltered English life.

Sometimes Mrs. Cridge, Mrs. Mouat, Doctor Helmcken, or some of Sir James Douglas's daughters, all of whom had lived in the old Fort, would start chatting about old days and then we younger people would stand open-mouthed thinking it must have been grand to live those exciting experiences.

"It was, my dears," said Mrs. Cridge, "but remember too that there were lots of things to face, lots of things to do without, lots of hardships to go through."

I was a very small girl when the business men of Victoria chartered a steamer and, accompanied by their families, made a tour of Vancouver Island. It took the boat, the *Princess Louise*, ten days to go all round the Island. My Father and two of my sisters went. I was thought to be too small but I was not too small to drink in every word they said when they came back.

Father was overwhelmed by the terrific density of growth on the Island. Once when they were tied up for three hours he and another man took axes and tried to see how far they could penetrate into the woods in the given time. When the ship's whistle blew they were exhausted and dripping with sweat but their attack on the dense undergrowth scarcely showed. Father told of the magnificent trees, of their closeness to each other, of the strangling undergrowth, the great silence, the quantity of bald-headed eagles. "Really bald, Father?" I asked, but he said they were a rusty black all over except for white heads which shone out against the blue sky and the dark forest. Great white owls flew silently among the trees like ghosts, and, too, they had seen bears and whales.

One of my sisters was more interested in the passengers on the boat and made a lot of new friends. The other told me about the Indian villages where the boat had touched. This was all far more interesting to me than the stories people had to tell when they came back from trips to the Old Country, bragging

about the great and venerable sights of the Old Land. I did not care much about old things. These wild, western things excited me tremendously. I did not long to go over to the Old World to see history, I wanted to see *now* what was out here in our West. I was glad Father and Mother had come as far as the West went before they stopped and settled down.

Saloons and Roadhouses

On almost every street corner in Victoria there was one saloon or more. There were saloons in the middle of every block as well.

I used to think that every saloon belonged to the Navy because sailors, wearing little boys' collars and wide trouser legs that flapped round their feet, rolled in and out of saloon doors at all times. These doors swung to noiselessly. They were only pinafore doors, made of slats and flapped to so quickly when a sailor went in or out that you never got a chance to see what it was they hid, not even if you were right in front when one was pushed open and nearly knocked you over. We were strictly forbidden to look at a saloon in passing. Grown-ups dragged you quickly past and told you to look up the street though there was nothing whatever to see there.

This made me long to know what was inside saloons. What was it that we were not supposed to see? Why was it naughty to twist your neck and look? You heard laughing and singing behind the swing doors. What did they do in there?

There were saloons, too, every few miles along the driving roads. These they called roadhouses. Each had two doors. Over one was written "Parlour", over the other, "Bar". These roadhouses were most attractive; they had verandahs with beautiful flower-boxes at the windows, filled with gay flowers and drooping, five-finger maidenhair fern. Very often they had cages of birds and of wild animals too. The Colonist Hotel in Beacon Hill Park had a panther on its verandah. The Four Mile House had a cage of raccoons. Another roadhouse had a baby bear and another a cage of owls.

Once when Aunt and Uncle were visiting us from San Francisco we took a long drive on a hot day. When we got to the top of the Four Mile Hill Uncle poked Father. Father ignored the poke and we passed the bar and drove to the bottom of the hill. Then Father dug the driver in the back and he pulled up his horses. Father, Uncle and the driver all toiled up the hill again on foot, leaving us sitting in the hack by the roadside. We children were allowed to get out and gather wild roses. I slipped behind the hack and started up the hill to have a

look at the coons in the cage. Mother called me back. Auntie said something about "the unwholesome nosiness of little people".

I said, "I just wanted to see the little coons, Auntie."

"Pick some roses for Auntie," she ordered, but when I did she threw them over the wheel. She said the dust on them made her sneeze.

Goodacre, the butcher, had a slaughter-house out on Cadboro Bay Road. Cattle and sheep were brought from the Mainland by boat and landed at the wharf in front of Father's store. They were then driven straight through the centre of the town, up Fort Street which, after it had gone straight in the town, wiggled and twisted and called itself "Cadboro Bay Road".

The wild range cattle were crazed with fright. They bellowed and plunged all over the sidewalk, hoofing up the yellow dust. Women ran to shut their gates before the cattle rushed in and trampled their gardens. All the way up the street doors banged and gates slammed as everyone hurried to shelter.

I had been to visit my sister who lived on Fort Street. I was to go home by myself as there was no one to fetch me that day. It was the first time I had been through town alone. When I was just opposite the Bee Hive Saloon a drove of these wild cattle came tearing up the street. They were almost on top of me before I knew what all the dust and shouting and bellowing was about. Men with long whips whooped, dogs barked, the street seemed to be waving up and down with the dull red movement of beasts' backs bumping through the dust. Suddenly I was snatched up in a pair of huge black arms, a black face was near mine. It had grinning white teeth. We backed through the swing door and I was inside a saloon at last. The big black man set me down on the bar. The barkeeper and the negro ran to the window to look over the painted green glass at the boiling tumult of cattle outside. I could only hear their bellowing and scuttling.

I looked around the Saloon. Shiny taps were beside me and behind the long counter-bar ran shelves full of bottles and sparkling glasses; behind them again was looking-glass so that there seemed to be twice as many bottles and twice as many glasses as there really were, and two barmen and two negroes and two me's! In the back half of the saloon were barrels and small wooden tables; chairs with round backs stood about the floor with their legs sunk in sawdust; bright brass spitoons were everywhere. The saloon was full of the smell of beer and of sawdust. There was nothing else, nothing that I could see to make anyone sing.

The noise moved on up the street. The two men returned to the bar. The barman poured something yellow into a glass and shoved it towards the negro who threw back his head and gulped it like medicine. Then he lifted me down,

held the swing door open and I went out into the still unsettled, choking dust of Fort Street.

My big sister had a kind heart. Nothing pleased her more than to drive old, lame or tired people into the country. There was always some ailing person tucked up in her little phaeton being aired. All about Victoria were lovely drives—Admiral Road, Burnside, Cadboro Bay, Cedar Hill. The country roads were very dusty and dry, so every few miles there was a roadhouse with a bar for men and a watering trough for horses—ladies went thirsty. No lady could possibly be seen going into a bar even if only for a glass of water.

We bought a new horse called Benny. His former master had been accustomed to look in at every roadhouse bar. Benny knew them every one. If my sister were talking to her invalid passenger and not noticing, Benny swerved gently up to the bar door and stopped so dead it unsettled the ladies' bonnets.

When my sister saw where she was she would give Benny a cut with the whip which would send him dashing from the saloon at a guilty gallop, my sister sitting very red and crooked behind him. She was sure just then to meet someone whom she knew and be too upset to bow and then she had double shame.

Ways of Getting Round

B eyond the few blocks of Victoria upon which the shops stood the roads were of dirt and had sidewalks of one, two or three planks according to the street's importance. A great many people kept cows to supply their own families with milk. When their own pasture field was eaten down they turned the cow into the street to browse on roadside grass along the edges of the open ditches, or to meander out to the grassy land on top of the cliffs off Dallas Road. Victoria cows preferred to walk on the plank sidewalks in winter rather than dirty their hooves in the mud by the roadside. They liked to time their chews to the tap, tap, tap of their feet on the planks. Ladies challenged the right of way by opening and shutting their umbrellas in the cows' faces and shooing, but the cows only chewed harder and stood still. It was the woman-lady, not the lady-cow who had to take to the mud and get scratched by the wild rose bushes that grew between sidewalk and fence while she excursioned round the cow.

If people did not wish their flowers to be turned into milk it was up to them to fence their gardens. Father's property was very securely fenced and his cows were always kept within their own pastures. We had a painted fence in front of our property, tarred fences on the sides, and our field had a snake fence.

There was no way to get about young Victoria except on legs—either your own or a horse's. Those people who had a field, a barn, and a cow usually kept a horse too. The horses did not roam; they had to be kept handy for hitching. All the vehicles used were very English. Families with young children preferred a chaise, in which two people faced the horse and two the driver. These chaises were low and so heavy that the horse dragged, despondent and slow. The iron tires made such a rumbling over the rough stony roads that it was difficult to hear conversation while travelling in a chaise especially when to the rumble was added the rattle of wheel spokes that had got over-dry and loosened. What you did then was to drive as deep as you dared into the first stream you knew of and let the chaise wheels soak, all the while encouraging the horse to go forward and back, turning the wheels in the water until they swelled again. You could not go into very deep water for fear of drowning the driver for the chaises were set so low that the driver sat right down among the wheel hubs. If children fell out of these low chaises they did not get hurt, only dusty. The horse stood so much higher than the driver that there was a tall iron rack in the front to hold the reins so that the horse could not swish his tail over them and pin the reins down so tight that he could not be guided.

Men preferred to drive in high, two-wheeled dogcarts in which passengers sat back to back and bumped each other's shoulder blades. The seat of the driver was two cushions higher than that of the other passengers. Men felt frightfully high and fine, perched up there cracking the whip over the horse's back and looking over the tops of their wives' hats. There were American buggies, too, with or without hoods which could be folded back like the top of a baby's pram.

In Victoria nobody was in a particular hurry to get anywhere—driving was done mostly for the pleasure of fresh air and scenery.

In town there were lots of livery stables where you could hire horses or could board your own. The smell of horse manure was so much a part of every street that it sat on your nose as comfortably as a pair of spectacles. Of course there were no livery stables among the drygoods, food, and chemists' shops. Everywhere else you saw "Livery Stable" printed above wide, cool entries and heard horses chewing and stamping, and saw long rows of tails swishing out of stalls on either side of a plankway while ugly, square vehicles called hacks stood handy waiting for horses to be hitched to them. These hacks for hire were very stuffy. The town had one imported hansom-cab which thought itself very smart, and there was Mr. Winter's picnic carriage, a huge vehicle that held as many children as the Old Woman's Shoe. When its wide, circular back seat was crammed and more children were heaped on top of Mr. Winter up on his high

driver's seat, and they were all yelling, and yellow dust rolling, and wheels rumbling, it looked and sounded like a beehive swarming. For immense affairs like Sunday School picnics and excursions there were yellow buses with long rows of windows, long wooden seats, uncushioned except for strips of carpet running from driver to door. They had no springs to speak of, and were so noisy that you could not hear your own groans being bumped out of you.

Victoria's baker and butcher boys delivered meat and bread on horse-back, carrying their loaves and joints in huge wicker baskets rested against their hips. As soon as they had one foot in the stirrup and while their other leg was still flying in the air over the horse as he galloped off, they shouted "Giddap!" It was a wonder the boys did not grow crooked balancing such heavy baskets on their hips, but they did not—they were straight and strong. I used to wish I were a delivery boy to throw my leg across a horse and shout "Giddap!" to feel myself rush through the air, but I should have preferred bread to meat in my basket.

The first time I knew that Victoria was slower than other towns was when, at the age of twelve, I was recovering from typhoid fever and a lady whom Mother knew, and whose two children had had typhoid in the same epidemic as I, took me along with her little girls for a trip to Puget Sound. It was my first visit to an American city and I felt giddy in the head from its rush. I heard Americans laugh and say "slow as Canadian" and call my town "sleepy old Victoria".

I heard one man say to another, "Went across the line this summer."

"Did eh? What sort of a place is Victoria?"

"Sleepiest ever!" laughed the first. "Every place of business had a notice up, 'Gone to lunch. Back in a couple of hours.'"

That was the first time I knew we were slow.

San Francisco was the biggest, the most important city on the Pacific Coast. It was a terrible trip in the small, bouncy steamer, down the rough coast. Victorians only went for something very, very important like a big operation or a complete change for health, to save their lives. Even then they stuck their noses up and said, "I am going across the line," or "going to the other side", as if the "other side" was an underneath and inferior side of the earth. But, if they had to have such an enormous operation that it was quite beyond Victoria's skill, then, rather than go all round the Horn back to England and either die before they got there or else get well and forget what the operation was for, they allowed San Francisco to "operate" them.

Americans dashed across the line sometimes to look at us Canadians and at British Columbia as if we had been dust-covered antiques. They thought English and Canadian people as slow and stupid as we thought the American

people uncomfortable rushers—makers of jerry-built goods that fell to pieces in no time. We preferred to wait ages for our things to come by sailing ship round the Horn from England rather than to buy American goods. This annoyed the American manufacturers.

An aunt of ours in San Francisco sent us American dolls. They were much prettier than English dolls. The first that came were made of wax but they melted when we left them in the sun. Next Christmas she sent us bisque dolls, very lovely but too breakable to hug; we could not even kiss them but they cracked. We went back to our lovable old wood and china dolls that took their time to come to us all round the Horn, and, even if they were plain, they were substantial and could bear all the loving we gave them.

Father's Store

V ictoria was like a lying-down cow, chewing. She had made one enormous effort of upheaval. She had hoisted herself from a Hudson's Bay Fort into a little town and there she paused, chewing the cud of imported fodder, afraid to crop the pastures of the new world for fear she might lose the good flavour of the old to which she was so deeply loyal. Her jaws went rolling on and on, long after there was nothing left to chew.

Government Street was the main street of the town. Fort Street crossed it and at the cross, in a little clump, stood most of the shops. On Yates, View and Broad Streets were a few lesser shops, several livery stables and a great many saloons. On Bastion Street stood the Courthouse and the Jail. Down on Wharf Street, facing the Harbour, were the wholesale houses. Fisgard, Cormorant and Johnson Streets were Chinatown. At the tail ends of all these streets were dwelling-houses set in gardens where people grew their own flowers and vegetables.

The rest of Victoria was higgledy-piggledy. It was the cows who laid out the town, at least that portion of it lying beyond the few main streets. Cow hooves hardened the mud into twisty lanes in their meanderings to and fro—people just followed in the cows' footsteps.

When the first settlers cut up their acreage, the resulting lots were all shapes and sizes. Owners made streets and lanes over the property anywhere that seemed convenient at the moment.

My father was a wholesale importer of provisions, wines and cigars. His store was down on Wharf Street among other wholesale places. The part of Wharf Street where Father's store stood had only one side. In front of the store was a great hole where the bank of the shoreline had been dug out to build

wharves and sheds. You could look over the top of these to the Songhees Indian Reserve on the opposite side of the Harbour. To one side of the hole stood the Hudson's Bay Company's store—a long, low building of red brick with a verandah. The Indians came across the Harbour in their dugout canoes to trade at the store. They squatted on the verandah, discussing new-bought goods, or their bare feet pattered up and down the board walks of Wharf Street. They were dressed in gay print dresses, plaid shawls and bright head handkerchiefs. Once I saw Father's man take out case after case of beautiful cluster Malaga raisins and pour them into the outspread shawls and handkerchiefs of the jabbering Indians, who held out their hands and stuffed their mouths, giving grunts of delight.

I asked Father, "Why do you give all these raisins to the Indians?"

He replied, "They are maggoty, the whole lot of them—but Indians love raisins and don't mind maggots at all."

At the opposite side of the Wharf Street hole stood the Customs House, close to the water's edge. Made of red brick, it was three storeys high and quite square. The Customs House steps were very dignified—high and widespread at the bottom. Underneath the steps was the Gregorys' door.

Gregory was an Old Country gardener. His wife was very homesick as well as really ill. The Gregorys were the caretakers of the Customs House. In front of their rooms they had a beautiful little garden, sheltered by a brick wall. Sometimes Mother sent Mrs. Gregory things and Mrs. Gregory gave us beautiful posies of flowers in exchange. On the lower floor of the Customs House, where the Gregorys had their quarters, there was a wide hall which ran straight through the building. The wind roared down this passage from a great doorway opening onto the Harbour. Furious that the Gregorys' door under the steps was not big enough to let it all out at once, it pounded and bellowed at all the doors down the hall as it passed them. The waves came dashing up the slip and rushed through the door and into the hall. I used to think that ships sailed right into the Gregorys' hall-way to do their customs business and I begged to go to see Mrs. Gregory on any excuse whatever, always hoping to meet a ship sailing down the hall-way. I was much disappointed that I never struck a tide high enough to bring a ship in. Once I thought I was going to but when no more than two waves had washed in through the great doors Mr. Gregory rushed out, shut and barred them.

The inside of Father's store was deep and dark. Cases, crates, and barrels stood piled on top of one another right up to the ceiling, with just a narrow lane running down the middle and ending in what was called "the yard"—not a yard at all, only a strong, rough board shed filled with "empties" and cats.

There were no windows; the cats, crawled in and out of the "empties" hunting for rats, their eyes shining in the black. Slits of daylight cut between the boards of the shed walls, and shadows thrown by a sputtering gas jet made it all spooky and unreal—different from the solid, comfortable feel of the outer store crammed with provisions.

Father had every colour of cat. He took fresh milk in a bottle from home every morning to them; he said a diet of straight rat was not healthy for cats. Only one of them was a comfortable, particular cat and came to sit by the stove in Father's office. The rest were just wholesale cats.

Father's office was beside the open front of his big store and in it Father sat in front of a large, square table covered with green baize; on it in front of him was a cupboard full of drawers and pigeon-holes. He sat in a high-backed wicker armchair. His beard was white and, after he went bald, he wore a black skull cap. A fat round stove, nearly always red hot, was between Father's table and the long, high desk where his men stood or sat on high stools doing their books when they were not trundling boxes on a truck. There was an iron safe in one corner of the office with a letter press on top and there were two yellow chairs for customers to sit on while Father wrote their orders in his book. Everything was dozened in Father's store: his was not a business that sold things by pinches in paper bags. High along the wall ran four long shelves holding glass jars of sample English sweets—all pure, all wholesome, all English. The labels said so.

New Neighbours

As I first remember it, James' Bay district had many fields and plenty of wooded land left, but houses began to creep nearer and nearer to ours and the fields were being cut up into town lots. I was very sorry when Bishop Cridge's big, wild field opposite us was sold. The Bishop's house sat back in the little bit of wood with an orchard and two fields. His driveway curved and had laurels and little bushes of yellow roses all the way up. We children used to play "ladies" in the Bishop's wild field with his three little girls. Being the youngest of the six children I could never be a "lady"—I had always to be "bad child", while the play mothers fed me on green gooseberries, wild and very sour.

The Bishop's house was built some time after Father's. The street was very narrow and in that one long block from Toronto to Simcoe Street there was only his house and ours. Father gave a good strip of his land to make the street wider; so the City named it Carr Street after Father. Carr Street would have

joined Birdcage Walk if Mrs. McConnell's cow farm had not stood in the way, and Birdcage Walk would have been Government Street if the James' Bay Bridge had not been there to get people over the mud flats. After many years Government Street swallowed them up—James' Bay Bridge, Carr Street and Birdcage Walk—and went straight out to Dallas Road.

One day when we were playing "ladies" in the Bishop's field and I, the "baby", was being hidden in the bushes from the ferocious wild beast which ate children but which was really the Bishop's gentle cow "Colie", some men climbed over the fence. They had instruments on three legs which they sat beside the road and squinted through. They came right into our mock-orange parlour and our gooseberry-bush dining-room. They swept the tin cans which had furnished our kitchen from our own particular log and sat down upon it and wrote in little books. They even tore pickets off the fence. The cow was taken to another enclosure, wagons dumped lumber and bricks all over the field. Soon real houses stood on top of our pretend ones, real ladies smacked real babies and pushed prams right on top of where our fun had been, and Mother was sending us across to ask if the new neighbour would like pots of tea or anything till her own stove was up.

Visiting Matrons

Victoria matrons did not fritter away their time in the paying of short calls. They had large families. The Chinese help could not be left in charge of the nursery while the mothers went visiting. So when they came to call, they brought their family along and stayed. Besides, unless people had a horse, there was no way of getting about other than on foot. So ladies took their families of young children along, packing the baby into the pram, wedging him in firmly with feeding bottles, infant necessities, a bag of needlework and the mother's little lace cap in a paper bag. After an early lunch they started immediately, prepared to make a day of it. The visit had been planned between the two ladies a long time ahead, weather permitting.

Average ladies had six children. When a family visited us the eldest wheeled the youngest in the pram. They all trooped through our gate. First the baby was exhibited, fed and put to sleep. Then the visitor took off her bonnet and put on her cap. The children dispersed to see dolls, pets and eat enormous quantities of fruit picked right off the trees. Our visitors were always very anxious about their families when they heard of all the plums, apples, cherries and pears they had eaten while the ladies sat sewing in the garden. Mother told

them not to worry and none of them ever died of it. Mother knew a certain number of families whom she invited to our garden for one long summer afternoon every year.

My big sister used to visit a friend who had three little girls the same ages as we three. We played with them while the ladies visited in the drawing-room.

Those children had all the things we did not, and we had what they did not. They lived on the waters of the Arm and had a boat. They had a pony and a big kennel of hunting dogs. Their Mama was stern and their Papa easy; *our* Father was stern, our Mother easy. Our garden was prim and theirs rambling.

Those friends were as far from town on the other side as we were from town on our side. There were two bridges to cross and ever so many different kinds of smells to pass through. From our own gate to the James' Bay Bridge wild rose bushes grew at the roadsides nearly all the way and their perfume was delicious. Then we came to the mud flats and our noses hurt with its dreadfulness when the tide was out. We had no sooner got over that than there was Chinatown with stuffy, foreign smells. Then came the gas-works— this smell was said to be healthful but it was not nice. Rock Bay Bridge had more low-tide smells, which were made easier by a sawmill; the new sawdust smelled so nice that you forgot your nose until the other end of the bridge came. There sat a tannery from which came, I thought, the worst smell of them all. There was one still more dreadful—Parker's slaughter-house and pig-gery—but that was two miles further on and we did not have to pass it on the way to call on our friends.

Sometimes our friends rowed us down to James' Bay Bridge in their boat and we slipped past all the smells and were home in no time.

In early Victoria there were family evening parties in which the father, mother and all sizes of growing children went together and at which they played cha-rades, dumb crambo, guessing games and forfeits. There was music, too, for nearly everyone could play at least one piece on the piano or sing a song or do a recitation, or they did things together. Nobody minded if it was not quite per-fect. Everyone laughed just the same. Everyone helped to entertain the others and you did some trick or told a story if you could not sing. My two big sisters went to Navy balls occasionally, but Father did not approve of the way Victoria mothers scrambled among the Navy to find husbands for their daughters. He was very strict; he had made a nice home for us and thought we should stay in it.

Another form of young Victoria entertainment was the church conver-sazione. The Bishop opened, shut and blessed the affair but the congregation did the talking. Conversaziones were held in the church schoolroom which

the ladies cut into little cubicles with benches—three sitting sides and one open. The benches were just close enough for one lady's lips to reach across confidentially to the opposite lady's ear. There was music for people who were not chatty and when everything had been done and encored tea was served. Young girls carried it to the cubicles. Both sexes and all ages came to conversaziones. You had to pay only two bits, which was twenty-five cents, for all the talking, listening, music, tea and the Bishop's blessing.

Presbyterians had what were called church socials but, as they were held in the church itself, personal conversation was very restricted. Dr. Reid told stories from the pulpit, there was choir singing and no tea.

As Victoria grew bigger, social groups grew smaller, selecting only those people who were congenial to each other. They became too a great deal more particular about the ability of performers and the quality of entertainment. Victoria stood like a gawky girl, waiting, waiting to be a grown-up city.

Servants

What with big families and only green little Chinese boys for servants, Victoria matrons were kept busy. The boys came from China at the age of twelve. It took much patience to teach these foreign children our language as well as how to work.

English servants who came out to Canada did so with the firm determination of finding a husband in a hurry and of making homes and raising families who would be not servants but masters. While waiting for the husbands these women accepted positions, grumbling from morning till night at the inconveniences of the West. There were hosts of bachelors trying to make good in this new world—men who were only too willing to marry a helpmate. Love did not much matter if she was competent and these women in their turn were glad enough to go through drudgery and hardship if they were working for themselves and for their own independence. Man and wife each got something from the bargain and pushed forward, keeping step choppily, getting used to each other's gait. While these imported-from-England domestics were creating a class to put themselves into, Victoria ladies made do with raw, neat pigtailed, homesick China boys. Many a muddly housewife, accustomed to good servants in the Old Country, had first herself to learn how to run a house before she could teach her Chinese help.

The Chinese all wore clothes cut from exactly the same pattern—long black pants, loose white shirts worn outside the pants, white socks and aprons, cloth

shoes with soles an inch thick and no heels. They scuffed along with a little dragging slip-slop sound.

The Chinese kept themselves entirely to themselves like rain drops rolling down new paint—learning our ways, keeping their own. When their work was done they put on black cloth coats made the same shape as their white shirts, let the pigtail which had been wound round their heads all day drop down their backs, and off they went to Chinatown to be completely Chinese till the next morning. They learned just enough of our Canadian ways to earn Canadian money—no more.

Our Chinaboy, Bong, was not pretty—he was pock-marked; but Bong was a good boy and was part of our childhood. He came to Mother at the age of twelve, green and homesick, without one word of English. When things were more than Bong could bear he sat down and cried. Then Mother patted his shoulder as if he had been one of her own children and said, "Come on, Bong, be a good boy," and Bong would rub his big sleeve across his eyes, run out to the barn and sing a little Chinese song to the cow. The cow was a great comfort to Bong. She would stop chewing, roll back her ears and listen to the Chinese words as if she understood them. Bong loved her.

Bong stayed with us for many years. We were all as fond of him as one could be of anything holding itself so completely aloof. He seemed really to love my little brother. When Bong went back to China to see his mother, he left a hole in our kitchen and a hole in the cow yard, queer, foreign holes, belonging and not belonging to us, for Bong never had become one bit Canadian in all the years he worked for us in Canada.

There was Wash Mary too, an Indian woman who came to wash for Mother every Monday. She was gentle, had a crinkled-up skin and was so small she had to stand on a block to reach her washtub. The Indian in Mary was more human and understandable than the Chinese in Bong.

The wash-house was across the yard. First Mary lit the stove; then she hung her shawl up on a nail and there was her thin, lumpy little body, buttoned into a pink print dress with a very full skirt reaching right to her bare feet. But her clothes were western, not eastern like Bong's. She took off the black silk hand-kerchief that bound her head. Her hair, thick and black, stood up from both sides of the parting that began at her forehead and ended at the back of her neck. On each side the hair was roped into a thick plait. The right plait had nothing to do with the left till after it had reached and rested on her shoulder blades; then the plaits were united again, tied together with a bit of string and looped across Mary's shoulders like a strong, splendid handle.

Mary was a wonderful washer. The suds boiled up to her shoulders and the steam about her faded the wrinkles till she looked almost young. Up and

down, up and down, she went over her washboard, her brown eyes staring and her mouth tied up in puckers. It was a big mouth that could hold six clothes pins at once. After our lines were full of washing and Mother's clothes white as snow, and after Mary had enjoyed a good dinner in our kitchen, she shut herself into the wash-house and washed and dried all the clothes she wore, drying them quickly over the fire. Then she knotted her dollar into the corner of her new-washed handkerchief and went smiling out of the gate.

Mary was not a Songhees Indian. She lived in a little house in Fairfield.

East and West

C hinaman and Indian played a very real part in young Victoria.

The Chinaman shuffled along in heelless shoes with his vegetable or fish baskets swinging. He peddled his wares with few words. The Indian's naked feet fell pat-pat upon the earth roads. It was the Chinese man but the Indian woman who shouldered the burden. The Chinaman's wife was back home in China. The Indian rolled leisurely and with empty hands, behind his squaw. A cedar-root burden basket of her own weaving was slung across the woman's back, steadied by a woven pack strap worn across the chest. Women of some tribes wore the strap across their foreheads, pushing their heads forward against the burden's weight.

The Indian squatted upon each doorstep to rest. The Chinaman never rested—he kept up his mechanical jog-trot all day. He lived frugally, sending the earnings of his brown, calloused hands and his sweating toil home to China. The Indian wasted no sweat on labour—he took from nature those things which came easiest. What money he earned he spent in the nearest store immediately, exchanging it for whatever pleased his eye or his stomach. The Indian's money circulated; he had no idea of its value nor of saving it. The satisfying of immediate needs was enough for him. To our sombre landscape his careless picturesqueness was an enrichment. He was the link between the primitive and civilization. Unlike the Chinese vegetable gardener who forced the land to produce so that he might make money from it, money to send back to China, taking the land's goodness, not caring to put anything back, the native Indian sat staring, enjoying leaving Nature to do her own work while he got along with a minimum of exertion and a great deal of happiness.

The white man more or less understood the childlike Indian; he belonged to his own hemisphere. The Oriental eluded him.

A Cup of Tea

One night an Indian family beached their canoe on the shore below Cook Street. Indians were allowed to pitch a tent and remain the night on any beach during their long canoe journeys up and down the Coast. This party of Indians was coming to Victoria but there was no hurry, the waves were high and night came down. The canoe contained the family and all they owned. There was a man, a woman, three children, one dog, two cats, a crate of fowls, besides a tent, bedding, cooking utensils, fishing gear, clothes and odd bits of hoarded possessions gleaned from Nature's bounty or from man's discards.

They flung an old tent across a conveniently low willow bough that stuck out of the bank. The unpegged sides of the tent flapped and billowed in the wind, rain drizzled. They tossed the bedding under the tent. The man, dog and cats crept at once into its cosiness.

The woman and children huddled round a low beach fire, tending the black iron cooking-pot and the tall tin for the brewing of tea. A sleeping child was tucked among the shapeless folds of the woman's motherliness, under her shawl. The movement of her arms across his sleeping body did not disturb him when she mended the fire. She was tired with his heaviness and from the sweep of her paddle all day long. She yawned, lolled back against a log and swept the bay with eyes used to judging what wind and waves were up to. Suddenly she called to her man; a lazy hand raised the canvas. The man followed with screwed-up eyes the woman's pointing finger.

Out in the bay a lone Chinaman in a clumsy fish-boat was wrestling with his sail. The unwieldy craft lay over first to one side, then to the other, her sail almost flat to the water. That the man in her did not tip out was a marvel.

The Indian man and woman left their fire and their supper. Waddling across the pebbles, they launched the heavy canoe. The woman laid her baby in the bow, close under the canoe's wolf-head prow, while she did a full share of the shoving and grunting necessary to launch the craft. It was she who stepped into the icy water to give the final freeing push, then she got into the canoe which was already staggering among the waves. She took her steering paddle and directed the canoe how to cut each wave. The man doggedly dipped, dipped, dipped his paddle, giving force, but not guidance.

They helped the Chinaman to ship his sail and clamber into their canoe. They brought him ashore, towing his boat behind them.

The Chinaman's face was a greenish mask; nervous grins of gratitude were strewn over it. He sat himself uncomfortably on a log near the Indians' fire.

They squatted round their fish pot, dog and cats skulked near, hoping. The man dipped, the woman and the children dipped. The Chinaman dipped but, too embarrassed, ate sparingly. No words were spoken. The only sound was that of clams being sucked from their shell and the brittle rap of the empties flung among the stones.

The woman poured tea into a tin cup and passed it to the Chinaman. The sham grin left the man's face, his Oriental mask dropped. Bowing to the woman, he raised the steaming liquid to his lips, made a kissing sound into the tea and sluiced its warmth noisily into every corner of his mouth before the great gulps gurgled down his throat. The woman nodded.

"Uh-huh!" she said, and smiled.

Cathedral

C hrist Church Cathedral sat on the top of Church Hill. The Hill sloped gently to the town on its north side and sharply down to James' Bay on the south, with shelves and sheer drops where rock had been blasted out for road-making.

A French family by the name of Jourand built Roccabella, a large boarding-house on the south side of Church Hill just below the Cathedral. It had a beautiful garden and was a quietly superior place in which to stay, holding its own even after modern conveniences in other boarding-houses overtook its level, clinging to its little open fireplaces and defying central heating. English guests particularly favoured Roccabella. They liked the sound of the Cathedral bells that came quavering in through their windows. They liked to sit by their own particular fire and to look across James' Bay to the snowy Olympics.

The first Cathedral was burned down. The one I remember was built of wood and had a square tower with a cross on top. As Victoria grew they kept adding wings and more wings to the Cathedral till it looked squat and mother-hennish. Brick and stone churches sprang up in other parts of the city but the national significance of the old wooden Cathedral, sitting on the top of its hill, made it, in comparison with the others, like the star on top of a Christmas tree. The tree's other ornaments seemed mere baubles. Christ Church Cathedral was the emblem of our National Faith. It meant something to every Briton, whether he realized it or not, whether he were Methodist, Presbyterian, Roman Catholic, no matter what he worshipped, even if he professed no religion at all. There was something particularly British, something secure about it.

Our family did not attend Christ Church Cathedral. Mother went to the Reformed Episcopal Church on Humboldt Street. Church Hill was too steep for her to climb and anyways she liked the evangelical service.

Bishop Cridge of the Reformed Episcopal Church had once been Dean of the Cathedral, but, long before I can remember, he and Bishop Hills had had a bitter clash of conscience—"High" and "Low", that same old controversy that never will be settled while people are people. Spiteful folks spoke of this church split as "the Big Church kicking the Little Church down the hill." The little church smiled up from the mud flats, the Cathedral frowned down, austere and national, and Victorians chose High or Low, whichever comforted them most.

Cemetery

T he first cemetery that I can remember was on Quadra Street. It was only one-half block big and was already nearly full when we went through it coming from church one Sunday morning. It had a picket fence and was surrounded by tall, pale trees whose leaves had silver backs. Except for what care relatives gave the graves, it was a wild place, grave being tied to grave by a network of brambles and vines. There were one or two handsome headstones among the mat of wild and tame, flowers and weeds—interwoven growth. It was a favourite nesting place for the few shy birds that were native to British Columbia.

On the far side of the cemetery the Chinese had erected a great stone altar on which they placed whole pigs roasted and great piles of white cakes, looking like pure grease, to please the appetites of their dead who lay in rows in front of unpainted headboards with only Chinese characters written on them. The graves were as much alike as the Chinese themselves had been in clothes, pigtails and customs in life. There those foreigners lay, temporarily pitted, like winter vegetables. When there were bones enough they would all be gathered together from the graves and shipped back to China.

When the old Quadra Cemetery was quite full, its gates were closed and it was left to go entirely wild. Only the very tallest monuments could peer above the bushes. They seemed to say, "Hush!" as we children clattered past on our way to school.

Victoria had made a big new cemetery at Ross Bay, much farther out of town. Funerals took far longer then. The horses were not allowed to go faster than a walk as long as the corpse was behind them. They might trot as briskly as they liked back to town with the empty hearse behind them. Hayward's

hearse had six enormous black plumes waving over the top of it. They swayed and writhed and were considered most dignified and in very good taste. Mr. Storey, the rival undertaker, had a hearse with six fuzzy black things on top having waists like the forms dressmakers used for fitting; they had woolly tails hanging down all round, waggling and lashing as the hearse went over the bumpy roads. They looked like six angry monkeys dancing over the coffin. Crêpe streamed from the hats of the undertaker, the driver, the widows' bonnets, the carriage whips and the knobs of the house doors where death waited for the hearse. The horses that dragged the dead were black and wore black plumes nodding on the top of their heads, black nets over their backs with drooping mournful fringes that ended in tassels tumbling over the shafts. Dead children had a little white hearse with white ponies and white nets and plumes. Funerals were made as slow and nodding and mournful as possible.

Every friend of the dead who owned a chaise or buggy and some hired hacks joined in the procession. Nobody thought of crossing the path of a funeral; people stood holding their hats in their hands with heads bowed patiently until the procession had passed. People drew down their front blinds as a funeral passed their houses. In Victoria the dead were buried as leisurely as the living lived.

The first graves in Ross Bay Cemetery looked very lonely and far apart, because Episcopalians could not lie beside Nonconformists, nor could Catholics rest beside Episcopalians. Methodists, Chinese, paupers buried by the City and people who believed in nothing at all, had to lie each in a separate part of the cemetery.

There were wide, gravelled driveways among the graves. Some of the graves were like little, low-walled gardens filled with flowers. This cemetery had a gravekeeper who kept the graves from getting muddled together with weeds and brambles.

But the waves of Ross Bay boomed against the cemetery bank and broke it. They bit into the earth, trying to wash out the coffins. They seemed to say, "I, the sea, can take better care of you, the dead, than the earth can. My gulls will cry over all of you alike. In me all denominations can mingle."

Schools

It took a generation and a half for English settlers in Victoria to accept the Canadian public school which they insisted on calling the "free school". They turned their noses up at our public schools as if they had been bad smells, preferring to send their children to old, ultra-genteel-hard-up English

Ladies' Academies. Of these there were quite a few in Victoria; in them learning was confined to good manners. Politeness-education ladies had migrated to Canada, often in the hope of picking up bread and butter and possibly a husband, though they pretended all the while that they had come out on a very special mission—to teach the young of English-born gentlemen how not to become Canadian, to believe that all niceness and goodness came from ancestors and could have nothing to do with the wonderful new land, how not to acquire Colonial deportment, which was looked upon as crude, almost wicked. The only teaching qualifications these ladies possessed, and for their services they charged enormously, had been acquired by generations of habit.

So young ladies whose papas had sufficient means learned English manners—how to shut a door, how to bow gracefully, how to address people of their own class and how a servant, how to write a dignified letter in beautiful script, how to hold their heads up, their stomachs in and how to look down their noses at the right moment. For all this the old ladies were very handsomely remunerated and the girls' brains remained quite empty. Canadian public schools taught book learning but no manners to speak of.

My parents sent their two eldest daughters to a Ladies' Deportment Academy. Their next three children died before they were of school age. We four younger children were sent to the Public School. Father said we could "learn manners at home", but we could not get education in those days at the private school out west.

Later, Angela College, a Church School for girls, was built and endowed by Lady Burdett-Coutts. A red brick building, it stood on Church Hill. Education in it was costly. All our friends went to Angela College, but Father was by this time so prejudiced against private schools that he sent us to the Public School and was very much criticized for doing so. Our manners were watched closely and apprehensively by our friends. It hurt Mother but Father was proud that all his children, with the exception of me, were good students by Canadian standards. I hated school with the exception of the first two years when, being too young for so long a walk, I went to Mrs. Fraser's school for little girls near our own house.

Mrs. Fraser had large white teeth, a great many little dogs and a brother, Lennie, who kept house for her while she taught school. We sneaked potatoes out of Lennie's fry-pan as we trooped through the lean-to kitchen so as not to track dirt into Mrs. Fraser's front hall. The dunce stool was very comfortable—much more so than the wooden forms where the good pupils sat; I had ample opportunity of knowing. You could almost say the dunce's stool was 'specially mine.

The thing that I loved best at Mrs. Fraser's school was a big book of *Grimm's Fairy Tales* owned by a girl called Lizzie. At lunch time out in the mint bed in the backyard we went fairy and under the school desk when Mrs. Fraser was busy with a sick dog or a pupil's mama we seized other snatches.

By and by other English settlers began to send their children to the Public School and the High School too; then that old ladies' type of private school faded out of existence because education required a certain standard set by our Public School system if people expected to obtain positions in Canada.

Those families who were able to send their sons and daughters to England to be "finished" did so. They came back more exaggeratedly English than the English themselves, "patering" and "matering" their father and mother, saying "Awfully jolly, don't you know!" and "No, not rawlly!" At first it seemed to us Canadians as if that "No" meant "You lie!" By and by, however, we found that it was only an English elegance in vogue just then.

Christmas

Victoria Christmas weather was always nippy—generally there was snow. We sewed presents for weeks before Christmas came—kettle holders, needle books, penwipers and cross-stitch bookmarkers. Just before Christmas we went out into the woods, cut down a fir tree and brought it home so alive still that the warm house fooled it into thinking spring had come, and it breathed delicious live pine smell all over the house. We put fir and holly behind all the pictures and on the mantelpiece and everywhere.

Plum puddings were dangling from under the pantry shelf by the tails of their boiling cloths. A month ago we had all sat round the breakfast-room table, stoning raisins while someone read a story aloud. Everyone had given the pudding a good-luck stir before it went into the bowls and was tied down and boiled for hours in the copper wash boiler while spicy smells ran all over the house. On Christmas Day the biggest pudding came out for a final boil before being brought to the table with brandy fire leaping up its sides from the dish, and with a sprig of holly scorching and crackling on its top.

On Christmas Eve Father took us into town to see the shops lit up. Every lamp post had a fir tree tied to it—not corpsy old trees but fresh cut firs. Victoria streets were dark; this made the shops look all the brighter. Windows were decorated with mock snow made of cotton wool and diamond dust. Drygoods shops did not have much that was Christmassy to display except red flannel and rabbit fur baby coats and muffs and tippets. Chemists had

immense globes of red, green and blue medicine hanging from brass chains in their shop windows. I wished some of us could be sick enough for Dr. Helmcken to prescribe one of the splendid globes for us. The chemists also showed coloured soap and fancy perfume in bottles. Castor oil in hideous blue bottles peered from behind nice Christmas things and threw out hints about over-eating and stomach-ache. A horrid woman once told my mother that she let her children eat everything they wanted on Christmas Day and finished them up with a big dose of castor oil. Mr. Hibben, the stationer, was nicer than that woman and the chemist. He hid all the school books behind story books left open at the best pictures. He had "Merry Christmas" in cotton wool on red cardboard in his window.

It was the food shops that Merry Christmassed the hardest. In Mr. Saunders', the grocer's, window was a real Santa Claus grinding coffee. The wheel was bigger than he was. He had a long beard and moved his hands and his head. As the wheel went round the coffee beans went in, got ground, and came out, smell and all. In the window all round Santa were bonbons, cluster raisins, nuts and candied fruit, besides long walking-sticks made of peppermint candy. Next to this splendid window came Goodacre's horrible butcher shop—everything in it dead and naked. Dead geese and turkeys waggled, head down; dead beeves, calves and pigs straddled between immense meat hooks on the walls; naked sheep had bunches of coloured paper where their heads ought to have been and flowers and squiggles carved in the fat of their backs. Creatures that still had their heads on stared out of eyes like poached eggs when the white has run over the yolk. Baby pigs looked worst of all—pink and naked as bathing babies, their cheeks drawn back to make them smile at the red apples which had been forced into their toothless, sucking mouths. The shop floor was strewn deep in sawdust to catch blood drips. You heard no footsteps in the shop, only the sharpening of knives, sawing of bones, and bump, bump of the scale. Everybody was examining meat and saying, "Compliments of the Season" to everyone else, Father saying, "Fine display, Goodacre, very fine indeed!" We children rushed out and went back to Santa while Father chose his meat.

The shop of old George, the poulterer, was nearly as bad as Goodacre's, only the dead things did not look so dead, nor stare so hard, having shut the grey lids over their eyes to die. They were limp in necks and stiff in legs. As most of them had feathers on they looked like birds still, whereas the butcher's creatures had been rushed at once from life to meat.

The food shops ended the town, and after that came Johnson Street and Chinatown, which was full of black night. Here we turned back towards James' Bay, ready for bed.

There was a high mantelpiece in the breakfast room. And while we were hanging our stockings from it my sister read:

"'Twas the night before Christmas and all through the house

Not a creature was stirring, not even a mouse."

On the way to bed we could smell our Christmas tree waiting in the dining-room. The room was all dark but we knew that it stood on the floor and touched the ceiling and that it hung heavy with presents, ready for tomorrow. When the lights were lit there would be more of them than any of us children could count. We would all take hands and sing carols round the tree; Bong would come in and look with his mouth open. There was always things on it for him but he would not wait to get his presents. He would run back to his kitchen and we would take them to him there. It seemed as if Bong felt too Chinese to Christmas with us in our Canadian way.

The Presbyterian Church did not have service on Christmas morning so we went to the Reformed Episcopal with my sister; Father stayed home with Mother.

All the week before Christmas we had been in and out of a sort of hole under the Reformed Church, sewing twigs of pine onto long strips of brown paper. These were to be put round the church windows, which were very high. It was cold under the church and badly lighted. We all sneezed and hunted round for old boards to put beneath our feet on the earth floor under the table where we sat pricking ourselves with holly, and getting stuck up with pine gum. The pricking made the ladies' words sharp—that and their sniffy colds and remembering all the work to be done at home. Everything unusual was fun for us children. We felt important helping to decorate the Church.

Present-giving was only done to members in one's immediate family. Others you gave love and a card to, and kissed the people you did not usually kiss.

New Year's Day had excitement too. It was the custom for ladies to stay at home, sitting in their drawing-rooms with decanters of wine and fine cakes handy. Gentlemen called to wish them the "Compliments of the Season". Right after lunch we went up to Mother's room where you could see farthest down the street, to watch for Mother's first caller, and it was always the shy Cameron brothers, coming very early so as to avoid other visitors.

Gentlemen paid their respects at Government House, too, on New Year's Day, and Naval officers made a point of returning the hospitality of those who had entertained them while stationed in Victoria.

Regatta

The beautiful Gorge waters were smooth as glass once Victoria Harbour had been crossed. The Gorge was an arm of the sea which ran into the land for three miles. Near its head was a narrow rocky pass with a hidden rock in the centre which capsized many a canoe and marooned many a picnic party above the Gorge until long after midnight, for when the tide was running in or out through the pass there was a four-foot fall with foam and great roaring. A bridge ran across from one side of the Gorge to the other, high above the water. The banks on both sides of the Arm were heavily wooded; a few fine homes snuggled among the trees and had gardens running to the water. Most of the other property was public—anyone could picnic on it.

The waters of the Gorge were much warmer than the water of the beaches round Victoria. Jones' Boathouse beside James' Bay Bridge rented out boats and canoes; many people living along the harbour front had boathouses and boats of their own, for regattas and water sports were one of Victoria's chief attractions. Visitors came from Vancouver and from the States on the 24th of May to see them.

The Navy and the Indian tribes up and down the Coast took part in the races, the Navy rowing their heavy ship's boats round from Esquimalt Harbour, manned by blue-jackets, while smart little pinnaces "pip-pipped" along commanded by young midshipmen. The Indians came from long distances in their slender, racing dugout canoes—ten paddles and a steersman to each canoe.

The harbour was gay with flags. Races started from the Gorge Bridge at 1 P.M. Our family went to the Regatta with Mr. and Mrs. Bales. Mr. Bales had a shipyard just below Point Ellice Bridge, at the beginning of the Arm waters. We got into Mr. Bales' boat at the shipyard where unfinished boats stood all round us just above high tide. They looked as we felt when we shivered in our nightgowns on Beacon Hill beaches waiting for the courage to dip into the sea. But rosy-faced Mr. Bales eased his boats gently into the water; he did not seize and duck them as my big sister did us.

When the picnic was all stowed into Mr. Bales' boat we pushed out into the stream and joined the others—sail boats, canoes, rafts and fish boats, all nosing their way up the Gorge along with the naval boats and war canoes. There were bands and mouth-organs, concertinas and flags. The Indian families in their canoes glided very quietly except for an occasional yapping from one of their dogs when he saw a foe in another canoe.

There was the hollow rumble of traffic over Point Ellice Bridge as we passed under it. Dust sprinkled down between the planks and fell on us. Out-of-town people came to the Regatta in wagons and buggies, driving up the Gorge Road on one side of the Arm or the Craigflower Road on the other side, tying their horses in the bush and carrying their picnic baskets through the woods to the shore. People lit small fires and picnicked near the water's edge where they could see the races pass.

The races started from the Gorge Bridge, came down the Arm, turned round Deadman's Island, an old Indian burial ground, and returned to the bridge.

The Indian canoe races were the most exciting of all the Regatta. Ten paddles dipped as one paddle, ten men bent as one man, while the steersman kept time for them with grunting bows. The men had bright coloured shirts and gay head-bands; some even had painted faces. The Kloochman's was an even grander race than the Indian men's. Solid, earnest women with gay shawls wound round their middles gave every scrap of themselves to the canoe; it came alive and darted through the water like a flash, foam following the paddles. The dips, heaves and grunts of all the women were only one dip, heave and grunt. Watchers from the banks yelled; the Indians watched from their canoes by the shore, with an intent, silent stare.

The Bluejacket Races were fine, too. Each boat was like a stout, brave monster, enduring and reliable—the powerful, measured strokes of the British Navy, sure and unerring as the earth itself, not like the cranky war canoes, flashing through their races like running fire.

At the end of the Regatta came something mean and cruel. An old hulk was towed to midstream; a long pole hung over the water at one end of her, and, suspended from its tip, was a crate crammed full of agonized pig squeals. The pole was greased and men tried to walk out to the end of it and dislodge the crate. The pole was supple, the crate swayed as each man crept out clinging desperately and finally fell off into the sea. The terrified pig in the crate squealed. People roared with laughter and greasers applied fresh grease for the next person's try. When at last a man was successful and with a great splash crate and pig plunged into the sea, sailors hurried to pull it into a boat before the poor pig drowned.

The band blared, "God Save The Queen" and everyone on the banks and in the boats raised their hats and sang with the band. "Queen! Queen!" echoed back from the trees and the rocks.

The wet, shivering pig in his crate did not care whether the Queen were saved or not. "God save *me!*" was his imploring squeal.

Characters

S trange characters came to little Victoria. It seemed as if people who could not fit in anywhere else arrived here sooner or later till Victoria poked, bulged and hollowed over queer shapes of strange people, as a snake, swallowing its food whole, looks lumpy during digestion. Victoria had some hard lumps to digest.

Sometimes they came, hurried by a firm push from behind given by relatives in the Old Country, around whose necks they had hung too heavily for many years, and who said, "Now that travel is so easy, why not, dear? . . . Door to door without a stop! . . . Such an adventure! Victoria is a crown colony, not Canadian—try it, darling!" So the "darlings" whose lives from birth had been humdrum, especially since the rest of the family had married and left the old home to them and nothing for its upkeep, nibbled at the thought, grabbed for the word "adventure", sold up and sailed. Relatives saw them off, calling them "old sports", begging them to write—they, who had never had anything to write about in their whole lives were now launched proudly into adventure.

Sometimes it was a bachelor brother and spinster sister of the glued-together type of family remnants.

After the whistle shrieked every mile of water washed the old land away fainter and fainter and hurried them into the unknown. They began to ache—such vast quantities of water! Such vast quantities of land! The ache grew and grew. By and by they saw the western forests and the little town of Victoria drowned in silent loneliness; there was then no describing how they felt. They rented uncomfortable, mean little cottages or shacks and did with incompetent hands what well-trained Old Country servants had all their lives done for them. Too late! Turning back was impossible; the old home was sold, its price already seeping away too fast. There were many of these sad people in Victoria, shuddering when they saw a Western funeral, thinking of the cosiness of Old Country churchyards.

There were maiden aunts, who had attached themselves to the family circle of a married brother and who undertook the diction and deportment of his children, bitterly regretting the decision of Brother to migrate to Canada, but never for one moment faltering in their duty to Brother's family, standing between his children and colonialism. The Maiden Aunts swallowed their crosses with a difficult gulp. Auntie's job was discounted in the New World; Canadian-born children soon rebelled at her tyranny. She sank into a wilted homesick derelict, sniffling by the fireside while the mother learned more or less to work with her own hands, so that she could instruct what Auntie called

her "heathen help" in kitchen low art. Auntie herself refused to acknowledge base presences such as cook-stoves and wash-tubs.

In our family there were no maiden aunts. Our delicate little Mother had six living children and three dead ones and, with the help of her older daughters and the Chinese boy, Bong, we managed very comfortably without aunts. Many a useless servant-dependent woman from the Old Country was shown by my mother how to use her own hands and her own brain in her Canadian home with no other help than green Chinese boys.

In Toronto Street over James' Bay way there lived a most astonishing family, consisting of two brothers, Fat O'Flahty and Lean O'Flahty and a sister, Miss O'Flahty. All were above middle age. They built a shanty entirely of driftwood which they gathered and hauled from the beach. They might be seen any hour of the day or night trundling logs home on a wheel-barrow, taking long rests on its handle while they smoked a pipe. The brothers never sawed the driftwood but used it any length, just as it came out of the sea—mostly longish, round tree trunks rubbed smooth by rocks and sea on their long swims, where from no one knew.

The O'Flahty's house looked like a bonfire heaped ready for lighting. The only place where the wood of the entire shanty was halfway level was at the ground and even there it was bumpy. The up ends of all the logs higgledy-piggledied into the sky, some logs long, some short. The door was made of derelict planks gathered on the beach, too, and the roof was of anything at all—mostly of tin cans. It had a stovepipe sticking through the top. The fence round the O'Flahty's small piece of ground was built to match the house.

The O'Flahtys had lived in this strange house for some years when Mother heard that Miss O'Flahty was very ill. She sent us post haste down, with some soup. We knocked on the gate which was padlocked. Fat O'Flahty came and let us in. We walked on a plank up to the door which was also padlocked.

"She's bad," he said and led the way into the shanty.

It was nearly dark and very smoky. In the centre of the one room stood a jumble of drift logs standing upright to make a little room. Fat O'Flahty moved two logs aside and, when we were accustomed to the dark, we saw a white patch lying in the corner. It was Miss O'Flahty's face. Her bed was made of logs too. It was built on the floor and had no legs. There was no space for us to step inside Miss O'Flahty's bedroom. There was scarcely room for even our looks to squeeze in.

Fat O'Flahty behind my sister said, "Does she look awful sick?" and Lean O'Flahty peering behind Fat with some of the soup in a tin cup, said also, "Does she seem turrible bad?" Their voices were frightened. Lean O'Flahty

held the tin cup of soup towards the sick woman. The dim patch of white face in the corner shook a feeble "No". The brothers groaned.

Miss O'Flahty died. Lean and Fat had her embalmed and put her into a handsome casket. She rode to the Outer Wharf in the same wheel-barrow which had lugged their building wood from the beach. The brothers trundled it. We were down at the Outer Wharf, seeing Auntie away by the San Francisco boat. "Ouch! It's a coffin!" squealed Auntie as her cloak brushed it. Far and Lean O'Flahty were sitting one on either handle of the barrow, crying. When all were aboard, the brothers, each with a fist in his eye and with loud sniffs, wheeled the coffin down between decks and the O'Flahty family disappeared. Next time we passed down Toronto Street their crazy house was gone too.

Another human derelict was Elizabeth Pickering—she wore a bright red shawl and roamed the streets of Victoria, intoxicated most of the time. Occasionally she sobered briefly and went to the kindly Bishop to ask help. The Bishop handed her over to his maiden sister who specialized in correction. Elizabeth would settle herself comfortably, drawing a chair to the fire to toast her toes and doze till she became thirsty again. Then, with a great yawn, she would reach for the little packages the Bishop's wife had put near her on the table. Regardless of whether Aunt Cridge had finished her lecture on drink or not she would rise with a sympathetic, "Feelin' yer rheumatics today, baint ye, pore soul? Me and you suffers the same—its crool!"

Old Teenie was another familiar figure of our school days. Teenie was half negro—half crazy. Her hut was on Fort Street in the centre of a rough field and lay a little below street level. Boys used to throw stones onto her tin roof and then run away. Out came old Teenie, buzzing mad as a whole nest of wasps. Muttered awfulness came from her great padded bonnet. It shook, her tatters shook, so did wisps of grey hair and old Teenie's pair of tiny black fists.

I don't know who looked after Teenie. She scoured with stick and sack the ditches and empty lots, putting oddments into her sack, shaking her stick at everyone, muttering, always muttering.

Nobody questioned where these derelicts came from. They were taken as much for granted as the skunk cabbages in our swamps.

Victoria's queer people were not all poor, either—there were doddering old gentlemen. I can remember them driving about Victoria in their little buggies—the fatter the man, the smaller the buggy! They had old nursemaid horses who trundled them as faithfully as any mammy does her baby in its

pram. Every day, wet or fine, the horses aired their old men on Dallas Road. Knowing that their charges slept through the entire outing, the faithful creatures never moved from the middle of the road nor changed from a slow walk. The public also knew by the lolling heads and slack reins that the old men slept and gave their buggies right of way. Street traffic was not heavy, time no object. Chaises, gentlemen's high dog-carts passed the nursemaid horses briskly. The dog-carts paused at roadhouse bars and again overtook the patient plodding horses who walked their charges to a certain tree on Foul Bay Road, circled it and strolled home again just as the old men's Chinese cooks put their dinner on the table. The old horses were punctual to the dot.

One of these old men was very fond of children. When he met us, if he happened to be awake, he pulled up with a wheezy "Whoa", meant both for us and for his horse. Taking a screw of paper from his pocket he bent over the wheel and gave us each a lollipop and a smile. He was so ugly that we were afraid, but Mother, who knew who he was told us he loved children and that it was all right. If, however, we saw his buggy coming in time we hid until it was past; he was such a very ugly old man!

A family we knew had one of those "Papa's-sister" Aunts who took it upon herself to be a corrector of manners not only for her own nieces but for young Canadians in general. In fact she aspired to introduce elegance into the Far West. This elegant and energetic lady walked across Beacon Hill at seven-thirty on fine summer mornings, arriving at our house in time for family prayers and breakfast. In site of her erect carriage she could flop to her knees to pray as smart as any of us. That over, she kissed us all round, holding each at arm's length and with popping, piercing eyes, criticized our tooth-brushing, our hair ribbons, our finger nails, recommended that we eat more porridge or less, told Mother to give us no raw fruit at all, always to stew it, no stone fruit at all, no candy, told us never to ask for second helps, but wait to be invited, had us do a little English pronouncing, then, having made us late, said, "Hurry! hurry! Lateness is unpardonable, dears! Ladies are never late."

Then there were Brother Charlie and Sister Tilly, evidently sworn each to see other into the grave. This pair minced up Birdcage Walk like elderly fowls, holding their heads each a little to one side—Charlie so that Tilly's lips could reach his deaf ear, Tilly so that she might direct her shriek straight into Charlie's drum. The harder she shrieked the higher she squeaked. Charlie, on the other hand, was far too gentlemanly to speak in public places above a whisper which he could not hear himself, so he felt it safest always to say "Yes,

yes, dear Tilly" or "Exactly so, Tilly dear" when he should often have said, "No, Tilly, certainly not!"

Brother and sister whispered and squeaked up Birdcage Walk where they lived. They hopped up the two steps to the inset door of their cottage and cooed themselves in.

"Yes, yes, dear Tilly, yes!"

Loyalty

Medina's Grove was a gentle place; its moist mildness softened even the starch in Father and begged the twinkle that sat behind his stern grey eyes to come our. The Grove had not the sombre weight that belongs to the forest, nor had it the bare coldness of a windswept clearing. It was beautifully half real, like the place you fall into after the candle is blown our, and sleep is just taking hold of you.

Victoria had to be 'specially loyal because she was named after the Queen. To her the most important day, after Christmas Day of course, was the Queen's Birthday, on the twenty-fourth of May. We made more fuss over the Queen's Birthday than did any other town in Canada.

May is just about our most lovely month. The lilacs, the hawthorn, the laburnums and the broom are all in blossom, just begging the keen Spring winds to let their petals hang on till after the twenty-fourth so that Victoria can look most splendid for the Queen's Birthday. On the twenty-third, one often had to stand on the chopping block and, hanging onto the verandah post with rain spittering in your face, sing right up into the sky—

"Rain, rain go away.
Come again another day
When I cook and when I bake
I'll send you up a patty-cake."

Sometimes the rain listened, sometimes it did nor. But most of our twenty-fourths were fine which was lucky because on the Queen's Birthday we wore our Summer frocks for the first time.

Mother prepared a splendid picnic. Father left his business frown and his home sternness behind him. Rugs, food and the black billy for making tea, were packed into the old baby buggy and we trundled it straight down Simcoe Street. Simcoe Street passed the side of our place and ended in Medina's Grove. In May,

what with the new green on the bushes, the Medina's calves skipping about, and Medina Grove birds nesting, it was like fairy land. Sea air blew in from the beach, just one field away! Seagulls swooped down to look for picnic bits. The ground was all bumpy from being crowded with more new grass than the cows could ear. There were some big trees in the Grove, but not thick enough to keep the sun out. Every kind of delicious spring smell was there. It was not like being in a garden to play; the Grove was gently wild but had not the awe of the forest. Bushes grew here in little groups like families. Each picnic could have its own place quite private; just the laughs tumbled through the bushes and mixed. There were no gates to remember to shut, no flower beds you must not scoot across. You might pick anything you liked and eat as much picnic as you could. These Medina Grove picnics were our first Queen's Birthdays. By and by we grew older and steady enough to sit still in boats; then we went to regattas, up the Arm, on the twenty-fourth. The Queen's Birthday changed then. It was not so much our own day. A shadowy little old lady owned it.

This Queen, after whom Victoria was named, did not mean any more to me than a name. The older ones knew all about her and so I suppose they thought I did. It was Mrs. Mitchell who made the Royal Family stop being fairy and turned Royalty into real live people for me. Mrs. Mitchell was a little, frail, old woman. Henry, her husband, was an English nurseryman. They came from England and started a nursery garden not far from our house, at the time when farm land was being cut into small personal pieces. Mother went to see any new people who came to live near us, if she saw that they were lonely and homesick. Mrs. Mitchell was very homesick and very lonely. She said she loved me from the first time my Mother took me to see her, because I was fat and rosy just like an English child. But I was not an English child and I didn't love her because she was English. I loved Mrs. Mitchell because she loved creatures, and I loved her garden, too, with its long rows of nursery stock, and its beds of pinks and mignonette. Mrs. Mitchell was gentle, small and frail. She had a little weak voice, which squeaked higher and higher the more she loved. Her guinea fowl and I cracked it altogether. She had four speckled guinea fowl— she and Henry loved them as if they had been real children. They opened the door of their cottage and called, "Coom, coom, coom, pretty little dears"—and the guineas came mincing through the kitchen into the sitting-room, and jumped into their laps.

The Mitchells' nursery garden was next to a farm rented by Jim Phillips. Jim got angry because the guinea fowl flew over the fence into his grain field and he shot three of them. The old couple cried and cried. They took it to law and got the price of the guineas but the price of the birds' flesh meant nothing to them.

It was the life gone from their birds that they cried for. Never having any children the guineas had been next best. This last bird of their four they never let out of their sight. Jim Phillips was furious that he had to pay for the bodies of the other three especially as he knew it was only for love, not value, that they cried.

Mrs. Mitchell cuddled the last bird in her little black silk apron and bowing her head on his speckled back cried into his feathers mournfully rocking him and herself. She took the little pink bow out of her black lace cap and its long black ties dropped over her shoulders as she bent crying. There was always a little bunch of everlasting flowers sewn into her cap over one ear, brittle, dried up little things like chrysalises; she let these be. She had a whole floor of everlasting flowers spread to dry in her front room. They smelled like hay and were just as much alive after they had been dead for a whole year. She made wreaths of them for funerals. Everlasting flowers reminded people there was no death, she said.

I went very often to Mrs. Mitchell to try to cheer her over the guinea fowl, but it seemed I could not cheer her at all. The remaining guinea's wings were all drooped with loneliness and she held him in her lap nearly all day. I looked around the sitting-room to find something happy to say. The walls were covered with pictures of gentlemen and ladies cut out of the *London News* and the *Daily Graphic*. Grand ladies with frizzled hair and lots of necklaces, men with medals on and sashes across their chests.

"Q-u-e-e-n V-i-c-t-o-r-i-a", I spelled out.

"Is that the lady who has the twenty-fourth of May birthday?"

"Yes, my dear," Mrs. Mitchell sniffled into the guinea's feathers. "Yes, our most gracious Queen Victoria."

"Who is the man beside her?"

"The late Prince Consort, my dear, and this is the Princess Royal, and here is the Prince of Wales and Princess Beatrice."

"Who *are* these people?" I asked. "I thought Princes and Princesses just belonged to fairy tales. What have they to do with Queen Victoria?"

Mrs. Mitchell was very much shocked indeed. She stopped crying and, using the guinea fowl as a pointer, she went from picture to picture telling the bird and me who all the Royalties were, how old, whom they had married and so on. At last we came to a lady in a black frame with a bow of crêpe over the top of it and a bunch of everlasting flowers underneath. "Princess Alice", said Mrs. Mitchell with a long, long sniffle, "now a blessed saint," and she began to cry all over again.

I thought these picture people must be relatives of Mrs. Mitchell's, she seemed to know them so well and cried so hard about Alice. The Queen's picture was everywhere. I knew she was someone tremendous, though to me she had

been vague and far off like Job or St. Paul. I had never known she was real and had a family, only that she owned Victoria, Canada, and the twenty-fourth of May, the Church of England and all the soldiers and sailors in the world. Now suddenly she became real—a woman like Mother with a large family.

Mrs. Mitchell took a great deal of pains to get the Royal family straight in my head and it was lucky she did, because who should come our to Canada, to Victoria, that very year and pay a long visit to Government House, but the Princess Louise and the Marquis of Lorne! This excited Mrs. Mitchell so that she stopped crying. She, who never went our, found a bonnet that I had never seen before, put a dolman over her best silk dress, locked the guinea fowl safe in her kitchen and got into a hack with Henry, her smelling-bottle and her cap, in which was a new bunch of everlasting flowers. The cap was in a paper bag on Henry's knee. They drove to the house of Dr. Ashe on Fort Street where the procession was to pass and sat in a bow window and waved at the Princess. When she saw the Princess smiling and dressed in gay colours, she realized that her beloved Princess Alice had been dead longer than she thought and that Court mourning was finished. She went home and took the crêpe off Alice but she left the everlasting flowers.

Mrs. Mitchell watched the papers for every crumb of news of her Princess while the visitors were in Victoria—how she had gone sketching in the Park, how she used to go into the shops and chat with people; how once she went into a bake-shop to buy some cakes and stepped behind the counter to point out the kind to the baker who ordered her back, saying gruffly, "Nobody ain't allowed behind my counter, mum," and then when she gave the address, the baker nearly died of shame and so did Mrs. Mitchell as she read it.

Seeing Royalty waked again all Mrs. Mitchell's homesickness for England. They sold everything and she and Henry went back to the Old Country to die. She gave me a doctor's book on diseases and an empty box with a lock and key. I did not like the disease book and could never find anything important enough to lock up in the box; so I put it away on a high shelf. Mrs. Mitchell cried dreadfully when she left Victoria but kept saying "I'm going home, my dear, going home."

The journey nearly killed her, and England did quite. All her people were dead except distant cousins. England was different from what she had remembered. She sent me Gray's *Elegy in a Country Churchyard* and Henry wrote saying she was crying for me and for Victoria now as she had cried for England and Princess Alice and the guinea fowl. Then came a silver and black card "In Memoriam to Anne Mitchell"—then I had something to lock away in the little box, with a little bunch of everlasting flowers, the last that Mrs. Mitchell gave me.

Doctor and Dentist

When Victoria was young specialists had not been invented—the Family Doctor did you all over. You did not have a special doctor for each part. Dr. Helmcken attended to all our ailments—Father's gout, our stomach-aches; he even told us what to do once when the cat had fits. If he was wanted in a hurry he got there in no time and did not wait for you to become sicker so that he could make a bigger cure. You began to get better the moment you heard Dr. Helmcken coming up the stairs. He did have the most horrible medicines—castor oil, Gregory's powder, blue pills, black draughts, sulphur and treacle.

Jokey people called him Dr. Heal-my-skin. He had been Doctor in the old Fort and knew everybody in Victoria. He was very thin, very active, very cheery. He had an old brown mare called Julia. When the Doctor came to see Mother we fed Julia at the gate with clover. The Doctor loved old Julia. One stormy night he was sent for because Mother was very ill. He came very quickly and Mother said, "I am sorry to bring you and Julia out on such a night, Doctor."

"Julia is in her stable. What was the good of two of us getting wet?" he replied.

My little brother fell across a picket fence once and tore his leg. The Doctor put him on our dining-room sofa and sewed it up. The Chinaboy came rushing in to say, "House all burn up!" Dr. Helmcken put in the last stitch, wiped his needle on his coat sleeve and put it into his case, then, stripping off his coat, rushed to the kitchen pump and pumped till the fire was put our.

Once I knelt on a needle which broke into my knee. While I was telling Mother about it who should come up the steps but the Doctor! He had just looked in to see the baby who had not been very well. They put me on the kitchen table. The Doctor cut slits in my knee and wiggled his fingers round inside it for three hours hunting for the pieces of needle. They did not know the way of drawing bits out with a magnet then, nor did they give chloroform for little things like that.

The Doctor said, "Yell, lassie, yell! It will let the pain out." I did yell, but the pain stayed in.

I remember the Doctor's glad voice as he said, "Thank God, I have got all of it now, or the lassie would have been lame for life with that under her knee cap!" Then he washed his hands under the kitchen rap and gave me a peppermint.

Dr. Helmcken knew each part of every one of us. He could have taken us to pieces and put us together again without mixing up any of our legs or noses or anything.

Dr. Helmcken's office was a tiny two-room cottage on the lower end of Fort Street near Wharf Street. It sat in a hummocky field; you walked along two planks and came to three steps and the door. The outer room had a big table in the centre filled with bottles of all sizes and shapes. All were empty and all dusty. Round the walls of the room were shelves with more bottles, all full, and lots of musty old books. The inner office had a stove and was very higgledy-piggledy. He would allow no one to go in and tidy it up.

The Doctor sat in a round-backed wooden chair before a table; there were three kitchen chairs against the wall for invalids. He took you over to a very dirty, uncurtained window, jerked up the blind and said, "Tongue!" Then he poked you round the middle so hard that things fell out of your pockets. He put a wooden trumpet bang down on your chest and stuck his ear to the other end. After listening and grunting he went into the bottle room, took a bottle, blew the dust off it and emptied out the dead flies. Then he went to the shelves and filled it from several other bottles, corked it, gave it to Mother and sent you home to get well on it. He stood on the step and lit a new cigar after every patient as if he was burning up your symptoms to make room for the next sick person.

Victoria's dentist was a different sort of person. He shammed. "Toothache, eh?" he said in a "pretend" sorry voice with his nose twisted against one cheek or the other as if he felt the pain most awfully himself. He sat you in a green plush chair and wound you up to his eye. Then he took your head in his wide red hand that smelled of fancy soap and pushed back your cheek, saying, "Let me just see—I am not going to do anything." All the time he was taking something from a tray behind you and, before you knew where you were, he had nearly pulled the head off your neck.

I shouted, "You lied!" and got slapped as well as extracted, while the blood ran down my chin.

My Father never had a toothache till he was sixty years of age, nor did he lose a tooth. When the dentist said four of my second teeth needed to be filled, Father said, "Nonsense! Pull them out." The dentist said it was a shame to pull the teeth and his shamming nose twisted; but all the time he was looking over my head at my pretty sister who had taken me. He grabbed my head; I clenched my teeth. They bribed me with ten cent pieces and apples till I opened and then I was sorry and bit down on his fingers.

I knew a girl who liked the dentist, but she had only had her teeth filled, never pulled, and he gave her candy. One day she said to me, "I wonder what the dentist's name is? His initials are R.B."

"I know. It is Royal Beast," I said.

Beast was a word we were never allowed to use. I always called the dentist "Royal Beast" after that. It made me feel much better.

Chain Gang

The two sisters a lot older than I taught the two sisters a little older about many things, but when I was old enough to puzzle over these same things and to ask questions I was told, "Don't pester! Don't ask questions just for the sake of asking." But two years and four years make a lot of difference in the sense and understanding of a small girl. At six I was not able to grasp what eight and ten could, so there were gaps in my knowing and a great many things that I only half understood such as Saloons, and the Royal Family, and the Chain Gang.

One day we were going to town with my big sister and passed a lot of men working at the roadside by the Parliament Buildings. They wore unusual clothes and had little round caps on top of heads shaved so close they looked like peeled apples stuck on top of their bodies. They sat on big rocks and crushed smaller rocks into little bits with sharp pointed hammers—Crack, tap! Crack, tap! Two men stood behind the workers watching their every move. Each held a gun and never took his eyes off them for one moment, staring as hard as the men stared at the stones. Nobody's stare shifted and nobody spoke. There was only the unhappy tap, tap of the little hammers and the slow roll of each piece of rock rolling down the little stone piles, falling at the feet of the men like enormous stone tears.

I looked up at my sister to ask but she gave me a "hush-frown" and dragged me quickly past. We had just got on to James' Bay Bridge when there was a clank, clank and a tramp, tramp, tramp behind us. The queer men were being marched into town and the two men with the guns were marching one in front and one behind them, watching as hard as ever. One leg of each man had a dragging limp. Then I saw that every man had a bar of iron fastened to one leg at the knee and again at the ankle. It took a long time for them to catch up to us and pass. We walked on the other side of the foot rail of the bridge. My sister was very put out at having to march beside the men; you could not help keeping time to the jangling tramp. We crossed Bastion Street on the way to

Father's store and came to an immense, close board fence with spikes on the top, which I had never noticed before. The fence broke suddenly into a gate which swallowed the marching men, shutting with a snap that cut off the limping clank before I could get even a peep of what was inside it. There was a red brick building with barred windows beside the fence. Again I looked up at my sister. "Jail," she said—"Chain Gang."

When Victoria was so nearly a city that there were many roads to be built, the town bought a noisy monster called "Lizzie". Lizzie snorted up to a rock pile and they fed her chunks of rock in iron buckets which ran round on a chain. She chewed and spat, chewed and spat until the rocks were ready for road making. So now the Chain Gang did not have to sit by the roadside and smack rocks any longer. Lizzie chewed instead and the Gang now worked on the grounds of Government House and the Parliament Buildings.

"Lizzie" fed for a very long time on Marvin's Hill on the James' Bay side of the mud flats. It had an immense quantity of rock. Horses hated the steepness of Marvin's Hill: the heavy chaises slipped back. The smart old horses zig-zagged them up sideways, pretending that they were not trying to climb a hill at all but just having fun making snake fence patterns in the deep dust.

Marvin's Hill and Church Hill frowned hard at each other; the mud flats, all soft and smelly, smiled between them. Blanshard Street dipped down Marvin's Hill and up Church Hill again. The deepest part of its dip was from Humboldt Street on the north to the top of Marvin's Hill. The town built a high sidewalk on stilts which made the climb for walking people easier. We went over the high sidewalk every Sunday on the way to church. It was the most exciting part of the two-mile walk. From the high sidewalk you looked out across the flats to James' Bay Bridge. There was a row of cabins on Humboldt Street. It was called Kanaka Row: the cabins rested their chins on the street and their hind legs stuck high out of the mud behind. Working men with Indian wives lived in Kanaka Row and Sunday was the day for the women to wash the men's clothes. The men lazed in bed while their shirts and pants flapped on clothes lines high over the mud.

On the corner of Humboldt and Blanshard stood the Reformed Episcopal Church; criss-cross from it was the White Horse Saloon. A great brick drain ran under Blanshard Street, gushing into the slough which rambled over the mud flats and out to the sea. Above the flats on the Belville Street side were Governor Douglas's and Doctor Helmcken's houses. There was always plenty to be seen from the high sidewalk. The Reformed Episcopal Sunday School was beside the church. It was sure to be either going in or coming out as we passed. There were

splendid slides on either side of its steps which must have spoiled heaps of boys' Sunday pants. Below the schoolhouse was a jungle of sweet-briar rose bushes and then came the mud, covered round the edges with coarse marsh grass.

There were nearly always Indians camped on the Flats. They drew their canoes up the slough. Some camped right in their canoes with a canvas tent across the top, some pitched tents on the higher ground. The smoke of their camp fires curled up. Indians loved camping here because for many, many years the mud flats were used as the town's rubbish dump. Square blue carts backed to the edge of Blanshard Street and spattered their loads overboard— old clothes, old stoves, broken baby buggies, broken crockery and beds. The Indians picked it all over, chose what they could use, stowed it away in their canoes to take to their houses. When the tide came up and flooded the slough and flats the canoes slipped away, the Indians calling to their dogs who lingered for a last pick among the rubbish. Then they waded through the mud and caught up with the canoes just before they reached the sea. You got excited watching to see if they'd make it.

The last and very meanest pick of all the rubbish was left to the screeching seagulls that swooped for the dregs of refuse, rising triumphant as kings with new crowns.

From the high sidewalk you could see all this besides looking down into the Convent garden lying on the other side of the raised walk. Here the Convent Sisters marched two and two along the garden paths with a long snake of boarders wiggling in front of them, in and out among flower beds. The nuns' veils billowed and flapped behind the snaky line of girls as if the sisters were shooing the serpent from the Garden of Eden.

At the top of Marvin's Hill, gaunt and quiet, stood the rock-chewing monster, "Lizzie". She did not chew on Sundays. Father measured how much she had done since last Sunday. He was stern about Lizzie. She was an American notion. She had cost the town a lot of money—Father was a tax-payer and a good citizen.

Cook Street

Cook Street crossed Fort Street just before the point at which a better class of houses mounted the Fort Street Hill and made it residential.

A few semi-nice houses did trickle round the corner of Fort into Cook but they got smaller, poorer and scarcer as Cook Street went south. At Fairfield Road Cook stopped being a street at all except on the town map in the

City Hall. In reality, from Fairfield Road to the sea, it was nothing but a streak of skunk-cabbage bog running between King's and Smith's dairy farms. Cows peered through the farm fence bars at the luscious greenery in the "street" where bushes were so snarled and tangled together that down there in the greasy bog among the skunk cabbages they could not tell which root was theirs.

In summertime the swamp dried out somewhat, enough at least for the stout shoes of school children to tramp a crooked little path through its centre. Skirting puddles and nobbledy roots, among which lurked dank smells of cat-flower and skunk cabbages, this path was a short cut to school.

In winter, if there was much rain, this so-called "Street" and the low-lying fields on either side lay all drowned together under a stretch of water which was called King's Pond. After several good frosts people went there to skate.

When James' Bay mud flats had become too "towny" to be a rubbish heap any more, the little two-wheeled, one-horse dump-carts trundled their loads of garbage to the unmade end of Cook Street and spilled it among the boggy ooze. Each load of rubbish built foothold as it went. The horse clung with his hooves to the last load while he spilt the next. The little blue carts tipped and splattered, tipped and splattered their contents over the edge. Every load helped to build a foundation for Cook Street, rubbish pounded to solidity by horses' hooves and children's boots. The street formed slowly, working from its middle and firming gradually to the fence on either side. Occasionally clay discarded from some building excavation was thrown on top to solidify wash boilers and stoves, old kettles and beds. It took all our school years for rusty iron to flake into dust. Soft things rotted and grew fungi or dissolved to a kind of jelly which by and by hardened and powdered to dust.

It took years to steady the underneath of Cook Street between Fairfield and Dallas Road. Here the map said that Cook Street stopped and the sea bounced and bellowed along the pebbly beach under the cliffs.

When I exercised the pony, old Johnny, after school hours I loved to ride through the Cook Street chaos of garbage. High and safe on the horse's back I could look down into it and see wild rose bushes forcing their blooms up through lidless cook stoves and skunk cabbage peeping out of bottomless per-ambulators, beds tipped at any angle, their years of restfulness all finished and done with.

The harder the town grew, the more back-door rubbish there was. The clay-coloured, padded bonnet of half-crazy, half-negro old Teenie bobbed among the garbage while her stick poked and her claw-like hands clutched, ramming gleanings into her sack with derelict mutterings scarcely more audible than the click of disintegration amongst the decay in which she rooted. Teenie

herself belonged to this sisterhood of discards. Back in her cabin she poured what she had rescued from her sack onto the floor, muttering and gibbering to the castoffs as if they were her friends.

At last the emptiness was flattened out of every discard, the chinks between were filled up with clay and Cook Street was hard and level; the Town drained and paved it and it became a finished highway running from the town to the sea. New houses set their faces to it, houses with flower gardens in front. All its old cow farms moved out into the country.

Our town now had a mature garbage system which towed our horribles out to sea in barges. It seemed, though, that the old kettles and much of the rubbish got homesick; back they danced patiently riding wave after wave to the beach below Cook Street to lie there, hideous in broken nakedness, no soft spread of greenery to hide their ugliness.

As Cook Street progressed from cow farm to residential district she had a spell of being Chinese vegetable gardens. In the fields on either side patient, blue-jean figures worked from dawn till dark, bending over the soil, planting, weeding, watering by hand from wells. The water was carried in five-gallon coal oil cans, one on either end of a bamboo pole slung over the Chinaman's shoulder. He stood the load among his vegetable rows and dipped a little to each plant.

When his vegetables were ready to market, the Chinaman put them into great bamboo baskets slung on each end of his pole. As he had carried water to his plants, so he carried vegetables to townspeople, going from door to door joggety-trot with baskets swaying.

Waterworks

Those Victorians who did not have a well on their own place bought water by the bucket from the great barrel water-cart which peddled it. Water brought in wooden pipes from Spring Ridge on the northern outskirts of the town was our next modernness. Three wonderful springs watered Victoria, one on Spring Ridge, one in Fairfield and one at Beacon Hill. People carried this sparkling deliciousness in pails from whichever spring was nearest their home.

My father was so afraid of fire that he dug many wells on his land and had also two great cisterns for soft water. Everyone had a rain barrel or two at the corners of his house. The well under our kitchen was deep and had a spring at

the bottom. Two pumps stood side by side in our kitchen. One was for well water and one was a cistern pump—water from the former was hard and clear, from the cistern it was brownish and soft.

When Beaver Lake water was piped into Victoria, everyone had taps put in their kitchen and it was a great event. House walls burst into lean-to additions with vent pipes piercing their roofs. These were new bathrooms. With the coming of the water system came sewerage. The wretched little "privies" in every backyard folded their evil wings and flapped away—Victoria had at last outgrown them and was going stylish and modern.

Father built a beautiful bathroom. Two sides of it were of glass. It was built over the verandah and he trained his grape-vine round the windows. The perfume of the vine in spring poured through the open windows deliciously. Father had tried to build several bathrooms before Beaver Lake came to town, but none of them had been any good. First he used a small north room and had a cistern put in the attic to fill the bathtub. But hot water had to be lugged upstairs in a bucket and anyway the cistern froze every winter; so that bathroom was a failure. He had made us an enormous, movable wooden tub like a baby's bath big enough for a grown-up to lie in flat. It was very heavy and lived on the back verandah. Bong brought it into the kitchen on Saturday nights before he left for town. It had to be filled and emptied over and over by the ladies of the household with a long-handled dipper until all the family had had their baths. Besides this Saturday night monster there were wooden wash tubs painted white which lived under our beds. We pulled these out at night and filled them with cold water. Into this we were supposed to plunge every morning. This was believed to harden us; if your nose were not blue enough at the breakfast table to guarantee that you had plunged, there was trouble.

Father later tried a bathroom off the wash-house across the yard. A long tin pipe hung under the chin of the wash-house pump and carried cold water, but hot water had to be dipped out of the wash boiler on the stove. This hot bath arrangement was bad; we got cold crossing the yard afterwards. So the wooden tub was invited into the kitchen again each Saturday night until we became "plumbed".

It was glorious having Beaver Lake pour out of taps in your kitchen and we gloated at being plumbed. Mothers were relieved to see wells filled in, to be rid of the constant anxiety of their children falling in and being well-drowned. Everyone was proud and happy about this plumbing until the first hard frost.

Victoria used to have very cold winters. There was always some skating and some sleighing and spells of three or four days at a time when the wind from the north would pierce everything. Mother's milk pans in the dairy froze solid.

We chopped ice-cream off the top to eat with our morning porridge. Meat froze, bread froze, everything in the house froze although the big hall stove was red hot and there were three or four roaring grate fires as well. Windows were frosted in beautiful patterns all day and our breath smoked.

It was then discovered that plumbers, over-driven by the rush of modern arrangements, had neglected to protect the pipes from frost. Most of the bathrooms were built on the north side of the houses and everything froze except our deep kitchen well. Neighbours rushed to the Carr pump, spilling new snow over Mother's kitchen floor till our house was one great puddle and the kitchen was filled with the icy north wind. Everyone suddenly grumbled at modern plumbing. When the thaw came and all the pipes burst everyone wished Beaver Lake could be piped right back to where it came from.

Once Victoria had started modern off she flew with all sorts of newfangled notions. Cows were no longer allowed to roam the streets nor browse beside open ditches. The ditches were replaced by covered drains and, if your cow wandered into the street, she was impounded and you had to pay to get her out. Dogs were taxed but were still allowed to walk in the streets. A pig you might not keep within so many yards of your neighbour's nose. Jim Phillips had to give up his James' Bay farm and remove his piggery to the country. Small farms like his were wanted for cutting into city lots. You never knew when new lumber might be dumped on any piece of land and presently the lumber was a house and someone was moving in.

Jim Phillips' big turnip field across from us was made into the Caledonian Park, a place for the playing of public ball and lacrosse games. It was fenced high and close and admission was charged. The gate of Caledonian Park was on the corner of Simcoe and Carr Streets, just opposite us. There was a long, unpainted building inside, which was the players' dressing room. Bob Foster lived there. He was the boys' trainer and one of those ousted-out-of-England ne'er-do-wells. There was some good in old Bob but drinking spoiled it. He trained, rubbed down and doctored the boys for sprains and hurts on the field. He took good care of the boys and the boys took care of Bob. He owned a little white dog whom he also trained to scour the neighbourhood for somebody else's hen and bring her home for Bob's dinner parties. The noise of these parties flew over our hedge, filled our garden all night and made our dreams bad.

Caledonian Park existed for many years but finally the lease expired and then the land was cut into building lots.

Just before the high board fence came down a Barnum and Bailey Circus (three rings and a menagerie) came to town. It came at night, so silently that

we slept through its arrival. Before it was fully light little boys had their eyes glued to knot holes in the board fence. Tops of great tents poked tantalizingly into the sky.

The Circus gave free passes to boys who lugged water for the animals. When every beast was full, even the elephants and the seven stomachs of the camel, a little boy came; he was too late to get any job. He was feeling very sad when a tall, lean man popped out of a tent.

"Say, son, I gotta have a dress shirt in an hour. Hand over one of your pa's and you git a pass."

As the little boy started to run home, the man shouted,

"Yer pa's far? Then bring along safety pins!"

The boy and his mother argued a bit about Pa's shirt, but the boy not only got into the big tent free, he could boast of having pinned a real live clown into his father's shirt—more exciting even than watering an elephant.

From Carr Street to James' Bay

When father started for town in the morning I went with him down the drive to the gate, holding his hand. The gate stood between two high, high Lombardy poplars. Their tops were right up in the sky. If you could have got to their tippy tops you could have spoken right into God's ear.

Father planted our poplars when they were little. The two by the gate were the tallest.

The bigger I grew the farther I was allowed to go with Father. When I was seven I went as far as the Lindsays'.

We got up early in our house. I came downstairs perfectly clean but when it was time for Father to go to town I was dirty because of being such great friends with the hens and ducks. And then I always sat by Carlow for a little because he was chained to his kennel. His feet and chain made lots of dust on me and the leaks from the can when I watered my own particular garden made it into mud.

As soon as Father began to go he went quickly, so Mother made me a "jump-on-top" of sprigged muslin. It went over my head so that there were no buttons to burst off. There were frills all round it and a tape tieback underneath. The front sat plain but the back bunched up into a bustle like a lady's. I had a pair of cloth-top, button boots and a sun-bonnet. I looked quite nice when I took Father's hand and we started.

Father walked fast and held my hand tight. The plank walk was just wide enough for us both but, if you did not watch, your foot slipped off into the mud. We did not talk much because Father was thinking of all the things he had to do at his big wholesale business where boxes and barrels and cases stood on top and on top and on top, till they touched the ceiling. When he thought hard a ditch came between Father's eyebrows; then I did not dare to chatter. I just looked at things as we went along. It was on the way home that I got to know "the ladies".

Our street was called Carr Street after my Father. We had a very nice house and a lovely garden.

Opposite our gate was Bishop Cridge's "wild field". It was full of trees and bushes and fallen logs and was a grand place to play ladies with little girls. The Bishop's house and garden were beyond the field. The drive was curved and had laurels and roses down it so you could not see his house. Then came his big field with the barn in the corner where his horse and cow lived. The field was so big it took up all the rest of Carr Street. There was a well in it where the Cridges got their water to wash and drink. Every morning we saw the Chinaman carrying two square coal oil cans of water across the field, they dangled one on each end of a pole and slopped a little over the stubble.

On the other side of Carr Street where our poplars ended the Fawcetts' place began. They had hundreds of heavy, wide children with curls. Their clothes were always too big. Their mother told our mother that she made them that way because she knew her children would grow. Mrs. Fawcett was wide too and had very crimpy hair and a crooked neck; "Pa" Fawcett was tremendously lean and tall and had a long, thin beard.

Then came the Bishop's field—not Bishop Cridge's but Bishop Hill's. He did not live in his field; there were cows there. One corner had a thicket with wild lilies growing in it. The two Bishops did not like each other much and it was a good thing there were two fences between their cows. There were picket fences all the way down Carr Street. The fences stopped suddenly because Mrs. McConnell's farm sat right in the way and had a rail fence of its own.

Carr Street was a very fine street. The dirt road waved up and down and in and out. The horses made it that way, zigzagging the carts and carriages through it. The rest of the street was green grass and wild roses. There was a grand, wide open ditch with high grass by the sides. The cows licked in great mouthfuls to chew as they walked up and down to the pasture land at the end of Carr Street down by the beach. In front of our place Father had made a gravel walk but after our trees stopped there were just two planks to walk on.

At Mrs. McConnell's farm Father and I turned into Toronto Street. It was not half so fine; there was only a one-plank walk so we had to go one in front of the other. The ditch was little and mean, too. When we came to "Marifield Cottage" we turned into Princess Avenue. It was smaller still and had no ditch and no sidewalk. It was just a green strip pinched in between two fences. If two carts came in at both its ends at the same time one of them had to back out.

Uncle Jack's garden was on one side of Princess Avenue. He was not uncle to everybody but everybody called him that. He was a kind man who did jobs. When he worked for Father he took us for rides in his cart. It had no seat—just a loose plank laid across the cart. If the plank slid, Uncle Jack held on to you. There was such a high fence round his place that nothing could look over except the lilacs and the may trees. Their smell tumbled right over the fence on to you.

Opposite Uncle Jack's was Mrs. Swannick's house. She had no nose, only a wrinkle and two holes. She had a sick son, too. Before he died Father sent him a bottle of brandy because he was so very sick. Mrs. Swannick was so glad she cried. Her hands went up and she said, "O Lor! It's 'three star', too!"

Mrs. Robinson's house came next. She was a stout lady. She had a great friend named Mrs. Johnson who lived up past our house. Mrs. Robinson went every day to see Mrs. Johnson and Mrs. Johnson walked home with Mrs. Robinson; then Mrs. Robinson walked back with Mrs. Johnson. They went up and down, up and down; at last they stopped at our gate which was just about half way and then each ran home alone. These ladies were very fond of each other.

The last house on Princess Avenue was Mrs. Lipsett's. She was skinny and red, her nose and chin and elbows were sharp. She was always brushing or shaking something but no dirt ever came out. Her skinny arms hugged the great mattresses and plumped them onto her window ledges, as far as they could go without falling out, so that they could be sunned. It made Mrs. Jack very angry to see Mrs. Lipsett's beds hanging out of the windows. That is why "Uncle" put up such a high fence. It went all round the corner onto Michigan Street and shut out everything else as well as the beds and made it dark for poor Mrs. Jack—like living behind the world. Mrs. McConnell's front came right next to Uncle Jack's fence.

Mrs. McConnell was a splendid lady; I liked her very much indeed. She had such a large voice you could hear it on Toronto Street, Princess Avenue and

Michigan Street all at once. She was so busy with all her children and cows and pigs and geese and hens that she had no time to be running after things, so she stood in the middle of her place and shouted and everything came running— Joseph, Tommy, Lizzie, Martha-Anne, Spot, Brownie and Daisie, and when she yelled "Chuck, Chuck, Chuckie" the whole farm was wild with wings. Something was always running to Mrs. McConnell. She sort of spread herself over the top of everything about the place and took care of it.

Mrs. McConnell worked very hard. She sold milk and eggs and butter and pork. She let people go through her place instead of round by Princess Avenue if they wanted to. Father did not, but I often used to come home that way because I liked Mrs. McConnell and her things. She called me "Lovey" and showed me her calves and little pigs. She said I was a "faithful lamb" taking my "Pa" to town every morning, but really it was Father who took *me*. She was Irish, with shiny eyes and high red cheeks, black hair and long teeth with wide gaps where there were not any; when she laughed you saw the gaps. The windows of Mrs. McConnell's and Mrs. Cameron's houses peered down Birdcage Walk like a pair of spectacles.

I don't remember what was on the corner of Birdcage Walk opposite Mrs. Cameron's "spectacle". Mrs. Cameron had a lot of cows, too, and a big barn with a little windmill on the top. All the wind running down Birdcage Walk caught it and turned the wheel. Mrs. Cameron had quite white hair, bundled into a brown net. She had a pink face with a hole of a mouth that had no teeth in it, only a pink tongue which rolled round when she talked, and a fluffy chin. She was a dear old lady and had two daughters. Jessie was the oldest and had a turned-up nose; her mouth turned up too when she laughed, and when she met her friends she began to bow by jerking her head away back on her neck and then she bounced it forward like a sneeze. Agnes was very clever: she taught school and quarrelled with the trustees. She wrote things that were printed too.

Mrs. McConnell's "spectacles" looked right across at Mrs. Plummer who was on the corner of Michigan and Birdcage Walk. Mrs. Plummer lived in a field— that is, her house sat in the middle of a very big field. Her cottage was made of corrugated iron and had a verandah all round it. The most splendid thing about it was that every window was a door made of glass and coming to the floor, so that Mrs. Plummer could rush straight out of any room into her gar-den—like a swallow darting out of a bank—she did not have to go through passages first. I expect that is why she built her house just like that, with so

many doors. Her garden had a little fence round it to keep the cows in the big field from eating her flowers. Because of there being two fences round Mrs. Plummer I did not get to know her, but I saw her sometimes. She had a reddish face and a purple dress and was thick round the middle. In my own mind I called her "Mrs. Plum". When a cow looked over her fence she burst out of one of the "door windows" shouting "Shoo-shoo-shoo!" and beat one of her mats to show the cow what she meant. I always hoped Mrs. Plummer would come rushing out as we passed.

Birdcage Walk was almost a very grand street because the Parliament Buildings were nearly on it. Just a little row of houses was between. Besides, if it had not been for James' Bay Bridge breaking in, Birdcage Walk would have been Government Street which was the most important street in Victoria. Birdcage Walk was wide and had a plank walk on both sides—wide enough to pass other people as you walked on it and it had a covered-in drain, too.

The Wilsons lived in the big house on the corner after Mrs. Plummer. They had a large family and a beautiful pine tree that was not a pine at all . . . it came from another country. The lawn where the children played was down three steps from the flower garden. Mr. Wilson was square and looked pressed hard as if he had grown up under something heavy. Mrs. Wilson was like a bird, with a sharp little nose. She wore her hair cut in a tiny fringe where the parting ended.

Then came the birdcagy part of Birdcage Walk—some funny little square houses with a chimney right in the middle of the top of each like a handle to hang it up by. In the first of these little houses Miss Wylie lived. She was squeaky and quite old. Her brother Charlie lived with her. He was very, very deaf. Miss Wylie had to squeak very high indeed for Charlie to hear her at all. Generally he said "Yes—yes—ah, yes—Tilly," but did not hear a word. Miss Wylie was a very timid lady. When she was coming to see Mother she sent word first so that Mother could send me down to fetch her, because she was so afraid of meeting a cow. I did feel brave walking up Carr Street on the ditch side of Miss Wylie, sucking one of her peppermints, particularly if there was a cow down in the ditch and I could look over the top of her back and horns.

Mrs. Green in the "birdcage" opposite the Wylies' was very kind to the Wylies because they were old. The Greens were important people: Mr. Green was a banker. They had a lot of children so they had to build more and more pieces on to their house till it did not look like a birdcage any more. The Greens had everything—a rocking-horse, real hair on their dolls, and doll buggies, a summerhouse and a croquet set. They gave a Christmas-tree party every

year and everyone got a present. The Mason's fence was at the end of the Greens' lawn; it was covered with ivy which was a bother for the Greens' croquet balls. The Masons had a grey house and a boy, Harry, who was rough and cruel to our dolls.

And now we had come to the Lindsays' and James' Bay Bridge was just in front. Then Father doubled down and kissed me goodbye. Across the Bridge there was a saloon on every corner, so I was not allowed to go any farther. I waved to Father on the Bridge and then I was free.

I peeped between the stalky parts of the Lindsays' lilacs. Their gate had an arbour and you went down two steps into the garden. Next to Mrs. Plummer's I liked the Lindsays' place the best. There was a round flowerbed in the middle of their garden with a little path round it. All the rest of the garden was bushes and shrubs. Everything sweet grew in the Lindsays' garden. Perhaps they did it because sometimes the mud flats under James' Bay Bridge smelt awful. There was mignonette and cabbage roses and little yellow roses and red ones and moss ones. You could hardly see the house for vines, honeysuckle and clematis—then there were the lilacs, much purpler and sweeter than anyone else's.

As I went on home everyone nodded to me, but Miss Jessie Cameron gave me a whole bow as if I were a grown-up lady.

I often took the short cut through Mrs. McConnell's farm. She never stopped flying round but she always said, "Well, Lovey, is it yourself sure?" I always shut her gates most carefully.

One morning Mother gave me a beautiful bunch of flowers. She said I was only to go with Father as far as Mrs. McConnell's front gate and then I was to take the flowers to Mrs. McConnell and say they were for the baby.

I tapped at the door . . . everything was quite still. Instead of shouting, "Come right in", Mrs. McConnell came and opened the door quietly. Her eyes were red.

"Mother sent some flowers for your baby, Mrs. McConnell."

"Come and give them to him, Lovey."

She took my hand and led me in. I looked round, expecting to see the baby sitting in his pram. I was going to bounce the flowers at him and hear him giggle. The pram was not there. There was a little table in the middle of the room with a white box on it. Mrs. McConnell put her hands under my arms and lifted me so that I could look into the box. The baby was there—asleep, but his eyes were not quite shut.

Mrs. McConnell said, "Kiss him, Lovey". I kissed the baby's cheek. It was

hard and cold. I dropped the flowers on his feet. Mrs. Cameron came in then, so I slipped out and ran home.

"Mother, why was Mrs. McConnell's baby so cold and funny?"

"Did you see the baby?"

"I kissed him. Mrs. McConnell told me to."

Mother looked vexed. She told me about death but I only half understood. I did not take the short cut for a long time after that but went round by Mrs. Lipsett's and Mrs. Swannick's.

The worst thing about Carr Street was that the houses were set far back in the gardens. There was nothing to see except what was in the street. Often the Bishop's chaise was going in or out and I ran to open the gate for Mrs. Cridge. It was a very big, low, wide chaise. There was a high hook for the reins to hang over so that they could not get swished under old Charlie's tail. He was a very lazy old horse and never ran. You could get in and out of the chaise while Charlie was going. They never stopped him because it was so hard to start him again. When Mrs. Cridge got very impatient to get anywhere she stood up and flapped the reins on Charlie's back. Then Charlie lashed his tail across the reins and pinned them down so tight that Mrs. Cridge could not drive at all and had to hang over the front and work at them. Her face went red and her bonnet crooked but all she ever said was "Ahem!" and "Oh, Charlie! Charlie!" The Bishop sat beside her smiling, with his eyes shut. Charlie held the reins down tight and pretended Mrs. Cridge was stopping him. Then by and by, when she had fished his tail up off the reins with the whip handle, he went on.

Every morning I met the Johnson girl on Carr Street. The Johnsons had a vegetable garden round the corner and their girl carried the vegetables to people in a basket. I don't know what her name was. We never spoke. She was taller than I and had a flat body and a meek face . . . which made me angry. After she had passed I always turned round and made a face at her. She knew I was going to so she looked back. One morning she had a big basket of potatoes on her arm and I made a dreadful face. She looked so hard and long that she tripped and sprawled in the mud, all her potatoes flying into the ditch. I laughed right out loud and stood watching while she fished them out. Her apron was all mud. She took it off and wiped each potato and put it back onto the basket. She did not look at me or say one word. When the potatoes were wiped and back in the basket she wiped first one of her eyes and then the other on the muddy apron, picked up her basket and went on down the street.

I went home too. I felt the meanest, meanest meanest thing I had ever heard of. Why didn't the Johnson girl hit me? Or throw mud, or say something? Why didn't she?

Father and Mother were talking about it . . . I was old enough but I cried every time I thought about going to school. My sisters tramped two miles night and morning. If I went with them I would not be able to see Mrs. Lipsett's bed or Mrs. Swannick's nose or Mrs. Plummer fly out or Miss Jessie's bow. We'd go on a straight, horrible road that had no friends on it . . . but, I did not have to.

Mrs. Fraser, the lady who had come to live in "Marifield Cottage" started a little school, so I went there. I could still go as far as the gate of the school every morning with Father, and on Saturdays I could go right to the Lindsays' and see all my friends.

When Saturday came I wanted to tell Father something, only it wouldn't come out. I looked up a lot of times but the ditch between his eyes was very deep—I was half afraid. We had passed the Greens' . . . we were at the Masons' steps . . . the Lindsays' lilacs were just coming.

"Father—Father—don't you think—now that I go to school I am too big to be kissed in the street?"

"Who said so?"

"The girls at school."

"As long as I have to stoop you won't be too big," Father said, and he kissed me twice.

Grown Up

Victoria's top grandness was the Driard Hotel; all important visitors stayed at the Driard. To sit in crimson plush armchairs in enormous front windows and gaze rigid and blank at the dull walls of the opposite side of View Street so close to the Driard Hotel that they squinted the gazer's eyes, to be stared at by Victoria's inhabitants as they squeezed up and down narrow View Street which had no view at all, was surely worth a visit to the capital city.

The Driard was a brick building with big doors that swung and squeaked. It was red inside and out. It had soft red carpets, sofas and chairs upholstered in red plush and rep curtains, red also. All its red softness sopped up and hugged noises and smells. Its whole inside was a jumble of stuffiness which pushed

itself into your face as you opened the outer door, licking the outside freshness off you greedily, making a dash for the open. But the Driard door squawked and slammed to before the stuffiness could escape and hit back smotheringly onto you. When you came out of the hotel you were so soaked with its heaviness you might have been a Driard sofa. Even the hotel bus had the Driard odour, although it did not actually live inside the hotel. It was a long, jolty two-horse bus with "Driard" painted on both its sides and a man shouting "Driard" from the back step. Stow-away Driard smells hid in the cushions of the bus and drove to the wharf ready to pounce on visitors.

The Driard visitors came mostly from San Francisco; Vancouver and Sound cities were too busy growing to waste time on visiting.

Victoria and Vancouver were always rivals and made jealous faces at one another. Vancouver had a finer harbour and grew faster; she was the easier to reach, being the end of the rail. Victoria had the Queen's name, was the capital of British Columbia and had the Esquimalt Naval Station.

When the East and West were linked by the Canadian Pacific Railway, Vancouver said, "Ha! I am the end of the rail; nobody will now bother about that little Victoria town on her island. Settlers and visitors will get off the train and stay here with me."

So she built factories, lumber mills, wharves and swelled herself furiously; but no matter how she swelled she could not help Victoria's being the capital of British Columbia or having the Naval Station. The navy men's wives came from England direct to Victoria to live while their husbands' ships were stationed at Esquimalt a mile or so out of the city.

Victoria kept in closer touch with England. She got more and more "Old Country"; Vancouver got more and more new-world. Vancouver covered Victoria's gentility; Victoria coveted Vancouver's business.

These two cities made Canada's West, her far Pacific edge which lured pioneers on and on till they came to the rim of the ocean, earth bent to the world's roundness—land and water circling the West back to the East again.

Pioneers slid across Canada's vastness on the C.P.R. trains and were so comfortable in doing it that they did not get off till they had to. Often the first Canadian land their feet touched was British Columbia. The stark West snarled a little when they touched her first but she was really nearer to England in her ways and feelings than the East was, although the West was some four thousand miles farther away in space. By and by the English forgave the West her uncouth vastness and the West forgave them their narrow littleness.

The C.P.R. watched the West grow. She saw Victoria's squatty little old red brick Parliament Buildings give place to magnificent stone structures—domes,

copper roofs—everything befitting a Capital City. Facing the Parliament Buildings across James' Bay arose a sedate stone and cement Post Office. Little old knock-kneed wooden James' Bay bridge still straddled the mud flats between the two. The C.P.R. pillowed their heads upon the mud flats and dreamed a dream. First they tore down the old wooden bridge and built in its place a wide concrete causeway, damming the Bay waters back from the flats. The sea was furious and dashed, but the concrete wall hurled it back. Smells got frantic and stank to high Heaven until engineers came and drained the seepage slough.

Pendray's soap works and Kanaka Row could not endure life without smells,—so they just faded out of existence. The soap-fat refuse from the soap works stopped playing glorious iridescent colours across the mud when the sun shone. No ride came in to sweep away Kanaka Row's refuse: their back doors were heaped round with it and were disgusting. The yellow clay of the mud flats parched and cracked. The mash grass, through which the Indian canoes had slithered so caressingly, turned harsh and brittle.

The City bartered with the Songhees Indians giving them money and a new reserve at Esquimalt in exchange for their fine harbour properties, which the City wanted for industrial purposes. All around Victoria's little harbour there was change. Even our dumpy little concept of Queen Victoria, drawn from the *Illustrated London News* changed when a swarthy stone amazon rose on a pedestal in front of the Parliament Buildings. Except for the crown and sceptre we would never have recognized this as our civic godmother.

While these changes were wrecking Victoria's calm, the C.P.R. were still dreaming their mud-flat dream and architects were making blue prints of it. To be private and undisturbed during their dreaming they built a huge hoarding the entire length of the causeway shutting the dream into the mud. A citizen's eye was applied to every knot-hole in the hoarding but they could make neither head nor tail of what was going on. The pile-driver gawked over the top of the hoarding. Thud, thud, thud! Her fearful weight obeyed the squeaky little whistle of her engine, driving mighty logs, each one a complete tree-bole, end down into the mud. There they stood shoulder to shoulder, a headless wooden army tramping the old mud-smells clean through to China. When the flats were a solid wooden pack the harbour bottom was dredged and the liquid mud pumped in between the standing logs. Thousands of men wheeled millions of barrowloads of earth and rocks for hundreds of weeks—dumping, loading till solid ground was made on which the C.P.R. could found their dream.

The dream took shape in reality. The hoarding came down at last and there stood the beautiful Empress Hotel. It never looked crude and new because,

while the back was building, the finished front was already given over to creepers and shrubs, and gardens were set the moment workmen's feet had stopped trampling. Beautiful conservatories sat right on top of where the city garbage dump had once been. Under their glass roofs bloomed rare flowers from all parts of the world, but none were more sweet, more lovely than the little wild briar roses that had so graciously soothed our noses over the old mud-flat smells.

The Driard Hotel could not blush herself any redder than she already was when confronted by her rival so she withered entirely away. No visitors wanted to sit enthroned on red plush, to stare at brick two feet from their noses when they could sit behind plate glass and look out over Victoria's lovely little harbour. Beautiful steamers snuggled up to the wharf, almost to the very door of the Hotel. From London dock to Empress Hotel door was one uninterrupted slither of easy travel.

Victoria ceased to be an English naval station: Canada navied herself. Esquimalt Harbour now had a huge dry-dock and a cannery. A few Indian dugout canoes stole in and out to the new reservation but most of the Indians now came and went in their new gas fishing-boats.

Victoria knew a little boom—a little bustle—but it was not her nature to boom and bustle; she slumped, settling to slow easy development—reticent, calm, deliberate.

These enormous happenings—the building of the Parliament Buildings, Empress Hotel and Causeway, the establishing of a first class boat service between the Island and the mainland stirred the heart of Victoria and sent lesser happenings quivering through her outskirts.

The narrow, three-mile strip of warm, inland sea opening out of the harbour and called the Gorge because of a narrow pass half-way up its course, one of Victoria's beauty spots where her people had bathed, and where regattas had been held on the Queen's birthday, became infested with booms of logs and saw-mills. Bathers protested. They did not like sawdust skins after bathing in the Gorge waters so went to the swimming tanks in the Y.M.C.A. and in the Crystal Pool of the new Empress Hotel. The Gorge that had once been so fine a residential district went unfashionable. The beautiful homes on its banks sold for a mere song. Canoes and row-boats ceased carrying pleasure parties up its protected waters to picnic. The fleet of sailing schooners still stuck to their winter quarters just below the Point Ellice bridge, where the harbour ended and the Gorge began, coming back to its safeness every winter like homing birds. A

hideous railway bridge now spanned the Harbour and carried trains from "up-island" into the city. Spanning the upper harbour this bridge hoisted a section of itself for the sealers to pass under and then shut them safe in shelter.

Cedar Hill lying to the north of the town went "snooty"; elevating her name to Mount Douglas, she became a Public Park, smug with tameness. Little Saanich Mountain hatted her crown with an observatory the white dome of which looked for all the world like an inverted white pudding basin.

Because there was no more English Navy stationed at Esquimalt there were no more navy balls and no sham battles between the soldiers and sailors on Beacon Hill. There were no more road-house saloons with lovely flower boxes and cages of wild animals and horses' drinking troughs—there were no more driving horses. Automobiles purred over oiled and paved highways and there was no dust to make people and horses thirsty.

From the top of Church Hill the Cathedral stepped one block back. Instead of dominating the city she now dominated the old Quadra Street cemetery long since replaced by the new Ross Bay burying ground. Brambles no longer overran the dead Pioneers. Victoria's early settlers slept tidily under well mown lawns. The old head-stones and name-boards had been huddled into a corner, glowering morosely from their pale names, resenting the nakedness of being without the clinging vines and the riot of undergrowth that had protected their dead and themselves. On benches the public sat on top of the dead. Children scampered over them—jangle of the new cathedral bells quivered the dead's stillness.

James' Bay is James' Bay still. The smart forsook her long ago. First they moved to Upper Fort Street, then to Rockland Avenue, then on to Oak Bay, finally to the Uplands where they could not keep a cow or hang out a wash or have too many children. The entire shore line of greater Victoria is now spread with beautiful homes.

Victoria's inner land being higher than her shore, every aspect is lovely, North, South, East and West—blue sea, purple hills, snow-capped Olympic mountains bounding her southern horizon, little bays and beaches heaped with storm-tossed drift, pine trees everywhere, oak and maple in plenty.

So stands tranquil Victoria in her Island setting—Western as West can be before earth's gentle rounding pulls West east again.

The House
of All Sorts

Contents

The House of All Sorts

Bobtails

Foundation

The House of All Sorts could not have been quite itself in any other spot in the world than just where it stood, here, in Victoria, across James' Bay and right next to Beacon Hill Park. The house was built on part of the original property my father had chosen when he came to the new world and settled down to raise his family. This lot was my share of the old cow pasture. Father's acreage had long ago been cut into city lots. Three houses had been built in the cow yard, more in the garden and others in the lily field. The old house in which I was born was half a block away; one of my sisters still lived in it, and another in her little schoolhouse built in what had once been the family vegetable garden.

Bothers cannot be escaped by property owners and builders of houses. I got my share from the very digging of the hole for the foundation of the House of All Sorts. But the foundations of my house were not entirely of brick and cement. Underneath lay something too deep to be uprooted when they dug for the basement. The builders did not even know it was there, did not see it when they spread the cement floor. It was in my memory as much as it was in the soil. No house *could* sit it down, no house blind what my memory saw—a cow, an old white horse, three little girls in pinafores, their arms full of dolls and Canton-flannel rabbits made and stuffed with bran by an aunt, three little girls running across the pasture to play "ladies" in the shrubberies that were screened from Simcoe Street by Father's hawthorn hedge, a hedge now grown into tall trees, flowering in the month of May.

I remembered how I had poked through the then young bushes to hang over those old rotted pickers, now removed to permit the dumping of the lumber for my house. I remembered how I had said to Bigger and Middle, "Listen, girls, see if you can tell what sort of person is coming up the street by the kind of tune I blow," and I put the harmonica to my lips and puffed my cheeks. But a gentle little old lady passed, so I played very softly. She stopped and smiled over the fence at the three of us, and at the dolls and foolish, lop-eared, button-eyed rabbits.

"Eh, dearies, but how you are happy playing ladies in this sweetie wee grove!"

And now my house was built in the "sweetie wee grove," and I was not playing "lady," but was an actual landlady with tenants, not dollies, to discipline. And tenants' pianos and gramophones were torturing my ears, as my harmonica had tortured the ears of Bigger and Middle. The little old lady had made the long pause—she would not come that way again.

Ah! little old lady, you, like cow, horse, dolls and rabbits, contributed a foundation memory to the House of All Sorts.

Friction

Friction quickly scraped the glamour of newness from my house—even from the start of its building. My Architect was a querulous, dictatorial man who antagonized his every workman. He had been recommended to me by an in-law; like a fool I trusted and did not investigate for myself, making enquiry of the two Victoria families he had built for since coming out from England. Always impatient, as soon as I decided to build I wanted the house immediately.

I drew up a plan and took it to the Architect asking what roughly such a building would cost. He took my plan, said it was "concise and practical"—if I would leave it with him a day or two he'd look it over and return it to me with some idea of the cost so that I could decide whether I wanted to build or not.

"A very good little plan," the man said. "But naturally I could make a suggestion or two."

In a few days he returned my drawing so violently elaborated that I did not recognize it. I said, "But this is not the house I want." He replied tartly that I would have to pay him two hundred dollars whether I accepted his plan or not because of the time he had spent mutilating it unasked! I made enquiry from the other people he had built for, finding out he had been most unsatisfactory. I was too inexperienced to fight. I knew nothing about house building; besides, I was at the time living and teaching in Vancouver. I could not afford to pay another architect as well as this one for his wretched plan. It seemed there was nothing to do but go on.

The man hated Canada and all her living. *He* was going to show her how to build houses the English way. He would not comply with Canadian by-laws; I had endless trouble, endless expense through his ignorance and obstinacy. I made frequent trips up and down between Vancouver and Victoria. Then the man effected measles and stayed off the job for six weeks, babying himself at home, though he lived just round the corner from my half-built house.

I had hundreds of extra dollars to pay because of the man's refusal to comply with the city by-laws and the building inspectors' ripping the work out. It was a disheartening start for the House of All Sorts, but, when once I was quit of the builders and saw my way to climbing out of the hole of debt they had landed me in, I was as thrilled as a woman is over her first baby even if it is a cripple.

The big boom in Victoria property tumbled into a slump, an anxious shuddery time for every land-owner. There had been no hint of such a reverse when I began building. Houses were then badly needed. Now the houses were half of them staring blankly at each other.

Tenants were high-nosed in their choosing of apartments. The House of All Sorts was new and characterless. It had not yet found itself—and an apartment house takes longer to find itself than do individual private houses.

I had expected to occupy the Studio flat and paint there, but now the House of All Sorts could not afford a janitor. I had to be everything. Rents had lowered, taxes risen. I was barely able to scrape out a living. Whereas I had been led to believe when I started to build there would be a comfortable living, all the rentals together barely scraped out a subsistence.

The House of All Sorts was at least honest even if it was not smart. People called it quaint rather than that. It was an average house, built for average tenants. It was moderately made and moderately priced. It had some things that ultra-modern apartments do not have these days—clear views from every window, large rooms and open fire-places as well as furnace heat. Tenants could make *homes* there. Lower East and Lower West were practically semi-detached cottages.

It takes more than sweet temper to prevent a successful Landlady from earning the title of "Old Crank."

Over-awareness of people's peculiarities is an unfortunate trait for a Landlady to possess. I had it. As I approached my house from the street its grim outline seemed to slap me in the face. It was mine. Yet by paying rent others were entitled to share it and to make certain demands upon me and upon my things. I went up a long, steep stair to my door. The door opened and gulped me. I was in the stomach of the house, digesting badly in combination with the others the House of All Sorts had swallowed, mulling round in one great, heavy ache. Then along would come Christmas or the signing of the armistice, or a big freeze-up with burst pipes, an earthquake, a heat wave—some universal calamity or universal joy which jumped us all out of ourselves and cleared the atmosphere of the house like a big and bitter pill.

Sounds and Silences

Sometimes I rented suites furnished, sometimes unfurnished, according to the demand. Two things every tenant provided for himself—sound and silence. His own personality manufactured these, just as he stamped

his imprint on every inch of his environment, placing his furniture just so, hoisting and lowering his window blinds straight or crooked. Even the boards of the floor creaked differently to each tenant's tread, walls echoed his noises individually, each one's hush was a different quiet.

Furniture is comical. It responds to humans. For some it looks its drabbest, for others it sparkles and looks, if not handsome, at any rate comfortable. And heavens! how tormenting furniture is to a guilty conscience—squeaking, squealing, scrooping! Let someone try to elude rent day or contemplate a fly-by-night. That man the furniture torments.

Old Attic

The attic was no older than the rest of the house. Yet, from the first to me it was very old, old in the sense of dearness, old as the baby you hug and call "dear old thing" is not old in years, but just in the way he has tangled himself round your heart, has become part of you so that he seems always to have existed, as far back as memory goes. That was the way with my attic. Immediately I came into the house the attic took me, just as if it had always "homed" me, became my special corner—the one place really my own. The whole house, my flat, even my own studio, was more or less public. People could track me down in any part of the house or even in the garden. Nobody ever thought of tracking me up to my attic.

I had a fine bedroom off the studio, but I kept that as a guest room, preferring to sleep in my attic. A narrow, crooked little stair in one corner of the studio climbed to a balcony, no more than a lower lip outside the attic door. If people could not find me about house or garden, they stood in the studio and shouted. Out I popped on the tiny balcony, high up on the studio wall, like a cuckoo popping out of a clock.

In the attic I could wallow in tears or in giggles,—nobody saw.

There was an outer hall and front door shared by the doll's flat and my own. If the doorbell rang while I was in my attic, I stuck my head out of the window in the gable without being seen, and called, "Who? Down in a second!"

That second gave me a chance to change my face. Those experienced in landladying told me, "Develop the 'landlady face,' my dear—not soft, nor glad, nor sorry, just blank."

Attic Eagles

The slope of my attic roof rose in a broad benevolent peak, poking bluntly into the sky, sinking to a four-foot wall. At one end of the gable were two long, narrow windows which allowed a good view to come into the room, a view of sea, roof tops and purple hills. Directly below the windows spread a great western maple tree, very green. Things about my place were more spready than high, myself, my house, the sheep-dogs, and Dolf, the Persian cat, whose silver fleece parted down the centre of his back and fluffed wide. Even my apple trees and lilacs grew spready.

In the wall, opposite the windows of my attic, was the room door with a tiny landing before it. Off this landing and over the studio was a dark cobwebby place, tangled with wiring, plumbing, ventilation and mystery. The plaster had oozed up through the lathing on the wrong side of the ceiling and set in bumpy furrows. I had a grim dislike of this place but the high studio ventilated through it, so the little square door had to be left ajar. I painted an Indian bear totem on this white-washed door.

On the generous slope of the attic roof I painted two Indian eagles. They were painted right on the under side of the roof shingles. Their great spread wings covered the entire ceiling of the attic. The heads of the eagles tilted upwards in bold, unafraid enquiry. I loved to lie close under these strong Indian symbols. They were only a few feet above my face as I slept in this attic bedroom. They made "strong talk" for me, as my Indian friends would say.

When, after twenty years, people bought my house and turned it into a fine modern block, they did not require the attic, so they took away the little stair leading from the studio, they removed the door and windows, but they could not remove my eagles without tearing the roof off the house. The eagles belonged to the house for all time.

Old eagles, do you feel my memories come creeping back to you in your entombed, cobwebby darkness?

Brooding and Homing

House, I have gone to bed in your attic crying with smart and hurt as though I had been a hen under whose wing hornets had built their nest and stung me every time I quivered a feather. House, I have slept too in your attic, serene as a brooding dove.

The Indian eagles painted on the underside of the roof's shingles brooded over my head, as I brooded over the House of All Sorts. Three separate sets of souls beside my own it housed, souls for whose material comfort I was responsible. Every hen loosens up her feathers to brood over what she has hatched. Often the domestic hen is badly fooled, finds herself mothering goslings, ducks or guinea-fowl instead of good, ordinary chickens. Only the hen who "steals her nest away" can be sure whose eggs she is sitting on.

The House of All Sorts seemed to get more goslings and guinea-fowl than plain chickens. I tried to be a square old hen, but the mincing guineas and the gawky goslings tried me. The guineas peeped complainingly, the goslings waddled into all the puddles and came back to chill my skin. In no time too they outgrew my brooding squat, hoisting me clear off my feet.

You taught me, old House, that every bird wants some of her own feathers in the lining of her nest.

At first I tried to make my suites into complete homes—arranged everything as I would like it myself—but people changed it all round, discarded, substituted. It is best in a House of All Sorts to provide the necessary only and leave each woman to do her own homing.

Space

Roof, walls, floor can pinch to hurting while they are homing you, or they can hug and enfold. Hurt enclosed is hurting doubled; to spread misery thins it. That is why pain is easier to endure out in the open. Space draws it from you. Enclosure squeezes it close.

I know I hurt my tenants sometimes—I wanted to; they hurt me! It took a long time to grind me into the texture of a landlady, to level my temperament, to make it neither all up nor all down.

The tenant always had this advantage—he could pick up and go. I could not. Fate had nailed me down hard. I appeared for the present to have no hammer-claw strong enough to pry myself loose. No, I was not nailed. I was *screwed* into the House of All Sorts, twist by twist. Every circumstance, financial, public, personal, artistic, had taken a hand in that cruel twirling of the driver. My screws were down to their heads. Each twist had demanded— "Forget you ever wanted to be an artist. Nobody wanted your art. Buckle down to being a landlady."

If only I could have landladied out in space it would not have seemed so hard. The weight of the house crushed me.

First Tenant

She was a bride just returned from honeymooning, this first tenant of mine. Already she was obviously bored with a very disagreeable husband. In her heart she knew he was not proud of her. He kept his marriage to this Canadian girl secret from his English mother.

The bride was a shocking housekeeper and dragged round all day in boudoir cap, frowsy negligée and mules—slip, slop, slip, slop. In my basement I could hear her overhead. Occasionally she hung out a grey wash, left it flapping on the line for a week, unless, for very shame, I took it in to her. "Awfully kind," she would say, "I've been meaning to bring it in these six days. Housekeeping is such a bore!" As far as I could see she did not do any. Even trees and bushes flutter the dust off, manage to do some renewing. Slip, slop—slip, slop—her aimless feet traipsed from room to room. She did not trouble to raise the lid of the garbage can, but tossed her discards out of the back door. Occasionally she dressed herself bravely and, hanging over the front gate, peered and peered. As people passed, going to Beacon Hill Park, she would stop them, saying, "Was there a thin man in grey behind you when you turned into this street?"

Astonished they asked, "Who would it be?"

"My husband—I suppose he has forgotten me again—a bachelor for so long he forgets that he has a wife. He promised to take me to the Races to-day—Oh, dear!"

Going into her flat she slammed the door and melted into negligée again.

He was a horrid man, but I too would have tried to forget a wife like that. Negligée, bad cooking, dirty house!

They had leased my flat for six months. Three days before the fourth month was up, the man said to me casually,

"We leave here on the first."

"Your lease?" I replied.

"Lease!" He laughed in my face. "Leases are not worth their ink. Prevent a landlady from turning you out, that's all."

I consulted the lawyer who admitted that leases were all in favour of the tenant. He asked, "Who have you got there?" I told him.

"I know that outfit. Get 'em out. Make 'em go in the three days' notice they gave you. Tell them if they don't vacate on the dot they must pay another full month. Not one day over the three, mind you, or a full month's rental!"

When I told the couple what the lawyer had said they were very angry, declaring that they could not move in three days' time, but that they would not pay for overtime.

"All right," I said. "Then the lawyer . . ."

They knew the lawyer personally and started to pack violently.

The bride and groom had furnished their own flat—garish newness, heavily varnished, no nearer to being their own than one down payment, less near, in fact, as the instalments were overdue. Store vans came and took the furniture back. The woman left in a cab with a couple of suitcases. The forwarding address she left was that of her mother's home. The man left a separate forwarding address. His was a hotel.

To describe the cleaning of that flat would be impossible. As a parting niceness the woman hurled a pot of soup—meat, vegetables and grease—down the kitchen sink. She said, "You hurried our moving," and shrugged.

The soup required a plumber.

The first tenant nearly discouraged me with landladying. I consulted an experienced person. She said, "In time you will learn to make yourself hard, hard!"

Dew and Alarm Clocks

P oetical extravagance over "pearly dew and daybreak" does not ring true when that most infernal of inventions, the alarm clock, wrenches you from sleep, rips a startled heart from your middle and tosses it on to an angry tongue, to make ugly splutterings not complimentary to the new morning; down upon you spills cold shiveriness—a new day's responsibilities have come.

To part from pillow and blanket is like bidding goodbye to all your relatives suddenly smitten with plague.

The attic window gaped into empty black. No moon, no sun, no street lamps. Trees, houses, telephone poles muddled together and out in that muddle of blank perhaps one or two half-hearted kitchen lights morosely blinking. Sun had not begun.

The long outside stair, from flat to basement, never creaked so loudly as just before dawn. No matter how I tiptoed, every tread snapped, "Ik!"

Punk, the house dog, walked beside me step by step, too sleepy to bounce.

Flashlights had not been invented. My arms threshed the black of the basement passage for the light bulb. Cold and grim sat that malevolent brute the furnace, greedy, bottomless—its grate bars clenched over clinkers which no shaker could dislodge. I was obliged to thrust head and shoulders through the furnace door. I loathed its black, the smell of soot. I was sure one day I should stick. I pictured the humiliation of being hauled out by the shoes.

Could I ever again be a firm dignified landlady after being pulled like that from a furnace mouth!

I could hear tenants still sleeping—the house must be warm for them to wake to. . . .

"Woo, Woo!" A tiny black hand drew the monkey's box curtain back. "Woo, Woo!" A little black face enveloped in yawn peeped out. One leg stretched, then the other. "Woo." She crept from her box to feel if her special pipe was warm, patted approvingly, flattened her tummy to the heat. The cat came, shaking sleep out of her fur. Crackle, crackle!—the fire was burning. Basement windows were now squares of blue-grey dawn.

Carrying a bucket of ashes in each hand I went into the garden, feeling like an anchor dropped overboard. Everything was so coldly wet, I so heavy. Dawn was warming the eastern sky just a little. The Bobbies were champing for liberty. They had heard my step. The warmth of their loving did for the garden what the furnace was doing for the house.

Circled by a whirl of dogs I began to live the day.

We raced for Beacon Hill, pausing when we reached its top. From here I could see my house chimney—mine. There *is* possessive joy, and anyway the alarm clock would not rouse me from sleep for another twenty-three hours—might as well be happy!

Up came the sun, and drank the dew.

Money

From the moment key and rent exchanged hands a subtle change took place in the attitude of renter towards owner.

The tenant was obviously anxious to get you out, once the flat was hers. She might have known, silly thing, that you wanted to be out—before she began to re-arrange things.

Bump, bump, bump! It would never do to let a landlady think her taste and arrangement were yours. Particularly women with husbands made it their business to have the man exchange every piece of furniture with every other. When they left you had to get some one to move them all back into place. When once they had paid and called it "*my* flat" they were always asking for this or that additional furniture or privilege.

There was the tenant who came singing up my long stair and handed in the rent with a pleasant smile. It was folded in a clean envelope so that the raw money was not handled between you. You felt him satisfied with his money's worth. Perhaps he did change his furniture about, just a little, but only enough to make it home him. Every hen likes to scrape the straw around her nest, making it different from every other hen's. There was the pompous person who came holding a roll of bills patronizingly as if he were handing you a tip. There was the stingy one, parting hardly with his cash, fishing the hot tarnished silver and dirty bills from the depths of a trouser pocket and counting them lingeringly, grudgingly, into your palm. There was the rent dodger who always forgot rent date. There was every kind of payer. But most renters seemed to regard rent as an unfairness—was not the earth the Lord's? Just so, but who pays the taxes?

Direct Action

Our district was much too genteel to settle disagreements by a black eye or vituperation. Troubles were rushed upstairs to the landlady. I wished my tenants would emulate my gas stove. In proud metallic lettering she proclaimed herself "Direct action" and lived up to it.

How bothersome it was having Mrs. Lemoyne mince up my stair to inform on Mrs. FitzJohn; having to run down the long stair, round the house and carry the complaint to Mrs. FitzJohn, take the retort back to Mrs. Lemoyne and return the ultimatum—upping and downing until I was tired! Then, often, to find that there was no trouble between the two ladies at all. The whole affair was a fix-up, to convey some veiled complaint against my house or against me, to have the complainer send a sweet message to the complained-of: "Don't give the matter another thought, my dear. It is really of no consequence at all," and from my window see the ladies smiling, whispering, nodding in the direction of my flat. I would have liked better an honest pig-sow who projected her great grunt from the depths of her pen right into one's face.

My sisters, who lived round the corner from the House of All Sorts, watched my landladying with disapproval, always siding with the tenant and considering my grunt similes most unrefined. But they did not have to be landladies.

Cold Sweat

H is hand trembled—so did his voice.

"You will leave the door of your flat unlocked tonight? So that I could reach the 'phone?"

"Certainly."

He went to the door, stood there, clinging to the knob as if he must hold on to something.

"Beautiful night," he said and all the while he was turning up his coat collar because of the storming rain outside. He went into the night. I closed the door; the knob was wet with the sweat of his hand.

Bump, bump, bump, and a curse. I ran out and looked over the rail. He was rubbing his shins.

"That pesky cat—I trod on her—" he cursed again. He loved that cat. I heard him for half an hour calling among the wet bushes. "Puss, Puss, poor Puss." Maybe that mother cat knew his mind needed to be kept busy and was hiding.

I was just turning in when he came again.

"She's all right."

"You have had word? I am so glad—"

"The cat, I mean," he said, glowering at me. "She was not hurt when I trod on her—shan't sleep tonight—not one wink, but if I should not hear your 'phone—would you call me?—leave your window open so I shall hear the ring?"

"All right, I'll call you; I am sure to hear if you don't."

"Thanks, awfully."

The telephone did not ring. In the morning he looked worse.

He came up and sat by the 'phone, scowling at the instrument as if it were to blame. At last he found courage to ring the hospital. After a terse sentence or two he slammed the receiver down and sat staring.

"That your porridge burning?"

"Yes!" He rushed down the stair, and returned immediately with the black, smoking pot in his hand.

"If it were not Sunday I'd go to the office—hang! I'll go anyhow."

"Better stay near the 'phone. Why not a hot bath?"

"Splendid idea. But—the 'phone?"

"I'll be here."

No sooner was he in the tub than the message came.

"You are wanted on the 'phone." I shouted through two doors.

"Take it." He sounded as if he were drowning.

I was down again in a moment. "A boy—both doing well." Dead stillness.

By and by I went down. He was skimming the cream off the milk jug into the cat's dish. The hair stuck damp on his forehead, his cheeks were wet.

"Thank God I was in the tub! I could not have stood it—I should never have thought of asking how she—*they*—were." Realization of the plural clicked a switch that lit up his whole being.

A Tyrant and a Wedding

She came from the prairie, a vast woman with a rolling gait, too much fat, too little wind, only one eye.

She stood at the bottom of the long stair and bribed a child to tell me she was there. Her husband sat on the verandah rail leaning forward on his stick, her great shapeless hand steadying him. This lean, peevish man had no more substance than a suit on a hanger. A clerical collar cut the mean face from the empty clothes.

The old lady's free hand rolled towards the man. "This," she said, "is the Reverend Daniel Pendergast. I am Mrs. Pendergast. We came about the flat."

The usual rigmarole—rental—comfortable beds—hot water . . . They moved in immediately.

I despised the Reverend Pendergast more every day. His heart was mean as well as sick. He drove the old lady without mercy by night and by day. She did his bidding with patient, adoring gasps. He flung his stick angrily at every living thing, be it wife, beast or bird—everything angered him. Then he screamed for his wife to pick up his stick—retrieve it for him like a dog. She must share his insomnia too by reading to him most of the night; that made the tears pour out of the seeing and the unseeing eyes all the next day. Her cheeks were always wet with eye-drips.

I was sorry for the old lady. I liked her and did all I could to help her in every way except in petting the parson. She piled all the comforts, all the tidbits, on him. When I took her flowers and fruit from my garden, it was he that always got them, though I said, most pointedly, "For *you*, Mrs. Pendergast," and hissed the "s's" as loud as I could.

She would beg me, "Do come in and talk to 'Parson'; he loves to see a fresh face."

Sometimes, to please her, I sat just a few minutes by the sour creature.

One morning when I came down my stair she moaned through the crack of the door, "Come to me."

"What is the matter?" I said. She looked dreadful.

"I fell into the coal-bin last night. I could not get up. My foot was wedged between the wall and the step."

"Why did you not call to me?"

"I was afraid it would disturb the Parson. I got up after a while but the pain of getting up and down in the night to do for my husband was *dreadful* torture."

"And he let you do it?"

"I did not tell him I was hurt. His milk must be heated—he must be read to when he does not sleep."

"He is a selfish beast," I said. She was too deaf, besides hurting too much, to hear me.

When I had helped to fix her broken knees and back, I stalked into the living-room where the Reverend Pendergast lay on a couch.

"Mrs. Pendergast has had a very bad fall. She can scarcely move for pain."

"Clumsy woman! She is always falling down," he said indifferently.

I can't think why I did not hit him. I came out and banged the door after me loudly, hoping his heart would jump right out of his body. I knew he hated slams.

There was an outbreak of caterwaulings. The neighbourhood was much disturbed. The cats were strays—miserable wild kittens born when their owners went camping and never belonging to anyone.

The tenants put missiles on all window ledges to hurl during the night. In the morning I took a basket and gathered them up and took them to the tenants' doors so that each could pick out his own shoes, hairbrushes, pokers and scent bottles. Parson Pendergast threw everything portable at the cats. The old lady was very much upset at his being so disturbed. At last with care and great patience, I enticed the cats into my basement, caught them and had them mercifully destroyed.

When I told the Pendergasts, the Parson gave a cruel, horrible laugh. "I crushed a cat with a plank once—beat the life out of her, just for meowing in our kitchen—threw her into the bush for dead; a week later she crawled home—regular jelly of a cat." He sniggered.

"You—a parson—you did that? You cruel beast! To do such a filthy thing!" Mrs. Pendergast gasped. I bounced away.

I could not go near the monster after that. I used to help the old lady just the same, but I would not go near the Reverend Pendergast.

One day, I found her crying.

"What is it?"

"Our daughter—is going to be married."

"Why should she not?"

"He is not the kind of man the Parson wishes his daughter to marry. Besides they are going to be married by a J.P. They will not wait for father. There is not another parson in the vicinity."

The old lady was very distressed indeed.

"Tell your daughter to come here to be married. I will put her up and help you out with things."

The old lady was delighted. The tears stopped trickling out of her good eye and her bad eye too.

We got a wire off to the girl and then we began to bake and get the flat in order.

The Parson insisted it should be a church wedding—everything in the best ecclesiastical style, with the bishop officiating. The girl would be two days with her parents before the ceremony. She was to have my spare room. However, the young man came too, so she had the couch in her mother's sitting room. They sent him upstairs without so much as asking if they might.

I was helping Mrs. Pendergast finish the washing-up when the young couple arrived. Mrs. Pendergast went to the door. She did not bring them out where I was, but keeping her daughter in the other room, she called out some orders to me as if I had been her servant. I finished and went away; I began to see that the old lady was a snob. She did not think me the equal of her daughter because I was a landlady.

It was very late when the mother and daughter brought the young man upstairs to my flat to show him his room. They had to pass through my studio. From my bedroom up in the attic I could look right down into the studio. My door was ajar. There was enough light from the hall to show them the way, but the girl climbed on a chair and turned all the studio lights up full. The three then stood looking around at everything, ridiculed me, made fun of my pictures. They whispered, grimaced and pointed. They jeered, mimicked, playacted me. I saw my own silly self bouncing round my own studio in the person of the old lady I had tried to help. When they had giggled enough, they showed the young man his room and the women went away.

I was working in my garden next morning when the woman and the girl came down the path. I did not look up or stop digging.

"This is my daughter. . . . You have not met, I think."

I looked straight at them, and said, "I saw you when you were in my studio last night."

The mother and daughter turned red and foolish looking; they began to talk hard.

The wedding was in the Cathedral; the old man gave his daughter away with great pomp. The other witness was a stupid man. I was paired with him. We went for a drive after the ceremony.

I had to go to the wedding breakfast because I had promised to help the old lady; I hated eating their food. The bride ordered me around and put on a great many airs.

The couple left for the boat. Mrs. Pendergast and I cleared up. We did not talk much as we worked. We were tired.

Soon the doctor said the Reverend Daniel Pendergast could go home to the prairies again because his heart was healed. I was glad when the cab rolled down the street carrying the cruel, emaciated Reverend and the one-eyed ingrate away from my house—I was glad I did not have to be their landlady any more.

A Visitor

Death had been snooping round for a week. Everyone in the house knew how close he was. The one he wanted lay in my spare room but she was neither here nor there. She was beyond our reach, deaf to our voices.

The sun and spring air came into her room—a soft-coloured, contented room. The new green of spring was close outside the windows. The smell of wall-flower and sweet alyssum rose from the garden, and the inexpressible freshness of the daffodils.

The one tossing on the bed had been a visitor in my house for but a short time. Death made his appointment with her there. The meeting was not hateful—it was beautiful and welcome to her.

People in the house moved quietly. Human voices were tuned so low that the voices in inanimate things—shutting of doors, clicks of light switches, crackling of fires—swelled to importance. Clocks ticked off the solemn moments as loudly as their works would let them.

Death came while she slept. He touched her, she sighed and let go.

We picked the wall-flowers and the daffodils, and brought them to her, close. There was the same still radiance about them as about her. Every bit of her was happy. The smile soaked over her forehead, eyelids and lips—more than a smile—a glad, silent expression.

Lots of people had loved her; they came to put flowers near and to say goodbye. They came out of her room with quiet, uncrying eyes, stood a moment by the fire in the studio, looking deep into it, and then they went away. We could not be sad for her.

The coffin was taken into the studio. One end rested on the big table which was heaped with flowers. The keen air came in through the east windows. Outside there was a row of tall poplars, gold with young spring.

Her smile—the flowers—quiet—possessed the whole house.

A faint subtle change came over her face. She was asking to be hidden away.

A parson came in his mournful black. He had a low, sad voice—while he was talking we cried.

They took her down the long stairs. The undertakers grumbled about the corners. They put her in the waiting hearse and took her away.

The house went back to normal, but now it was a mature place. It had known birth, marriage and death, yet it had been built for but one short year.

The Doll's House Couple

I t was made for them, as surely as they were made for each other. I knew it as soon as I saw the young pair standing at my door. They knew it too the moment I opened the door of the Doll's House. His eyes said things into hers, and her eyes said things into his. First their tongues said nothing, and then simultaneously, "It's ours!" The key hopped into the man's pocket and the rent hopped into mine.

One outer door was common to their flat and to mine. Every time I came in and out passing their door I could hear them chatting and laughing. Their happiness bubbled through. Sometimes she was singing and he was whistling. They must do something, they were so happy.

At five o'clock each evening his high spirits tossed his body right up the stair—there she was peeping over the rail, or hiding behind the door waiting to pounce on the tragedy written all over him because he had not found her smiling face hanging over the verandah rail. She pulled him into the Doll's House, told him all about her day—heard all about his.

She tidied the flat all day and he untidied it all night. He was such a big "baby-man," she a mother-girl who had to take care of him; she had always mothered a big family of brothers. They had taught her the strangeness of men, but she made more allowance for the shortcomings of her man than she had done for the shortcomings of her brothers.

I was making my garden when they came to live in my house. They would come rushing down the stair, he to seize my spade, she to play the hose so that I could sit and rest a little. They shared their jokes and giggles with me.

When at dusk, aching, tired, I climbed to my flat, on my table was a napkined plate with a little surprise whose odour was twin to that of the supper in the Doll's House.

Sometimes, when my inexperience was harried by Lower East or Lower West, when things were bothersome, difficult, so that I was just hating being a landlady, she would pop a merry joke or run an arm round me, or he would say, "Shall I fix that leak?—put up that shelf?"

Oh, they were like sunshine pouring upon things, still immature and hard by reason of their greenness. Other tenants came and went leaving no print of themselves behind—that happy couple left the memory of their joyousness in every corner. When, after they were gone, I went into the Doll's House emptiness, I felt their laughing warmth still there.

References

Experience taught me to beware of people who were glib with references. I never asked a reference. I found that only villains offered them.

There was a certain Mrs. Panquist. The woman had a position in a very reputable office. Her husband was employed in another. Her relatives were people of position, respected citizens. She gave me this voluntary information when she came to look at the flat.

"It suits me," she said. "I will bring my husband to see it before deciding."

Later she rang up to say he was not coming to see it. They had decided to take the flat and would move in early the next morning. She would bring her things before business hours. Furthermore she asked that I prepare an extra room I had below for her maid. To do this I had to buy some new furniture.

She did not come or send her things next morning; all day there was no word of her. I had the new furniture bought and everything ready.

Late in the evening she arrived very tired and sour.

She snatched the key out of my hand.

"It is usual to exchange the rent for the key," I said knowing this was wartime and that there was some very shady fly-by-nights going from one apartment house to another.

"I am too tired to bother about rent tonight!" she snapped. "I will come up with it in the morning before I go to work."

Again she failed to keep her promise. I asked her for the rent several times but she always put me off. Finally she said rudely, "I am not going to pay; my husband can."

I went to the man, who was most insolent, saying, "My wife took the flat; let her pay."

"Come," I said. "Time is going on, one or the other of you must pay." I pointed to the notice on my kitchen door "RENTS IN ADVANCE". He laughed in my face. "Bosh!" he said. "We don't pay till we are ready."

I began to make enquiries about the couple, not from those people whose names they had given as reference, but from their former landlady. Their record was shocking. They had rented from a war widow, destroyed her place, and gone off owing her a lot of money.

Both of the Panquists had jobs; they could pay and I was not going to get caught as the war widow had been.

I consulted the law—was turned over to the Sheriff.

"Any furniture of their own?"

"Only a couple of suitcases."

"Not enough value to cover the rental they owe?"

"No."

"This is what you are to do. Watch—when you see them go out take a pass key, go in and fasten up the flat so that they cannot get in until the rental is paid."

"Oh, I'm scared; the man is such a big powerful bully!"

"You asked me for advice. Take it. If there is any trouble call the police."

I carried out the Sheriff's orders, trembling.

The Panquists had a baby and a most objectionable nursemaid. She was the first to come home, bringing the child.

I was in my garden. She screamed, "The door is locked. I can't get in!"

"Take the child to the room I prepared for you." (The woman had decided she did not want it after I had bought furniture and prepared the room.) I took down milk and biscuits for the child. "When your mistress has paid the rent the door will be opened," I said. The maid bounced off and shortly returned with the woman, who stood over me in a furious passion.

"Open that door! You hear—open that door!"

"When the rent is paid. You refuse, your husband refuses. The flat is not yours till you pay. I am acting under police orders."

"I'll teach you," she said, livid with fury, and turned, rushing headlong; she had seen her husband coming.

He was a huge man and had a cruel face. His mouth was square and aggres-

sive; out of it came foul oaths. He looked a fiend glowering at me and clenching his fists.

"You—(he called me a vile name)! Open or I will break the door in!" He braced his shoulder against it and raised his great fists. I was just another woman to be bullied, got the better of, frightened.

I ran to the 'phone. The police came. The man stood back, his hands dropping to his sides.

"What do you want me to do?" said the officer.

"Get them out. I won't house such people. They got away with it in their last place, not here."

I was brave now though I shook.

"The town is full of such," said the officer. "House owners are having a bad time. Scum of the earth squeezing into the shoes of honest men gone overseas. How much do they owe?"

I told him.

He went to the man and the woman who were snarling angrily at one another.

"Pay what you owe and get out."

"No money on me," said the man, "my wife took the flat."

"One of you must," said the officer.

"Shell out," the man told the woman brutally.

She gave him a look black with hatred, took money from her purse and flung it at me. My faith in proffered references was dead.

Dogs and Cats

At first, anxious to make people feel at home, happy in my house, I permitted the keeping of a dog or a cat, and I endured babies.

My Old English Bobtail Sheep-dogs lived in kennels beyond the foot of my garden. They had play fields. The tenants never came in contact with the dogs other than seeing them as we passed up the paved way in and out for our run in Beacon Hill Park. One old sheep-dog was always in the house with me, always at my heels. He was never permitted to go into any flat but mine. There was, too, my great silver Persian cat, Adolphus. He also was very exclusive. People admired him enormously but the cat ignored them all.

I enjoyed my own animals so thoroughly that when a tenant asked, "May I keep a dog or a cat?" I replied, "Yes, if you look after it. There are vacant lots all round and there is Beacon Hill Park to run the animal in."

But no, people were too lazy to be bothered. They simply opened their own door and shoved the creature into the narrow strip of front garden, let him bury his bones and make the lawn impossible. Always it was the landlady who had to do the tidying up. I got tired of it. Anyone should be willing to tend his creature if he has any affection for it. They managed cats even worse, these so-called "animal lovers." Stealthily at night a basement window would open, a tenant's cat be pushed through. The coal pile became impossible. I was obliged to ban all animals other than a canary bird, although I would far rather have banned humans and catered to creatures.

Matrimony

I had never before had the opportunity of observing the close-up of married life. My parents died when I was young. We four spinster sisters lived on in the old house. My girlhood friends who married went to live in other cities. I did not know what "till-death-do-us-part" did to them.

Every couple took it differently of course, but I discovered I could place "Marrieds" in three general groupings—the happy, the indifferent, and the scrappy.

My flat being at the back of the house I overlooked no tenant nor did I see their comings and goings. The walls were as soundproof as those of most apartments, only voice murmurs came through them, not words. No secrets were let out. I neither saw nor heard, but I *could* feel in wordless sounds and in silences; through the floor when I went into my basement to tend the furnace I heard the crackle of the man's newspaper turning and turning—the creak of the woman's rocker.

There are qualities of sound and qualities of silence. When the sounds were made only by inanimate things, you knew that couple were the indifferent type. When you heard terse jagged little huddles of words, those were the snappers! If there was a continuous rumbling of conversation, contented as the singing of a tea kettle or the purring of a cat, you knew that couple had married happily. There was the way they came to pay the rent too, or ask a small favour, or project a little grumble. The happily married ones spared each other; the wife asked or grumbled for the husband, the husband for the wife.

Snappy couples tore up my stairs, so eager to "snap their snaps" that they often found themselves abreast of each other anxious to be first!

It was immaterial whether the man or the woman of the indifferent pair came. They handed in the rent grudgingly and went away without comment. I liked them the least.

Life Loves Living

There were four western maple trees growing in the lot upon which I built my house. Two were in the strip of front lawn, clear of foundations, but when the builders came to overhead wiring they found one of the trees interfered. The line-men cut it down. The other front-lawn maple was a strong, handsome tree. I circled her roots with rock and filled in new earth. The tree throve and branched so heavily that the windows of Lower West and the Doll's Flat were darkened. Experts with saws and ladders came and lopped off the lower branches. This sent the tree's growth rushing violently to her head in a lush overhanging which umbrellaed the House of All Sorts. She was lovely in spring and summer, but when fall came her leaves moulted into the gutters and heaped in piles on the roof, rotting the cedar shingles. It put me to endless expense of having roof-men, gutter-men and tree-trimmers. At last I gave the grim order, "Cut her down."

It is horrible to see live beauty that has taken years to mature and at last has reached its prime hacked down, uprooted.

The other two maple trees had stood right on the spot where my house was to be built. The builders had been obliged to saw them to within three or four feet of the ground. Both trees' roots were in that part underneath the house which was not to be cemented; it would always be an earthy, dark place. The maple stumps were left in the ground. One died soon. The other clung furiously to life, her sap refused to dry up; grimly she determined to go on living.

The cement basement was full of light and air, but light and air were walled away from that other part, which was low. I could not stand there upright; there was but one small square of window in the far corner. The old maple stump shot sickly pink switches from her roots, new switches every year. They crept yearningly toward the little square of window. Robbed of moisture, light and air, the maple still remembered spring and pushed watery sap along her pale sprouts, which came limper and limper each year until they were hardly able to support the weight of a ghastly droop of leaves having little more substance than cobwebs.

But the old maple stump would not give up. It seemed no living thing in the House of All Sorts had less to live for than that old western maple, yet she clung to life's last shred—she loved living.

Brides

L ower East and Lower West were both rented to brides.

The brides sat in their living-rooms with only a wall dividing; they looked out at the same view. They did not know each other.

In the East flat, the young husband was trying to accommodate himself to a difficult and neurotic wife.

In the West flat a middle-aged groom was trying to slow a bright young girl down to his dullness. The girl drooped, was home-sick, in spite of all the pretty things he gave her and the smart hats she made for herself (she had been a milliner in New York before she married the middle-aged man). It was freedom she thought she was marrying—freedom from the drudgery of bread-and-butter-earning. When he dangled a "home of her own" before her eyes, she married him and was numbed; now came the pins and needles of awaking.

I had known the other bride since she was a child. When I welcomed her into my house, she chilled as if to remind me that she was a popular young bride—I a landlady; I took the hint. I had put the best I had into her flat, but she scornfully tossed my things into her woodshed, replacing them with things of her own. The rain came, and spoiled my things. When I asked her to hand back what she did not want, so that I might store them safely, she was very insulting, as if my things were beyond contempt or hurting.

The little New York bride was very, very lonely, with her dull, heavy husband. She came up to my flat on any excuse whatever. One day she cried and told me about it. She said that she knew no one. "The girl next door is a bride too; she's smart; she has lots of friends. I see them come and go. Oh, I do wish I knew her." Then she said, "You know her; couldn't you introduce me? Please!"

"I have known her since she was a child, but I could not introduce you to each other."

"Why?"

"It is not my place to introduce tenants. People make opportunities of speaking to each other if they are neighbours, but they would resent being compelled by their landlady to know each other."

"But you have known this girl since she was little—couldn't you? I have no friends at all. Please, please."

"Listen, it would not make you happy. She is a snob."

I would not subject this unhappy, ill-bred, little bride, with her ultra clothes worn wrong, her overdone make-up and her slangy talk, to the snubs of the stuck-up bride next door.

"You'll come and see me, won't you? Come often—he is out so much."

"I will come when I can."

She went slowly down to her empty flat, this lonely little bride who had sold her pretty face for laziness and a home.

Next day she ran up, all excitement.

"My opportunity came! The postman asked me to deliver a registered letter, because my neighbour was out; you are all wrong, she is lovely. I expect we shall see a lot of each other now. I am so happy."

She flew down-stairs, hugging her joy.

I missed her for some days. I went to see if she were ill, found her crumpled into a little heap on the sofa. She had red eyes.

"Hello! Something wrong?"

She gulped hard. "It is as you said—she is a snob. We met in the street. They saw me coming. When I was close they looked the other way and talked hard. Her husband did not even raise his hat!"

"Perhaps they did not see it was you."

"They could not help seeing—not if they'd been as blind as new kittens. I spoke before I saw how they felt," she sobbed.

"Pouf! Would I care? She is not worth a cry! What pretty hats you make!"

She had been working on one—it lay on the table half finished.

"You like them? I make them all myself. I was a milliner in New York—head of all the girls. They gave me a big pay because I had knack in designing—big fine store it was too!"

"Here you are crying because a snob who couldn't make one 'frump's bow' did not speak to you! Come, let's go into the garden and play with the pups."

She was soon tumbling with them on the lawn, kind whole-hearted clumsy pups, much more her type than the next-door bride.

Always Something

She was so young, so pretty, so charming! But when it came to a matter of shrewd bargaining, you couldn't beat her. Her squeezing of the other fellow's price was clever—she could have wrung juice from a raw quince. Her big husband was entirely dominated by his tall, slender wife; he admired her methods enormously. Sometimes he found it embarrassing to look into the face of the "squeezed." While she was crumbling down my rent, he turned his back, looking out of the window, but I saw that his big ears were red and that they twitched.

It was the Doll's Flat she bargained for, which seemed ridiculous seeing that he was so large, she so tall, and the Doll's Flat so little.

"Won't it be rather squeezy?" I suggested.

"My husband is used to ship cabins. For myself I like economy."

She was an extremely neat, orderly person, kept the Doll's Flat like a Doll's Flat—no bottles, no laundry, no garbage troubles, as one had with so many tenants. She made the place attractive.

She entertained a bit and told me all the nice things people said about her flat.

"If only I had 'such and such a rug' or 'such and such a curtain' it would be perfect!" and she wheedled till I got it for her. But these added charms to make her flat *perfect* always came out of my pocket, never out of hers.

I had a white cat with three snowball kittens who had eyes like forget-me-nots. When the tall, slim wife was entertaining, she borrowed my "cat family," tied blue ribbons round their necks. Cuddled on a cushion in a basket they amused and delighted her guests—inexpensive entertainment. Flowers were always to be had out of my garden for the picking.

"If only toasted buns grew on the trees!" She liked toasted buns for her tea parties—the day-before's were half-price and toasted better. . . . I heard her on my 'phone.

"Not deliver five cents' worth! Why should I buy more when I don't require them?" Down slammed the receiver and she turned to me.

"They do not deserve one's custom! I shall have to walk to town: it is not worth paying a twelve-cent carfare to fetch five cents' worth of stale buns!"

I swore at the beginning of each month I would buy nothing new for her, but before the month was out I always had, and wanted to kick myself for a weak fool. I liked her in spite of her meanness.

She was proud of her husband's looks; he wore his navy lieutenant's clothes smartly.

"Ralph, you need a new uniform."—He ordered it. "How much is the tailor charging? . . . Ridiculous!"

"He is the best tailor in town, my dear."

"Leave him to me."

The next day she came home from town. "I've cut that tailor's price in half."

"What a clever wife!" But the lieutenant went red. He took advantage of her bargaining but he shivered at her boasting in front of me about it.

She did hate to pay a doctor. She had been a nurse before she married; she knew most of the doctors in town. It was wonderful how she could nurse along an ailment till someone in the house fell sick, then she just "happened to be coming in the gate" as the doctor went out. He would stop for a word with the pretty thing.

"How are you?"

Out came tongue and all her saved-up ailments. She ran down to the drug-gist's to fill the prescription, to shop a little. Butcher, grocer always added a bit of suet, or a bone, or maybe she spotted a cracked egg, had it thrown in with her dozen. They *loved* doing it for her, everybody fell before her wheedle.

"I am going to stay with you forever," she had said as an inducement to make me lower the rent and buy this or that for her flat. Then, "The very smartest apartment block in town—Ralph always fancied it, but it was too expensive for us. But—only one room, a bachelor suite—the man is sub-letting at *half* its usual price, furniture thrown in. He will be away one year. Wonderful for us! Such a bargain, isn't it my dear?"

"One room!"

"But, the block is so smart: such a bargain!"

They went to their bargain room. A professor and his wife moved into my Doll's Flat. They were as lavishly open-handed as the others had been stingy. The professor was writing a book. He had a talkative wife whom he adored, but though he loved her tremendously, he could not get on with his book because of her chattering. He just picked her up, opened my door, popped her in.

"There! chatter, dear, all you like." He turned the key on his peace—what about mine? I pulled the dust-sheet over my canvas. Landlady's sighs are heavy—is it not enough to give shelter, warmth, furniture? Must a landlady give herself too?

Mean Baby

The baby had straight honey-coloured hair, pale eyes, puckered brow, pouting mouth, and a yell, a sheer, bad-tempered, angry yell which she used for no other reason than to make herself thoroughly unpleas-ant. Bodily she was a healthy child.

Her family brought her to my house suddenly because the whole lot of them had come down with measles while staying in a boarding house nearby. The other boarders got panicky and asked them to go! Early in the morning the mother came to me, very fussed. Lower West was empty and measles being a temporary complaint, I let the woman have the flat.

When the taxi load of spotty children drove up to my door I was hustling to warm up the beds and make up extras. Some of the children sat limp and mute waiting, while others whimpered fretfully. The infant, a lumpy child of unwalk-

ing, un-talking age, was the only one who had not got measles. The mother set the child on the floor while she went to fetch the sick, spotty miseries from the cab. The infant's head, as it were, split in two—eyes, cheeks, brow retired, all became mouth, and out of the mouth poured a roar the equal of Niagara Falls.

The lady in the Doll's Flat above stuck her head out of the window and looked down. "Measles," I warned, and she drew her own and her small son's head back, closed her windows and locked her door.

The measles took their course under a doctor and a trained nurse. I ran up and down the stairs with jellies and gruel. Night and day the baby cried. The House of All Sorts supposed she was sickening for measles and endured it as best they could. The baby did not get measles. After fumigation and quarantine were over and nothing ailed the child we had the Doctor's word as assurance that it was only a cranky, mean temper that was keeping us awake all night. The tenants began coming to me with complaints, and I had to go down and talk to the mother.

I said, "No one in the house can sleep for the child's crying, something will have to be done. I cannot blame my tenants for threatening to go and I cannot afford to lose them." The woman was all syrupy enthusing over the soups and jellies I had sent the measles; but she suddenly realized that I was in earnest and that my patience for my household's rest was at an end.

If only I could have gone down to the mother in the middle of the night when we were all peevish for sleep, it would have been different, but, with the child sitting for the moment angel-like in her mother's lap, it was not easy to proceed. I looked out the window. Near the front gate I saw the child's pram drawn up dishevelled from her morning nap. What my tenants resented most was not that the child kept the whole household awake at night but that the mother put her baby to sleep most of the day in the garden, close by the gate through which people came and went to the house. After listening to her yelling all night every one was incensed to be told in the daytime, "Hush, hush! my baby is asleep: don't wake her." The mother pounced upon the little boy upstairs, upon baker, postman, milkman, visitors; every one was now afraid to come near our house; people began to shun us. I looked at the disordered pram and took courage.

"Would you please let the baby take her day naps on the back verandah; she would be quiet there and not interfere with our coming and going."

"My baby on the back porch! Certainly not!"

"Why does the child cry so at night? My tenants are all complaining; something will have to be done."

"People are most unreasonable."

She was as furious as a cow whose calf has been ill-treated.

"Who is it that suffers most, I'd like to know? Myself and my husband! It is most ill-natured of tenants to complain."

Standing the baby on her knee and kissing her violently, "Oose never been werry seepsy at night has Oo, Puss Ducksey?"

The child smacked the mother's face with extraordinary vigour, leaving a red streak across the cheek. The mother kissed the cruel little fist.

"Something will have to be done, otherwise I shall have an empty house," I repeated determinedly for the third time.

"What, for instance?"

"A few spankings."

The woman's face boiled red.

"Spank Puss! Never!"

My hand itched to spank both child and mother.

"Why don't you train the child? It is not fair to her, only makes people dislike her."

"As if any one could dislike Puss, our darling!" She looked hate at me.

During our conversation Puss had been staring at me with all her pale eyes, her brow wrinkled. Now she scrambled from her mother's lap to the floor and by some strange, crablike movement contrived not only to reach me but to drag herself up by my skirt and stand at my knee staring up into my face.

"Look! Look! Puss has taken her first steps alone and to you, you, who hate her," said the angry mother.

"I don't hate the youngster. Only I cannot have a spoiled child rob me of my livelihood and you must either train her or go elsewhere."

She clutched the honey-haired creature to her.

"The people upstairs have left because of your baby's crying at night. They gave no notice. How could I expect it: the man has to go to business whether your child has yelled all night or not. Another tenant is going too. I wish I could leave myself!"

I saw that my notice was being ignored. I had sent it in when I served her last rent. Go she must! It was in her hand when she came up to pay.

"Of course you don't mean this?" She held out the notice.

"I do."

"But have you not observed an improvement? She only cried four times last night."

"Yes, but each time it lasted for a quarter of the night."

"Sweet Pussy!" she said, and smothered the scowling face with kisses. "They don't want us, Puss!"

"That notice stands," I said, looking away from Puss. "I got no notices from the tenants Puss drove away."

The angry mother rushed for the door. I went to open it for her and a little pink finger reached across her mother's shoulder and gave me a little, pink poke and a friendly gurgling chuckle.

"What I cannot understand," the woman blazed at me as she turned the corner, "is *why* Puss, my shy baby who won't allow any one to speak to her, appears actually to *like* you, you who hate her."

But did I hate the little girl with honey-coloured hair? She had cost me two tenants and no end of sleep, had heated my temper to boiling, yet, somehow I could not hate that baby. The meanest thing about her was the way she could make you feel yourself. One has to make a living and one must sleep. It is one of the crookednesses of life when a little yellow-haired baby can cause you so much trouble and yet won't even let you hate her.

Puss sailed off to her new home in a pram propelled by an angry parent.

"Ta ta," she waved as they turned the corner—and I? I kissed my hand to Puss when her mother was not looking.

Bachelors

When a flat housed a solitary bachelor, there was a curious desolation about it. The bachelor's front door banged in the morning and again at night. All day long there was deadly stillness in that flat, that secret silence of "Occupied" emptiness, quite a different silence from "To Let" emptiness.

Pedlars passed the flat without calling. The blinds dipped or were hoisted at irregular levels. Sometimes they remained down all day. Sometimes they were up all night. There were no callers and there was no garbage. Men are out.

Bachelors that rent flats or houses do so because they are home-loving; otherwise they would live in a boarding-house and be "done" for. They are tired of being tidied by landladies; they like to hang coats over chair backs and find them there when they come home. It is much handier to toss soiled shirts behind the dresser than to stuff them into a laundry bag; men do love to prowl round a kitchen. A gas stove, even if it is all dusty over the top from unuse, is home-like, so is the sink with its taps, the saucepan, the dishes. The

men do not want to cook, but it is nice to know they could do so if they wished. In the evening, when I tended the furnace, I heard the bachelor tramp, tramp, tramping from room to room as if searching for something. This would have fidgeted a wife, but, if the bachelor had had a wife he would probably not have tramped.

During the twenty-odd years that I rented apartments I housed quite a few bachelors. Generally they stayed a long while and their tenancy ended in marriage and in buying themselves a home.

A bachelor occupied Lower West for several years. Big, pink and amiable, he gave no trouble. Occasionally his sister would come from another town to visit him. He boarded her with me up in my flat. I enjoyed these visits, so did her brother. I saw then how domestic and home-loving the man was. He loved his sister and was very good to my Bobtail dogs. Once the sister hinted—there *was* "somebody," but, she did not know for certain; brother thought he was too old to marry—all fiddlesticks! She hoped he would. Therefore, I was not surprised when the bachelor came into my garden, and, ducking down among the dogs to hide how red he was, said, "I am going to be married. Am I an old fool?"

"Wise, I think."

"Thank you," he said, grinning all over—"I have been happy here."

He gave formal notice, saying, "I have bought a house."

"I hope you will be very happy."

"Thanks. I think we shall."

He went to the garden gate, turned, such a sparkle in his eye it fairly lit the garden.

"She's fine," he said. "Not too young—sensible."

Then he bolted. I heard the door of his flat slam as if it wanted to shut him away from the temptation of babbling to the world how happy he was.

The wedding was a month distant. During that month, when I tended the furnace there was no tramp, tramp, tramp overhead. I heard instead the contented scrunch, scrunch of his rocking chair.

The morning of the wedding he bounded up my stair, most tremendously shaved and brushed, stood upon my doormat bashfully hesitant. I did not give him the chance to get any pinker before I said, "You *do* look nice."

"Do I really?" He turned himself slowly for inspection. "Hair, tie, everything O.K.?"

"Splendid." But I took the clothes brush from the hall stand and flicked it across his absolutely speckless shoulders. It made him feel more fixed.

His groomsman shouted from the bottom of the stair, "Hi there!" He hurried down and the two men got into a waiting cab.

Bangs and Snores

A young lawyer and his mother lived in Lower West. They were big, heavy-footed people. Every night between twelve and two the lawyer son came home to the flat. First he slammed the gate, then took the steps at a noisy run, opened and shut the heavy front door with such a bang that the noise reverberated through the whole still house. Every soul in it was startled from his sleep. People complained. I went to the young man's mother and asked that she beg the young man to come in quietly. She replied, "My son is my son! We pay rent! Good-day."

He kept on banging the house awake at two A.M.

One morning at three A.M., my telephone rang furiously. In alarm I jumped from the bed and ran to it. A great yawn was on the other end of the wire. When the yawn was spent, the voice of the lawyer's mother drawled, "My son informs me your housedog is snoring; kindly wake the dog, it disturbs my son."

The dog slept on the storey above in a basket, his nose snuggled in a heavy fur rug. I cannot think that the noise could have been very disturbing to anyone on the floor below.

The next morning I went down and had words with the woman regarding her selfish, noisy son as against my dog's snore.

Petty unreasonableness nagged calm more than all the hard work of the house. I wanted to loose the Bobtails, follow them—run, and run, and run into forever—beyond sound of every tenant in the world—tenants tore me to shreds.

Zig-Zag . . . Ki-Hi

S imultaneously, two young couples occupied, one Lower East, one Lower West. The couples were friends. One pair consisted of a selfish wife and an unselfish husband. The other suite housed a selfish husband and an unselfish wife.

Zig-zag, zig-zag. There was always pulling and pushing, selfishness against unselfishness.

I used to think, "What a pity the two selfish ones had not married, and the two unselfish." Then I saw that if this had been the case nobody would have got anywhere. The unselfish would have collided, rushing to do for each other. The selfish would have glowered from opposite ends of their flat, refusing to budge. . . .

Best as it was, otherwise there would have been pain—stagnation.

The unselfish wife was a chirping, cheerful creature. I loved to hear her call "Ki-hi, Ki-hi! Taste my jam tarts." And over the rail of my balcony would climb a handful of little pies, jam with criss-cross crust over the top! Or I would cry over the balcony rail, "Ki-hi, Ki-hi! Try a cake of my newest batch of home-made soap."

We were real neighbours, always Ki-hi-ing, little exchanges that sweetened the sour of landladying. This girl-wife had more love than the heart of her stupid husband could accommodate. The overflow she gave to me and to my Bobtails. She did want a baby so, but did not have one. The selfish wife shook with anxiety that a child might be born to her.

Zig-zag, zig-zag. Clocks do not say "tick, tick, tick," eternally—they say "tick, tock, tick, tock." We, looking at the clock's face, only learn the time. Most of us know nothing of a clock's internal mechanism, do not know why it says "tick, tock," instead of "tick, tick, tick."

Lady Loo, my favourite Bobtail mother, was heavy in whelp. Slowly the dog paddled after my every footstep. I had prepared her a comfortable box in which to cradle her young. She was satisfied with the box, but restless. She wanted to be within sight of me, or where she heard the sound of my voice. It gave the dog comfort.

Always at noon on Sundays I dined with my sisters in our old home round the corner. I shut Lady Loo in her pen in the basement; I would hurry back. When I re-entered the basement, "Ki-hi"—a head popped in the window of Loo's pen. On the pavement outside sat little "Ki-hi."

"Loo whimpered a little, was lonely when she heard you go. I brought my camp stool and book to keep her company. Ki-hi, Lady Loo! Good luck!" She was away!

I think that little kindness to my mother Bobtail touched me deeper than anything any tenant ever did for me.

Blind

Mother and daughter came looking for a flat, not in the ordinary way—asking about this and that, looking out of the windows to see what view they would have. They did not note the colour of the walls, but poked and felt everything, smoothed their fingers over surfaces, spaced the distance of one thing from another. I sensed they sought something particular; they kept exchanging glances and nods, asked questions regarding noises. They went away and I forgot about them. Towards evening they came back; they were on their way to the Seattle boat, had decided to take my flat, and wanted to explain something to me. The cab waited while we sat on my garden bench.

"There will be three people in the flat," said the woman. "My mother, my daughter and my daughter's fiancé."

"It is necessary to get the young man away from his present environment; he has been very, very ill."

She told me that while he was making some experiments recently something had burst in his face, blowing his eyes out. The shock had racked the young man's nerves to pieces. His fiancée was the only person who could do anything with him. She was devoted. The grandmother would keep house for them. They asked me to buy and prepare a meal so that they could come straight from the boat next day and not have to go to a restaurant.

The meal was all ready on the table when the girl led the crouching huddle that was her sweetheart into the flat. Old grandmother paddled behind—a regular emporium of curiosities. She looked like the bag stall in a bazaar; she was carrying all kinds—paper, leather, string and cloth. They dangled from her hands by cords and loops, or she could never have managed them all. She hung one bag or two over each door-knob as she passed through the flat, and then began taking off various articles of her clothing. As she took each garment off, she cackled, "Dear me, now I must remember where I put that!" Her hat was on the drainboard, her shoes on the gas stove, her cloak on the writing desk, her dress hung over the top of the cooler door. Her gloves and purse were on the dinner-table, and her spectacles sat on top of the loaf. She looked pathetic, plucked. After complete unbuilding came reconstruction. She attacked the bags, pulling out a dressing sacque, a scarf, an apron and something she put on her head. She seemed conscious of her upper half only, perhaps she used only a handmirror. Her leg half was pathetic and ignored. The scant petticoat came only to her knees, there was a little fence of cro-

cheted lace around each knee. Black stockings hung in lengthwise folds around the splinters of legs that were stuck into her body and broke at right angles to make feet. Her face-skin was yellow and crinkled as the shell of an almond—the chin as pointed as an almond's tip.

The girl led the boy from room to room. She held one of his hands, with the other he was feeling, feeling everything that he could reach. So were his feet—shuffling over the carpet, over the polished floor. Grannie and I kept up a conversation, turning from him when we spoke so that he could hear our voices coming from behind our heads and not feel as if we were watching him.

Grannie "clucked" them in to dinner; I came away.

It was natural enough that the blind man should be fussy over sounds. Grannie flew up to my flat and down like a whiz cash-box. The wind caught her as she turned the corner of my stairs, exposing a pink flannelette Grannie one week and a blue flannelette Grannie the next. She was very spry, never having to pause for breath before saying, "Tell those folks above us to wear slippers—tell them to let go their taps gently—have a carpenter fix that squeaky floor board."

Then she whizzed downstairs and the door gave back that jerky smack that says, "Back again with change!"

On Sunday morning the house was usually quiet. Settling in families was always more or less trying. I determined to have a long late lie, Grannie and family being well established. At seven A.M., my bell pealed violently. I stuck my head out into the drizzling rain and called, "What is wanted?"

Grannie's voice squeaked—"You!"

"Anything special? I am not up."

"Right away! Important!"

I hurried. Anything might have happened with that boy in the state he was.

When I opened the door, Grannie poked an empty vase at me, "The flowers you put in our flat are dead. More!"

The girl and the boy sat in my garden at the back of the house. It was quiet and sheltered there, away from the stares the boy could not bear. The monkey was perched in her cherry-tree, coy as Eve, gibbering if some one pulled in the clothes-line which made her tree shiver and the cherries bob, stretching out her little hands for one of the pegs she had coveted all the while that the pyjamas, the dresses and aprons had been drying. The girl told him about it all,

trying to lighten his awful dark by making word-pictures for him—the cat on the fence, the garden, flowers, me weeding, the monkey in her cherry-tree.

"Is that monkey staring at me?"

"No, she is searching the dry grass round the base of the cherry-tree for earwigs now. Hear her crunch that one! Now she is peeping through the lilac bush, intensely interested in something. Oh, it's the Bobtails!"

I had opened the gates from dog-field and puppy-pen. Bobtails streamed into the garden. People sitting with idle hands suggested fondling, which dogs love. They ringed themselves around the boy and girl. The mother dog led her pups to them—the pups tugged at his shoelaces, the mother dog licked his hand. He was glad to have them come of themselves. He could stoop and pick them up without someone having to put them into his arms. He buried his blackness in the soft black of their live fur. A pup licked his face, its sharp new teeth pricked his fingers, he felt its soft clinging tongue, smelled the puppy breath. The old dog sat with her head resting on his knee. He could feel her eyes on him; he did not mind those eyes. The sun streamed over everything. His taut nerves relaxed. He threw back his head and laughed!

The girl gathered a red rose, dawdled it across his cheek and forehead. She did not have to tell him the colour of the rose; it had that exultant rich red smell. He put his nose among the petals and drew great breaths.

Suddenly the back door of their flat flew open—PLOSH!—Out among the flowers flew Grannie's dishwater. Grannie was raised in drought. She could not bear to waste water down a drain.

Old Grannie over-fussed the young folks. She was kind, but she had some trying ways. Afternoon house-cleaning was one of them.

The new bride in Lower East was having her post-nuptial "at home" and Grannie must decide that very afternoon to house-clean her front room. She heaved the rugs and chairs out onto the front lawn; all the bric-a-brac followed. She tied the curtains in knots and, a cloth about her head, poised herself on a table right in front of the window. Everyone could see the crochet edging dangling over the flutes of black stocking. She hung out—she took in; her arms worked like pistons. The bride's first guest met a cloud of Bon Ami as Gran shook her duster. The waves from Gran's scrub bucket lapped to the very feet of the next guest—dirty waves that had already washed the steps. The bride came up the next day to see me about it.

Why—oh, why—oh, why—could one not secure tenants in packets of "named varieties"—true to type like asters and sweet peas? The House of All Sorts got nothing but "mixed."

Snow

Tall—looseknit—dark-skinned—big brown eyes that could cry grandly without making her face ugly—sad eyes that it took nothing at all to fire and make sparkle.

That funny joker, life, had mated her to a scrunched-up whipper-snapper of a man, with feet that took girls' boots and with narrow, white hands. They had a fiery-haired boy of six. His mother spoiled him. It was so easy for her to fold her loose-knit figure down to his stature. They had great fun. The father scorned stooping. Neither his body nor his mind was bendable.

I heard mother and son joking and sweeping snow from their steps. Sweeping, snowballing—sweeping, laughing. That was on Monday. By Wednesday more snow had fallen, and she was out again sweeping furiously— but she was alone.

"Where is your helper?"

"Sick."

"Anything serious?"

"I have sent for the doctor. I am clearing the snow so that he can get in." She had finished now and went in to her flat and banged the door angrily— evident anger, but not at me.

The doctor came and went; I ran down to her.

"What does the doctor say?"

"Nothing to be alarmed over."

She was out in the snow again. Little red-head was at the window; both were laughing as if they shared some very good joke. Then I saw what she was doing. She was filling snow back into the path she had cleared in the morning, piling the snow deeper than it was before, spanking it down with the shovel to keep it from blowing away. She carried snow from across the lawn, careful not to leave any clear path to her door.

"Why are you doing that?"

Her eyes sparkled; she gave the happiest giggle and a nod to her boy.

"My husband would not get up and shovel a path for the doctor. Do you think he is going to find a clear path when he comes home to lunch? Not if I know it, he isn't."

"If it were not already finished, I would be delighted to help," I said and we both ran chuckling into our own flats.

Arabella Jones's Home

Arabella Jones ran out of the back door, around the house and into the front door of her flat. Over and over she did it. Each time she rang her own door bell and opened her own front door and walked in with a laugh as if such as delightful thing had never happened to her before.

"It is half like having a house of my own," she said, and rushed into the garden to gather nasturtiums. She put them into a bowl and dug her nose down among the blossoms. "Bought flowers don't smell like that, and oh, oh, the kitchen range! and a pulley clothes-line across the garden! my own bath! Nothing shared—no gas plate hidden behind a curtain—no public entrance and no public hall! Oh, it is only the beginning too; presently we shall own a whole house and furniture and our own garden, not rented but our very own!"

It was not Silas Jones but "a home" that had lured Arabella into marriage. When dull, middle-aged Silas said, "I am tired of knocking round, I want a home and a wife inside that home—what about it, Arabella?" she lifted her face to his like a "kiss-for-a-candy" little girl. And they were married.

That was in Eastern Canada—they began to move West. It was fun living in hotels for a bit, but soon Arabella asked, "When are we going to get the home?"

"We have to find out first where we want to be."

The place did not matter to Arabella. She wanted a home. They travelled right across Canada, on, on, till they came to Vancouver and the end of the rail.

"Now there is no further to go, can we get our home?"

"There is still Vancouver Island," he said.

They took the boat to Victoria. Here they were in "Lower West," while Silas Jones looked around. He was in no hurry to buy. The independence of a self-contained flat would satisfy his young wife for the time being.

Arabella Jones kept begging me, "Do come down to our flat of an evening and talk before my husband about the happiness of owning your own home."

Mortgage, taxes, tenants, did not make home-owning look too nice to me just then—I found it difficult to enthuse.

Silas had travelled. He was a good talker, but I began to notice a queerness about him, a "far-offness"—when his eyes glazed, his jaw dropped and he forgot. Arabella said, "Silas is sleeping badly, has to take stuff." She said too, "He is always going to Chinatown," and showed me vases and curios he bought in Chinatown for her.

One night Silas told me he had been looking round, and expected to buy soon, so I could consider my flat free for the first of the next month should I have an applicant.

The following day I was going down my garden when he called to me from his woodshed. I looked up—drew back. His face was livid—eyes wild; foam came from his lips.

"Hi, there, you!" he shouted. "Don't you dare come into my flat, or I'll kill you—kill you, do you hear? None of your showing off of my flat!"

He was waving an axe round his head, looking murderous. I hurried past, did not speak to him. I went to the flat at the other side of the house; this tenant knew the Joneses.

I said, "Silas Jones has gone crazy or he is drunk."

"You know what is the matter with that man, don't you?"

"No, what?"

"He"—a tap at the door stopped her. Silas Jones's young wife was there.

"Somebody wants to see over our flat," she said.

"Would you be kind enough to show it to them?"

"It would be better for you to do it yourself," she said shortly. I saw she was angry about something.

"I can't—your husband—"

"My husband says you insulted him—turned your back on him when he spoke to you. He is very angry."

"I do not care to talk to drunken men."

"Drunken? My—husband—does—not—drink. . . ." She spoke slowly as if there were a wonder between every word; her eyes had opened wide and her face gone white. "I will show the flat," she said.

I stood on the porch waiting while the women went over the Joneses' flat. Suddenly, Silas was there—gripping my shoulder, his terrible lips close to my ear.

"You told . . .!"

His wife was coming—he let go of me. I went back to my other tenant.

"What was it you were going to tell me about Silas Jones?"

"Dope."

"Dope! I have never seen any one who took dope."

"You have now—you have let the cat out of the bag, too. Did you see the girl's face when you accused her husband of being drunk? She was putting two and two together—his medicine for insomnia—his violent tempers—Chinatown. . . . Poor child. . . ."

I kept well out of the man's way. He was busy with agents. His wife was alternately excited about the home and very sad.

I knew it was her step racing up the stairs. "My husband has bought a house,

furniture and all. It is a beauty. It has a garden. Now I shall have a home of my very own!"

She started to caper about . . . stopped short . . . her hands fell to her sides, her face went dead. She stood before the window looking, not seeing.

"I came to ask if you know of a woman I could get, one who would live in. My husband wants to get a Chinaman to do the work, but I . . . I *must* have a woman."

Her lips trembled, great fear was in her eyes.

She came back to me a few days after they had moved, full of the loveliness of the new home.

"You must come and see it—you will come, won't you?"

"I had better not."

"Because of Silas?"

"Yes."

"If I 'phone some day when he is going to be out, please, will you come?"

"Yes."

She never telephoned. They had been in their new home less than a month when this notice caught my eyes in the newspaper:

"For sale by public auction, house, furniture and lot."

The name of the street and the number of the house were those of Arabella Jones's new home.

Awful Partic'lar

"Price of flat?"

"Twenty-five a month."

"Take twenty?"

"No."

"Twenty-two?"

"No."

"Quiet house? No children? No musical instruments? No mice? My folks is partic'lar, awful partic'lar—awful *clean!* . . . They's out huntin' too—maybe they's found somethin' at twenty. Consider twenty-three?"

"No. Twenty-five is my price, take it or leave it."

He went back to pinch the mattress again, threw himself into an easy chair and moulded his back into the cushions. . . . "Comfortable chair! Well, guess I better go and see what's doin' with the folks. Twenty-three fifty? Great to get partic'lar tenants, you know."

I waved him to the door.

Soon he was back with his wife, dry and brittle as melba toast, and a daughter, dull and sagging. Both women flopped into easy chairs and lay back, putting their feet up on another chair; they began to press their shoulder-blades into the upholstery, hunting lumps or loose springs. Meanwhile their noses wriggled like rabbits, inflated nostrils spread to catch possible smells, eyes rolling from object to object critically. After resting, they went from one thing to another, tapping, punching; blankets got smelled, rugs turned over, cupboards inspected, bureau drawers and mirrors tested.

"Any one ever die in the apartment?"

"No."

"Any one ever sick here?" The woman spat her questions.

"Any caterwauling at nights?"

"We do not keep cats."

"Then you have mice—bound to."

"Please go. I don't want you for tenants!"

"Hoity, toity! Give my folks time to look around. They's partic'lar. I telled you so."

The woman and the girl were in the kitchen insulting my pots and pans. The woman stuck a long thin nose into the garbage pail. The girl opened the cupboards.

"Ants? Cockroaches?"

I flung the outer door wide. "Go! I won't have you as tenants!"

Melba toast scrunched. Pa roared. "You can't do that! You can't do that! The card says 'Vacant.' We've took it."

His hand went reluctantly into his pocket, pulled out a roll of bills, laid two tens upon the table; impertinently leering an enquiring "O.K.?", he held out his hand for the key. I stuck it back into my pocket—did not deign an answer. Slowly he fumbled with the bill-roll, laid five ones on the table beside the two tens. Between each laying down he paused and looked at me. When my full price was on the table I put my hand in my pocket, handed him the key.

At six o'clock the next morning the "partic'lar woman" jangled my door-bell as if the house was on fire.

"There's a rust spot on the bottom of the kettle—Old Dutch."

I gave her a can of Old Dutch. She was scarcely gone before she was back.

"Scoured a hole clean through. Give me another kettle."

Hardly was she inside her door before the old man came running. "She says which is hot and which cold?"

"Tell her to find out!"

No other tenant in that or any other flat in my house left the place in such filth and disorder as those *partic'lar* people.

Gran's Battle

The family in Lower West consisted of a man, a woman and a child. A week after they moved in, the woman's sister came to stay with her. She was straight from hospital and brought a new-born infant with her—a puny, frail thing, that the doctor shook his head over.

Immediately the baby's grandma was sent for, being, they declared, the only person who could possibly pull the baby through. Grandma could not leave her young son and a little adopted girl, so she brought them along.

The flat having but one bedroom, a kitchen and living-room, the adults slept by shifts. The children slept on sofas, or on the floor, or in a bureau drawer. Gran neither sat nor lay—she never even thought of sleep; she was there to save the baby. The man of the family developed intense devotion to his office, and spent most of his time there after Gran moved in.

We were having one of our bitterest cold snaps. Wind due north, shrieking over stiff land; two feet of snow, all substances glibbed with ice and granite-hard. I, as landlady, had just two jobs—shovelling snow—shovelling coal. Gran's job was shooing off death—blowing up the spark of life flickering in the baby.

No one seemed to think the baby was alive enough to hear sounds. Maybe Gran thought noise would help to scare death. The cramming of eight souls into a three-room flat produced more than noise—it was bedlam!

The baby was swaddled in cotton-wool saturated with the very loudest-smelling brand of cod-liver oil. The odour of oil permeated the entire house. The child was tucked into his mother's darning-basket which was placed on the dining table.

The infant's cry was too small to be heard beyond the edge of the table. We in the rest of the house might have thought him dead had not Gran kept us informed of her wrestling, by trundling the heavy table up and down the polished floor day and night. The castor on each of the table-legs had a different screech, all four together a terrible quartette with the slap, slap of Gran's carpet slippers marking time. Possibly Gran thought perpetual motion would help to elude death's grip on the oiled child.

Periodically the aunt of the infant came upstairs to my flat to telephone the doctor. She sat hunched on the stool in front of the 'phone, tears rolled out of her eyes, sploshed upon her chest.

"Doctor, the baby is dying—his mother cries all the time—when he dies she will die too. . . . Oh, yes, Gran is here, she never leaves him for a minute; night and day she watches and wheels him on the table."

The whole house was holding its breath, waiting on the scrap of humanity in the darning basket. Let anybody doze off, Grandma was sure to drop a milk bottle, scrunch a tap, tread on a child! The house has to be kept tropical. Gran was neither clothed nor entirely bare. She took off and took off, her garments hung on the backs of all the chairs. She peeled to the limit of the law, and snatched food standing. Three whole weeks she waged this savage one-man battle to defeat death—she won—the infant's family were uproarious with joy.

Gran toppled into bed for a long, long sleep. Mother and aunt sat beside the darning basket planning the baby's life from birth to death at a tremendous age.

Gran woke refreshed—vigorous, clashed the pots and pans, banged doors, trundled the table harder than ever, and sang lullabies in a thin high voice, which stabbed our ears like neuralgia.

The House of All Sorts was glad the child was to live. They had seen the crisis through without a murmur. Now, however, they came in rebellion and demanded peace. The doctor had said the child could go home with safety—my tenants said he must go! I marched past twelve dirty milk-bottles on the ledges of the front windows. Gran opened, and led me to the basket to see the infant, red now instead of grey.

I said, "Fine, fine! All the tenants are very glad, and now, when is he going home?"

"Doctor says he could any day. We have decided to keep him here another month."

"No! A three-room flat cannot with decency house eight souls. I rented my flat to a family of three. This noise and congestion must cease."

Grandmother, mother, aunt all screeched reproaches. I was a monster, turning a new-born infant out in the snow. They'd have the law.

"The snow is gone. His mother has a home. His grandmother has a home. I rented to a family of three. The other tenants have been kindly and patient. The child has had his chance. Now we want quiet."

My tenant, the aunt of the baby, said, "I shall go too!"

"Quite agreeable to me."

A "vacancy" card took the place of the twelve dirty milk bottles in the front window of Lower East.

Peach Scanties

Coming up Simcoe Street I stopped short and nearly strangled! There, stretched right across the front windows of the Doll's Flat, the street side of my respectable apartment house, dangled from the very rods where my fresh curtains had been when I went out—one huge suit of men's natural wool underwear, one pair of men's socks, one pair of women's emaciated silk stockings, a vest, and two pairs of peach scanties.

Who, I wondered, had gone up the street during the two hours of my absence? Who had seen my house shamed?

I could not get up the stairs fast enough, galloping all the way! There was enough breath left for: "Please, *please* take them down."

I pointed to the wash.

Of course she was transient—here today, gone tomorrow—not caring a whoop about the looks of the place.

"I like our underwear sunned," she said with hauteur.

"There are lines out in the back."

"I do not care for our clothes to mix with everybody's—and there are the stairs."

"I will gladly take them down and hang them for you."

"Thanks, I prefer them where they are. It is *our* flat. We have the right—"

"But the appearance! The other tenants!"

"My wash is clean. It is darned. Let them mind their own business, and you yours."

"It *is* my business—this house is my livelihood."

The woman shrugged.

Merciful night came down and hid the scanties and the rest.

Next wash-day the same thing happened. The heavy woollies dripped and trickled over the tenant's clean washed windows below; of course she rushed up—furious as was I!

Again I went to the Doll's Flat. I refused to go away until the washing was taken down and the curtains hung up. "If you live in this house you must comply with the ways of it," I said.

On the third week she hung her wash in the windows the same as before. I gave her written notice.

"I shall not go."

"You will, unless you take that wash down and never hang it on my curtain rods again!"

Sullenly, she dragged the big woollen combination off the rod, threw it on the table; its arms and legs kicked and waved over the table's edge, then dangled dead. Down came the lank stockings, the undervest—last of all the peach scanties. Both pairs were fastened up by the same peg. She snapped it off viciously. A puff of wind from the open door caught and ballooned the scanties; off they sailed, out the window billowing into freedom. As they passed the hawthorn tree its spikes caught them. There they hung over my front gate, flapping, flapping—"Oh dear! Oh dear! Oh dear!"

Sham

As the world war progressed rentals went down till it became impossible to meet living expenses without throwing in my every resource. I had no time to paint so had to rent the studio flat and make do myself with a basement room and a tent in my back garden. Everything together only brought in what a flat and a half had before the war.

A woman came to look at the Studio flat and expressed herself delighted with it.

"Leave your pretty things, won't you?" she begged with a half sob. "I have nothing pretty now and am a widow, a Belgian refugee with a son in the army."

She spoke broken English. We were all feeling very tender towards the Belgians just then.

"Come and see me; I am very lonely," she said and settled into the big studio I had built for myself. I granted her request for a substantial cut off the rental because of her widowhood, her country and her soldier son. Poor, lisping-broken-English stranger! I asked her several questions about Belgium. She evaded them. When she did not remember she talked perfect English, but when she stopped to think, the words were all mixed and broken. When she met any one new her sputterings were almost incoherent. I asked her, "How long since you left Belgium?" She hesitated, afraid of giving away her age, which I took to be fifty-five or thereabouts.

"I was born in Belgium of English parents. We left Belgium when I was four years old."

"You have never been back since?"

"No."

She saw me thinking.

"How the first language one hears sticks to the tongue!" she remarked. "It's queer, isn't it?"

"Very!"

As far as I was concerned, I let her remain the brave little Belgian widow with a son fighting on our side, but the son came back to his mother, returned without thanks from training camp, a schoolboy who had lied about his age and broken down under training. Now the widow added to her pose, "Belgian refugee widow with a war-broken son."

Tonics and nourishing dishes to build Herb up were now her chief topic of conversation with her tenant neighbours. Daily, at a quarter to twelve, one or the other of us could expect a tap on our door and . . . would we lend the mother of Herb a cup of rice, or macaroni, or tapioca, an egg for his "nog" or half a loaf. The baker was always missing her, or the milkman forgot. We got sick of her borrowings and bobbed below the windows when she passed up the stair, but she was a patient knocker and kept on till something on the gas stove began to burn and the hider was obliged to come from hiding. She never dreamed of returning her borrowings. The husbands declared they had had enough. They were not going to support her. She appeared very comfortably off, took in all the shows, dressed well, though too youthfully. Having no husband to protest I became the victim of all her borrowings, and the inroad on my rice and tapioca and macaroni became so heavy my pantry gave up keeping them.

When the "flu" epidemic came along, Herb sneezed twice. His mother knew he had it, shut him in his bedroom, poking cups of gruel in at the door and going quickly away. She told every one Herb had "flu" and she knew she was getting it from nursing him, but Herb had not got "flu" and, after a day or two, was out again. Then the widow told every one she had contracted "flu" from Herb. She hauled the bed from her room out into the middle of the Studio before the open fire and lay there in state, done up in fancy bed-jackets, smoking innumerable cigarettes and entertaining anybody whom she could persuade to visit. For six weeks she lay there for she said it was dangerous to get out of bed for six weeks if you had had "flu." The wretched Herbert came to me wailing for help.

"Get mother up," he pleaded. "Make her take her bed out of the studio; make her open the windows."

"How can I, Herbert? She has rented the flat."

"Do something," he besought. "Burn the house down—only get mother out of bed."

But she stayed her full six weeks in bed. When she saw that people recognized her sham and did not visit her any more she got up—well.

It was a year of weddings. The widow took a tremendous interest in them, sending Herb to borrow one or another of my tenants' newspapers before they

were up in the morning to find out who was marrying. She attended all the church weddings, squeezing in as a guest.

"You never know who it will be next," she giggled, sparkling her eyes coyly, and running from flat to flat telling the details of the weddings.

One day she hung her head and said, "Guess." Several of us happened to be together.

"Guess what?"

"Who the next bride is to be?"

"You!" joked an old lady.

The widow drooped her head and simpered, "How *did* you guess?"

He was a friend of Herbert's and "coming home very soon," so she told us.

The house got a second shock when from somewhere the widow produced the most terrible old woman whom she introduced as "My mother, Mrs. Dingham—come to stay with me till after the wedding."

Mrs. Dingham went around the house in the most disgusting, ragged and dirty garments. Her upper part was clothed in a black sateen dressing sacque with which she wore a purple quilted petticoat. Her false teeth and hair "additions" lay upon the studio table except in the afternoons when she went out to assist the widow to buy her trousseau. Then she was elegant. Herb's expression was exasperated when he looked across the table and saw the teeth, the tin crimpers that caught her scant hair to her pink scalp. The House of All Sorts was shamed at having such a repulsive old witch scuttling up and down the stairs and her hooked nose poking over the verandah rail whenever there was a footstep on the stair. It was a relief when she put all her "additions" on and went off to shop.

I wanted my Studio back; I was homesick for it, besides I knew if I did not rescue it soon it would be beyond cleaning. Two years of the widow's occupancy had about ruined everything in it. When I heard that Herb and the old mother were to keep house there during the honeymoon, while the bridegroom was taking some six weeks' course in Seattle, I made up my mind.

The groom came—he was only a year or two older than Herb. The boys had been chums at school. He was good-looking with a gentle, sad, sad face, like a creature trapped. She delighted to show him off and you could see that when she did so they bit him to the bone, those steel teeth that had caught him. On one point he was firm, if there was to be a wedding at all it was to be a very quiet one. In everything Herb was with his friend, not his mother.

They were married. After the ceremony the old woman and daughter rushed upstairs to the studio. Herb and the groom came slowly after. The bride's silly young fixings fluttered back over their heads, and the old woman's cackle filled the garden as they swept up the stair. They had a feast in the studio to which I was not invited. I had raised the rent and they were going—violently indignant with me.

Mrs. Pillcrest's Poems

S ometimes a word or two in Pillcrest's poems jingled. More occasionally a couple of words made sense. They flowed from her lips in a sing-song gurgle, spinning like pennies, and slapping down dead.

Mrs. Pillcrest was a small, spare woman with opaque blue eyes. While the poems were tinkling out of one corner of her mouth a cigarette was burning in the other. The poems were about the stars, maternity, love, living, and the innocence of childhood. (Her daughter of ten and her son aged seven cursed like troopers. The first time I saw the children they were busy giving each other black eyes at my front gate while their mother was making arrangements about the flat and poeming for me.)

I said, "I do not take children."

"Canadian children . . . I can *quite* understand . . . *my* children are *English!*"

"I prefer them Canadian."

"Really!" Her eye-brows took a scoot right up under her hat. She said, "Pardon," lit a cigarette from the stump of the last, sank into the nearest chair and burst into jingles!

I do not know why I accepted the Pillcrests, but there I was, putting in extra cots for the children—settling them in before I knew it.

The girl was impossible. They sent her away to friends.

On taking possession of the flat, Mrs. Pillcrest went immediately to bed leaving the boy of seven to do the cooking, washing, and housework. The complete depletion of hot water and perpetual smell of burning sent me down to investigate.

Mrs. Pillcrest lay in a daze of poetry and tobacco smoke. The sheets (mine) were punctured lavishly with little brown-edged holes. It seemed necessary for her to gesticulate with lighted cigarette as she "poemed."

She said, "It is lovely of you to come," and immediately made a poem about it. In the middle there was a loud stumping up the steps, and I saw Mr. Pillcrest for the first time.

He was a soldier. Twice a week the Canadian army went to pot while Dombey Pillcrest came home to visit his family. He was an ugly, beefy creature dressed in ill-fitting khaki, his neck stuck up like a hydrant out of a brown boulevard.

Poems would not "make" on Mr. Pillcrest, so Mrs. Pillcrest made them out of other things and basted him with them. He slumped into the biggest chair in the flat, and allowed the gravy of trickling poems to soothe his training-camp and domestic friction—as stroking soothes a cat.

Mrs. Pillcrest told me about their love-making. She said, "My people owned one of those magnificent English estates—hunting—green-houses—crested plate—Spode—everything! I came to visit cousins in Canada, have a gay time, bringing along trunks of ball dresses and pretty things. I met Dombey Pillcrest. . . ."

She took the cigarette from her lips, threw it away. Her hands always trembled—her voice had a pebbly rattle like sea running out over a stony beach.

"Dombey told me about his prairie farm; the poetry of its endless rolling appealed, sunsets, waving wheat! We were married. Some of the family plate, the Spode and linen came out from home for my house.

"We went to Dombey's farm . . . I did not know it would be like that . . .too big . . . poems would not come . . . space drowned everything!

"The man who did the outside, the woman who did the inside work kept the place going for a while . . . babies came . . . I began to write poems again—our help left—I had my babies and Dombey!"

She poemed to the babies. All her poems were no more than baby talk—now she had an audience. . . . The blue-eyed creatures lying in their cradle watched her lips, and cooed back.

As the children grew older they got bored by Mother's poems and by hunger. They ran away when she poemed. It hurt her that the children would not listen.

She had another bitter disappointment on that farm. "I did so want to 'lift' the Harvesters! When they came to thresh was my chance. I was determined they should have something different, something refined. For *once* they should see the *real thing*, eat off Limoges, use crested plate! I put flowers on the table, fine linen; I wrote a little poem for each place. The great brown, hungry men burst into the room—staggered back—most touching! . . . none of the bestial gorging you see among the lower classes. They stared; they ate little. Not one of them looked at a poem. If you believe it, they asked the gang foreman to request 'food, not frills' next day. Ruffians! Canadians, my dear!"

"I am Canadian," I said.

"My *deear!* I supposed you were English!"

"One day Dombey said, 'Our money is finished. We cannot hire help; we must leave the farm. You cannot work, darling!'"

They scraped up the broken implements and lean cows and had a sale. Mrs. Pillcrest sat on a broken harrow in the field and made a poem during the sale. Mr. Pillcrest wandered about, dazed. The undernourished, over-accented children got in everybody's way. When it was over, the Pillcrests came out west and hunted round to find the most English-accented spot so that their children should not be contaminated by Canada. That was Duncan, B.C., of course. War came; Dombey joined up. Here they were in my flat.

"I had *so* hoped that you were English, my dear!"

"Well, I'm *not.*" Mrs. Pillcrest moaned at my tone.

Potato-paring seemed to be specially inspiring for Mrs. Pillcrest. She liked to do it at the back door of her flat, looking across my garden, poeming as she pared. She always wore a purple chiffon scarf about her throat; it had long floating tails that wound round the knife and got stabbed into holes. The thick parings went slap, slap on the boards of the verandah. The peeled flesh of the potatoes was purpled by the scarf while poems rolled out over my garden.

"Have you ever published your poems, Mrs. Pillcrest?"

"I do not write my poems. They spring direct from some hidden source, never yet located, a joyous—joyous source!"

"Curse you, Mother! Come get dinner, instead of blabbing that stuff!"

"Son—my beloved son!" Mrs. Pillcrest said, and kissed the boy's scowling face.

The Pillcrests were not with me very long because Mr. Pillcrest's training camp was moved.

Just as their time was up—the flat already re-let—Mrs. Pillcrest and son disappeared. Time went on, the new tenant was fussing for possession. After five days elapsed without sign or sound, I climbed a ladder and looked through the windows. Everything was in the greatest confusion.

I rang the barracks. "Mr. crest? Mrs. Pillcrest's tenancy expired five days ago."

"Yes? Oh, ah—Mrs. Pillcre isiting; she will doubtless be returning soon."

"But the flat—the new te is waiting . . ." I found myself talking over a dead wire.

She tripped home sparkli ith poems.

"Your rent was up five d o, Mrs. Pillcrest."

"Really! Well, well! Shall I pay five days extra?" (With some rhyme about "honey," "money" and "funny.") My patience was done—"Nothing funny about it! It is not business!"

Taut with fury Mrs. Pillcrest's poem strangled. "Business! Kindly remember, Landlady, Mr. Pillcrest and I do *not belong to that class*."

"That is evident, but at six tonight I have promised the key to the waiting tenant! *That* is business."

Unmarried

Perhaps the most awkward situation for the inexperienced young landlady was how to deal with "unweds." Every apartment house gets them. They are often undiscernible, even to the experienced. One learns in time to catch on to little indications. . . .

The supposed husband makes all arrangements, the supposed wife approving of everything. A woman who does not nose into the domestic arrangements of the place she is going to occupy gives the first hint, for a woman indifferent to the heating, furnishing, plumbing, cooking utensils of her home is not wifely.

My first experience of this sort was with a very prepossessing couple. Their tenancy was secured by an excessively moral old lady living in Lower West. I was out when the couple came seeking. The old lady next door showed them over. She was delighted at having made so good a "let" for me. Within a week it was put to me by the renters of the other suites, "Them or us?" The couple left.

My second experience of the same kind posed as brother and widowed sister, just out from the Old Country. They offered Old Country references which would have taken six weeks to verify, yet they wanted immediate possession. Things looked all right—I was unsuspicious. You can't ask to see people's marriage certificates. They had my studio flat. It had the required number of rooms and they were delighted with the studio. I had removed myself to a tent in the garden and a gas-ring in the basement for the summer months, ends being difficult to make meet.

The couple had not been in a week before Mrs. "Below" and Mrs. "Next Door" rushed simultaneously to the garden to and bumped nose to nose.

The House of All Sorts was in ferment. If I going to cater to that class—!

I went to the hotel the couple had staye before taking my flat. Here they had registered as man and wife. I took perplexity to an experienced apartment-house landlady.

"Mm. . . . We all get them."

"How are they got rid of? Must I wait until their month is up to serve the customary notice?"

"Mm . . .! If you can prove they are 'that kind' you need give no notice at all, but be sure—libel suits are ugly. Send your janitor into their suite on some pretext or other."

"I am my own janitor."

"Mm!"

I told her I had been to the hotel and how the couple had registered. Again the experienced one said, "Mm." I went home. I could "Mm" there just as well myself.

Mrs. Doubtful was chatty, always running down to my garden to ask advice about cookery. Brother John was fond of this or that, and how was it made? She asked me queer questions too. Was it possible to get lost in British Columbia? To take a cabin in the far woods and disappear? It would be so amusing to vanish!

Between the Doll's Flat and my studio was a locked door, a sofa backed up to the door. The Doubtfuls liked to sit on this sofa and converse. It appeared that Mrs. Doll's Flat's favourite chair was just the other side of the door. Sitting here her ear was level with the keyhole. The man said to the woman:

"Go to the garden, darling. Chat casually with our landlady. Watch her face, her manner."

The woman returned.

"Well?"

"She suspects."

The man came to me.

"How long notice is required?"

"None."

The man bowed. No one saw them go. They left no forwarding address.

Studio

I t would not be fair to the House of All Sorts were I to omit describing its chief room—the Studio—around which the house had been built. The purpose of its building had been to provide a place in which I could paint and an income for me to live on. Neither objective was ever fully realized in the House of All Sorts.

From the front of the house you got no hint that it contained the finest studio in the town. The tell-tale great north light was at the back of the house

and overlooked my own garden, dominating its every corner. There were open fields surrounding my garden—fields that were the playgrounds of my Bobtail Sheepdogs, kenneled behind the lilacs and apple-trees at the foot of the garden. It was not a very large garden, centred by a lawn which again was centred by a great olivet cherry tree. In the crotch of the tree a shelter box was fixed for the comfort of my monkey, Woo, during the summer months.

The garden was fenced and gated. It belonged exclusively to the animals and myself. No one intruded there. Visitors or tenants who came to pay or to grumble mounted the long outside stair, that met the paved walk on the west side of the house, and took their complaints to me in the studio. The garden seemed more exclusively mine than the studio. People came to the studio to see me on business; if I wanted to see myself I went to the garden. If I was angry I seized a spade and dug my anger into the soil. When I was sad the garden earth swallowed my tears, when I was merry the garden lawn danced with bouncing dogs, monkey, the Persian cat, Adolphus, and me. We did have good times in that old garden. It was in fact but a projection of my studio into the open at ground level. The square ugliness of the apartment house cut us off from the publicity of tenants and the street. High board fences determined the garden's depth and width.

The studio was a high room; its east end was alcoved and had five casement windows in a row, out of them you looked across two vacant lots to Beacon Hill Park. Every bit of the Park was stuffed with delicious memories—not its present sophistication with cultivated lawns, formal lakes, flowerbeds, peacocks and swans. Wild wind-tossed trees, Creator-planted, and very old, tangled bushes were what my memory saw. It saw also skunk cabbage swamps, where frogs croaked in chorus all the summer nights, and owls hooted. I saw too the wicked old "Park Hotel" roaring its tipsy trade. Now where it had stood the land had gone back to respectable brambles that choked everything.

The studio had to be an "everything-for-everybody" place. Its walls were cut by five doors and five windows in addition to a great north light. It was not a good room for showing pictures but fine to paint in. The walls were buff, very high and very crowded: I had no other place to store pictures than on the walls.

The centre space of the room was high emptiness. To ease congestion I suspended my extra chairs from the ceiling. There they dangled, out of the way till wanted, when they were lowered to the floor. Each worked on a pulley of its own.

In one corner of the room was an immense black-topped table, rimmed and legged with massive polished maple wood.

It was an historical table but I forget exactly why. It used to be in the Parliament Buildings and important things had been signed at it.

On top of the table was heaped every kind of article that you could think of, including Susie the white rat, whose headquarters were there. There were also huge lumps of potter's clay and unfinished potteries draped in wet rags to keep them moist during construction.

I had the great brick fire-place with the open grate blocked up. It looked very nice but used enormous quantities of fuel and heated heaven only, so I substituted an open-fronted stove which kept the studio very cosy. It was a lovable room.

In the centre of the studio floor was a long narrow black box not unlike a coffin except that it did not taper. I kept sketches in this box and on its top stood a forest of paint brushes and turpentine bottles. Between this glass-and-bristle forest and the great north light the space was particularly my own. People never walked there for fear of their shoes squeezing paint tubes or crushing charcoal. Canvases stood on two homemade bench-easels.

I never painted if any one was around and always kept my canvases carefully shrouded in dust sheets. I never did paint much in that fine studio that I had built: what with the furnace, tenants, cleaning and the garden there was no time.

The pictures on my walls reproached me. All the twenty-two years I lived in that house the Art part of me ached. It was not a bit the sort of studio I had intended to build. My architect had been as far from understanding the needs of an artist as it would be possible to believe. The people of Victoria strongly disapproved of my painting because I had gone from the old conventional way. I had experimented. Now I paused. I wished my pictures did not have to face the insulting eyes of my tenants. It made me squirm. The pictures themselves squirmed me in their own right too. They were always whispering, "Quit, quit this; come back to your own job!" But I couldn't quit; I had this house and I had no money. A living must be squeezed from somewhere.

There were two couches in my studio, one in my own special part, the other near the fireplace for visitors. The only chance I got to rest was when a visitor came. I could not leave the visitor upright while I relaxed on a sofa. When I flung myself down, what you might have taken for a fur rug in front of the fire broke into half a dozen pieces, ran to my couch and, springing, heaped themselves on top of me—cat, dogs, monkey and rat. Life in this studio was pleasant. Its high, soft north light was good, yet it was not the sort of studio I wanted.

In Toronto I had seen the ideal artist's studio—a big room about the size of mine. There was not a picture in the room, the walls were calm restful grey.

The canvases were stowed in racks in an ante-room. The furnishings were of the simplest. They consisted of a table, a large working easel, a davenport, a quiet-coloured floor covering. The building contained several studios and was set in the quiet corner of a Park. Here the artist came and shut himself in with his work; there he and his work became one. But then he did not have to run a House of All Sorts.

After twenty-two years I sold the House of All Sorts.

Art and the House

I t was strange that the first and only specially built, specially lighted studio I ever owned should have been a torment for me to work in. Through the studio only could you enter my four-room flat. A tap at the door—I was caught there at my easel; I felt exposed and embarrassed as if I had been discovered in my bathtub! It was a curious agony.

Possibly it was the ridicule my work had been subject to in Victoria which made me foolishly supersensitive. Even at Art School I had preferred to work in a corner, back to the wall, so that people could not look over my shoulder. In this house, if a tenant found me at my easel, I felt as though I had been cornered committing a crime.

Even while landladying, Art would keep poking me from unexpected places. Art being so much greater than ourselves, it will not give up once it has taken hold.

Victoria had been very stern about my art. Being conservative in her tastes, she hated my particular kind, she believed in having well-beaten tracks and in sticking to them.

The house was fuelling. A huge Negro came to me protesting, "Dat monk in de basement slam de winder ev'time de sacks come fo' to empty. What us do?"

I went below, moved the monkey, left Negro and monkey making friends.

By and by the man came up for me to sign his book. He stood at the studio door.

"Gee! I's envy yous."

"Because I have a monkey?"

"Because you's kin paint. Seem dat what I want all de life of me."

Later that week I was suddenly aware of two men's faces peering through my studio window. Screening hands framed their stare.

In a fury I bounced out the door on to the little balcony where the men stood.

"How dare you stare into my window? Don't you know a person's home is private? Go away."

The men fell back. Then I saw that one was my baker. The other man was a stranger.

"Pardon, Miss. We didn't mean to be rude—this 'ere feller," thumbing towards the stranger, "loves pictures. Come along, I sez, I'll show you!"

I was shamed. Humble people, here in my own town, *wanted* to see and know about Art. They might not like my special kind? What matter? They were interested in pictures.

In Victoria I had only come up against my own class. The art society, called "Island Arts and Crafts," were the exponents of Art on Vancouver Island, an extremely exclusive set. They liked what they liked—would tolerate no innovations. My change in thought and expression had angered them into fierce denouncement. To expose a thing deeper than its skin surface was to them an indecency. They ridiculed my striving for bigness, depth. The Club held exhibitions, affairs of tinkling teacups, tinkling conversation and little tinkling landscapes weakly executed in water colours. None except their own class went to these exhibitions. A baker, a coal-carrier! Good gracious! Ordinary people would never dream of straying into an "Arts and Crafts" exhibition, would have been made to feel awkward had they done so.

An idea popped into my head. I would give an exhibition for ordinary people, invite the general public, but *not* invite the Arts and Crafts. I would invite the people who walked in Beacon Hill on Saturday afternoon and on Sunday. My house was practically *in* Beacon Hill Park. Lower East had just fallen vacant. Lower West was going to be empty next week. I had a carpenter cut me a connecting door. This gave me six large, well-lighted rooms. I invited three other artists to show with me, one a portrait painter, one a lady just returned from England where she had been painting English cottage scenes, the third a flower painter. In one room I would hang my Indian canvases. Examples of my new and disliked work I would hang in the kitchens.

At the last moment the flower painter, finding that the show was not to be sponsored by the Arts and Crafts, did not show. As I read her curt, last-minute withdrawal, a young Chinese came to my door carrying a roll of paintings. He had heard about the exhibition, had come to show his work to me—beautiful

water colours done in Oriental style. He was very anxious to carry his work further. He had asked admittance to the Arts and Crafts Sketching Class, and had been curtly refused because of his nationality. I invited him to show in place of the flower painter and he hung a beautiful exhibit.

The exhibition was a varied show and so successful that a few of us got together, working on the idea of starting a People's Art Gallery in these six rooms of mine. It was winter time, there were no Band Concerts in the Park. People walked until they were tired, then went home chilled. To drop in, sit by an open fire, warm, rest themselves and look at pictures, might appeal to the public. It was also suggested that there might be study classes. Young people came to see me saying how ardently they hoped the idea would be carried out.

We elected temporary officers and called a meeting of important people who could help if they would—the Lieutenant Governor, Mayor, Superintendent of Parks, a number of wealthy people with influence. We called the meeting while the exhibition was still on the walls. The rooms were thronged; there was interest; the plan was discussed. I offered Lower East and Lower West to the City at the lowest possible rental, offering also to shoulder a large proportion of the work connected with the hanging of new shows from time to time.

My friend Eric Brown, of the Canadian National Gallery at Ottawa, was enthusiastic over my plan and promised to send exhibitions out from Ottawa. But influential Victorians were uninterested, apathetic. Why, they asked, was it not sponsored by the Arts and Crafts Society? Vancouver had just built herself a fine Art Gallery. It was endowed. Unless Victoria could do something bigger and more flamboyant than Vancouver she would do nothing at all.

The Lieutenant Governor said that if the City would acquire a property and erect a fireproof building, he would be willing to lend two small etchings, very fine etchings—but he would not lend to be shown in any ordinary building.

Victoria's smart set said Beacon Hill was out of the way.

We replied, "It is handy for those who walk in the Park. You others have your cars."

The Mayor said, "The City has provided artificial lakes, a very fine pair of swans, innumerable ducks, a peacock and a Polar bear. What more could the public desire!"

The people's gallery did not materialize. The everyday public were disappointed. The wealthy closed their lips and their purses. The Arts and Crafts Society smiled a high-nosed superior smile. Lee Nam, the Chinese artist, many boys and girls and young artists were keenly disappointed.

I closed the connecting door between the suites and again rented Lower East and Lower West as dwellings.

The wise, painted eagles on my attic ceiling brooded—sorry for my disappointment. The Indians would say, "They made strong talk for me." Anyway they sent me down to the studio to forget my disappointment and to paint earnestly.

Eric Brown wrote, "I am sorry the people's gallery did not go through." He spoke kindly about my own work. I was now an invited contributor to art shows in the East. Sympathetic criticisms were unnumbing me; I desired to paint again. "After all," wrote Mr. Brown, "the people's gallery might have further crippled your own work. Victoria just is not art minded. Go ahead, paint, don't give way to discouragement. Paint, paint!"

Men Called Her Jane

Nice-looking couple. He had a courtesy that was slightly foreign. She blushed readily and was gentle, had dainty smartness from shoes to the chic little hat that looked to have flown to the top of her head and perched there at just the right angle.

In my garden she bent and sniffed, "May I have a flower?"

"The madame likes flowers. You could spare her a little corner of your earth? This bit by our door, perhaps?"

"I will plant sweet peas to climb the fence," she said happily.

Their blinds never went up till noon was well past. He claimed that work brought him home late at night—very late.

Everybody said they were an attractive-looking couple. The name he gave was "Petrie."

One day I had occasion to take "madame" some things. Her door stood open. I kept to one side while I knocked. There was no answer. I stepped forward, meaning to lay the things inside the door and go away. I saw that "madame" was in the room, arms folded across the back of a chair, head bowed, crying bitterly. I put the things down, came away.

My flat was just above the Petries'. Sometimes I thought I heard crying. Again, there would be long monotonous sounds as of someone pleading unanswered; sometimes for days everything would be deadly still.

One morning, between two and three o'clock, all the house wrapped in sleep, shriek after shriek came from the Petries' flat. Crockery smashed. There were screams and bangs, dull murderous thuds. I jumped out of bed, ran to the room above their flat, leaned out the window.

There were three voices, two men's and a woman's. Desperate fury was in them all—low, bestial, fighting hatred.

I trembled violently, not knowing what to do. The rest of the flats were rented to women—women who expected to live here quietly, decently. It was a quiet, respectable district! How was I going to face them tomorrow, burning with shame for my house?

The door below was torn open. Bump, bump, bump! A man was ejected, thudding on each step, finally lying in a huddle on the cement walk. The door slammed. The man and the woman inside resumed their screaming and snarling.

Was he dead? I could not take my eyes off that still huddle on the pavement. By-and-by a groan—he crawled on hands and knees to the door—beat upon it with his fists.

"Jane! Jane! Listen, Jane! Let me in. Oh, Jane! Jane!" They were making such a noise they did not hear. He leant against the door, mopping his face. I could see dark stains spreading on his white handkerchief. After a long, long while he stumbled down the street.

The fighting stopped—terrible quiet—I could hear my clock ticking, or perhaps it was my heart. I went to bed hating tenants.

Next morning Petrie swaggered up to my flat, asked to use my telephone. I trembled, wondering what I was going to say to him. He 'phoned a rush order to a dry-cleaner, also for an express to take a trunk to the boat.

"You going away?" I asked.

"The madame is—we've quarrelled in fact."

"It was shameful . . . my tenants. . . ." The man shrugged.

"You wish to serve me notice?"

"Law does not require that such tenants be given notice."

The express came and took away a trunk. At dusk the woman limped down the street sagging under the weight of a heavy suitcase.

There was no sound from Lower East. All day blinds remained close drawn. The gas man came, asking that I let him into that silence to read the meter.

"That flat is still occupied, far as I know."

"Your tenant ordered his final reading this morning."

I took a pass key and went down. The place was in wild disorder. There were dozens of liquor bottles. In an attempt to be funny they had been arranged ridiculously as ornaments. Things were soiled with spilled liquor. The place smelled disgusting. The bedding was stripped from the bed. The laundry man returned it later and told me it had been soaked with blood. My carving knife belonging to that flat was missing.

Holding out a handful of carefully selected pants' buttons that he took from the meter, the gas man said, "That is what the Gas Company got. How about you, got your rent?"

"Yes, advance."

"Good," he said kindly . . . "job enough getting the liquor stains cleaned up."

I saw an envelope at my feet. In the dusk I could see the name was not Petrie, but a short name like my own. I tore it open, supposing it mine.

"Rose, my baby, my dear, why don't you write? If you did not get the job, come home, we will manage somehow. No work for Pa yet, he is sick—so am I—anxiety mostly—Rosie, come home—Mother."

I gave the letter back to the Postman.

"I opened it in the dusk by mistake; there was no forwarding address."

"I suspected," said the Postman. "Her name wasn't his name—nice-looking couple they was too . . . well . . . New to this rentin' bizness, eh? You'll larn—tough yerself to it."

His look was kind.

Furniture

Once I turned a zinc pail down over the head of a widow tenant. She was on the top step of my back stair; I was on the landing above. She would neither pay nor go. The law had told me I must retain certain of her possessions until she did one thing or the other. She had given me notice; another tenant was waiting for the flat, but go the widow would not. When I did as the law directed and seized a basket full of her household goods from the back porch, she followed me upstairs screeching. It was only pots and pans, not worth the screech. "Take it then—this too," I said and popped a pail of hers, none too clean, over her head. As the pail swallowed her tatty, frizzled head she seized the basket from my arms and, blinded by the pail, sank, step by step, down, down,—bucket and widow together. She could not see where to put her feet; they pushed like flat irons into the corner of each step. It was a narrow stair. She could cling by her elbows and the basket. At the foot of the stair, a twinkle in his eyes, stood the policeman who had ordered the restraint on her goods. She raised her zinc helmet to find herself circled by his arms.

She said—"Aoow!"

Law and I laughed. Law said, "Pay, or give up the keys."

She paid and went.

A gentleman had married her. Perhaps it would be more correct to say—a gentleman married her purse full of savings. First he spent her money, then he died, leaving her with a pile of debts, a yellow-haired son and twelve rooms of furniture.

She was angry at having a child to support, ignored the debts and adored the furniture—cheap tawdry stuff, highly varnished. She talked a great deal about "my beautiful period furniture." It was shoddy, mock, not "period," always "after," executed in imitation woods.

She moved the twelve roomfuls of furniture, piano and all, into my three-roomed Lower West Flat. Its entire floor space was packed solid to the ceiling. The yellow-haired boy crawled among the legs of furniture and bumped on bric-a-brac.

The dining-table, uncollapsible and highly varnished, the piano, the chesterfield, stuffed chairs and a few sofas made a foundation on which to heap lesser articles. On top, and on top, and on top, the heaped furniture rose to the ceiling. A narrow alleyway ran through the middle enabling her to pass through the flat—but she had to squeeze. In front of the window stood the piano. The woman could be seen and heard singing to it.

The kitchen had standing room only in front of the cook stove and at the sink. In the bedroom, she climbed over high-boys and bureaus to hurl the child into the bed beyond with a screeching of bed springs which delighted him.

She called me in to see how things were, saying "You will simply *have* to give me more storage space."

"You have much more than your share of the basement now. You saw what space there was before you took the flat. How could you expect three rooms to accommodate the furniture of twelve? Sell what you don't need."

"Sell my furniture! My beautiful furniture! Never!"

"You don't want all of it. It only makes you uncomfortable."

"I want every bit of it—to sell would be to lose money. I shall keep every bit; I expect to entertain members of the Choral Society I belong to."

So she went on living in great discomfort. The verandah and woodshed were crammed to bursting. The stuff was all wrapped in paper and rags to keep it from chafing and spoiling. The back of the House looked fearful because of her.

The child was a stupid pathetic creature whom she perpetually slapped and snapped at. Through the walls we heard the smacks on his wet skin when she bathed him, each smack followed by a wail.

His pants (mother-made) had no slack; his yellow hair hung dank and lifeless; the stare in his stupid eyes alone told which way he faced. She put him out to be minded, and took a job. Every morning the no-seat little pants went slowly down the street with stilted steps. The shapeless creature stumbled and

bumped into every thing, ambling half a block behind the widow who sulkily approached her job. Every step said, "I hate my job, I hate it! I married to be free! He spent my money, died, left me with *that!*"

"Come on there!"—a backward step and a crack on the yellow head.

The widow acknowledged frankly that she was not averse to a second marriage; only next time she'd see to it he had money and she would spend it.

She invited members of the Choral Society (one at a time) to come back with her "for a little music" after the Choral Practice. The child had been locked in, barricaded with furniture. She had been compelled to part with some to allow even two adults to sit by the fire comfortably. There was more than enough left. Scrambling over furniture and lowering herself to the arm of a stuffed chair, she performed, head thrown back. The window blinds were always up to the top so we could see her open mouth, stiffened back, hands beating, black eyes rolling and long horsey teeth munching the words of sentimental songs which echoed at a gallop among the jardinieres and rattled the corpulent glass front of the china cabinet.

She began at the antique shops, next she tried high-class-used, then second-hand—finally a van came and took some of the furniture to the auction rooms. It was like drawing teeth to part with it.

Now as she sang she sighed over the remaining furniture and caressed its shiny surfaces. Every visitor said he had enjoyed himself immensely, but he had so many engagements it was impossible for him to make another date.

She almost wished she had not sold the furniture. She began blaming my house, said it was not a sociable district. She fell behind in the rent, suggested I accept my rental in kind—the kind being a worn-out worthless gas range. I refused—she became abusive. I had to consult the law—that was when I popped the pail over her head and finally got her out of the House of All Sorts.

Making Musicians

I hate pianos, tenants' pianos. They can make a landlady suffer so hideously. Lumbering tanks awaiting the touch (often unskilled) that will make them spill horrible noise, spitting it through their black and white teeth.

First the dreadful bump, bump of arrival, cruel gasps of men with backs bent—bruised and nicked woodwork—screech of rollered push-boards. Radios were a new invention then but it seemed every transient lugged around an old tin kettle of a piano.

Prospective tenants said, "You have no objection to a piano, *of course.*"

"Oh, no," one lied, because one was dependent on tenants to pay mortgages and taxes.

So the piano was installed and we waited edgily till the performer operated. We did not mind child practice as much as adult jazz.

There was a sweet young girl who aspired to be a professional musician, very much in earnest, trying to unlearn previous faulty tuition. Scales rolled up and scales rolled down, noises leaped or dived or shivered out of her piano all day long. She began at 7 A.M. and laboured at it till 10 P.M. The performance took place just under my studio. Each note might have been pounded on my vertebrae. This was to go on for ever and ever—at least till the girl was made into a musician. Alas! She was very young.

Lower Westers and Doll's Flatters came to me.

"Are they permanent?"

"I am afraid so."

"The instrument is against my wall."

"It is underneath me."

There were heavy supposings "that we shall get used to it in time."

Get used to it we could not. Every day our nerves got more jangled no matter how we thundered vacuums and carpet sweepers, pots and pans. The scales boomed through every household noise.

The little girl was most persistent. When a bit of her noise went wrong she patiently repeated and repeated over and over till she won out. We were distracted.

After a fortnight we began to resign, as a nose settles down to the smell of frosted cabbage in winter. The bright spot of our day was when the little musician took her daily airing, three to four P.M.

One day we were settling to enjoy this respite when squealing wails pierced walls and floor. What torture equals a violin under the untutored hand! We realized what our peace had been when only the piano had agonized us.

The little girl did not neglect the old for the new either. For the sake of the violin she gave up her daily airing but not her piano practice.

My tenants came again. They sat down, one on either side of me.

"Yi . . . Yi . . . eee . . . ee," wailed the violin underneath us.

The tenants were as nice as possible, but it was not possible to be entirely nice. We were all agreed that the musician's family were lovely people—but— under the circumstances . . . well, something *must* be done about the circumstances. I said, "I will talk with them," but I shirked.

Days went by. I dodged past the windows of the other tenants quickly. They watched, but I just couldn't.

High note, low note, run and quiver! I drew the dust sheet over my canvas and rushed for the garden.

I went. Mother opened the door. The girl was seated at the piano. Her pale little hands on the keyboard did not look strong, wicked or big enough to torture a whole household.

I began to talk of everything in the world except musical instruments. After a pleasant visit I sneaked back upstairs without a glance towards my tenants' windows. I sat at my easel and began to paint. Wail, wail, wail! Every wail wound me tighter. I was an eight-day clock, overwound, taut—the key would not give another turn!

I flew down the stairs.

Mother looked surprised at another visit from me so soon. Father was there and the little girl looking sweeter than ever against the curve of the rich brown violin. I turned my back so that I should not see her. Father understood. Before I got a word out he said, "I know," and nodded towards the instruments.

Sneakily I stammered, "Other tenants . . . object. . . ."

"Exactly."

Papa and Mama exchanged nods.

"Perhaps the violin practice could be arranged for where she learns."

"Impossible," said Mama.

"At the home of one of her aunts, then?"

"Both live in apartments where musical instruments are not tolerated!"

"The Park band-stand," groaned Papa with a nervous glance towards Mama. "I suggest the Park band-stand."

The little girl rushed from the room crying.

"I fear we must look for a house," said Mama.

"An isolated house," groaned Papa.

Through the open door I heard little, hurt, gasping sobs.

John's Pudding

John was a young bachelor who for several years occupied my Doll's Flat. One Christmas his mother sent him a plum pudding from England. It travelled in a white stone-ware basin, a perfect monster of a pudding.

"Look at the thing!" John twirled it by its stained tie-down cloth. "Cost her six shillings for postage! Me out of work, *needing* underwear, socks! And *wanting* books, books, lots of books. Take the thing—three months *solid* eating."

He handed me the pudding. I shook my head. With a final twirl of the cloth he landed the pudding on the drain-board. The boy had told me of the book hints he had given Mother—of his hopes of what Christmas might bring.

"Orphanage, Salvation Army, both eat, I s'pose," he said. "I'll give 'em the dough. Want the crock? Do to feed the dogs in."

"It would not be quite fair to your mother, John. Let's give a party—feed the party pudding."

"How stomach-achey—nothing else? Who'd come?"

"Widows, spinsters, orphans. I'll get a turkey."

Lower East housed a new widow, Lower West an old widow, also her widowed daughter with a young son. My religious sister and my scholastic sister were invited, John asked his girl. All accepted. The house bubbled with activity and good smells.

We joined three tables which left just enough space for the guests to squeeze into their places. John and I sat near the kitchen door to be handy for toting dishes. There were red candles on the table, holly and apples from the garden. My monkey, dressed in her best scarlet apron, sat warming her toes before the studio fire, all "pepped up," aware that something was going to happen. As the guests poured through the door the monkey squealed at the widows and the widows at the monkey.

The turkey had blushed his nakedness to a rosy brown and was set cross-legged and blasé in the oven doorway, a boat of gravy beside him.

When the heart of the haughty English pudding in the solid masonry of her basin had been warmed and softened by the wooing of Canadian steam, when every last thing was ready, the widows in black silk rustled into the dining-room, also my two spinster sisters with an orphan or two from the school, and John's girl.

Because of the newness of her widowhood, the East flat widow had brought for the feast a few tears as well as a dish of "foamy rolls"—"My late husband's favourites" . . . sniff! She rushed the rolls into my hands so that she could use her hankie. The seasoned widow brought loganberry wine of her own brew. The young widow brought her young son who ate too much and got sick. My religious sister brought walnuts from her own tree, and the schoolmarm a homemade loaf and her three orphan boarders with all diet restrictions removed for the day. John's girl was shy and talked to everybody except John. My little dogs sat on their tails—their snub noses wiggled in anticipation.

When all had trooped into the dining-room, leaving the monkey alone, she raged and jabbered. The guests poured like liquid along the narrow path

into their seats, talking vivaciously about nothing, pretending they were not thinking of gone Christmases.

The turkey cut like a dream, juice trickled out as the sharp knife sliced the white breast—pink ham, turkey stuffing, green peas, potatoes mashed smooth as cream, cranberry sauce not a mite too tart. The widow's rolls melted in our mouths.

When the queenly pudding came in, attended by brandy sauce and mounted on a blue platter, she looked like the dome of the Parliament Buildings riding the sky. Her richness oozed deliciously, spicy, fragrant, ample. The steam of her rose in superb coils as if desirous of reaching the nostrils of the widows' dead husbands. Each plated slice slid down the table, followed by a dish of brandy-sugar sauce. Everyone praised the pudding. John thought with deep affection of his mother.

When appetites were satisfied, John uncorked the widow's wine and solemnly filled all glasses, except that of my "teetotal" sister who shook her head and took her glass to the kitchen tap. We all stood up, raised our glasses to the light, admired the beauty of the wine, its clearness, its colour. We complimented the maker, yet no one drank. All seemed waiting for somebody to say something, but nobody did. Each blinked at his wine, each was thinking— the widows of their "had-beens," we spinsters of our "never materialized." John and his girl smiled their hopes into each other's eyes. We others were relics—a party of scraps and left-overs, nobody intensely related. The people of one suite shared no memories in common with those in any other.

Somebody ventured "The King." We all sipped. My "teetotal" sister choked on one of her own walnuts. The widows darted forward with kindly intended thumps.

"Water!" she spluttered, and everyone put down his wine-glass to rush a water tumbler up to the choke.

"My Mother!" John raised his glass and everyone drank.

"The pudding!" I said solemnly; everyone drank again.

The monkey's patience was entirely at an end. Clank, clank, clank—the iron poke being beaten against the side of the stove. Shriek upon shriek of monkey rage!

We drank what was left of the wine quickly, put the small remnant of pudding on a tin plate, took it in to the waiting monkey and watched her eat, plum by plum, the last of John's pudding.

How Long!

He was crude, enormous, coarse; his fleshy hands had fingers like bananas. You could feel their weight in the way they swung at the end of his arms.

Ridiculous that he should choose the Doll's Flat for a home while he was grinding out the life of his little third wife. She was slowly disintegrating under the grim, cruel bullying.

The Doll's Flat suited his purpose because he could keep his eye on all its rooms at once, cow her every movement crawling to do his bidding. His stare weighted her eyelids and her feet. She felt rather than heard him creeping behind with the stealth of a lerry tom cat stalking a bird, never allowing it beyond the range of his seeing lest it creep aside and die before his teeth got a chance to bite into its warmth, his hand to feel the agony racing through its heart.

The great bulk of him grazed the door posts as he pushed his way from room to room. He mounted the dining table on four blocks of wood so that his huge stomach could find room beneath. I do not know whether his wife was allowed to eat standing beside him, or did she eat at the kitchen sink? His was silent cruelty. I seldom heard voices—the quiet was sinister.

The man wore glasses with thick lenses; it magnified his stare—because he was deaf, his staring was more intense.

When they went out it was he who locked the door behind them. She waited, holding his thick brutal stick. She preceded him down the stair, down the street. It must have been awful to have that heavy crunching step behind and his eyes watching, always watching. She was a meek, noiseless thing.

Bitter cold came. I stuffed the furnace to its limit, hung rugs over north windows. The hot air wouldn't face north wind, it sneaked off through south pipes.

Up and down, up and down the long outside stair I ploughed through snow which fell faster than I could sweep. During the night, snow had made the stair into one smooth glare—no treads. I shovelled a path as I descended, but the wind threw the snow back just as quickly.

The house, with the exception of the Doll's Flat, were considerate and kindly, realizing my difficulties. Every house-owner knows the agony and the anxiety regarding freeze-up and pipe bursts. Victoria's cold snaps are treacherously irregular. Hot-air pipes are cranky. My tenants were not entirely dependent on the whims of the furnace, each suite had also an open fire and

could be cosy in any weather. Nothing froze except one tap in a north bathroom, the bath of the brutal man—one hand-basin tap.

He had hot and cold in his kitchen and bath, but he roared, "This house is unfit to live in. Get a plumber *immediately*."

I said, "That is not possible. People everywhere are without drinking-water, plumbers are racing round as fast as they can. We must manage without one hand-basin for a day or two."

The man followed me into my basement. I did not hear his footfalls in the snow. As I stooped to shovel coal his heavy fist struck across my cheek. I fell among the coal. I stumbled from basement to garden.

"House! House! how long?"

From the frozen garden I looked at it, hulking against the heavy sky.

Bobtails

To My Sister Alice

I think I could turn and live with animals,
they're so placid and self-contain'd,
I stand and look at them long and long.

From WALT WHITMAN'S

Song of Myself

Kennel

The idea of a Bobtail kennel did not rush into my mind with a sudden burst. It matured slowly, growing from a sincere love of and admiration for the breed, awaked by my dog, Billie, a half-bred Old English Bobtail Sheep-dog. Billie's Bobtail half was crammed with the loyalty, lovableness, wisdom, courage and kindness of the breed. His something-else half was negligible, though it debarred him from the show bench. Heart, instincts, intelligence—all were pure Bobtail.

When Billie was offered as a gift to me, I refused him, not because of his being cross-bred but because of circumstances. Billie magnificently ignored my refusal and gave himself to me in the wholesome, wholehearted way a Bobtail's devotion works. It was not the easily transferable love of a puppy, for Billie was then three years old. He had the reputation of being wicked and had several bites to his discredit.

First I bathed Billie, then I beat him for killing a chicken—this only glued this self-given allegiance to me the tighter.

He was mine for thirteen years. When he died at the age of sixteen he left such a blank that the Bobtail kennel idea, which had been rooting in me those many years, blossomed. The question was where to obtain stock. There were only a few Bobtails in Canada, brought out as "settlers' effects" from the Old Country. Their owners would as soon have thought of selling their children as their Bobtails. Some of these dogs were excellent specimens, but they were unregistered because the settlers had not bothered to enter them in the Canadian live-stock records at Ottawa, and after a generation or so had elapsed the puppies of these dogs were not eligible for registration.

After long searching I located a litter of Bobtails on a prairie farm and sent for a female puppy. I named her Loo.

Loo was a sturdy puppy of good type and the beautiful Bobtail-blue. The next step was to locate a sire. Friends of mine on a farm up-island had a Bobtail for stock work—a good dog. They mated him to a Bobtail bitch on a neighbouring farm. I never saw the so-called Bobtail mother, but the puppies from the mating were impossible. My friends gave me one.

Intelligence the pup had and a Bobtail benevolent lovableness had won him the name of "Mr. Boffin." But he had besides every point that a Bobby should not have—long nose, short, straight hair, long, impossible tail, black-and-white colour. I bred Loo to a butcher's dog, a Bobtail imported from England—well-bred, powerful, of rather coarse type but intelligent.

The butcher came to select a puppy from Loo's litter. Dangling his choice by the scruff, he said, "Work waitin', young fella. Your dad was killed last week."

The man sighed—set the pup down gently.

"Shouldn't put a pup to cattle much under a year," he said, and, looking down, saw Boffin standing beside me. Boffin had eased the dog-field gate open and come to me unbidden.

"Go back, Boffin!" I pointed to the gate. The dog immediately trotted back to his field.

"What breed is that dog?"

"Supposedly a Bobtail."

"Bobtail nothin'—I want that dog," said the butcher.

"Not for sale."

"You can't sire a Bobtail kennel by him; 'twouldn't be fair to the breed."

"Don't intend to. That dog is my watch and companion."

"Companion fiddlesticks! That dog wants to work. I want that dog."

"So do I. . . . Hen, Boffin!" I called.

From the field Boffin came and with steady gentleness persuaded the hen from the garden back into her yard.

"I want that dog," the butcher repeated and, taking Boffin's head between his hands, looked into the dog's face. "I want him for immediate work."

"He is untrained."

"He knows obedience. Instinct will do the rest. That dog is just crazy to work. Be fair to him—think it over."

I did think—but I wanted Boffin.

At dusk that night a boy came with a rope in his hand. "Come for the dog."

"What dog?"

"The one my father saw this morning—this fella I guess."

Boffin, smelling cow-barn on the boy's clothes, was leaping over him excitedly.

"We drive cattle up-island tomorrow at dawn," said the boy and threw an arm about the dog.

My Boffin, happy till then in rounding up one hen! My Boffin behind a drove of cattle! How mad—joyful he'd be! I slipped the rope through Boffin's collar, handed it to the boy. He persuaded gently. Boffin looked back at me.

"Go, Boffin!"

The smell of cow was strong, exciting his herding instincts. Boffin obeyed.

Splendid reports came of Boffin's work. I did not go to see him till six months were past, then I went. His welcome of me was overwhelming. The dog was loved and was in good shape. He stuck to my side glue-tight. We stood

in the barnyard on the top of the hill. Suddenly I felt the dog's body electrify, saw his ears square. Sheep-bells sounded far off; Boffin left my side and went to that of his new master.

"Away then, Boffin!"

The man waved an arm. The dog's lean, powerful body dashed down the hill. When the dust of his violence cleared, a sea of dirty white backs was wobbling up the hill, a black-and-white quickness darting now here, now there, straightening the line, hurrying a nibbler, urging a straggler. Soberly Boffin turned his flock into their corral, went to his master for approval, then rushed to me for praise.

I was many blocks past the butcher's when I sensed following.

"Boffin!"

I had seen them shut Boffin behind a six-foot fence when I left the butcher's. The wife had said, "Father, shut Boffin in. He intends to follow."

It hurt me to return him, but I knew the job that was his birthright must prevail. . . .

Punk

Loo's strong, beautiful pups found a ready market. A soldier in Victoria owned a fine Old English Bobtail Sheep-dog. When he went to the war his Bobtail was desolate. I heard of the dog and went to the soldier's house, saw the shaggy huddle of misery watching the street corner around which his master had disappeared. I knocked on the house-door; the dog paid no heed, as if there was nothing now in that house that was worth guarding. A woman answered my knock.

"Yes, that is my husband's dog, 'Punk,' sulking for his master—won't eat—won't budge from watching that street corner."

A child pushed out of the door past the woman, straddled the dog's back, dug her knees into his sides and shouted, "Get up, Punk."

The dog sat back on his haunches, gently sliding the child to the ground—she lay there kicking and screaming.

"Will you sell the dog?" I asked.

"I cannot; my husband is ridiculously attached to the creature."

I told the woman about wanting to start a Bobtail kennel and my difficulty in locating a sire.

"Take Punk till my husband returns. I'd gladly be rid of the brute!"

I went to the dog. After tipping the child off he lay listless.

"Punk!"

Slowly the tired eyes turned from watching the street corner and looked at me without interest.

"He will follow no one but his master," said the woman.

The dog suffered my hand on his collar; he rose and shambled disheartenedly at my side, carrying the only luggage he possessed—his name and a broken heart.

"Punk!" Not much of a name to head a kennel! But it was the only link the dog had with his old master; he should be "Punk" still.

Loo cheered the desolation from him slowly. Me he accepted as weariness accepts rest. I was afraid to overlove Punk, for fear the woman, when she saw him washed, brushed, and handsome, might want him back. But when I took him to see her, neither dog nor woman was pleased. He followed me back to my house gladly.

Punk and Loo made a grand pair, Loo all bounce, Punk gravely dignified. They were staunchly devoted mates.

My Bobtail kennel throve; the demand for puppies was good. The government was settling returned soldiers on the land. Land must be cleared before there was much stock-work for sheep and cattle dogs. But Bobtails were comradely; they guarded the men from the desperate loneliness in those isolated places.

Punk had been with me a year. He loved Loo and he loved me; we both loved Punk. I came down the outside stair of my house one morning and found a soldier leaning over my lower landing, hands stretched out to the dogs in their field. Punk was dashing madly at the fence, leaping, backing to dash again, as breakers dash at a sea-wall. The woman who had lent me Punk and the child who had tormented him were beside the man.

"You have come for him?"—my heart sank.

The man's head shook.

"I shall be moving about. Keep him—I am glad to see him happy."

He pushed the hair back from the dog's eyes and looked into them.

"You were comfortable to think about over there, Punk." The man went quickly away.

Parting from his master did not crush Punk this time; he had Loo and he had me.

Beacon Hill

I n the early morning the dogs burst from their sleeping quarters to bunch by the garden gate, panting for a race across Beacon Hill Park. Springs that had wound themselves tighter and tighter in their bodies all night would loose with a whirr on the opening of the garden gate. Ravenous for liberty, the dogs tore across the ball grounds at the base of Beacon Hill, slackened their speed to tag each other, wheeled back, waiting to climb the hill with me.

The top of Beacon Hill was bare. You could see north, south, east and west. The dogs rested, tongues lolling, while I looked at the new day, at the pine trees, at the sky, at the sea where it lay flat, and at the broom bushes drooped with early morning wetness. The song of the meadow-lark crumbled away the last remnants of night—three sad lingering notes followed by an exultant double chuckle that gobbled up the still-vibrating three. For one moment the morning took you far out into vague chill, but your body snatched you back into its cosiness, back to the waiting dogs on the hill top. They could not follow out there, their world was walled, their noses trailed the earth. What a dog cannot hear or smell he distrusts; unless objects are close or move he does not observe them. His nature is to confirm what he sees by his sense of sound or of smell.

"Shut that door! Shut that door!" staccato and dictatorial shouted the voice of the quail as they scuttled in single file from side to side of the path, feet twinkling and slick bodies low-crouched. The open-mouthed squawks of gulls spilled over the sea. From behind the Hill came the long resentful cry of the park peacock, resentful because, having attained supreme loveliness, he could push his magnificence no further.

Pell-mell we scampered down the hillside. A flat of green land paused before letting its steepness rush headlong down clay cliffs. The sea and a drift-piled beach were below. Clay paths meandered down the bank. They were slippery; to keep from falling you must lodge your feet among the grass hummocks at the path-side. The dogs hurled their steady four-footed shapes down the steepness, and awaited me on the pebbly beach. Sea-water wet their feet, wind tossed their hair, excitement quivered in every fibre of their aliveness.

On our return the house was waking. The dogs filed soberly under yet blinded windows, mounted three steps to the landing, sank three steps to the garden, passed into their play-field, earnest guardians of our house. I went to my daily tasks.

Whenever the Bobbies heard my step on the long outside stair, every body electrified. Tongues drew in, ears squared, noses lifted. The peer from all the eyes under all the bangs of crimpy hair concentrated into one enormous "looking," riveted upon the turning of the stair where I would first show. When I came they trembled, they danced and leapt with joy, scarcely allowing me to squeeze through the gate, crowding me so that I had to bury my face in the crook of an arm to protect it from their ardent lickings, their adoring Bobtail devotion.

The Garden

The garden was just ordinary—common flowers, everyday shrubs, apple-trees. Like a turbulent river the Bobtails raced among gay flowers and comfortable shrubs on their way from sleeping-pen to play-field, a surge of grey movement weaving beautiful patterns among poppy, rose, delphinium, whose flowers showed more brilliantly colourful for the grey intertwistings of shaggy-coated dogs among them.

In the centre of the lawn grew a great cherry-tree better at blossoming than at fruiting. To look into the heart of the cherry-tree when it was blossoming was a marvel almost greater than one could bear. Millions and millions of tiny white bells trembling, swaying, too full of white holiness to ring. Beneath the cherry-tree the Bobbies danced—bounding, rebounding on solid earth, or lying flat in magnificent relaxation.

East, west, north the garden was bounded by empty lots; its southern limit was the straight square shadow of my apartment house.

The depth and narrowness of my lot made the height above it seem higher, a height in which you could pile dreams up, up until the clouds hid them.

Sunday

Religious people did not know more precisely which day was Sunday than did my Bobtails. On Sunday the field gate stood open. Into the garden trooped a stream of grey vitality, stirring commotion among the calm of the flowers. The garden's Sunday quiet fastened almost immediately upon the dogs. In complete abandon their bodies stretched upon the grass, flat as fur rugs. You could scarcely tell which end of a dog was head and

which tail, both were so heavily draped in shagginess. At the sound of my voice one end lifted, the other wobbled. Neither could you tell under the mop over his eyes whether the dog slept or woke—in sleep he was alert; awake, he was dignified, intent.

When Sunday afternoon's quiet was broken by five far-off strokes of the town clock, we all sprang for the basement. In the entrance hall was a gas-ring; on it stood a great stew-pot. There was also a tap and a shelf piled with dinner pans. The dogs ranged themselves along the basement wall, tongues drawn in, ears alert. I took the big iron spoon and served from the stew-pot into the dinner pans. As I served I sang—foolish jingles into which I wove each dog's name, resonant, rounded, full-sounding. Each owner at the sound of his own name bounced and wobbled—waiting, taut, hoping it would come again.

The human voice is the strongest thing a dog knows—it can coax, terrify, crush. Words are not meaning to a dog. He observes the lilt, the tone, the music—anger and rebuke have meaning too and can crush him. I once had a stone-deaf dog and once I had one that was stone-blind. The deaf dog had nothing to respond to but the pat of pity. She could only "watch"; at night her world was quite blank. The blind dog's blackness was pictured with sounds and with smells. He knew night-scents and night-sounds from day-scents and day-sounds; he heard the good-natured scuffle of dog-play, barkings, rejoicings; he heard also the voice of the human being he loved. The blind dog's *listening* life was happy. The deaf dog's only happiness was to be held close and warm—to feel.

Puppy Room

The puppy room in the basement brimmed with youngness, with suckings, cuddlings, lickings, squirmings—puppies whose eyes were sealed against seeing, puppies whose ears were sealed against hearing for the first ten days of life, puppies rolling around in their mother's box like sausages, heaving in the middle and with four legs foolishly sticking out sideways, rowing aimlessly and quite unable to support the weight of their bodies.

Some Bobtails are born entirely tailless, some have tails which are docked at the age of three days, some have stumps, some twists.

Loo was never happy with a new family until she had brought Punk in to inspect it. Punk lumbered behind his mate, nosed into her box, sniffed and ambled out again, rather bored. It satisfied Loo. The other Bobtail mothers never brought Punk to see their families, but Loo was Punk's favourite mate.

Bobbies have large families—nine is an ordinary litter. Once Flirt had four-teen pups at one birth. I never allowed a mother to raise more than six pups unaided. If the demand was good I kept more, but I went round the family three times a day with a feeding bottle so that all the pups were satisfied and my mothers not overtaxed. One spring thirty pups were born in the kennel nursery within one week. It took me three hours a day for three weeks "bot-tling" pups, but they throve amazingly. Sometimes a pup was stubborn and would not take the bottle; then I tickled him under the chin; this made him yawn and I popped the bottle into his yawn and held it there till he sucked. The mothers watched me with great interest; my yawn method was a joke between us. They were most grateful for my help, those patient, loving dog mothers.

Poison

The butcher lifted half a pig's head to his nose, sent it flying with a dis-gusted hurl into the bundle of scrap that Bobtail Meg was waiting to carry home in her saddle-bags for the kennel. Meg loved to lug the butcher-scraps home for me. When her saddle-bags were filled Meg rose, shook butcher-floor sawdust from her coat and waddled the bones away with pompous pride. Meg never was so happy as when she was busy.

There was something sinister in that pig's one eye when I stuck his half-head into the dog-pot. It made the soup into a rich, thick jelly and smelled good.

Flirt, Loo's daughter, had a litter two weeks old. Flirt was ravenous and gob-bled a generous portion of soup and meat. The next day a pup was sick, others were ailing. The veterinary ran a stubby finger around the sick pup's gums. "Teething," he said, and, taking a pocket knife, slashed the pup's gums, wiped the knife on his pants and rammed it into his pocket along with my two dol-lars. That night the pup died. I was furious—puppies never bothered over teething! I called another veterinary. "Poison," said the old man, and I remem-bered the butcher's nose and the pig's eye. This vet shook his head and killed the sickest pup to prove his diagnosis by post mortem. He said, "This is a mat-ter for nursing not doctoring. I think all of them will die."

Every pup was bespoken. I did not want them to die and the pups wanted to live—they put up a good fight and won.

I took them away from Flirt. They were too listless to suck a bottle. I spooned brandy and milk down their throats, and to the amazement of the veterinary reared the entire litter. The runt was the grittiest pup of all; for days

he writhed out of one convulsion into the next—calmed from one only to go through it all over again. One morning before dawn I found him stiff, tongue lolling, eyes glazed. I had for several days *almost* decided to put an end to his misery. From force of habit I trickled brandy over the lolling tongue—no response. A grave to dig in the morning! Dazed with tiredness I put the pup into his basket and went back to the garden room where I was sleeping during the poison trouble so that I might watch over the puppies. Sticking basket and feeding-bottle into a far corner of the room I tumbled into bed.

The sun and a queer noise woke me. I peeped overboard to see the runt seated on the floor in a patch of sunshine, the feeding-bottle braced between his paws, sucking with feeble fury.

I cried, "You gritty little beast!", warmed his milk and a hot-water bottle, tucked him into his basket and named him "Grits."

Grits turned into a fine and most intelligent dog. He was sold and sent as a love-gift to a man's sweetheart in Bermuda. Another of that poisoned litter went to France, pet of a wealthy man's children; another to Hollywood, where he saved two children from drowning while sea bathing. He was filmed. But mostly my Bobbies homed themselves in Canada. They won in the local dog shows. I did not show them further afield. To raise prize-winners was not the objective of my kennel. I aimed at producing healthy, intelligent working stock and selling puppies at a price the man of moderate means could afford, yet keeping the price high enough to insure the buyer feeling that his *money's worth* must be given due care and consideration.

Naming

E very creature accepting domesticity is entitled to a name.

It enraged me to find, perhaps a year later, that a pup I had sold was adult and unnamed, or was just called "Pup," "Tyke," or some general name. Were humans so blind that a creature's peculiarities suggested no name special to him?—nothing but a *class* tag? In selling a young pup, the naming was always left to the buyer. If I raised or half-raised a dog, I named him. For my kennel I liked the patriarchs—Noah, Moses, David, Adam. They seemed to suit the grey-bearded, rugged dignity of the Bobbies whose nature was earnest, faithful, dutiful.

At dog shows kennel-men smiled at the names on my entries. They said, "Why not 'Prince,' 'Duke,' 'King'?—more aristocratic!" But I clung to my patriarchs. The Old English Bobtail Sheep-dog is more patriarch than aristocrat.

Meg the Worker

Bobtail Meg was registered. I bought her by mail; I sent the money but no dog came. After writing a number of letters which were not answered, I applied to a lawyer. He wrote—Meg came. Her seller claimed that the dog had been run over on the way to be shipped. She was a poor lank creature with a great half-healed wound in her side. I was minded to return her. Then I saw the look in Meg's eyes, the half-healed, neglected wound, and I could not send her back to the kind of home she had obviously come from. I saw too how ravenously she ate, how afraid she was to accept kindness, how distrustful of coaxing.

Her coat was a tangled mass, barbed with last year's burs, matted disgustingly with cow dung. Before I let her go among my own dogs, she had to be cleaned. I got a tub and a pair of shears. When the filth was cleared away Meg shook herself; her white undercoat fluffed patchily, she looked chewed but felt clean and was eased by the dressing of her wound. She felt light-hearted, too, and self-respecting. Before the shears had finished their job Meg have given me her heart.

The kennel accepted Meg; Meg had no ears or eyes for any living thing, beast or human, but me. All day she sat in the dog-field, her eyes glued to my windows or the stair, waiting, trembling to hear my step, to see my shadow pass.

When her coat grew Meg did not look too bad. She was very intelligent and had been taught to work. Idleness irked Meg; her whole being twitched to obey; her eyes pleaded, "Work!" On Beacon Hill she bustled in and out among the broom hunting imaginary sheep and would slink shamely to my heel when she failed to find any.

I invented work for Meg. I was clearing the smaller stones off the far field, Meg following my every trip to a far corner where I emptied my basket. I stitched a pair of saddle-bags and bound them on to Meg. The dog stood patiently while I filled them with small stones and then trotted them to the dumping place proudly. I took her and her saddle-bags to the butcher's for the daily kennel rations. Meg lugged them home, nose high when she passed the dog-field where the others sniffed enviously. The bone that was her reward did not please Meg much, she let the others take it from her. Had any of them taken her job, Meg's heart would have been broken.

A kind-voiced man rushed into the kennel one day.

"I want a trained, cattle-dog to take with me to the Cariboo immediately!"

He fancied Meg; I liked the way he handled her. I let Meg go to the big spaces and the job that was hers by right.

Basement

C reeping around a basement in the small dark hours is not cheerful. A house's underneathness is crushing—weight of sleep pressing from the flats above, little lumps of coal releasing miniature avalanches which rattle down the black pile, furnace grimly dead, asbestos-covered arms prying into every corner.

Just inside the basement door was a yawn of black. This portion of basement was uncemented, low-ceiled, earthy, unsunned. Often in daytime I must creep here among the cobwebs to feel hot-air-pipes and see that each tenant got his just amount of heat. Ghastly white pipes twisted and meandered through the dimness. A maple stump was still rooted here. Every year it sprouted feebler, paler shoots, anaemic, ghastly! Punk kept bones under the hollow of this old root. At night when we went down to tend puppies or sick dogs I scuttled quickly past the black. Cobwebby darkness did not worry Punk; he dashed in and dug up a bone to gnaw while I tended puppies.

Night

M any a winter night Punk, who slept upstairs in my flat, and I crept down the long outside stair to the basement, sometimes crunching snow on every step, sometimes slipping through rain. Old moon saw us when she was full. When new, her chin curled towards her forehead and she did not look at us. The corners of the stairway were black. Sometimes we met puffs of wind, sometimes wreaths of white mist. It was comfortable to rest a hand on Punk, envying his indifference to dark, cold, fear. I envied Punk his calm acceptance of everything.

The Dog-Thief

I loved sleeping in the garden room, my garden room where flowers and creatures were so close.

It was nearly time for the moon to turn in and for me to turn out. Punk, lying on the mat beside my bed, got up, crept to the open door—stood, a blurred mass of listening shadow.

The blind man in my downstairs flat had twice before told me of rustlings in the dog-field at night. His super-sensitiveness had detected fingers feeling

along the outer wall of his flat.

"I think," he had suggested, "that someone is after a pup."

I threw on a gown and stood beside Punk. The shadow by the pup-house door looked, I thought, unusually bulky. Punk and I went down the cinder path. Punk growled, the shadow darted behind the lilac bush, uttering a high sing-song squeal. There was light enough to show Chinese cut of clothes—I heard the slip-slop of Chinese shoes.

"What do you want?"

"Me loosed," he whined.

"You are not lost. You came in by my gate. Put him out, Punk!"

Whites of slant, terrified eyes rolled as the dog allowed him to pass but kept at his heels until he was out in the street. Whoever bribed that Chinaman to steal a pup had not reckoned on Punk's being loose, nor had he counted on my sleeping in my garden.

Selling

A stranger stood at the garden gate. Young dogs leapt, old dogs stiffened and growled, enquiring noses smelled through the bars of the gate at the head of the garden steps. Fore-paws rested a step higher than hind-paws, making dogs' slanted bodies, massed upon the steps, look like a grey thatch. Strong snuffing breaths were drawn in silently, expelled loudly.

I came into the middle of the dog pack and asked of the stranger, "You wanted something?"

The man bracketed dogs and me in one disdainful look.

"I want a dog."

The coarse hand that swept insolently over the dogs' heads enraged them. They made such bedlam that an upper and a lower tenant's head protruded from the side of the house, each at the level of his own flat.

"What price the big brute?"—indicating Punk.

"Not for sale."

"The blue birch?"—pointing to Loo.

"Not for sale."

"Anything for sale?" he sneered.

"Puppies."

"More bother'n they're worth! . . . G'ar on!"

He struck Punk's nose for sniffing at his sleeve.

"D'you want to sell or d'you not?"

"Not."

The man shrugged—went away.

Money in exchange for Bobbies was dirty from hands like those.

Kipling

The dogs and I were Sundaying on the garden lawn. Suddenly every dog made a good-natured rush at the garden gate. A man and a woman of middle age were leaning over it. The dogs bunched on the steps below the gate. The woman stretched a kindly hand to them. The man only stared—stared and smiled.

"Were you looking for somebody?" I asked.

"Not exactly—he," the woman waved a hand towards the man, "has always had a notion for Bobtails."

I invited them into my garden.

"Would you like to see the pups?" I said, and led the way to the puppy pen. The woman leant across, but the man jumped over the low fence and knelt on the earth among the puppies.

"Your 'Sunday,' Father!" reminded the woman.

He gave a flip to his dusty knees, but continued kneeling among scraping, pawing pups. Picking up a sturdy chap, he held it close.

"Kip, Kip," he kept saying.

"Kipling and Bobtails is his only queerness," the woman apologized.

"I suppose they are very expensive?" the man said, putting the puppy down on the ground. To the pup he said, "You are not a necessity, little fellow!" and turned away.

"There's times *wants* is *necessities*, Father," said the woman. "You go ahead and pick. Who's ate them millions and millions of loaves you've baked these thirty years? Not you. Jest time it is that you took some pleasure to yourself. Pick the best, too!"

With shaking hand the baker lifted the pup he had held before, the one he had already named Kip. He hurried the puppy's price out of his pocket (Ah! He had known he was going to buy!), crooked one arm to prevent the pup from slipping from beneath his coat, crooked the other arm for his wife to take hold. Neither of them noticed the dust on his "Sundays" as they smiled off down the street.

Sales like this were delicious—satisfactory to buyer, seller, dog.

Lorenzo Was Registered

Only once did I come upon a Bobbie who was a near-fool; he was a dog I bought because of his registration, for I went on coveting registration for my dogs. Lorenzo was advertised: "A magnificent specimen of the noble breed—registered name—'Lorenzo.'" He was impressive enough on paper; in the flesh he was a scraggy, muddle-coloured, sparse-coated creature, with none of the massive, lumbering shagginess of the true Bobbie. His papers apparently were all right. His owner described the dog as "an ornament to any *gentleman's* heel." I wanted dignity of registration for my kennels, not ornament for my heels.

Lorenzo had acquired an elegant high-stepping gait in place of the Bobtail shamble, also a pernickety appetite. He scorned my wholesome kennel fare, toothing our dainties and leaving the grosser portions to be finished by the other dogs.

Lorenzo was mine for only a short time. I had a letter asking for a dog of his type from a man very much the type of Lorenzo's former owner. The letter said, "I have a fancy for adding an Old Country note to my Canadian farm in the shape of an Old English Bobtail Sheep-dog. I have no stock to work, but the dog must be a good heeler—registration *absolutely necessary.*"

High-stepping Lorenzo was in tune with spats and a monocle, was registered and a good heeler. I told the man I had better-type dogs unregistered, but a check came by return emphatically stating that Lorenzo was the dog for him.

Lorenzo's buyer declared himself completely satisfied with foolish, high-stepping, bad-typed Lorenzo—Lorenzo was registered.

Sissy's Job

The earth was fairly peppered with David Harbin's cousins. No matter what part of the world was mentioned David said, "I have a cousin out there." David was a London lawyer. During law vacation he visited cousins all over the world. He always came to see me when visiting Canadian cousins.

David and I were sitting on my garden bench talking. David said, "My last visit (to a Canadian cousin) has left me very sad. Cousin Allan and I were brought up together; his parents died and my Mother took Allan. He was a deaf-mute. His dumbness did not seem to matter when we were boys. We used

dumb language and were jolly. When Allan had to face life, to take his dumbness out into the world, that was different—he bought a ranch in Canada, a far-off, isolated ranch. Now he is doubly solitary, surrounded by empty space as well as dead silence."

While David talked a Mother Bobtail came and laid her chin on his knee. His hand strayed to her head but he did not look at her. His seeing was not in the garden; it was back on the lonely ranch with dumb Allan. The dog sensed trouble in David's voice, in his touch she felt sadness. She leapt, licked his face! David started.

"Down, Sissy," I called.

But David shouted, "Dog, *you're* the solution. Is she for sale?"

"Sissy," I said, "was intended for a kennel matron. But she was temperamental over her first litter, did not mother them well. She will do better next time perhaps, unless. . . ."

I caught David's eye. . . .

"Unless I send her over to mother dumb Allan!"

David fairly danced from my garden, he was so happy in his solution for Allan's loneliness.

From England he wrote, "Allan's letters have completely changed, despondency gone from them. Bless Bobtails!—Sissy did it."

Min the Nurse

In the public market the butcher's scale banged down with a clank. The butcher grinned first at the pointer, then at me. The meat on the scale was worth far more than I was paying.

"Bobtails," murmured the butcher caressingly—"Bobtails is good dogs! . . . 'Member the little 'un I bought from your kennel a year back?"

"I do. Hope she turned out well—good worker?"

"Good worker! You bet. More sick nurse than cattle driver. Our Min's fine! Y'see, Missus be bed-fast. Market days she'd lay there, sun-up to sun-down, alone. I got Min; then she wan't alone no more; Min took hold. Market days Min minds wife, Min minds farm, Min keeps pigs out of potatoes, Min guards sheep from cougars, Min shoos coon from hen-house—Min, Min, Min. Min runs the whole works, Min do!"

He leaned a heavy arm across the scale, enraging its spring. He wagged an impressive forefinger and said, "Females understands females." Nod, nod, another nod. "Times there's no easin' the frets of Missus. Them times

I off's to barn. 'Min,' I sez, 'You stay,' an' Min stays. Dogs be powerful understandin'."

He handed me the heavy parcel and gave yet another nod.

"Fido's chop, butcher!"

The voice was overbearing and tart; then it crooned down to the yapping, blanketed, wriggling, "Pom" under her arm, "Oo's chopsie is coming, ducksie!"

The butcher slammed a meagre chop on the scale, gathered up the corners of the paper, snapped the string, flung the package over the counter, tossed the coin into his cash box—then fell to sharpening knives furiously.

Babies

The dogs and I were absorbing sultry calm under the big maple tree in their play-field. They sprawled on the parched grass, not awake enough to seek trouble, not asleep enough to be unaware of the slightest happening.

A most extraordinary noise was happening, a metallic gurgle that rasped in even-spaced screeches. The noise stopped at our gate; every dog made a dash. Punk and Loo, who had been sitting on top of the low kennel against which I rested, leaped over my head to join the pack. The fence of their field angled the front gate. A weary woman shoved the gate open with the front wheels of the pram she pushed. A squeal or two and the noise stopped.

The woman drove the baby-carriage into the shade of the hawthorn tree and herself slumped on to the bench just inside my gate. Her head bobbed forward; she was so asleep that even the dogs' barking in her ear and pushing her hat over one eye, pawing and sniffing over the fence against which the bench backed, did not wake her. For a few seconds her hand went on jogging the pram, then dropped to her side like a weighted bag. I called the dogs back and every soul of us drowsed out into the summer hum. Only the sun was really awake. He rounded the thorn-tree and settled his scorch on to the baby's nose.

The child squirmed. He was most unattractive, a speckle-faced, slobbery, scowling infant. A yellow turkish-towelling bib under his chin did not add to his beauty. In the afternoon glare he looked like a sunset. He rammed a doubled-up fist into his mouth and began to gnaw and grumble. The woman stirred in her unlovely sleep, and her hand started automatically to jog the pram handle. I had come from the dog field and was sitting beside her on the bench. Eyes peering from partly stuck-together lids like those of a nine-day-old kitten, she saw me.

"Teethin'," she yawned, and nodded in the direction of the pram; then her head flopped and she resumed loose-lipped, snorting slumber.

"Wa-a-a-a!"

The dogs came inquisitively to the fence.

"'Ush, 'Ush!"

She saw the dogs, felt their cool noses against her cheek.

"Where be I?—Mercy! I come for a pup! *That's* where I be! 'Usband says when we was changin' shifts walkin' son last night. 'Try a pup, Mother,' 'e sez—'We've tried rattles an' balls an' toys. Try a live pup to soothe 'is fretti-ness.' So I come. 'Usband sez, 'Git a pup same age as son'—Sooner 'ave one 'ouse-broke me'self—wot yer got?"

"I have pups three months old."

"Ezzact same age as son! Bring 'em along."

She inspected the puppy, running an experienced finger around his gums.

"Toothed a'ready! 'E'll do."

She tucked the pup into the pram beside the baby who immediately seized the dog's ear and began to chew. The pup as immediately applied himself greedily to the baby's bottle and began to suck.

"Well, I never did!" said the mother. "Let 'im finish—'ere's a comfort for son."

She dived into a deep cloth bag.

"That pup was brought up on a bottle," I explained.

"That so? Tote!" she commanded. I operated the pram's screech till the comfort was in the baby's mouth and the pup paid for.

Loo and I, watching, heard the pram-full of baby whine down the street. Loo, when satisfied that the noise was purely mechanical, not puppy-made, shook herself and trotted contentedly back to the field—finished with that lot of puppies. Nature would now rest Loo, prepare her for the next lot of puppies. Life, persistent life! Always pushing, always going on.

Distemper

Distemper swooped upon the kennel. Dance went from strong, straight legs leaving trembling weakness. Noses parched, cracked with fever, eyes crusted, ears lay limp; there were no tailless, all-over wobbles of joy, anticipation, curiosity; dinners went untouched.

One veterinary advocated open air and cold, the other swearing in a steam-box. I tried every distemper remedy then known. Death swept the kennel. A bucket of water stood always ready beside the garden tap for the little ones.

When convulsions set in, I put an end to the pup's suffering. After convulsions starred the case was hopeless.

These drowning horrors usually had to be done between midnight and dawn. The puppies yelped in delirium. (Tenants must not be disturbed by dog agony.) In the night-black garden I shook with the horror of taking life—when it must be done, the veterinary destroyed adult dogs that could not recover.

That bout of distemper took the lives of fifteen of my Bobtails, and took two months to do it in. Creena, a beautiful young mother dog I had just bought, was the last adult to die. The vet took her body away; there was room for no more graves in my garden. Two half-grown dead pups in dripping sacks lay in the shed waiting for dark—of Loo's eight puppies (the ones the Prince of Wales had admired and fondled in the Victoria show a few weeks earlier) only two were left; they were ramping around their box in delirium. I could endure no more. It might be several days yet before they died. I took them to the garden bucket.

Now the kennel was empty except for Loo, Punk and Flirt. We must start all over again. That night when dark came I heaped four dripping sacks into the old pram, in which I brought bones from the butcher's, and trundled my sad load through black, wild storm to the cliffs off Beacon Hill. Greedy white breakers licked the weighted sacks from my hands, carried them out, out.

Punk waited at home. The tragedy in the kennel he did not comprehend— trouble of the human being he loved distressed the dog sorely. Whimpering, he came close—licked my hands, my face for sorrow.

Gertie

T he man said, "The garden belongs to my cousins, I board with them."
I could see he minded being only a "boarder," minded having no ground-rights.

The resentful voice continued, "Gertie has outgrown her pen and her welcome."

Pulling a stalk of wild grass, he chewed on it furiously. This action, together with the name of the dog, made me remember the man. A year ago he had come to my kennel. I had been impressed with the hideousness of the name "Gertie" for a dog. He had looked long at Loo's pups, suddenly had swooped to gather a small female that was almost all white into his arms. "This one!" he exclaimed, "daintiest pup of them all!" and, putting his cheek against the

puppy, he murmured, "Gertie your name is, Gertie, *Gertie!*" Then he tucked her inside his coat and went sailing down the street, happy.

Now Gertie was up for sale and I was buying her back.

With a squeezing burst Gertie shot through her small door to fling herself upon her master. We stood beside the outgrown pen.

"I made it as big as the space they allowed would permit," giving a scornful glance at the small quarters of the big dog. "All right when she was little. Now it is cruel to keep a creature of her size in it."

Gertie was circling us joyously. Her glad free yelps brought the cousins rushing from their house, one lady furnished with a broom, the other with a duster. One dashed to the pansy-bed waving the duster protectively. The other broomed, militant, at the end of the delphinium row.

"Leash her!" squealed Pansy.

"Leash her!" echoed Delphinium.

The man took a lead from his pocket and secured Gertie. The women saw me take the lead in my hand, saw me put Gertie's price into his. He dashed the money into his pocket without a look, as if it burned his hand to hold it, turned abruptly, went into the house. The duster and the broom limped. The women smiled.

"Destructive and clumsy as a cow!" said Pansy, and scowled as Gertie passed them on her way to the gate, led by me.

"Creatures that size should be banned from city property!" agreed Delphinium with a scowl the twin of Pansy's.

Gertie, her head turned back over her shoulder, came with me submissively to the gate; here she sat down, would not budge. I pushed her out on to the pavement and shut the gate behind her—neither coaxing nor shoving would get Gertie further.

Suddenly there was a quick step on the garden walk—Gertie sprang, waiting for the gate to open, waiting to fling herself upon her adored master, pleading. I let go the lead, busied myself examining blight on the hedge. I was positive the sun had glittered on some unnatural shininess on the man's cheek. He handed me Gertie's lead. "I shall not come to see her. Will you give her the comfort of retaining the sound of her old name? Gertie," he whispered, "Gertie!" and the dog waggled with joy.

Gertie! Ugh, I *loathed* the name—Gertie among my patriarchs!

I said, "Yes, I'll keep the sound."

He commanded, "Go, Gertie."

The dog obeyed, rising to amble unenthusiastically in the direction of his pointing finger and my heels.

Honestly, I "Gertied" Gertie all the way home. Then, taking her head between my hands and bending close said, "Flirtie, Flirtie, Flirtie," distinctly into the dog's ear. She was intelligent and responded just as well to "Flirtie" as to "Gertie." After all, I told myself, it was the *sound* I promised that Gertie should keep.

The "ie" I gradually lopped off too. Maybe her master had abbreviated to "Gert" sometimes. Flirt became one of the pillars of my kennel.

She was frightened to death of her first puppies. She dug holes in the earth and buried them as soon as they were born. I dug the pups up, restored them to life, but Flirt refused to have anything to do with them. In despair I brought old Loo into the next pen and gave the pups to her. She bathed and cuddled them all day. More she could not do as she had no puppies of her own at that time. At evening when the pups squealed with hunger and Loo was just a little bored, I sat an hour in Flirt's pen reasoning with her. Little by little the terrified, trembling mother allowed her puppies to creep close, closer, finally to touch her.

Her realization of motherhood came with a rush. She gave herself with Bobtail wholeheartedness to her pups, and ever after was a genuine mother.

The Cousins' Bobtails

Two men, cousins, came to buy Bobtails. One cousin was rich and had a beautiful estate; the other was poor and was overseer and cowman for his cousin.

The rich cousin bought the handsomest and highest-priced pup in the kennel. After careful consideration the poor man chose the runt of the litter.

"This pup has brains," he said.

A chauffeur carried the rich man's pup to his car. The poor man, cuddling his puppy in his arm, walked away smiling.

A year later the rich cousin came to see me. He said, "I am entering my Bobtail in the show. I would like you to look him over." He sent his car and I went to his beautiful estate. His dog, Bob, was Loo's pup, well-mannered, handsome. I asked how the dog was for work.

"Well, our sheep are all show-stock, safely corralled. There *is* no work for Bob except to be ornamental. The women folks are crazy about him, never allow him 'round the barns. My cousin's dog does our cattle work."

We went to the cattle-barns, Bob walking behind us with dignity. The cow-cousin and a burly Bobtail were bringing in the dairy herd. They gave a nod and a "woof" in our direction and continued about their business. When the

cows were stalled the man said "Right, Lass!" and man and dog came to where we stood. Wisps of straw stuck in the work-dog's coat, mud was on her feet, she reeked of cow. She stood soberly beside her master paying no heed either to Bob or to us.

"She handles the cows well," I said to the cow-cousin.

"Wouldn't trade Lass for a kingdom!" He directed a scornful eye and a pointing finger towards Bob, muttering, "Soft as mush!"

"Are you entering Lass in the show?"

"Show Lass! Lass has no time to sir on show-benches—on her job from dawn till dark—cows, pigs, hens. Leghorn fowls are pretty flighty you know, but Lass can walk into the midst of a flock—no fuss, just picks out the hen of my pointing, pins the bird to the ground by placing her paw squarely but gently on its back, holds on till I come. She can separate hens from pullets, cajoling each into their right pens—off then to the bushes for those tiresome youngsters that *will* roost in the trees. No peace for bird or beast 'round this farm unless it obeys Lass!"

Bob went to the show. He won "the blue," delighting in the fuss and admiration. Lass at home commanded her pigs, drove hens, plodded after cows, but no fluttering ribbon of blue on Lass's collar could have exalted her Bobtail pride as did "Good girl, Lass!"—her master's voice, her master's praise.

Blue or Red

Her skin was like rag ill-washed and rough-dried. Both skin and clothing of the woman were the texture of hydrangea blossoms—thin, sapless. On exaggeratedly high heels here papery structure tottered.

"I want a dog."

"Work dog or companion?"

"One-o-them whatcher-callum—the kind you got."

"Bobtail Sheep-dogs."

"I ain't got no sheep, jest a husband. Lots younger'n me. I tried to keep my years down to his—can't be done,"—she shrugged.

The shrug nearly sent her thin shoulder blades ripping through the flimsy stuff of her blouse. She gripped a puppy by the scruff, raised him to eye-level, giggled, shook the soft, dangling lump lovingly, then lowered him to her flat chest. She dug her nose into his wool as if he had been a powder puff, hugging till he whimpered. She put him on the ground, rummaged in a deep woollen bag.

The money was all in small coin, pinches here and pinches there hoarded from little economies in dress and housekeeping. When the twenty-five and fifty-cent pieces, the nickels and the dimes were in neat piles on the garden bench, she counted them three times over, picked up her pup and went away. The silly heels tap-tapped down the garden path. She gave backward nods at the little piles of coin on the bench, each coin might have been a separate lonesomeness that she was saying goodbye to, grateful that they had brought her this wriggling happy thing to love.

A year later I was working in my garden and the little hydrangea person came again. Beside her lumbered a massive Bobtail. When he saw his brethren in the field his excitement rose to a fury of prances and barkings.

"Down, Jerry, down!"

No authority was in the voice. The dog continued to prance and to bark.

"Must a dog on the show bench be chained?"

"Most certainly he must be chained."

"That settles it! Jerry, Jerry, I *did* so want you to win the blue!"

"He is fine," I said.

"Couldn't be beaten, but Jerry will neither chain nor leash!"

"He could easily be taught."

"I dare not; Jerry is powerful. I'd be afraid."

I took a piece of string from my pocket, put it through Jerry's collar, engaged his attention, led him down the garden and back. He led like a lamb.

"See." I gave the string into her hand. The dog pulled back, breaking the string the moment her thin uncertain grasp took hold.

"Leave Jerry with me for half an hour."

She looked dubious.

"You won't beat him?"

"That would not teach him."

Reluctantly she went away. Jerry was so occupied in watching the dogs in the field he did not notice that she was gone. I got a stout lead, tied Jerry to the fence, then I took Flirt and Loo to the far field and ran them up and down. Jerry wanted to join in the fun. When he wanted hard enough I coupled him to Flirt. We all raced. Jerry was mad with the fun of it. Then I led him alone. By the time the woman came back Jerry understood what a lead was. He was reluctant to stop racing and go with his mistress. I saw them head for home, tapping heels and fluttering drapes, hardly able to keep up with the vigorous Jerry.

Jerry took his place on the show-bench and chained all right, but, in the show ring, his mistress had no control over him. He and his litter brother were competing, having outclassed all entries. Bob, Jerry's competitor, was obedi-

ent, mannerly. The Judge turned to take the red and the blue ribbons from the table, the frown of indecision not quite gone. Blue ribbon in right hand, red in left, he advanced. Jerry was flying for the far end of the ring, leash swinging. His mistress was dusting herself after a roll in the sawdust. The Judge handed the blue ribbon to Bob's master, to the hydrangea lady he gave the red. Bob's master fixed the blue to Bob's collar, the red ribbon dangled in the limp hand of Jerry's mistress. She did not care whether its redness fell among the sawdust and was lost or not—her Jerry was beaten!

Decision

P unk in his prime was siring magnificent puppies, but I had to think forward. Punk and Loo, the founders of my kennel, would one day have to be replaced by young stock. Bobbies are a long-lived breed. Kennel sires and matrons, however, must not be over old if the aim of the kennel is to produce vigorous working stock. It was time I thought about rearing a young pair to carry on.

I had a beautiful puppy, a son of Punk's, named David. I had also a fine upstanding puppy of about the same age that I had imported from the prairies and named Adam. In points there was little to choose between the youngsters, both were excellent specimens and promised well. I watched their development with interest. The pups were entirely different in disposition; they were great chums. David was gentle, calm—Adam bold, rollicking. David's doggy brain worked slow and steady. Adam was spontaneous—all fire. He had long legs and could jump a five-foot fence with great ease. If Adam did not know my exact whereabouts he leapt and came to find me; David lay by the gate patiently waiting, eyes and ears alert for the least hint.

From early puppyhood Adam dominated David; not that David was in any way a weakling, but he adored Adam and obeyed him. Their pens were adjacent. At feeding time Adam bolted his dinner and then came to the dividing partition. David, a slower eater, was only half through his meal, but when Adam came and stood looking through the bars, David pushed his own food dish, nosing it close to Adam's pen. Adam shoved a paw under the boards and clawed the dish through to finish the food that was David's. This happened day after day; there was deliberate uncanny understanding between the two dogs—David always giving, Adam always taking.

One day I was housecleaning and could not have too many dogs under

my feet. I shut them all into the play-field, all except David who lay on the lawn quietly watching my coming and going. Young Adam leapt the fence in search of me. Taking him to the far field I chained him and chained Eve at his side for company.

When it began to rain I was too busy to notice, and by the time I went into the garden to shake some rugs everything was soaking wet.

"Oh, poor Adam and Eve!" I exclaimed. "Chained in the open without shelter!"

I went to put them into the shed. To my amazement I found Adam and Eve each cuddled down on to a comfortable warm rug. It was queer for I knew these rugs had been hanging on a line in the basement. While I wondered I heard a chuckle from the porch of a downstair flat.

"David did it," laughed my tenant. "I watched him. The chained dogs got restive in the wet. David went up to Adam. I saw him regard the chained pup. He then went to Eve, snuffed at her wet coat and turned back into the basement. Next thing I saw was David dragging the rug to Adam who lay down upon it. Then he went back and fetched the other rug for Eve. That David is uncanny!"

Yet for all David's wisdom Adam was the dominant character of the two. Both dogs possessed admirable traits for a kennel sire. I could not decide which to keep. At last the day came—the thing had to be faced.

I built a crate and furnished it with food and water. I took the buyer's letter from my pocket; my hand trembled as I printed the man's name on the crate. I did not know which dog was going, which one would stay. I read the letter again; either pup would meet the man's requirements—"Young, healthy, well-bred."

I leant over the gate watching the dogs at play in the field. David saw me, came, snuffed at my trouble through the bars, thrust a loving tongue out to lick joy back into me.

"David, I cannot let you go!"

"Adam," I called, "Adam!" But my voice was low, uncertain.

Adam was romping with Eve and did not heed.

Common sense came hanging over the gate beside me and, looking through my eyes, said, "David is of Punk's siring. Adam's new blood would be best for the kennel." My face sank, buried itself in David's wool.

"Dog ready?" The Express Company's van was at the gate. The man waited to lift the crate. The two loose boards, the hammer, the nails were ready, everything was ready, everything but my decision.

"Hurry! We have that boat to make!"

I opened the field gate. David rushed through, jumped into the crate. I nailed the loose boards over David. Adam still romped in the field with Eve.

"David! David!"

Loo

Loo reached me first, her motherliness, always on the alert to comfort anything, pup or human, that needed protection.

I had watched someone die that night. It was the month of February and a bitter freeze-up—ground white and hard, trees brittle. The sick woman had finished with seeing, hearing and knowing; she had breathed laboriously. In the middle of the night she had died, stopped living as a blown-out candle stops flaming. With professional calm the nurse had closed her eyes and mouth as if they had been the doors of an empty cupboard.

When it was nearly dawn I went through bitter cold and half-light back to my apartment-house. It was too early to let the Bobbies out, but I wanted the comfort of them so I freed them into the garden, accepting their loving. Warmth and cosiness sprang from the pens when I opened the doors, then I went to tend my furnace. As I stooped to shovel coal, a man's heavy hand struck me across the face. A tenant living in one of my flats bellowed over me, "I'll teach you to let my pipes freeze!"

The shovel clanked from my hand—I reeled, fell on the coal pile. I had not seen the man follow me into the basement. Before I righted myself the man was gone, leaving the basement door open. Icy wind poured in. I sprang to slam the door, bolt the brute out. He was on the step, his hand lifted to strike me again. Quick as lightning I turned on the tap with hose attached at the basement door and directed the icy water full into his face; it washed the spectacles from his nose. Too choked, too furious, too wet even to roar, he turned and raced to his flat upstairs. I waited for his door to shut, then I ran into the garden, ran to the Bobbies.

The eagerness of Loo's rush to help me knocked me down. I did not get up, but lay on the hard snow path, my smarting cheek against its cold. Loo stood over me wanting to lick my hurt. I struck at her for a clumsy brute—told her to go away. The amazed dog shrank back. Punk and the rest crowded round; Loo, shamed and pitiful, crept behind the lilac bush. When I saw her crestfallen, broken-hearted, peeping from behind the bush, great shame filled me. A bully had struck his landlady. I had struck Loo whom I loved; Loo, symbolizing motherliness, most nearly divine of all loves, who had rushed to comfort me.

"Loo! Loo!"

She came, her forgiving as wholehearted as her loving. I buried my face in her shaggy warmth, feeling unworthy, utterly unworthy.

"Work is breaking me, Loo!"

The dog licked my hands and face.

But the apartment-house must be run; it was my living. The kennel? . . . I had supplied the Bobtail market. For the present the kennel was but expense. Dusting the snow off myself I went up to the studio taking Punk and Loo with me. On the table lay an open letter. A kindly woman on a farm wanted a dog— "Mother Bobtail already bred," she wrote. Giving myself no time to think I quoted Loo. Loo's chin rested on my knee as I wrote. I dared not look below my pen. Soon Loo would have another family.

"The joy of Loo in her puppies will ease her strangeness," I told myself, but—"Loo, Loo, I love you."

Remorseful, bitter—I loathed the money when it came, hated the approving nods, the words "wise," "sensible," which people stuffed into my ears when they knew of my decision. I loathed myself, cursed the grind that broke me and took my dogs from me. Punk searched every corner for Loo. Most he searched my face.

Last of the Bobtails

Loo had been gone two days when a dowdy little woman came and held out a handful of small change.

"A guardian and companion for my daughter—delicate, city-bred, marrying a rancher on a lonely island. She dreads the loneliness while her husband is out clearing his land. I thought a sheep-dog . . ."

The price was not that of half a pup. She saw how young my puppies were and began to snivel. "It will be so long before they are protective!"

I took her small money in exchange for Punk, took it to buy value for him in her eyes. Those meagre savings meant as much to her as a big price meant to a rich person. A dog given free is not a dog valued, so I accepted her pittance.

Loo gone, Punk gone—emptying the kennel was numbness. I let every dog go—all except Adam. I would keep just one. Their going gave me more leisure, but it did not heal me. I took young Adam and went to the Okanagan to try high air. I struck a "flu" epidemic and lay six weeks very ill in Kelowna.

They were good to Adam. He was allowed to lie beside my bed. At last we took the lake boat going to Penticton to catch the Vancouver train. The train came roaring into the station and the platform shook. Adam, unused to trains, bolted. In a jiffy he was but a speck heading for the benches above Penticton.

The station master took Adam's chain and ticket.

"Hi, Bill!" he called to a taxi-driver, "Scoot like hell! Overtake that dog. Put him aboard at the water tank two miles down the line. You can make it easy!"

At the tank no Adam was put aboard. I was forced to go on alone. I wired, wrote, advertised. All answers were the same. Adam was seen here and there, but allowed no one to come near him. A shaggy form growing gaunter ever gaunter slunk through the empty streets of Penticton at night, haunting wharf and station. Everyone knew his story, people put out food. Everyone was afraid to try catching him. At great distances a lost terrified dog with tossing coat was seen tearing across country. It was hopeless for me to go up. No one could tell me in what direction to search. Then for months no one saw him. I hoped that he was dead. Two winters and one summer passed—I got a letter from a woman. She said, "We moved into a house some miles out of Penticton. It had been empty for a long while. We were startled to see a large shaggy animal dart from under the house. 'Adam!' I cried, 'Adam!' for I knew about the dog. He halted and looked back one second, then on, on, a mad terrified rush to get away from humans. There was a great hole under our house hollowed to fit his body," said the woman.

At night she put out food. She heard the dog snuff at the door crack. She did not alarm him by opening the door or by calling out. Adam was known the country over as "the wild dog."

One day the woman worked in her garden; something touched her. Adam was there, holding his great paw up. She wrote me, "Come and get him." But before I could start, a wire came saying, "Adam shipped."

I went into the Victoria freight shed. The tired dog was stretched in sleep.

"Adam!"

He quivered but he did not open his eyes.

"Adam!"

His nose stretched to my shoe, to my skirt—sniffing.

"Adam!"

One bound! Forepaws planted one on each of my shoulders, his tongue reaching for my face.

Everyone said, "Adam will be wild, impossible after nineteen months of freedom."

He had forgotten nothing, had acquired no evil habit. Only one torment possessed Adam—fear of ever letting me out of his sight again—Adam, the last of my Bobtails.

Growing Pains

AN AUTOBIOGRAPHY

Contents

Part III

Foreword

Dear Emily:

You have asked me to write a foreword to your autobiography—this summing up of a number of things that have mattered in your life. It is a hard task but one for which I thank you.

What can I say? Certainly nothing that can possibly matter much. I know how courageous your life has been, how dauntless your purpose, how unshaken and unshakeable your faith that this is not all, that we go on. I know too how intensely you have felt the influence of nature—its loveliness, its deep solemnity, its mystic, overwhelming power to strike awe and sometimes terror in our hearts. You have told us of your reactions to those forces in your painting and your writing. Canadians will remember as they open this book and will be grateful.

You will understand when I say that I should like a poem to stand as preface to your book, a poem which we have both admired so much, Thomas Hardy's *Afterwards*. I know and you know that Hardy did not think it a sad poem—just a comment and a summing up. So, Emily, I shirk my task and set as foreword to your autobiography these lines:

> *When the present has latched its postern behind my tremulous stay*
> *And the May month flaps its glad green leaves like wings,*
> *Delicate-filmed as new-spun silk, will the neighbours say,*
> *"He was a man who used to notice such things"?*

> *If it be in the dusk when, like an eyelid's soundless blink,*
> *The dew-fall hawk comes crossing the shades to alight*
> *Upon the wind-warped upland thorn, a gazer may think,*
> *"To him this must have been a familiar sight."*

> *If I pass during some nocturnal blackness, mothy and warm,*
> *When the hedgehog travels furtively over the lawn,*
> *One may say, "He strove that such innocent creatures should come to no harm,*
> *But he could do little for them; and now he is gone."*

> *If, when hearing that I have been stilled at last, they stand at the door,*
> *Watching the full-starred heavens that winter sees,*
> *Will this thought rise on those who will meet my face no more,*
> *"He was one who had an eye for such mysteries"?*

And will any say when my bell of quittance is heard in the gloom,
And a crossing breeze cuts a pause in its outrollings,
Till they rise again, as they were a new bell's boom,
"He hears it not now, but used to notice such things"?

There is a change somewhere in the east. In my western garden this evening grosbeaks are paying their annual visit, a brief pause in our elm trees during their migration; and high in the Canadian sky wild geese, great flocks of them, are shouting their mysterious cry. They are all going on as you and I must, Emily. Life will not stand still.

So, fare forward, dear soul.

IRA DILWORTH

Part One

Baptism

My baptism is an unpleasant memory. I was a little over four years of age. My brother was an infant. We were done together, and in our own home. Dr. Reid, a Presbyterian parson, baptized us. He was dining at our house.

We were playing in the sitting room. Brother Dick was in his cradle. Mother came into the room with water in her best china bowl. While she lighted the lamp my big sister caught me, dragged me to the kitchen pump and scrubbed my face to smarting. I was then given to Dr. Reid who presented me kicking furiously to God.

I would have been quite content to sit on Dr. Reid's knee, but his tipping me flat like a baby infuriated me. I tried to bolt. Dr. Reid hung on to a curl and a button long enough to splash water on my hair ribbon and tell God I was Emily; then the button burst off and I wrenched the curl from his hand and ran to Mother. Dr. Reid and Mother exchanged button for baby. Dick gurgled sweetly when the water splashed him.

Father sat at the table with the fat family Bible open at the page on which the names of his seven other children were written. He added ours, Richard and Emily, which as well as being ours were his own name and Mother's. The covers of the Bible banged, shutting us all in. The Bible says that I was born on the thirteenth day of December, 1871.

Mother

To show Mother I must picture Father, because Mother was Father's reflection—smooth, liquid reflecting of definite, steel-cold reality.

Our childhood was ruled by Father's unbendable iron will, the obeying of which would have been intolerable but for Mother's patient polishing of its dull metal so that it shone and reflected the beauty of orderliness that was in all Father's ways, a beauty you had to admire, for, in spite of Father's severity and his overbearing omnipotence, you had to admit the justice even in his dictatorial bluster. But somehow Mother's reflecting was stronger than Father's reality, for, after her death, it lived on in our memories and strengthened, while Father's tyrannical reality shrivelled up and was submerged under our own development.

Father looked taller than he really was because he was so straight. Mother was small-made and frail. Our oldest sister was like Father; she helped Mother raise us and finished our upbringing when Mother died.

I was twelve when Mother died—the raw, green Victoria age, twelve years old.

The routine of our childhood home ran with mechanical precision. Father was ultra-English, a straight, stern autocrat. No one ever dreamt of crossing his will. Mother loved him and obeyed because it was her loyal pleasure to do so. We children *had* to obey from both fear and reverence.

Nurse Randal has told me of my first birthday. I was born during a mid-December snow storm; the north wind howled and bit. Contrary from the start, I kept the family in suspense all day. A row of sparrows, puffed with cold, sat on the rail of the balcony outside Mother's window, bracing themselves against the danger of being blown into the drifted snow piled against the window. Icicles hung, wind moaned, I dallied. At three in the morning I sent Father ploughing on foot through knee-deep snow to fetch Nurse Randal.

I never did feel that it was necessary to apologize to my father for being late. It made variety for him, seeing that he always got his way in everything—when Father commanded everybody ran.

Every evening at a quarter to six Mother would say, "Children, is every gate properly shut and fastened? Are no toys littering the garden, no dolls sitting on humans' chairs? Wash your faces, then, and put on clean pinafores; your father will soon be home."

If visiting children happened to be playing with us in our garden, or a neighbour calling on Mother, they scurried for the gate as fast as they could. Father would not have said anything if he had found them in his house—that was just it, he would not have said anything to them at all. He would have stalked in our front door, rushed through the house and out of the side door frowning terribly, hurrying to tend Isabella, the great, purple-fruited grapevine that crawled half over our house and entirely over Father's heart. Her grapes were most beautifully fogged with dusky bloom, behind which she pretended her fruit was luscious; but they were really tough-skinned, sour old grapes.

Father was burstingly proud of miserable old Isabella. He glassed her top so that her upstairs grapes ripened a whole month earlier than her downstairs ones. He tacked Isabella up, he pinched her back, petted, trained her, gave her everything a vine could possibly want, endured far more waywardness from her than all of us together would dare to show.

After Father had fussed over Isabella and eaten a good dinner, he went upstairs to see Mother who was far more often in bed ill than up. He was good to Mother in his own way, gave her every possible comfort, good help, good doctoring, best food, but I resented that he went to Isabella first and Mother after. He was grumpy too when he did go. He sat beside her bed for half an hour in almost complete silence, then he went downstairs to read his paper till bedtime.

I heard a lady say to Mother, "Isn't it difficult, Mrs. Carr, to discipline our babies when their fathers spoil them so?"

Mother replied, "My husband takes no notice of mine till they are old enough to run round after him. He then recognizes them as human beings and as his children, accepts their adoration. You know how little tots worship big, strong men!"

The other mother nodded and my mother continued, "Each of my children in turn my husband makes his special favourite when they come to this man-adoring age. When this child shows signs of having a will of its own he returns it to the nursery and raises the next youngest to favour. This one," she put her hand on me, "has overdrawn her share of favouritism because there was no little sister to step into her shoes. Our small son is much younger and very delicate. His father accuses me of coddling him, but he is the only boy I have left—I lost three."

Father kept sturdy me as his pet for a long time.

"Ah," he would say, "this one should have been the boy."

The very frailness of her little son made Mother love him harder. She did not mind the anxiety and trouble if only he lived.

Father insisted that I be at his heels every moment that he was at home. I helped him in the garden, popping the bulbs into holes that he dug, holding the strips of cloth and the tacks while he trained Isabella. I walked nearly all the way to town with him every morning. He let me snuggle under his arm and sleep during the long Presbyterian sermons. I held his hand during the walk to and from church. This all seemed to me fine until I began to think for myself—then I saw that I was being used as a soother for Father's tantrums; like a bone to a dog. I was being flung to quiet Father's temper. When he was extra cranky I was taken into town by my big sister and left at Father's wholesale warehouse to walk home with him because my chatter soothed him. I resented this and began to question why Father should act as if he was God. Why should people dance after him and let him think he was? I decided disciplining would be good for Father and I made up my mind to cross his will sometimes. At first he laughed, trying to coax the waywardness out of me, but when he saw I was serious his fury rose against me. He turned and was harder on me than on any of the others. His soul was so bitter that he was even sometimes cruel to me.

"Mother," I begged, "need I be sent to town any more to walk home with Father?"

Mother looked at me hard. "Child," she cried, "what ails you? You have always loved to be with your father. He adores you. What is the matter?"

"He is cross, he thinks he is as important as God."

Mother was supremely shocked; she had brought her family up under the English tradition that the men of a woman's family were created to be worshipped. My insurrection pained her. She was as troubled as a hen that has hatched a duck. She wanted to question me but her loyalty to Father forbade.

She said to me, "Shall you and I have a picnic?"—She knew that above all things I loved a picnic.

"All to ourselves?" I asked.

"Just you and I."

It was the most wonderful thing she could have suggested. I was so proud. Mother, who always shared herself equally among us, was giving to me a whole afternoon of herself!

It was wild lily time. We went through our garden, our cow-yard and pasture, and came to our wild lily field. Here we stood a little, quietly looking. Millions upon millions of white lilies were sprangled over the green field. Every lily's brown eye looked down into the earth but her petals rolled back over her head and pointed at the pine-tree tops and the sky. No one could make words to tell how fresh and sweet they smelled. The perfume was delicate yet had such power its memory clung through the rest of your life and could carry you back any time to the old lily field, even after the field had become city and there were no more lilies in it—just houses and houses. Yes, even then your nose could ride on the smell and come galloping back to the lily field.

Between our lily field and Beacon Hill Park there was nothing but a black, tarred fence. From the bag that carried Mother's sewing and our picnic, she took a big key and fitted it into the padlock. The binding-chain fell away from the pickets. I stepped with Mother beyond the confines of our very fenced childhood. Pickets and snake fences had always separated us from the tremendous world. Beacon Hill Park was just as it had always been from the beginning of time, not cleared, not trimmed. Mother and I squeezed through a crack in its greenery; bushes whacked against our push. Soon we came to a tiny, grassy opening, filled with sunshine and we sat down under a mock-orange bush, white with blossom and deliciously sweet.

I made a daisy chain and Mother sewed. All round the opening crowded spiraea bushes loaded with droops of creamy blossom having a hot, fluffy smell. In these, bees droned and butterflies fluttered, but our mock-orange bush was whiter and smelled stronger and sweeter. We talked very little as we sat there.

Mother was always a quiet woman—a little shy of her own children. I am glad she was not chatty, glad she did not perpetually "dear" us as so many English mothers that we knew did with their children. If she had been noisier or quieter, more demonstrative or less loving, she would not have been just right. She was a small, grey-eyed, dark-haired woman, had pink cheeks and struggled

breathing. I do not remember to have ever heard her laugh out loud, yet she was always happy and contented. I was surprised once to hear her tell the Bishop, "My heart is always singing." How did hearts sing? I had never heard Mother's, I had just heard her difficult, gasping little breaths. Mother's moving was slow and weak, yet I always think of her as having Jenny-Wren-bird's quickness. I felt instinctively that was her nature. I became aware of this along with many other things about my mother, things that unfolded to me in my own development.

Our picnic that day was perfect. I was for once Mother's oldest, youngest, her companion-child. While her small, neat hands hurried the little stitches down the long, white seams of her sewing, and my daisy chains grew and grew, while the flowers of the bushes smelled and smelled and sunshine and silence were spread all round, it almost seemed rude to crunch the sweet biscuit which was our picnic—ordinary munching of biscuits did not seem right for such a splendid time.

When I had three daisy chains round my neck, when all Mother's seams were stitched, and when the glint of sunshine had gone quiet, then we went again through our gate, locked the world our, and went back to the others.

It was only a short while after our picnic that Mother died. Her death broke Father; we saw then how he had loved her, how alone he was without her—none of us could make up to him for her loss. He retired from business. His office desk and chair were brought home and put into the room below Mother's bedroom. Here Father sat, staring over his garden. His stare was as empty as a pulpit without a preacher and with no congregation in front of it. We saw him there when we came from school and went stupidly wandering over the house from room to room instead of rushing straight up to Mother's bedroom. By-and-by, when we couldn't bear it any longer, we'd creep up the stairs, turn the door handle, go into emptiness, get caught there and scolded for having red eyes and no bravery.

I was often troublesome in those miserable days after Mother died. I provoked my big sister and, when her patience was at an end, she would say, trying to shame me, "Poor Mother worried about leaving you. She was happy about her other children, knowing she could trust them to behave—good reasonable children—you are different!"

This cut me to the quick. For years I had spells of crying about it. Then by-and-by I had a sweetheart. He wanted me to love him and I couldn't, but one day I almost did—he found me crying and coaxed.

"Tell me."

I told him what my big sister had said. He came close and whispered in my ear, "Don't cry, little girl. If you were the naughtiest, you can bet your mother loved you a tiny bit the best—that's the way mothers are."

Drawing and Insubordination

I wanted to draw a dog. I sat beside Carlow's kennel and stared at him a long time. Then I took a charred stick from the grate, split open a large brown-paper sack and drew a dog on the sack.

My married sister who had taken drawing lessons looked at my dog and said, "Not bad." Father spread the drawing on top of his newspaper, put on his spectacles, looked, said, "Um!" Mother said, "You are blacked with charred wood, wash!" The paper sack was found years later among Father's papers. He had written on it, "By Emily, aged eight."

I was allowed to take drawing lessons at the little private school which I attended. Miss Emily Woods came every Monday with a portfolio of copies under her arm. I got the prize for copying a boy with a rabbit. Bessie Nuthall nearly won because her drawing was neat and clean, but my rabbit and boy were better drawn.

Father pruned the cherry tree under our bedroom window. The cherry sticks were twisty but I took three of the straightest, tied them at one end and straddled them at the other and put two big nails in the wood to hold a drawing-board. With this easel under the dormer window of our bedroom I felt completely an artist. My sister Alice who shared the room complained when she swept round the legs of the easel.

When I went to the big public school with my sisters we were allowed on Fridays after school to go to Miss Withrow's house for drawing lessons. I got sick for fear I'd be kept in and miss any of the lesson, so Mother wrote a note to the teacher asking that I be let out on time. My sisters Lizzie and Alice painted flowers, I drew heads.

Miss Withrow sewed small photographs into little squares with white cotton thread, then she ruled a big sheet of paper with big squares and I drew as much in a big square as there was in a little one. In this way I swelled Father and Mother and my sister's baby. Father put Mother and himself in gilt frames and gave me five gold dollars. My sister thought my drawn baby was not good enough to be her child.

The Victoria tombstone-maker got some plaster casts of noses, hands, lips and eyes, to help him model angels for his tombstones. I heard that to draw from casts was the way they learned at Art schools, so I saved my pocket money and bought some of these over-size human features and drew them over and over.

My mother died when I was twelve years old and my father died two years later. When Father died I was still at school getting into a great deal of trouble for drawing faces on my fingernails and pinafores and textbooks. My sisters

and brother were good students. When I moved up a grade the new teacher said, "Ah, another good Carr!" but was disappointed.

After Father and Mother died my big sister ruled; she was stern like Father. She was twenty years older than the youngest of us. Our family had a wide gap near the top where three brothers had died, so there was Mother's big family of two grown-up girls and her little family of three small girls and a boy. The second of the big sisters married. The biggest sister owned everything and us too when Father died.

Lizzie and Alice were easy children and good. Lizzie was very religious. Alice was patient and took the way of least resistance always. Dick too was good enough, but I was rebellious. Little Dick and I got the riding whip every day. It was a swishy whip and cut and curled around our black stockinged legs very hurtfully.

The most particular sin for which we were whipped was called insubordination. Most always it arose from the same cause—remittance men, or remittance men's wives. Canada was infested at that time by Old Country younger sons and ne'er-do-wells, people who had been shipped to Canada on a one-way ticket. These people lived on small remittances received from home. They were too lazy and too incompetent to work, stuck up, indolent, considering it beneath their dignity to earn but not beneath their dignity to take all a Canadian was willing to hand out.

My two elder sisters were born in England. The one who ruled us felt very much "first born" in the English way, feeling herself better than the rest of us because she was oldest. She was proud of being top. She listened to all the hard-luck stories of the remittance people and said, "I too was born in England." She sympathized with their homesickness and filled our home with these people.

Dick and I hated the intruders. Lizzie and Alice resented them too, but quietly. My sister tried to compel my brother and me by means of the riding whip.

A couple called Piddington sat on us for six months. The wife was a hypochondriac and exploited ill-health. The man was an idle loafer and a cruel bully. Anger at his impertinence and sponging kept the riding whip actively busy on our young legs. Things came to a climax when we rented a sea-side cottage in the holidays. The man took a party of boys and girls out in the boat. The sea was rough. I asked to be put ashore. Seeing my green face the man shipped his oars and cried delightedly, "We'll make the kid seasick." He rocked the boat back and forth till he succeeded. I was shamed before all the boys and girls. He knew, too, how it infuriated me to be called "kid" by him.

"You are not a gentleman anyway!" I cried. "You are a sponger and a bully!"

Purple with rage the man pulled ashore and rushed to his wife saying, "The kid has insulted me!"

For insulting a guest in her house my sister thrashed me till I fainted; but I refused to apologize, and the bully and I went round glowering at each other. I said to my sister, "I am almost sixteen now and the next time you thrash me I shall strike back." That was my last whipping.

Dick went East to school. The whip dangled idle on the hall peg, except after school and on Saturdays when I took it out as an ornament and went galloping over the country on old Johnny.

Johnny had been a circus pony. He knew a lot. When he had galloped me beyond the town and over the highway till all houses and fences were passed, he would saunter, stopping now and then to sniff the roadside bushes as if considering. Suddenly he would nose into the greenery finding a trail no one else could see, pressing forward so hard that the bushes parted, caressing him and me as we passed, and closing behind us shutting us from every "towny" thing. Johnny pressed and pressed till we were hidden from seeing, noise and people. When we came to some mossy little clearing where soft shade-growing grass grew Johnny stopped with a satisfied sigh. I let down his bridle and we nibbled, he on the grass, I at the deep sacred beauty of Canada's still woods. Maybe after all I owe a "thank you" to the remittance ones and to the riding whip for driving me out into the woods. Certainly I do to old Johnny for finding the deep lovely places that were the very foundation on which my work as a painter was to be built.

Graduation

Though I had graduated from whippings life at home was neither easy nor peaceful. Outsiders saw our life all smoothed on top by a good deal of mid-Victorian kissing and a palaver of family devotion; the hypocrisy galled me. I was the disturbing element of the family. The others were prim, orthodox, religious. My sister's rule was dictatorial, hard. Though her whip beat me no more her head shook harder and her tongue lashed. Not content with fighting my own battles, I must decide to battle for the family rights of all us younger children. I would not sham, pretending that we were a nest of doves, knowing well that in our home bitterness and resentment writhed. We younger ones had no rights in the home at all. Our house had been left by my father as a home for us all but everything was in big sister's name. We younger ones did not exist.

I marched to the dignified, musty office of the old Scotch gentleman whom my father had appointed as our guardian. He knew nothing of our inner home life. His kind, surprised eyes looked at me over the top of his glasses. No other ward of his—he had others beside us—had ever sought him personally in his den.

"What can I do for you, Emily?"

"Please, I want to go away from home. There is an Art School in San Francisco—may I go there?"

My guardian frowned. He said, "San Francisco is a big and wicked city for a little girl to be alone in."

"I am sixteen, almost."

"You do not look it."

"Nobody is allowed to grow up in our house."

My guardian grew stern.

"Your sister," he said, "is an excellent woman and has been a mother to you younger children. Is this Art idea just naughtiness, a passing whim?"

"No, it is very real—it has been growing for a long time."

He looked at me steadily.

"It can be arranged."

When he smiled at me I was glad I had come.

My sister, when she heard what I had done without her advice, blackened. The breaking storm was checked by her chuckle, "So you want to run away from authority? All right, I shall place you under the supervision of the Piddingtons!"

I had forgotten that the hated Piddingtons were now living in San Francisco. I was so glad for them to have moved that I had not cared where they went; but neither the Piddingtons nor the wickedness of San Francisco could crack my joy. Without my sister watching I could defy the Piddingtons. I'd be busy studying Art. I had always been fond of drawing and of beautiful places, particularly woods, which stirred me deeper than anything. Now I would learn how to put the two together. The wickedness of San Francisco caused me no anxiety. Big naughtiness like immorality, drunkenness, vice I knew nothing of. Lies, destructiveness, impertinence were the worst forms of evil of which I was aware.

The wickedness of San Francisco did not show in the least when our boat pushed through sea-fog and entered the Golden Gate. Telegraph Hill sticking up on our right was very naughty the Captain said but it looked beautiful to me perched on the bluff as I stood on the bridge beside the Captain. The sordid shabbiness of Telegraph Hill was wreathed in mist. Our ship eased slowly up to a dirty wharf. Here, smart and trim, stood Mrs. Piddington, an eye full of "ogle" ready for the Captain to whose care I had been entrusted. I was feeling like a tissue-wrapped valuable when he handed me over, but as Mrs. Piddington took me I changed into a common brown paper bundle. She scowled at my luggage—a straw suitcase and a battered birdcage containing a canary in full moult. I felt like a stray pup following elegant Mrs. Piddington from the wharf.

The Piddingtons lived in a large private hotel on Geary Street. They occupied a corner suite on the first floor. A little room was found for me at the top of the house. Until I looked out of its window I had not known there were so many chimney-pots in the world. I hung old Dick in the window and he began to sing at once, and then the strangeness of everything faded and my eyes were full of curiosity.

The San Francisco people swallowed Mrs. Piddington. She tasted nice to them because her tongue made glib use of titles and her voice was extra English. Americans did not notice the missing "aitches"; they liked the cut of her clothes. She was not at all proud of me and was careful to explain that I was no relation, just a Canadian girl put under her care come to San Francisco to study Art.

She hustled me down to the school as soon as possible. The San Francisco School of Art was up over the old Pine Street Public Market, a squalid district, mostly wholesale. From the dismal street you climbed a dirty stair. In a dark, stuffy office at the top sat a lean, long-bearded Curator tugging and tugging at his whiskers as if they operated his brain and he had to think a great deal. Mrs. Piddington did not consider him worth ogling. She told him I was Canadian, but as Canada had no Art Schools and England was too far there was nothing to be done but send me here. She intimated that personally she thought very little of America. However, being handy to Canada,—could I enroll?

The Curator pulled his beard and asked, "What d'you know, girl?"

"Nothing," I replied.

"Oh," said Mrs. Piddington, "she draws very prettily!"

I could have killed her when I saw her hold out a little roll of my drawings that she had got from my sister.

The Curator pushed them aside and said to me, not Mrs. Piddington, "You come along." There was nothing for her to do but go and for me to do but follow.

We passed through a big room hung with oriental rugs and dust. It was not part of the Art School. The Art School lay beyond, but this was the only way in. The School had been a great hall once. The centre was lit by a big skylight, there were high windows all down the north side. Under those windows the hall was cut into long alcoves by grey screens. One corner was boarded closed,—on the door was printed "Life Class, Keep Out". The whole place smelt of rats. Decaying vegetables lay on tables—still-life studies.

Long rows of students sat with lap-boards which had straddled hind legs that rested on the floor. Other students stood at easels drawing. In the centre of the room under a skylight were great plaster images on pedestals. More students were drawing from these images. I was given a lap-board in the first alcove, and a chunk of bread. A very dirty janitor was hacking up a huge crusty

loaf; all the students were scrambling for pieces. The floor was littered with old charcoal-blackened crusts. Charcoal scrapings were everywhere. There were men students as well as women. All wore smocks or very dirty painting pinafores. I went back to the office with the Curator to buy charcoal and paper, then I took my place in the long row. On one side of me was a fair, sharp-featured, sweet-faced girl with long, square-toed shoes like a pair of glove boxes. She wore a black dress and a small black apron of silk with a pocket from which she kept pulling a little lace-bordered handkerchief to flip the crumbs and charcoal from her lap. On the other side of me sat a dirty old man with a tobacco-stained beard. Art School was not exactly what I had expected but this was a beginning and I was eager to attack the big plaster foot they set before me to draw.

"My name is Adda," said the little girl in black with the flipping handkerchief. "What is yours?"

"Emily."

"I was new last week. I come from Los Angeles. Where is your home?"

"Canada!"

"Oh how terrible for you! I mean coming from a foreign country so far away! How long were you on the sea coming?"

"Three days."

"It took me less than one whole day. I'd die if I was farther than one day away from Momma and Poppa. I have a little sister too and a brother. I am dreadfully homesick. The School is very dirty, isn't it? Just wait till you see the next alcove and smell it, dead birds and fish, and rotting vegetables, still life you know. Shoo, shoo!" Her voice rose to a shrill squeal and the lace bordered handkerchief flipped furiously. A rat was boldly marching a crust to his hole under the pedestal of a near image. "Momma said I must be prepared to face things when I went out into the world, but Momma never dreamt there would be rats!"

Adda seemed much older than I but, after a while, I discovered that she was younger. She knew more about the world. Her mother had prepared her to meet any emergency, had told her how to elude evil and, if she could not dodge, then how to face it. Adda said, "Momma says San Francisco is very, very wicked!"

"That is what my guardian said too. It doesn't look bad to me, does it to you?"

"Momma would never say it was bad if it wasn't. She came all the way up from Los Angeles to find a safe home for me to live in. How did your mother manage to see you were safe fixed? You live so far away."

"My mother is dead."

"Oh!" Adda said no more but from that moment she took care of me, sharing with me Momma's warnings, advice, extracts from Momma's letters.

Reasons

Beyond the last alcove in the great hall was a little dressing room which contained a cracked mirror, a leaky wash-basin, a row of coat pegs, and a twisty little stair leading to an attic. I was searching for still-life material. Being quite new to the school I did not know its queer corners. One of the High Society students, Miss Hatter, was powdering her nose, trying to make the crack in the looking glass divide her face exactly so that she could balance the rouge and powder on both cheeks. She spat out a mouthful of swansdown puff to say, "Lots of junk for studies up there," and pointed to the attic.

That was the way in this old San Francisco School of Art, even a top-swell student was ready to help little new nobodies.

I climbed the stair and squeezed gingerly through a small door which the wind caught and banged behind me. The attic was low-roofed and dim. My sleeve brushed something that vibrated—a dry crackly rattle, some shadowy thing that moved. I put out my hand to feel for the door knob—the attic was nearly dark. I found myself clutching the rib of a skeleton whose eyesockets poured ghastly stares over me, vacant, dumbing stares. The dreadful thing grinned and dangled its arms and legs. The skeleton hung rotating from a hook on the low roof. It was angry with my sleeve for disturbing the stillness. I saw the white knob of the door-handle and, wrenching the door open, tumbled down the stairs screeching!

"Heavens, child, look what you've done to me!" Miss Hatter was dimmed by a blizzard of powder. "One would think you had seen a ghost up there!"

"Oh, worse—more dead—horrible!"

"Why, that's only old Bonesy. He lives up there! One of these days you will be drawing him, learning what is underneath human skin and fat."

"I couldn't sit up in that spooky attic being stared at by a skeleton!"

"Of course not, Bonesy will come down to you. He loves little holidays and if he can make people's teeth chatter so much the better. It is the only way he can converse with fellow bones. People are too cluttered with flesh for Bonesy to feel companionable with."

I saw that we were not alone in the dressing room. A pair of sad, listening eyes was peeping from behind the row of jackets on the rack. The eyes belonged to Nellie McCormick, a student. She came out when Miss Hatter left the room.

"Say, d'you believe in spooks? Up in the attic there is a table that raps. Let's Therese, Lal, you and me go up at lunch-time—ask the spooks things. Lal has only one arm, so it makes seven hands for the table. Spooks like the number seven."

"Couldn't a two-handed person put just one hand on the table?"

"Wouldn't be the same—got to be wholehearted with spooks or they won't work."

Bolting our lunches we hurried to the attic.

The rapping-table was close beside Bonesy. His stare enveloped us. Finger to finger, thumb to thumb, our hands spread themselves upon the table. We trembled a little in the tense silence—rats scuttled—an enormous spider lowered himself from the roof, swayed above the circle of hands, deciding which, dropped on Lal's one hand. Lal screamed. Nellie scowled, rats squeaked, the table tipped a little, tipped harder, rapped, moved sideways, moved forward, became violent! We moved with it, scuffling our feet over the uneven floor, pushing Bonesy crooked. All his joints rattled, his legs kicked, his hands slapped, his head was fast to the hook on the rafter but his body circled, circled. A city clock struck one. We waited until the cackle of voices in the dressing-room subsided. Then four nerve-flushed girls crept down the attic stairs.

Nellie McCormick's strangeness drew me as apparently I drew her. She had few friends; you found her crouched beside the pedestal of this or that great image, the Venus de Milo, the Dancing Faun, the Greek Slave. Nellie was always thinking—her eyes were such a clear blue there seemed only the merest film between her thoughts and you. Had she thought in words you could have read them.

We talked little when we were together, Nellie and I. One day turning to me sharply she asked, "Is your mother decent?"

"My mother is dead."

"Lucky for you. My mother is a beast!"

There were many different nationalities represented in the Art School. Every type of American; there were Jews, Chinese, Japs, poor and wealthy students, old and young students, society women, cripples, deformed, hunchbacked, squint-eyed. There was a deaf-mute girl with one arm, and there was a halfwit. Most of them had come to study seriously, a few came for refuge from some home misery. There was one English girl (Stevie), fresh from the Old Country, homesick. I was not English but I was nearer English than any of the others. I had English ways, English speech, from my English parents though I was born and bred Canadian.

Stevie took comfort in me. Every morning she brought a tiny posy of mignonette and white sweetpeas and laid it on my easel board. I smelled it the moment I rounded the screen. Its white sweetness seemed rather "in memoriam" to me. I felt as though I ought to be dead; but it was just Stevie's way of paying tribute to England's memory. She felt me British or, at least, I was not American.

Students never thought of having their overall work-aprons washed. We were a grubby looking lot. A few of the swell girls wore embroidered smocks. The very swellest wore no protection for their fine clothes, intimating that paint spots were of no moment, they had plenty more clothes at home.

A shy girl with a very red pigtail and a very strong squint came to the School. She was strange. Everyone said, "Someone ought to do something to make her feel better." Her shyness made us bashful. It was agreed that the first one who could catch her eye should speak but the shy girl's eyes were so busy looking at each other behind her nose that nobody could catch one. There was more hope of capturing one of her looks under the red pigtail than there was of catching one in her face.

A big circus parade came to San Francisco. We all climbed out of the attic window onto the flat roof to watch the procession. Poor "Squinty" slipped on a skylight and her leg, knitted into a red worsted stocking, plunged through the skylight to the market below, plunged right to the knee. Everyone held their breath while "Squinty" pulled her leg out with both hands. When we were sure the red worsted stocking was not blood, when we saw that "Squinty" herself laughed, everyone roared, thinking how funny it must have looked below in the market to see a scarlet leg dangling from the roof. Laughing broke "Squinty's" shyness; she brought her little parcel of lunch and joined us round the school stove after that. We always gathered about the Art School stove to eat our lunches.

Anne said, "Confound Jimmy Swinnerton!" and screwed her lunch paper hard and flung it into the stove. It flared and jammy trickles hissed out.

"Jimmy's frightfully clever, isn't he?" asked "Squinty".

"Clever? Baa! Look at our morning's work!" The floor of the big room was strewn with easels sprawled on their backs; smudged, smeared, paled, charcoal studies, face down or face up.

To roam in and out among the easels, a ball of twine unrolling as he went, was one of Jimmy's little "jokes"; its point was to go behind the screen and pull the string. With a clatter every easel fell. Every study was ruined, every student infuriated.

Mrs. Major, a stout, motherly student known as "The Drum" sighed, "Poor orphan, he's being ruined by the scandalous prices the newspapers pay for his cartoons, enough to send any lad to the devil, poor motherless lamb!"

"Mothers are just as likely to drive one to the devil as to pull them back," said Nellie McCormick, bitterly adding, "I come to Art School to get away from mine."

Adda's lips tightened to pale threads.

"I suppose half of us don't really come here to study Art," said Sophie Nye.

"What do they come for then?" snapped Adda.

"To have fun and escape housework."

"If my parents like to think they have produced a genius and stick me in Art School let 'em—passes the time between school and marriage."

The speaker was so unattractive one wondered how long the interval between school and marriage might be for her.

"In my family there is a tradition," said a colourless girl who produced studies as anaemic and flavourless as herself, "that once in every generation a painter is born into our tribe. Aunt Fan, our last genius, painted a picture and when it was hung in an exhibition she was so astonished she died! Someone had to carry on—rest of clan busy—I was thrown to art." She shrugged.

The little hunchback was crouched by the pedestal of the Venus de Milo. She rose to her full mean height, wound long spidery arms about the feet of Venus. "I adore beauty," she cried, "beauty means more to me than anything else in the world. I'm going to be a great artist!"

We all drew long sorry breaths. Poor little hunchback, never had she won any other "crit" from the drawing master than, "Turn, make a fresh start." Her work was hopeless.

Suddenly a crash of irrelevant chatter, kind, hiding chatter. A few had kept out of the discussed reasons for "our Art". There was a general move to pick up the Jimmy-spoiled studies, set easels on their legs. Adda and I alone were left sitting beside the stove.

"Adda, were you pushed into Art or did you come because you wanted to?"

"I wanted to, and you, Dummy?"

I nodded. I was always "Dummy" in the San Francisco Art School. I don't know who gave me the name or why, but "Dummy" I was from the day I joined to the day I left.

The Outdoor Sketch Class

Of all the classes and all the masters the outdoor sketching class and Mr. Latimer were my favourites.

Every Wednesday morning those students who wished met the master at the ferry boat. There were students who preferred to remain in the Art School and work rather than be exposed to insects, staring eyes, and sun freckles. We sketchers crossed the Bay to some quiet spot and I must say people *did* stare. Thirty or forty men and women of all ages and descriptions done up in smocks, pinafores and sunbonnets, sitting on campstools before easels down in cow pastures or in vacant lots drawing chicken houses, or trees, or a bit of fence and a bush, the little Professor hopping from student to student advising and encouraging.

Outdoor study was as different from studio study as eating is from drinking. Indoors we munched and chewed our subjects. Fingertips roamed objects, feeling for bumps and depressions. We tested textures, observed contours. Sketching outdoors was a fluid process, half looking, half dreaming, awaiting invitation from the spirit of the subject to "come, meet me halfway". Outdoor sketching was as much longing as labour. Atmosphere, space cannot be touched, bullied like the vegetables of still life or like the plaster casts. These space things asked to be felt not with fingertips but with one's whole self.

Nellie and the Lily Field

One sultry Public Holiday the Art School was empty but not shut. Having nothing particular to do I followed my heels and they took me the daily way. I climbed the dirty Art School stair and found the big, drab room solemn with emptiness. Even the rats were not squeaking and scuttling; there were no breadcrusts to be scrimmaged for. Half-drawn, half-erased studies on the drawing-boards looked particularly like nothing. Everything had stopped in the middle of going-to-be. The parched stare of a big red tommy-cod and a half dozen dried-to-a-curve, smelly smelts sprawled on one of the still-life tables. On another table was a vase of chrysanthemums prematurely dead, limp petals folded over their starved hearts. Even the doings of the plaster images seemed to have halted before completing their objectives. The Dancing Faun had stopped in the middle of his dance. The Greek Slave's serving was suspended, Venus was arrested at the peak of her beauty.

A moment's quiver of homesickness for Canada strangled the Art longing in me. To ease it I began to hum, humming turned into singing, singing into that special favourite of mine, *Consider the Lilies*. Whenever I let that song sing itself in me, it jumped me back to our wild lily field at home. I could see the lilies, smell, touch, love them. I could see the old meandering snake fence round the field's edge, the pine trees overtop, the red substantial cow, knee-deep and chewing among the lilies.

Still singing, I looked up—there over the top of my drawing-board were Nellie McCormick's clear blue eyes staring straight into mine. I knew that Nellie was seeing our lily field too. I knew the clearness of her eyes was visioning the reflection from my own. Perhaps she did not see the actual lilies—I do not know, but she was feeling their loveliness, their glow, their stillness.

I finished the song. Except for the scrape of my charcoal against the paper there was silence in the room.

"Sing it again."

Again I sang the lily song. Then a long quiet brooded over the big, empty room—only the charcoal's scrape and a sigh that was half sob from Nellie. "You rest me," she said, and was gone.

It was not me, it was the lilies that rested Nellie. I knew our wild lilies. They rested me too, often.

When no one was about Nellie would say to me, "Sing it," and Nellie and I together went into the lovely home lily field.

Difference Between Nude and Naked

Adda was of Puritan stock. I was Early Victorian. We were a couple of prim prudes by education. Neither her family nor mine had ever produced an artist or even known one—tales of artists' life in Paris were not among the type of literature that was read by our people. If they had ever heard of studying Art from the nude, I am sure they only connected it with loose life in wicked Paris, not with Art. The modesty of our families was so great it almost amounted to wearing a bathing suit when you took a bath in a dark room. Their idea of beauty was the clothes that draped you, not the live body underneath. So because of our upbringing Adda and I supposed our art should be draped. Neither of our families nor we ourselves dreamed that Art Schools in new clean countries like Canada and the United States would have any other kind. It was a shock to us to see that close walled corner in the school with the notice "Life Class—Keep Out". Mrs. Piddington nosed curiously and asked me questions; balked by the "keep out" notice on the Life Class door, satisfied that my ignorance and indifference were not put on, she gave up bothering.

One morning a student of the Life Class, a woman of mature years and of great ability, offered to give me a criticism. Everyone acknowledged that "a crit" from a life-class student was worthwhile. They did not know how to draw. The woman gave my work keen attention.

"You should now go into the Life Class, your work is ready," she said.

"I will never draw from the nude."

"Oh? Then you will never be a true artist, never acquire the subtlety in your work which only drawing from the nude teaches both hand and eye, tenderness of flowing line, spiritual quality, life gleaming through living flesh."

"Why should Art show best through live bareness? Aren't statues naked enough?"

"Child, you've got things wrong, surface vision is not Art. Beauty lies deep, deep; it has power to draw, to absorb, make you part of itself. It is so lovely it actually makes you ache all the time that it is raising you right up out of your-

self, to make you part of itself." Her eyes strayed across the room to the Venus, beautiful but cold standing there on her pedestal. "One misses warmth of blood, flutter or breath in that."

A girl model slipped through the outer door and darted behind the curtain that hung before the entrance to the Life Class. Priggishly stubborn, I persisted, "I shall go on studying from the cast. Look how the creature scuttles behind the curtain hiding herself while she turns the door knob."

The woman's voice softened. "Poor little shrinking thing ashamed of her lovely body, never trained to have a model's pride."

"Is there anything to learn in being a model? Could a model be proud of being a model?"

"Indeed, there is much to learn and professional models are very proud of their job; most of them too are deeply interested in Art. San Francisco is too new yet, there are not enough professional artists for nude models to earn a livelihood at posing. The school picks up any unfortunate who, at his wit's end to make an honest living, takes what he can get."

"Modelling an honest living!"

"Assuredly, that little girl supports her aged parents, hiding from everyone how she does it, burning with shame, in constant agony that someone will find out. A trained model would exult in her profession, be proud of her lovely body, of the poses she has taught it to hold by long hours of patient practice, proud that artists should rejoice in her beauty and reproduce it on their canvas, proud of the delight and tenderness that flow through the artist's hand as he directs the paint or the charcoal, proud that it was her lovely life that provoked his inspiration, made her come alive on the canvas, will keep her there even after her flesh-self has gone. Child, don't let false ideas cramp your Art. Statues are beautiful but they do not throb with life."

Her talk showed me the difference between the words nude and naked. So convinced was I of the rightness of nude and the wrongness of naked in Art that I said nothing to Adda. Momma was always hovering in Adda's background. Momma's eye was a microscope under which her every action was placed. Had it not been for Momma I could have made Adda understand. Momma never would. I did not discuss naked and nude with Adda.

Beany

Miss Beaner the little hunchback did not feel herself insignificant. She did not come up to any of our shoulders as she stood at her easel.

She always picked the biggest images to draw from, preferably Venus. There she stood, her square little chin thrust out, her large feet firmly planted, claw-fingers clutching her charcoal, long arms swinging, and such pitifully poor results! She stood so close under the great images she drew that they were violently foreshortened and became twice as difficult to draw. With her pathetic eyes rolled upwards devouringly and her misshapen body Beany looked fore-shortened herself as if a heavy weight had crushed her head down into her hips forcing what was between into a cruel humped ridge.

Beany's art efforts were entirely ineffectual. The drawing-master obviously disliked going near the deformed creature. Noted always for his terse criticism, all Beany ever got from him was, "Turn over and begin again." Beany turned and turned, her eyes filled with tears. She never got beyond beginnings.

As soon as the master left the room one or another student would go to Beany and say, "He gave everyone a rotten lesson today." That made Beany feel better. Then the student would find something encouraging to say about the poor lines and smudges on her paper and Beany's long spidery arms would flurry around the helper's neck, her head burrow into their waist-line. Beany hugged with a horrible tightness when grateful.

Coming from school one day I found a kitten trapped behind the heavy street door at the foot of the outer stair. It was ravenous for food and for pet-ting. It begged so hard to be hugged that I thought of Beany. Maybe the kitten would satisfy her hug-longing. I took it home that night and offered it to Beany next day. She was delighted. As it was a half-holiday, I said I would take it to her house that afternoon.

Beany lived in one of the older and shabbier parts of San Francisco. The front door of the house opened right into the parlour, a drab room full of vases filled with artificial flowers. There was, too, a stuffed canary under glass and some sea shells. The room was a sepulchre. The mantelpiece was draped with the stars and stripes. On the stone hearth (fireless because it was summer) sat a plate of fish cleaned and ready to cook. The kitten made a dart towards the fish. Beany raised them to the mantelpiece, remarking as she fanned her hot face with a small brass fire shovel, "Our parlour hearth is the coolest place in the house." She was delighted with her kitten and hugged and hugged, first the kitten, then me. Poor Beany, she had so little and could have done with so much. I felt furious all over again with the drawing master's cruel "crits", his not bothering to hide how he loathed her person and despised her work.

The Frenchman who taught us painting was different from the drawing-master. His crits' were severe, but his heart was soft—too soft almost. He championed any poor, weak thing. One day he found the little halfwit Jew-boy with his head down on a table of still-life stuff crying into the heap of carrots, onions and beets.

"What is it, Benny?" The master's hand on the boy's head covered it like a hat.

Benny lifted a wet, swollen cheek.

"Dis' mornin' I woked an' de' look-glass tell, 'You got de' toot'-ache, Benny.' Boys dey say, 'Why you so fat one side, Benny?' I say, 'De look-glass say I got toot'-ache.' Boys make tease of me!"

A group of grinning students were peeping from behind the screen.

"Make off there! None of that!" roared the professor.

After that he always kept an eye on Benny. That was the spirit of the old Art School. It seemed that here there was always a champion for the Beanys and the Bennys.

Evil

I was too busy at the Art School to pay much heed to Lyndhurst and Piddington affairs. Mrs. Piddington was watching me closely. Because she was English she called me "my dear" which did not in the least mean that I was dear to her nor she to me. I kept out of Frank's way. Mrs. Piddington had a good many friends (those people in the Lyndhurst hotel whom she thought worthwhile). Among them was a widow with two daughters about my own age. I had nothing in common with these girls.

Mrs. Piddington said, "Marie is having a birthday party. She is not asking you because she says she knows no friends of hers who would get on with you."

"Thank goodness she is not asking me. I hate her stuck-up companions."

"It is a pity you are not more friendly. You are very much alone."

"I have lots of friends, thank you, and I have my work."

"That Art School outfit!" sniffed Mrs. Piddington.

One day Mrs. Piddington said, "How did you get through the square today? I went out just after you and found it impossible because of the dense throng attending that large funeral in the Anglican church."

"I managed. I found a quiet, lovely little street, so quaint, not one soul in it. The house doors opened so quaintly right onto the pavement. All the windows had close green shutters, nearly every shutter had a lady peeping through. There was a red lantern hanging over each door. It was all romantic, like old songs and old books! I wonder if the ladies flutter little lace handkerchiefs and throw red roses to gentlemen playing mandolins under their windows at night?"

"Stop it! Little donkey!" shouted Mrs. Piddington. "Don't tell me you went through Grant Street?"

"Yes, that was the name."

"You went into Grant Street? Haven't you seen the headlines in the newspaper for the last week? Grant Street a scandal in the heart of San Francisco's shopping area!"

"I have not time to read the paper. Why is Grant Street a scandal?"

"It is a red light district."

"What is a red light district?"

"A place of prostitutes."

"What are prostitutes?"

Mrs. Piddington gave an impatient tongue click.

"If I ever hear of your going into Grant or any other such place again, home I send you packing! Straight to school, straight home again! Main thoroughfares, no short cuts, d'you hear?"

Frank came into the room. There was an evil grin on his face. He had heard her snapping tones, saw our red faces.

"In hot water, eh kid?"

I hurried from the room.

We had just come up from dinner. Mrs. Piddington was commenting on the family who sat opposite to us at table.

"The man seems very decent to that child."

"Why shouldn't he be decent to his own son?" I asked.

"The child is not his."

"Was the woman married twice? The child calls him father."

"No, she was not married twice, the boy is not the man's son."

"He *must* be!"

She noted my frown of puzzle.

Frank was out. "Sit there, little fool, your sister has no right to send you out into the world as green as a cabbage!" She drew a chair close to mine, facing me. "Now, it is time you learned that it takes more than a wedding ring to produce children. Listen!"

Half an hour later I crept up to my own room at the top of the house afraid of every shadowed corner, afraid of my own tread smugged into the carpet's soft pile. Horrors hid in corners, terrors were behind doors. I had thought the Lyndhurst provided safety as well as board and lodging. Boarding houses I had supposed were temporary homes in which one was all right. No matter if San Francisco was wicked, I thought the great heavy door of the Lyndhurst and my board money could shut it all out. Mrs. Piddington told me that evil lurked everywhere. She said even under the sidewalks in certain districts of San Francisco were dens that had trap doors that dropped girls into terrible places when they were just walking along the street. The girls were never heard of again. They were taken into what was called "white

slavery", hidden away in those dreadful underground dens, never found, never heard of.

Mrs. Piddington spared me nothing. Opium dens in Chinatown, drug addicts, kidnappings, murder, prostitution she poured into my burning, frightened ears, determined to terrify the greenness out of me.

I was glad when the carpet of the hallways and stairs came to an end, glad when I heard my own heels tap, tap on the bare top-stair treads and landing. I looked around my room fearfully before I closed and locked my door. Then I went over to the window. I wanted to see if San Francisco looked any different now that I knew what she was really like. No, she did not! My hand was on old Dick's cage as I looked over the chimneys and roofs. Old Dick nibbled at my finger. It gave me such a curious feeling of protection and reality.

"Dick, I don't believe it, not all. If it was as wicked as she said the black would come up the chimneys and smudge the sky; wicked ones can shut their doors and windows but not their chimneys. There is direct communication always between the inside of the houses and the sky. There is no smudge on the sky above the chimneys. San Francisco's sky is clear and high and blue. She even said, Dick, that she was not sure of that dirty old Art School of mine—it was in a squalid district and that I was never, never to go off the main thoroughfares. I was never to speak to anyone and I was never to answer if anyone spoke to me. All right, Dick, I'll do that but all the rest I am going to forget!"

The most close-up ugliness I saw during my stay in San Francisco was right in the Lyndhurst, in Mrs. Piddington's own private sitting room.

It was Christmas Eve. The Piddingtons had gone to the theatre and left me sitting there by their fire writing letters home. There was a big cake on the table beside me just come from home along with parcels that were not to be opened till Christmas morning.

A tap on the door. A friend of Frank Piddington's was there with a great bunch of roses to Christmas Mrs. Piddington.

"She is not in," I said.

"'Sno matter, I'll wait."

"They will be very late."

"Thas-all-right."

He pushed past me into the sitting room, steadying himself by laying his hands one on either of my shoulders. He was very unsteady. I thought he was going to fall.

"Don' feel s'good," he said, and flung himself into an arm chair and the roses onto the table.

I went to get water for the flowers and when I came back he was already heavily asleep. His flushed face had rolled over and was pillowed on my home cake.

I stood looking in dismay. He must be very ill. He had seemed hardly able to walk at all. He had gone to sleep with a lighted cigar between his fingers, its live end was almost touching the upholstery of the chair. I dare not take it from his hand, I dare not go to my room and leave it burning. The evening was early. I sat and watched and watched. The cigar smouldered to its very end. The ash did not fall but kept its shape. Would the cigar burn him when it reached his skin and wake him? No, just before it reached the end it went out.

Creak, slam! creak, slam! went the heavy old door of the Lyndhurst, surely it must have swallowed all its inmates by now; but the Piddingtons did not come. I could not go now because Mrs. Piddington enjoyed fainting at shocks. If she came in after midnight and saw a man asleep in her sitting-room she was sure to faint. Half after midnight I heard her hand on the door-knob and sprang!

"Don't be frightened, he's asleep and very ill!"

"Who's asleep? Who's ill?"

"Mr. Piddington's friend."

Mrs. Piddington circled the sleeping man sniffing.

"Frank, take that drunk home!"

Frank burst into guffaws of coarse laughter.

"Our innocent!—entertaining drunks after midnight on Christmas Eve! Ha, ha!"

The Roarats

Mrs. Piddington twiddled the envelope. Her eyes upon my face warned me. "Don't forget I am your boss!"

"You are to call on the Roarats at once," she said, and shook my sister's letter in my face.

"I don't intend to call upon the Roarats, I hate them."

"Your hating is neither here nor there. They were old friends of your parents in the days of the California gold rush. Your sister insists."

"And if I won't go?"

"In place of your monthly check you will receive a boat ticket for home. You have the Roarats' address? Very well, next Saturday afternoon, then."

Mrs. Piddington approved the Roarats' address.

"Um, moneyed district."

"They are disgustingly rich, miserably horrible!"

The following perfectly good Saturday afternoon I wasted on the Roarats. The household consisted of Mr., Mrs., Aunt Rodgers, a slatternly Irish servant and an ill-tempered parrot called Laura.

Mr. Roarat was an evil old man with a hateful leer, a bad temper, and cancer of the tongue. Mrs. Roarat was diminutive in every way but she had thickened up and coarsened from long association with Mr. Roarat. She loathed him but stuck to him with a syrupy stick because of his money. Aunt Rodgers had the shapeless up-and-downness of a sere cob of corn, old and still in its sheath of wrinkled yellow, parched right through and extremely disagreeable. Ellen the Irish maid had a violent temper and a fearful tongue. No other family than one specializing in bad temper would have put up with her. The parrot was spiteful and bit to the bone. Her eyes contracted and dilated as she reeled off great oaths taught her by Mr. Roarat. Then with a slithering movement she sidled along her perch, calling, "Honey, honey" in the hypocritical softness of Mrs. Roarat's voice.

The Roarats said they were glad to see me. It was not me they welcomed, anything was a diversion. When I left I was disgusted to discover that I had committed myself to further visits and had, besides, accepted an invitation to eat Thanksgiving dinner at their house.

The turkey was overcooked for Mr. Roarat's taste, the cranberry too tart for Mrs. Roarat's. Aunt Rodgers found everything wrong. Ellen's temper and that of the parrot were at their worst.

Laura, the parrot, had a special dinner-table perch. She sat beside Mr. Roarat and ate disgustingly. If the parrot's plate was not changed with the others she flapped, screamed and hurled it on the floor. Throughout the meal everyone snarled disagreeable comments. Aunt Rodgers' acidity furred one's teeth. The old man swore, and Mrs. Roarat syruped and called us all "Honey".

"Pop goes the weasel!" yelled Laura, squawking, flapping and sending her plate spinning across the floor.

"There, there, Laura, honey!" soothed Mrs. Roarat and rang for Ellen who came in heavy-footed and scowling with brush and dustpan. When she stooped to gather up the food and broken plate Laura bit her ear. Ellen smacked back, there was a few moments' pandemonium, Mr. R., Aunt R., Ellen and Laura all cursing in quartette. Then Mrs. Roarat lifted Laura, perch and all, and we followed into the parlour. For my entertainment a great basket of snapshots was produced. The snaps were all of Mrs. Roarat's relatives.

"Why do they always pose doing silly things?" I asked.

"You see, Honey, this household being what it is, my folks naturally want to cheer me."

Aunt Rodgers gave a snort, Mr. Roarat a malevolent belch. The parrot in a sweet, tender voice (Mrs. Roarat's syrupiest) sang, "Glory be to God on high!"

"Yes, Laura, honey," quavered Mrs. Roarat, and to her husband, "Time you and Laura were in bed."

Mr. Roarat would not budge, he sat glowering and belching. Aunt Rodgers put the parrot in her cage and covered it with a cloth but Laura snatched the cloth off and shrieked fearfully. Aunt Rodgers beat the cage with a volume of poems by Frances Ridley Havergal. It broke a wire of the cage and the book did not silence the bird who screamed and tore till her cover was in shreds.

Mrs. Roarat came back to her relatives in the snapshot basket for comfort.

"Here is a really funny one," she said, selecting a snap of a bearded man in a baby's bonnet kissing a doll.

Mr. Roarat was now sagging with sleep and permitted his wife and Aunt Rodgers to boost one on either side till they got him upstairs. It took a long time. During one of their halts Ellen came from the back in a terrible feathered hat.

"Goin' out," she announced and flung the front door wide. In rushed a great slice of thick fog. Mrs. Roarat looked back and called to me, "It's dense out, Honey, you will have to stay the night." I drew back the window curtain; fog thick as cotton wool pressed against the window.

The Roarats had a spare room. Mr. and Mrs. Piddington would get home very late and would suppose I was up in my bed. Mrs. Roarat's "honey" and Aunt Rodgers' vinegar had so neutralized me that I did not care what I did if I could only get away from that basket of snapshots.

The door of the spare room yawned black. We passed it and out rushed new paint smells. "Redecorating," said Mrs. Roarat. "You will sleep with Aunt Rodgers!"

"Oh!"

"It's all right, Honey, Aunt Rodgers won't mind much."

Aunt Rodgers' room had no air space, it was all furniture. She rushed ahead to turn on the light.

"Look out!" she just saved me a plunge into a large bath tub of water set in the middle of the floor.

"Fleas—San Francisco's sand this time of year! Each night I shake everything over water, especially if I have been out on the street."

Immediately she began to take off and to flutter every garment over the tub. When she was down to her "next-the-skins", I hurried a gasping, "Please, what do I sleep in?"

Too late, the "skin-nexts" had dropped!

Aunt Rodgers said, "Of course child!" and quite unembarrassed but holding a stocking in front of her she crossed the room and took the hottest gown I ever slept in out of a drawer. I jumped it over my head intending to stay under it till Aunt Rodgers was all shaken and reclothed. I stewed like a teapot under its cosy. At last I *had* to poke my head out of the neck to breathe; then I dived my face down into the counterpane to say my prayers.

After a long time the bed creaked so I got up. On Aunt Rodgers' pillow was a pink shininess, on the bed post hung a cluster of brown frizz, there was a lipless grin drowning in a glass of water. Without spectacles Aunt Rodgers' eyes looked like half-cooked gooseberries. Her two cheeks sank down into her throat like a couple of heavy muffins. A Laura's claw reached for the light pull. I kept as far to my own side of the bed as possible.

Dark—Aunt Rodgers' sleeping out loud! It had never occurred to me that I *could* ever be homesick for my tiny room on top of the old Lyndhurst but I was.

Gladness

I n Geary Street Square, close to the Lyndhurst, was a Church of England with so high a ritual that our Evangelical Bishop would have called it Popish.

On Easter morning I went into the Geary Street Square. The church-bell was calling and I entered the church and sat down in a middle pew. The congregation poured in. Soon the body of the church was a solid pack of new Easter hats. From the roof the congregation must have looked like an enormous bouquet spread upon the floor of the church. But the decoration of the ladies' heads was nothing compared to the decoration of the church, for her flowers were real, banks of Arum and St. Joseph's lilies, flowers of every colour, smell and texture. Every corner of the church was piled with blossoms, such as we would have had to coax in greenhouses in Canada; but here, in California, there was no cold to frighten flowers, nothing had to be persuaded to grow. Stained-glass windows dyed some of the white flowers vivid. White flowers in shadowy corners glowed whiter because of the shine of lighted candles. Incense and flower-perfume mixed and strayed up to the roof. Hush melted and tendered everything. The hush and holiness were so strong that they made you terribly happy. You wanted to cry or sing or something.

Suddenly high up under the roof, where incense and the fragrance of flowers had met, sounded a loveliness that caught your breath. For a moment you thought a bird had stolen into the church, then you found there were words as well as sound.

"Jesus Christ is risen today, Hallelujah!"

Quickly following the words, a violin exquisitely wailed the same thought, and, bursting hurriedly as if they could hardly wait for the voice and the violin to finish, the booming organ and the choir shouted, "Hallelujah! Hallelujah!"

It was a tremendous gladness to be shut up in a building; it was the gladness of all outdoors.

Either the church or I was trembling. The person on either side of me quivered too, even the artificial hat-flowers shook.

A clergyman climbed up into the pulpit and lifted arms puffy in Bishop's sleeves.

The church hushed to even greater stillness, a stillness like that of the live flowers which, like us, seemed to be waiting for the Bishop's words.

Colour-Sense

I had advanced from the drawing of casts and was now painting "still life" under the ogling eye of the French Professor. I was afraid of him, not of his harsh criticisms but of his ogle-eyes, jet black pupils rolling in huge whites, like shoe buttons touring round soup-plates.

He said to me, "You have good colour-sense. Let me see your eyes, their colour."

The way he ogled down into my eyes made me squirm; nor did it seem to me necessary that he should require to look so often into my "colour-sense".

He was powerful and enormous, one dare not refuse. His criticism most often was, "Scrape, re-paint".

Three times that morning he had stood behind my easel and roared, "Scrape!" When he came the fourth time and said it again, my face went red.

"I have, and I have, and I have!" I shouted.

"Then scrape again!"

I dashed my palette knife down the canvas and wiped the grey ooze on my paint rag.

In great gobbing paint splashes I hurled the study of tawny ragged chrysanthemums onto the canvas again. Why must he stand at my elbow watching—grinning?

The moment he was gone I slammed shut my paint-box, gathered up my dirty brushes, rushed from the room.

"Finished?" asked my neighbour.

"Finished with scraping for that old beast." She saw my angry tears.

The Professor came back and found my place empty.

"Where is the little Canadian?"

"Gone home mad!"

"Poor youngster, too bad, too bad! But look there!" He pointed to my study—"Capital! Spirit! Colour! It has to be tormented out of the girl, though. Make her mad, and she can paint."

The hard-faced woman student, the one who ordered birds for her still-life studies to be smothered so that blood should not soil their plumage, the student we called "Wooden-heart", spoke from her easel in the corner.

"Professor, you are very hard on that young Canadian girl!"

"Hard?" The Professor shrugged, spread his palms. "Art—the girl has 'makings'. It takes red-hot fury to dig 'em up. If I'm harsh it's for her own good. More often than not worthwhile things hurt. Art's worthwhile."

Again he shrugged.

Sisters Coming—Sisters Going

Having once gone to my guardian for advice, I continued to do so. The ice was broken—I wrote him acknowledging my check each month and telling him my little news, dull nothings, but he troubled to comment on them. He was a busy man to be bothered writing the formal little interested notes in answer to my letters. I respected my guardian very much and had a suspicion that my going to him direct for advice had pleased him. He was Scotch, wise, handled our money with great care but had no comprehension of Art whatsoever. The camera satisfied him. He sent my board and school fees. I don't suppose it ever occurred to him I needed clothes and painting material. I had to scrape along as best I could in these matters.

My guardian thought very highly of my big sister. I have no doubt that his consenting to let me go to San Francisco was as much for her peace as for my art education. I was not given to good works and religious exercises like the rest of my family. I was not biddable or orthodox. I did not stick to old ways because the family had always done this or that. My guardian thought it was good for me to go away, be tamed and taught to appreciate my home. Art was as good an excuse as any.

Undoubtedly things did run smoother at home without me but, after I had been away one year, the family decided to follow me. My sister rented the old home and the three of them came to San Francisco for a year. My big sister still had a deep infatuation for Mrs. Piddington. It was really Mrs. Piddington that she wanted to see, not me.

Mrs. Piddington took a flat and we boarded with her but domestic arrangements did not run too smoothly. My sister liked bossing better than boarding, and, in a final clash, dashed off home leaving my other two sisters to follow. Almost simultaneously Frank Piddington got a better job in another city and they too left San Francisco. Then I was all alone among San Francisco's

wickedness. Mrs. Piddington handed me over to a friend of a friend of a friend, without investigating the suitability or comfort of my new quarters. The woman I was donated to was an artist. She lived in Oakland. I had to commute. I plunged wholeheartedly into my studies.

The year that my family spent in San Francisco my work had practically been at a standstill. I did attend the Art School but joined in all the family doings, excursions, picnics, explorings. No one took my work seriously. I began to get careless about myself.

Mrs. Tucket, the friend of the friend was a widow with two children, no income and a fancy for art. She resented that she could not give her whole time to it, was envious that I should be able to. The living arrangements of her cottage were most uncomfortable. Still, I enjoyed my independence and worked very hard. Perhaps after all the "ogle-eyed" French professor and my big sister were right, maybe I needed the whip, needed goading and discomfort to get the best out of me. Easy, soft living might have induced laziness. The harder I worked the happier I was, and I made progress.

We were a happy bunch of students. I do not remember that we discussed Art much; as yet we had not accumulated knowledge enough to discuss. We just worked steadily, earnestly, laying our foundations. San Francisco did not have much to offer in the way of art study other than the school itself, no galleries, no picture exhibitions. Art was just beginning out west. The school was new. Students came here to make a start. Their goal was always to press further afield. San Francisco did not see the finish, only the beginning of their art.

Last Chance

During my sisters' visit I said to Alice, "Can it be possible that the entire wicked awfulness of the world is stuffed into San Francisco?"
"Why do you think that?"
"Mrs. Piddington said. . . ." But I did not tell Alice what Mrs. Piddington said. She was a contented person, did not nose round into odd corners. This and that did not interest Alice, only the things right in the beaten path. The things she had always been accustomed to—those she clung to.

Before leaving Victoria various friends had asked of her, "Look up my cousin, look up my aunt." Alice good naturedly always said, "Certainly," and accepted a long list of miscellaneous look-ups. People could just as well have sent a letter to ask how their friends did, or if they liked the New World. They all seemed to have come from the Old. When I said so, Alice replied that I was selfish and that people liked hearing from the mouth of an eye-witness how

their relatives are. Alice was rather shy and made me go along though I was not amiable about these visits.

First we went to see the cousin of a friend. She was eighty and had an epileptic son of sixty. He had stopped development at the age of seven or eight; mind and body were dwarfed. He had an immense head, a nondescript body, foolish little-boy legs that dangled from the chair edge as he sat in the parlour opposite to us, nursing his straw hat as if he were the visitor.

His mother said, "Shake hands with the ladies, Jumble." (Jumble was the name he had given himself and it was very appropriate.)

Jumble leapt from his chair as if he were leaping from a house-top, skipped to the far side of the room and laid his hat down on the floor. He came running back and held out two wide short-fingered paws. We each took one and he gave us each a separate little hop which was supposed to be a bow.

"The ladies come from Canada, Jumble."

He clapped his hands. "I like Canada. She sends pretty stamps on her letter; Jumble has a stamp book! Jumble likes stamps, he likes plum cake too! Jumble wants his tea, quick! quick!" He pattered in to the adjoining room where tea was laid, climbed into his chair and began to beat on his plate with a spoon.

"He is all I have," sighed the woman and motioned us to follow, whispering, "I hope, my dears, you are not nervous? Jumble may have a fit during tea."

We had never seen anything but a cat in a fit but we lied and said we were not nervous.

Jumble consumed vast wedges of plum cake but he did not have a fit.

After tea they saw us to our tram—eight-year hobble and trot, trot of a halfwit, escorting us. Once aboard, I groaned, "Who next?"

Alice produced her list.

"Mable's Aunt; now don't be mean, Millie. People naturally want to hear from an eye-witness."

"Pleasanter for them than seeing for themselves."

Mable's Aunt was gaunt. She lived in a drab district. She kissed us before ever we got the chance to say why we had come, but, when we said we came from Mable she fell on us again and kissed and kissed. She had never seen Mable but she had known Mable's mother years before Mable was born. Every time we mentioned Mable's name she jumped up and kissed us again. Needless to say she was English. In time we learned to avoid mention of Mable. That restricted conversation to the weather and Mable's Aunt's cat, a fine tabby. While we were grappling for fresh talk material, the Aunt said:

"Oh my dears, such a drive! Such lovely, lovely flowers!"

"Where? When?" We were eager at the turn the conversation had taken,— flowers seemed a safe pleasant topic.

"My son took me this morning. It is a long way. There were marvellous carpets of flowers, every colour, every kind. Oh my dears, such flowers!"

"My son is a doctor, visiting doctor for the 'Last Chance'. He takes me with him for the drive. Flowers all the way! I don't mind waiting while he is inside. I look at the flowers."

"What is the 'Last Chance'?" I asked.

"Terrible, terrible, oh my dears! Thank God that you are normal, usual." She sprang to kiss us again because we were complete, ordinary girls.

Again I asked, "What is the 'Last Chance'?"

"A place behind bars where they put monstrosities, abnormalities while doctors decide if anything can be done for them." She began describing cases. "Of course I've only seen a little through the bars."

The little she had seen was enough to send Alice and me greenish white. We tried to lead her back to the flowers. It was no use, we took our leave.

We walked along in silence for some time. "Let's forget it," I said. "All the people on your list seem to have some queerness, be the same type. Suppose we lose the list!"

Alice said, "For shame, Millie. People at home want to hear about their relatives. It is selfish of you to grouse over their peculiarities!"

"Relatives' peculiarities would do just as well in letters and only cost three cents. I'd willingly pay the stamp. They are not even relatives of our own friends. For them we might endure but for these nearly strangers why should we?"

Again Alice's, "For shame, selfish girl!"

It happened that Mrs. Piddington had arranged a flower-picking picnic for the very next Saturday. Someone had told her of a marvellous place. You walked through Golden Gate Park and then on and on. There were fields and fields of flowers, all wild and to be had for the picking.

At last we got there only to be confronted by a great strong gate on which hung a notice "Keep Out"! The flowers were beautiful all right. Just outside the gate was a powerhouse and a reservoir. We asked permission at the office and were told we might go through the gate and gather.

"What is the big building just inside the enclosure?" asked Mrs. Piddington but just then the man was summoned back into the office.

"Last Chance," he called over his shoulder. Alice and I looked at each other. We felt sick. "Know-it-all" old Piddington explained. "Windows all barred! Um, doubtless it is a reformatory of some sort."

We scuttled under the barred windows, Alice and I trying to draw our party over toward a little hill away from the building. The hill was lightly wooded and a sunny little path ran through the wood. Flowers were everywhere—also snakes! They lay in the path sunning themselves and slowly wriggled out of

our way quivering the grass at the path side. You had to watch your feet for fear of treading on one. Alice and I could not help throwing scared glances behind at the brick, bar-windowed building. Shadowy forms moved on the other side of the bars. We clothed them in Mable's Aunt's describings.

There were not many big trees in the wood. It was all low scrub bush. You could see over the top of it. I was leading on the path. I had been giving one of my backward, fearful glances at "Last Chance" and turned front suddenly. I was at the brink of a great hole several yards around. My foot hung over the hole. With a fearful scream I backed onto the rest of the party. They scolded and were furious with me.

"Look for yourselves, then!"

They did and screamed as hard as I.

The hole was several feet deep. It was filled with a slithering moil of snakes, coiling and uncoiling. Had my lifted foot taken one more step, I should have plunged headlong among the snakes and I should have gone mad! Mrs. Piddington was too horrified even to faint. She yelled out, "I've been told there are 'rattlers' this side of the park too!" Turning aside, we broke into mad running, helter skelter through the thicket heading for the open. Snakes writhed over and under the scrub to get out of our way. The flowers of our gathering were thrown far and wide. Horrible, horrible! Our nerves prickled and we sobbed with hurrying. We passed the "Last Chance" with scarcely one glance and rushed through the gate, coming back empty-handed. We did not even see the flowers along the way, our minds were too full of snakes.

"Girls," I cried, "I want to go back to Canada. California can have her flowers, her sunshine and her snakes. I don't like San Francisco. I want to go home."

But when my sisters did go back to Victoria I was not with them. I was stuck to the Art School.

Mrs. Tucket

The woman who was supposed to have assumed Mrs. Piddington's custody of me bodily and morally ignored everything connected with me except the board money I paid. I was her income. I had to be made to stretch over herself, her two children and myself. The capacity of my check was so severely taxed by all our wants that towards the end of the month it wore gossamer and ceased altogether. Then we lived for the last few days of each month on scraps fried on my spirit lamp to economize kitchen fuel.

The woman's children (a girl of six and a boy of four) any Mother might have been proud of, but she referred to them as "my encumbrances" because

they prevented her from devoting her entire time to Art. Mrs. Tucket was jealous of my youngness, jealous of my freedom. An Art dealer had once praised a sketch done by her and from that time she knew no peace from the longing which possessed her to give her life, all of it, to Art.

The boy Kirkby, aged four, and I were great chums. He was at my heels every moment I was in the house—a loving little fellow who had two deep terrors—blood and music. The sight of blood would turn the child dead white, one note of music would send him running outdoors away anywhere from the sound, his hands to his ears. He angrily resented my guitar; pushing it out of my lap he would climb in himself and, reaching his hand to my forehead, would say, "I feel a story in there, tell it." It was a surprise to his Mother and to me, after a few months, instead of pushing away the guitar he would sidle up, pat the instrument, and say, "I like her a little now, sing!"

Mrs. Tucket had health notions, all based on economy. Uninterrupted passage of air through the cottage was one. She said it nourished as much as food. All the inner doors of the house were removed, there was no privacy whatever. No hangings were at the windows, no cushions on chairs or couch. The beds were hard and had coverings inadequate for such cyclonic surges of wind as swept in and out of the rooms. No comfort was in that cottage.

Mrs. Tucket had, too, absolute faith in a greasy pack of fortune-telling cards. She foretold every event (after it had happened). *After* Kirkby had cut his head open she knew he was going to be cut. *After* Anna got the measles she knew the child had been exposed. When I missed the ferry-boat she said the cards had foretold it (but so had the clock). After the dealer had praised her sketch she vowed that she had been prepared because the cards indicated someone would. She was angry because I laughed and would not have my cards read. I got so sick of being haunted by the ace of spades and the queen of hearts that I suggested we read a book aloud after the children were in bed at night. Mrs. Tucket read well but chose depressing books, delighting in deathbed scenes and broken love affairs. She would lay the book down on the table and sob into her handkerchief. It embarrassed me so much that I said, "S'pose we find a good merry funeral story to cheer us up!" Then she was offended and said I was without romance or sentiment.

One day as I came in from school Mrs. Tucket beckoned to me from the doorway of her bedroom. The wind was busy in there, tearing the covers off the bed, whirling the pincushion and clanking the window blind.

"Listen!" In the middle of the turmoil a cruel, tearing breathing.

"Kirkby's!"

I bent over the bed. The child did not know me.

"Get a doctor quick!"

"But doctors are so expensive," she complained.

"Quick." I stamped my foot.

She got a homeopathist, not that she believed in homeopathy but this doctor-woman was a friend of hers and would not charge. We moved a cot into the unfurnished front of the cottage and took turn and turn about sitting on an apple box beside it watching.

Little Kirkby battled with death in this grim setting. The crisis came one night just as I had turned in for my four hours of rest.

"Come!"

The cottage was full of moonlight. She had switched out all the lights so that Kirkby should not see the blood. There was hemorrhage. We worked in and out between shadows and moonlight, doing what we could. The exhausted child dropped back on the pillow like a wilted snowdrop. The woman yawned.

"I'll take forty winks now, your bed I think, handier should you need me."

As she passed through the living room she switched on a light and stood, wrapped in admiration of the sketch the dealer had praised. It was framed and hung on the wall. I heard a deep, deep sigh, then blackness, the sounds of sleep. Moonlight flooded the bare room. The life of the child flickered. Kirkby in the bed was scarcely more tangible than the moonlight. I sat the night out on the apple box. "Art I hate you, I hate you! You steal from babies!" I cried and would not go to school next morning. I did not go back for a whole week. I told stories and sang to Kirkby feeling very tender towards the child and bitter towards Art and the woman.

Summer vacation came. I did not like summer vacation. I was compelled to spend it at Auntie's in San Jose. Auntie undertook to discipline me for two years each vacation, the year that was past and the year to come. Between Aunt and me there was no love.

Mrs. Tucket was giving up the cottage. She was joining a friend in Chicago. They were to run a boarding house. She was full of plans. Kirkby and I watched her packing, Kirkby, a mere shadow child, clinging to his chair to keep the wind from blowing him away. Mrs. Tucket held up his little patched pants. The wind filled them; their empty legs were vigorous with kickings. Kirkby laughed.

"My pants are fatter than me."

The woman pressed the wind out of the pants and tumbled them into the trunk.

"I am not going to Chicago!"

She banged down the trunk lid.

"What has happened?" I asked. "All your arrangements are made."

"The cards say I shall not go!"

When I returned from San Jose the cottage was for rent. I never heard of Mrs. Tucket, her Art or little Kirkby again.

Telegraph Hill

E xit Mrs. Piddington, and vice and terror faded from my consciousness. Free, unfearful I roamed San Francisco interested in everything, most particularly interested in my art studies. Suddenly I was brought face to face with Piddington horrors again.

I was taking guitar lessons from an old German professor. The frets on my guitar needed resetting, the professor said.

"Take to de' musics-man he sharge you big moneys. My fren' dat make fiddle he do sheep for you!"

He wrote an address on a card and off I started, my guitar in a green cloth bag. I called in at Adda's on the way. It was Saturday afternoon. We often spent the half holiday together.

"Where are you going?"

"To get my guitar fixed."

"I'll come for the walk."

"Hurry then, Adda, it dusks early."

On and on we tramped. It seemed a very long way but we asked direction now and again from people we met. Yes, we were going in the right direction but—they looked at us queerly as if they wondered.

By and by the smells of the sea and tarry wharf smells met our noses. Ah, here was the name on our card. We turned into a wide, quiet street. It had an abandoned, strange look. In front of us was a great building with a sign, "Telegraph Hill Foundry and Storage". Telegraph Hill! "Why, Adda, this is the awful, wicked place Captain pointed out as we came through the Golden Gate, the place I was never to go near."

"It does look very queer," said Adda. "Shall we turn back?"

"No, this is number 213. Ours will be two blocks further on. It is best to show our business but it is almost too dark to see the numbers over the doors."

We walked the two blocks in silence except that I said, "Adda, let's walk in the middle of the street."

Suddenly a burst of light from street lamps and simultaneously over every door came a little red twinkling light. There were big shop windows dazzlingly bright on either side of the way. In them were displayed, not goods but women, scantily clad women, swaying in rocking chairs and showing a great deal of leg. Some toyed with fancy work, some simpered, some stared with blank, unseeing eyes, all rocked restlessly.

"Momma, Momma!" gasped Adda again. "Shall we turn back?" she asked of me.

My head shook. I shook all over because of Mrs. Piddington's horrible tales.

"Here's the great mock fiddle. I'll go in and show why I came. Oh, Adda!"

I was quaking. "Hold the door wide, Adda, don't let them shut me in! Don't, don't!"

Adda braced, spread her members like a starfish, clinging octopus-wise to the floor and to all sides of the door's frame.

The little shop was full of men and smoke. There was only one dim light in the place. An old man pushed forward to take the green bag from my arms. He rook the guitar out, touched her strings lovingly.

"She is sweet-toned," he smiled down at me, "but these frets, ach, they tear the little fingers! She is ready Monday."

He laid the instrument upon his work shelf.

Adda released the door posts and grabbed me as if I had just come back from the dead. Momma herself could not have been more protecting towards me, more belligerent towards my danger than was dear, staunch Adda.

We hurried into the middle of the street with firm stepping, determined not to break into a tell-tale run. We nearly burst ourselves for wanting to draw deep breaths and not daring to do so for hurry and worry. We turned the corner and met a policeman. I never knew a policeman could look so beautiful, so safe.

"Momma, Momma, if you knew!" whispered Adda, to me, "Of course you won't go back for the guitar, Dummy?"

"I must, Adda. It belongs to my big sister. You see if I went home without it I would have to explain—and then . . . !"

"I'll go with you, but I won't tell Momma till afterwards. Of course I couldn't deceive Momma. I must tell sometime, but after will be best."

The Mansion

One morning I climbed the old grubby stair of the Art School to find everything in excitement and confusion. Clumps of students congested the Oriental Rug Room, groups of students were in the hall, the office was full. The old Curator was tugging at his beard harder than ever, shaking his head, nodding answers or ignoring questions as excitement permitted.

Supposing it to be some American anniversary, I strode through the hubbub into the work hall. Here I found professors, model and janitor in close confabulation around the stove. Obviously some common interest had levelled rank and profession. The only unmoved person I could see was the wooden-faced, stone-hearted painter of still life, the woman who ordered her birds smothered so that their plumage should not be soiled by blood for her studies, the woman who painted tables full of fish with eyes that ogled even

when dead and whose stiffened bodies curled and smelled in spite of the fact that she kept trying to revive one last glitter by slopping water over them periodically. On a still-life table stood a forsaken vase of red roses, sagging, prematurely dead, no water. Stevie dashed in to stick her daily posy of mignonette and sweet peas on my easel board—dashed out again. What! Stevie too? Then this was no American do, this excitement. Stevie would not be so unpatriotic as to recognize an American occasion! In bustled Adda tying the strings of her little black silk apron.

"Aren't you excited, Dummy?"

"Excited? What about?"

"The move, of course!"

"What move?"

"Dummy, you *are* dumb! The School move, of course."

"Is the School moving?"

"This very day. Look!" She pointed out the window, where men were tearing down our chimneys, ripping at our roof.

"Time this dilapidated dreadfulness disappeared," scorned Adda. "A mansion! A perfectly clean mansion fallen from the sky! Oh, won't Momma be pleased!"

"Adda, do tell me what it is all about!"

"Well, our lease was up and the market and Art School building is condemned. Haven't you seen how the poor old Curator has torn at his beard the last week? I wonder he did not pull it out! No place for his School to go! Then this mansion falls straight from heaven! Mrs. Hopkins could not take it with her, could she? So she dropped it from heaven's gate. Down it tumbled stuffed with her best wishes for Science and Art!"

Adda's sharp little teeth bit on her lip.

"Oh, Momma, I'm so sorry, you would not, I know, like me to mix heaven and Art. But Dummy, no more smells, no more rats! Lovely, lovely!"

I frowned.

"I'm sorry. I love this old place and don't want to move."

"Oh, Dummy, imagine anybody loving this old School."

Adda's lace-bordered hanky swished, a rat scuttled.

I said, "It is the underneath of it that I love."

"Underneath! that disgusting market!"

"Not exactly, though the market with its honest old roots and chickens and cheese is all right, it is comfortable, commonsense. But I was not thinking of the marker, Adda. It is the space and freedom we have here in this old School. We can splash and experiment all we like. Nobody grumbles at us. Our work is not hampered by bullying. 'Don't, don't.' We sharpen charcoal, toss bread crusts. Nobody calls us pigs even if they think we are. Art students are a little

like pigs, aren't they, Adda? They'd far rather root in earth and mud than eat the daintiest chef-made swill out of china bowls."

Adda shuddered.

"Dummy, you are . . . ! What would Momma say? Momma never eats pork, not even bacon, and she can't bear the mention of a pig!"

The mantels, banisters and newel posts of the mansion were all elaborately carved. There were all sorts of cunningly devised secret places in the mansion, places in which to hide money or jewels. (Mrs. Hopkins could not have had much faith in banks.) In the dining room you pressed a certain wooden grape in a carved bunch over the mantel and out sprang a little drawer. In the library you squeezed the eye of a carved lion and out shot a cabinet. A towel rack in the bathroom pulled right out and behind it was an iron safe. There were panels that slid and disclosed little rooms between walls. We delighted in going round squeezing and poking to see what would happen next. All the treasure places were empty. Mrs. Hopkins had cleared them all out before she willed the mansion.

The public roamed from room to room and stared; of course they did not know about all the strange corners that we knew. Occasionally "a public" would stray up our stairs and gaze at us as if we had been part of their fifty cents' worth. They need not have thought us so extraordinary for in the mansion we were quite ordinary, quite normal. If it had been the old school, well . . . but no sightseers had ever thought of climbing those dirty stairs. Art students were just part of the squalor that surrounded the market. Nobody was interested in them! But now that we were stupid and elegant and an institution people wanted to see how we looked.

Back to Canada

San Francisco boarding houses were always changing hands. Sometimes I stayed by the change, sometimes I moved.

All boarding houses seemed to specialize in derelict grandmothers and childless widows, nosey old ladies with nothing to do but sleep, eat, dress up, go out, come back to eat again. Being lonely and bored they swooped upon anything that they thought ought to be mothered. They concentrated on me. I was soon very overmothered. They had only been out in the New World a generation or two. My English upbringing reminded them of their own childhood. They liked my soap-shiny, unpowdered nose, liked my using the names Father and Mother instead of Momma and Poppa. Not for one moment would they exchange their smart, quick-in-the-uptake granddaughters for me but

they did take grim satisfaction out of my dowdy, old-fashioned clothes and my shyness. Their young people were so sophisticated, so independent. They tried lending me little bits of finery, a bow or a bit of jewellery to smarten me, should I be invited out, which was not often. One old lady of sixty wanted me to wear a "pansy flat" (her best hat) when someone took me to see *Robin Hood*. It hurt them that I refused their finery, preferring to wear my own clothes which I felt were more suitable to age and comfort even though they were not smart. I had a birthday coming and three of them got together and made me a new dress. The result disheartened them—they had to admit that somehow I looked best, and was most me, in my own things.

The landlady's daughter and I were friends. We decided we would teach ourselves to sew and make our own clothes. We bought Butterick's patterns, spread them on the floor of the top landing where our little rooms were, and in which there was not much more than space to turn round.

One day I was cutting out on the hall floor. The landlady's daughter was basting. Spitting out six pins she said, "Seen Mother's new boarder?" and pointed to the door of a suite up on our floor.

I replied, "No, what flavour is she?"

"Loud! The old house tabbies are furious at Ma for taking her but we have to live, there is so much competition now."

"The house is big. Those who wish to be exclusive can keep out of each other's way."

"The new girl has her own sitting room—double suite if you please! I don't think I like her much and you won't but she's going to your Art School so you will see her quite a bit."

"If she is such a swell she won't bother about me."

Next morning I slammed the front door and ran down the steps. I had no sooner reached the pavement than the door re-opened and Ishbel Dane, the new boarder, came out.

"Can I come along? I rather hate beginning."

She had large bold eyes, a strong mouth. You would not have suspected her of being shy, but she was. She was very smartly dressed, fur coat, jewellery, fancy shoes. I took her into the school office and left her signing up. I went on up to the studios.

"Who?" I was asked and nudged by students.

"New boarder at my place."

Adda frowned, she had never approved of my boarding house—too big, too mixed. Adda was an only boarder and only sure about places that were "Momma-approved". Suddenly she had a thought. Diving into her pocket she brought out a letter.

"Momma is coming!" she said. "Brother is taking a course at Berkeley University; Momma and sister are coming along; I will join them. We shall rent a house in Berkeley. I've given notice. Why not take my room? Shall I ask them to save it for you?"

"No, thanks, I am very well where I am."

Adda said no more. She watched Ishbel but refused to meet her.

In the evenings I practised on my guitar. There was a tap on my door and there was almost pleading in Ishbel Dane's voice as she said, "Come to my sitting room and have a cup of tea with me?"

I went wondering. We had not got to know each other very well. We were in different studios at School. My "grandmother guardians" in the boarding house advised of Ishbel Dane, "Not your sort my dear." Having found they could not direct my clothes they were extra dictatorial over my morals. I resented it a little, though I knew they meant well. They were very cool to Ishbel, confined conversation to the weather. All they had against the girl was her elegant clothes—she overdressed for their taste.

Ishbel had made her sitting room very attractive—flowers, books, cushions, a quaint silver tea service which she told me had been her mother's. She saw my eyes stray to a beautiful banjo lying on the sofa.

"Yes, I play. I belong to a banjo, mandolin and guitar club. Wouldn't you like to join? It helps one. I have learnt ever so much since I practised with others."

I said slowly, "I'll think." I knew the old grandmothers, the landlady's daughter and Adda would disapprove. When I left, Ishbel took my hand.

"Come again," she said. "It's lonely. My mother died when I was only a baby; Father brought me up. Father's friends are all men, old and dull. A few of them have looked me up for Father's sake. Father is in the South."

I joined the practice club. My friendship with Ishbel warmed while the old ladies' affection chilled towards me. Adda was actively distressed. She moved to Berkeley. Her last shot as she started for her new home was, "My old room is still vacant."

Trouble was in her eyes, anxiety for me, but I liked Ishbel and I knew Ishbel and I knew my friendship meant a lot to her.

I had to go to the music studio for some music. The Club leader was giving a lesson. He shut his pupil into the studio with her tinkling mandolin, followed me out onto the landing. As I took the roll of music from him he caught me round the wrists.

"Little girl," he said, "be good to Ishbel, you are her only woman friend and she loves you. God bless you!" His door banged.

I a woman's friend! Suddenly I felt grown up. Mysteriously Ishbel—a woman—had been put into my care. Ishbel was my trust. I went down stairs

slowly, each tread seemed to stretch me, as if my head had remained on the landing while my feet and legs elongated me. On reaching the pavement I was grown up, a woman with a trust. I did not quite know how or why Ishbel needed me. I only knew she did and was proud.

While I was out a letter had come. I opened it. My guardian thought I had "played at Art" long enough. I was to come home and start Life in earnest.

Ishbel clung to me. "Funny little mother-girl," she said, kissing me. "I am going to miss you!"

A man's head was just appearing over the banister rail. She poked something under my arm, pushed me gently towards my own room. A great lump was in my throat. Ishbel was the only one of them all who hadn't wanted to change some part of me—the only one who had. Under my arm she had pushed a portrait of herself.

I came home one week before Christmas. The house was decorated, there was some snow, fires crackled in every grate of every room, their warmth drew spicy delight from the boughs of pine and cedar decorating everywhere. There were bunches of scarlet berries and holly. The pantry bulged with good things already cooked. In the yard was something for me, something I had wanted all my life, a dog!

They were glad to have me home. We were very merry. All day the postman was bringing cards and letters; flitter, flitter, they dropped through the slit near the front door and we all darted crying, "Whose? whose?"

I got my full share but there were two disappointments—no letter from Nellie McCormick, none from Ishbel Dane. New Year passed before I heard of either.

Adda wrote, "Nellie McCormick could endure home tyranny no longer, she shot herself."

From the boarding house one of the grandmothers absolutely sniffed in writing, "Ishbel Dane died in the 'Good Samaritan' hospital on Christmas Eve. Under the circumstances, my dear, perhaps it was best."

Nellie my friend! Ishbel my trust!

I carried my crying into the snowy woods. The weather was bitter, my tears were too.

Part II

Home Again

The type of work which I brought home from San Francisco was humdrum and unemotional—objects honestly portrayed, nothing more. As yet I had not considered what was underneath surfaces, nor had I considered the inside of myself. I was like a child printing alphabet letters. I had not begun to make words with the letters.

No one was teaching drawing in Victoria: mothers asked me to start a children's class. I did not want to teach. I was afraid of pupils, but I did teach and soon I got fond of the children and liked the work. I taught my class in our dining room. The light was bad; the room got messed up; there was trouble after every class.

We had two large barns: one housed our cow, the other our horse. Clambering over the cow, I explored her loft. Low roof, only one tiny window, no door other than a small trap-door over the cow's head and a great double door that opened into space and had a gibbet over the top for the hauling up of bales of hay. The boards of the floor and walls were knotholed, the wood buckled, the roof leaked. But it was a large loft, high in the middle, low at the side walls.

My eldest sister was tyrannical, an autocrat like Father. She claimed every inch of the old home, though really it belonged to us all. Independence had taught me courage.

"Can I have the loft of the old cow barn for a studio?"

"Certainly not. It's the cow's."

"Couldn't the cow share with the horse?"

"Have you come home to unsettle the family and worry the cow?"

My sister knew the cow's barn was very much out of repair. When I offered to mend it she reluctantly consented to my using the loft. I called in a carpenter.

"It's the floor," I said.

"No, the roof," my sister corrected.

"It's the walls!" declared the carpenter with a determined tongue-click and a head-shake.

I said, "As long as everything relates in being bad, let's patch all over and let it go at that. But, carpenter, there *must* be an outside stair up to the big door and another window for light."

So the carpenter let in a wide dormer, hung a little stair onto the outer wall, patched leaks, straightened boards and we were snug. But it was still too dark for work and all my money was spent. The old garden Chinaman and I mounted the roof with saws and cut a great hole. This we fitted with two old

window sashes, making a skylight. Now we had lots of light and lots of leak too. I put a tin gutter all round the skylight and drained the leaks into a flower box, shoved a stovepipe into the wash-house chimney which ran through the loft, blocked up pigeon holes, burlapped walls. There we were cosy as anything, with little more than an eggshell's thickness of wood full of splits, knotholes and cracks and perched right out in the middle of the elements— rain drumming, wind whistling, sun warming, and everybody happy—pupils, me, even the cow and chickens below.

Under my loft the barn contained a wash-house, an apple-storing room, a tool shed, three cow stalls, a chicken house and an immense wood-shed, big enough to accommodate twelve cords of wood (half oak, half fir, for the household's winter burning).

"Please, the cow smells like a cow, may she move to the other barn?" I asked my sister.

"She may not."

I did not really mind sharing with the cow—I was really not keen on her smell but she cosied things.

When I worked at night under a big coal-oil lamp suspended from the rafter under an immense reflector, made by myself out of split coal-oil cans, it was nice to hear the cow's contented chew, chew, chew below. I loved to stick my head through the trap-door above her stall into the warm dark and say, "Hello, old cow." She answered with great hay-fragrant sniff-puffs that filled the barn. Any sudden noise sent the hens on their roosts below hiccoughing in their sleep. On moonlight nights the rooster crowed. Rats and mice saw no reason to change their way of living because we had come—after I brought home a half-drowned kitten from the beach it was different. A peacock came down from Beacon Hill Park and made his daytime quarters on the studio roof, strutting before the doubled-back dormer, using it as a mirror. Most splendid of all was my very own big dog. No studio has ever been so dear to me as that old loft, smelling of hay and apples, new sawed wood. Monday washings, earthy garden tools.—The cow's great sighs! Such delicious content!

In dusk's half-light the dog and I left the studio and raced over Beacon Hill and the beach. Specially permitted friends held trysts in the studio with their sweethearts, sitting on the model throne looking down into the pure delight of a blossoming cherry tree below, or toasting their toes, along with the cat, in front of the open-fronted stove.

I was rebellious about religion. In our home it was forced upon you in large, furious helps. The miserableness of continually sprawling across doubled-over ladies, with their noses on the seats of our chairs, and their praying knees

down on our carpets, annoyed me. You never knew in which room nor at what hour.

The Y.W.C.A. was just beginning in Victoria; my sisters were among its founders, and enthusiastic over the concern. As the society had, as yet, no headquarters, they used to come to our house to pray. I was always bursting in on them. The knocked-over-ones glowered, and, over their horizontal backs, my sister's eyes shot fire at me. She hung on to her prayer voice till afterwards—and then—!

Then too there was the missionary blight. My second sister wanted to be a Missionary and filled our house with long-faced samples. Missionaries roosted on us during migration, others hopped in to meals while waiting for boats. Missionary steamers had no particular dates or hours of sailing, because they went to outlandish places and waited for cargoes. There was the Sunday School blight too. That was very bad. All there was left of home on Sunday afternoon was the wood pile or you could go off to the lily field. Every room in the house accommodated a Sunday School class. My sister wanted me to conduct one for small boys in the kitchen and called me stubborn and ungodly because I refused.

Artists from the Old World said our West was crude, unpaintable. Its bigness angered, its vastness and wild spaces terrified them. Browsing cows, hooves well sunk in the grass (hooves were hard to draw!), placid streams with an artistic wriggle meandering through pastoral landscape—that was the Old World idea of a picture. Should they feel violent, the artists made blood-red sunsets, disciplined by a smear of haze. They would as soon have thought of making pictures of their own insides as of the depths of our forests.

I was tremendously awed when a real French artist with an English artist-wife came to Victoria. I expected to see something wonderful, but they painted a few faraway mountains floating in something hazy that was not Canadian air, a Chinaman's shack on which they put a curved roof like an Eastern temple, then they banged down the lids of their paintboxes, packed up, went back to the Old World. Canada had no scenery, they said. They said also that the only places you could learn to paint in were London or Paris. I was disappointed at hearing that, but immediately began to save. I slung an old pair of shoes across the studio rafters. When pupils paid me I shoved the money away in my shoes.

"I am going abroad to study!" I told my astonished family.

A Missionary took a liking to me. She had a very long face but a good heart. She was negotiating for my sister to accompany her back to her lonely mission up the West Coast of Vancouver Island, so that she might try out the loneliness and Indians. When the Missionary saw how interested I was in her

description of these wild places, she said to me, "Wouldn't you like to come to Ucluelet to sketch in the summer holidays?"

"I would like to frightfully," I replied.

The Willapa was a small coast steamer. I was the only woman on board, indeed the only passenger. We nosed into dark little coves to dump goods at canneries. We stood off rocky bluffs, hooting until a tiny speck would separate itself from the dark of the shoreline. It grew and presently sprouted legs that crawled it across the water. The black nob in its middle was a man. We threw him a rope and he held on, his eyes chewing the parcel in the purser's hands, his face alight.

"Money?" shouted the purser. The man's face unlit. He made a pretence of searching through his ragged clothes and shook his head. The purser threw the parcel back on our deck and tossed a letter into the man's boat. The man ripped the envelope, tore out his remittance and waved it, the parcel thudded into the boat! We tooted and were away. The tiny boat got smaller and smaller, a mere speck on the grey spread of water. Then it was gone. Vastness had swallowed boat and man.

Life in the Mission House was stark, almost awesome, but you could not awe our Missionary, she had no nerves. She was of cement hardened into a mould. She was not inhuman, there was earth underneath. It was just her crust that was hard and smooth. The slow, heavy Indians had not decided whether or not to accept religion. They accepted missionary "magic" in the shape of castor oil and Epsom salts. But religion? They were pondering. The Missionaries were obliged to restrain their physic-giving. If you gave an Indian a bottle of medicine he drank it all down at once and died or not according to his constitution. He had to be given only one dose at a time. But the Missionaries expected to give the Indians the whole of religion at one go. The Indians held back. If physic was given in prolonged doses, why not religion?

"Toxis", as the Indians called the Mission House, squatted back to forest face to sea just above the frill of foam that said, "No further," to the sea and, "So far," to the land. The Indian village was a mile distant on one side of the Mission House, the cannery store a mile on the other. At high tide we went to them by canoe, at low tide we walked in and out among the drift logs lying stranded on the beach.

No part of living was normal. We lived on fish and fresh air. We sat on things not meant for sitting on, ate out of vessels not meant to hold food, slept on hardness that bruised us; but the lovely, wild vastness did something to it all. I loved every bit of it—no boundaries, no beginning, no end, one continual shove of growing—edge of land meeting edge of water, with just a ribbon

of sand between. Sometimes the ribbon was smooth, sometimes fussed with foam. Trouble was only on the edges; both sea and forests in their depths were calm and still. Virgin soil, clean sea, pure air, vastness by day, still deeper vastness in dark when beginnings and endings joined.

Our recreation in the Mission House was the pasting together of broken prayer- and hymn-books. It seemed the churches sent all their cripples to missions.

After the Missionaries blew out their candles and the ceiling blackened down to our noses, the square of window which the candle had made black against outside dark cleared to luminous greys, folding away mystery upon mystery. Out there tree boles pillared the forest's roof, and streaked the unfathomable forest like gigantic rain streaks pouring; the surge of growth from the forest's floor boiled up to meet it. I peered at it through the uncurtained window while the Missionaries prayed.

To attempt to paint the Western forests did not occur to me. Hadn't those Paris artists said it was unpaintable? No artist that I knew, no Art School had taught Art this size. I would have to go to London or to Paris to learn to paint. Still those French painters who had been taught there said, "Western Canada is unpaintable!" How bothersome! I nibbled at silhouetted edges. I drew boats and houses, things made out of tangible stuff. Unknowingly I was storing, storing, all unconscious, my working ideas against the time when I should be ready to use this material.

Love and Poetry

Immediately upon my return from the West Coast Mission, I tasted two experiences for the first time—love, and poetry. Poetry was pure joy, love more than half pain. I gave my love where it was not wanted; almost simultaneously an immense love was offered to me which I could neither accept nor return. Between hurting and being hurt life went crooked. I worked and taught for all I was worth. When my teaching for the day was over, with a book of poetry under my arm and with my dog, I went to the Beach or roamed the broom bushes on Beacon Hill. From the underscored passages in my poets, poetry did not touch love as deeply as it touched nature and beauty for me. Marked passages are all earth and nature.

Up to this time my painting had followed the ordinary Art School curriculum—drawing from the antique, still-life painting, portraiture, design and landscape. Now it took a definite list toward pure landscape.

When, dangling from the studio rafters, the old pair of hoarding shoes were crammed with money from my teaching, I announced, "I am going to London."

"You have friends or relatives there?" asked an old lady friend.

"I have neither, but for my work I must go."

"London is big, much noise, many people; you will miss your pine trees and your beaches, child."

"London will be beastly; all the same, I'm going."

"My sister, Amelia Green, accepts a few paying guests."

"What are paying guests—boarders?"

"My dear! Ladies of good family in England do not take boarders. If circumstances compel them to accept remunerative visitors, they call them paying guests," said the shocked old lady.

"PG's? Then all right, I'll become of your sister's PG's."

It was arranged that Aunt Amelia, wearing something green in her buttonhole, should meet me at Euston Station.

Nearly everyone in Victoria gave me a life-size portrait photograph of himself or sometimes of the entire family grouped. I was supposed to cart them along as a preventative for homesickness. I locked them into my stow-away cupboard at home. But more friends brought more photographs to the boatside. On entering my stateroom I was greeted by cardboard stares, male and female, propped against the tooth mug, the waterbottle, the camp stool; a family group rested on my pillow. The nicest family of all slid out the porthole. Undulating on a great green wave it smiled back at me. I gathered the rest into my cabin trunk, I could not be comfortably seasick with them looking on. I was provided also with a bale of introductory letters asking people to be kind. If England could not be kind for my own sake I did not want charity niceness from my friends' friends!

Canada's vastness took my breath. The up-and-downness of the Rockies, their tops dangled in clouds, thrilled and were part of natural me, though I had to steel myself as we glided over trestle-bridges of great height spanning gorges and ravines with rivers like white ribbons boiling far below, and lofty trees looking crouched and squat down there in the bottom of the canyon while we slid over their tops. We squeezed through rocky passes, hid in tunnels, raced roaring rivers, slunk through endless levels of dead, still forest, black-green and mysterious, layer upon layer of marching trees, climbing trees, trees burned, trees fallen, myriad millions of trees and loneliness intertwisted. Our engine gulped endless miles, each rail-length one bite. On, on, till the mountains ended and the train slithered over level land munching space rhythmically as a chewing cow. Was there never to be an end? Did our engine

spin track as she advanced like a monster spider? Would we finally topple over the brink into that great bonfire of a sunset when we came to the finish of this tremendous vastness?—No rocks, no trees, no bumps, just once in a great, great way a tiny house, a big barn, cattle in that great space sizing no bigger than flies—prairie houses, cows, barns, drowned in loneliness.

When at last we came to Canada's eastern frontier, just before she touched the Atlantic ocean, she burst into a spread of great cities, clean, new cities. The greedy, gobbling train turned back to regobble Canada's space, while we launched into sea-bounce that grieved the stomach, wearied the eye.— Nothingness, nothingness, till your seeing longed and longed—whale, bird, anything rather than nothing piled on top of nothing!

The Voyage and Aunt Amelia

The woman in the deck chair next to mine stroked a strand of red hair from her forehead with a freckled hand.

"Oh, my head!"

"Have my smelling bottle."

She took three long sniffs and then pointed the bottle across the deck.

"Awful woman!" indicating a loud, lounging woman in noisy conversation with the Captain.

"Discussing whisky! Irish against Scotch! Glad she prefers Irish, I should feel her preference to Scotch a desecration of my country."

Captain crossed the deck. He looked enquiringly from one to the other of us.

"Miss Carr?"

"Yes, Captain."

"This lady wants to meet you, her maiden name was Carr."

The Captain indicated the loud woman with whom he had been discussing whisky. The Captain's lady flopped noisily into the chair the smelling bottle and the Scotch lady had hastily vacated.

"Any London relatives?" she asked sharply.

"None."

"What are you by birth?"

"Canadian."

She beckoned the Captain back to her side. Irish versus Scotch was again discussed—they forgot me.

Suddenly I felt awful. The former Miss Carr made a swift move. I felt the cold scratchy hardness of an immense sunburst which Mrs. Downey (the former

Miss Carr) wore upon her breast, then I was in my berth, and my cabin was full of people but most full of Mrs. Downey. Sometimes I was there, sometimes not; finally I sailed out into blankness entirely.

In those times c.p.r. boats took ten days to cross the Atlantic. We were almost across before I woke. First I thought it was me crying, then I opened my eyes and saw it was Stewardess.

"Are you hurt?" She patted me and mopped herself. "How could your mother send you this great way alone?"

"Mother's dead. I am older than I look."

The Captain, doctor, Stewardess and Mrs. Downey had been in conference. A girl belonging to no one and for the moment not even to herself had to be landed. It was a problem. Stewardess had volunteered to take me home with her for the week that she was in port and nurse me, but now I had waked up.

They carried me to the upper deck for air. We were lying in the Mersey, not landing our passengers till morning. The air revived me. Doctor said I might take the special boat train in the morning providing there was anyone going my way who would keep an eye on me. There was not, until Mrs. Downey made it her business and changed her route. She sent stewards scuttling with wires. Miss Green was to meet me at Euston. Just because a girl had her maiden name, Mrs. Downey made it her business to see I was delivered safe and sound into competent hands.

The ship's little Irish Doctor saw us comfortably tucked into our train. I heard Mrs. Downey say, "Then come on up, I'll give you a time."

The Doctor waved his cap.

I could not lie back resting, as Mrs. Downey wanted me to. We were skimming across the Old World—a new world to me—entirely different, pretty, small. Every time I looked at Mrs. Downey she was looking at me. Suddenly she said, "You're not a-goin' to that Amelia person. You're a-comin' to me."

"I'm promised to Miss Green, Mrs. Downey."

"She's no relative—bust the promise; I'll fix'er! 'Twon't cost you nothin' livin' with me. You c'n go to your school, but nights and Sundays you'll companion my little daughter."

"Have you a daughter?"

"Same age as you—'flicted, but we'll 'ave good times, you an' me and my girl. That doctor chap is stuck on you. 'E tole me so. I was lookin' for company for my Jenny. . . . Only jest 'appened . . . 'er 'fliction. . . ." She choked . . . snuffled.

As we pulled into Euston's sordid outskirts of grime and factories the station's canopied congestion threw a shadow of horror over me.

"That white-pinched little woman has green in her button hole, Mrs. Downey."

"She's no gittin' you."

Her fingers gripped my arm as in a vice.

"Miss Green?"

The two women stared at each other belligerently.

"She's comin' to me—been sick—not fit to be among strangers, she isn't. I'm 'er friend."

"I'm promised, Mrs. Downey. My people expect it."

The wiry claw of the lesser woman wrenched me away so that I almost fell. I was clutched fiercely back to the scratchy sunburst, then released with a loud, smacking kiss.

"Any 'ow, come an' see my little girl . . . she needs . . .," the woman choked and handing me a card turned away.

"Frightful person! The entire platform must have heard that vulgar kiss," gasped Miss Green.

"I was very ill on board; she was kind to me, Miss Green."

"You must never see her again, one cannot be too careful in London."

She glanced at the address on the card in my hand. "Brixton! Impossible!"

"I shall have to go just once to thank her, and to return her umbrella. She gave it to me to carry while she took my heavier things."

"You can post the umbrella. I *forbid* you to associate with vulgar people while living in my house."

"I am going once."

Our eyes met. It was well to start as I meant to continue. I was only Miss Green's PG. My way, my life were my own: it was well she should understand from the start.

Aunt Amelia's PG House

L ondon was unbearable. August was exceptionally hot. Aunt Amelia lived in West Kensington—one of those houses in a straight row all alike and smeared with smug gentility. I felt the shackles of propriety pinch me before the door was shut.

The six PG's without one direct look amongst them disdainfully "took me in" at lunch. "Colonial!" I felt was their chilly, sniffy verdict. I hated them right away. Their hard, smooth voices cut like ice skates, "dearing" each other while they did not really like each other one bit. The moneyed snob who had

the big front room swayed the establishment; next came the opulent Miss Oopsey, a portrait photographer who only "portrayed" titles. The PG's dwindled in importance till at the tail came Miss Green's niece, a nobody who was the snootiest of the lot and earned her keep by doing unnecessary things that were good form around the PG house.

London stewed, incorporating the hot murk into her bricks all day and spitting it out at you at night. The streets were unbearable. Everyone who could get out of London had got and were not missed. I used to wonder where any more population could have squeezed. Certainly if there were many more people in London they would have to ration air for the sake of fairness.

"Miss Green, is there any place one can go to breathe?"

"There are London's lovely parks."

"Just as crammed—just as hot as everywhere else!"

Miss Green clicked, "Dear me! You Canadians demand a world apiece. I have offered to take you to Hyde Park, show you our titled people riding and driving, but no, you Canadians have no veneration for titles—jealously, I presume."

"I'll admit I do prefer cool air to hot celebrities, Miss Green. Now, about a breathing place?"

"Kew—if it is roots and bushes you want, go to Kew Gardens."

To Kew I went.

The great gates of Kew Gardens were plastered with many notices—"Nobody is allowed in these gardens unless respectably attired."—"No person may carry a bag, parcel, or basket into the gardens; all such impedimenta to be checked at the porter's lodge."—"No one may carry food into the gardens; tea may be procured in the tea-houses."—"You must not walk upon the grass, or run or sing or shout."

Striding past the lodge, clutching my bag, I walked down the main way and, turning into a woodsey path, began to sing. First hint of Autumn was in the air, there were little piles of dead leaves and fallen twigs burning, shreds of blue smoke wandered among the trees deliciously.

Kew was a bouquet culled from the entire world. I found South America, and Asia, Africa, China, Australia—then I found Canada (even to a grove of pines and cedars from my own Province). I rubbed their greenery between my hands— it smelled homey. I stabbed my nose on our prickly blue-pine. I sat down on the grass beneath a great red cedar tree. From close by came the long-drawn cry of a peacock. Suddenly I was back in the old barn studio! I threw up my chin and gave the answering screech which my peacock had taught me—my beauty on the old barn roof. I waited for an ejecting keeper, but my teacher had taught well, no keeper came. I went back to stuffy West Kensington refreshed, happy.

Again Miss Green in company with that swell who snobbed it over her PG's offered to conduct me to see the Hyde Park Parade. The "swell" boarders, Miss Green told me, always sat on penny chairs.—"Much more refined than to sit on a free bench, my dear," drawled Miss Green.

"I'd rather go to the Zoo," I replied and went.

Resignation if not content was in the eye of the captive creatures. Having once acquired a taste for the admiration and companionship of man animals like it. Here and there you saw a rebellious or morose newcomer furiously pacing, but most of the creatures were merry and all were well tended. All here looked more satisfied with life than the weary "great" looked in Hyde Park. I loved Kew.

St. Paul's

W estminster School of Art did not open until September. When I was a little rested, a little steadier, I climbed the curving little iron stairways at the backs of omnibuses and, seated above the people, rode and rode, watching the writhe of humanity below me. I had never seen human beings massed like this, bumping, jostling, yet as indifferent to each other as trees in a forest.

I puzzled, wondering. What *was* the sameness with a difference between a crowd and a forest? Density, immensity, intensity, that was it—overwhelming vastness. One was roaring, the other still, but each made you feel that you were nothing, just plain nothing at all.

History always had bored me. *Little Arthur's History of England* in its smug red cover—ugh, the memory of it! And now here before me was the smugness of it ossified, monumented, spotted with dates thick as an attack of measles. The English had heads twisted round onto their backs like drowsy ducks afloat, their eyes on what they had passed, not on what they were coming to.

Dickens had taught me far more about England than had *Little Arthur*. Dickens' people still walked the streets, lived in the houses of old London. Little Arthur's Great were shut up in dull books, battered monuments.

Deep in the City I happened one day upon Paternoster Row, a dark narrow little way lined with book shops. All the Bibles, prayer-books, hymnals in the world began life here. I saw them sprawled open at the fly-page. All the religious books that I remembered had had Paternoster Row printed inside them.

I did not, as Miss Green's other PG's did, attend some fashionable church in the West End. Sunday was the day on which I crept into London's empty

heart. Everyone had gone from it, all business houses were closed. The lonely old churches were open but empty; all the light was pinched out of them by the grim huddle of business establishments. The old churches still had their bells, still rang them. Empty London threw back their clamour in echo. Often an entire congregation consisted of me, sitting under a very indifferent preacher, ushered in and out by a very pompous verger in a black robe almost as cleric as the clergy. My coin looked pitiful in the pompous collection-plate. Echo made the squeaky old parson's whisper hit back at you from every corner of the bare church.

London's national religion was conducted either in St. Paul's Cathedral, the heart of London's heart, or in Westminster Abbey in the West End. All immense events were solemnized in one or the other of these churches.

The business houses and shops of St. Paul's Churchyard fell back from the cathedral allowing it breathing space and sunshine. The steps up to her great doors were very, very wide. Beginning from each side of the steps was a circle of space encompassing the cathedral. It was lightly railed but the gates were flung wide, flowers and shrubs and benches were about and always there were people, sitting on the benches, eating things out of paper bags, feeding the pigeons and resting.

St. Paul's is the kernel of London as London is the kernel of England.

Westminster Abbey is beautiful too but rather historical and it was made a little cheap by sightseers who whispered and creaked. It had not the unity of St. Paul's; there were chapels here and chapels there—all sorts of pokes and juts, tablets, monuments and statues, "great ones" bouncing from niches and banners flapping. St. Paul's was domed under one immense central round. High, pale light flooded down; roll of organ, voice of chorister, prayer trembled upward.

Always there were people in St. Paul's standing, sitting, praying, or doing nothing, not even thinking, wanting only to be let alone.

At five o'clock each afternoon the great organ played, flooding the cathedral with music. The prayer-soaked walls came alive. Great, small, rich and shabby Londoners crept into St. Paul's to find sanctuary.

Sightseers climbed hundreds of steps to look down from a high gallery running round the inside of the dome. It was considered a thing to do, one of London's sights. I did not want to "sight-see" St. Paul's. The people moving up there in the high gallery were black spots in the mystery. I remained among the solid, silent company on the paved floor of the cathedral.

Letters of Introduction

Turmoil, crowding, too many people, too little air, was hateful to me. I ached with homesickness for my West though I shook myself, called myself fool. Hadn't I strained every nerve to get here? Why whimper?

Aunt Amelia's mock-genteel PG's galled me at every turn—high-bridged noses, hard, loud, clear voices, veneering the cold, selfish indifference they felt for each other with that mawkish, excessive "dearing". My turbulent nature was restive to be at work; it made me irritable and intolerant. Miss Green suggested the British Museum as a sedative.

To the British Museum I went and loathed it—the world mummified. . . . No matter which turn I took I arrived back in the mummy-room, disgusting human dust swaddled in rags, dust that should have been allowed centuries back to build itself renewingly into the earth. The great mummy halls stank of disinfectants. Visitors whispered and crept. . . . Place of over-preservation, all the solemnity choked out of death, making curiosity out of it, prying, exposing, indecent.

Miss Green said, "The British Museum is marvellous, is it not, my dear?"

"It's disgusting!—Good decent corpses for me, Miss Green, worms wriggling in and out, hurrying the disagreeables back to dust, renewing good mother earth."

Aunt Amelia screeched, "My dear, you are revolting!"

Recoiling from mummies I turned to parsons. Our clergyman at home had given me two introductory letters to brother clergy—his own particular brand—in London's suburbs. One had a fancy name, the other was Rev. John Brown who lived at and parished in Balham. Balham was two hours out of London by train. In the same suburb I had been commissioned by a Victoria widow to call on her well-to-do sister-in-law. The widow's husband had just suicided and left his family in difficult financial circumstances. I was to furnish the well-to-do "in-law" with the distressing particulars and hint at the straitened circumstances facing the widow.

The sister-in-law received me in a hideous drawing-room. She rustled with silk from the skin out, and served tea, very strong, together with plum cake as black and rich as bog-earth. She said, "To suicide was very poor taste, especially if you had not first made comfortable provision for your family."

Then at my request she directed me to the residence of the Rev. John Brown.

I meandered through paved suburban streets that called themselves "groves", and along "terraces" sunk below ground level, and "crescents" that were as straight as knitting needles.

A slatternly maid, very frilly as to cap and apron, said, "Wite 'ere," and took my letter into a room where tea cups clattered. After a pause the Reverend came out holding my opened letter. He snapped his reading glasses into their case and adjusted a dangling pince-nez to his nose and looked me over from hat to shoes.

"What is it you want me to do for you, young woman?"

I felt myself go scarlet.

"Nothing! Nothing at all, sir! I *had* to come because our home parson would have been mad if I hadn't! They'd have fussed if I had not promised— my people I mean."

I rushed towards the door.

"Stop!"

His roar was as if he were thundering "amen" over a huge congregation. Again he changed glasses, scrutinized me and re-read my letter.

"You'd better have a cup of tea and meet my wife."

He said it ponderingly as if wondering if I would pour my tea into the saucer and blow it.

"I have had tea, thank you."

"But you have not met my wife."

He gestured me into the drawing room with furious authority. A voice, submerged in the vagueness that comes of deafness, called, "John, dear, your tea is getting cold. I've sugared it."

"My dear," he waited for her to adjust the tin ear-trumpet and close her eyes against the impact of his bellow . . . "Canadian, my dear!"

His shout must have filled the trumpet to make her realize that I was standing in front of her. He took her hand and held it out, at the same time tapping the side of the trumpet sharply.

Mrs. Reverend Brown winced, her mild, kind eyes smiled into mine, while she prepared for me a cup of tea, lavishly sugared. The Reverend then began to fire statistic questions at me, roaring them in duplicate into the trumpet.

I did not know the population of Ontario, nor how many cases of salmon British Columbia shipped in export each year. He began to look suspicious, then bellowed his final test watching my face narrowly.

"You have heard my brother, the Reverend Samuel Brown, preach in Chicago?"

"I have never been in Chicago."

"What! So few cities of importance in America and not know Chicago! Every American should be familiar with such cities as they have."

"But I do not live in America. I am Canadian."

"Same thing, same continent!"

Now he *knew* I was an impostor.

"You have finished your tea?"

He rose, took my cup, glanced towards the door.

I rushed back to London, burned the balance of my letters of introduction.

Westminster Abbey—Architectural Museum

I went to Westminster to hunt up my Art School.

I was to become very familiar with Westminster Abbey because the Art School lay just behind it, being housed in the Architectural Museum in Tufton Street. There stood the richly magnificent Abbey stuffed with monumental history, then a flanking of dim, cold cloisters, after that the treed, grassed dignity of Dean's yard and then you passed through an archway in a brick wall and were in Tufton Street. Here was the Architectural Museum, a last shred of respectability before Westminster plunged into terrible slum. In the Architectural Museum was housed the Westminster School of Art.

I climbed the Museum's grimy steps, pushed my shoulder against the heavy swing-door, entered a dark, lofty hall smelling of ossification—cold, deadly, deadly cold.

"Wat'cher wantin'?"

"I am looking for the Westminster School of Art."

"'Ere, but 'olidayin'."

The old janitor thumbed to a door up two steps, muttered, "Orfice" and lighted a gas jet over the door. Down the entire length of the hall was lying a double row of stone couches, on each of which was stretched a stone figure.

"Who are these?"

"Them is Great Uns, Miss."

The janitor's grim, dirty face went proud.

In the office I found Mr. Ford, the Curator, a white-bearded, tall old man, gentle, clean, too lovely for this grim setting. He smiled kindly, pen poised over his figuring.

"Yes?"

"Please, may I join the Art School?"

He reached for his enrolment book, wrote, "Emily Carr, Victoria, B.C. . . . English?"

"No, Canadian."

"Ah! Canadian, eh?"

His smile enveloped Canada from East to West, warming me. So few over here accepted Canada. These people called us Colonials, forgot we were British. English colonists had gone out to America with a certain amount of flourish, years and years ago. They had faded into the New World. Later, undesirable not-wanteds had been shipped out to Canada. It was hoped that America would fade them out too—all the west side of the earth was vaguely "America" to England. This courteous old gentleman recognized Canada as herself—as a real, separate place.

"How soon can I start work?"

"As soon as the class rooms open next Monday, Miss Hurry."

The Museum was lighted when I came out of the Office. A dreary young man in rusty black was drawing in a little black book propped against a stone dove on a shelf, bits of cornices, stone lilies, and saints with their noses worn off. Why must these people go on, and on, copying, copying fragments of old relics from extinct churches, and old tombs as though those were the best that *could ever* be, and it would be a sacrilege to beat them? Why didn't they *want* to outdo the best instead of copying, always copying what had been done?

I walked down the centre of the hall between the rows of stone sofas. I could not see the faces of the "Great Uns". The crowns of their recumbent heads were towards me. Some had stone hair, some hoods of stone, the heads of some were bald. It chilled one to see their bareness against stone pillows— hands crossed over stone bosoms, feet exactly paired, chipped old noses sticking up from stone faces, uncosy stone robes draping figure and sofa. Except for the Curator, the Westminster Architectural Museum was grim.

Something smelly was very close. The janitor was "shooing" the dreary young man out. He held wide the heavy door, beckoned me and cupped his filthy paw for a tip. . . .

"Closing time!"

Fog was in dirty Tufton Street. I did not put a tip into the dirtier hand. He banged the door after me. Newton expected a tip for every nothing he did or did not do. That janitor was loathsome—my first experience of that type of cockney.

Life Class

When school opened Monday morning at nine sharp I was at the Westminster School of Art. I went first to the Office, enquiring how I was to act. Mr. Ford took me up the broad stairway leading to the balcony off which our class rooms opened. There were two "life" rooms

for women. Mr. Ford introduced me to the head student, a woman dour and middle-aged.

"Ever worked from life?" she snapped.

"Only portrait."

"It is usual for new students to work first in the Antique Class."

"I have had three years study in antique and still life at the San Francisco School of Art."

The head student gave a mighty snort, grunted, "Colonial" with great disfavour. She had not the right to place me. Mr. Ford had put me into the Life Class.

"Stars in the West bump pretty hard when they compete with civilized countries!" she said acidly. "Well, Professor will put you where you belong when he returns."

She proceeded to put numbers on a lot of pieces of paper. The students were about to draw for a place in class. I, being the new student, had the last number and therefore no choice.

Around the model throne were three rows of easels—low, higher and high.

"Pose!"

The curtains of a little recess parted, out stepped the model and took her place on the throne.

I had dreaded this moment and busied myself preparing my material, then I looked up. Her live beauty swallowed every bit of my shyness. I had never been taught to think of our naked bodies as something beautiful, only as something indecent, something to be hidden. Here was nothing but loveliness . . . only loveliness—a glad, life-lit body, a woman proud of her profession, proud of her shapely self, regal, illuminated, vital, highpoised above our clothed insignificance.

The confusion of re-assembly after the holidays stilled. Every eye was upon her as she mounted the throne, fell into pose. Every student was tallying her with perfection, summing up balance, poise, spacing, movement, weight, mood. Charcoal began to scrape on paper and canvas . . . swishing lines, jagged lines, subtle curve, soft smudge. Tremblingly my own hand lifted the charcoal—I was away, lost in the subtlety, the play of line merging into line, curve balancing curve.

"Rest!"

I could not believe the first forty-five minutes had gone. The model broke pose, draped a kimono round herself and sat on the edge of the platform to rest for fifteen minutes. Students too relaxed, moving from easel to easel look- ing—saying little. No one looked at my work nor spoke to me. I was glad; nevertheless I was chilled by these cold students. In California there was

comradeship from the first day and kindliness towards the new student. I was glad to hear "Pose!", to see that serene creature, with trembling life in every inch of her, snap back into model queen of the room. Everything was for her. The notice on the outside of the door, "Life Class, Keep Out" was for her. Heat, light, hush—all were for her. Unprotected flesh made us tender, protective, chivalrous. Her beauty delighted the artist in us. The illuminated glow of her flesh made sacred the busy hush as we worked.

At four o'clock the model stepped down from her throne, rubbed tired muscles a little, disappeared behind the curtain, emerged ordinary, a woman clothed shabbily, all the beauty she had lent us hidden.

The professor did not return to his class for two weeks. I had but one fear during that time—would I be turned back into the Antique Class? His criticisms were gruff, uninspiring; however, he let me stay in the Life Class.

Mrs. Radcliffe

Mrs. Radcliffe was the aunt of friends of ours at home. They did not give me a letter of introduction but wrote direct to her. They said to me, "Go and see Aunt Marion," and their faces sparkled at her mention. So, while waiting for school to open, I went.

"I've heard all about you from my nieces," she said and accepted me as you accept a letter from the postman. It may contain good. It may contain bad. There I was. She received me kindly but without demonstration.

Mrs. Radcliffe was a widow with one son who was almost middle-aged, a London lawyer. She was Scotch by birth and raising, had spent her married life in Canada, but by inclination she was pure London through and through. Almost her first question to me was, "And how do you like London?"

"I hate it."

Her brown, starey eyes popped, grew angry, were hurt as if I had hit her pet pup. She said, "Dear me, dear me!" four times. "London is the most wonderful city in the world, child!"

"It is stuffy, hard and cruel—Canada . . . is . . ."

"Canada!" biting the word off sharp. "Canada is crude!"

She spread her hands as if she would drip all memories of Canada from her fingertips.

"London will soon polish Canada off you, smooth you, as your English parents were smooth. You are entitled to that. Make the most of your opportunities in London, child."

"I am Canadian, I am not English. I do not want Canada polished out of me."

"Dear me! Dear me!" said Mrs. Radcliffe, shifting the conversation to her Canadian cousins and nieces. "Come to me whenever you want to, child; I am always home on Sunday at tea time."

We parted, feeling neither warm nor cold towards each other.

I went to Mrs. Radcliffe's most Sundays. It got to be a habit. She liked me to come and I liked going. Usually I stayed and went with Mrs. Radcliffe and her son, Fred, to Evening Service in Westminster Abbey, then back with them to supper. Son Fred saw me safely home. Fred was nearly twice my age. He was kindly—teased me about Canada. In his mother's presence he pretended to be all English. She had educated him so—English schools, Cambridge University, taking him back to England as a small boy at the death of her husband. Down deep Fred loved to remember his early boyhood in Canada. If he saw that I was dreary or homesick he would chatter to me about the woods and the Indians.

One night Fred said, "Tell me about the comic old Indian who threw a tombstone overboard at the spot in the sea where his brother was drowned."

I had been feeling morose at England, homesick for Canada that week. We all started to laugh at the Indian story. Suddenly Fred, looking at me, said, "Now I see why the Indians called you 'Klee Wyck'—means laughing one, doesn't it?" After that the Radcliffes always called me "Klee Wyck".

Mrs. Radcliffe's Sunday tea parties were always masculine for friends of Fred's. Mrs. Radcliffe never asked girls; occasionally she had an old lady, a contemporary of her own. She gave out plainly that she intended to share her son's affections with no woman during her lifetime. She never thought of me as a woman; besides, Fred liked girls stylish and very English. She was not afraid of his liking me.

Mrs. Radcliffe was my English backbone. Her kind, practical strength of character was as a pole to a vine. In all my difficulties I went to her.

Mrs. Radcliffe had a dainty, little old lady friend called Mrs. Denny, who also was a widow with a son a good deal younger than Fred. The two men were warm friends.

Mrs. Denny had three little white curls dangling in front of each ear and wore widow bonnets with long crêpe weepers dangling behind. She was fragile, pink and white, and lowest low Evangelical in religion. Mrs. Radcliffe leaned towards the High Church. The ladies never discussed degrees of ritual, but confined conversation to their sons and to London. Mrs. Denny was as rabid a Londoner as Mrs. Radcliffe. She was as anxious to see "son Ed" happily married before she died, as Mrs. Radcliffe was determined that her son Fred should remain a bachelor. The ladies put their heads together and decided

that, with some taming down and brushing up, I would be all right as a wife for Ed Denny. The first thing to be done was so to fill me with London that I would be quite weaned from the crudities of Canada.

Mrs. Denny said to me, "My dear, you stick far too close to that Art School; confinement is telling on your health. Now I tell you what we will do. Every Thursday my daughter Loo and I will call at your school at noon, take you out to lunch; then we will spend the afternoon exploring London. You will come back to dinner with us and Ed will see you home."

"But my work, Mrs. Denny!"

"One afternoon a week will make no difference. There is more to be learned in life than Art."

"Art is what I came over to London for."

"Who knows, you may love here, may never want to go back to Canada—"

"Oh, I hope not! I would not want that."

She kissed me, very fondly pinching my cheek. Then her fingers took hold of a little cornelian cross that I wore.

"Don't wear this as an ornament, child, it savours of R.C."

She never said "Roman Catholics" out loud, only whispered, R.C. Once I saw her take a half-crown from her purse to tip a "Beef-Eater" who had conducted us round the Tower of London. Her hand was half out when the sun glinted on a little cross dangling from his watch chain. She slipped the half-crown back into her purse, substituted a shilling for it.

Under Mrs. Denny's guidance I saw a lot of London. She always carted a little red *Baedeker* under her arm with the "sight" we were "doing" marked by a slip of paper. We stood before the sight and read *Baedeker* and tried to memorize the date. The wretched part of these excursions was Ed's meeting us for tea. When we came out of the tea shops Loo and her Mother always took a quick, wrong turn on purpose, and left me alone with him for the rest of the time.

I would say, "Oh dear!" in dismay and start hunting them but Ed only laughed and said, "Don't worry, Mother knows her way about London as well as the nose on her face. They will be waiting at home." But it provoked me.

English women were horrid about this marrying business. They seemed to think the aim of every girl was to find a husband. Girl students "adored" their stuck-up, autocratic art masters, or their clergy or their employers. Men and women students did not work together in the Westminster Art School. I was glad. English husband-seeking girls shamed me.

Miss Green's PG's were all women—all silly. Shortly after I came to Miss Green's two men came up to London to see me. One was an Englishman from

Liverpool whom I had met out in Canada. The other was the ship's doctor, an Irishman. The Englishman was a brother of Frank Piddington whom I had so detested as a child at home. Clifton had visited Frank in Canada. He did not ask me to marry him there, but came home to think it over and wasted a postage stamp on it. I could not have been more emphatic in saying, "No", but, as soon as he found I was in London, he came from his home in Liverpool to see how I looked in English setting. He sat very uncomfortably on the edge of a chair in Miss Green's drawing room. The PG's were all in a twitter.

When Clifton had got as red as he could get, he said, "Shall we go out and see some sights?"

Anything was better than that horrible drawing room, so I said, "That would be nice . . . what shall we see?"

"I have always had a hanker to see Madame Tussaud's wax works," said Clifton.

Off we went. We punched the real policeman, asked the wax policeman the way, tried to buy a catalogue from the wax dummy, watched the chest of the Sleeping Beauty hoist and flop. Then we came to the head of a dark little stair and a man asked us for an extra sixpence. Over the drop into a cellar was the notice, "Chamber of Horrors. Expectant mothers and nervous persons warned."

"Need we, Clifton?"

"Of course."

Sinking into that dim underworld was horrid. Red glistened and dripped from a severed head in the guillotine, King Somebody was lying in a bath of red ink, having cut his veins in suicide, Indians were scalping, murderers murdering, villains being villainous. Once outside again, even the dirty London air seemed pure.

"What next, Clifton?"

"Well, I thought—Euston Station?"

"Must you be going so soon?" I said politely.

"Not for several hours yet . . . want to see the engines—very newest models, you know."

I said, "Oh!"

Clifton was an engineer; engines were meat and drink to him. He ran from platform to platform patting the snorting brutes as they slithered panting into their places, calling them "beauties", explaining their internals to me.

"You sit here. There is the four-thirty special. I must see her—the very, very newest."

I sat down on a luggage truck while he ran and dodged and ducked. Then I

saw him engage the engineer in conversation. They investigated every bolt and screw of the miserable thing. He came back exhilarated. "Going to let me ride home in the cab with him! Starts in an hour, time for tea first."

We went to an A.B.C. and ate crumpets.

"Good-bye!" His hand was clammy with excitement, he gasped, "Very latest model!"

He grabbed my hand.

"It's been splendid! . . . the Chamber of Horrors, the engines—you."

I was relieved. It was so delightfully plain that this was to be our final meeting.

The Irish doctor's ship was in port. The doctor came to London and to the Art School.

"Impatient young man downstairs in the Museum waiting to see our young Canadian." Mr. Ford smiled at me and gave my arm an affectionate little pat. "Young man unable to wait till the janitor was free. Ordered my old bones to run upstairs and fetch you at once."

He rubbed a rheumatic knee. Dear old man! Descending the stair we saw that the janitor's amble was unusually brisk. He came lashing his feather duster and glowering down the aisle between the architectural tombs. There sat the little Irish ship's doctor on the stomach of a "Great One", impatiently kicking his heels against its stone sofa.

"Oh, doctor, their stomachs are sacred, please don't!"

He jumped down.

"Shall we go into St. James's Park and sit on a bench? It is quite close."

It was a wide bench. The doctor sat down on one end and I on the other. Soon he was so close to my end of the bench that I fell off. I walked round the bench and sat down on its other end,—he did not look nearly so nice or nearly so well-bred in plain clothes. He was ill-at-ease too, trying to make conversation.

I said, "Don't they squabble?" meaning the sparrows who, down in the dust, were having a battle over a crust. A dove swooped down and took the crust.

"Gentlest of all birds!—a dove—" sighed the doctor. He was slithering up the bench again.

"Doves squabble like the dickens," I replied.

The doctor said, "Your tongue is losing its Canadian twist; you have changed in these few months."

"I should hope so! Wasn't I flabby and ghastly? Let's walk."

I jumped up just as his hand touched my arm. We strode silent three times round the duckpond.

"What time is it?"—Being late for dinner is one of the unpardonable sins in England.

"Good-bye."

I held out my hand. He hurried South, I North, neither looked back. Was it his uniform, not he, that had been a little attractive? Perhaps doctors, too, prefer girls meek and sick.

But for that hint, I was grateful to the doctor. I was trying to speak more like the English, ashamed a little of what they ridiculed as my colonialisms. Bless you, doctor, for the warning! Unconsciously I'd tried to be less different from the other students,—I who had seen many Canadian-born girls go to England to be educated and come back more English than the English. I had despised them for it. I was grateful for the doctor's visit and I swore to myself I would go home to Canada as Canadian as I left her.

Mrs. Simpson's

A cross from the dim archway of the Architectural Museum was a tiny grocer shop owned and run by Widow Simpson, a woman mild-voiced and spare. The little shop was darkly over-shadowed in the narrow street by the Architectural Museum. Pinched in between the grey of the street and the black of the interior, goods mounted to the top of the shop's misty window, pyramids of boxes and cans which Mrs. Simpson sold across a brown counter under a flickering gas jet, sold to ragged children and draggled women who flung their money upon the counter with a coppery clank. Mrs. Simpson's trade was "penny." She handed goods to children unwrapped but for the "lydies" she wrapped in old newspapers. At the back of the little shop was a door with a pane of glass inset. This door led into Mrs. Simpson's "Tea-room for Students." Here students, who wanted an entire light meal or to supplement their carried lunches, hurried at noon across Tufton Street, hatless, hungry and in paint-spotted pinafores.

The small Tea-room was centred by a round table on which stood a loaf, potted meat, jam, apples, biscuits, cheese and butter cut into ha'penny portions. In the middle of the table stood a handleless delft cup. Business was run on the honour system. You ate a penny's worth, hurled a penny into the delft cup, ate another pennyworth and hurled in another penny. Anyone mean enough to cheat Mrs. Simpson was very low.

Mrs. Simpson trusted us about the food but not with her "cats and her kettles." On either side of the bars of the grate fire were black hobs and on

them sat copper kettles. On the floor before the fire was a spread of cats, black, tortoiseshell and tabby, so close packed that they resembled an immense, heaving fur rug. No footgear but Mrs. Simpson's old felts could judge its placing among tails and paws. So Mrs. Simpson herself filled the great brown teapot over and over from the kettles. No one else was allowed to for fear they might scald a cat. When a kettle was empty Mrs. Simpson picked her way among students and cats to a tiny door in the corner and climbed two steps. On the first step she "shoo'd," on the second she "hist" and was answered by a concerted meowing. In her bedroom Mrs. Simpson kept special cats, along with the great jugs of fresh water drawn from some public tap in the district. The jugs were ready to refill the tea kettles and the cats to dart to alley freedom.

The Tea-room boasted two chairs and a stool. Mrs. Simpson usually lunched some dozen or more students. The first three got the chairs and stool, the next six sat on the floor, the remainder squirmed a foothold among the sitters and stood. It took planning to reach the food and to make sure it found its way into your mouth before somebody's elbow jogged and upset it.

The Tea-room window was never open. It looked into a small yard, piled with "empties." This place was the cats' opera-house and sports-field. It was very grimy, a vista of dim congestion, that filtered to us through a lace curtain, grey with the grime of London.

Mrs. Simpson's was a cosy, affectionate institution, very close to the Art School's heart. From Mr. Ford down to the last student every one spoke gently of the little, busy woman, faded, work-worn cockney. There was a pink ridge prominent above her eye-hollows. It was bare of eyebrows. Above the ridge was a sad-lined forehead. The general drag of her features edged towards a hard little walnut of grizzled hair, nobbed at the rounding of her skull.

Even in that slum setting there was something strong, good and kindly about Mrs. Simpson that earned our respect, our love. The men-students helped her "stock-take" and shamble through some crude form of bookkeeping. When the chattering, paint-daubed mob of us pressed through the shop into the little back-room Mrs. Simpson's smile embraced us—her young ladies and gentlemen—as sober and as enduring as the Abbey's shadow. We were the last shred of respectability before Westminster slummed. The Abbey had flung us over the Dean's Yard wall into Tufton Street. Too poor for the Abbey, too respectable for the slum, the Architectural Museum and the art students hovered between dignity and muddle.

Leaving Miss Green's—Vincent Square

The make-believe gentility of Miss Green's Paying-Guest-House became intolerable to me. An injury received to my foot out in Canada was causing me great pain. Transportation from Miss Green's to the Westminster School was difficult and indirect. I made this my excuse to change my living quarters. Miss Green was terribly offended at my leaving her house. She made scenes and shed tears.

I took a room in a house in Vincent Square where two other Art School students lodged. One of these girls, Alice Watkin, was the girl in the school I liked above any other. The other student was the disagreeable head of the Life room. We three shared an evening meal in their sitting room. The disagreeable student made it very plain that I was in no way entitled to use the sitting room, except to eat the miserable dinner with them, sharing its cost. The room was dismal. It was furnished with a table, three plain kitchen chairs of wood, a coal-scuttle and a sugar basin. The sugar basin was kept on the mantelpiece. It was the property of "Wattie" and me who kept it full to help to work our puddings down. Because the disagreeable student was on diet and did the catering our meals were sugarless and hideous. Our grate fire always sulked. Old Disagreeable would often pour some of *our* sugar on the black coals to force a blaze.

Vincent Square was grimly respectable though it bordered on the Westminster slums. The Square lay just behind Greater Victoria Street. You could reach the Architectural Museum in an entirely respectable way by cutting through a little street into "Greater Victoria" which was wide, important and mostly offices. When you came to the Abbey you doubled back through Dean's Yard into Tufton Street and so to the Architectural Museum but this way was circuitous. The others always took it, but I cut through the slums because every saved foot-step spared me pain. The slum was horrible—narrow streets cluttered with barrows, heaped with discards from high-class districts, fruit having decay-spots, wilted greens, cast-off clothing. Women brushed their hair in the street beside their barrows while waiting for trade. Withered, unwashed babies slept among shrivelled apples on the barrows.

I tried not to see too much slum while passing through. It revolted my spirit. Wattie said, "Don't go that way, Carlight"—that was always her name for me. When I came to the School motor-cars were just coming into use; they were fractious, noisy, smelly things. It was not a compliment to be called "Motor." Wattie had invented her own name for me. She never called me "Motor" like the others, always "Carlight"!

"Carlight," Wattie pleaded, "don't go through the slum! How can you!"

"Oh, Wattie, my foot hurts so!"

I continued to limp through the murk, odours, grime, depravity; revolting ooze, eddying in waves of disgustingness, propelled by the brooms of dreadful creatures into the gutters, to be scooped into waiting Corporation wagons dripping in the street.

One raw, foggy morning, as I hobbled along, a half-drunk street-sweeper brought his broom whack across my knees. They bent the wrong way, my bad foot agonized! Street filth poured down my skirt.

"'Ere you! Obstructin' a gent's hoccipation."

"Yer mucked the swell good, 'Enery," chuckled a woman.

"Let 'er look out, what 'er 'ere for, any'ow? Me, I'm a doin' of me dooty."

I boiled but dared not speak, dared not look at the creature. I could have fought. I think I could have killed just then. Doubling over, the nearest I could to a run, I managed to get to the school cloak-room.

Wattie found me crying over the wash-basin swishing my skirt about in the water, crying, crying!

"Carlight!"

"I got muddied, Wattie."

She groaned, "That wretched foot!" She thought I had tripped. She finished washing the skirt, took it off to the fire to dry, draped a cover-all apron over my petticoat, took me into her arms and rocked. That was Wattie's way. When one was in great tribulation she faced you, crooned, wound her arms round and rocked from side to side. She was such a pretty girl and gentle; had it not been for that clear-cut hardness of English voice, I could have forgotten her nationality.

Wattie would never have cried from being muddied. She would have squared her chin, stuck her high-bridged nose in the air but she would have kept out of slums and not have got herself muddied to begin with. English girls were frightfully brave in their great cities, but when I even talked of our big forests at home they shivered just as I shivered at their big, dreadful London.

While I lived in Vincent Square I breakfasted in my own room. The view from my window was far from nice. I looked directly across a narrow yard into a hospital. Nurses worked with gas full on and the blinds up. I saw most unpleasant things. I could not draw my own blind or I was in complete black—my landlady cut the gas off at dawn. She went by the calendar, not the weather, and daylight was slow piercing through the fogs of Westminster.

The landlady got a notion.

"'Ere's wot," she said. "You eat in my 'sittin' downstairs; save me luggin' up, cosy fer yous."

I breakfasted there once only. Her "sittin'" window looked into a walled pit under the street which was grated over the top. The table was before it. Last night's supper remnants had been pushed back to make room for my cup and plate. A huge pair of black corsets ornamented the back of my chair. There was an unmade bed in the room. The air was foul. The "sittin'" was reached by a dreadful windowless passage in which was the unmade bed of the little slatternly maid-of-all-work. I rushed back up the stair, calling to the woman, "I prefer to breakfast in my own room."

The woman was angry; she got abusive. I did not know how to tackle the situation, so, as was now my habit, I went to Mrs. Radcliffe, who immediately set out and found nice rooms near to her own. Wattie and I moved into them. Old Disagreeable remained in Vincent Square.

I could scarcely bear to put my foot to the ground. I had to stay at home, penned in dreariness, eating my heart out to be back at work. Wattie was away all day. London landladies are just impossible! Lodgers are their last resort. This woman had taken to drink. She resented my being home all day; there was no kindness in her. I had to have a mid-day meal. She was most unpleasant about it. She got drunk. With difficulty I hobbled to Mrs. Radcliffe. She was seated under an avalanche of newspapers when I burst in. The Boer War was at its height. Mrs. Radcliffe followed its every up and down, read newspapers all day.

Flopping onto the piano stool I burst into tears. "I can't bear it!"

Mrs. Radcliffe looked up vexed.

"What now, Klee Wyck! Dear me, dear me, what a cry-baby! Pull yourself together. A brisk walk is what you need. Exercise—exercise—That stuffy Art School!"

"My foot is bad. I *can't* walk."

"Corns? Nonsense, every one has *them*."

"It is not corns. Where is there a doctor? My foot will have to be cut off or something—I *must* get back to school."

"Doctor, fiddlesticks! You homesick baby! Stop that hullabaloo! Crying over a corn or two!"

The portière parted—there stood Fred. He had heard. I nearly died of shame. He was never home at this hour. I had not dreamed he would be in the dining room.

"Mother, you are cruel!"

I felt Mrs. Radcliffe go thin, cold, hard. Hiding my shamed, teary face in the crook of my arm I slithered off the piano stool. Fred held the door for me, patted my shoulder as I passed out.

"Cheer up, little Klee Wyck."

I did not cheer. Afraid to face the drunk landlady I crawled to a bus, scrambled to its top somehow, got close to the burly, silent driver, rode and rode. The horses were a fine pair of bays. I watched their muscles work. At the end of the route I put fresh pennies in the box and rode back to the start. Back and forth, back and forth, all afternoon I rode. The jogging horses soothed me. At dusk I went home.

"Mrs. Radcliffe has been twice," Wattie said. "She seemed worried about you—left these."

She held up a beautiful bunch of the red roses with the deep smell Mrs. Radcliffe knew I loved so well.

"I don't want her old roses. I hate her, I am never going near her again. She is a cruel old woman!"

"She loves you, Carlight, or else she would not bother to scold. She thinks it is good for you."

Wattie rocked, dabbing the red roses against my cheek as she rocked. Something scratched my cheek. It was the corner of a little note nestling among the blooms.

"Come to dinner tonight, Klee Wyck."

"Wattie, d'you know what hell would be like?"

"Father does not like us to joke about hell, Carlight; he is a clergyman, you know."

"This is not a hell joke, Wattie, at least it is only London hell! London would be hell without you and without Mrs. Radcliffe. But I must hurry or I shall be late for Mrs. Radcliffe's dinner, and she'll scold all over again."

"Good old Carlight. I am glad you are going."

All the houses in Mrs. Radcliffe's street looked exactly alike. I hobbled up the steps I thought were Mrs. Radcliffe's. A young man came out of the door. He stepped aside—I entered. The door closed, then I saw I was in the wrong house. I could not open the door so I went to the head of the stair and rang a bell. A woman came hurrying.

"I got in by mistake, please let me out."

"That's your yarn is it, Miss Sneak-thief; tell it to the police."

She took a police whistle from the hook and put it to her lips; her hand was on the door knob.

"Wait, really, honestly! A man came out and I thought he was the lodger above Mrs. Radcliffe, next house. I ran in before he shut the door. I am going to dine with Mrs. Radcliffe. Please let me out quick. She hates one to be late."

"A likely story!"

"It's true."

She opened the door but stood in front so there was no escape. Taking a leap in the dark, I said, "You know Mrs. Radcliffe; she often sends you roomers. Please ask Mrs. Radcliffe before you whistle the police."

The woman paused, she did not wish to lose custom. My chance leap had been lucky. I had not really known which side Mrs. Radcliffe lodged her visitors. I knew only that it was next door. The woman let me out, but she watched, whistle to lips, till I was admitted to Mrs. Radcliffe's.

Dinner had just been brought up. Fred laughed when I told my story. Mrs. Radcliffe frowned.

"You always manage to jump into situations, Klee Wyck! My nieces don't have these experiences when they come to London."

"They are not Canadian, perhaps."

"Some are."

"But Eastern Canadians. I come from far, far West."

Mrs. Radcliffe smiled, gentler than I had ever seen her smile.

"I have made an appointment with my surgeon-cousin. He is going to have a look at that foot of yours tomorrow," she said.

Pain and Mrs. Radcliffe—The Vicarage

The doctor found my foot had a dislocated toe, a split bone—results of an old injury. His treatment made no improvement.

"We will have to amputate that toe," he said. "I do not care to do it, though, without the consent of your home people; your general condition is bad."

"To write home and wait an answer will take so long, do it this afternoon. I want to get back to school. Please do it quick."

"Not so fast. The fact is I do not care to take the responsibility."

"It's my foot. I have no parents."

"Tell cousin Marion to come and see me," said the surgeon. Mrs. Radcliffe went.

"I will accept responsibility," she told her cousin. "If that toe must come off, do it." To me she said, prefacing her words as usual with "dear me!"—"My cousin is a good surgeon. If he says amputation is best, it is. You don't mind, I suppose, don't feel sentimental over a toe?"

"Goodness, no! I only want to get back to work."

"Of course a toe is not like your hand or head. I've told Cory to go ahead," said Mrs. Radcliffe.

The foot went wrong. I suffered cruelly. Every day Mrs. Radcliffe tramped clear across London in fierce heat to sit by my bed. She kept a vase full of red roses, velvety red ones with the glorious smell, always fresh by my bedside. She sat close, rocking in a rocker. The toe of her shoe struck the bed with every rock, each vibration was agony, but I would not cry out. I bit my lips and my cheeks were scarlet.

She said to the nurse, "Klee Wyck looks fine! Such bright colour! That foot must be doing splendidly!"

"She is suffering," said the nurse.

"Oh, well! The restless creature—doubtless she bangs that foot about all night."

I longed to yell, "Turn the cruel old thing out!" and yet, when Mrs. Radcliffe had gone, I turned my face into the pillow crying, counting the hours until she would come again. She was my strength; without her I was jelly.

Mr. Ford sent his daughter with flowers. Aunt Amelia Green came, wagging her pinched little head, saying, "I told you. . . . You should never have left my house. My Canadian nieces were the same—wayward."

Wattie had won her diploma. She was down in Cambridgeshire, at her Father's vicarage. She wrote, "Come to us, Carlight, the moment they will let you leave the nursing home. You will love the vicarage garden, the wonderful old church. I will take such care of you."

When Wattie left London I had moved to Mrs. Dodds' big boarding house for students.

The vicarage garden was a tangled wilderness, the church and vicarage tumbling down. The Vicar had passed his eightieth year and was doddery. He was, however, still possessed of a beautiful intoning voice, so the Church retained his services. Wattie from her seat in the choir, her sister from the organ bench, agonizingly watched their father. After the Vicar had filled the solemn old church with his voice, reading lessons and intoning the service, his strength was spent. Tottering up the pulpit stair, gasping out the text of his sermon, his eye roved vaguely over the congregation. A halting sentence or two, a feeble lifting of his arms to bless, the congregation was dismissed to its dinner.

But for the old man's prattle Sunday dinner in the vicarage would often have been very sad. One after the other his three daughters taking me aside said, "Father ought to be retired," but, in the next breath, "Isn't his intoning voice rich and mellow?" They were proud of him, but the Church was not being fair to the congregation.

The vicarage garden was high-walled with red brick circled by venerable elm trees in which was a rookery. Daws and starlings chattered around the disused stable. The Vicar could not afford to keep a horse. He had an old gardener, an old cook, and an old nurse to maintain as well as himself and three daughters. The daughters helped to eke out the living expenses by teaching drawing and music and by running his house. The cook was too old to cook, the gardener too old to dig, the nurse too old to be bothered with children; besides, the vicarage nursery had been empty for the last fifteen years.

Wattie, scouring the unpruned rose bushes for a house posy, said to me, "Our gardener is beyond work, besides which he is lazy and drunken."

"Why don't you sack him?"

"Carlight! Sack an old servant! In England servants remain with us until they die."

"What do they do?"

"Cook can still peel potatoes. The gardener sweeps up the paths, when he is not too drunk to hold the broom. Nurse dusts the nursery and makes our underwear all by hand."

"Can't she run a sewing machine?"

"Our family wearing machine-made body linen! Oh, Carlight!"

"Dozening hand stitches when you could million better, stronger ones by machine! Life's too short! Come to Canada, Wattie."

"Canada! Why, Carlight? England is the only place in the whole world to live."

"Your brothers have all gone abroad, haven't they?"

"Men are different, more adventurous. The world needs educated Englishmen. All my seven brothers went to college. It meant pinching a bit at home. They have all done so well for themselves in the Civil Service—India, China . . ."

"Why don't they do a bit for you girls now, make up for your pinch? Why should everything be for the boys and men in England?"

"Mother brought us up that way—the boys first always. The boys have wives now."

"I'm glad I'm Canadian! I don't like your English ways, Wattie!"

"Being English is my greatest pride, Carlight."

A narrow, walled way led from the side door of the vicarage to the church vestry, a sombre interlude in which to bottle secular thoughts and uncork sacred. Through a squeaky, hinged gate you could pass from vicarage garden to churchyard, from overgrown, shady green to sunny, close-clipped graves. Some of these had gay posies snuggled to the tombstones. Some stones staggered and tipped, almost as if they were dancing on the emerald turf.

Everything was so sombre about the vicarage and church it made the graves seem almost hilarious. Gaiety accompanied you through the churchyard, but, at the threshold of the church the merry spirit fell back into the sunlight, sky, air of the graveyard. The church was too dead, too dreary for that bright spirit. It belonged to life, to perpetual living.

"Rebellious Carlight!" Wattie would say, with a shake of her head, and a few swaying rocks to my shoulders. "Rebellious little Carlight!"

There had been moments when I nearly envied Wattie's uneventful calm at Art School. We worked easel-to-easel. Wattie's work was stable, evenly good. Sometimes my work was better than hers, sometimes worse. She neither lifted nor sank. She had enough South Kensington certificates to paper the Vicarage. I had none. She new Art History from the Creation to now. She knew the Elgin Marbles and the National Gallery, the South Kensington Museum, all the art treasures of London. She knew the anatomical structure of the human body, bone for bone. She stepped with reverent tip-toeing among the stone couches of the "Great Ones" in the Architectural Museum, but neither our Art nor our hearts had anything in common other than that we loved one another deeply. Each went her own way unfalteringly, staunch to her own ideals. When our ideals clashed, each jumped back into silence, because we wanted to keep both our friendship and our own opinion.

Kicking the Regent Street Shoe-Man

Mrs. Radcliffe's surgeon cousin advised a surgical support in my shoe. "I will take her to my own shoe-man in Regent Street," said Mrs. Radcliffe and off we went.

My foot was very sore, very painful to the touch, for a long time after the operation.

I said to the fitter, "Do not handle the shoe when it is on my foot, I will put it on and off myself."

It was a very swell shop. The clerks were obsequious, oily tongues, oily hair, oily dignity and long-tail black coats like parsons. Our salesman was officious, he would persist in poking, prodding, pressing the shoe to my foot in spite of my repeated protests.

At last angry with pain, I shouted, "You stop that!"

Mrs. Radcliffe explained to him that I had recently had an operation on my foot which had left it tender. The man still persisted in pinching; after he had

forced about seven squeals out of me, I struck with the well foot giving the princely creature such a kick square amidships that he sprawled flat and backwards, hitting his head against a pile of shoe boxes which came clattering down on him spreading him like a starfish. Every customer, every clerk in the store paused in consternation while the enraged shoe-man picked himself up.

"Klee Wyck!" gasped Mrs. Radcliffe.

"Well, he would persist when I told him not to," I cried. "Serves him right!"

I dragged on my old shoe by myself and we left the shop, Mrs. Radcliffe marching in stony, grim quiet while I limped beside her, silent also.

We waited for our bus, standing among all the Oxford Circus flower women on the island. The flowers were gay in their baskets, the women poked them under our noses, "Tuppence-a'penny a bunch, lydy! Only tuppence!"

"Um, they do smell nice, don't they, Mrs. Radcliffe?"

Mrs. Radcliffe's thoughts were back in the Regent Street shoe shop.

"Thirty years," she moaned, "I have dealt there! Dear me, dear me! I shall never be able to face those clerks again."

Our bus jangled up to the curb. We got in. I knew I was not a nice person. I knew I did not belong to London. I was honestly ashamed of myself, but London was . . . Oh, I wanted my West! I wasn't a London lady.

Are You Saved?

I took my letter from the rack and read it while waiting for Mrs. Dodds, my landlady, to finish totting up a long row of figures. I liked going down to pay my weekly board. Mrs. Dodds' office was cosy, she was kindly. She knew London like a book and could tell every one of her fifty lady-student boarders all they wanted to know about everything and every place in the world.

"I won't!" I exclaimed, reading down the page. Mrs. Dodds looked up from her figuring.

"Won't what?"

"Pay a snot-visit in Upper Norwood over the week-end. I don't know the people."

"The Handel Festival is being held this week; it is in the Crystal Palace which is at Upper Norwood. Probably that is why your friends are inviting you down. Don't miss a treat like that, child."

"They are not my friends, I've never seen them. My sister did the woman a kindness when she was ill out in Canada. The woman thinks she ought to pay back."

"Well, let her.—Why not?"

"She does not owe me anything. They have money. I refused to bring over a letter of introduction to her. I won't have anybody feel they have got to be good to me because my sister was good to them. They don't owe me a thing!"

"Take all the fun that comes your way, don't be stupid. That foot operation has taken it out of you. Go, have a good time."

"I'd like to hear that festival all right!"

On reconsidering, I wrote, "I've had an operation on my foot. I still limp. If you will excuse a limp and a soft shoe, I would be pleased, etc. . . ."

I loathed the snoopy little woman with boiled-gooseberry eyes from the moment I saw her peering down the platform looking for something resembling my sisters. She knew all about my foot and that I was just out of nursing home—my sister had written her. They had corresponded ever since they met in Victoria.

"I suppose you can walk? It is only one mile."

"No, I am afraid I cannot."

"Then shall I call you a cab?"

She made it plain that it was *my* cab. When we got to her gate she turned her back till I had paid the cabby.

"You do not look the least like any of your sisters."

"So I believe."

They were people of very considerable means. On the way from the station she told me that her son had been in the Boer War. He got enteric. The whole family—father, mother, three sisters and the son's fiancée—had gone out to South Africa to bring him home. They were just back.

"It was such a nice little pleasure jaunt!"

That was the scale on which these people could afford to do things. Six passages to Africa cost a great deal of money!

All the way in the cab she had stared at me.

"No," she said, "I see no resemblance whatever. Three fine women—if ever there are fine women outside . . ." She stopped to consider and added, "Three Godfearing, fine women."

She led me into a tasteless, chapel-like, little drawing room, its walls plastered with framed texts and goody-goody mottos.

"Put your foot up!" indicating a hard shiny sofa in an alcove. As soon as I was settled, she drew a chair to the side of the sofa, also arranged a small table on which stood an aspidistra plant, that beastly foliage thing so beloved of English matrons, because it requires no care, will thrive in any dingy room. English boarding houses always have aspidistras. I think it is the only growing

plant that I loathe; it is dull, dry, ugly. When the woman had securely barricaded me into the alcove by her disagreeable self and the hateful plant she turned full upon me her gooseberry-green stare, scummed over the green with suspicion, mistrust and disappointment.

Again she stabbed, "You differ from your family." Then in a voice, harsh, hateful, cruel, "Are you saved?"

Quite taken aback I faltered, "I . . . I . . . don't know . . ."

"That settles the matter, *you are not!* I know that I am saved. I know that my entire family—myself, my husband, our three daughters, my son, my son's fiancée—all are saved, thank God!"

She rolled her eyes over the aspidistra, as if she pitied the poor thing for not being included in family salvation.

The door opened, in marched her three daughters, two stumpy, one lank. Behind them came a maid carrying the tea tray. All the girls had strong, horsey, protruding teeth like their mother. Introductions followed. I was so shaken by my sudden shove into damnation that, not being yet fully recovered from my illness, tears came. I had to wink and sniff during the introductions to the daughters. For five minutes nobody spoke; strong, white teeth chewed insufficiently buttered muffins, hard lips sipped tepid tea. I did the same. The silence got unwelcome. I wanted to reinstate myself after my lack of self control. Mama was obviously upset that my salvation had been interrupted by tea. She drank three cups silently and straight off in long earnest gulps. Looking out of window, I cried, "Oh, is that the roof of the Crystal Palace glittering over there?"

"Yes."

"That is where the Handel Festival is being held, is it not?"

"Yes."

"Have you seen Beerbohm Tree in *Henry the Eighth?* I was taken last night, it was simply splendid!"

Silence.

"I heard the *Elijah* in Albert Hall last week. The vast enclosed empty space made me feel quite queer when we first went into the hall. Does it make you feel that way?" I turned to the lean daughter as being most human.

"No."

The girl was fingering the harmonium in the centre of the drawing room.

"Are you fond of music?" I ventured, and from Mama, in a tornado burst, came, "*Our music* is hymns at home. Of that, yes! Of concerts, theatres, NO! We are Christians."

"But . . . the *Elijah*, the *Messiah*, are sacred." I faltered.

"Sacred! The worst music of all! What do those professionals think of as they sing? Their own voices, their own glory, not the glory of God. We are Christians. We would not attend such performances."

A hymn book fell off the harmonium. Did I see the lean daughter's foot steal towards it as if she would kick it under the instrument? Mama stooped and replaced the book on the harmonium.

"I am very tired," I pleaded. "May I go to my room and rest a little?"

The lean daughter showed me the way, but she did not speak.

Next morning a letter was passed round at breakfast. The lean daughter tossed it across the table to Father when she had read it.

The eldest daughter remarked, "What luck, dear Mama!"

"Providence, not luck, my child!"

The lean daughter scowled and Mama announced, "Brother Simon and Sisters Maria and Therese will be with us for luncheon." Turning to her son, "It is my wish that you be here for lunch, my son. Brother Simon and the Sisters will wish to see you and ask about Africa."

In an aside the lean daughter whispered in my ear, "Relatives by faith, not by blood!"

"Certainly I will be present, dear Mama," said the son of the house.

Faint and chill the door bell tinkled under the hand of Brother Simon at noon. It was as if the pull were frozen by Brother's touch, but the maid heard and admitted. Mama left the drawing room; there were whisperings in the hall, whisperings that chilled me but made my ears burn. I was introduced. Six eyes tore me as a fox tears a rabbit.

"Let us pray," said Brother Simon, lifting fat red hands—the finger nails were very dirty. We all flopped where we were and ducked our noses into the seats of the chairs. My chair was in the bay window close to the street. I felt as if I were "praying on a housetop." I was sure passers-by could hear Brother's roar. At every footstep I peeped to see how pedestrians were taking it. Suddenly I heard my own name bellowed by Simon. He was explaining me to God as "the stranger within our gates." He told God mean things about me, such personal things as made me feel almost as if I were eavesdropping. He told God that I came of religious stock but that I was rebellious. I felt my face was crimson when I got up from my knees.

The maid was in the doorway waiting to announce lunch. She looked very sorry about something, either a beastly lunch or my sins.

The lunch was certainly dreadful. The three visitors bragged how they had

defied nurses and doctors to crawl to the bedsides of dying men in Africa for a last remonstrance with them about their sins. They discussed fallen soldiers with the son of the house.

"Was he saved?"

"No, no! I said a few words but I fear. . . ." Not one of those dead soldiers did Brother Simon credit with being saved or deserving to be.

At last lunch was over. The three trailed drearily away; they were booked for a religious meeting. All embraced Mama and the girls effusively. I'd have done them a damage had any of their kisses attacked my cheek. Brother took my hand in a clammy grip. One of his hands below mine, the other on top, was like being folded between raw kippers. "I shall," he said, "continue to pray for you, my child!"

"Thank you, dear Brother," murmured Mama. The kippers fell apart, releasing me.

The lean daughter's hand slipped through my arm, her whisper was directed straight into my ear. "Brother and Sisters by faith, *not* by blood, thank God!"

Queen Victoria

One day when Wattie and I were crossing Leadenhall Street we were halted by a Bobby to let a carriage pass. The wheels grazed our impatient haste. We looked up petulantly into the carriage and our eyes met those of Queen Victoria, smiling down on us.

Chatter ceased, our breath held when Her Majesty smiled right into our surprised faces. She gave us a private, most gracious bow, not a majestic sweeping one to be shared by the crowd. The personal smile of a mother-lady who, having raised a family, loves all boys and girls. The carriage rolled on. Wattie and I stared, first after the carriage, then at one another.

"Carlight—the Queen!"

How motherly! was my impression. The garish, regal chromos on Mrs. Mitchell's walls had been Queens only. This kindly old lady in a black bonnet was woman as well as Queen.

Wattie had never before seen the Queen close. She had been only one of a bellowing multitude watching her pass. She was tremendously excited.

Having just won her final South Kensington teaching certificate she was tip-toey anyhow and she was going out to a married brother in India for a year. I had moved to Mrs. Dodds' big boarding house for students in Bulstrode Street. Wattie had run up to London to bid me goodbye.

Mrs. Radcliffe, surrounded by the daily newspapers, was as near tears as I could imagine her being. Mrs. Denny opposite was openly crying, curls bobbing, handkerchief mopping, the delicate little face all puckered. In the students' boarding house all was silent, the usual clatter stilled. London had hushed, England was waiting and Queen Victoria lay dying. Bulletins were posted every hour on the gates of Buckingham Palace. We stole out in twos and threes all through the day to read them. The ones at home looked up on our return, saw there was no change, looked down again. Every one was restless. Fräulein Zeigler, the German, at present cubicled in our room in Bulstrode Street, was retrimming her winter hat. From his moth-ball wrappings she took a small green parrot with red beak and glassy eyes. Smoothing his lack-lustre plumage she said, "So, or so, girls?" twisting the mangy bird's stare fore, then aft. Advising heads poked out between cubicle curtains. Nobody's interest in the German woman's hat was keen.

"Extry! Extry! 'Er Majesty gorn!" shrilled the newsboys. Everyone took a penny and went out to buy a black-bordered "Extry." Then they read the bulletin posted on the gate which said,

"Osborne, January 23, 1901.

My beloved Mother has just passed away, surrounded by her children and grandchildren.

Signed 'Albert Edward'."

The following morning, passing through St. James's Park on my way to school, I was halted for a passing carriage. In it sat the new, uncrowned King— Edward VII. He looked sad and old. When they had said to him, "The Queen is dead. Long live the King!" he had replied, "It has come too late!"

I remarked to Wattie, "Queen Victoria might have sat back and let Edward reign a little before he got so old."

"Carlight! It is poor taste to criticize England's Queen, particularly after she is dead."

"She was our Queen too, Wattie. All the same, I do not think it was fair to Edward."

London completely blacked herself. It was ordered so. Shops displayed nothing but black, lamp posts and buildings draped themselves in black rag which fog soon draggled. Bus-horses wore crêpe rosettes on their bridles. Black bands were round the drivers' arms, cab and bus whips floated black streamers. Crêpe was supremely fashionable. The flower women couldn't black the flow-

ers so they favoured white and purple varieties, ignoring the gay ones. Dye-shops did a roaring trade; so many gay garments visited them and returned sobered. The English wallowed in gloom, glutted themselves with mourning.

On the first black Sunday Marie Hall, a young violinist in our house, asked to come to service in the Abbey with me. Young Marie, sure of herself since Kubelik had kissed her and told her she was the prodigy of the day, had just bought a new hat—bright cherry. "I don't care. It's my only hat; I shan't black it."

Instead of sitting in her usual seat beside me, Mrs. Radcliffe crossed to the far side of the Abbey. After service she whispered coldly in my ear. "How could you, Klee Wyck! The whole loyal Abbey blacked—that screaming hat!"

"Can I help it, Mrs. Radcliffe, if an English girl won't kill her hat in honour of her dead Queen?"

In the boarding-house Fräulein angrily removed the green parrot. "I don't see why I should," she grumbled, rolling "Polly" back in his moth-ball wrappings, slapping a black bow in his place and sulking under it.

The funeral preparations were colossal. Every Royalty in Europe must be represented. Mouse-like queens no one had ever heard of came creeping to the show—and Kaiser William with his furious moustachios! Hundreds of bands throbbed dead marches, the notes dragging so slow one behind another the tune was totally lost. London's population groaned and wept.

I did not want to go to the Queen's funeral procession—Little Kindle, my cubicle neighbour in the new boarding house, begged, "Come on, you may never see such another."

We rose at five; at six we took position in the Piccadilly end of St. James Street, front row. The procession was not due till eleven. In one hour we had been forced back to the sixth row by soldiers, police and officials who planted themselves in front of us. In defiance of the law, I carried a little camp-stool, but by the time I was sitting-tired the crowd was too tight to permit my doubling to sit. You could not even raise an arm. St. James Street had a gentle rise, the upper crowd weighted down on those below. Air could only enter your mouth, you were too squashed to inflate. Each soul was a wedge driven into a mass as a tightener is forced into an axe handle.

Those with seats reserved in upper windows along the route came much later than the crowd. Police tore a way for them through the people. The seat-holders hanging on to the Bobby, the crowd surged into the gap to better their position. They fought tooth and nail.

"Kindle!"

She half-turned, looked, groaned, pounded a Bobby on the vertebrae, said, "My friend, get her out quick, Bobby."

"Way there! Lydy faintin'!" shouted the policeman.

A great roaring was in my ears—then nothing. I recovered, draped over an area railing in a side street. I was very sore, very bruised.

"My camp-stool, Kindle?"

"Back among the legs—rejoicing in the scoop it took out of my shin. I told you not to bring the thing!"

She bound a handkerchief round her bloody stocking.

"Come on," she growled.

"Home?"

"Not after we have waited this long! The Mall, it's wide; hurry up!"

I dragged. I know exactly how a pressed fig feels.

I saw a corner of the bier, Kindle saw the Kaiser William's moustachios. Oh, the dismal hearing of those dead-march bands, which linked the interminable procession into one great sag of woe, dragging a little, old woman, who had fulfilled her years, over miles of route-march that her people might glut themselves with woe and souse themselves in tears on seeing the flag that draped the box that held the bones of the lady who had ruled their land.

English Spring

The Westminster Art School closed for a short Easter recess, when I had been nine months in London, nine months of hating the bustle, the crowd, the noise, the smell.

I said, "Mrs. Radcliffe, is there a little village that you know of where I could go and be in real country?"

"There is the village of Goudhurst in Kent. It has a comfortable Inn; I have stayed there myself."

There was another student in the school who came from Victoria. She decided to come to Goudhurst for the holiday, too.

The village was a tiny sprawl of cottages on the top of a little hill. We were met and wavered up the Goudhurst Hill by the Inn's ancient host and his more ancient horse and chaise. The village was all of a twitter because tomorrow the Butcher's daughter was to marry the Baker's son. Everyone was talking of the coming event.

The Inn parlour was low-ceiled, and beamed. There was a bright fire on the open hearth and its glow pinked the table cloth, the teacups, and the cheeks of our host and hostess, who were garrulous about the wedding.

My bedroom was bitterly cold, the bed felt clammy with damp. I woke to a

sharp spring rain next morning, but the sky did not want to wet the wedding, clouds scuttled away and soon the sun shone out. Villagers swallowed hasty breakfasts and hurried with flowers to decorate the church which was just across from the Inn.

I too hurried across the churchyard but not to the wedding. I saw a wood just beyond the graves. There was a stile across the graveyard fence. Thrushes, blackbirds, every kind of song bird was shouting welcome. From the centre of the graveyard two larks rose up, up—wings and song twinkling. The notes scattered down to earth clear as rain drops. I sat one moment on top of the stile. The church bells began to peal such a merry jangle. They must have seen the bride coming down the village street and were reporting to the people. Dog carts, pony carts, chaises from all over the neighbourhood nosed up to the churchyard fence, dogs barked, a donkey brayed—long, derisive, melancholy brays. I climbed over the stile. The gravestones were blackening with sitters waiting the bride.

I heard enough churchbells, saw enough people in London. I pressed hurriedly into the wood, getting drenched by the dripping greenery. Deeper, deeper I penetrated among foliage illuminated by the pale, tender juices of Spring. There were patches of primroses pale as moonlight, patches of bluebells sky colour, beds of softest moss under my feet. Soon my feet were chilled and wet.

"Cuckoo, cuckoo!" Live throats uttered the call I had heard voiced only by little wooden painted birds connected with a mechanical apparatus, unmannerly birds who shrieked "cuckoo!", burst open a door in the front of the clock and slammed it shut again. Violent little birds!

"Oh, London! Oh, all you great English cities! *Why* did you do this to England? Why did you spoil this sublime song-filled land with money-grabbing and grime?"

Baby daffodils hooked the scruffs of their necks up through the moss under my feet; those whose heads were released from the moss were not yet bold enough to nod. Spring was very young. I was so happy I think I could have died right then. Dear Mrs. Radcliffe, I loved her for directing me to Goudhurst. I would gather a big boxful of bluebells, primroses and daffodils, post them for her Easter in London. Oh, the spring smells! The lambs bleating in the field beyond the graveyard! The shimmer of the greenery that was little more than tinted light! How exquisite it all was! How I hated to go back to London!

I burst in on Mrs. Radcliffe, reading the war news as usual.

"Mrs. Radcliffe! Oh, oh, oh!"

"You like our English Spring, Klee Wyck?"

Mrs. Radcliffe was not a kissy person. I was shy of her, but I could not help what I did. I attacked from behind her chair. Her cheek was not soft, not used to being kissed—my hug knocked her hat crooked.

"Dear me, dear me!" she gasped. "What a—what a 'Klee Wyck' you are, child!"

My Sister's Visit

I had been a year in England when my favourite sister came from Canada to visit me.

Wild with excitement I engaged rooms in the centre of the sightseeing London. Houses and landladies had to be approached through a rigorous reference system of Mrs. Radcliffe's. I pinned my best studies on the wall of the rooms, thinking my sister would want to see them.

She came in the evening. We talked all through that night. At five A.M. my senses shut off from sheer tiredness. My last thought was, "She will want a pause between travel and sightseeing."

At seven the next morning she shook me.

"Wake! What sight do we see today?"

"Won't you want to rest a little after travel?"

"The trip was all rest. I am a good traveller."

We started off She entered the sights in her diary every night—date, locality, description.

At the end of a week I remarked, "Not interested in my work, are you?"

"Of course, but I have not seen any."

"I suppose you thought these were wallpaper?" pointing to my studies on the wall. My voice was nasty. I felt bitter. My sister was peeved. She neither looked at nor asked about my work during the whole two months of her visit. It was then that I made myself into an envelope into which I could thrust my work deep, lick the flap, seal it from everybody.

Martyn

Martyn came all the way from Canada to London just to see me and with him he lugged that great love he had offered to me out in Canada and which I could not return. He warned of his coming in a letter, carefully timed to be just too late for me to stop him even by wire. For I would have pleaded, "Dear Martyn, please don't come."

I had been spending the long summer holiday with friends in Scotland. I got his letter there. I had been on the point of returning to London, but, on receipt of that letter, I dallied. It made me unhappy. I wanted time to think.

Martyn got to London first. He was on the platform at Euston waiting for me, had been in London for three days rampaging round, nearly driving my landlady distracted by his frequent—"Have you heard anything of her yet?"

But Martyn on the platform at Euston Station was like a bit of British Columbia, big, strong, handsome. I had to stiff myself not to seem too glad, not to throw my arms round him, deceiving him into thinking other than I meant. He gave me all sorts of messages from everybody at home. Then he searched my face keenly.

"How tired you look!"

"I am, Martyn; please take me straight home."

In the cab we were silent. On my doorstep he said, "What time tomorrow?"

"I am meeting Mrs. Radcliffe at the Abbey door at five to eleven—join us there."

He frowned. "Must she be along? Must anyone but you and me?"

"Mrs. Radcliffe and I always sit together in church. She is fine—you will like her."

Mrs. Radcliffe and Martyn impressed each other at once. Martyn was Canadian born but his parents had raised him ultra-English. After service Mrs. Radcliffe, with a coy smile and one or two "dear me's", left us, taking her way home by a route entirely different to the one that was her habit.

"Goodbye, children!" I don't know how many "dear me's" her eyes twinkled as she said it.

"Bring your friend in to tea with me this afternoon, Klee Wyck." In one of her piercing, tactless whispers she spilled into my ear, "Poor Eddie!"

Martyn and I were alone, Mrs. Radcliffe's back fading down Great Victoria Street.

Martyn asked, "Who is Eddie?"

"The friend of Mrs. Radcliffe's son, Fred."

Martyn frowned. We walked along quiet and stupid.

After lunch Martyn called for me and we went to Kensington Gardens and got things over, sitting uncomfortably on a bench near the lake side. Everywhere was black with children and their nurses. The children sailed boats on the lake and shrieked. The roar and rumble of London backgrounded all sounds. I was glad of London's noise that day and of her crowds.

Martyn had three months' leave. I undertook to show him London. Mrs. Denny and Eddie, Mrs. Radcliffe and Fred, as well as my many solitary pokings

round the great city, had made me an efficient guide. Every day at four o'clock I found Martyn ambling among the tombs of the "Great Ones" down below our workrooms at the Architectural Museum, his eyes always directed to the doors leading off the upper balcony of the great hall, closed doors behind which we studied. From his office old Mr. Ford gave us a kind smile as we passed, politely amused smiles but never objectionable nor coy like the ones English ladies and the students lipped at you when they saw you with a man.

I showed Martyn every sight I thought would interest him. We went to the theatres. Martyn liked Shakespearian plays best, but it did not matter much what the play was, whenever I took my eyes off the stage I met Martyn's staring at *me*.

"What's the good of buying tickets!" I said crossly—"you can see my face for nothing any day." He asked me on an average of five times every week to marry him, at my every "No" he got more woebegone and I got crosser. He went to Mrs. Radcliffe for comfort and advice. She was provoked with me about Martyn, she kept his time, while I was at school, divided between intercession services and sentimentality. I wished she would tell him how horrid, how perverse I really was, but she advised patience and perseverance, said, "Klee Wyck will come round in time."

We used to go to tea at the Radcliffes' every Sunday afternoon, stay on and go with her to the Abbey for evening service. One night Mrs. Radcliffe and I were putting on our hats in her bedroom. She returned unexpectedly to the sitting room for her scarf and surprised Martyn on his knees before the fire warming my cloak. He was patting the fur collar as if the thing were a live kitten. Mrs. Radcliffe was delighted.

"Dear me! So romantic, Klee Wyck! Don't be a fool, child!"

"He's a silly goat!" I snapped.

Ever after that night, when Mrs. Radcliffe spoke to me of Martyn, she called him the Knight of the Cloak.

Martyn and I had one perfect day during his stay in London—the day we went to Epping Forest. For a long, long day Martyn promised me that he would not *ask* that day. You could depend on Martyn to keep his promises.

First we pretended that Epping Forest was our Canadian woods, but it was no good, there was not one bit of similarity. We gave up and sipped England's sweetness happily. Here were trees venerable, huge and grand but tamed. All England's things were tame, self-satisfied, smug and meek—even the deer that came right up to us in the forest, smelled our clothes. There was no turmoil of undergrowth swirling round the boles of the trees. The forest was almost like a

garden—no brambles, no thorns, nothing to stumble over, no rotten stumps, no fallen branches, all mellow to look at, melodious to hear, every kind of bird, all singing, no awed hush, no vast echoes, just beautiful, smiling woods, not solemn, solemn, solemn like our forests. This exquisite, enchanting gentleness was perfect for one day, but not for always—we were Canadians.

We hired a pony and cart and drove through the straight *made* roads of the forest, easy, too easy. Soon we returned the pony and went on foot into the forest's lesser ways. Here greenery swished against us, rubbed shoulders with old tree boles. It was good to get our feet on the grass-grown paths and against the cool earth. When we came into the wider ways again, we took hands and ran. Martyn gathered some sprigs of holly for me in the forest.

The woman who hired us the pony said, "Keepers would jail ye shure, ef they sawed you with that there 'olly."

It had never occurred to us we could not gather a twig. At home we might take anything we wanted from the woods.

Epping Forest was honey sweet—rich as cream. That was a perfect day, but too many days like that would have cloyed. We ate our picnic lunch among the trees, enjoying it thoroughly, but all the while there was a gnaw in us for wild, untrimmed places. This entranced, the other satisfied; this was bounded, the other free.

Martyn and I made a great many mistakes in England not realizing that we were doing wrong according to English standards.

One evening we took a bus ride and at the terminus got off to walk in the cool. Tiring, we stepped inside a wide open gateway and sat down on a bench to rest. The place appeared to be a park, no house was in sight. Very soon a man came and walked round our bench several times, staring at us. He went away and brought another man. They both stood staring at us. Simultaneously they shouted, "How dare you!"

Seeing they meant us, Martyn asked, "How dare we what?"

"Trespass."

"We are only resting a few moments, the gate was open."

"Do you think select tennis clubs are for the resting of vagabonds?"

They drove us out and locked the gate. I had difficulty keeping Martyn cool. "Hateful snob-country! Emily, come home," he begged.

After Art School one late autumn day we went to walk in Kensington Gardens. It was one of Martyn's *asking days*; they always depressed us.

"Come," I said, "it must be near closing time."

Martyn looked at his watch—"Half an hour yet." We sauntered to the great gates; to our horror we found them shut, locked. Nobody could possibly scale that mile-high iron fence. There we stood between the dusking empty gardens and the light and roar of Piccadilly.

I said, "There is a keeper's lodge close to the Albert Memorial, Martyn. He has a tiny gate. I've noticed it."

We tapped at the door of the lodge and explained that, being strangers, we did not know about winter hours—this it seemed was the first day of the winter change; the time had been hurried on by half an hour. The man said vile things, was grossly insulting. Martyn boiled at the things the man said, the language he used before me. It was all I could do to hold him back.

"Don't," I whispered, "let us get out first."

The man led to the little gate, stood before it with outstretched palm. We must tip before he would open.

"Lend me sixpence," whispered Martyn. "I have only big coin in my pocket. I will not give the brute more than sixpence!"

In my flurry I took half a sovereign from my purse, thinking it was sixpence. The lodge keeper became polite and servile at once when he saw gold. I never dared tell Martyn about my mistake.

We were always doing things that were right for Canada but found they were wrong in England.

"Martyn, I hate, hate, hate London!"

"Come home, Emily; marry me; you don't belong here."

"I can't marry you, Martyn. It would be wicked and cruel, because I don't love that way. Besides—my work."

"Hang work; I can support you. Love will grow."

"It is not support; it is not money or love; it's the work itself. And, Martyn, while you are here, I am not doing my best. Go away, Martyn; please go away!"

"Always that detestable work!"

Dear Martyn, because he loved me he went away.

"Martyn's gone back to Canada."

Mrs. Radcliffe's eyes bulged.

"When are you marrying him, Klee Wyck?"

"Never."

Mrs. Radcliffe jumped to her feet. "Little silly! What more do you want? Is it a prince you wait for?"

"I wait for no one; I came to London to study."

The Radcliffes' Art and District Visiting

T
he Westminster Art School students did not discuss Art in general very much. They soberly drudged at the foundations, grounding themselves, working like ditch-diggers, straightening, widening, deepening the channel through which something was to flow—none were quite sure what as yet.

I never wrote home about my work nor did my people ask me about it. A student said to me once, "Are any of your people Artists?"

"No."

"Take my advice, then—don't send any of your nude studies home."

"Goodness gracious, I would never dream of doing so! Why, they'd have me prayed for in church. My family are very conservative, they suppose I only draw clothes. If my drawings intimated that there was flesh and blood under the clothes they'd think I'd gone bad!"

The other girl said, "My people wrote begging me, 'Send us home some of your studies to see.' I did. They wrote again, 'Oh, please do not send us any more; we wanted to be able to show your work to our friends—well, the only place we could hang them was in the bathroom.'"

Mrs. Radcliffe and Fred were Art-lovers but they only liked or tolerated old masters or later work of the most conservative type. They knew every continental gallery by heart, had volumes of photos of the masterpieces of the world. The modern school of painting was as indecent to them as my nude studies would have been to the home folks. The Radcliffes had arty cousins, studying in Paris and in Rome. They talked about the Art exploits of these cousins till I was sick of them. Perhaps a little of my disgust came from jealously, for I was beginning to feel that Paris and Rome were probably greater centres for Art than London. The Art trend in London was mainly very conservative. I sort of wished I had chosen to study in Paris rather than in London. What had decided me was the difficulty my tongue had always experienced in crawling round foreign words; even the difference in English and Scotch words from those we used in Canada was perplexing at times. The students ridiculed what they called my colonialism.

Fred asked, "Klee Wyck, do you go often to the National Gallery?"

"I did at first, but not now. It is a dreary place. Besides, one wet day, when the rooms were dark and empty, I was alone in a big gallery. One of the guards came into the room and said something horrid to me. I have never been back to the National Gallery since."

"The man should have been reported," said Fred angrily. "Come with Mother and me next Saturday."

I went. Mrs. Radcliffe and I stood, one on either side of Fred. Fred told us what pictures to look at, the date of each picture's painting. Fred knew every date of every happening in the world. He knew why the artist painted the picture and how. The older they were and the more cracked and faded, the better he loved them. He loved the Old Masters like blood brothers. If he had eaten and shaken hands with them he could not have seemed more intimate with the artists.

Every year the Radcliffes swallowed the Royal Academy show, a week of steady gulping, as if it were a great pill. They went on opening day, bought their catalogues and ticked off just how many pictures they had to do a day. They knew to a minute just when they would *finish* the Academy and were scrupulously conscientious, giving even the more modern canvases (though there were very few with even a modern taint in the Academy show) an honest stare before passing on. They liked sentiment, something that told a story. The more harrowing the story the better. "The Doctor" by Luke Fields was a great favourite of theirs. They wracked themselves over the dying child, the agonized mother, the breaking dawn and the tired doctor. They liked "The Hopeless Dawn" too. I forget whom that was by. It showed the waiting wives and mothers in a fisherman's cottage on the night after a terrific storm. And the Radcliffes liked Arnesby Brown's cow pictures very much—billows of breath bursting from the cows' nostrils like steam from tea kettles. The dark spots in the dewy grass where the milkmaid's feet had smudged the wet, making the grass a deeper green, nearly brought tears to Mrs. Radcliffe's eyes, though, of course, she would have said, "Dear me, dear me! No, I am not the least sentimental."

I found on the whole that it was better not to discuss Art with the Radcliffes. We did not agree about London. We conversed a good deal about churches—not as to their degree of highness or lowness as much as about their mellow old beauty. Even the jump from high to low ritual was not so violent as that between ancient and modern Art. Mrs. Radcliffe leaned towards the high but all churches were more or less acceptable to her. She and I both attended morning service at an unfashionable old church behind Westminster Abbey. It was called St. John's and Canon Wilberforce preached grand sermons there. In the evening we went to Westminster Abbey and Fred came with us.

It provoked Mrs. Radcliffe that I would not cut morning school by an hour every day to attend intercession services for the troops in the Boer War.

Canon Wilberforce called for district visitors in the parish. Mrs. Radcliffe volunteered and said to me, "Klee Wyck, I think you should offer to take a district too."

"Oh, I couldn't, Mrs. Radcliffe. I think it is beastly to go poking into the houses of the poor, shoving tracts at them and patting the heads of their dirty babies, pretending you are benevolent."

"That is not the idea. A district visitor simply calls in a friendly spirit and reports any cases of sickness or distress to the visiting curate, asks if they would care to have him visit them. Don't let Art be a selfish obsession, Klee Wyck. Art is all very well, but be of some real, practical use in the world, too."

"All right, I'll try to swallow a lump of Westminster slum, but I don't like it and I know the slummers will hate me."

I was to visit two long stacks of three-storey tenements in a dirty court—deadly places. Each family's quarters opened onto a long landing or balcony. Door, window—door, window, down the whole row, monotonous as "knit, purl, knit, purl". All the doors had the most aggressive bangs, all the windows had dirty curtains.

When I knocked, the curtain waggled and a stare peered out. If they *did* open the door it was only so that they might bang it harder against my nose, as they shouted through the keyhole, "Don't want no visitors pokin' round 'ere."

"Mrs. Radcliffe, I tremendously loathe slumming!"

"Dear me! you have only just started, Klee Wyck. You will get fond of the unfortunate creatures by and by."

So I sneaked out of school one afternoon every week, telling no one where I was going. I'd have died of shame if the students had known I was district-visiting in the Westminster slums. At last, after a week or two, a girl twice my own age in what she knew about life, and half my span of years, opened a door after I had passed it and called, "'Ere you! Ma says, 'Come,' she's took bad."

I went into the tiny stifling room. An enormous, roaring coal fire burned in the grate. Besides that in the tiny room there was a great bed, a chair and a half eaten pie on a tin plate. The pie sat on the bed beside the woman; it was black with flies. The girl flipped the pie onto the floor. The swarm of flies rose and buzzed angrily up to the tight-closed dirty windows as if they were all going to be sick and wanted to get out immediately. I felt that way myself, especially when the morose, aggressive woman in the bed discoursed on her symptoms. She had dropsy and rolled her great body round in the bed so that I might hear her dropsy swish.

"Tell that there Curate feller 'e can come see me ef 'e wants ter."

I came away and the filthy court seemed as a pure lily after that fetid room.

I rushed round to the door of St. John's church and got the address of the visiting curate from the notice board.

"Reverend be 'ome," said the slattern who opened the door to me, adding, "foller!"

We went upstairs, the slattern flung the door back. The Curate was having tea at a littered, messy table, reading as he ate, his book propped against the sugar basin. There was no fire in the room. Late afternoon had dimmed London; it was cold, drab and full of fog, yellow fog that crowded up to the window panes.

A flickering gas jet was over the Curate's head—it "haloed" him. He was ugly and so lean you saw the shape of his teeth through his cheeks. The Curate's bed was draped with brown cotton hangings. Table, bed, chair, were loaded with books. He stopped chewing to stare at me, first over, then under, finally through his spectacles.

"Mrs. Crotch in Catfoot Court says you can go and see her if you want to. Here's my district card; I can't district-visit any more. It is beastly, how can you!"

The Curate's face twisted into a sighing little smile. He stretched a bloodless hand and took my card. He said, "You are young," and looked as if it were a long time since he had felt young.

"Mrs. Radcliffe, I'm through with slumming!"

"Oh, Klee Wyck!" She looked disgustedly at me.

"Yes, I have abandoned good works; they never were in my line. Ugh, those revolting creatures, rude, horrible! I am much sorrier for the Curate in his wretched lodging than for those slum people with their roaring fires, their dropsies, their half-eaten pies swarming with flies."

"What do you know about the Curate's lodging?"

"Went there, to hand in my district visitor's card."

"You went to the Curate's room!"

"Had to give my card in, didn't I?"

"You should have taken it to the Church House."

"Church House! What's that? I never heard of one, and goodness, my sisters were churchy enough, too."

"All parish work is conducted through the Church House in London parishes. Workers never go direct to the clergy."

"Well, I did and he was the miserablest human I ever saw."

Mrs. Radcliffe assumed a sly simper. "I wonder what he thought of you?" She looked so coy, so hinting, I wanted to hit her. Mrs. Radcliffe twitted me so about that wretched visit to the Curate that I stopped going to St. John's.

To Mrs. Denny I was frankly a disappointment. She had taught me London, pointed out the wrongness of Roman Catholicism, had even intimated that

she was willing to share with me the love of her very precious son. And London's history bored me! I continued to wear Mother's little cornelian cross, to go to the Brompton Oratory on occasion to hear magnificent music. Most astounding of all I did not want Ed's love! No wonder she was disappointed. At least I had the decency to be honest with Ed, to show him and his mother, too, that I had no intention of marrying him, that I did not want his love! I spared Ed the humiliation of a "No" by not allowing him to ask me.

The heads of Mrs. Denny and Mrs. Radcliffe nodded a duet of amazement and sorrow. Next to Martyn as a husband for me, Mrs. Radcliffe favoured Eddie. The two old ladies had tried to remodel me. I was so difficult to mould. After a couple of years they gave up, concluding that after all I had really come to London seeking Art, not a husband. By this time they had got to love me a little for myself, had accepted me as an assorted bundle of good and bad. Everyone was much more comfortable when at last they realized that love won't be pushed into contrary channels.

Good Ed did not marry; he cared devotedly for his old mother till she died. Fred wrote out to Canada at the time of the World War, "Ed is over-age for active service but he drives himself beyond human limit on the home front to release younger men."

London Tasted

Now that my sister's visit was over, now that Martyn had come and gone, foot troubles were straightened out, London explored, and now that I was comfortably settled in Mrs. Dodds' boarding house for students in Bulstrode Street, it seemed that things were shaped for steady, hard work.

Besides all-day Life Class at the Westminster School of Art, I joined night classes—design, anatomy, clay modelling. Against London I was not quite so rebellious, though I did not like life in a great city.

I made a few friends in the school and some in the boarding house. Wattie was out in India. I plunged into work, not noticing that my face had become pasty; but, because I was always tired, I pushed and goaded myself harder. It was a long way I had come to get what London had to give. I must make the best of it, learn all I could.

I knew London well—not the formal sights only, but I knew her queer corners too. Mrs. Denny and Mrs. Radcliffe had shown me national astonishments,

great sights, picture-galleries, Bank of England, British Museum, Mint, Guildhall, Tower of London, Buckingham Palace, and Windsor. I had canoed with Fred and his mother up the Thames and down. London had instructed, amazed, inspired, disgusted me. The little corners that I had poked into by myself interested me most. My sight-showers would have gasped had they known the variety and quality of my solitary wanderings. It would have puzzled them that I should want to see such queerness.

The orthodox sights I found wearing. The Zoo I never tired of, nor of Kew Gardens, St. Paul's, the Abbey cloisters. I took endless rides on bus-tops, above the crowd yet watching intently the throngs of humanity. I went into the slums of Whitechapel, Poplar, and Westminster and roamed the squalid crookedness of Seven Dials, which is London's bird-shop district, entering the dark stuffiness of the little shops to chirp with bird prisoners, their throats, glory-filled and unquenchable, swelled with song even in these foul captive dens. There was Paternoster Row too—the street of books, Lincoln's Inn Fields—the world of Dickens, haunted by Dickens' houses, Dickens' characters, as St. Bartholomew's, Smithfield was haunted by smell of fire and the burning flesh of martyrs. From the "gods" of the great theatres I saw Shakespeare's plays, cried over Martin Harvey in *The Only Way*, roared over *Charlie's Aunt*, saw Julia Nielson in *Nell Gwyn*. That play I saw first from the "gods"; afterwards I saw it from stalls with swell friends from home. I liked it best from the "gods," distance dimmed the make-up, the sham. In the "gods" it was vision and carried me away.

So I looked at London from different sides, mostly hating it; cities did not sit on me comfortably. There were a few little tag ends I loved, insignificant things that most Londoners scorned, but the oldness and history of it made little appeal to me.

There were fifty-two women and girls in Mrs. Dodds' boarding house, every kind of student and all nationalities. Once I counted fourteen countries dining at one table of sixteen souls. Sometimes nationalities clashed but not often. Many foreigners were here to learn English. They learnt squabble English and slang as well as the pure language in our boarding house.

We had two large sitting rooms; one was talkative and had a piano, the other was silent for writing and study. Occasionally I went into the silent room and always got into trouble for drawing caricatures and rhyming, not for talking. Another student would look over my shoulder, see some of our queer ones— giggles were forbidden in the silent room. I would be ejected. But, being out at classes most nights, the sitting room students were not bothered by me much.

The few private rooms at Mrs. Dodds' were small and very dismal. The other rooms were very large and were divided into cubicles by red and yellow curtains.

The girl in the cubicle next mine was a North Country farm girl, jolly and wholesome. We drew back the dividing curtains, so making our cubicles one, and had fun. We kept a big box of goodies and had feasts, making cocoa on a spirit lamp after night-school. My cubicle had a private window—windowed cubicles cost a shilling a week extra. There was a curtained alley down the middle of the big room; a window was at one end of the through alley, the door with a ventilator over it at the other.

There were five cubicles in our room. Three of us were permanent, the other two cubicles were let to transients. It was amusing to wonder who would come next into the transients' cubicles. We had a Welsh singer, a German governess, a French mademoiselle, some little Swedish girls. Often we had two Scotch sisters in the spare cubicles. They quarrelled over the shutting and opening of the public ventilator in the aisle and sneaked on each other when one thought the other asleep. Each had to stand on her bed to reach the hook of the ventilator using her umbrella handle. Stealthily, stealthily they sneaked, but the other always heard—clash! whack! whack! whack! went umbrellas over the curtain tops!

"Ye hurrt me," Little Scot would whimper.

"A' meant ta," Big Scot would reply.

Bed springs squeaked impatiently, the three permanents were disturbed. Three "shut-ups!" came from their cubicles.

The food at Mrs. Dodds' had no more variety than a calendar. You knew exactly what the kitchen saucepans were doing without the help even of your nose. Sunday's supper was the peak of misery. The maids were out; we helped ourselves to the everlasting monotony—same old cold ham, same salad, same cake, same sliced pineapple. Why couldn't the salad have been other than beetroot and lettuce? Why must the cake always be raspberry slab? Why not another canned fruit than pineapple? Everyone who could wangle an invite to sup out on Sunday wangled.

When it came to bed time, one cubicle would brag, "I had roast beef and Yorkshire."

Groans!

"I had duck and green peas," from another cubicle.

More groans.

"Must you gloat over your greed!" from a cubicle who had suppered at home. Bedclothes dragged over heads, there was savage, "goody-hungry" quiet.

The Other Side of Life

When Westminster School closed for the long summer vacation I, with other students, joined a sketching class at Boxford down in Berkshire. The quaintness of thatched cottages in the village delighted me. The sketching master was a better teacher than painter, I learned a lot from him. It was the first time I had sketched out-doors in England. Even across one field there was soft hazy distance, distance gradations were easier here to get than in our clear Canadian atmosphere and great spaces; everything was faded, gentle here. Colour did not throb so violently. English landscape painting was indolent seeing, ready-made compositions, needing only to be copied. I was very happy in my work, sorry when the summer ended.

The other students went home. I lingered, hating to leave woods and fields for chimney-pots and clatter. The weather grew sharp and a little wet. The master and his wife lived in another village. The man was drinking. He forgot his lesson dates, smelled beery. I stopped taking lessons from him and worked on alone.

I had given the landlady my week's notice. She came to me in distress.

"A lady from Westminster Art School wants accommodation immediate. 'Er wants comin' afore weather's broke. I got no 'sittin'' till you goes!—Plenty bedrooms, no 'sittin's'."

"Who is the lady?"

"Miss Compton."

"I know her; she may share my sitting room, if it is any convenience for you and her."

"Thanks, miss."

Mildred Compton came. At school I knew her only slightly; she was older than I, wealthy, stand-offish, prim.

"We will have little in common, but any way I shall only be in Boxford one week," I thought.

Mildred Compton was a society girl. I decidedly was not. We ate together, sat together, worked together—amiable, not intimate.

"I'm going back to London tomorrow," I said one night.

Mildred looked as if I had loosed an evil upon her.

"Oh! I did want to get two whole weeks sketching here, in Boxford."

"Does my going make any difference?"

"Of course, I could not *possibly* stay in a strange village all alone. Nothing but villagers!"

"They are quite tame."

"Queer things happen in out-of-the-way places!"

Mildred had been born condensed. Space alarmed her. She was like a hot loaf that had been put immediately into too small a bread-box and got mis-shapen by cramping. She was unaware of being cramped, because she was unconscious of any humans except those of her own class. The outer crowd propped her, but she was unaware of them. Away from crowds Mildred flopped.

I said, "I am in no hurry; I can stay another week if you like."

"Would you? How very kind!"

She was glad to have me. I was glad to elude London a little longer. Gladness drew us into companionship in spite of our different upbringings.

Cows and cobwebby barns terrified Mildred as history and crowds terrified me. The weather broke, there was nothing but cowbarns and sheds to shelter in against wind and rain while we worked. Smartly-dressed, lily-fair Mildred crouched on a campstool, set on a not too clean stable floor, hens scratching in the straw about her feet, a sow and litter penned in the corner, did seem unnatural, topsy-turvy, I'll confess.

Mildred, hurrying her things into her sketch-sack, asking breathlessly, "Doesn't the cow come home about this time, Motor?" Mildred saying, "I had no idea hens had such a vocabulary. The speckled thing has made six entirely different squawks in as many minutes. She makes me nervous, Motor!"

"Not as nervous as you make her."

"Ouch! there's a mouse!—behind that barrel—ouch, ouch!" She pinched her skirt in close.

"Mice much prefer the bran barrels to you!" I laughed.

She gathered up her things.—"Let's go."

"Motor, will you visit us for a week when we go back to London?"

"Me! Why, your life would scare me worse than the barn and hen scare you, Mildred. Besides . . . I couldn't."

"Why not?"

"Clothes!"

"*You* would be inside the clothes, Motor. We don't love our friends for their clothes. I want you to know my mother; I want my mother to know you. She is an old lady, a little lonely, a very lonely old lady sometimes!"

"Thank you, Mildred, I'd be a sparrow in a peacock house,—still—if a washed-to-bits muslin dress won't shame your dinner-table, I'll come. I would love to meet your mother."

I dreaded the ordeal, but I'd see London from another side. Yes, I'd go to Mildred's.

The Comptons lived in a dignified mansion in Belgrave Square. Every house in that square was important, wealthy, opulent. A little park was in the centre

of the Square; none but residents were permitted a key to the gate in its high iron fence. Belgravians seldom walked. Very few of the Belgrave Square people were aware of having legs, all owned horses. You could not drive in the little park; there were no roads, only trees, shrubs, grass, seats, and gravel paths.

The Compton family consisted of Mrs. Compton, her companion, an elderly lady named Miss Bole, who was a family institution—began as governess, continued as secretary till Mr. Compton died and was now companion to Mrs. Compton. Mildred divided her time between being a society girl and an Art student of Westminster. A staff of twelve servants attended to the creature comforts of the three women.

The Compton mansion was enormous and not half as cosy as one of our Western homes—thousands of stairs, no elevator, no telephone, no central heating. There were roaring grate-fires in every room but the halls and passages were like ice.

There was a marble swimming bath, a glass-topped billiard room, a conservatory and a walled garden through which I longed to run, unlock an arched doorway in the wall and pass into the mews where the Compton carriages lived. I hinted to Mildred about wanting to visit the horses, but Mildred hinted back that it was not done by London ladies, and I did not want to shame Mildred before her family.

The servants ran the house like clockwork, but they upset me dreadfully. The maids were so superior, and I wanted to push the footmen out of the way to save tumbling over them, rushing to do things for me I had rather do for myself. They made me feel as stupid as a doll.

Mildred's mother was beautiful. She was plump, with a tiny waist and great dignity, white hair, blue eyes, pink cheeks. I loved her the moment she took my hand and said, "So this is our little Motor." I was always "our" little Motor to her.

Miss Bole was plump too, with bright brown eyes like a robin's, black hair smoothed back. She always dressed in plain, rich black.

Belgrave food was marvellous, each help faded into your appetite without effort, like a tiny dream, not like the boarding-house stuff. This was food which, somehow, you never connected with a kitchen or a cook. The butler juggled it off the sideboard like a magician. A footman slid the silver dishes noiselessly to your elbow. Sometimes I remembered the heavy plates of heaped monotony slapped down in front of us by a frowsy maid at Mrs. Dodds' student home and laughed to myself.

Besides three table-meals a day we ate snacks in other rooms—wine and biscuits in the library at eleven in the morning, afternoon tea in the drawing-room, a little something in the library before going to bed, the early

morning tea in bed that destroyed your loveliest sleep and from which I begged to be excused.

When I asked, "Must I have that early tea, Mildred?" she exclaimed, "No early morning tea, Motor! Oh, you'd better."

So a prettiness in a frilly cap and apron stole into my room very early. She pulled back the heavy silk curtains, lit a fire in the grate, laid a downy pink rug before it; on that she set a white bath, half pudding-basin and half arm-chair. On either side of the tub she stood a great covered can of hot water, draped over the top with a snowy bath towel. Then she fetched a dainty tea tray, put it on a little table at the bedside, and, bending close, whispered, "Tea, Miss," and was gone. At Bulstrode Street yawns and groans would that minute be filtering through the cubicle curtains. The dressing bell—we called it the distressing bell—would clang, there would be pandemonium. And yet this wealth of luxury weighted me, not being born to it.

I had not dreamt that social obligations could be so arduous. After breakfast we marched soberly into the library to write notes, notes of inviting or of accepting. Every dinner, tea, house-party, call, must be punctiliously returned. I was rather sorry for these rich, they could so seldom be themselves; even their smiles were set, wound up to so many degrees of grin for so much intimacy. Their pleasures seemed kept in glass cases just out of reach. They saw but could not quite handle or feel their fun, it was so overhung with convention.

When later I told Mrs. Radcliffe where I had been staying, her eyes popped. She said "dear me!" six times, then she exclaimed, "Fred, Klee Wyck in Belgravia!" and again, "dear me!" After that she had nothing more to say.

While the ladies attended to the answering of the morning notes, Miss Bole took me and the key and went into the Park in the centre of the Square. This was the time I felt I really had got ahead of London. In the middle of the little park, among the trees and bushes, you were quite hidden from London and London was quite hidden from you. There was no traffic in Belgrave Square, only the purring roll of carriages and the smart step of dainty horses outside the railing of the little park. Even London's roar was quite cut off by great, high mansions all round. Every house-front was gay with flower-boxes. There was no grime, scarcely any sparrows—only a few very elegant pigeons who strutted in the park cooing. Miss Bole and I watched them, we did not talk much but we liked each other.

Mildred had a married sister who despised me for one of Mildred's "lowdown student friends." When she came to the house I was unhappy. She talked over my head and made me feel so awfully naked, as if I had no clothes

on at all. I felt ugly, shy, shabby and nervous the moment she came into the house, and feeling that way made me so.

One night Mrs. Compton gave a dinner party. The married daughter came. I slunk from my bedroom in the old white muslin, to find Mildred waiting for me on the stairs. She looked lovely, dressed in a gown all colours yet no colour at all, just shimmer. She held her hand to me. "Come, my poppet!"

"Oh, Mildred, I am so shabby in this wretched old muslin!"

"Motor, you are *Spring*."

She caught me up and kissed me. Suddenly I did not care about the old muslin any more. Mildred had sent Spring bubbling up into my heart, I knew she loved me for me, not for my clothes.

We "Noah-arked" into the dining-room. The men's coat tails swished so elegantly, the silks of the women rustled and billowed. Then came Miss Bole in her rich black, very quiet and clinging to her arm was me, just a little cotton rattle. Mrs. Compton placed me close to her. I watched, shy and very quiet till Mrs. Compton said, "Tell that little Indian story you told us at lunch, Motor." My face burned—I thought I should have died, but to please her I tried. It went all right till a beastly footman slithered a dish of peas close to my elbow and made me jump—the peas upset. The married daughter began to talk and laugh very loud. I wanted to hurl the peas, along with a frightful face, at her. I wish now that I had.

"Look at my face, Mildred."

"It is rather greeny white, isn't it? It's those stuffy rooms in the Westminster Art School, Motor."

"Is there any part of England where one can work outdoors all the year round?"

"At St. Ives there is an Art Colony who work outdoors nearly all the year."

"I'm going there."

Mrs. Compton ordered a great hamper to be packed for me. In it were four bottles of wine, a great plum cake, biscuits, nuts and fruit—the kind she knew I liked. I was to stay at the Temperance Hotel in St. Ives until I found rooms.

I went to say goodbye to Mrs. Radcliffe and to Mrs. Denny. Mrs. Radcliffe was a little glad; I think she resented the Comptons having me. Perhaps she thought Mrs. Compton would make me soft with too much petting. I did love Mrs. Compton, but I could not have got along without Mrs. Radcliffe's bullying and strength.

Mrs. Denny shook her head. "My dear," she said, "the R.C.'s are strong in Cornwall, beware!" She frowned at the little cornelian cross I still wore in spite

of her protests. The next day Ed staggered to Belgrave Square carrying two huge books, one under each arm—*Roman Catholicism Exposed, Volumes I and II!*

"Mother wants you to take these with you to read in your spare time."

"I shan't have any spare time, I am going to St. Ives to work like blazes, Ed. I have more luggage now—work things and food—than I can manage."

Kind Ed tucked the volumes under his arms again saying, "I understand." I liked Ed better that moment than I ever had before, loyal to his mother—understanding both to his mother and to me.

St. Ives

As our train slithered through the small prettiness of Devonshire I was angered. My parents had so lavishly praised its beauty to us when we were children. I wondered if after many years in Canada it would have seemed as small and pinched to them as it did to me seeing it for the first time—something one could fold up and put in his pocket, tiny patches of grass field hemmed about with little green hedges.

When we came to Cornwall, the land grew sterner and more jagged—stony fields, separated by low stone walls, stunted, wind-blown trees, wild but not with the volume of Canada's wildness. Cornwall's land had been punished into tameness, but her sea would always be boisterous, stormy. From Devonshire to Cornwall the land changed; Devon was, as it were, pernickety check, while Cornwall loosened to broader plaid.

My luggage looked sneaky and self-conscious wheeled into the Temperance Hotel. I knew Mrs. Compton's red wine blushed in its middle. I tried to forget its presence as I entered the Hotel, a sour-faced structure down in the old town. Never having stayed alone in a hotel before, I entered timidly.

The old town of St. Ives lay low, its rocky edges worn by the violence of the sea. On the hillside above was a smarter, newer St. Ives, composed of tourist hotels, modern houses and fine studios of Artists who had inherited wealth or made names—few students could afford the heights. Most students other than snobs and the ultra-smarts lived down among the fisherfolk in the old town. Fisherfolk packed themselves like sardines in order to enlarge their incomes by renting rooms to student lodgers. Many of the old sail lofts were converted into studios.

A few students lived at the Temperance Hotel and from them I made enquiry about studios.—Did I want *work* or studio tea-parties?—Work? Then go to Julius Olsen's Studio; he worked you to the last gasp!

To Julius Olsen I presented myself.

Julius Olsen's studio had been an immense sail loft overlooking the sea. The massive, blue-eyed Swede carelessly shoved my fee into the sagging pocket of his old tweed jacket, waved a hand towards the beach and left me stranded like a jelly fish at low tide, he striding off to criticize canvases which some boy students were turning from the walls.

"I'll show you," said an Irish voice at my elbow.

Hilda was the only girl student in the room.

"You will want to outfit?" she asked.

"I have my kit."

She looked at it with disapproval.

"Too light—'Jo' insists on weight,"—she exhibited her own equipment.

"Gracious! That easel is as heavy as a cannon and that enormous brass-bound paintbox! I can't, I *won't* lug such heaviness."

"Jo bellows if you cross his will," warned Hilda.

"Let him roar!"

She led me to the open front of the studio. Great doors folded back, creating an opening which was wide enough to admit three or four fishing boats abreast. A bar was fixed across the opening, we leaned on it looking at the busy fisher life buzzing on the beach below. Morning fish market was in progress. Buyers raced down from London on swift express trains, bartered for the night's catch, raced it back to London's markets.

Not Cornwall ate St. Ives' fish, but London. In St. Ives you could not buy so much as one herring.

Shrill-voiced fish-wives bargained, children yelled, cats yowled. Every house-roof, every street, every boat, swarmed with cats.

Each wife had seven sacks,
Each sack had seven cats,
Each cat had seven kits!

This was obviously the *cat* St. Ives of our nursery rhyme book.

The tide was far out. Looking down on it all, I was suddenly back in Mrs. Compton's drawing room standing before Moffatt Linder's picture, "St. Ives' Beach." Sky, sea, mudflats were shown but he had left out the bustle and the smell.

"Now," said Hilda, "to the sands and work!"

"Not work on those sands amid that turmoil!"

"Jo insists—white boats in sunlight—sunlight full on the canvas, too."

"Jo will find me in a shady street-end sitting with my back to the wall so that rubbernoses can't overlook."

Hilda's head nodded forebodings beyond working. "I'd advise that you don't let him see you work sitting," was her parting headshake. Leaving me to my fate she went off, lugging her heavy kit.

Stump, stump, I heard Jo's heavy footfalls on the cobbles and trembled, not scared of Jo, the man, but of Jo's artist eye, a splendid eye for colour, space, light. Nervous as a cat, I waited.

"Sitting to work!"

"Bad foot, sir."

"Huh! I said the sands, didn't I? Sunshine on sea and white boats. With the first puff that thing will blow out to sea," pointing to my easel. "Get the weighty 'Standard'."

"Too heavy to lug, sir. Mine is weighted. See!"

I showed him a great rock suspended in a paint rag and hung from my easel top.

"If you please, sir, the glare of sea and white sand blind me with headache."

Jo snorted, strode away—adoring English students never argued with their masters. He came back by-and-by, gave a grunt, made no comment and was away again! That was my first day of study under Julius Olsen. We remained antagonistic always. I believe each admired the other's grim determination but neither would give in.

The St. Ives students were a kindly lot—ready to give, ready to take, criticism. We numbered ten or more in the studio. Three Australian boys, a Frenchman, an ultra-Englishman, and an ultra-Englishwoman, (swells rooming up on the hill), a cockney boy, the Irish girl, myself, and the nondescript old women who are found in most studios just killing time.

We met in the big studio at eight each morning to receive "crits" on the work done the afternoon before. Olsen gave us criticisms three times a week, his partner, Talmage, the other three days. What one taught the other untaught; it was baffling but broadening. After "crit" we dispersed. The master came wherever we were working to examine our work on the spot. From eight in the morning till dusk we worked outdoors, in all weathers except during hurricanes. The great studio doors were shut then and we huddled under the studio skylight and worked from a model. But St. Ives was primarily a school for land- and seascape painting.

I found living quarters next to the churchyard. My host was a maker of antiques; he specialized in battering up and defacing old ship's figure-heads and grandfather clocks. Six grandfathers higgledy-piggledyed their ticks in my

sitting room. When they all struck high-count hours simultaneously your hands flew to your ears, and your head flew out the window.

My window opened directly onto the cobblestoned street with no mediating sidewalk. Heavy shoes striking cobblestones clattered, clattered day and night.

Student heads, wrapped in student grins, thrust themselves through my window announcing, "We are about to call!" Then I rushed like a flurried hen to protect "the complete beach." This object was an enormous mahogany and glass cabinet in which was displayed everything nautical except a mermaid— shells, coral, seaweed, fish bones, starfish, crabs—all old and brittle as eggshell. My foot and that of every student who called on me itched to thrust through the prominent glass corporation of this rounded glass monster, to crush, to crackle. My hosts, the Curnows, valued the thing highly. When a student warned through the window, I pushed the six straight-backed leather chairs whose leather laps were usually under the big mahogany dining-table (as if the chair feet had corns and were afraid of having them tramped on) and circled the chairs, round "the complete beach." The room was not any too large. What with this massive furniture, a fireplace, the cat and me in it, it was over-full.

My bedroom was marvellous! You reached it through an ascending streak of black between two walls. The treads were so narrow that they taught your toes the accuracy of fingertips on a keyboard. But glory dawned when I opened my bedroom door. Two large windows overlooked the sea. In the centre of the room stood an enormous bed—mahogany, carved with dolphins galloping on their rails. Mrs. Curnow told me this treasure-antique was built in the room by Pa Curnow himself. It would have sold many times over, only it had been built in the room, and could never be moved because no door, no window, certainly not our stair, would have permitted the passage of its bulk! There were four posts to the bed and a canopy of pink cotton. I was solemnly warned not to lay so much as a pocket handkerchief across the foot-board for fear of scratching or otherwise defacing a dolphin. Even on the side-boards dolphins galloped. I had to taut myself, run and vault in order to avoid touching one, when at night I retired to rest on the hard unbouncy mattress. Beside the bed there was little else in the room—a meagre washstand, a chair, a clothes closet set in the wall. The closet contained all the family's "best." This is a Cornish way; rental of a room does not include its cupboards.

My Curnow family were reputed the cleanest folk in St. Ives because for years they had threatened to install a bath in their house. No other family had gone that far. I bargained for a hot wash once a week. The three women, mother and two girls who would never see forty again, gravely consulted. It

could be managed, they said mournfully, but Saturday was always an anxious and disturbed day for the Curnow family.

Ma tiptoed into my room after supper and, carefully shutting the door, whispered, "The cauldron, Miss, it is heated to wash your feet."

She would not have allowed "the girls" to hear mention of such a thing as a bath. No one suspected of such indecency as taking an "all-over"! The tin footbath was set as far as possible from the dolphins, who were draped in pink calico for the event. Greatest secrecy was exercised in getting the bath down the dark stair and through the kitchen without old Curnow or a visitor seeing. The girls frankly admitted they preferred men lodgers. If they must bathe they did it in the sea.

When storms came the whole St. Ives Bay attacked my room with fury and with power. The house was built partly on the sea-wall, and waves beat in thuds that trembled it. The windows, of heavy bottle-glass stoutly braced, were dimmed with mazed green lights. I was under the sea. Sea poured over my roof, my windows were translucent, pouring green, which thinned, drew back receding in a boil of foam, leaving me amazed that the house could still be grounded. Water raced up the alley between the graveyard wall and our house, curled over the cobble-street to meet the flood pouring over the low roof-top of the house on the other side of ours. We were surrounded by water. Privies, perched on the sea wall, jaunted gaily off into the bay. Miles inland bundles of white fluff, dry as wool, clung to the trees; it was beaten foam, carried inland by tearing wind. These storms were, of course, exceptional but there was usually breeze in St. Ives, though she had many, many bright, glistening days—sea sparkling, air clear, mudflats glowing.

Tides ruled the life of the town and of the fishermen. All night lanterns bobbed, men shouted, boats clattered over cobbles, cats prowled the moonlight, their eyes gleaming.

The Irish girl Hilda and I were warm friends. Outdoors we did not work together—she was for sea, I for land. But we hired fisher children to pose for us in the evenings, working by a coal-oil lamp in my sitting-room. The boy students jeered at our "life class" but they dropped in to work with us off and on.

The atmosphere of Julius Olsen's studio was stimulating. He inspired us to work. He was specially nice to his boy students, inviting them up to his own fine studio on the hill, showing them his great seascapes in the making, discussing an artist's problems with them, treating them as fellow workers.

Mrs. Olsen was a billowy creature who only called on those of her husband's students who were worth while; she did not call on me.

I never liked Jo much, but I respected his teaching and the industry which he insisted that his students practise and which he practised himself.

Christmas came, everyone went home except me. The Olsens went to Sweden on their yacht. Noel, a nice English student, came to bid me goodbye.

"I say, it's going to be beastly lonely for you with everybody gone—studio shut. What shall you do with yourself?"

"Explore. Albert will still be here, he will pilot me, he knows Cornwall."

"Albert! That wretched little cockney!" said the autocrat, Noel, with a lift of his nose.

"I *could* visit, too, if I wanted." I tossed a letter across for Noel to read.

"Whew—horses to ride and all and you turned this down!" he exclaimed.

"Don't like the outfit, connections by marriage, snobs, titled too!"

"What matter? Put likes and dislikes in your pocket, silly; take all the good times you can get."

"Take and hate the giver?"

Noel shrugged, "I *was* going to ask Mother to invite you to visit us in the summer holidays. How about it, Miss Snifty?"

"Try."

"Tell me, what are you doing at this present moment?" asked Noel. "Hat, felt slipper, snipping, sewing—it's beyond my figuring entirely!"

"Felt from under hat ribbon provides patch for toe of slipper. See, Mr. Dull-Head?" I fitted the patch.

Noel's roaring laugh—"Canadian thrift!" He vaulted through the window shouting, "I'll ask Mother about the summer visit."

Cornish people love a wrench of misery with every joy. The Curnows wept all through Christmas. I came upon Pa, Ma, and both girls, stirring the plum pudding, eight eyes sploshing tears down into the mixing bowl.

"Anything wrong?"

"Always something wrong for we," wailed Ma.

It seemed some relative preferred to Christmas elsewhere than with the Curnows. Their grief seemed so disproportionate to the cause that I laughed. Eight mournful looks turned upon me.

"You be awfu' merry, Miss. Thousands of miles betwixt you and yours, yet you larf!" There was reproach in the voice.

Under the guidance of Albert I saw Polperro, Mouse-hole, St. Earch, St. Michael's Mount and more places. Little cockney Albert enjoyed having company. He was not quite one of us—no one bothered about him.

For one week Albert and I holidayed, then I fell on work with doubled fury. I knew I was a fool, grinding, grinding, but I had so much to learn, so little time.

They all came trooping back to the studio. Olsen outstayed himself by a matter of six weeks. Talmage took charge. High on the hill I had discovered

Tregenna Wood—haunting, ivy-draped, solemn Tregenna. Talmage saw what I had been doing up there during the holidays, away from the glare and racket of St. Ives. He was a calm, gentle man, one who understood.

"Trot up to your woods; that's where you love to be. I will come there and give you your lesson."

I gave a delighted squeal. "Oh, but, Mr. Talmage, wouldn't it be too far for you to come for my lesson alone. None of the other students work there."

"Trot along; one works best where one is happy."

Tregenna Wood was solemn, if not vast. A shallow ravine scooped through its centre. Ivy crept up the tree-trunks to hang down in curtains. No students worked here, few people passed this way. A huge white sow frequented Tregenna, a porky ghost, rustling through the bushes. She aimed always to pass at lunch hour so that she might share my lunch. If I had any form of pig-meat (Mrs. Curnow often gave me fat pork sandwiches), then, out of delicacy, I did not offer anything but the breadcrust.

The students teased me about my "lady friend in Tregenna" but I loved my sow. I wrote a poem and made a skit about the students and her. It was more complimentary to the sow than to the students.

I said to Talmage, "I don't care if Jo never comes back; I learn much more from you than from him."

"Jo is the better artist," replied Talmage. "Jo is a genius. What I have got has been got through grind. Probably that helps me to understand my students' problems better."

He praised my woods studies highly, so did the students.

Jo came home.

"Jo's home! 'Crits' in the studio at eight tomorrow!" A student's head thrust the news through my window.

I had a vast accumulation to show Jo. I knew the work was good—happy, honest stuff. I swung into the studio with confidence. Jo was pacing the floor. The Frenchman sat crying before his easel. Jo gave me a curt nod, "Fetch your stuff."

I turned my canvases face out, waited—silence, except for Jo's snorts through a dead pipe.

"Maudlin! Rubbish!" he bellowed, pointing his dead pipe at my canvases. "Whiten down those low-toned daubs, obliterate 'em. Go out *there*," (he pointed to the glaring sands) "out to bright sunlight—PAINT!"

Kicking the unlucky canvases into a corner, I bolted. No one was going to see me as I had seen Frenchie.

On a desolate road far beyond the town I came to my unhappy self. On either side the way were fields of frosted cabbages. I crept among them to sit

down on a boulder, rocking myself back and forth, crying, crying till I was very hideous and very hungry.

I got up. I'd see how the others came out. I dragged myself back to town.

Burgess, one of the Australians, studied under Jo, but he had a studio of his own. Burgess and I had a pact. He had chased away a fisherman who had religious mania and tormented any student he could find working in a quiet corner, as to their views on purgatory. In return I went to Burgess' studio when the Frenchman had declared his intention of giving him a "crit," because, unless Burgess had company, the Frenchman *would* kiss him, not only on one but on both cheeks.

It took three knocks to rouse a dreary, "Come in." When I pushed open the door Burgess was seated on a three-legged stool before a dead grate, his red hair wild, his hands shaky. He kicked forward another stool.

"Poor Mother, she will be so disappointed. Do you suppose Grant's will take back that gold leaf frame?"

"The one for your Academy picture?"

"Academy! I'm returning to Australia right away. You may have the pile of canvas stretchers."

"Thanks, but I'm thinking of leaving for Canada myself immediately."

Shamed grins spread over our faces.

"Let's call on the rest, see what Jo did to them."

We met Ashton; he was whistling.

"Get a good 'crit', Ashton?"

"You bet."

"Liar," muttered Burgess. "Hello! There's Maude, . . . morning, Miss Horne, Taken your 'crit'?"

"Criticism first morning after Jo's vacation! Not I. Jo always returns in a rage. This time it is two rages—his usual and a toothache. You pair of young fools!" she grinned at our grief-wracked faces. "Poor children, I s'pose you knew no better." Maude put on airs.

"I'm hungry as a hunter, Burgess. I'll run home for a bit, then the sun will be just right for painting those cottages in the Diji. Oh, about those canvas stretchers?"

"Needing them myself!"

We exchanged grins. Burgess had forgotten Australia. I had forgotten Canada. With noses and hopes high we were off again to work.

When long vacation came I went back to London.

A sneezing creature sitting next to me in the train gave me 'flu. When that was through with me, I crawled to Westminster. 'Flu had sapped the energy I

had forced so long. Mildred found me huddled on a bench in the Architectural Museum, among the tombs—idle.

"Why, Motor!"

"After 'flu, Mildred."

"If we were not just starting for Switzerland I'd take you home right now."

Mrs. Radcliffe groaned, "You'd best take a strong tonic, Klee Wyck. Why you should fall to pieces the moment you come to London I can't imagine. London suits *me* all right."

Always kind, Fred said, "Try Bushey, Herts, Klee Wyck—Herkomer's Art School, a big art colony. Bushey is an easy run up to London for exhibitions and galleries. You just don't thrive as Mother does in London."

To Bushey I went.

Bushey

The Station Master's direction was accurate. "Bushey? Turn by that 'ere pub and keep a-goin'."

The road was a long squirm without any actual turnings.

Herkomer had built a theatre in connection with his Bushey art school; more time was now devoted to drama, they said, than to Art. For earnest Art I was advised to go to John Whiteley, Number 9, Meadows Studios.

The Meadows Studios stretched in a long row. Of unplaned lumber, linked together like stitches in a chain of crochet, they ran across a hummocky field, spattered with kingcups. Each frame building was one room and a thin corridor wide. Each had a door into the emaciated passage and a large north window.

The land around Bushey dipped and rose pastorally and was dotted with sheep, cows and spreads of bluebells. Everything was yellow-green and pearly with young spring. Larks hurried up to Heaven as if late for choir practice. The woods in the hollows cuckooed all day with cuckoos; the air melted ecstatically into the liquid of nightingale music all night.

John Whiteley was a quiet man and shy, his teaching was as honest as himself. There were sixteen students in his class, men and women. We worked from costumed models, often posed outdoors among live greenery. The students were of the Westminster type—cold, stand-offish. They lodged in the village. Being mid-term, all rooms were full, so I had to climb the hill to a row of working men's houses to find accommodation. Many in the row were glad to let rooms. The man and wife in my house kept the kitchen and the front bedroom for their own use, renting the front room downstairs, into which the

house door opened, and the back, upstairs bedroom. The back door was their entrance. They were expecting their first baby—and were singing happy about it, so happy that they just had to do something for somebody. They showed me many kindnesses. When there was nothing else she could think of the woman would run into their tiny patch of back garden and pull half a dozen rosy, tender-skinned radishes for my tea. The man, returning from labouring as a farm hand, would ask of me, "Can 'er go through you, Miss; it be a long round from back. 'Er's not spry jest now. Us likes listenin' to nightingales down to valley"—and, passing hand in hand through my room, they drifted into the dimness of the dusky fields.

Mr. Whiteley's was a silent studio. No one talked during pose; few spoke during rests. To English girls Canadians were foreigners. A snobby trio in the studio were particularly disagreeable to me. They rented a whole cottage and were very exclusive. The bossiest of the three was "Mack," an angular Scotch woman. The other two were blood sisters and English. They had yellow hair and black eyes and were known as "The Canaries." After an ignored week, I came into the passage one morning to find a scrawny youth trying to make up his mind to knock on Mr. Whiteley's door.

"This Mr. Whiteley's studio?"

"Yes."

"Can I see him?"

"He does not come for 'crit' before ten."

The youth fidgeted.

"What'll I do? I'm a new student."

"Come on, I'll show you."

He threw a terrified look round the room when I opened the door, saw the work on the easels and calmed. I think he had expected a nude model. I got him an easel and board, set him in a far corner where he could not be over-looked, showed him where to get charcoal and paper. He was very grateful, like a chicken from a strange brood that an old hen has consented to mother. He stuck to me. The Canaries and Mack froze, throwing high noses and cold glances over our heads.

That night there was a tap at my door. A tall, loose-knit boy stood there. He said, "I'm from St. Ives. The students said to be sure to look you up. My name is Milford and do you mind if I bring Mother to see you? I'm going to Whiteley's too. Mother's come to settle me in—she's two doors off."

Milford had a stepfather who considered both stepsons and art unneces-sary nonsense. The mother doted on Milford. "That dear boy won't chew, such poor digestion. Keep an eye on his eating," she pleaded, "insist that he chew

and, if you would take charge of his money. He spends it all the first day, afterwards he starves!"

I said I would do my best over Milford's chewing and cash. I felt very maternal with two boys under my wing.

Milford lived down the street; his table was pushed close to the window. I passed at mealtimes whenever possible and yelled up, "Chew, Milford, chew!" He kept his weekly allowance in a box on my mantelpiece.

"Can I run up to London this week-end?"

We would get the box down and count. Sometimes I would say, "Yes," and sometimes, "No, Milford, you can't."

Milford and I sketched around the Bushey woods. Little Canary followed us. Presently we would find her easel set close to ours. Milford and I humanized those Canaries. (We never tackled Mack.) Little Canary soon ate out of my hand; she was always fluttering around me, and I gave her a hard flutter too. I made her smoke, damn, crawl through thorny hedges, wade streams. I brought her home in such tatters as made Big Canary and Mack gasp. They were provoked at Little Canary for accepting my lead. I behaved outrageously when Mack and Big Canary were around; I wanted to shock them! I was really ashamed of myself. The boys grinned; perhaps they were ashamed of me too—they were English. Mack would say, "Where *were* you brought up?" and I would retort, "In a different land from you, thank Heaven!"

One Saturday morning I came to Studio late. The door banged on me and I "damned". I felt shudders and tension in the room, then I saw two strangers—a doll-pretty girl, and an angular sourness, who knitted beside the doll while she drew.

Kicking Little Canary's shin, I mouthed, "Who?"

"Wait till rest," Little Canary mouthed back.

It seemed that the silk-smocked, crimp-haired girl was titled and a tremendous swell, an old pupil of Mr. Whiteley's. The other was her chaperon. They had been abroad. This was their first appearance since I had been at Mr. Whiteley's studio. The girl only "arted" on Saturday mornings and was always chaperoned. The chaperon had been heard to allude to Mr. Whiteley's Studio as "that wild place!" Her lips had glued to a thread-thin line when I "damned." She stopped knitting, took a shawl from their various luggages, draped it over the doll's shoulder that was nearest to the wind which had rushed in with my entry. She took the doll's spectacles off her nose, polished them and straddled them back again, sharpened six sticks of charcoal neatly into her pocket-handkerchief, then shook the dust and sharpenings over the other students and resumed knitting. After class they were escorted to their

waiting carriage by a foot-man bearing the girl's work gear. The Canaries and Mack bowed as they passed.

I laughed all the way home, then I drew and rhymed a skit in which we all decided that we must bring chaperons to this "wild place." Even the Master had to "bring his loving wife and she their children three."

The model said, "I will not sit
In solitude alone,
My good old woman too must come
And share the model throne!"

I took my skit to class on Monday. The Canaries were very much shocked,—a student caricaturing a master!

"Suppose he saw!" they gasped.

"It would not kill him," I grinned.

At rest I was sitting on the fence, giggling over my skit with the boys when Mr. Whiteley came by.

"Can I share the joke?"

The boy holding the sketch wriggled, "It does not belong to me, sir, it is Miss Carr's."

Mr. Whiteley looked enquiringly at me.

"Just some nonsense, but certainly if you wish to, Mr. Whiteley."

He took the skit in his hand, called "Pose"; it was the last pose of the morning. Dead silence in the studio, Canaries very nervous. Noon struck, model and students filed out, Mr. Whiteley settled himself to read, to look. The Canaries hovered; they were going to be rather sorry to see me evicted from the class—in spite of my being colonial and bad form it had been livelier since I came, they said.

Chuckle, chuckle, laugh, roar! Great knee-slap roars! No one ever dreamed Mr. Whiteley could be so merry. The hovering Canaries stood open-mouthed.

"May I take this home to show my wife?"

"Certainly, Mr. Whiteley."

"This chaperon business has always amused her."

He did not bring my skit back next morning, instead he took from the wrapping a beautiful sketch of his own.

"Will you trade?" he held out the sketch—"My wife simply refuses to give your skit up!"

"She is most welcome to it, Mr. Whiteley, but it is not worth this."

"We think so and, anyway, I should like you to have a sketch of mine to take back to Canada."

There was wild jealousy. Mack happened to be home ill. Little Canary asked, "May I take Mr. Whiteley's picture to show Mack?"

Mack said, "Huh! I doubt *that Canadian* is capable of appreciating either the honour or the picture!"

In the little wood behind the Meadows Studio, where the cuckoos called all day, I learned a lot. Like Mr. Talmage, Mr. Whiteley said, "Trot along to your woods; I will give you your 'crit' there, where you are happy and do your best work."

That was a luscious wood, lovely in seeing, smelling and hearing. Perpetual spring seemed to be there.

I remember with affection and gratitude something special that every Master taught me. Mr. Whiteley's pet phrase was, "The coming and going of foliage is more than just flat pattern." Mr. Talmage had said, "Remember, there is sunshine too in the shadows," when my colour was going black. Sombreness of Tregenna! Sunshine of Bushey! Both woods gave me so much, so much, each in its own splendid way, and each was interpreted to me by a good, sound teacher.

Birds

I worked in Bushey till late Autumn, then decided to winter again in St. Ives. But first I must return to my London boarding house and get my winter clothing from a trunk stored at Mrs. Dodds'. (We were allowed to store trunks in her basement at tuppence a week, a great convenience for students like me who were moving around.)

Always, when approaching London, a surge of sinking awfulness swept over me as we came to its outskirts, and the train began slithering through suburban manufacturing districts. Open country turned to human congestion, brick and mortar pressed close both sides of our way—ache of overcrowded space, murk, dullness stared from behind the glazed fronts and backs of brick houses. No matter how hard I tried, I could not take interest in manufacturing districts—they wilted me. Love of everything, that swamped me in the country, was congealed here, stuffed away like rotten lettuce. Nothing within me responded to the hum of machinery.

A crawling slither and the train oozed into the allotted slot, opened her doors and poured us into Euston's glare and hurry. Worry about luggage came first. To me the wonder is that any ever *was* found—no checking system, identification established solely by means of a pointing finger. The hot, hard pavements of London burned my foot soles.

"Why must you fuss so immediately upon coming to town?" I enquired angrily of my aching feet, and took a huge china water-pitcher from my cubicle to the floor below for hot water. The stair was straight and very long, the jug of water heavy. Only one step more, but one too many! I reeled; every step registered a black bump on me. There I lay in a steaming pool, among pieces of broken pitcher. I might have been an aquatic plant in a fancy garden.

The steaming water seeped beneath the doors of rooms. I hurt terribly, but the water must be mopped up. My groans brought students to doors which they slammed too quick and grumpily to keep the water out of their rooms.

I was unable to rise next morning. I sent a wire to Mildred, "Tumbled downstairs, can't come." Mildred sent the carriage and insisted. So I went. I managed to keep going till bedtime. That night is a blur of awfulness. When Mildred came into my room next morning she sent quickly for the doctor. Two nurses came, straw was laid on the pavement to dull the rumble even of those elegant, smooth-rolling carriages. For six weeks I lay scarcely caring which way things went.

"Send me to a nursing home," I begged. But Mrs. Compton's cool hand was over mine, "Go to sleep, little Motor, we're here." She always wore three rings—a hoop of rubies, a hoop of sapphires, and a hoop of diamonds. Even in the darkened room the gems glowed—they are the only gems I have ever loved. They were alive and were on a loved hand.

The doctor came and came. One day after a long, long look at me, he said, "You Canadians, I notice, don't take kindly to crowded cities. Try the sea-side for her, Mrs. Compton."

"There will be trees and air," I thought, and was glad.

There were no trees. The small, private convalescent home was kept by a fool. Because she had nursed in the German Royal Family she fancied herself. Every day she took their Royal Highnesses' photographs from the mantelpiece and kissed their ugly faces before us all. It made us sick. She was the worst kind of a snob ever made.

The sea was all dazzle and the sands white. My room was white, even the blinds. I asked for dark—the glare hurt my head. If I sat in dark corners Nurse said I was morbid! From my window I saw a scrub willow-tree. I took a rug and lay in the little back lane under the willow. Looking up into its leaves rested my eyes. Nurse rushed out, furious.

She shrieked, "Morbid nonsense! Get out onto that beach, let sunshine burn the germs out of you!"

I was wretched but I shammed robust health to get away from her house. I fooled the nurse so that she let me travel to Noel's mother. She had come

several times to Belgrave Square and said, "Come to us as soon as they will let you travel. Don't wait to be well, come and get well in our garden—my four boys to wait on you!"

The journey relapsed me. I was so desperately ill that they wired to Canada. I did not know that until my sister Lizzie marched into the room. They sent her because she was on the edge of a nervous breakdown and they thought the trip would do her good. It was bad for both of us. This sister and I had never got on smoothly. We nearly sent each other crazy. She quarrelled with my doctor and my nurse, got very homesick, wanted to take me home immediately. The doctor would not let me travel. She called him a fool, said he knew nothing. She scolded me. I went to a London specialist. He was as determined about the travel as my own doctor.

"Complete rest, freedom from worry and exertion for at least one year."

He recommended an open-air Sanatorium, and, above all, that my sister go home, leave me.

Lizzie was very, very angry. She refused to go because of what people would say. By luck my guardian and his wife came tripping to the Old Country. When my guardian saw me all to bits, tears ran down his cheeks.

"Anything to get you well, Millie," he said, and prevailed on my sister to return home leaving me in a Sanatorium—no work for me for at least one year!

East Anglia Sanatorium was primarily for tuberculosis. They also took patients like myself, who required rest, good feeding and open air. The Sanatorium was situated in a beautiful part of England. I was there for eighteen months, surrounded by slow-dyings, and coughing! . . . But for birds I doubt I could have stood it.

The countryside was alive with song-birds. It was gentle, rolling country, open fields, little woods, such as birds love. There were wild rabbit warrens too, so undermined with rabbit-holes that few humans walked there. The birds had it all to themselves and let me share.

I could not walk as the lung patients were made to under doctors' orders, slow, carefully timed walks. I was kept in bed a good deal. When up, I was allowed to ramble where I would, my only restriction was, "Do not overtire." I would lie in the near woods for hours, watching the birds.

Everyone was very good to me. The Sanatorium was run entirely by women—women doctors, women gardeners. The head doctor came down from London twice a week. Often she talked with me about Canada—she had a desire to go there.

"England beats Canada in just one thing," I said.

"What is that?"

"Song-birds."

"Why don't they import some?"

"They did, but in such a foolish way they all died—poor trapped, adult birds, terrified to death."

"Could it be successfully done?"

"I know how I'd go about it. First, I would hand-rear nestlings, take them to Canada, keep them in semi-captivity in a large, outdoor aviary. I would never liberate those old birds, but let them breed till there was a strong band of young ones to free."

"Sounds reasonable, go ahead," said the doctor.

"You mean I could raise my little birds here?"

"Why not, open air, birds in plenty!"

My life began again. I sent to London for books on how to hand-raise English song-birds. I decided to concentrate on thrushes and blackbirds. One month now and they would start nesting. Buds on hedge-rows were no more than reddish bulges when blackbirds and thrushes began hurrying twigs and straws into the larger crotches and firming sticks for foundations, lining the nests with mud. Mother thrush and I were friends long before the eggs hatched; she did not suspect me of being a sneak-thief.

I took young birds, nest and all, just before consciousness chased the blank from the fledglings' eyes. Once they saw, it was too late, for they cowered down in the nest and would not feed. My hand must be the first idea in their brains connected with food. Had they seen their feathered mother before me, they would have preferred her. Mother thrush was delighted to be relieved of her responsibility. She was already planning her next nest. If you went out after a steal early next morning, she was busy building again, quite happy. Had I taken but half of her family, left the rest for her in the old nest, she would have let them die.

My nurse was co-operative. Anything that relieved the flat monotony of San life was welcomed by the patients. They were all twittery over the birds for Canada. Suddenly they became interested in ant hills and grubs. Offerings were left for my birdlings on my window ledges when patients came from walks. Soon I had all the nestlings I could care for.

The nests stood on a table by my bedside; I fed the birds every two hours between dawn and dusk, poking the food into their gaping mouths with a tiny pair of pincers I made out of wood. My nestlings grew with such furious intensity you almost saw the feathers unfold. The biggest surprise was when inspiration first touched the wings and, wriggling to be free from the crowding of brothers, the fledgling rose to his feet, flopped one wing over the side of the nest.

Then suddenly he knew the ecstasy of flight. Once having spread his wings, never again could he endure the crowded nest. Oh, I knew how it felt! Hadn't I been thrilled when first I felt freedom? Now London had winged me, but I had once known what it was to be free! When they had mastered flying and feeding, the birds were put into a big cage built for them in the yard.

All the San loved my birds. Old Mr. Oakley, broken by the Boer War, wracked by coughing, crawled, by the aid of a nurse and a stick, to the cage every morning to watch my birds take their bath. Therese, the dying child in the room next mine, tapped in our special code, "How are the birds?" I would scrabble little taps all over the wall to describe their liveliness. Gardeners left tins of grubs and worms on my window sill, cook sent things from the kitchen. Patients took long-handled iron spoons on their walks and plunged them into ant-hills to rob the ants of their eggs for my thrushes. Kitchen maids donated rhubarb and cabbage leaves to lay on the grass. These, watered, drew little snails to their underneath cool—bird delicacies.

When the thrushes and blackbirds were out of hand, I took two nests of bullfinches to rear. These were the San darlings. If a patient was feeling sad, a nurse would say, "Lend the soldiers;" and off would go the cage with a row of little pink-breasted bullies sitting, singing and dancing with the bullfinch comic shuffle to cheer somebody's gasping despondency. Oh, the merry birds did help!

The big Scotch house-doctor christened me "Birdmammy" because one day she paid her rest-hour visit to find five baby bullfinches cuddled under my chin. Their wings had just become inspired. This was their first flight and made to me, the only mother they had ever known.

What birds meant to the East Anglia San only those who have lain helpless among slow-dying know. The larks, hoisting their rippling songs to Heaven, sinking with fluttering pause back into an open field! The liquid outpourings from thrush and blackbird throats! A great white owl, floating noiselessly past our open rooms, turned her head this way and that, the lights of our rooms shining her gleaming eyes. A sudden swoop—another field-mouse's career finished! Birds of East Anglia! You almost compensated for torn lungs and overwork breakdowns.

On her weekly visits to the Sanatorium the London specialist scuttled past the door of my room, ashamed to face me. For months she had promised to write home to my people. (It took six weeks for an answer to a letter in those days.) Every week the little house-doctor pleaded with the big specialist.

"Don't forget to write to Canada about Mammy's condition." I was getting nowhere, nothing was being tried to help me.

Each week the "Big One" would say, "Dear me, I have been too busy to think of it. I will do it this week."

Then she would neglect writing again. Little house-doctor was bitter about it—I was disheartened. Had my check to the San not come regularly the "Big One" would have stirred herself to look into matters at once. Had I been a celebrity or possessed of a title she would have remembered. I was only a student who had overworked. The East Anglia Sanatorium was a company. The London doctor was its head. She snivelled over me, pretending devotion. My faith in this country was broken. I had no faith or confidence in the big, bragging doctor. She was a tuberculosis specialist. I saw patients contract all sorts of other troubles in that San. As long as their lungs healed and added glory to her reputation! Nothing else mattered.

Bitter Goodbye

W hen they were about nine months old, my birds began to get very quarrelsome, damaging each other by fighting. From my bed I heard trouble in the cage but I could not go to them. I had now been in the Sanatorium for over a year. I was losing, not gaining. At last, to my dismay, I found that all my contemporaries were either dead or had gone home to continue the outdoor treatment there. A few, a very few, were cured.

The big Scotch house-doctor who was at the San when I came had been succeeded by a little English woman doctor of whom I was very fond. Most of the old nurses, too, were gone, new ones had come.

One day the London doctor introduced me to a visiting physician she had brought down with her for the week-end.

She said of me, "This is the San's old-timer." Shame swept me as she said, "Sixteen months, isn't it, Mammy?" She turned to the visitor, explaining, "She's Mammy to every bird in the neighbourhood, raising nestlings to take back to Canada where they have few songsters."

Canada! Why, I was no nearer the voyage than I had been sixteen months back. I knew by everyone's gentleness to me, by the loving, evasive letters I received from old patients, it was not expected I would ever get back to Canada.

I was troubled about my birds. The old friends, who had always been willing to lend a hand with them when I was laid up, were gone—newcomers were indifferent. They did not know the birds, did not know me. The birds themselves were increasingly quarrelsome. The whole situation bothered, worried me. I pondered, unhappy.

At last the doctor had written to my people in Canada. It was decided to try a severe, more or less experimental, course of treatment. A special nurse was brought down from London, a masseuse, callous, inhuman, whom I hated. The treatment consisted of a great deal of massage, a great deal of electricity and very heavy feeding. This nurse delighted in telling horrible stories, stories of deformities and of operations while she worked over me. Her favourite story was of a nephew of hers, born without a nose. One hole in the middle of his face served as both nose and mouth; it sickened me. I appealed to the doctor who forbade nurse talking to me during the long hours of massage. This angered the woman; she turned mean to me.

The day before treatment started I said to the little house-doctor whom I was fond of, "What about my birds?"

The treatment was to last from six to eight weeks. Doctor was silent. I went silent too.

I asked, "May I get up for half an hour today?"

"You are too weak, Mammy."

"There is something I must attend to before treatment starts."

"Your nurse will do anything."

"This thing only I can do."

She gave a humouring consent. I knew she thought it made little difference. Her eyes filled; she was a dear woman.

In the quiet of the rest hour, when nobody was about, I slipped from my room, out through a side door in the corridor, into the yard where my birdcage stood. The birds heard my stick, my voice—they shrieked delightedly. I caught them every one, put them into a box which I took back into my bedroom.

Panting heavily I rang my bell, "Send doctor!"

Doctor came hurrying.

"Chloroform my birds."

"Oh, Mammy! Why not free them?"

"I love them too much! Village boys would trap the tame things—slow starvation on a diet of soaked bread and earth worms! Please, doctor! I've thought it all out."

She did what I asked.

The next day I was moved into a quiet, spacious room—treatment under the new nurse began. She would allow no one to come into the room but the doctor. I was starved on skim milk, till they had brought me as low as they dared. Gradually they changed starvation to stuffing, beating the food into my system with massage, massage, electricity—four hours of it each day. The nurse was bony-fingered, there was no sympathy in her touch; every rub of her hand

antagonized me. The electricity sent me nearly mad. I was not allowed to read, to talk, to think. By degrees I gained a little strength but my nerves and spirit were in a jangle. By and by I got so that I did not want to do anything, to see anybody, and I hated the nurse. I had two months of this dreadful treatment—eighteen months in the East Anglia Sanatorium all told! Then the doctor said, "Now we will try letting you go back to work."

Work! I had lost all desire to work now. When first ill I used to ask, "When can I get back to work, when can I get back to work?" continually, and they had answered, "When you have ceased wanting to." I suppose they had got me in that place now—thought they had killed eagerness and ambition out of me.

Nurse took me up to London. I spent a wretched day or two in the house of the "Big One." At the time she was in a burst of exhilaration because she had been summoned to attend the wife of the Dean of St. Paul's. If it was not Lady this or Lord that, it was the Very Reverend Dean. Stretching after Big Pots, yearning to hang on to the skirts of titled, of "worthwhile" people—English worship of aristocracy! Oh, I loathed it! I left the doctor's house and went down to Bushey, forbidden ever to attempt working in London again.

The Bushey Studios were closed; classes would not re-open for two weeks. I took rooms in the village, disheartened, miserable, broken, crying, always crying, couldn't stop.

The San's little house-doctor took a long, round-about, cross-country journey from the San to Bushey specially to see me. I cried through her entire visit. She was deeply distressed at my condition, and I was shamed.

Through my tears and a pouring rain, I watched her wash down Bushey High Street. Yet doctor's parting words had done me vast good. This is what they were,—"I realize how hard it is after eighteen months of absolute inertness to find yourself again adrift, nobody, nothing, weak as a cat! I am proud of the fight you are putting up." After she had gone she ran back up the steps again to take me in her arms, hold me a moment tight, tight, say again, "I am proud of you!"

Oh how could she be proud of such a bitter-hearted, sloppy old coward? In my room she saw evidence of trying to pick up life's threads again. She guessed the struggle. I wished I had not cried all the time she was there! I'd make her laugh yet. "I'll make Little Doctor and all of them laugh!" I vowed and, running to my trunk, dug up a sketch book and fell to work.

Two weeks I laboured incessantly over a satire on the San, and on the special treatment. I wrote long doggerel verses and illustrated them by some thirty sketches in colour, steadily crying the while. The paper was all blotched

with tears. I just ignored the stupid tears. The skit was funny—*really funny*; I bound the pages together, posted them off to Little Doctor—waited—.

Promptly her answer came.

"Bravo! How the staff roared!—all the staff but matron and me, we knew its price."

The world was upside down! The ones I had aimed to make laugh cried. I loved doctor's and matron's tears all the same and, believe it or not, their tears dried mine.

I went back to Mr. Whiteley's studio and slowly got into work again. It was not easy. I was weak in body, bitter in spirit. In about three months I was to be allowed to travel.

Five years and a half in London! What had I to show for it but struggle, just struggle which doesn't show, or does it, in the long run?

Mrs. Radcliffe, Mrs. Denny, Mildred had all been down to the San, from time to time, to visit me. Just now I could not bear Mrs. Radcliffe's bracing, Mrs. Denny's religion, Mrs. Compton's and Mildred's love. No, my pride could not face them, not just now. Without good-byes, I slipped through London, straight to Liverpool. Good-bye to my high hopes for work, to my beautiful birds, to my youngness! Good-bye, good-bye, good-bye—surely enough good-byes. Yet my ungracious creeping past those in London who were so kind to me has always left deep down in me a sore feeling of shame and cowardice.

I did not know the land which haze was swallowing was Ireland. I only knew I was glad to be leaving the Old World.

"Sure, it's Ireland is your home, too?" an Irish voice said at my side. I looked into the blue eyes of an Irish boy, homesick already.

"Canada is my home," I replied.

He faded into the crowd. I never saw but I thought often again of that kind boy who took for granted that my sadness was homesickness, same as his. Sad I was about my failures, but deep down my heart sang: I was returning to Canada.

Part III

Cariboo Gold

J ust before I left England a letter came from Cariboo, out in British Columbia. It said, "Visit us at our Cariboo Ranch on your way west." The inviters were intimate friends of my girlhood. They had married while I was in England. Much of their love-making had been done in my old barn studio. The husband seconded his wife's invitation, saying in a P.S., "Make it a long visit. Leave the C.P.R. train at Ashcroft. You will then travel by horse-coach to the One Hundred and Fifty Mile House up the Cariboo Road, a pretty bumpy road too. . . . I will make arrangements."

I had always wanted to see the Cariboo country. It is different from the coast, less heavily wooded, a grain and cattle-raising country. Coming as the invitation did, a break between the beating London had given me and the humiliation of going home to face the people of my own town, a failure, the Cariboo visit would be a flash of joy between two sombres. I got happier and happier every mile as we pushed west.

I loved Cariboo from the moment the C.P.R. train spat me out of its bouncy coach. It was all fresh and new and yet it contained the breath and westernness that was born in me, the thing I could not find in the Old World.

I will admit that I did suffer two days of violence at the mercy of the six-horse stage-coach which bumped me over the Cariboo Road and finally deposited me at the door of One Hundred and Fifty Mile House where my friend lived, her husband being manager of the Cariboo Trading Company there. It had been a strange, rough journey yet full of interest. No possible springs could endure such pitch and toss as the bumps and holes in the old Cariboo road-bed played. The coach was slung on tremendous leather straps and, for all that it was so ponderous, it swayed and bounced like a swing.

A lady school-teacher, very unenthusiastic at being assigned a rural school in the Cariboo, shared the front top seat with the driver and me. She did not speak, only sighed. The three of us were buckled into our seats by a great leather apron. It caught driver round the middle and teacher and me under our chins. We might have been infant triplets strapped abreast into the seat of a mammoth pram. If we had not been strapped we would have flown off the top of the stage. At the extra-worst bumps the heads of the inside passengers hit the roof of the coach. We heard them.

We changed horses every ten miles and wished we could change ourselves, holding onto yourself mile after mile got so tiresome. The horses saved all their prance for final show-off dashings as they neared the changing barns; here they galloped full pelt. Driver shouted and the whip cracked in the clear

air. Fresh horses pranced out to change places with tired ones, lively and gay, full of show-off. When blinkers were adjusted on the fresh horses so as not to tell tales, the weary ones sagged into the barn, their show-off done. The whole change only took a minute, scarcely halting our journey. Sometimes the driver let us climb a short hill on foot to ease the load and to uncramp us.

It was beautiful country we passed through—open and rolling—vast cattle ranges, zig-zag snake-fences and beast-dotted pasturage with little groves of cotton-poplars spread here and there. There were great wide tracts of wild grazing too.

The cotton-poplars and the grain-fields were turning every shade of yellow. The foliage of the trees were threaded with the cotton-wood's silver-white sterns. Long, level sweeps of rippling gold grain were made richer and more luscious by contrast with the dun, already harvested stubble fields. Men had called this land "Golden Cariboo" because of the metal they took from her soil and her creeks, but Cariboo's crust was of far more exquisite gold than the ore underneath—liquid, ethereal, living gold. Everything in Cariboo was touched with gold, even the chipmunks had golden stripes running down their brown coats. They were tiny creatures, only mouse-big. They scampered, beyond belief quick, in single-file processions of twinkling hurry over the top rail of the snake-fences, racing our stage-coach.

At dark we stopped at a road-house to eat and sleep. Cariboo provides lav-ishly. We ate a huge meal and were then hustled off to bed only to be torn from sleep again at two A.M. and re-mealed—a terrible spread, neither breakfast, din-ner, nor supper, but a "three-in-one" meal starting with porridge, bacon and eggs, and coffee, continuing with beef-steak, roast potatoes, and boiled cab-bage, culminating in pudding, pie, and strong tea. The meal climaxed finally on its centre-piece, an immense, frosted jelly-cake mounted on a pedestal plat-ter. Its gleaming frosting shimmered under a coal-oil lamp, suspended over the table's centre. At first I thought it was a wedding-cake but as every meal in every road-house in Cariboo had just such a cake I concluded it was just Cariboo. The teacher's stomach and mine were taken aback at such a meal at such an hour. We shrank, but our hostess and the driver urged, "Eat, eat; it's a long, hard ride and no stop till noon." The bumps would digest us. We did what we could.

At three A.M. we trembled out into the cold stillness of starry not-yet-day. A slow, long hill was before us. The altitude made my head woozey. It wobbled over the edge of the leather apron buckled under our chins. Between teacher and driver I slept, cosy as jam in a "roly-poly."

The One Hundred and Fifty Mile trading post consisted of a store, a road-house where travellers could stop or could pause between stages to get a meal,

and a huge cattle barn. These wooden structures stood on a little rise and, tucked below, very primitive and beyond our seeing and hearing (because the tiny village lay under the bluff on which sat the Cariboo Trading Company) were a few little houses. These homes housed employees of the Company. On all sides, beyond the village, lay a rolling sea of land, vast cattle ranges, snake-fenced grain-fields—space, space. Wild creatures, big and little, were more astonished than frightened at us; all they knew was space.

My friend met the coach.

"Same old Millie!" she laughed. Following her point and her grin, I saw at my feet a small black cat rubbing ecstatically round my shoes.

"Did you bring her all the way uncrated?"

"I did not bring her at all; does she not belong here?"

"Not a cat in the village."

Wherever she belonged, the cat claimed me. It was as if she had expected me all her life and was beyond glad to find me. She followed my every step. We combed the district later trying to discover her owner. No one had seen the creature before. At the end of my two months' visit in the Cariboo I gave her to a kind man in the store, very eager to have her. Man and cat watched the stage lumber away. The man stooped to pick up his cat, she was gone—no one ever saw her again.

I can never love Cariboo enough for all she gave to me. Mounted on a cow-pony I roamed the land, not knowing where I went—to be alive, going, that was enough. I absorbed the trackless, rolling space, its cattle, its wild life, its shy creatures who wondered why their solitudes should be plagued by men and guns.

Up to this time I had always decorously used a side-saddle and had ridden in a stiff hat and the long, flapping habit proper for the date. There was only one old, old horse, bony and with a rough, hard gait that would take side-saddle in the Cariboo barns. My friend always rode this ancient beast and used an ortho-dox riding-habit. I took my cue from a half-breed girl in the district, jumped into a Mexican cow-boy saddle and rode astride, loping over the whole country, riding, riding to nowhere. Oh goodness! how happy I was. Though far from strong yet, in this freedom and fine air I was gaining every week. When tired, I threw the reins over the pommel and sat back in the saddle leaving direction to the pony, trusting him to take me home unguided. He never failed.

I tamed squirrels and chipmunks, taking them back to Victoria with me later. I helped my host round up cattle, I trailed breaks in fences when our cat-tle strayed. A young coyote and I met face to face in a field once. He had not seen nor winded me. We nearly collided. We sat down a few feet apart to con-sider each other. He was pretty, this strong young prairie-wolf.

The most thrilling sight I saw in the Cariboo was a great company of wild geese feeding in a field. Wild geese are very wary. An old gander is always posted to warn the flock of the slightest hint of danger. The flock were feeding at sundown. The field looked like an immense animated page of "pothooks" as the looped necks of the feeding birds rose and fell, rose and fell. The sentinel honked! With a whirr of wings, a straightening of necks and a tucking back of legs, the flock rose instantly—they fell into formation, a wedge cutting clean, high air, the irregular monotony of their honking tumbling back to earth, falling in a flurry through the air, helter-skelter, falling incessant as the flakes in a snow storm. Long after the sky had taken the geese into its hiding their honks came back to earth and us.

Bands of coyotes came to the creek below our windows and made night hideous by agonized howlings. No one had warned me and the first night I thought some fearfulness had overtaken the world. Their cries expressed woe, cruelty, anger, utter despair! Torn from sleep I sat up in my bed shaking, my room reeking with horror! Old miners say the coyote is a ventriloquist, that from a far ridge he can throw his voice right beside you, while from close he can make himself sound very far. I certainly thought that night my room was stuffed with coyotes.

In Cariboo I did not paint. I pushed paint away from me together with the failure and disappointment of the last five years.

There was an Indian settlement a mile or two away. I used to ride there to barter my clothing for the Indians' beautiful baskets. At last I had nothing left but the clothes I stood in but I owned some nice baskets.

My friend was puzzled and disappointed. We had known each other since early childhood. She had anticipated my companionship with pleasure—but here I was!

"Millie!" she said disgustedly, "you are as immature and unsophisticated as when you left home. You must have gone through London with your eyes shut!" and, taking her gun, she went out.

She seldom rode, preferring to walk with gun and dog. She came home in exasperated pets of disgust.

"Never saw a living creature—did you?"

"All kinds; the critters know the difference between a sketching easel and a gun," I laughed.

We never agreed on the subject of shooting. She practiced on any living thing. It provoked her that creatures would not sit still to be shot.

"London has not sophisticated you at all," she complained. "I have quite outgrown you since I married."

Perhaps, but maybe London had had less to do with retarding my development than disappointment had. She was bored by this country as I had been bored by London. Quite right, we were now far apart as the poles—no one's fault. Surfacely we were very good friends, down deep we were not friends at all, not even acquaintances.

Winter began to nip Cariboo. The coast called and Vancouver Island, that one step more Western than the West. I went to her, longing yet dreading. Never had her forests looked so solemn, never her mountains so high, never her drift-laden beaches so vast. Oh, the gladness of my West again! Immense Canada! Oh, her Pacific edge, her Western limit! I blessed my luck in being born Western as I climbed the stair of my old barn studio.

During my absence my sister had lent the studio to a parson to use for a study. He had papered the walls with the *Daily Colonist*, sealed the windows. There were no cobwebs, perhaps he had concocted them into sermons. As I ran across the floor to fling the window wide everything preached at me.

Creak of rusty hinge, the clean air rushed in! The cherry tree was gone, only the memory of its glory left. Was everything gone or dead or broken? No! Hurrying to me came Peacock, my Peacock! Who had told him I was come? He had not been up on the studio roof this last five years. Glorious, exultant, he spread himself.

Victoria had driven the woods back. My sister owned a beautiful mare which she permitted me to ride. On the mare, astride as I had ridden in Cariboo, my sheep-dog following, I went into the woods. No woman had ridden cross-saddle before in Victoria! Victoria was shocked! My family sighed. Carrs had always conformed; they believed in what always has been continuing always to be. Cross-saddle! Why, everyone disapproved! Too bad, instead of England gentling me into an English Miss with nice ways I was more *me* than ever, just pure me.

One thing England had taught me which my friends and relatives would not tolerate—smoking! Canadians thought smoking women fast, bad. There was a scene in which my eldest sister gave her ultimatum. "If smoke you must, go to the barn and smoke with the cow. Smoke in my house you shall not."

So I smoked with the cow. Neither she nor I were heavy smokers but we enjoyed each other's company.

And so I came back to British Columbia not with "know-it-all" fanfare, not a successful student prepared to carry on art in the New World, just a broken-in-health girl that had taken rather a hard whipping, and was disgruntled with the world.

Of my three intimate school friends two were married and living in other places, the third was nursing in San Francisco. I made no new friends; one does

not after school-days, unless there are others who are going your way or who have interests in common. Nobody was going my way, and their way did not interest me. I took my sheep-dog and rode out to the woods. There I sat, dumb as a plate, staring, absorbing tremendously, though I did not realize it at the time. Again I was struck by that vague similarity between London crowds and Canadian forests; each having its own sense of terrific power, density and intensity, but similarity ceased there. The clamorous racing of hot human blood confused, perhaps revolted me a little sometimes. The woods standing, standing, holding the cool sap of vegetation were healing, restful after seeing the boil of humanity.

It did me no harm to sit idle, still pondering in the vastness of the West where every spilled sound came tumbling back to me in echo. After the mellow sweetness of England with its perpetual undertone of humanity it was good to stand in space.

Vancouver

Everything was five and a half years older than when I left home but then so was I—five of the most impressionable years of life past. I was glad some things had changed, sorry others had. I was sorry to say good-bye to my little self—I mean the little self that is always learning things without knowing that it is doing so.

It was nice now to go to church by choice and not be pushed there. It was nice even to miss occasionally without feeling "helly". The Y.W.C.A. were now firmly established in a fine new building of their own and did not have to pray all over our floors. My sisters belonged to many religious and charitable societies. The choice was left to me—Ladies' Aid, Y.W.C.A., King's Daughters, a dozen others. I joined none.

There were no artists in Victoria. I do not remember if the Island Arts and Crafts Club had begun its addled existence. When it did, it was a very select band of elderly persons, very prehistoric in their ideas on Art.

It was nice to be home, but I was not there for long because the Ladies' Art Club of Vancouver asked me to accept the post of Art teacher to their Club. So I went to live in Vancouver. The Vancouver Art Club was a cluster of society women who intermittently packed themselves and their admirers into a small rented studio to drink tea and jabber art jargon.

Once a week I was to pose a model for them and criticize their work. I had been recommended by one of their members who was an old Victorian and who had known me all my life. She was abroad when I accepted the post.

The Art Club, knowing I was just back from several years of study in London, expected I would be smart and swagger a bit. When they saw an unimportant, rather shy girl they were angry and snubbed me viciously, humiliating me in every possible way. Their President was a wealthy society woman. Floating into the studio an hour or more late for class, she would swagger across the room, ignoring me entirely and change the model's pose. Then she would paint the background of her study an entirely different colour to the one I had arranged. If I said anything, she replied, "I prefer it so!"

Other members of the class, following her lead, and tossing their heads, would say with mock graciousness, "You may look at my work if you would like to, but I wish no criticism from you." At the end of my first month they dismissed me. Perhaps I did look horribly young for the post.

On her return to Vancouver my sponsor sent for me.

"I hear the Ladies' Club have dismissed you, my dear."

"Yes. I am glad!"

"All were unanimous in their complaint."

"What was it?"

"Millie, Millie!" she smiled, "You tried to make them take their work seriously! Society ladies serious! My dear, how could you?" she laughed.

"They are vulgar, lazy old beasts," I spluttered. "I am glad they dismissed me and I am proud of the reason. I hate their kind. I'd rather starve."

"What shall you do now?"

"I have taken a studio in Granville Street. The only woman in the Art Club who was decent to me (an American) has sent her little daughter to me for lessons. The child has interested her schoolmates. Already I have a class of nice little girls."

"Good, with them you will be more successful. The Club's former teacher was 'society'. She understood the Club ladies, complimented and erased simultaneously, substituting some prettiness of her own in the place of their daubs, something which they could exhibit. They liked that. She was older, too."

The snubbing by the Vancouver Ladies' Art Club starched me. My pride stiffened, my energy crisped. I fetched my sheep-dog and cage of bullfinches from Victoria, added a bunch of white rats, a bowl of goldfish, a cockatoo and a parrot to my studio equipment and fell into vigorous, hard, happy work, finding that I had learned more during those frustrated years in England than I had supposed—narrow, conservative, dull-seeing, perhaps rather mechanical, but nevertheless honest.

Because I did not teach in the way I had been taught, parents were sceptical, but my young pupils were eager, enthusiastic. Every stroke was done from objects or direct from life-casts, live-models, still life, animals.

Young Vancouver had before been taught only from flat copy. I took my classes into the woods and along Vancouver's waterfront to sketch. A merry group we were, shepherded by a big dog, each pupil carrying a campstool and an easel, someone carrying a basket from which the cockatoo, Sally, screeched, "Sally is a Sally." That was Sally's entire vocabulary. If she was left in the studio when the class went sketching she raised such a turmoil that the neighbours objected. Out with the class, joining in the fun, Sally was too happy even to shout that Sally was a Sally.

We sat on beaches over which great docks and stations are now built, we clambered up and down wooded banks solid now with Vancouver's commercial buildings.

Stanley Park at that time was just seven miles of virgin forest, three quarters surrounded by sea. Alone, I went there to sketch, loving its still solitudes—no living creature but dog Billie and me, submerged beneath a drown of undergrowth. Above us were gigantic spreads of pines and cedar boughs, no bothersome public, no rubbernoses. Occasional narrow trails wound through bracken and tough salal tangle. Underfoot, rotting logs lay, upholstered deep in moss, bracken, forest wastage. Your feet never knew how deep they would sink.

I loved too the Indian reserve at Kitsilano and to the North Vancouver Indian Mission Billie and I went for long days, our needs tucked into my sketch-sack and great content in our hearts.

Vancouver was then only a little town, but it was growing hard. Almost every day you saw more of her forest being pushed back, half-cleared, waiting to be drained and built upon—mile upon mile of charred stumps and boggy skunk-cabbage swamp, root-holes filled with brown stagnant water, reflecting blue sky by day, rasping with frog croaks by night, fireweed, rank of growth, springing from the dour soil to burst into loose-hung, lush pink blossoms, dangling from red stalks, their clusters of loveliness trying to hide the hideous transition from wild to tamed land.

The foundationless Ladies' Art Club of social Vancouver was crumbling; their President came to me, asking that I give up my studio and share theirs thereby lessening their rental. I refused. Then she said, "Shall we give up ours and come to share yours? Our teas of course—but," smirked the lady, "prestige of the Vancouver Ladies' Art Club behind your classes!"

"No, no, no! I don't want your prestige—I won't have the Ladies' Art Club in my studio!"

The President tore down my stairs. I had not imagined Presidents could rush with such violence.

The first year that I lived and taught in Vancouver my sister Alice and I took a pleasure trip up to Alaska.

The Klondyke rush had been over just a few years. We travelled on a Canadian boat as far as Skagway, end of sea travel for Klondyke. Prospectors had left steamers here and gone the rest of the way on foot over a very rough trail. Those who could afford to, took pack-beasts; those who could not, packed their things on their own backs.

The mushroom town of Skagway had sprung up almost overnight. It consisted of haphazard shanties, spilled over half-cleared land. The settlement lay in a valley so narrow it was little more than a ravine heading the shallow, muddy inlet. Three tipsy plank walks on crooked piles hobbled across the mud to meet water deep enough to dock steamboats. Each runway ended in a blob of wharf.

Jumping gaps where planks had broken away, I went out on to the end of one wharf to look back at Skagway. Bits of my clothing and sketching equipment blew off into the sea.

Wind always moaned and cried down the little valley, smacking this, overturning that shanty. The little town was strewn with collapsed buildings. Crying, crying, the valley was always crying. There was always rain or mist or moaning wind. It had seen such sadness, this valley—high hopes levelled like the jerry-built shanties, broken, crazed men, drinking away their disappointments.

A curious little two-coach train ran up the valley twice a week. Its destination was White Horse. It followed the old Klondyke trail. We took it up as far as the summit. Here, side by side, where their land met, fluttered two flags, British and American. The train jogged and bumped a good deal. We passed through valleys full of silence, mocking our noisy little train with echoes because our black smoke dirtied the wreaths of white mist which we met in the valleys.

A stark, brooding, surly land was this, gripping deep its secrets. Huddles of bones bleached by the wayside—bullock bones, goat and horse bones, beasts for whom the lure of gold did not exist but who, broken under burdens of man's greed, had fallen by the way, while man, spurred on by the gold glitter, shouldered the burdens of the dead beasts and pushed further. In the valley, drowned under lush growth, we stumbled upon little desolate log shanties, half built. The finger of the wild now claimed the cabins, saying, "Mine, mine!", mossing them, growing trees through the mud floors and broken roofs.

"How do these come to be here?" I asked.

"Failures—men who lacked the courage to go home beaten. Most drank themselves to death. For many, a gun was their last, perhaps their best, friend."

No wonder the valley cried so! Of those who stayed in Skagway it was seldom said, "He made good. He struck it lucky!" The lucky ones went down to the cities, scarred by their Klondyke experience, seldom happier for their added gold.

We stayed one week in Skagway; then, taking an American steamer, crossed to Sitka on Baronoff Island.

Sitka had an American army barracks, a large Indian village, and an ancient Russian church. It also had many, many very large, black ravens, sedate birds but comical. They scavenged the village, calling to one another back in the woods. The male and the female made different squawks; the cry of one was a throaty "Qua", the other answered, "Ping!", sharp and strident as a twanged string. At the top of its flagpole the barracks had a gilt ball which had great attraction for the ravens. There were always three or four of them earnestly trying to get firm foothold on the rounded surface. It was amusing to watch them.

As we walked through the little town of Sitka I saw on a door, "Picture Exhibition—Walk In". We did so.

The studio was that of an American artist who summered in Sitka and wintered in New York where he sold his summer's sketches, drab little scenes which might have been painted in any place in the world. He did occasionally stick in a totem pole but only ornamentally as a cook sticks a cherry on the top of a cake.

The Indian totem pole is not easy to draw. Some of them are very high, they are elaborately carved, deep symbolical carving, as much or more attention paid to the attributes of the creature as to its form.

The Indian used distortion, sometimes to fill spaces but mostly for more powerful expressing than would have been possible had he depicted actualities—gaining strength, weight, power by accentuation.

The totem figures represented supernatural as well as natural beings, mythological monsters, the human and animal figures making "strong talk", bragging of their real or imagined exploits. Totems were less valued for their workmanship than for their "talk".

The Indian's language was unwritten: his family's history was handed down by means of carvings and totemic emblems painted on his things. Some totems were personal, some belonged to the whole clan.

The American artist found me sketching in the Indian village at Sitka. He looked over my shoulder; I squirmed with embarrassment. He was twice my age and had had vastly more experience.

He said, "I wish I had painted that. It has the true Indian flavour."

The American's praise astounded me, set me thinking.

We passed many Indian villages on our way down the coast. The Indian people and their Art touched me deeply. Perhaps that was what had given my sketch the "Indian flavour." By the time I reached home my mind was made up. I was going to picture totem poles in their own village settings, as complete a collection of them as I could.

With this objective I again went up north next summer and each successive summer during the time I taught in Vancouver. The best material lay off the beaten track. To reach the villages was difficult and accommodation a serious problem. I slept in tents, in roadmakers' toolsheds, in missions, and in Indian houses. I travelled in anything that floated in water or crawled over land. I was always accompanied by my big sheep-dog.

Indian Art broadened my seeing, loosened the formal tightness I had learned in England's schools. Its bigness and stark reality baffled my white man's understanding. I was as Canadian-born as the Indian but behind me were Old World heredity and ancestry as well as Canadian environment. The new West called me, but my Old World heredity, the flavour of my upbringing, pulled me back. I had been schooled to see outsides only, not struggle to pierce.

The Indian caught first at the inner intensity of his subject, worked outward to the surfaces. His spiritual conception he buried deep in the wood he was about to carve. Then—chip! chip! his crude tools released the symbols that were to clothe his thought—no sham, no mannerism. The lean, neat Indian hands carved what the Indian mind comprehended.

Indian Art taught me directness and quick, precise decisions. When paying ten dollars a day for hire of boat and guide, one cannot afford to dawdle and haver this vantage point against that.

I learned a lot from the Indians, but who except Canada herself could help me comprehend her great woods and spaces? San Francisco had not, London had not. What about this New Art Paris talked of? It claimed bigger, broader seeing.

My Vancouver classes were doing well. I wrote home, "Saving up to go to Paris."

Everybody frowned—hadn't London been a strong enough lesson but I must try another great city?

But I always took enough from my teaching earnings to go north and paint in the Indian villages, even while saving for Paris.

One summer, on returning from a northern trip, I went first to Victoria to visit my sisters. There I received a curt peremptory command: "Hurry to the Empress hotel. A lady from England wishes to see you on business connected with your Indian sketches."

The woman was screwed up and frumpy, so stuffed with her own importance that she bulged and her stretched skin shone.

"I wish to see those Indian sketches of yours."

"For the moment that is not possible; they are stored in my Vancouver studio and it is rented," I replied.

"Then you must accompany me to Vancouver tonight and get them out."

"Do you wish to buy my sketches?"

"Certainly not. I only want to borrow them for the purpose of illustrating my lectures entitled 'Indians and Artists of Canada's West Coast'."

"Where do I come in?"

"You?—Publicity—I shall mention your work. Oxford! Cambridge!"

Her eyes rolled, her high-bridged nose stuck in the air. I might have been a lump of sugar, she the pup. Oxford and Cambridge signalled. Pup snapped, Oxford and Cambridge gulped—me.

"I shall see you at the midnight boat, then? You may share my stateroom, magnanimously."

"Thanks, but I'm not going to Vancouver."

"What! You cannot be so poor spirited! My work is patriotic. I am philanthropic. I advance civilization—I educate."

"You make nothing for yourself exploiting our Indians?"

"After expenses, perhaps just a trifle. . . . You will not help the poor Indian by lending the Alert Bay sketches? My theme centres around Alert Bay."

My interest woke.

"You have been there? Are you familiar with it?"

"Oh, yes, yes! Our boat stopped there for twenty minutes. I walked through the village, saw houses, poles, people."

"And you dare talk and write about our Coast Indians having only that much data! The tourist folders do better than that! Good-bye!"

"Stop!"

She clutched my sleeve as I went out the hotel door—followed me down the steps hatless, bellowed at me all the way home, spluttering like the kick-up waves behind a boat. She stalked into our drawing room, sat herself down.

I said, "Excuse me, I am going out."

She handed me a card.

"My London Club. It will always find me. Your better self will triumph!"

She smiled at, patted me.

I said, "Listen! England is not interested in our West. I was in London a few years ago, hard up. A well known author wrote a personal letter for me to a big London publisher.

'Take this to him with a dozen of your Indian sketches,' she said, 'and what a grand calendar they will make! England is interested in Canada just now.'

A small boy took my letter and returned, his nasty little nose held high, his aitchless words insolent.

'Leave yer stuff, Boss'll look it over *if* 'e 'as toime.'

I started down the stair.

''Ere, where's yer stuff? Yer ha'n't left any?'

'It is going home with me.'

At the bottom of the third flight the boy caught up with me.

'Boss says 'e'll see you now.'

The elegant creature spread my sketches over his desk.

'America, eh? Well, take 'em there. Our British public want this.' He opened a drawer crammed with pink-coated hunting scenes. 'Indians belong to America; take 'em there.'

'Canada happens to be British,' I said, 'and these are Canadian Indians.'

I put the sketches back in their wrappings.

Teach your English people geography, Madam! Then maybe they will be interested in British things. Half the people over here don't know that all the other side of the Atlantic does not belong entirely to the Americans."

France

"Two parrots out in Canada waiting your return! Is it absolutely necessary that you buy another, Millie?"

"Those at home are green parrots; this is an African-grey. I have always wanted an African-grey frightfully. Here we are in Liverpool, actually at Cross's, world-wide animal distributors—it is the opportunity of a lifetime."

Perhaps pity of my green, sea-sick face softened my sister's heart and opened her purse. Half the price of the "African-grey" stole into my hand.

We called the bird Rebecca and she was a most disagreeable parrot. However, nothing hoisted my spirits like a new pet, the delight of winning its confidence!

Hurrying through London, we crossed the Channel, slid through lovely French country—came to Paris.

My sister knew French but would not talk. I did not know French and would not learn. I had neither ear nor patience. I wanted every moment of Paris for Art.

My sister studied the history of Paris, kept notes and diaries. I did not care a hoot about Paris history. I wanted *now* to find out what this "New Art" was about. I heard it ridiculed, praised, liked, hated. Something in it stirred me, but I could not at first make head or tail of what it was all about. I saw at once that it made recent conservative painting look flavourless, little, unconvincing.

I had brought with me a letter of introduction to a very modern artist named Harry Gibb. When we had found a small flat in the Latin Quartet, Rue Campagne Premier, off Montparnasse Avenue, I presented my letter.

Harry Gibb was dour, his wife pretty. They lived in a studio overlooking a beautiful garden, cultivated by nuns. I stood by the side of Harry Gibb, staring in amazement up at his walls. Some of his pictures rejoiced, some shocked me. There was rich, delicious juiciness in his colour, interplay between warm and cool tones. He intensified vividness by the use of complementary colour. His mouth had a crooked, tight-lipped twist. He was fighting bitterly for recognition of the "New Art." I felt him watching me, quick to take hurt at even such raw criticism as mine. Mrs. Gibb and my sister sat upon a sofa. After one look, my sister dropped her eyes to the floor. Modern Art appalled her.

Mr. Gibb's landscapes and still life delighted me—brilliant, luscious, clean. Against the distortion of his nudes I felt revolt. Indians distorted both human and animal forms—but they distorted with meaning, for emphasis, and with great sincerity. Here I felt distortion was often used for design or in an effort to shock rather than convince. Our Indians get down to stark reality.

I could not face that tight-lipped, mirthless grin of Mr. Gibb's with too many questions. There were many perplexities to sort out.

Strange to say, it was Mrs. Gibb who threw light on many things about the "New Art" for me. She was not a painter but she followed the modern movement closely. I was braver at approaching her than her husband with questions.

I asked Mr. Gibb's advice as to where I should study.

"Colorossi," he replied. "At Colorossi's men and women students work together. At Julien's the classes are separate. It is of distinct advantage for women students to see the stronger work of men."—Mr. Gibb had not a high opinion of the work of woman artists.

The first month at Colorossi's was hard. There was no other woman in the class; there was not one word of my own language spoken. The French professor gabbled and gesticulated before my easel—passed on. I did not know whether he had praised or condemned. I missed women; there was not even a woman model. I begged my sister to go to the office and enquire if I were in the wrong place. They said, "No, Mademoiselle is quite right where she is. Other ladies will come by and by."

I plodded mutely on, till one day I heard a splendid, strong English "damn" behind me. Turning, I saw a big man ripping the lining pocket from his jacket with a knife. I saw, too, from his dirty brushes how badly he needed a paint rag.

I went to the damner and said, "Mr., if you will translate my lessons I will bring you a clean paint-rag every morning."

Paint-rags were always scarce in Paris. He agreed, but he was often absent.

The Professor said I was doing very well, I had good colour sense.

That miserable, chalky, lifelessness that had seized me in London overtook me again. The life-class rooms were hot and airless. Mr. Gibb told me of a large studio run by a young couple who employed the best critics in Paris. Mr. Gibb himself criticized there. Students said he was dour and very severe, but that he was an exceedingly good teacher. I would also have the advantage of getting criticism in my own language.

I studied in this studio only a few weeks and, before Mr. Gibb's month of criticism came, I was flat in hospital where I lay for three hellish months and came out a wreck. The Paris doctor said, as had the London one, I must keep out of big cities or die. My sister and I decided to go to Sweden.

While gathering strength to travel, I sat brooding in an old cemetery at the foot of our street. Why did cities hate, thwart, damage me so? Home people were wearying of my breakdowns. They wrote, "Give Art up, come home—stay home."

I showed some of my Indian sketches to Mr. Gibb. He was as convinced as I that the "New Art" was going to help my work out west, show me a bigger way of approach.

We enjoyed Sweden. She was very like Canada. I took hot salt-baths. In spring we returned to France, but I never worked in the studios of Paris again. I joined a class in landscape-painting that Mr. Gibb had just formed in a place two hours run from Paris. The little town was called Cressy-en-Brie. Mrs. Gibb found me rooms close to their own. My sister remained in Paris.

Cressy was quaint. It was surrounded by a canal. Many fine houses backed on the canal; they had great gardens going to the edge of the water and had little wash-booths on the canal—some were private, some public. The women did their laundry here and were very merry about it. Shrill voices, boisterous laughter, twisted in and out between the stone walls of the canal. Lovely trees drooped over the walls to dabble their branches. Women knelt in wooden trays, spread washing on flat stones before the washing-booths, soaped, folded, beat with paddles, rinsed. Slap, slap, went the paddles smacking in the soap, and out the dirt, while the women laughed and chatted, and the water gave back soapy reflections of their rosy faces and white coifs.

The streets of Cressy were narrow, and paved with cobblestones. Iron-rimmed cartwheels clattered noisily, so did wooden shoes. Pedlars shouted, everybody shouted so as to be heard above the racket.

Opposite my bedroom window was a wine-shop. They were obliged to close at midnight. To evade the law the wine vendors carried tables into the middle of the street and continued carousing far into the night. I have watched a wedding-feast keep it up till four in the morning, periodically leaving the feast to procession round the town, carrying lanterns and shouting. Sleep was impossible. I took what fun I could out of watching from my window.

Distant from Cressy by a mile or by a half-mile, were tiny villages in all directions. Each village consisted of one street of stone cottages, whitewashed. A delicate trail of grape-vine was trained above every cottage door, its main stem twisted, brown and thick as a man's arm, its greenery well tended and delicately lovely.

They grow things beautifully, these Frenchmen—trees, vines, flowers—you felt the living things giving back all the love and care the growers bestowed on them. A Scotch nurseryman of wide repute told me arboriculturists went to France to study; nowhere else could they learn better the art of growing, caring for, pruning trees.

I tramped the country-side, sketch sack on shoulder. The fields were lovely, lying like a spread of gay patchwork against red-gold wheat, cool, pale oats, red-purple of new-turned soil, green, green grass, and orderly, well-trimmed trees.

The life of the peasants was hard, but it did not harden their hearts nor their laughter. They worked all day in the fields, the cottages stood empty.

At night I met weary men and women coming home, bent with toil but happy-hearted, pausing to nod at me and have a word with Josephine, a green parrot I had bought in Paris and used to take out sketching with me. She wore an anklet and chain and rode on the rung of my camp-stool. The peasants loved Josephine; Rebecca was a disappointment. She was sour, malevolent. Josephine knew more French words than I. I did flatter myself, however, that my grin had more meaning for the peasants than Josephine's French chatter.

Mr. Gibb took keen interest in my work, despite my being a woman student. His criticisms were terse—to the point. I never came in contact with his other students. They took tea with Mrs. Gibb often. Mr. Gibb showed them his work. He never showed it to me. Peeved, I asked, "Why do you never allow me to see your own work now, Mr. Gibb?"

The mirthless, twisted grin came, "Don't have to. Those others don't know what they are after, you do. Your work must not be influenced by mine. You will be one of the painters,—women painters," he modified, "of your day."

That was high praise from Mr. Gibb! But he could never let me forget I was only a woman. He would never allow a woman could compete with men.

One day I ruined a study through trying an experiment. I expected a scolding. Instead, Mr. Gibb, grinning, said, "That's why I like teaching you! You'll risk ruining your best in order to find something better."

He had one complaint against me, however. He said, "You work too hard. Always at it. Easy! Easy! Why such pell-mell haste?"

"Mr. Gibb, I dare not loiter; my time over here is so short! Soon I must go back to Canada."

"You can work out in Canada—all life before you."

I replied, "You do not understand. Our far West has complete art isolation . . . no exhibitions, no artists, no art talk. . . ."

"So much the better! Chatter, chatter, chatter—where does it lead?" said Mr. Gibb. "Your silent Indian will teach you more than all the art jargon."

I had two canvases accepted and well hung in the Salon d'Automne (the rebel Paris show of the year). Mr. Gibb was pleased.

My sister returned to Canada. The Gibbs moved into Britanny—I with them.

St. Efflamme was a small watering place. For six weeks each year it woke to a flutter of life. People came from cities to bathe and to eat—the little hotel was famed for its good food. The holiday guests came and went punctually to the minute, then St. Efflamme went to sleep again for another year.

The Gibbs' rooms were half a mile away from the hotel. I had no one to translate for me. Except for talk with my parrots I lived dumb. Madame Pishoudo owned the hotel, her son cooked for us, her niece was maid. All of them were very kind to the parrots and me.

I was at work in the fields or woods at eight o'clock each morning. At noon I returned to the hotel for dinner, rested until three. Mr. Gibb, having criticized my study of the morning out where I worked, now came to the hotel and criticized the afternoon work done the day before. My supper in a basket, I went out again, did a late afternoon sketch, ate my supper, then lay flat on the ground, my eyes on the trees above me or shut against the earth, according as I backed or fronted my rest. Then up again and at it till dark.

I had a gesticulating, nodding, laughing acquaintance with every peasant. Most of them were very poor. Canadian cows would have scorned some of the stone huts in which French peasants lived. Our Indian huts were luxurious compared with them. Earth floor, one black cook-pot for all purposes—when performing its rightful function it sat outside the door mounted on a few stones, a few twigs burning underneath—cabbage soup and black bread appeared to be the staple diet. The huts had no furniture. On the clay floor a

portion framed in with planks and piled with straw was bed for the whole family. There was no window, no hearth, what light and air entered the hut did so through the open door. Yet these French peasants were always gay, always singing, chattering.

I watched two little girls playing "Mother" outside a hut one day. For babies one dangled a stick, the other a stone. They sang and lullabied, wrapping their "children" in the skirt of the one poor garment clinging round their own meagre little figures. Whatever they lacked of life's necessities, nature had abundantly bestowed upon them maternal instinct.

I stuffed paint rags with grass, nobbed one end for a head, straw sticking out of its top for hair. I painted faces on the rag, swathed the creatures in drawing paper, and gave each little girl the first dolly she had ever owned. She kissed, she hugged. Never were grand dolls so fondly cherished.

On a rounded hill-top among gorse bushes a little cow-herd *promenaded* her *vache*. I loved this dignified phrase in connection with the small, agile little Breton cows. The child's thin legs were scratched by the furze bushes as she rustled among them, rounding up her little cows. She had but one thin, tattered garment—through its holes you saw bare skin. She knitted as she herded. Shyly she crept nearer and nearer. I spoke to her in English. She shook her head. Beyond *promener la vache* I could not understand her. She came closer and closer till she knelt by my side, one grimy little hand on my knee. All the time she watched my mouth, intently. If I laughed, her face poked forward, looking, looking. Did the child want to see my laugh being made? I was puzzled. There was great amazement in her big, dark eyes. Presently she fingered her own white teeth and pointed to mine.

"D'or, d'or," she murmured. I understood then that it was my gold-crowned tooth which had so astonished her.

There was an aloof ridge of land behind the village of St. Efflamme. I climbed it often. On the top stood three cottages in a row and one stable. Two of the cottages were tight shut, their owners working in the fields. In the third cottage lived a bricklayer and his family. The woman was always at home with her four small children. They ran after her like a brood of chicks. The children sat round me as I worked; always little Annette, aged four, was closest, a winsome, pretty thing, very shy. I made the woman understand that I came from Canada and would soon be returning. She told the children. Annette came very close, took a corner of my skirt, tugged it and looked up beseeching.

The mother said, "Annette wants go you Canada."

I put my arm round her. With wild crying the child suddenly broke away, clinging to her mother and to France.

This woman was proud of her comfortable house; she beckoned me to *come see*. The floor was of bare, grey earth, swept clean. Beds were concealed in the walls behind sliding panels. There was a great open hearth with a swinging crane and a huge black pot. There were two rush-bottom chairs and four little wooden stools, a table, a broom and a cat. On the shelf were six Breton bowls for the cabbage soup smelling ungraciously this very moment as it cooked. A big loaf of black bread was on the shelf too.

They were a dear, kind, happy family. I made a beautiful rag doll for Annette. It had scarlet worsted hair. Annette was speechless—she clutched the creature tight, kissing its rag nose as reverently as if it had been the Pope's toe. She held her darling at arm's length to look. Her kiss had left the rag nose black. Laying the doll in her mother's arms she ran off sobbing. . . . We saw her take a little bucket to the well in the garden. When Annette came back to us there was a circle round her mouth several shades lighter than the rest of her face. The front of her dress was wet and soapy. She seized her doll—hugged and hugged again.

There was a farm down in the valley—house, stables and hayricks formed a square. The court sheltered me from the wind. I often worked there. A Breton matron in her black dress and white cap came out of the house.

"Burrr! pouf! pouf!" she laughed, mocking the wind. Then, pointing to my blue hands, beckoned me to follow. She was proud of her cosy home. It was well-to-do, even sumptuous for a peasant. Fine brasses were on the mantel-shelf, a side of bacon, strings of onions, hanks of flax for spinning hung from the rafters. There was a heavy, black table, solid and rich with age, a bench on either side of the table, a hanging lamp above. There was a great open hearth and, spread on flat stones, cakes were baking before the open fire—a mountain of already baked cakes stood beside the hearth. The woman saw my wonder at so many cakes and nodded. Laying three pieces of stick on the table, she pointed to the middle one—"Now", she said; to the stick on the left she pointed saying, "Before"; to the right-hand stick, "After." She went through the process of sham chewing, pointing to the great pile of cakes, saying "threshers." I nodded comprehension. The threshers were expected at her place tomorrow. The cakes were her preparation. She signified that I might sketch here where it was warm instead of facing the bitter wind. Again she sat herself by the hearth to watch the cakes and took up her knitting.

The outer door burst open! Without invitation, a Church-of-England clergyman and two high-nosed English women entered. Using English words and an occasional Breton one, the man said the English ladies wished to see a Breton home. The woman's graciousness congealed at the unmannerly entry of the three visitors. She was cold, stiff.

The visitors handled her things, asking, "How much? how much?"

"Non! Non!"

She clutched her treasures, replaced her brasses on the mantel-shelf, her irons on the hearth.

They saw the pile of cakes. The clergyman made long jumbled demands that they be allowed to taste.

"The English ladies want to try Breton cakes."

"Non, non, non!"

The woman took her cakes and put them away in a cupboard.

At last the visitors went. The woman's graciousness came back. Going to the cupboard, she heaped a plate with cakes and, pouring syrup over them, brought and set them on the table before me.

"Pour mademoiselle!"

Such a smile! Such a nod! I must eat at once! Shaking her fist at the door, the woman went outside, shutting the door behind her—burst it open—clattered in.

"Ahh!" she scolded. "Ahh!"

Again going out she knocked politely, waited. She was delighted with her play-acting, we laughed together.

Some five miles from St. Efflamme was a quaint village in which I wanted to sketch. I was told a butcher went that way every morning early, coming back at dusk. I dickered with the butcher and drove forth perched up in the cart in front of the meat, hating the smell of it. I sketched the old church standing knee deep in graves. I sketched the village and a roadside calvary. Dusk came but not the butcher. Dark fell, still no butcher. There was nothing for it but I must walk the five miles back. The road was twisty and very dark. I decided it would be best to follow along the sea-shore where there was more light. My sketch-pack weighed about fifty pounds. The sand was soft and sinky. I was always stopping to empty it out of my shoes. I dragged into the hotel at long last, tired and very cross. Madame Pishoudo beckoned me from her little wine shop in the corner, beyond the parlour.

"That butcher! Ah! Yes, he drunk ver' often! His forget was bad; but Madame she does not forget her little one, her Mademoiselle starving in a strange village."

Madame had remembered—she had kept a little "piece" in the cupboard. Its littleness was so enormous a serving of dessert that it disgusted my tiredness. Madame Pishoudo forgot that she had supplied "her starved Mademoiselle" with a basket containing six hard-boiled eggs, a loaf split in half and furnished with great chunks of cold veal, called by Madame a sand-

wich, half a lobster, cheese, a bottle of wine, and sundry cookies and cakes. If one did not eat off a table, under Madame's personal supervision, one starved!

One day I shared a carriage with two ladies from Paris and we went sightseeing. I have half-forgotten what we saw of historical interest but I well remember the merry time we had. The ladies had no English, I no French words. We drank "cidre" in wayside booths, out of gay cups of Breton ware that had no saucers. I persuaded the woman to sell me two cups. I knew they sold in the market for four pennies. I offered her eight pennies apiece. She accepted and with a shrug handed them over saying the equivalent of "Mademoiselle is most peculiar!" We went into a very old church and my companions bowed to a great many saints. They dabbled in a trough of holy-water, crossing themselves and murmuring, "Merci, St. Pierre, merci." One of the ladies took my hand, dipped it into the trough, crossed my forehead and breast with it, murmuring, "Merci, St. Pierre, merci!" It would be good for me, she said.

"Mr. Gibb, I have gone stale!"

The admission shamed me.

Mr. Gibb replied, "I am not surprised. Did I not warn you?—rest!"

"I dare not rest; in a month, two at most, I must return to Canada."

I heard there was a fine water colourist (Australian) teaching at Concarneau, a place much frequented by artists. I went to Concarneau—studied under her. Change of medium, change of teacher, change of environment, refreshed me. I put in six weeks' good work under her.

Concarneau was a coast fishing town. I sketched the people, their houses, boats, wine shops, sail makers in their lofts. Then I went up to Paris, crossed the English Channel, and from Liverpool set sail for Canada.

Rejected

I came home from France stronger in body, in thinking, and in work than I had returned from England. My seeing had broadened. I was better equipped both for teaching and study because of my year and a half in France, but still mystified, baffled as to how to tackle our big West.

I visited in Victoria, saw that it was an impossible field for work; then I went to Vancouver and opened a studio, first giving an exhibition of the work I had done in France.

People came, lifted their eyes to the walls—laughed!

"You always were one for joking—this is small children's work! Where is your own?" they said.

"This is my own work—the new way."

Perplexed, angry, they turned away, missing the old detail by which they had been able to find their way in painting. They couldn't see the forest for looking at the trees.

"The good old camera cannot lie. That's what we like, it shows everything," said the critics. This bigger, freer seeing now seemed so ordinary and sensible to me, so entirely sane! It could not have hurt me more had they thrown stones. My painting was not outlandish. It was not even ultra.

The Vancouver schools in which I had taught refused to employ me again. A few of my old pupils came to my classes out of pity,—their money burnt me. Friends I had thought sincere floated into my studio for idle chatter; they did not mention painting, kept their eyes averted from the walls, while talking to me.

In spite of all the insult and scorn shown to my new work I was not ashamed of it. It was neither monstrous, disgusting nor indecent; it had brighter, cleaner colour, simpler form, more intensity. What would Westerners have said of some of the things exhibited in Paris—nudes, monstrosities, a striving after the extraordinary, the bizarre, to arrest attention. Why should simplification to express depth, breadth and volume appear to the West as indecent, as nakedness? People did not want to see beneath surfaces. The West was ultraconservative. They had transported their ideas at the time of their migration, a generation or two back. They forgot that England, even conservative England, had crept forward since then; but these Western settlers had firmly adhered to their old, old, outworn methods and, seeing beloved England as it had been, they held to their old ideals.

That rootless organization, the Vancouver Ladies' Art Club, withered, died. It was succeeded by The Fine Arts Society, an organization holding yearly exhibitions in which I was invited to show.

My pictures were hung either on the ceiling or on the floor and were jeered at, insulted; members of the "Fine Arts" joked at my work, laughing with reporters. Press notices were humiliating. Nevertheless, I was glad I had been to France. More than ever was I convinced that the old way of seeing was inadequate to express this big country of ours, her depth, her height, her unbounded wideness, silences too strong to be broken—nor could ten million cameras, through their mechanical boxes, ever show real Canada. It had to be sensed, passed through live minds, sensed and loved.

I went to the Indian Village on the North Shore of Burrard Inlet often. Here was dawdling calm; no totem poles were in this village. The people were bas-

ket-weavers, beautiful, simple-shaped baskets, woven from split cedar roots, very strong, Indian designs veneered over the cedar-root base in brown and black cherry bark.

Indian Sophie was my friend. We sat long whiles upon the wide church steps, talking little, watching the ferry ply between the city and the North Shore, Indian canoes fishing the waters of the Inlet, papooses playing on the beach.

The Village was centred by the Catholic Church—its doors were always wide. Wind entered to whisper among the rafters. The wooden footstools creaked beneath our knees. A giant clam-shell held holy water in the vestibule. The bell-rope dangled idly. When Sophie and I entered the church she bowed and crossed herself with holy water; so did I because it grieved Sophie so that I was not Catholic. She talked to the priest about it. The good man told her not to worry, I was the same and it was all right. Sophie and I were glad for this.

Behind the Indian Village, way up in the clouds stood "The Lions," twin mountain peaks, their crowns gleaming white against blue distance, supporting the sky on their heads.

In Spring the Village shimmered with millions of exquisite, tongueless bells of cherry-blossom (every Indian had his cherry-tree). Springtime flooded the village with new life, human, animal, vegetable. The dirt streets swarmed with papooses, puppies and kittens; old hens strutted broods, and squawked warnings against hawks and rats. Indian mothers had new papoose-cradles strapped on their backs or resting close beside them as they squatted on the floors of their houses, weaving baskets. Indian babies were temporary creatures: behaviour half-white, half-Indian, was perplexing to them. Their dull, brown eyes grew vague, vaguer—gave up—a cradle was empty—there was one more shaggy little grave in the cemetery.

When I visited Sophie her entertainment for me was the showing off of her graves. She had a huge family of tiny tombstones. She had woven, woven baskets in exchange for each tombstone.

We took the twisty dirt road to the point of land on which the cemetery lay. Passing under a big wood cross spanning the gateway, we were in a tough, grassed field bristling with tipping crosses, stone, iron, wood crosses. In the centre stood a big, straight, steady cross raised on a platform, a calm, reassuring cross. Here Sophie knelt one moment before parting brambles to search for her own twenty-one crosses—babies dated barely one year apart.

"Mine, mine," Sophie stooped to pat a cold little stone, "this my Rosie, this Martine, this Jacob, this Em'ly." Twenty-one she counted, saying of each, "Mine, all me—all my baby."

The blue waters of the Inlet separated the hurry and hurt of striving

Vancouver from all this peace—stagnant heathenism, the city called it.

Having so few pupils, I had much time for study. When I got out my Northern sketches and worked on them I found that I had grown. Many of these old Indian sketches I made into large canvases. Nobody bought my pictures; I had no pupils; therefore I could not afford to keep on the studio. I decided to give it up and to go back to Victoria. My sisters disliked my new work intensely. One was noisy in her condemnation, one sulkily silent, one indifferent to every kind of Art.

The noisy sister said, "It is crazy to persist in this way,—no pupils, no sales, you'll starve! Go back to the old painting."

"I'd rather starve! I could not paint in the old way—it is dead—meaningless—empty."

One sister painted china. Beyond mention of that, Art was taboo in the family. My kind was considered a family disgrace.

Victoria had boomed, now she slumped. We had not sold during the boom, now we were compelled to because of increased taxation. My father's acreage was divided into city lots and sold at a loss—each sister kept one lot for herself. Borrowing money, I built a four-suite apartment on mine. One suite had a fine studio. Here I intended to paint, subsisting on the rentals of the other three suites. No sooner was the house finished than the First World War came. Rental sank, living rose. I could not afford help.

I must be owner, agent, landlady and janitor. I loathed landladying. Ne'er-do-wells swarmed into cities to grab jobs vacated by those gone to war. They took advantage of "green" landladies. No matter how I pinched, the rentals would not stretch over mortgage, taxes and living.

I tried in every way to augment my income. Small fruit, hens, rabbits, dogs—pottery. With the help of a chimney sweep I built a brick kiln in my back yard, firing my own pots. The kiln was a crude thing, no drafts, no dampers, no thermometer—one door for all purposes. Stacking, stoking, watching, testing, I made hundreds and hundreds of stupid objects, the kind that tourists pick up— I could bake as many as five hundred small pieces at one firing.

Firing my kiln was an ordeal. I stoked overnight, lighting my fire well before day-break so that nosy neighbours would not rush an alarm to the fire department when the black smoke of the first heavy fire belched from the chimney. The fire had to be built up gradually. The flames ran direct among the pots, sudden heat cracked the clay. First I put in a mere handful of light sticks, the clay blackened with smoke. As the heat became stronger the flames licked the black off. Slowly, slowly the clay reddened passing from red hot to white of an awful transparency, clear as liquid. The objects stood up holding

their shapes with terrifying, illuminated ferocity. A firing took from twelve to fourteen hours; every moment of it was agony, suspense, sweat. The small kiln room grew stifling, my bones shook, anticipating a visit from police, fire chief, or insurance man. The roof caught fire. The floor caught fire. I kept the hose attached to the garden tap and the roof of the kiln-shed soaked. The kiln had to cool for twenty-four hours before I could handle the new-fired clay.

I ornamented my pottery with Indian designs—that was why the tourists bought it. I hated myself for prostituting Indian Art; our Indians did not "pot", their designs were not intended to ornament clay—but I did keep the Indian design pure.

Because my stuff sold, other potters followed my lead and, knowing nothing of Indian Art, falsified it. This made me very angry. I loved handling the smooth cool clay. I loved the beautiful Indian designs, but I was not happy about using Indian design on material for which it was not intended and I hated seeing them distorted, cheapened by those who did not understand or care as long as their pots sold.

I never painted now—had neither time nor wanting. For about fifteen years I did not paint.

Before I struck bottom it seemed there was one lower sink into which I must plunge. Taking over the entire upper storey of my house I turned it into a Ladies' Boarding House. Womanhood at its worst is the idle woman of small means, too lazy to housekeep, demanding the maximum, paying the minimum, quarrelling with other guests and demanding entertainment as well as keep and all for the smallest possible price.

Under the calm north light of the big studio window ten women satisfied their greed for all the things of which they had been deprived during the war. Limitation was over, but price still high. They were greedy over those foods which had been scarce. It was hard to satisfy them. I hated sitting at the head of my table forcing a smile—these creatures were my bread-and-butter, so I had to.

They jeered at my pictures on the wall, jeered before my very nose. (Could not the creatures see a burning red ear stuck onto either side of my head?)

Mrs. Smith would say to Mrs. Jones, "I am changing my place at table. Those totems turn the food on my stomach!"

"Mine too! I am positively afraid to come into this room after dark. The stare of those grotesque monsters! Do you suppose the things will ever have money value, Mrs. Smith?"

"Value? Possibly historical, not artistic," Mrs. Smith suggested.

"Daubs, bah! An honest camera—that is what records history."

There was no place other than the walls to store my pictures. I had to head my table and endure.

The ladies liked my food. When I started the boarding house people had said, "Artist cookery! Artist housekeeping!" and rolled their eyes. I proved that an artist could cook and could housekeep; but that an artist could paint honestly and keep boarders simultaneously I did not prove.

Clay and Bobtails saved me. I established a kennel of Old English Bobtail Sheep-dogs in the yards behind my garden. My property was bounded on three sides by vacant lots, treed and grassed. Here my "Bobbies" played; here I rushed to them for solace when the boarders got beyond bearing.

There was good demand for working dogs in those days. The war done, soldiers were settling on the land, raw land in lonely districts. There was not much sheep or cattle work for dogs but there were men to be guarded from themselves, from solitude after army life. No dog is more companionable than a Bobby.

I raised some three hundred and fifty Bobtail puppies. A large percentage of the pups went to soldiers. Clay and Bobtails paid my taxes—clay and Bobtails freed me from the torture of landladying.

"Eric Brown, Canadian National Gallery, speaking . . . I should like to call upon Miss Emily Cart to see her Indian pictures."

I had never heard of Eric Brown nor of the Canadian National Gallery. To be reminded that I had once been an Artist hurt. I replied tartly through the phone, "My pictures, with the exception of a very few on my walls, are stored away."

"May I see those few on the walls?"

I gave grudging consent.

Mr. and Mrs. Brown came; looking, talking together while I stood indifferently apart, my eyes on a lump of clay upon the table, losing its malleability.

"Marius Barbeau, Government Anthropologist, told me of your work," said Mr. Brown. "He heard about it from the Coast Indians. We are having an exhibition of West Coast Indian Art in the Gallery this autumn. Will you lend us fifty canvases? We pay all expenses of transportation. Come over for the show. I can get you a pass on the railway."

"Fifty of my pictures! Me go East! Who did you say you were?" I frowned at Mr. Brown, dazed.

Mr. Brown laughed—A Canadian artist who did not even know that Canada *had* a National Gallery!

"Artists this side of the Rockies don't keep up with art movements, do they? Where did you study?"

"London, Paris, but I am not an Artist any more." A boarder passed through the room. I turned sullen.

"Obviously you have done some study along the line of the modern way. There is a book just out. *A Canadian Art Movement*—read it—all about the Group of Seven and their work—by F. B. Housser."

"Who are the Group of Seven?"

"Seven men who have revolutionized painting in Eastern Canada. Come East, I will see that you meet the Group."

"Oh, but I could not! I could not get away."

Mr. Brown said, "Think that over."

He had seen interest wake in me when he mentioned "New Art." No sooner was he out of the house than I ran to town and bought a copy of *A Canadian Art Movement*, and read it from cover to cover, and was crazy to start that very moment. To my great astonishment when I told my sisters about it they said, "Why not?" and offered to tend the house during my absence.

"I can come," I wrote Mr. Brown, then shipped my pictures east, and off I went, breaking my journey at Toronto. All the Group of Seven men lived there.

The Exhibition of West Coast Art was at Ottawa but I was not going East to see the Exhibition. I wanted to meet the Group of Seven and see their work. I did not know how it was going to be arranged, but I stopped off at Toronto, hoping something might happen, or possibly I should see some of their work around the city.

I had been only a few hours in Toronto when I received a telephone message through the Women's Art Association, inviting me to go to the various studios of the Group members. The women of the Art Association were to conduct me. My eagerness turned suddenly to quakes. These men were workers, I a quitter.

On the steps of the Association I was introduced to Mrs. Housser.

"Wife of the book!" I exclaimed, thrilled.

"Come to tea with us tomorrow and meet 'Mr. Book'."

Mrs. Housser was an artist too. I marvelled how they all accepted me.

First my escorts took me to the studio of A. Y. Jackson. Then we went to Mr. Lismer's, then to J. E. H. MacDonald's. Varley was away, Carmichael and Casson lived further out of town. They were more recent members of the Group. I met them later. Last of all we went to the studio of Lawren Harris.

"This is an honour," my conductress said. "Mr. Harris is a serious worker, he does not open his studio to every passerby."

I am glad Mr. Harris's studio came last. I could not so fully have enjoyed the others after having seen his work.

I had been deeply impressed by his two pictures reproduced in Mr. Housser's book. The originals impressed me yet more deeply. As Mr. Harris showed us canvas after canvas I got dumber and dumber. My escort was talka-

tive. Mr. Harris left me alone to look and look and look. When it was time to go a million questions rushed to my mind. I wanted to talk then, but it was too late. As he shook hands Mr. Harris said, "Come again." Eager questions must have been boiling out of my eyes and he saw.

I went to Ottawa but all the while I was there I was saying to myself, "I must see those pictures of Mr. Harris's again before I go West." They had torn me.

The Ottawa show was a success. All the familiar things of my West—totem poles, canoes, baskets, pictures (a large percentage of the pictures were mine). It embarrassed me to see so much of myself exhibited. The only big show I had been in before was the Salon d'Automne in Paris. Out West I found it very painful and unpleasant to hang in an exhibition. They hated my things so! Here everyone was so kind that I wanted to run away and hide, yet I did want, too, to hear what they said of my work. I had not heard anything nice about it since I was in France.

In Ottawa all the time I was longing to be back in Toronto to see again Mr. Harris's pictures. I was saying to myself, "I must see those pictures again before I go West." They had torn me; they had waked something in me that I had thought quite killed, the passionate desire to express some attribute of Canada.

I arranged to spend two days in Toronto on may way home. I went straight to the telephone, then scarcely had the courage to ring. I had wasted one whole afternoon of Mr. Harris's work time, had I the right to ask for another? Urgency made me bold.

"I go West the day after tomorrow, Mr. Harris. West is a long way. May I see your pictures again before I go?"

"Sure! Tomorrow. Stay—come and have supper with us tonight; there are pictures at home, too. I will pick you up."

Oh, what an evening! Music, pictures, talk—at last "goodnight" and Mr. Harris said, "What time at the studio tomorrow?"

"You mean *this* is not instead of *that*," I gasped.

"Sure, we have not half talked yet."

So I went to Mr. Harris's big, quiet studio again.

"What was it you particularly wanted to see?"

"Everything!"

Starvation made me greedy—he understood and showed and showed while I asked and asked. No one could be afraid of Mr. Harris. He was so generous, so patient when talking to green students.

"I understand you have not painted for some time?"

"No."

"Are you going to now?"

"Yes."

"Here is a list of books that may help. You are isolated out there. Keep in touch with us. The West Coast Show is coming on to our Gallery after Ottawa. I shall write you when I have seen it."

"Please criticize my things hard, Mr. Harris."

"I sure will."

Three days after my return from the East I was at my painting. Mr. Harris wrote, "The exhibition of West Coast Art is at the Gallery. As interesting a show as we have had in the Gallery. Your work is impressive, more so than Lismer had led me to believe, though he was genuinely moved by it in Ottawa. I really have, nor can have, nothing to say by way of criticism. . . . I feel you have found a way of your own wonderfully suited to the Indian spirit, Indian feeling for life and nature. The pictures are works of art in their own right . . . have creative life in them . . . they breathe."

This generous praise made my world whizz. Not ordinary technical criticism, such as others had given my work. Mr. Harris linked it with the Indian and with Canada.

Sketch-sack on shoulder, dog at heel, I went into the woods singing. Not far and only for short whiles (there was still that pesky living to be earned), but household tasks shrivelled as the importance of my painting swelled.

By violent manœuvring I contrived to go North that summer, visiting my old sketching grounds, the Indian villages, going to some, too, that I had not visited before. Everywhere I saw miserable change creeping, creeping over villages, over people. The Indians had sold most of their best poles. Museums were gobbling them. The recent carvings were superficial, meaningless; the Indian had lost faith in his totem. Now he was carving to please the tourist and to make money for himself, not to express the glory of his tribe.

I sent two canvases east that year, thrilled that "The Group" included me among their list of invited contributors. Eastern Artists expressed amazement at the improvement, the greater freedom of my work. A. Y. Jackson wrote, "I am astonished." Like Mr. Gibb, Jackson patronized feminine painting. "Too bad, that West of yours is so overgrown, lush—unpaintable," he said, "too bad!"

I always felt that A.Y.J. resented our West. He had spent a summer out at the coast sketching. He did not feel the West as he felt the East.

Mr. Harris's letters were a constant source of inspiration to me. He scolded, praised, expounded, clarified. He too had tasted our West, having sketched in the Rocky Mountains. He understood many of my despairs and perplexities. Sometimes my letters were bubbling with hope, sometimes they dripped woe. I wrote him of the change taking place in the Indian villages—in Indian work-

manship. His advice was, "For a while at least, give up Indian motifs. Perhaps you have become too dependent on them; create forms for yourself, direct from nature."

I went no more then to the far villages, but to the deep, quiet woods near home where I sat staring, staring, staring—half lost, learning a new language or rather the same language in a different dialect. So still were the big woods where I sat, sound might not yet have been born. Slowly, slowly I began to put feeble scratchings and smudges of paint onto my paper, returning home disheartened, wondering, waiting for the woods to say something to me personally. Until they did, what could I say?

"Wondering?" wrote Mr. Harris, "Why I can almost see your next step. In wondering we dedicate ourselves to find a new approach, fresh vision. . . . Wondering is a process of questioning. Why has the thing I am trying to express not a deep fullness of life? Why is it not clearly and exactly what I am trying to convey? . . . Deeper problem than most of us realize . . . has to do with the highest in us. . . . A talent or aptitude should be developed," he wrote. "Should be worked hard, if we are so placed that we can work (as far as I know you are so placed). Your peculiar contribution is unique. . . . In some ways if a body is removed from the fuss as you are, and, providing the creative urge is strong to keep him working, he is fortunate. . . . Good zest to your work, you can contribute something new and different in the Art of this country. The more joy in the work the better. No one feels what you feel. It will surely develop far reaching results."

These letters cheered and stimulated me. Of course I got into great snarls of despondency. Bitterly in my letters I would cry out, "When I hear of you Eastern Artists going off in bunches, working, sharing each others' enthusiasms and perplexities, I am jealous, furiously jealous!"

"Solitude is swell!" replied Mr. Harris. "Altogether too much chatter goes on."

I knew he was right—stupid me—hadn't I always chosen solitude, squeezing into tight corners in class, always trying to arrange that no one could stand behind and watch me work?

"You old silly!" I said to myself, and took myself in hand.

Two things I found of great help. First, there was the companionship of creatures while working (particularly that of a dog). I have taken birds, a monkey, even a little white rat into the woods with me while studying. The creatures seemed somehow to bridge that gap between vegetable and human. Perhaps it was their mindless comprehension of unthinking life linking humanity and vegetation. The other help was a little note book I carried in my sketch-sack and wrote in while intent upon my subject. I tried to word in the

little book what it was I wanted to say. This gave double approach for thoughts regarding what you were after.

I stopped grieving about the isolation of the West. I believe now I was glad we were cut off. What I had learned in other countries now began to filter back to me transposed through British Columbia seeing. Ways suitable to express other countries, countries tamed for generations, could not expect to fit big new Canada.

At long last I learned, too, to surmount the housekeeping humdrum which I had allowed to drift between me and the painting which I now saw was the real worth of my existence.

An American Artist came to visit at my house.

"Come, let us go to Beacon Hill or the sea, while morning is still young," he said.

"The beds! the dishes! the meals!" I moaned.

"Will wait—young morning on Beacon Hill won't. Don't tether yourself to a dishpan, woman! Beds, vegetables! They are not the essentials!"

Suddenly I realized brag and stubbornness had goaded me into proving to my family that an artist could cook, could housekeep. Silly, rebellious me! Hadn't I for fifteen years bruised body and soul, nearly killed my Art by allowing these to take first place in my life?

I corresponded with several Artists in the East and I made three trips to Eastern Canada during Exhibitions of the original Group of Seven, shows to which I was an invited contributor. These visits were a great refreshment and stimulus. The first time I came back a little disgruntled that I must always work alone, while they worked in companies and groups; after awhile I came West again from these visits happy. It was good to go when opportunity opened, good to see what others were doing, but the lonely West was my place. On one of my Eastern trips I slipped across the line. This is how it came about that I saw New York.

New York

"**W**hy not?" Mr. Harris said and closed the book of New York's splendours he had been showing me, photographs of the gigantic wonders, her skyscrapers, bridges, stations, elevated railways.

"Why not see New York now, while you are on this side of the continent? It is only a step across the line. New York is well worth the effort."

I protested, "I hate enormous cities cram-jam with humanity. I hate them!"

Mr. Harris said no more about New York. I had been much interested in his telling of his reactions to New York. He was just back from there, had gone to see a big picture exhibition. In spite of myself my curiosity had been aroused. Instead of sleeping that night as I ought to have done, I lay awake thinking, planning a trip to New York. Next day I acted; curiosity had won over fright. As I bought my ticket my heart sank to somewhere around my knees, which shook with its weight; but common sense came along, took a hand, whispering, "Hasn't it been your policy all through life to see whenever seeing was good?"

"I'm going," I said to Mr. Harris. "Can you give me a list of New York's Art Galleries, the most modern ones?"

"Good," he said and also gave me introduction to a very modern artist, the President to the "Société Anonyme" (New York's Modern Art Society).

This lady, Miss Katherine Dreier, was a painter, a lecturer and a writer. Her theme throughout was Modern Art. She had just published *Western Art and the New Era*, quite a big volume.

A couple of warm friends of mine who used to farm out west had written me when they knew I was coming to Toronto inviting, "Cross the line and visit us." They now lived on Long Island where the husband had been for some years manager of a millionaire's estate. I wired my friend asking, "Could you meet me at the station in New York? I'm scared stiff of New York!"

Arrangements made, myself committed, I sat down to quake. I do not know why I dreaded New York. I had faced London and Paris unafraid. Perhaps *this* fear was because of what they had done to me and the warnings I had been given to "keep away from great cities". I said to myself, "This is only just a little visit, seeing things, not settling in to hard work."

Before ever the train started I had an argument with the porter. He insisted that my berth be made up so that I rode head first. I insisted that I would ride facing the engine, in other words feet first.

"If there is a axiden yous sho a dead woman ridin' dat-a-way."

"Well, perhaps there won't be an accident. If I ride head first, I shall be a seasick woman sure, certain, accident or not!"

He grumbled so much I let him have his way, then remade my bed while he was at the other end of the coach.

I had no sooner fallen asleep than a flashlight, playing across my face, woke me. It was the quota and immigration official. "We are about to cross the line." He proceeded to ask all sorts of impertinent questions about me and my antecedents. I heard other angry passengers in other berths being put through the same foolish indignity. The dark coach hushed to quiet again except for

the steady grind of the train-wheels a few feet below the passengers prone bodies and ragged-out tempers. That was not the end. I was just conscious again when a tobacco-smelling coat sleeve dragged across my face and turned my berth light on. Bump, bump! the porter and the customs were under my berth grappling for my bags. First they rummaged, then they poured everything, shoes, letters, brushes, tooth paste, hairnets, over me.

"Anything to declare?"

"Only that you are a disgusting nuisance!" I snapped, collecting my things back into their bags.

"If folks will cross the line!" he shrugged.

"Drat your old line!" I shouted. "It is as snarly as long hair that has not been brushed for a year!"

No good to try and sleep again! I knew by the feel inside me that we were nearing a great city. The approach to them is always the same.

"New York! New York!" The porter and his ladder bumped into the people, uncomfortably dressing in their berths.

I raised my blind—tall, belching factory chimneys, rows and rows of workmen's brick houses, square, ugly factories, with millions of windows. Day was only half there, and it was raining.

Noises changed, we were slithering into a great covered station. There on the platform, having paddled through rain at that hour, was my friend, Nell. I nearly broke the window rapping on it. She waved her umbrella and both hands.

The station was about to wake and have its face washed. Sleepy boys were coming with pails and brooms. The breathless hither and thither rush common to all stations had not started as yet. Nell skirted the cleaners amiably. I never remember to have seen her ruffled or provoked. Once out west I went with her to feed the sow. Nell lodged her pail of swill in the crotch of the snake fence while she climbed over. Evangeline the sow stood up and snouted the entire pailful over Nell. There Nell stood, potato peeling in her hair, dripping with swill and all she said was, "Oh, Evangeline!"

Well, I suppose if one's disposition could take that it could take New York.

The distance from station to station seemed no way at all, we were talking so hard. Suddenly, I remembered and said, "Why, Nell, is this New York?" Soon our train began skimming over beautiful green fields. The very up-to-datest farm buildings and fences were here and there, and such beautiful horses were in the pastures.

"Nell, where are we?"

"On Long Island. This is where the millionaires and the multi-millionaires come to recuperate when Society ructions have worn them threadbare.

These sumptuous estates are what the millionaires are pleased to call their 'country cottages'."

My friends lived on the home farm of their own particular millionaire's estate, in a large, comfortable farm house.

During my week's stay on Long Island I never saw or heard a millionaire but I saw the extravagances on which they poured their millions and it amazed me. They had tennis courts glassed over the top so that they could play in all weathers. They had private golf courses, private lakes for fishing, they had stables full of magnificent race horses and every style and shape of motor cars. They had gardens and conservatories and, of course, they had armies of servants to keep the places in order and have them in readiness any moment the owners took the whim—"I'm sick of Society, it is such hard work. We will run down to our cottage on Long Island." Then a string of motor cars as long as a funeral would tear over the Island roads, endangering dogs and every one else's life, motors stuffed with the fancy equipment millionaires consider indispensable.

It was nothing, my friends told me, for a New York florist to send in a bill of seventy-five dollars just for providing cut flowers to decorate the house for a single week-end, and there were the rest of us mortals thinking twice before spending one dollar on a plant! The extravagance fairly popped my eyes.

The week of my stay on Long Island happened to be Easter. Our millionaires were giving a week-end party. They kept the manager hopping. My friend's husband was the very finest type of Englishman. Life had given him some pretty hard knocks and left him strong, fine, honourable. The same applied to his wife. The millionaires thought the world of the pair and gave them complete trust, respect and love.

The beginning of Easter week the manager was bidden to search the Island nursery-gardens catering to the wealthy, till he could locate half a dozen blossoming trees. They must be in full bloom. It seemed that there were to be fishing parties on their private lake. Their stables were close to the lake side. The trees must be as high as the stables and hide the buildings from the fisher's eyes. But trees would not hurry growth for any old millionaire. They clamped their buds tight as a good parson's lips clamp on an occasion when only one well-rounded word could express his feelings.

At the last nursery we found six forsythia trees in full bloom. They were as gold as butter and as high as the stables. It took a separate lorry to move each tree. About an acre of dirt had to accompany each tree's roots. It took a battalion of men to do the job. They did it well. The forsythias did not wilt and the reflection in the lake was lovely. The millionaires were pleased. I have no idea what the performance must have cost!

The manager was also instructed to see that the tennis court was in good shape for play. An expert was called in to inspect.

"Carn't do nothin' by Easter," he said. "Court needs makin' over from foundation. Best I can do is to patch her so she'll play 'em over the week-end. Patch'll cost three hundred dollars."

The owners said, "Certainly, go ahead." But the expensive patch was never used once during the Easter holiday.

Our millionaires were childless. Besides this place they had a mansion in New York. Also the wife, who was a millionaire in her own right, had a magnificent estate in Belgium. It was their favourite of the three estates. They frequently visited there.

I heard that the Martha Washington Hotel in New York was a nice place for a lady alone so I went there. It was not as tall or as high priced as many of the newer hotels but it was very comfortable and conveniently situated for everything.

I quaked up to Martha's desk and asked the clerk, "Have you such a thing as a ground-floor room or at least one on second or third floor that can be reached by the stairway?"

The clerk's look was scornful and plainly commented "hayseed". He said, "We have such rooms, Madam; there is little demand for them. Higher the floor, better the light and air."

"I dislike elevators."

The clerk led the way to a room half a storey higher than Martha's lounge. He turned on the light. It was never more than twilight in that room, but I liked it in spite of its dimness. It had a private bath and I thought the price most moderate. My window opened into a well and I was at the very bottom; about a thousand other windows, tier upon tier, opened into my well.

Martha homed many girlish grandmothers, derelicts who had buried their husbands, or divorced them, married off their children and did not quite know what to do with life. They were be-curled, be-powdered and tremendously interested in their food. Martha had glass doors leading from the lounge to the restaurant. These grandmother-girls were always the first to be at the glass doors when the maids unlocked them at meal times. Martha's food was excellent. There was a door leading direct from the street into the dining room. Men were permitted to lunch at Martha's and a tremendous lot of business men came there for lunch. Martha's food was good and very reasonable.

My Long Island friend came up and took sightseeing tours with me. We went in big buses with bigger megaphones which deafened us when they told

us about all the marvels we were passing. First we did the "High-Town" and then we did the "Low-Town" and by that time we were supposed to know New York by heart.

My dread of going around New York alone had completely vanished. I have often wondered what caused that fear, almost terror, of New York before I saw her. I had been raised on this continent and was much more in sympathy with the New than with the Old World. New York was clean, the traffic wonderfully managed and the people courteous.

I hunted up the Art Galleries. Alas, I found them mostly located on top storeys. My heart sank to a corresponding depth under the earth. I kept putting off the visiting of Art Galleries. I did do one on the fifteenth floor (with the exception of Roerich Gallery this was about the lowest). Shooting up was fearful but the thought of sinking down again appalled me. It spoiled the pleasure of the pictures.

On the fifteenth floor I stood aside, waiting for the other passengers to enter the elevator. Half in and half out, I paused. The operator got restive. Suddenly I backed out of the cage.

"Where's the stairs?" I started to run in the direction of his pointing thumb. His scorn followed me.

"Yer won't get to the bottom within a week!"

I knew I ought to be ashamed, and I was. I was sure the cable would break, or that the sink would stop my heart-beat entirely.

The Roerich Museum was on the banks of the river. The building was only half a dozen storeys high. The picture galleries occupied the three lower floors. Everything in the building was Mr. Roerich. . . .His pictures covered the walls of all the galleries. There was one room stacked to the ceiling with parchment rolls, whether by or about him I do not remember. He was for sale in book form and by photograph at the desk on the ground floor. The attendant lowered her voice to whispering every time she uttered his name. I am afraid I do not yet know just who Roerich was; his museum did not greatly interest me. He seemed to have a large following and everybody knew all about him.

I was not alone while I visited the Roerich Gallery. As I went in the door I met Arthur Lismer of the Toronto Group of Seven and a lady Art Teacher of Toronto. They turned and went back with me. They were up in New York to study the method of Art Teaching in the schools there and also to see the spring Exhibitions. The Art Teaching Lady immediately became a devotee of Roerich. She was voluble as we went through the galleries, Mr. Lismer rather silent. Presently the lady left us to run back to the desk below and secure a few more books and photographs.

I said to Mr. Lismer, "These pictures don't make me 'quake', do they you? They are spectacular enough but . . ."

Mr. Lismer nodded, laid his finger across his lips and rolled his eyes in the direction of the lady from Toronto.

"Don't spoil her delight: she is such an ardent adorer!" He pulled his watch out. "Time!" he shouted over the stair rail to the lady, and to me he said, "Old Toronto student of mine meeting us here to conduct us to the new spring shows, come along."

"I'd love to, only . . ." He laughed, knowing my pet horror.

"Elevators? I'll fix that with the operators, come on."

Each time we were about to drop like a pail filled with rocks Mr. Lismer whispered in the elevator man's ear and we slid down slowly and gently. I have always felt gratitude towards Arthur Lismer for that.

Those modern exhibitions were a wonderment beyond my comprehension, but they were certainly not beyond my interest. In some of them I found great beauty which stirred me, others left me completely cold; in fact some seemed silly, as though someone was trying to force himself to do something out of the ordinary.

We saw Kandinsky, Bracque, Ducamp, Dove, Archipenko, Picasso and many others. Some had gripping power. The large canvas, *Nude Descending a Staircase*, hung in one gallery. I had seen reproductions of this painting before. Mr. Lismer stood looking at it intently. His student, the lady from Toronto and I were arranged beside him looking too, but with less understanding. The four of us were dumb, till Lismer said, "One thing certain, the thing is very, very feminine."

Not until my last day in New York did I meet Mr. Harris's artist friend, the President of the "Société Anonyme." I had tried to communicate with her by 'phone from Martha but without success—she lived in such swell Mansions. Ordinary people were not permitted to communicate with the mansion-dwellers except by some special telephonic gymnastics far too occult for me to grasp, so I wrote her a note. She immediately called at my hotel, which was most gracious of her. I happened to be out, so she left a message at the desk. Martha neglected to deliver it till within two hours of the departure of my train for Toronto. I was annoyed with Martha. I wanted to meet Miss Dreier. Martha atoned the best she could by sticking me into a cab and heading me for the Mansions. They faced on a beautiful park and were of over-powering magnificence. There were as many guards, door-attendants, bellboys, eleva-tresses and enquiry clerks as if it had been a legation (spies expected). All of them looked down their noses. I was such a very ordinary person to be asking for one of their tenants! Half a dozen attendants consulted. It was decided that

one of the elevatresses, who, by the way, was costumed in black velvet, should take a bellboy and ascend. The boy would take my message and see if it was Miss Dreier's wish to receive me.

It *was* Miss Dreier's wish to receive me, but, the black-velveted lady informed me, "She is about to go out, so the visit must be brief!"

Such rigmarole! I began to wish I had not come, but, as soon as I saw Miss Dreier I was glad I had. She was friendly and kind. I explained about Martha's negligence in delivering her message. She asked about Mr. Harris and his work and a little about me and my work out West. I got up to go saying, "I believe, Miss Dreier, you were just about to go out."

"Only to my bank," she replied. "That can wait till another day. I do not meet artists from Canada every day."

She bade me sit down again. Her house was sumptuous. On the walls were fine paintings, all were canvases by Moderns, all "abstract." Then she brought out many canvases of her own painting. She talked about abstraction and abstractionists. She was particularly proud of a Franz Marc which had just come into her possession.

Among her own canvases was one called *Portrait of a Man*. I would never have suspected it. From the midst of squirming lines and half circles was something which rather resembled the outer shape of a human eye, but through its centre was thrust a reddish form that was really a very healthy carrot.

I looked a long time. I had to say something so I asked, "Please, Miss Dreier, why is that carrot stuck through the eye?"

"Carrot!" Miss Dreier gasped. "Carrot! I did think I had so plainly shown the man's benevolence! He was the most benevolent person I ever knew!"

I felt dreadfully wilted, dreadfully ignorant. To put me at ease Miss Dreier told me about her new book just published, *Western Art and the New Era*.

"I shall get it," I said. "Maybe it will teach me something about abstract art."

We discussed Georgia O'Keefe's work. I told of how I had met her in the gallery of Mr. Steiglitz.

I said, "Some of her things I think beautiful, but she herself does not seem happy when she speaks of her work."

Miss Dreier made an impatient gesture.

"Georgia O'Keefe wants to be the greatest painter. Everyone can't be that, but all can contribute. Does the bird in the woods care if he is the best singer? He sings because he is happy. It is the altogether-happiness which makes one grand, great chorus."

I have often thought of that statement of Miss Dreier's, also of how extremely nice she was to me.

"Thank Mr. Harris for sending you. I am so glad I had not already left for my bank," were her good-bye words.

Lawren Harris

M y first impression of Lawren Harris, his work, his studio has never changed, never faltered. His work and example did more to influence my outlook upon Art than any school or any master. They had given me mechanical foundation. Lawren Harris looked higher, dug deeper. He did not seek to persuade others to climb his ladder. He steadied their own, while they got foot-hold.

The day that I picked my way over that Toronto slush pile outside the Studio Building, under a bleak, wintry sky, against which the trees of Rosedale Park stood bare and stark . . . the day I entered the dreary building, climbed the cold stair, was met by Mr. Harris and led into his tranquil studio,—that day my idea of Art wholly changed. I was done with the boil and ferment of restless, resentful artists, cudgelling their brains as to how to make Art pay, how to "please the public." Mr. Harris did not paint to please the public, he did not have to, but he would not have done so anyway.

Just once was I angry with him; that was over a canvas, painted by myself, entitled *The Indian Church*.

I had felt the subject deeply, painting it from a close-to-shore lighthouse at Friendly Cove Indian Village out West. Immediately on completion I sent the canvas to an Eastern Exhibition. I had a red-hot hustle to get it to the show in time. *The Indian Church* had three would-be purchasers. To my unqualified joy and pride it was bought by Mr. Harris.

A few months later I went East for a "Group" Show. After the preview, Mr. Harris entertained the Artists at his home.

Taking me by the arm, "Come and look!" he said.

Above the supper-table, beautifully framed and lighted, hung my *Indian Church*.

Surely Mr. Harris's house must have bewitched the thing! It was better than I had thought. I had hurried it into its crate, having hardly given a second glance at it.

I had scarcely the courage to look now. There were people all round the picture saying kind things about it. I was embarrassed, being unused to criticism of that sort. Out West, why, only a week before, I had attended an exhibition of the Island Arts and Crafts Society. My sisters invited me to take tea with

them at the social function connected with the affair. I draggled behind them hating it. We had tea and gossip with friends. No one mentioned my two canvases, so I hoped that perhaps they had been rejected, for I shrank from facing them with my sisters present and with people I knew standing about, people who, I was aware, hated my work.

They were hanging in the last room, right in front of the door. With an angry snort my most antagonistic sister saw and turned sharply back.

"We will go again to the flower paintings. I like them," she said pointedly and we wheeled. My other sister gave one backward glance.

"Millie," she said, "I do like—" My breath stopped! She had never expressed liking of anything of mine.—"your frames," she finished.

Many times Mr. Harris wrote me enthusiastically of *The Indian Church*. He sent it to an exhibition in the United States and wrote, "I went to the U.S. Show. Your Church was the best thing there, a swell canvas. I do not think you will do anything better."

At that I flew into a rage. Mr. Harris thought I had reached the limit of my capabilities, did he! Well, my limit was not going to congeal round that Indian Church! I sent other work east. He compared it unfavourably with the Indian Church—I had thought this work just as good, perhaps better. Mr. Harris did not. He still praised the Indian Church.

"You limit me! I am sick of that old Church. I do not want to hear any more about it!" I wrote angrily.

His answer was, "Good! Still, that Indian Church is a grand thing, whatever and despite what you think of it."

We dropped the subject, but he went on writing helpful, encouraging letters. A lesser man might have huffed at my petulance, even stopped writing. If he had I would have broken.

I had now become independent of Indian material. It was Lawren Harris who first suggested I make this change.

I had become more deeply interested in woods than in villages. In them I was finding something that was peculiarly my own. While working on the Indian stuff I felt a little that I was but copying the Indian idiom instead of expressing my own findings.

To gain freedom I saw I must use broad surfaces, not stint material nor space. Material in the West was expensive, space cheap enough. I bought cheap paper by the quire. Carrying a light, folding cedar-wood drawing board, a bottle of gasoline, large bristle brushes and oil paints, I spent all the time I

could in the woods. Once or twice each summer I rented some tumble-down shack in too lonesome a part to be wanted by summer campers. Here, with three or four dogs and my monkey, all my troubles left at home, I was very happy and felt my work gain power.

I sent a bundle of these paper sketches East. Mrs. Housser showed them to a group of artists in her house and wrote their comments to me. The criticism did not help much. However, they did all seem to feel that I was after something and this cheered me.

Lawren Harris wrote, "I saw the sketches. They are vigorous, alive, creative. . . . Personally I do not feel that your sketches are subject to criticism, they represent vital intentions. One can only say, 'I like this one or I do not like that.' They are unusually individual and soaked with what you are after, more than you realize, perhaps. . . . Don't let anything put you off . . . even if you come through with but one out of three or four endeavours, hitting the mark, the thing woven into vital song . . . keep at it."

"When, in my last letter," wrote Mr. Harris, "I said there is no evolution in Art . . . that I think is true, but not with each individual artist. Each artist does unfold, come to his or her particular fulness. But in Art as a whole, there is not evolution; there is change of idiom, approach and expression—development of means, media, and paraphernalia. . . . The old Masters have not been surpassed. Modern artists do different things in terms of their day, place and attitude. Great works of Art are the same yesterday, today and forever. We but endeavour to be ourselves, deeply ourselves; then we approach the precincts of Great Art— timeless—the Soul throughout eternity in essence."

Lawren Harris did not separate Art from life. You could chatter to him freely about what to most people seemed trivialities; observations on woodsey things and about animals as well as about work, honest observations interested him. I wrote him of my friendship with Sophie, the Indian woman.

"It goes to prove," he replied, "that race, colour, class and caste mean nothing in reality; quality of soul alone counts. Deep love transcends even quality of soul. . . . It is unusual, so deep a relationship between folks of different races."

Sometimes my letters were all bubble-loveliness of the woods and creatures—again, they dripped with despairs and perplexities. Then he would try to set my crookedness straight. He would write, "In despair again? Now that is too bad. Let us be as philosophical as we can about it. Despair is part and parcel of every creative individual. Some succumb to it and are swamped for this life. It can't be conquered, one rises out of it. Creative rhythm plunges us into it, then lifts us till we are driven to extricate. None of it is bad. We cannot stop the

rhythm but we can detach ourselves from it—we need not be completely immersed . . . we have to learn not to be! How? By not resisting. Resistance is only an aggravation!—one I think that we should escape from if we learned that all things must be faced, then they lose their potency. It is no good to tell you that your work does not warrant despair. Every creative individual despairs, always has since the beginning of time. No matter how fine the things are, there are always finer things to be done and still finer *ad infinitum*. . . . We have to be intense about what we are doing but think what intensity does, what it draws into itself—then, do you wonder that, if things do not go as well as we anticipate, the reaction from intensity is despair? Keep on working, change your approach, perhaps, but don't change your attitude."

Arthur Lismer, the lecturing member of the Group of Seven, came west. He visited my studio, went through my canvases. Lismer's comments were so mixed with joke either at his own or at your expense that you never quite knew where you stood. His criticism left me in a blur. On the lecture platform Lismer draped himself over the piano and worked modern Art enthusiastically, amusing as well as impressive.

Lawren Harris wrote, "Lismer is back from the West, full of his trip. He had great things to say of your present work, could see it emerging into fruition. . . . If I could convey to you his look when he talked about your work, discouragement would never enter your mind again. . . . I suppose we are only content when all our sails are up and full of the winds of heaven—certainly the doldrums are trying. . . . I hope all your sails are up and full of the winds of heaven under high great skies."

Mr. Harris wrote me of making a selection of pictures for an All Canadian Show in the United States, "The choice was left to Jackson and me. Yours were all damned good things. I feel there is nothing being done like them in Canada . . . their spirit, feeling, design, handling, is different and tremendously expressive of the British Columbia Coast—its spirit—perhaps far more than you realize. We who are close to certain things hardly realize the intensity and authenticity of what we do to others who are less close. Your work is a joy to us here, a real vital contribution."

Thus he cheered, gave me heart.

In answer to a perplexed letter of mine he wrote, "The lady you speak of who was moved by your work was right; you may not think so, but, perhaps you are not seeing what you do entirely clearly. You get immersed in problems, the reaction from creative activity, dissatisfaction from the feeling that you have not realized what you desired. We all are in such matters, and it is all as it

should be, there is no finality, no absolute standard, no infallible judge. . . . Life is creative and Art, creative Art is Life."

Every letter he wrote stimulated me to search deeper. Lawren Harris made things worthwhile for their own sake.

Again he wrote, "Everything you say describes the true Artist . . . there is no realization, only momentum towards realization. The *becoming of all*, satisfying, completion, fulfilment, something indeed that we cannot attain individually, separately, only as the complete spiritual solidarity, mankind. . . . Strive we must. . . ."

Again, "Your canvases hang in the o.s.a. show. The consensus of opinion, best opinion, is that they are a very great advance on your previous work. It is as if your ideas, vision, feelings, were coming to precise expression; yet nowhere is the work mechanical, laboured or obvious. For goodness sake, don't let temporary depression, isolation, or any other feeling interfere with your work. . . . Keep on . . . do what you feel like doing most. Remember, when discouraged, that there is a rhythm of elation and dejection; and that we stimulate it by creative endeavour. . . . Gracious, what we stir up when we really come to live! When we enter the stream of creative life, then we are on our own and have to find self-reliance, active conviction, learn to see logic behind the inner struggle. Do, please, keep on and know, if it will help you, that your work has tremendously improved; know, too, that the greater it becomes the less you will be aware of it, perhaps be almost incapable of being convinced; what does that matter? There is only one way—keep on.—How can greatness be true greatness unless it transcend any personal estimate? How can it live in great searchings, in the true spirit, in the informing unity behind the phenomena, if it knows itself as great? . . . Creative imagination is only creative when it transcends the personal. . . . Personality is merely the locale of the endless struggle, the scene of the wax and wane of forces far greater than itself."

So Lawren Harris urged, encouraged, explained. I was often grumbly and not nice. On one occasion when I was cross I wrote a mean old letter to a fellow artist in the East who had annoyed me in some trivial matter. Lawren saw the letter. He scolded me and I felt very much shamed. He wrote me, "Tell you what to do, when you have need of 'ripping things up a bit' get it off your chest by writing to me. The party you tore up was a sensitive soul. Write me when you are rebellious, angry—Bless you and your work."

Once when I was in perplexity he wrote, "I don't suppose you do know precisely what you are after. I don't think in the creative process anyone quite knows. They have a vague idea—a beckoning, an inkling of some truth—it is only in the process that it comes to any clarity. Sometimes, indeed often, we

work on a theme with an unformed idea and, when it has passed through the process, its final result is something we could never have predicted when we commenced. . . . Of course there must be the urge, the indefinable longing to get something through into terms of plastic presentation, but results are nearly always unpredictable."

"Sold my apartment house! Moved into a cottage in a dowdy district, old fashioned high windows—think I can paint here," I wrote to Lawren Harris.

He replied, "Sounds good to me. Occasionally uprooting is good for work, stirs up a new outlook, or refreshes the old one."

When later I reported, "Bought a hideous but darling old caravan trailer, am now independent of cabins for sketching trips," "Swell!" was Lawren Harris's hearty comment. "Swell!"

"Yes, I too have been working. My present approach is by way of abstraction. I have done quite a number and with each one learn a little more, or increase that particular way of perceiving. Feeling can be as deep, as human, spiritual and reso-nant in abstract as in representational work: but, because one has less to rely on by way of association, it requires a greater precision. . . . A struggle all right. . . . There is no doubt in my mind that abstraction enlarges the scope of painting enormously. It replaces nothing, it adds to the realm of painting, makes possible an incalculable range of ideas that representational painting is closed to, increases the field of experience—enlarges it—that is surely all to the good, but abstraction definitely cannot displace or replace representational painting. . . . If one has not zest, conviction and feeling, one is no better off in abstract, indeed less so.

"Our limitations may make abstraction seem remote, but then once we extend those limitations, which is the purpose of Art, the remoteness disap-pears. . . . Abstraction can have all the virtue of representational painting plus a more crystallized conviction. I feel that it will become more and more the language of painting in the future and no man can say what it may yet dis-close. Some day I may return to representational painting—I do not know. At present I am engrossed in the abstract way.—Ideas flow, it looks as though it would take the rest of my life to catch up with them. . . . When, in your letter, you refer to 'movement in space', that is abstract, try it. . . . Take an idea, abstract its essence. Rather, get the essence from Nature herself, give it new form and intensity. You have the 'innards' of the experience of nature to go by and have done things which are so close to abstraction that you should move into the adventure much more easily than you perhaps think."

I was not ready for abstraction. I clung to earth and her dear shapes, her den-sity, her herbage, her juice. I wanted her volume, and I wanted to hear her throb.

I was tremendously interested in Lawren Harris's abstraction ideas, but I was not yet willing to accept them for myself. They seemed the right and natural development for his work. Now that I have seen his beautiful abstractions I think I would be sorry to see him return to representational painting. I do not pretend to understand, to be able entirely to follow the principle of abstract truth, but I do feel unwordable depths in it that move me very much. In Lawren Harris's abstractions I am as aware of truth as I was aware of the calm deep sincerity which uplifted the onlooker in his earlier representational work and in them too I am aware of great beauty and power. I cannot explain why Lawren Harris's abstracts move me so, I feel power there whereas in some abstractions I feel emptiness.

Green

Woods you are very sly, picking those moments when you are quiet and off guard to reveal yourselves to us, folding us into your calm, accepting us to the sway, the rhythm of your spaces, space interwoven with the calm that rests forever in you.

For all that you stand so firmly rooted, so still, you quiver, there is movement in every leaf.

Woods you are not only a group of trees. Rather you are low space intertwined with growth.

Bless John Whiteley! Bless Algernon Talmage! the two painting masters who first pointed out to me (raw young pupil that I was) that there was coming and going among trees, that there was sunlight in shadows.

In the roof-peak of the apartment house I built was a little attic room, my favourite of all the rooms in that house.

A crooked stair led to it. The stair was in the corner of the studio. I chose this room with its wide view for my bedroom. It had low-drooped walls but the centre of the room was high. Its end walls were peaked. The naked ridge pole and studding showed, because the room was unlined. Rain pattered on the cedar shingles only a few feet above my face.

In its west-end wall the room had two large windows which appeared to be narrow because they were so high, beginning at the floor and ending right in the point of the gable. These windows let in an extensive view, a view of housetops, trees, sea, purple mountains and sky. The view seemed to come companionably into the room rather than to draw me out; and it had an additional glory, but for this glory you must look *out*, look *down*. Then you saw

right into the heart of a great Western maple tree. Its huge bole culminated in wide-spread, stout branches. There was room for immense life in this bole.

The maple tree was always beautiful, always gracious. In spring it had a sunlit, pale-yellow glory, in summer it was deep, restful green, in autumn it was gold and bronze, in winter it was a gnarled network of branches. It was in winter you saw best the tree's reality, its build-up and strength.

On the whitewashed underside of the roof shingles of my attic room I painted two immense totemic Indian Eagles. Their outstretched wings covered the entire ceiling. They were brave birds, powerful of beak and talon. Their plumage was indicated in the Indian way—a few carefully studied feathers painted on wing, breast, and tail gave the impression that the bird was fully plumed.

Sleeping beneath these two strong birds, the stout Western maple tree beneath my window, is it wonder that I should have strong dreams, dreams that folded me very close!

One night I had a dream of greenery. I never attacked the painting of growing foliage quite the same after that dream I think; growing green had become something different to me.

In my dream I saw a wooded hillside, an ordinary slope such as one might see along any Western roadside, tree-covered, normal, no particular pattern or design to catch an artist's eye were he seeking subject-matter. But, in my dream that hillside suddenly lived—weighted with sap, burning green in every leaf, every scrap of it vital!

Woods, that had always meant so much to me, from that moment meant just so much more.

Alternative

"Ladies approaching seventy must not expect to work like girls of seventeen—it is unreasonable."

The doctor's voice was reproving but kindly.

"Overdoing has enraged your heart. To begin with we will see what a good long rest in hospital will do."

"How long?"

The doctor resorted to a professional shrug and the spreading of his palms.

"Another thing . . ." he paused. . . . His eyes roved round my studio, finally resting contemplatively on a small monkey and a mother dog and her four

pups on the hearth rug. "I notice you have an aviary of birds on the veranda," he mused. "Livestock entails work. You must limit yourself now to a minimum of exertion, throw everything not imperatively necessary overboard. Goodness, you have done a lot of work!"

His eyes roved from my menagerie to my full canvas racks.

My breath caught, "Not half what I want to, Doctor. You don't mean— you are not telling me my painting days are done! Oh, lovely, all-alone caravan-days in the quiet, woodsey camps with my creatures! Seventy isn't so frightfully old!"

"We will talk of that after we see what rest does for that heart; meantime, take things very, very easy. I will engage a room in the hospital for you. One thing certain! Trips alone must be given up."

"Ugh, my stupid heart needs a chaperon! No thank you, I will stay at home. I never could work with danglers hanging round."

The weeks in hospital sauntered slowly by till Eric Newton, noted Art Critic for the *Manchester Guardian*, paid a visit to the West. Eric Brown, Director of the Ottawa National Gallery, had asked Mr. Newton while out west to select some fifteen pictures of mine and ship east. He had prospective buyers. Mr. Newton wired me from Vancouver. Finding I was in hospital he came there to see me.

He said, "As I drove over the Island Highway I saw *Emily Carr pictures* in the woods no matter in which direction I looked. You have caught the Western spirit." Folding his hand over my two sick ones he added, "Get better, these hands are too clever to lie idle."

I turned my face away. What good getting better if I was never to roam the woods again, paint-sack on shoulder, dog at heel?

"Wa! Wa! Wa!"

The maternity ward was across the court from my room. New-borns were taking the unknown life before them hard. Ah! The price of being was this adjusting ourselves to life at different angles.

I blinked hard a time or two and turned back to Mr. Newton.

"All right, I'll try to get well."

When Lawren Harris advised me, "Put aside the Indian motifs, strike out for yourself, Emily, inventing, creating, clothing ideas born of this West, ideas that you feel deep rooted in your heart," I sat before the woods and stared, lost, frustrated. I had let myself be bound. It was not handling of paint but handling of thoughts which overwhelmed me. Trying to get around this problem, I took always in my sketch-sack a little note book. When I had discovered

my subject, I sat before it for some while before I touched a brush, feeling my way into it, asking myself these questions, "What attracted you to this particular subject? Why do you want to paint it? What is its core, the thing you are trying to express?"

Clearly, and in as few words as possible, I had answered these questions from myself to myself, wording them in my little note book, presenting essentials only, discarding everything of minor importance. I had found this method very helpful. This saying in words as well as in colour and form gave me double approach. I knew nothing about the rules of writing.

The only author I had ever met was Fred Housser, who wrote *A Canadian Art Movement*. When I stayed with the Houssers in the East, Fred had let me read two of his manuscripts. He talked with me about them afterwards. When I went home I wrote an Indian story and sent it to Fred, asking criticism. He liked my story and wrote me a wonderful letter, finding much fault in my construction, taking infinite pains to explain a story's build-up.

"You do not want 'eye-wash'," he wrote and struck hard. The letter made a great impression on me.

When I grinned back at Mr. Newton and said, "I'll try to get better," I had this idea in the back of my mind—"One approach is apparently cut off, I'll try the other. I'll 'word' those things which during my painting life have touched me deeply."

"Doctor, may I write?"

"Write? Write what?"

"Describe places I've seen on my sketching trips, woods, Indians and things—nice Canadian things of the West, things that will heal, not rile my heart."

"You can try, but don't get excited, don't overtire."

The nurse was told to watch. She kept bouncing in and grabbing my wrist—she did not approve of the doctor's permission, but had to admit that, instead of doing me harm, it soothed and calmed me.

I did not know book rules. I made two for myself. They were about the same as the principles I used in painting—Get to the point as directly as you can; never use a big word if a little one will do.

So I wrote the stories that were later to be known as *Klee Wyck*, reliving those beautiful, calm places among the dear Indians. Their quiet strength healed my heart. Of course it could not heal old age, but it healed me enough that I could go home and take up that easy, easy life the doctor prescribed. No more was I to go off in my old van alone—that was too strenuous. About that he was firm.

While I was still in hospital, Eric Brown wrote me. For a good many years he had taken interest in and been most helpful about my work. He said my isolation out West was making me think for myself and it showed in my canvases. (I was sending each year to Eastern Exhibitions.) He now wrote, "Will you collaborate with a biographer? We want the 'struggle story' of your work out West written. Better still, will you write it yourself?"

"I don't know how to write," I answered Mr. Brown. "My Indian stories (I had told him about writing them) are just fun and they're medicine. I go back so vividly on those sketching trips, that I forget being sick."

I was fond of Eric Brown; he had dug me out of that dreadful slough of despair at the time when I was too disheartened to paint. I wanted to please him.

I said, "Nobody could write my hodge-podge life but me. Biographers can only write up big, important people who have done great deeds to which the public can attach dates. I could not be bothered with collaborators, nor would they be bothered with the drab little nothings that have made up my life. However, to please you, Mr. Brown, I will have a try."

I had only a few chapters written, and was still in hospital, when I got word that Eric Brown was dead. Following close on the news of his death came the death of my Indian friend Sophie around whom many of my Indian stories were written. Writing as well as painting paused a little inside of me, but soon the "easy" life began to bore me and I continued the biography.

I had two faithful women friends who were very patient in listening to my script—Ruth Humphrey and Flora Burns. It is a tremendous help to hear words with the ears as well as to see them with the eyes; so I read aloud to these friends and received helpful criticism from them.

When I had about three chapters of the biography written I read them to my only surviving relative—a sister. She was very, very angry. She accused me of being disloyal to my family and altogether abominable.

It had been absolutely necessary for truth's sake to include a short few pages on our home life which for me had not been happy after the death of our parents. I had to show what drove me to the woods and to the creatures for comfort, what caused the real starting point of my turn to Art. My family had never been in sympathy with my painting, nor entered into my life as an artist. My home life was always a thing entirely apart from my art life.

My Indian sketches lay in my bureau drawer. My two friends thought I should endeavour to seek a publisher for them. They suggested I send them to a publishing firm in Toronto. I did so. For months I received no word, good or bad. At last I wrote the publishers and was coolly informed that they had been

unable to use the stories but unfortunately they had lost them. They regretted the fact, but there it was—they were lost!

I was furious at their indifference and their carelessness. I wrote and wrote, giving them no peace. I wrote to the head, and the tail, and all the other members of the firm that I could attach a name to. I said, "I have no other copy of the manuscript. It is up to you—it must be found."

The manuscript remained lost for one whole year. Then it was returned to me. They claimed it had slipped off a desk and fallen among a box of books being packed for Queen's College. If that was the case, why had not Queen's College returned it to the publishers when they unpacked their books, not held it for a year? I am convinced it never would have turned up but for the unpleasant nagging I gave the entire lot of them. They told me they never were so glad to return anything to anybody. I had tormented them so.

I too was weary of the nuisance by then. I did not try another publisher. I stuck the manuscript way in a drawer and forgot it.

One of the faithful "listening ladies" who had sat patiently while I read my stories aloud borrowed them, took them to Vancouver and showed them to Ira Dilworth, one-time principal of Victoria High School, later Professor of English at the University of British Columbia and now attached to the CBC at Vancouver.

He was interested and said he would like to have some of the stories read over the radio. He came to see me about it.

The first series of six readings was done by Dr. G. G. Sedgewick of the University of British Columbia, who had seen some of my work earlier. The second series was read by Mr. Dilworth himself. They pleased the air audience. Shortly after reading the second series, Mr. Dilworth went East, taking with him the manuscript which he showed to his friends, Mr. and Mrs. Clarke. On his return from the East he came to see me. He said, "Mr. Clarke wants to publish two volumes of your writings,—one of the Indian stories, the other stories of your childhood."

"Is it possible!" I gasped.

My one publishing try had been so disastrous. I supposed my stories not up to much as they were so indifferent when they were lost.

"What about my punctuation and spelling, Mr. Dilworth? They are awful, you know."

"We can get around that. If it is all right with you, I shall act as your honorary editor."

I can well imagine the relieved "Oh!" I gave then. Spelling and punctuation always were such a horrible trial to me, and now here was a genuine professor

offering to stand behind me, ready to be appealed to! His kindness lifted a tremendous load from me, just as if he had kicked all the commas, full stops, quotes and capitals right to another planet.

Mr. and Mrs. Clarke came West that autumn. Mr. Dilworth brought them to see me. We were to proceed with the work at once. They conferred as to which book should be published first. At first it seemed in order that it should be the childhood stories. On the other hand, my Indian pictures had been exhibited quite a bit in the East. That would, to some extent, lay a foundation for the Indian stories. It was, therefore, decided that these should have first place.

I cannot describe the terror-shakings that overtook me as the stories and I awaited our Editor. I felt so shamed, so terrifically ignorant. I wished I had been a better student, that I had not scuttled off to San Francisco Art School, skipping my last year of "High". I had heard of Mr. Dilworth as a scholar and a very fine teacher. I should die of shame.

We sat down at a table in my studio and alternately read to each other from the script. In two seconds I was not afraid any more.

"Two 'l's' there, one 's' only," he corrected as we read, or, "New sentence here, new paragraph there," but he made me feel such things were subservient and of secondary importance to the spirit of the text. At once I knew he loved Indians and the West just as I did. My Editor never altered my wording arbitrarily. Occasionally he suggested re-phrasing a sentence, always explaining why. He never added or omitted anything without consulting me. Sometimes he made suggestions, but he made me re-word the thought myself. He was a million times younger, a million times cleverer than I but he never made me feel an old fool, or finished, or stupid, or ignorant. Long before the work on the manuscript was finished he was just plain "Eye" to me.

I shall never forget the editing of *Klee Wyck*—the joy of those hours—nor all it taught me. I was almost sorry to see her finished and shipped off to the publisher. After a while she came back—a book!

Seventieth Birthday and a Kiss for Canada

*K*lee *Wyck* made her first appearance a few days before I was seventy. Victoria was astonished at her. Victoria had never approved of my style in painting. When my painting was accepted in the East a few Westerners tolerated it, a smaller number found they actually liked it. *Klee Wyck* and, a year later, *The Book of Small* Victorians took straight to their hearts and loved even before the favourable Eastern reviews appeared.

Klee Wyck got wonderful press reviews right across Canada. Letters, phone calls came from everywhere. People were not only warm but enthusiastic. I was staggered. My Editor wrote a foreword for *Klee Wyck*. He was also asked by *Saturday Night* of Toronto to write two articles, one on my work, one on me. Following the publication of *Klee Wyck* these appeared in two consecutive issues. Eye showed the script of them to me before sending it east. I wriggled with embarrassment. Those things could not be about me and my work! It was so strange a hearing for my ears. Out west they had slanged, ridiculed my painting.

I had just finished reading the two articles when Lawren Harris came to see me. He too had written a beautiful review of *Klee Wyck* for *The Canadian Forum*. I showed him Ira Dilworth's articles and told him how I felt about the whole matter. This was his answer—"Keep your nose from where it does not belong. We painters and writers have our own work to do—good, let us do it. The critic has his work to do. That is his business, not ours."

I put the critics and their reviews clean out of my head. When reviews came, praise after praise from all over Canada (some from England too; the Oxford University Press have their head office there), I was just very pleased, read them to my sister who wanted to hear, put them away and thought no more about them. I had letters from such different kinds of people, from University professors, very kind about the way I used English in my writing, from lumbermen and fishermen who said, "It is our West Coast, dense, rugged and lavishly watered with mist and rain", from children who said, "We just love *Klee Wyck*!" Even two Missionaries who had worked among the Indians on the West Coast wrote liking the book. She was accepted by libraries and reading clubs, and was the subject of book reviews over the radio.

The Victoria Branch of the University Women's Club did me the honour of inviting me to be an honorary member of their branch. I was so astonished I did not quite know how to act. I had always maintained that unearned honours were stupid shams. Look how hard real members worked to earn their membership—why should I, never having even squeaked through High School, be honoured by a University Club membership? Half of me said, "I can't!" The other half said, "But, I would be very proud." So I took, thanked and am.

A few days before my seventieth birthday, a member of the University Women's Club telephoned me congratulations on *Klee Wyck*. She said, "Our Club would like to honour you and *Klee Wyck* by having a little tea-party for you. Are you well enough? We know how ill you have been—and, by the way, have you not a birthday coming pretty soon?"

I replied that I had not been out since my illness, but that I thought I could

manage it, that it was very kind of them and that the following Saturday was my seventieth birthday.

"Then that is the day we will set for the party," she said, "I am lending my home for it. Some of the Club ladies will call for you."

I imagined it would be a gathering of perhaps six or at most a dozen of the Club members.

On Saturday I was dressed and waiting when in walked Eye.

"Ready?" he asked. "I've come to take you to the party."

"The University Women's tea-party? I am expecting them to pick me up, they promised, so I can't go with you, but how did you know there was to be a party?"

"I am invited. Furthermore, I am going to read out of *Klee Wyck*. It's a big affair, men as well as women coming to honour you and *Klee Wyck*."

"Oh," I said, "I thought it was only half a dozen ladies and a cup of tea."

"It's going to be mammoth—your townspeople, as many as the house will hold—don't get scared."

"Will there be speeches?"

"I should say so!"

"Will I have to reply?"

"I do not think it will be expected of you. They know you have been ill."

"It would be very ungracious to say nothing at all. They have been so kind to me and to the book; I'll scribble a few words and if, as so often happens, my voice goes, will you read them for me, Eye? Oh, I am so glad you are going to be there, I'm frightened."

"Don't worry, you'll be all right."

I scratched a few words on an envelope and clapped it in my spectacle case; then the ladies came for my sister and me.

Our hostess, Mrs. Young, had a big house, large rooms. When I saw them packed with people I dropped into the first chair inside the front door and wilted. Mrs. Young came and stood beside me protectingly so that people would not know I had come. After a few moments I got up and took her arm.

"I'm ready."

She led me into the drawing room and sat me on a pink sofa under a stand lamp. It had commenced to blow and snow outside. Inside all was cosy. My sister was on another sofa across the room and Mrs. Young saw that she had people about her that she knew because my sister is shy and nearly blind; she looked happy and I made up my mind I was going to enjoy my party to the full.

"The Reverend T. Laundy," Mrs. Young said, "will open the occasion with a short invocation."

The Reverend offered a short prayer. I was glad Mrs. Young had invited God to my party.

Then the master of ceremonies came forward, a sheaf of open letters in his hand—letters of congratulation from Victoria's citizens and from the various organizations in the city, good wishes for my birthday and for *Klee Wyck*. A mail box had been placed beside my sofa and I had wondered why. Now I saw that many of the guests carried envelopes. The first letter read was from the Lieutenant-Governor regretting he was not able to be present but sending best wishes; then came letters from the Mayor and Aldermen, the University Women's Club, the Canadian Club, the Native Daughters. There was one from the head of Indian Affairs on behalf of himself and the Coast Indians. After the master of ceremonies had read that many aloud, men and women representatives from many other organizations in Victoria stepped up to my mail box, dropped in their societies' letters and shook hands with me.

Eye stood close beside my sofa. If I did not quite know how to act or what to say, he told me. He was strength and comfort as he had been over editing *Klee Wyck*. Dear Eye! He knew the right way and it made me feel safe.

There were flowers, such beautiful flowers! Bouquets, boxes, corsages heaped round my sofa—someone was always coming up with more. It was like having a beautiful funeral only being very much alive to enjoy it. Such an easy, comfortable party! I found myself having a very good time.

After my right hand had nearly been shaken off there were speeches. Lovely things were said about *Klee Wyck*. When everybody had said everything there was to say, came a tiny pause. I whispered to Eye, "Is it my turn now?" I was shaking with fright. He nodded but, when I went to rise, he put his hand on my shoulder and kept me sat.

"Sure you can make it?"

"Yes," I replied.

My voice rang out strong as a bull's and I was not scared. This is what I said—the envelope is still in my spectacle case—"Thank you everybody for giving me such a splendid, happy birthday party and for being so kind to *Klee Wyck*. I would rather have the good-will and kind wishes of my home town, the people I have lived among all my life, than the praise of the whole world; but I did not write *Klee Wyck*, as the reviewers said, long ago when I went to the West Coast Villages painting. I was too busy then painting from dawn till dark. I wrote *Klee Wyck* one year ago in hospital. They said I would not be able to go about painting here and there any more, lugging and tramping. I was

sore about it, so, as I lay there, I relived the villages of *Klee Wyck*. It was easy for my mind to go back to the lovely places. After fifty years they were as fresh in my mind as they were then because while I painted I had lived them deep. I could sail out of hospital and forget about everything. It was *Klee Wyck* gave my sick heart courage enough to get better and go home to the easy life the doctor had told me I had to expect now."

"Bravo! You'll be a public speaker yet!" whispered Eye in my ear. Then he took *Klee Wyck* in his hands and stood in a central spot to read. When the chairs and sofas were full, people sat round on the floor.

Eye is a beautiful reader. He read *Canoe* and *Juice*. Then he talked about several of the longer stories. He commented on *Klee Wyck*'s place in Canadian literature and how privileged I had been to see the Indian people in their own homes and villages. He said by writing *Klee Wyck* and by painting our woods I had made a contribution to Canada's art and literature.

Eye stopped speaking and the room was very still, so still I was scared— "Perhaps everyone does not like Indians!"

Then everybody began to chatter at once. Praise, praise, praise for *Klee Wyck*. I ducked my face into a box of beautiful chrysanthemums and red carnations that the Canadian Press had sent me.

I did not see or hear Eye cross the room, but suddenly I was aware of a great kindness there before me and the kindness stooped and kissed my cheek!

It was the proudest moment of *Klee Wyck*'s success when, before them all, Eye stooped and gave me that kiss for Canada, prouder far than when *Klee Wyck* won the Governor-General's medal for best non-fiction for Canada in 1941. The medal looked to me to be made of the same metal as our old cowbell. "It is the honour," everyone said, "and remember it is war time!" But the kiss for Canada was made of the pure, real stuff, unadulterable.

We had refreshments and a huge lighted birthday cake and grapefruit punch for healths and "God Save the King." Again I went to stand, again Eye's hand kept me down. "You are tired enough," he said. "Come," and took my sister and me home to begin my seventy-first year.

The Book of Small

One year after the publication of *Klee Wyck*, *The Book of Small* appeared. I had wintered in a Nursing Home. Domestic help and fuel problems were difficult owing to war. I was quite eligible for a Nursing Home because I was really ill.

There I lay waiting and waiting for Small to come from the publisher. The publishing houses were under a heavy war strain—men, presses, material; but at last the book came in a smart green jacket with a medallion of the little old Small in the centre.

The Book of Small was entirely different from *Klee Wyck*. She was bigger. Some people liked her more, some less. The first half of Small was a collection of childhood (our childhood) stories, the life we lived in the far West where Father and Mother pioneered and raised their large family.

The other half of Small was called *A Little Town and a Little Girl*. It told of little old Victoria before she was even a town. Nearly all the people who lived there were English and they had a good many difficulties to cope with. They had only small Chinaboys as helps, no plumbing, only pumps and wells, no electric light and no telephone. Indians went round the streets selling their beautiful cedar-bark baskets or trading them for old clothes, or peddling clams or pitch wood tied in bundles for the lighting of fires. *The Book of Small* told of the slow, conservative development of Canada's most Western city.

My Editor was up north on a business trip. He had waited impatiently for the appearance of Small. She came the day he left. He wrote me, "I suppose you are being swamped with fan mail."

No, Small lay shut in a drawer. I could not bear to look at her. She lay there for three or more weeks. No reviews, no letters came about *The Book of Small*. They had followed the appearance of *Klee Wyck* immediately or within a few days. In bitterness and disappointment I turned to the wall. My Editor came back from the North and, coming to Victoria, dashed into my room.

"The reviews? The letters?"

"There aren't any. Oh, Ira, she's flopped. Small has flopped dead. I'm so shamed!" and I cried till I nearly drowned him. He looked perplexed.

"I can't understand it. Clarke and I both thought she was the equal, if not better than *Klee Wyck*. She can't have flopped!"

I hid my shamed face in the pillow.

"I don't care so much about Small and me, but I've disappointed you and Bill Clarke."

I howled quarts of tears that had been strangled back for three weeks.

"The Press too, Small will be a dead loss to them. I wrote Bill last night and told him how dreadful I felt."

"Cheer up, remember it's war time and everything is higgledy-piggledy. There has been a hold-up somewhere. It's a marvel to get a book published at all these days! All dates are uncertain. Reviewers can't review till they have got the stuff, nor the booksellers sell till they have the books."

He left me cheered, but not convinced. I could only wail, "She's flopped, she's flopped! Small's flopped!"

"Silly!" said my Editor, "you'll see. Small's all right. Look at the reception *Klee Wyck* got; Small will too—give her time."

Letters came from both Mr. and Mrs. Clarke. Kind letters they were, very upset that I should have thought Small had flopped. There had been delays, just as Eye had said, owing to war conditions. The date of publication had had to be postponed several times, the reviews could not come out till the critics got the books and read them. Shipments of books had been late going to the bookstores and libraries. The reviews were just as good, just as complimentary, as those of *Klee Wyck*.

Eye wrote from Vancouver, "What did I tell you? All who read Small (and everyone is reading her now) love her. Bookstores are sold out of copies!"

Mr. Clarke made his autumn trip to the West—dear Bill and his kind little wife felt so sorry about all the doldrums I had been through because of Small. Bill's first question was, "Is the next book ready? I plan to publish one each year." The script was ready, but we were deeper than ever in war. Hitler is a nuisance from every possible angle!

Wild Geese

S pring was young, I over seventy. With Spring all about me I sat sketching in the clearing that was now given over to second growth—baby pines, spruce, hemlock, cedar and creeping vines, fireweed, bracken.

The clearing was off the Happy Valley Road at Metchosen, not far from Victoria. Seventy years had maimed me, loggers had maimed the clearing. I could no longer scramble over great logs nor break my way through networks of brambles, creep under bushes and drown myself crown-high in lush, young growth. I had to be taken out, set down and called for, which was a nuisance, but I got immense delight in just being there, in the quiet wood, nobody for company but Spring.

Though everything was so still, you were aware of tremendous forces of growth pounding through the clearing, aware of sap gushing in every leaf, of push, push, push, the bursting of buds, the creeping of vines. Everything expanding every minute but doing it so subtly you did not actually see anything happen.

In spite of the doctor I went into the woods to paint a few times more. The longing was too terrific to subdue and I felt better. I did not go in my old van

(it was deteriorating with unuse so I had sold it). I rented a cabin and took a maid along to cook and carry for me.

The maid was too busy attending to her own work to bother about me; she carried my things out into the woods and came back for them and me later. I was very happy but the last expedition I over-did and came smash.

For a year painting lay dormant but I did some writing. One day a friend took my sister driving. On the way they planted me in a thick lonely place just off the high road while they took a long ride. It was here that I painted *The Clearing* and here the wild geese flew over.

Hark! Hark! High up in the blue, above the clearing, wild geese migrating. Honk, honk, ya honk! A triangle of noisy black dots.

Every Canadian thrills at the sound—the downpour of cackling honks broken, irregular, scattering with the sharp monotony of hailstones while the geese sail smooth and high, untroubled by fear of men, for migrating geese fly far, far above man's highest shooting.

On the ground the wild goose is a shy, quiet fellow. In the sky he is noisy and bold.

I lifted my face to watch the honking triangle pass across the sky. The day was clear, not dazzle-bright. I could look into the face of the sky without blinking. There was just one cloud. The geese caught up with the cloud. The leader dove into it, his flock followed. For a few seconds the cloud nestled the geese to her breast, emptying the sky, muffling the honkings, but the company pierced through the cloud. The leader and those few birds that fly in close formation behind him appeared, then the two long wavering side lines of singly-spaced birds emerged, to continue their way sailing, sailing into the north, one glad rush of going, one flock unswervingly following one leader. At that height each bird appeared no bigger than a small black bead, evenly strung one goose behind the other, a live necklace flung across the throat of heaven.

The racket passed over the clearing, the sky was again still, my eyes came back to the greying stumps amongst which I sat. Young growth had already hidden some. Even the echoes had forgotten how they had shrieked sympathy when the axes bit into the great original forest giants, forgotten the awful crash, the groan, the tremble of the ground as each tree fell.

Today the clearing was not sun-dazzled, rather it was illumined with Spring, every leaf was as yet only half unfurled and held light and spilled some.

Today at seventy I marvelled more at the migration of the geese than I had at the age of seven when, standing in our cow-pasture holding Father's hand and

looking up into the sky, I heard Father tell the story of bird-migration and only half believed. Today a new wondering came to me as I watched the flight. What of the old or maimed goose who could not rise and go with the flock? Of course there *was* the old, the maimed goose. What of him when the flock, young and vigorous, rose leaving him grounded? Did despair tear his heart? No, old goose would fill the bitter moment, pouring out proud, exultant honks that would weave among the clatter of the migrating flock. When the flock were away, animal-wise he would nibble here and nibble there, quietly accepting.

Old age has me grounded too. Am I accepting? God give me the brave unquestioning trust of the wild goose! No, being humans, we need more trust, our hopes are stronger than creatures' hopes. Walt Whitman's words come ringing,—*We but level this lift to pass and continue beyond.*